MANCHESTER CATHEDRAL

Manchester University Press

MANCHESTER CATHEDRAL

A history of the
Collegiate Church
and Cathedral,
1421 to the present

Edited by
JEREMY GREGORY

Manchester University Press

Published by Manchester University Press
Oxford Road, Manchester M13 9PL

www.manchesteruniversitypress.co.uk

This publication was made possible thanks to the generous support of the Friends of Manchester Cathedral

British Library Cataloguing-in-Publication Data

A catalogue record for this book is available from the British Library

ISBN 978 1 5261 6126 0 hardback

First published 2021

Typeset in Great Britain by Dave Rodgers
Printed in Great Britain
by Bell & Bain Ltd, Glasgow

Contents

Illustrations

Chapter 1

Chapter 2

Chapter 3

Chapter 4

Chapter 5

Chapter 6

Chapter 7

Chapter 8

Chapter 9

Chapter 10

Chapter 11

Chapter 12

Chapter 13

Contributors

Peter Arrowsmith is an independent archaeological consultant and a former Deputy Director of the University of Manchester Archaeological Unit.

Ian Atherton is Senior Lecturer in Early Modern British History at Keele University. He is a co-editor of *Norwich Cathedral: Church, City and Diocese, 1096–1996* (London: Hambledon, 1996) and has written a number or essays and articles about post-Reformation British cathedrals, including in Dee Dyas and John Jenkins (eds), *Pilgrimage and England's Cathedrals: Past, Present, and Future* (Basingstoke: Palgrave Macmillan, 2020), P. S. Barnwell and Trevor Cooper (eds), *Places of Worship in Britain and Ireland, 1550–1689* (Donington: Shaun Tyas, 2019) and Anthony Milton (ed.), *The Oxford History of Anglicanism*, 1: *Reformation and Identity, c.1520–1662* (Oxford: Oxford University Press, 2017).

Sarah Boyer is the author of several articles on seventeenth-century English liturgical music. She has taught at the University of Manchester and for the Open University, and her work as a music examiner has taken her round the world. Her current research is concerned with a study of various music manuscripts, and the role of their copyists.

Arthur Burns is Professor of Modern British History at King's College London and Academic Director of the Georgian Papers Programme. He is a former Vice-President of the Royal Historical Society and a member of the Council and Executive of the Historical Association. He is the author of *The Diocesan Revival in the Church of England c. 1800–1870* (Oxford: Oxford University Press, 1999) and a co-editor of *St Paul's: The Cathedral Church of London, 604–2004* (New Haven, CT, and London: Yale University Press, 2004), *Rethinking the Age of Reform: Britain 1780–1850* (Cambridge: Cambridge University Press, 2003) and *Walking Histories* (Basingstoke: Palgrave, 2016). He is a Co-director of the online Clergy of

the Church of England Database 1540–1835, and has published widely on the modern history of the Church of England.

John Dickinson is Senior Governance Officer at Lancaster University. He has given many public lectures on misericords and is the author of *Misericords of North West England: Their Nature and Significance* (Lancaster: Centre for North-West Regional Studies, Lancaster University, 2008).

Jeremy Gregory is Pro-Vice-Chancellor for the Faculty of Arts and Professor of the History of Christianity at the University of Nottingham. He previously worked at the University of Manchester, where this project was conceived. He is the author of *Restoration, Reformation, and Reform, 1660–1828: Archbishops of Canterbury and their Diocese* (Oxford: Oxford University Press, 2000) and the editor of *The Oxford History of Anglicanism, 2: Establishment and Empire, 1662–1829* (Oxford: Oxford University Press, 2017). He contributed to Patrick Collinson, Nigel Ramsay, and Mary Sparks (eds), *A History of Canterbury Cathedral, 598–1982* (Oxford: Oxford University Press, 1995) and Derek Keene, R. Arthur Burns, and Andrew Saint (eds), *St Paul's: The Cathedral Church of London, 604–2004* (New Haven, CT, and London: Yale University Press, 2004).

Matthew Grimley is Mark Reynolds Fellow and Tutor in History at Merton College, Oxford, and Associate Professor of History at the University of Oxford. He is the author of *Citizenship, Community and the Church of England: Liberal Anglican Theories of the State between the Wars* (Oxford: Oxford University Press, 2004), and co-edited *Redefining Christian Britain: post 1945 Perspectives* (London: SCM, 2006) and *The Church of England and British Politics since 1900* (Woodbridge: Boydell, 2020). He also contributed a chapter to Jeremy Morris (ed.), *The Oxford History of Anglicanism, 4: Global Western Anglicanism, c.1910–present* (Oxford: Oxford University Press, 2017).

Clare Hartwell is an architectural historian with a focus on the north-west of England, where she studied and worked for almost forty years. Publications include *The Pevsner City Guide, Manchester* (Harmondsworth: Penguin, 2001) and *The History and Architecture of Chetham's School and Library* (New Haven, CT, and London: Yale University Press, 2004). Hartwell was a revising author and co-author for a number of county volumes in the Buildings of England series by Nikolaus Pevsner, including those covering Lancashire, Cheshire, and Derbyshire.

Marion McClintock, MBE, is Honorary Archivist and Honorary Fellow at the University of Lancaster, and an external consultant to Manchester Cathedral. Following a career in university administration, she is a trustee to historically related charities in the north-west. She has published on university history, and on vernacular and ecclesiastical architecture.

Jeremy Morris is Master of Trinity Hall, Cambridge and a canon of Ely Cathedral. He is a specialist in modern religious history, including the Anglican tradition, the ecumenical movement, and arguments about secularization. His books include *The Church in the Modern Age* (London: I. B. Tauris, 2007), *The High Church Revival in the Church of England: Arguments and Identities* (Leiden: Brill, 2016) and (as editor and contributor) *The Oxford History of Anglicanism, 4: Global Western Anglicanism c.1910–present* (Oxford: Oxford University Press, 2017) and *A People's Church: A History of the Church of England* (forthcoming). He is a former Deputy Chair of the Faith and Order Commission of the Church of England.

Henry D. Rack is Honorary Fellow and retired former Bishop Fraser Senior Lecturer in Ecclesiastical History, University of Manchester. He is author of *Reasonable Enthusiast. John Wesley and the Rise of Methodism* (3rd edn; Peterborough: Epworth, 2002) and editor of *The Methodist Societies: The Minutes of Conference*, volume 10 of *The Bicentennial Edition of the Works of John Wesley* (Nashville, TN: Abingdon, 2011). He has written a number of specialist journal articles on religion in eighteenth-century Manchester and contributed biographies of a number of the clergy associated with the Collegiate Church to the *Oxford Dictionary of National Biography* (Oxford: Oxford University Press, 2004).

Lucy Wooding is Langford Fellow and Tutor in History at Lincoln College, Oxford, and Associate Professor of History at the University of Oxford. She was formerly Reader in History at King's College London. She is the author of *Rethinking Catholicism in Reformation England* (Oxford: Oxford University Press, 2000) and *Henry VIII* (London: Routledge, 2009).

Terry Wyke taught economic and social history at Manchester Metropolitan University, retiring in 2017. His publications include *Bridgewater 250: The Archaeology of the World's First Industrial Canal* (Salford: Centre for Applied Archaeology, University of Salford, 2012 with Michael Nevell), *Spindleopolis: Oldham in 1913* (Oldham: Oldham Council and Manchester Metropolitan University, 2013 with Alan Fowler), *Manchester: Making the Modern City* (Liverpool:

Liverpool University Press, 2016 with Alan Kidd), *Manchester: Mapping the City* (Edinburgh: Birlinn, 2018 with Brian Robson and Martin Dodge) and *A Bread and Cheese Bookseller: The Autobiography of James Weatherley*, CS 3rd series 55 (Manchester: Chetham Society, 2021 with Michael Powell). He was one of the founder editors of the *Manchester Region History Review*.

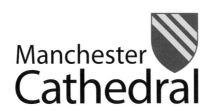

Manchester
Cathedral

Foreword

When Henry V granted the licence to Thomas de la Warre in 1421 for the transformation of a church named for the Virgin Mary into a collegiate foundation dedicated to St Mary the Blessed Virgin, St George, and St Denys, he was marking the significance of the earlier church and paving the way for an illustrious future. Queen Victoria's approval in 1847 of the foundation becoming a cathedral was its final step to national prominence. It is a matter of pride and pleasure that in 2021 we commemorate the six hundredth anniversary of the Collegiate Church, while recollecting with gratitude the millennium and more that a church on this site has stood for the worship of God and service to all.

This volume recounts that history, as well as exploring important themes such as the architecture and the music that help to complete the story. The Cathedral's long pre-history and history mirrors the many tumults of the periods it covers, from Domesday through the Reformation and the Civil War, the Industrial Revolution, the anti-slavery movement, two world wars, and a terrorist assault on Manchester in 1996. A new millennium has brought fresh challenges, the most recent a virus that has brought our society to a halt in a manner never anticipated. Amidst constant change, the single certainty about the future is that the Cathedral should remain a steady worshipping presence in the City of Manchester, continuing its act of service begun six hundred years earlier.

We are deeply grateful to all the contributors for the time and care they have devoted to this volume, to Jeremy Gregory for his editorship over a long period, and to the late Michael Powell for the part he played in taking the volume forward. We also thank Marion McClintock for her help, and for her generous

sponsorship of the book launch, and Manchester University Press for their care in bringing the book to completion. Our hope is that readers will find much of interest, reflection, and surprise in its pages, and that as a result they will come to know us better as we look together to the future.

The Very Reverend Rogers Govender,
Dean of Manchester

The Right Reverend Dr David Walker,
Lord Bishop of Manchester

Feast of the Blessed Virgin Mary, 2021

Preface

The project of writing this official modern history of Manchester's Collegiate Church and Cathedral was first mooted as long ago as 2007 and I am very grateful to the Dean and Chapter, and the contributors, for their forbearance. I would like to thank the Cathedral and the University of Manchester for supporting the series of workshops, held in the Cathedral's Visitor Centre, where authors first shared their thoughts, Dean Rogers Govender and Canon Andrew Shanks for their early commitment to this enterprise, the Friends of Manchester Cathedral for their subvention towards this publication, and Matthew Frost, Alun Richards, and colleagues at Manchester University Press. Thanks, too, to Anthony O'Connor, the Cathedral's Director for Fundraising and Development, for his help in the final stages and in particular with the photography, and to the University of Nottingham. Tim Grass, as always, has been a superb copy-editor.

Endeavours such as this are highly dependent on the expertise and skills of archivists and librarians. It is highly unlikely that we would have begun this venture were it not for Christopher Hunwick, who, as Cathedral Archivist from 2003 to 2007, did a herculean job in ordering the archives. Kevin Boulton, formerly Principal Archivist, Manchester City Archives, and Fergus Wilde, Chetham's Library, also provided valuable assistance.

Above all, we owe a huge debt to Michael Powell, Chief Librarian, Chetham's Library, for thirty-five years, and honorary archivist and honorary lay canon of Manchester Cathedral from 2012. From the start, Michael was enthused by this undertaking and he shared his unrivalled knowledge of the College and Cathedral with us, and was able to read draft chapters before his untimely death in early 2019. While I dearly wish he had been able to work with me on the final version – where he would have corrected some egregious errors which no doubt remain – I hope he would have been pleased with the end result. We dedicate this volume to his memory.

Jeremy Gregory

Abbreviations

BIA	Borthwick Institute for Archives
BJRL	*Bulletin of the John Rylands Library*
BL	British Library
Bodl.	Bodleian Library
CALS	Cheshire Archives and Local Studies
CERC	Church of England Record Centre
CL	Chetham's Library
CS	Chetham Society
CSPD	*Calendar of State Papers Domestic*
EHR	*English Historical Review*
ESTC	English Short Title Catalogue
GMCRO	Greater Manchester County Record Office
HJ	*Historical Journal*
HLRO	House of Lords Record Office
HMC	Historical Manuscripts Commission
HMSO	Her/His Majesty's Stationery Office
JEH	*Journal of Ecclesiastical History*
JRL	John Rylands Library
LPL	Lambeth Palace Library
LRO	Lancashire Record Office
MC	*Manchester Courier*
MCA	Manchester Cathedral Archives
MCL	Manchester Central Library
MCM	Manchester Cathedral Muniments
MEN	*Manchester Evening News*
MG	*Manchester Guardian*
MM	*Manchester Mercury*
MT	*Manchester Times*

NH	*Northern History*
ns	new series
ODNB	H. C. G. Matthew (ed.), *Oxford Dictionary of National Biography*, 63 vols (Oxford: Oxford University Press, 2004)
os	old series
RSLC	Record Society of Lancashire and Cheshire
SCH	Studies in Church History
s.n.	*sub nomine* (under the name)
SPCK	Society for Promoting Christian Knowledge
SRO	Staffordshire Record Office
THSLC	*Transactions of the Historic Society of Lancashire and Cheshire*
TLCAS	*Transactions of the Lancashire and Cheshire Antiquarian Society*
TNA	The National Archives
UL	University Library
VCH	Victoria History of the Counties of England

*Facing page and overleaf:
Fire Window;
'A little dusty angel'*

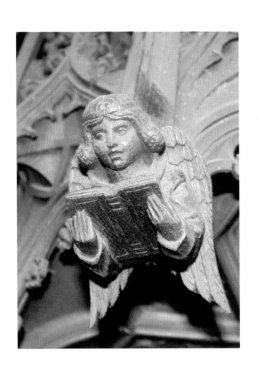

⊹ 1 ⊹

'A perpetual college': writing the history of Manchester's Collegiate Church and Cathedral

JEREMY GREGORY

FOUNDED IN 1421, the Collegiate Church of Manchester, which became a cathedral in 1847, is of outstanding importance – both historically and architecturally – but has not yet received a full modern scholarly study, largely because until recently its archives and records were not properly ordered and catalogued. The histories which have been written are now mostly well over a century old and are based on a relatively small number of sources. It is therefore fitting that this up-to-date history is published during the sexcentenary of the College's foundation and that it presents a state-of-the-art history of the first six hundred years of the College and Cathedral.

'A perpetual college' is a phrase from the first charter of 1421, which envisaged Manchester College lasting for ever.[1] As this history emphasizes, while right from the start national and even international factors and contexts had a vital bearing on the institution's history, yet enshrined in its foundation documents, and building on its predecessor's function as a parish church, was the crucial role of the Collegiate Church in Manchester's life. A mid-seventeenth-century fellow of the College, summarizing the early charter, underlined the part played by the parish commu-

1 Samuel Hibbert-Ware, *The History of the Foundations in Manchester of Christ's College, Chetham's Hospital, and the Free Grammar School*, 3 vols (Manchester: Agnew and Zanetti, 1828–33), vol. 1, p. 41. The phrase was repeated in the foundation charters of Elizabeth and Charles I: *ibid.*, pp. 90, 154. See also Samuel Hibbert-Ware, *The Ancient Parish Church of Manchester, and why it was Collegiated* (Manchester: T. Agnew, 1848), p. 162. For translations of the various foundation documents, where 'for ever' and 'perpetual' recur, see Thomas Turner, *The Second Appendix to Mr Turner's Letter to the Bishop of Manchester, consisting of Translations of the several Foundation Charters of the College of Manchester, with other Documents relating to the Collegiate and Parish Church* (London: Thomas Ridgway, 1850).

nity in the original foundation: '& all & every Parishioner[s] gathered together at the sound of the Bell & the community and univers[al]ity of the sayd parish so farr as this might any way concerne them did for themselves, their heirs & successors give their free assent and consent thereunto'.[2] The Collegiate Church continued both to shape and to be shaped by this local milieu in the following centuries, helping to give at least a partial collective identity to the town, and later city, in ways which are akin to the Italian concept of *campanilismo*, where the bell-tower of the communal church represents (and gives) a sense of place and belonging to inhabitants. Even after it became a cathedral in 1847, and without denying or downplaying its wider diocesan role during the next hundred and seventy years, this volume underscores the religious, social, political, cultural, and economic contribution of the Collegiate Church and Cathedral to the history of Manchester.

'A perpetual college' thus alludes to the ways in which, even after the mid-nineteenth century Cathedral foundation, loyalties to, and associations with, what was affectionately called 'Th'Owd Church'[3] continued to be central to what Manchester's Cathedral stood for. The Dean of Manchester may have been overstating the case in 1921 when he claimed that 'today I think it might be said without exaggeration that no Cathedral is more closely in touch with the Community than is Manchester',[4] but the remark is at least suggestive of the ways the Cathedral engaged with the locality during the twentieth century. The Cathedral's position in the life of the city remains strikingly strong in the twenty-first century (arguably even stronger now than at some times in its past) and aspects of its contemporary role and symbolic influence, seen for example in the special services to mark particular Manchester events, such as those after the 2017 Manchester

2 Manchester, CL, MS A.6.51, Richard Hollingworth, 'Mancuniensis', fol. 30 (see n. 10 below for the published work).

3 Literally 'The Old Church'. The term was in use long before it became a cathedral, probably to demarcate it from other churches built in Manchester in the eighteenth century: Defoe called it 'the old church' in contradistinction to the 'new church' (St Ann's): *A Tour thro' the Whole Island of Great Britain*, 4th edn (London: S. Birt *et al.*, 1748), p. 246. For a description of 'The Old Church', see Benjamin Love, *Manchester as it is; Or, Notices of the Institutions, Manufactures, Commerce, Railways etc. of the Metropolis of Manufactures: interspersed with much valuable information useful to the merchant and stranger* (Manchester: Love and Barton, 1839), p. 43. See also Arthur Burns's Chapter 6.

4 *The Ancient Collegiate Church of Manchester: Quincentenary Celebration, 1421–1921* (Manchester: Sherratt & Hughes, 1921), p. 79.

Arena bomb,[5] echo the civic responsibilities and aspirations of its early fifteenth-century founders. Over the course of the six hundred years covered by this volume, the population of Manchester potentially most closely connected to this building rose from little more than 3,000 in 1421[6] to around 550,000 today (with in excess of 2.5 million in Greater Manchester), and it is perhaps remarkable that the institution persists in having such an impact on the people of Manchester, reaching far beyond Church of England and even Christian affiliations. One explanation might be that, unlike some other collegiate churches and many cathedrals, Manchester's Collegiate Church and Cathedral has never been detached from its environs by a wall or close and this may have helped connect it to its surrounding world and account, to some extent, for its continuing resonance with Mancunians. The author of an early twentieth-century history noted how near the Cathedral was to the city's shops, warehouses, and hotels, and 'the scream of railway engines, the bells of tramcars, and the roar of the traffic' which marked it off from most other cathedrals;[7] today it is cheek-by-jowl with the designer shops, restaurants, bars, public spaces, and the tram stop around Exchange Square.

Reflecting its foundation documents, this volume also places the history of Manchester's Collegiate Church and Cathedral within a national and international context. Throughout the chapters, references are made to the world beyond Manchester, and in particular to London and Europe, especially France. Furthermore, the volume sheds light on what the Manchester evidence can contribute to our broader understanding of the role of collegiate churches and cathedrals, and the history of Christianity in England more generally, in the six centuries after 1421, so that in some measure the volume is a micro-study of aspects of England's religious history from the fifteenth century to the present.

5 A service was held on 22 May 2018, the first anniversary of the bombing. The Dean welcomed the congregation who had 'come together as people of different faiths and none' and short addresses were given by a number of the city's other faith leaders, including Jewish and Muslim. The service was screened to a large crowd outside the cathedral and also to congregations in York Minster, Liverpool Metropolitan Cathedral, and Glasgow Cathedral. For the role of modern cathedrals more broadly, see Stephen Platten (ed.), *Holy Ground: Cathedrals in the Twenty-First Century* (Durham: Sacristy Press, 2017).

6 Latest population figures are taken from 'Population UK', www.ukpopulation.org/manchester-population/, last accessed 3 December 2020.

7 Thomas Perkins, *The Cathedral Church of Manchester: A short History and Description of the Church and of the Collegiate Buildings now known as Chetham's Hospital* (London: George Bell, 1901), p. 24.

The current volume builds on a long heritage of historical writing about Manchester's Collegiate Church and Cathedral. The composition of cathedral histories, and those of other ecclesiastical institutions, has served many functions and has had an extended pedigree, although the definition of what might be regarded as such a history is extremely elastic. Some of the earliest manuscripts which might just about bear the title, since they included accounts of the foundation of the institution concerned, were penned in the Anglo-Saxon period, and were usually written as part of a life of a saint or prominent churchman, or to defend jurisdictional or property rights against a monarch, a bishop, another ecclesiastical body, or neighbouring landowner, and these became more numerous in the Middle Ages.[8] The founding texts of Manchester's Collegiate Church, compiled in 1421–23, were, in some ways, such a history, detailing the reasons for its establishment, its purpose, privileges, and income. Not surprisingly, these documents (and those of the subsequent re-foundations in 1556, 1578, and 1635) featured heavily in future histories, and some of these were in fact just re-wordings and digests of those original records.

In the 1650s, Richard Hollingworth, a Presbyterian fellow of the College, was writing a history of Manchester, which was largely a history of the Collegiate Church and of religious life in Manchester more broadly – work which continued almost until his death in 1656. The nineteenth-century historian of the College considered this 'the ground-work of most that is known of this period',[9] but it remained largely hidden as an unfinished manuscript in the College Archives until it was published in 1839.[10] Nationally, more serious attention to the history of ecclesiastical institutions emerged in the late seventeenth and eighteenth centuries, as antiquaries (often of a Tory bent) became fascinated by the ecclesiastical remains of the medieval past.[11] The College was referenced by a number of these in their findings, although pretty fleetingly. Names of some of the wardens were given very brief notices in William Dugdale's

8 See Antonia Gransden, *Historical Writing in England*, vol. 1, c. *550–c. 1307* (London: Routledge & Kegan Paul, 1974), pp. 67–91, 105–35, 219–68, 356–403; vol. 2, c. *1307 to the Early Sixteenth Century* (London: Routledge & Kegan Paul, 1982), pp. 342–424.

9 Hibbert-Ware, *History*, vol. 1, p. xii.

10 Richard Hollingworth, *Mancuniensis: or, a History of the Towne of Manchester and what is most memorable concerning it* (Manchester: William Willis, 1839).

11 David C. Douglas, *English Scholars, 1660–1730* (London: Jonathan Cape, 1939); Rosemary Sweet, *Antiquaries: The Discovery of the Past in Eighteenth-Century England* (London: Hambledon, 2004).

Monasticon Anglicanum (1655), and a late nineteenth-century commentator remarked that 'he might perhaps be regarded as the antiquary who supplied the first incitement to the compilation of a continuous history of the College, for he printed a copy of the charter of Henry V for the collegiation of the parish church'.[12] The College was name-checked in Browne Willis's monumental *A History of the Mitred Parliamentary Abbies and Conventual Churches* (2 vols, 1718–19) and *A Survey of the Cathedrals* (1727),[13] but as none of these works focused on collegiate churches to any great extent there was little sustained attention to the College, even though it was mentioned favourably in John Strype's *Annals* as a 'noble and useful foundation for learning and propagation of religion in those northern parts'.[14] Defoe included a short account of the College in his tour of Britain as one of the 'four extraordinary Foundations' in Manchester, 'all very well supported'.[15] Although there exists a broadsheet from the 1720s which has elements of a historical record of Manchester's Collegiate Church,[16] perhaps the earliest publication which can be considered to be called a published 'history' of the College was the anonymous: *An Account of the Wardens of Christ's Collegiate Church, Manchester since the foundation in 1422 to the present time* (1773).[17] This provided a short description of each warden from John Huntingdon, appointed in 1422 while Rector of Ashton-under-Lyne, up to and including Samuel Peploe Junior, who succeeded his father in 1738 (and died in 1781). *The Charters of the Collegiate Church, the Free Grammar School, and the Blue Coat Hospital*

12 F. R. Raines, *The Rectors of Manchester and Wardens of the Collegiate Church of that Town*, 2 vols, CS ns 5, 6 (Manchester: Chetham Society, 1885), vol. 1, p. iii; William Dugdale, *Monasticon Anglicanum*, vol. 3, pt 2 (London: Richard Hodgkinson, 1655), pp. 174–5.

13 Browne Willis, *A History of the Mitred Parliamentary Abbies and Conventual Churches*, 2 vols (London: R. Gosling, 1718–19), vol. 2, p. 320; Browne Willis, *A survey of the cathedrals of York, Durham, Carlisle, Chester, Man, Lichfield, Hereford, Worcester, Gloucester, and Bristol*, 2 vols (London: R. Gosling, 1727), vol. 1, pp. 307, 375, 684; vol. 2, pp. 107–8.

14 J. Strype, *Annals of the Reformation and Establishment of Religion and other various occurrences in the Church of England*, vol. 2 (London: Thomas Edlin, 1725), pt 1, p. 515. Strype also noted some problems with the management of the College.

15 Defoe, *Tour*, p. 244: the others were the School, the Hospital, and Chetham's Library.

16 *Reasons humbly offer'd against the bill now depending in Parliament, to impower his Majesty to visit the Collegiate Church of Manchester, during such time as the wardenship of the said church is, or shall be held in commendam with the bishoprick of Chester* ([London]; n.p., [1725]).

17 Some books put the foundation in 1422 because this was when the first warden and fellows were actually appointed.

(with a frontispiece illustration of the Church) was published in 1791,[18] and *The History of the Collegiate Church of Christ, in Manchester* appeared in 1804.[19]

A feature of eighteenth- and especially nineteenth-century descriptions of the Collegiate Church and later Cathedral were the images which accompanied the text. A stimulus to these was the copperplate engravings made by Samuel and Nathaniel Buck which included the panoramic 'The South West Prospect of Manchester in the County Palatinate of Lancaster' (1728),[20] with the Collegiate Church dominating the skyline and referred to in the extensive descriptive caption as 'a noted building with its lofty pile and fine tower, built in the Gothick manner'. Robert Whitworth's massive (over four feet by sixteen inches) 'South West Prospect of Manchester and Salford' (*c.* 1734) placed the Collegiate Church even more centre stage, with the townscape surrounded by a large area of rural hinterland.[21] John Aikin's *Description of the Country from thirty to forty miles round Manchester* (1795) incorporated illustrative plates within the text, including one of the Collegiate Church.[22]

Samuel and Nathaniel Buck, 'The South West Prospect of Manchester in the County Palatinate of Lancaster', 1728

18 T. Harper, *The Charters of the Collegiate Church, the Free Grammar School, and the Blue Coat Hospital, and the Last Will and Testament of Catherine Richards, with other Ancient Curiosities* (Manchester: T. Harper, [1791]). Mrs Richards, whose will was dated 3 March 1711, was the owner of Strangeways.

19 *A brief Description, and a short Sketch of the History of the Collegiate Church of Christ, in Manchester* (Manchester: Joseph Aston, 1804).

20 Samuel and Nathaniel Buck, *A collection of engravings of town panoramas and prospects of cities and towns in England and Wales* (London: Samuel and Nathaniel Buck, 1721–53), in Chetham's Library.

21 A copy is in Chetham's Library.

22 J. Aikin, *Description of the Country from thirty to forty miles round Manchester* (London: John Stockdale, [1795]), p. 148. It is noticeable that Aikin's description of 'commercial Manchester' included a record of the churches and chapelries (pp. 30–1) and an account of the College (pp. 147–55).

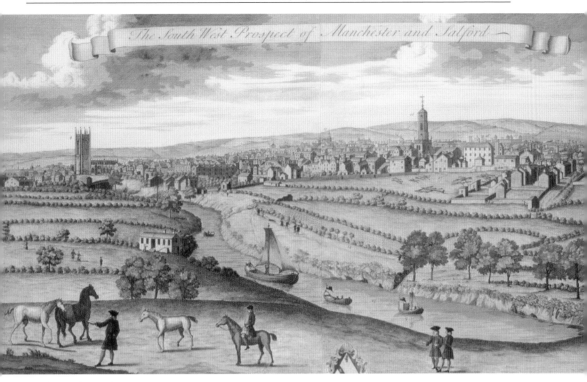

Robert Whitworth, 'South West Prospect of Manchester and Salford', c. 1734

Histories written from the perspective of the institution's own official records, accompanied by pictorial images, reached an apogee in the Manchester-born (but Edinburgh-based) antiquary and geologist Samuel Hibbert-Ware's authoritative study of the College included in *The History of the Foundations in Manchester of Christ's College, Chetham's and the Free Grammar School* (3 vols, 1828–33), which had a team of distinguished engravers and illustrators.[23] The publishers' preface to this major enterprise emphasized the importance of researching the benefits these institutions had brought to Manchester and (in a way which seems to have been in part a fundraising campaign) aimed

23 The original conception was that Hibbert-Ware would write the histories of all these institutions himself, before the immensity of the project of writing the history of the Collegiate Church became all-consuming and others were commissioned to write the histories of Chetham's and the School. Hibbert-Ware's history is in vol. 1, 'History of the College and Collegiate Church, Manchester'; vol. 2, 'Continuation of the History of the Collegiate Church'. Vol. 2 also included 'An Architectural Description of the Collegiate Church and College of Manchester', by the architect John Palmer; vol. 3 comprised 'History of Chetham's Hospital and Library' (1828) and 'History of Manchester School' (1833), by William Robert Whatton, the Manchester surgeon and antiquary. The engravers and illustrators were Charles Pye, John Fothergill, and John Le Keux.

'to perpetuate the names of Founders and Benefactors, to enumerate their useful labours, to specify their munificent grants, and to describe the internal regulations which have been established for the government of the institutions to which they have contributed', celebrating those who 'have devoted their talents, their time, or their wealth to the important end of ameliorating and advancing the conditions of their fellow-citizens'.[24] Within this overarching agenda, Hibbert-Ware's history of the College adopted a firmly chronological approach, allocating a chapter chronicling the 'annals' of each of the wardens and printing the charters of the successive foundations, providing both originals and translations (and noting that the 1791 edition of the charters had 'some very bad translations').[25] Hibbert-Ware acknowledged that much of the underpinning source material for his research had been collected by John Greswell, the schoolmaster at Chetham's who had been working on the College's history before he died in 1781; when Hibbert-Ware first agreed to take on the task of writing the history he believed he would be just finishing off Greswell's work, only to find that although Greswell had collected material he had not in fact 'composed a single line of the history'.[26] Hibbert-Ware was keen to emphasize the role of Manchester's College in the life of the region and nation, observing that it 'gave impulse to all the most important events in Lancashire between 1558 and 1745 and during the mid-seventeenth century it illuminated national history',[27] which explained the great deal of space he gave to the development of the Manchester Presbyterian classis, a topic which is considered in Ian Atherton's Chapter 4 in this volume. His conclusion, reflecting his own moderate churchmanship and his broader liberal views, which as he later noted were in tune with the liberalism of François Guizot as evidenced in his *Histoire de la civilisation en France* (1830),[28] stressed the importance of an institution which could avoid the extremes of religious fanaticism and religious scepticism.[29]

The complete set of volumes was re-issued in 1848, the year after the Collegiate Church had been promoted to cathedral status, under the title, *The Episcopal See of Manchester. The foundations of Manchester: comprising the College and*

24 Hibbert-Ware, *History*, vol. 1, Preface, p. iv.
25 *Ibid.*, Addenda, p. 415.
26 *Ibid.*, p. xiii.
27 *Ibid.*
28 Hibbert-Ware, *Ancient Parish Church*, pp. 199–200.
29 Hibbert-Ware, *History*, vol. 2, p. 179; Hibbert-Ware, *Ancient Parish Church*, p. 22. Guizot (1787–1848) was a French centrist liberal statesman and historian.

Collegiate Church, the Free Grammar School and Chetham's hospital.[30] This fresh edition was dedicated to James Prince Lee, the first Bishop of Manchester, and the Dean and canons, thereby accentuating not only the continuity between the College and the Cathedral, but also, at least cosmetically through its title, the links between these and the newly formed diocese. As if to give prominence to the medieval roots and local context of the modern Cathedral, and highlighting the ties between that, the College, and the former parish church, this edition included a 'fourth and supplemental volume' which Hibbert-Ware remarked should 'properly speaking' be seen as 'the introduction' to the history of the College:[31] *The Ancient Parish Church of Manchester, and why it was Collegiated*, dedicated to Cecil Wray, Vice-Dean of the new Cathedral and fellow of the former Collegiate Church. This additional tome gave further scrutiny of the original foundation documents, providing much greater consideration of these than had been allocated in the first volume, supplying a full précis and contextual analysis.[32] Hibbert-Ware saw the College founders as being motivated by disgust with the state of the Church at the time and viewed them as sharing the ideals and language of the proto-reformer John Wyclif: 'thus the collegiating of the ancient parish church of Manchester assimilated itself with the earliest movement of reform in England'.[33] It is interesting to compare that judgement with Lucy Wooding's Chapter 3 in this volume, which argues that the founding of the College was in fact more a sign of the vitality and health of the Church than a precursor of a Reformation reacting against the supposed corruptions of late medieval Catholicism.[34]

Hibbert-Ware's concern to publish the College's original charters, and with translations he deemed accurate, had especial resonance and impact in the early and mid-nineteenth-century

30 Samuel Hibbert-Ware, *The Episcopal See of Manchester. The foundations of Manchester: comprising the College and Collegiate Church, the Free Grammar School and Chetham's hospital*, 4 vols in 3 (Manchester: Thomas Agnew, 1848).

31 Hibbert-Ware, *Ancient Parish Church*, p. xvi.

32 He explained that much more evidence had some to light since the 1830 edition, that the foundation documents of 1421–23 were 'written in the most abbreviated form', and that some were almost illegible and other words were faded, which meant that until now many of the original documents had not been published: *ibid.*, pp. 194–5.

33 *Ibid.*, p. vii.

34 The extent to which Wyclif should be seen as a reaction against the corruption and lifelessness or a sign of the vitality and innovation of the late medieval Church has been a subject of debate: contrast A. G. Dickens, *The English Reformation* (London: B. T. Batsford, 1964), with Richard Rex, *The Lollards* (Basingstoke: Palgrave, 2002).

disputes about the role and rights of the College in the context of arguments about the creation of new parishes in Manchester and debates about funding the new Cathedral, as discussed in Chapters 5 and 6 by Henry Rack and Arthur Burns respectively. Hibbert-Ware was himself acutely aware of these issues and the ways in which the documents he reproduced, translated, cited, and paraphrased in the course of his history could be used to support contemporary ecclesiastical and political disagreements. Of his *Ancient Parish Church of Manchester*, he reflected:

> As this work makes its appearance at a time when a misunder-standing prevails between the Collegiate Chapter and a party in Manchester, the Author judged it necessary to state: '... that the documents in the possession of the Chapter House – now edited, translated, and commented upon – were intrusted to the Author's inspection long before these unhappy disputes had commenced' and that 'in any comments passed upon these documents, the Author does not identify himself with any party whatsoever'.[35]

During the mid-nineteenth century, the historical documents relating to the foundations of the Collegiate Church received renewed scrutiny and were utilized as evidence in controversies as both reformers and defenders of the status quo consulted and deployed them in their disputes over church rates and 'The Manchester Church question' which concerned the division of the original parish into smaller ones. Much ink was spilt, includ-ing in the local newspapers, the *Manchester Courier* and the *Manchester Guardian*, on accusations of misquotation in rival interpretations of the founding documents, and how those docu-ments should be interpreted in subsequent ages. The crux of the debates centred on whether the income given to the Church was to support the religious nourishment of the population of Man-chester, or whether the income was to be retained for the College *per se* as private property. At the height of these controversies, and indicating the contemporary reach and resonance of these historical documents, Thomas Wheeler, a leading Manchester lawyer and son of the printer of *Wheeler's Manchester Chronicle*, published his translation of the *Foundation Charter of Christ's College Manchester, granted by King Charles the first (and dated*

35 Hibbert-Ware, *Ancient Parish Church*, Advertisement. He also noted that he would have liked to have undertaken a final check of the original docu-ments, but because of the party disputes of the time, 'the muniment chest of the College was considered as closed': *ibid.*, p. 195.

2 October 1635) (1847).[36] The Caroline charter was of particular note since it was hard to see a copy of the original in the early nineteenth century, and Hibbert-Ware had been at pains to print one.[37] Defending the Cathedral's position and denying that the revenues of the Cathedral were parish funds and were instead private funds, Robert Cox Clifton, a fellow of the College who became one of the first canons of the new Cathedral, published in 1850 *The Collegiate Church of Manchester from its Foundation in 1422 to the present time, with Observations on the Proposed Bill for the subdivision of the Parish of Manchester, and for the appropriation of the revenues of the Chapter*,[38] neatly demonstrating in its title how a historical-sounding publication was in fact using historical documents to address a contemporary issue. In the same year, and partly in rejoinder to Clifton's pamphlet, Thomas Turner wrote *A letter on the Collegiate Parish Church of Manchester with remarks on the Bill before Parliament for the Division of the Parish, and other Purposes, addressed (by Permission) to the Right Reverend James Prince, Lord Bishop of Manchester* (1850), which included in a separate appendix translations of the Henrician, Marian, and Caroline charters 'in order that my readers might, as far as possible, learn from the lips of the Founders themselves, what their views in the original establishment of the College really were'.[39] The bulk of Turner's argument had been first aired in his letters to Henry Charlewood printed in the *Manchester Guardian* in 1848, which he now republished as a further appendix and which defended the 'Manchester reformers' as 'acting in the spirit of the original founders'.[40] His overall proposition drew on the foundation documents to claim that the

36 Thomas Wheeler, *Foundation Charter of Christ's College Manchester, granted by King Charles the first (and dated 2 October 1635)* (Manchester: Cave and Sever, 1847). The chief alteration of the Caroline charter was to limit the powers of the wardens and restrict leases to twenty-one years.

37 Hibbert-Ware, *History*, vol. 1, Addenda, p. 402.

38 Robert C. Clifton, *The Collegiate Church of Manchester from its Foundation in 1422 to the present time, with Observations on the Proposed Bill for the subdivision of the Parish of Manchester, and for the appropriation of the revenues of the Chapter* (Manchester: Sowler, 1850).

39 Thomas Turner, *A Letter on the Collegiate Parish Church of Manchester with remarks on the Bill before Parliament for the Division of the Parish, and other Purposes, addressed (by Permission) to the Right Reverend James Prince, Lord Bishop of Manchester* (London: J. Ridgway, 1850), p. 39; Turner, *Second Appendix*.

40 Turner, *Letter*, p. 89; Thomas Turner, *The First Appendix to Mr Turner's Letter to the Bishop of Manchester: consisting of Six Letters on the Collegiate Church of Manchester, addressed principally to Henry Charlewood Esqr of Manchester and first published in the Manchester Guardian newspaper in the course of the year 1848* (London: J. Ridgway, 1850).

present church was not doing enough to minister to the spiritual needs of Manchester's growing population.

During the nineteenth century, cathedral histories were often descriptions of the fabric and architecture to the extent that some 'cathedral histories' were almost solely 'architectural histories'. In Manchester's case this was particularly true of the architect John Palmer's *A Brief Guide to the Collegiate Church of Christ, Manchester* (1829), which was very similar to the volume he wrote for Hibbert-Ware's project. Palmer defended his approach on the grounds that 'the history and transactions of the wardens of the collegiate church have been so repeatedly treated on, we shall abstain from any observation on that head in this account', referring the reader to Hibbert-Ware's forthcoming publication.[41] In a similar vein was Thomas Worthington's *An historical account and illustrated description of the Cathedral church of Manchester, an essay* (1884). Worthington was the founding member of a prominent Manchester architectural family and his monograph was a survey of the fabric, including a description of the major restoration carried out in 1840s under the supervision of Canon Wray. J. S. Crowther, diocesan architect, who was working on the late nineteenth-century restoration when he died, published *An Architectural History of the Cathedral Church of Manchester* in 1893.

These architecturally heavy histories of the Cathedral fed into the increasing vogue for tourism. Of particular note was the 'Cathedral series' brought out by the publisher George Bell, which issued a short history of every English Cathedral in the late nineteenth and early twentieth centuries, aiming to supply visitors with 'accurate and well-illustrated guide books'.[42] The Manchester volume, billed as a 'short history and description', published in 1901, was written by the Revd Thomas Perkins, Rector of Turnworth, Dorset, a friend of Thomas Hardy and a keen supporter of the Society for the Protection of Ancient Buildings. He wrote seven other histories of churches and cathedrals for Bells,[43] including *An Itinerary of the English Cathedrals for the Use of Travellers* and histories of the Cathedral at Amiens and the churches in Rouen.

Most of the histories of Manchester's Collegiate Church and Cathedral written in the seventeenth, eighteenth, nineteenth, and

41 John Palmer, *A Brief Guide to the Collegiate Church of Christ, Manchester* (Manchester: John Parker, 1829), p. 10.

42 Bells Cathedral series, General Preface. The Manchester volume was number 21 in the series.

43 Including St Albans, Romsey Abbey, Wimborne Minster, and Christchurch Priory.

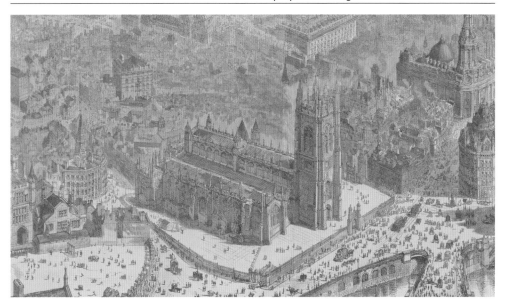

A bird's eye view of Manchester in 1889 by H.W. Brewer

early twentieth centuries were largely 'in-house' histories, usually single-authored, and compiled by a lay or clerical member of the Church of England who often had some association with the College and Cathedral. These 'histories' were by and large either reprints, summaries, or potted versions of the various charters and official records, descriptions of the architecture, or listings of wardens, fellows, deans, and canons.[44] Some of these were full biographical accounts of those who had been appointed to these posts, most notably Francis Robert Raines, *The Rectors of Manchester and Wardens of the Collegiate Church of that Town* (2 vols, Chetham Society, 1885), and his *Fellows of the Collegiate Church of Manchester* (Chetham Society, 1891). These volumes gave a substantial biographical record of each of the wardens from John Huntingdon until the death of William Herbert in 1847 (who became the first Dean and who was in post only a few months before he died), and of the fellows from the foundation until the death of Canon Robert Cox Clifton in 1861. A flavour of Raines's biographical approach and assessment can be seen in his warm, but amused, characterization of Herbert, written from the affectionate standpoint of someone who knew him and who was an insider to the Cathedral:

44 Various lists of wardens and fellows were known to have been in existence in the eighteenth century, but several of these were lost by the early nineteenth century: Raines, *Rectors and Wardens*, vol. 1, pp. iv–v.

His great natural abilities were devoted to the healing of party feuds, and a restless desire to do some good in Manchester enabled him to infuse a large portion of charity and forbearance into the seething community by which he was surrounded … His conversational powers, however, were not remarkable, and, while he maintained that the *pulpit* was the true place for the Clergy, he was himself a dull preacher, without animation or any of the recommendations of a popular orator – except an expressive and benevolent countenance. And yet he was beloved …[45]

Raines's biographies were doing for the local institution what on a national level was being undertaken in the great enterprise of the *Dictionary of National Biography*, and the collections of biographical data of Oxbridge alumni.[46] More specialist studies included H. A. Hudson, 'The Organs and Organists of the Cathedral and Parish Church of Manchester'.[47]

The first half of the twentieth century saw little that could be regarded as innovative in the writing of cathedral histories on the national stage. But the quincentenary of the founding of Manchester's Collegiate Church in 1921 was seen as an opportunity to educate the laity of the diocese, in particular, on the College's history and resulted in an imaginative series of events and a publication. The Dean of Manchester, Joseph Gough McCormick, in his foreword to *The Ancient Collegiate Church of Manchester. Quincentenary Celebration, 1421–1921*, the official record of the week-long festivities from 29 May to 5 June 1921, announced that these events had not been 'designed to be a mere beating of Anglican drums – a sort of ecclesiastical

45 Raines, *Rectors and Wardens*, vol. 2, p. 185. Raines was appointed an honorary minor canon of the Cathedral in 1849.

46 Leslie Stephen *et al.*, *Dictionary of National Biography*, 63 vols (London: Smith, Elder, 1885–1900); Joseph Foster, *Alumni Oxonienses. The Members of the University of Oxford, 1500–1714; their Parentage, Birthplace, and Year of Birth, with a Record of their Degrees*, 4 vols (Oxford: Parker, 1891–92); Joseph Foster, *Alumni Oxonienses. The Members of the University of Oxford, 1715–1886; their Parentage, Birthplace, and Year of Birth, with a Record of their Degrees*, 4 vols (Oxford: Parker, 1888); John Venn and J. A. Venn, *Alumni Cantabrigiensis. A Biographical List of all known Students, Graduates and Holders of the University of Cambridge, from the Earliest Times to 1900. Part 1. From the Earliest Times to 1751*, 4 vols (Cambridge: Cambridge University Press, 1922–27); J. A. Venn, *Alumni Cantabrigiensis. A Biographical List of all known Students, Graduates and Holders of the University of Cambridge, from the Earliest Times to 1900. Part II. From 1752 to 1900*, 6 vols (Cambridge: Cambridge University Press, 1940–54).

47 H. A. Hudson, 'The Organs and Organists of the Cathedral and Parish Church of Manchester', *TLCAS* 34 (1917), pp. 111–35.

Hurrah', but were 'designed to be an educational and spiritual landmark in the history of our city'.[48] A series of special services and sermons reflected on the history of the Collegiate Church, with William Temple, Bishop of Manchester, in tune with his own churchmanship, using his sermon at 'the Civic Service' to stress the importance of the Labour movement and more centrally to see the history of the Collegiate Church as a symbol of the 'abiding identity of the true dwelling-place of man in all generations' during five centuries of national change.[49] McCormick's own sermon, reflecting his personal liberal evangelicalism, applied the history of the Collegiate Church to instruct members of the Free Churches in Manchester in the importance of unity and ecumenism: 'we ... will in a not too distant future', he proclaimed, 'see a great service of Thanksgiving for the Re-Union of Evangelical Christians',[50] and J. E. C. Welldon, the Dean of Durham (preaching during the miners' strike) instructed the trade unions in Manchester to behave more like medieval guilds. There were also specially conceived services for 'Women' and for 'the Clergy'. The services included music drawn from the five centuries of the Collegiate Church's life. Public lectures on 'Religion' in each of those centuries were delivered by a stellar line-up of speakers, with A. L. Smith, Master of Balliol College, Oxford, on the fifteenth century; Walter Frere, Superior of the Community of the Resurrection, Mirfield, on the sixteenth; T. F. Tout, Professor of Medieval History at Manchester, on the seventeenth; E. W Watson, Professor of Ecclesiastical History at Oxford, on the eighteenth; and William Inge, Dean of St Paul's, on the nineteenth. The official record also included a short 'History of Manchester Cathedral' by J. J. Scott, the Sub-Warden, which was almost solely concerned with the various charters and the architectural and fabric record of the building, including the plate.

For the next fifty years, histories of Manchester Cathedral largely reused and repackaged the information in these preceding volumes, even in John Prudhoe's intriguingly titled *Heart of a City: A History of Manchester Cathedral in Sound, Light, Spectacle and Dramatic Episode* (1966).[51] Information was increasingly distilled to make these histories more user-friendly for the modern tourist, and from the 1970s the guides were

48 *Ancient Collegiate Church*, p. 7.
49 *Ibid.*, p. 47.
50 *Ibid.*, p. 73.
51 John Prudhoe, *Heart of a City: A History of Manchester Cathedral in Sound, Light, Spectacle and Dramatic Episode* (Manchester: Manchester Cathedral, 1966). This was an in-house history published by the Cathedral.

enriched with colour photographs, as in Hedley Hodkin, *Manchester Cathedral* (1972).[52] The Cathedral also received some treatment in Arthur J. Dobb's *Like a Mighty Tortoise: A History of the Diocese of Manchester* (1978), but the originality of this was to describe the formation and development of the diocese, rather than adding anything significantly new to the history of the Cathedral itself.[53]

Since the late 1970s, nationally there has been something of a minor industry in the scholarly writing of cathedral histories, with well over a dozen produced.[54] Taken together, these have greatly expanded what we know of the role of these cathedrals

52 Hedley Hodkin, *Manchester Cathedral* (London: Pitkin Pictorials, 1972).

53 Arthur J. Dobb, *Like a Mighty Tortoise: A History of the Diocese of Manchester* (Littleborough: Upjohn and Bottomley, 1978).

54 The first example of a *modern* cathedral history, almost the *ur*-text of the genre, was *A History of York Minster*, edited by Gerald Aylmer, then a professor at York University, and Reginald Cant, the Minster's Chancellor, published in 1977 by Oxford University Press to mark the 1350th anniversary of the foundation. The York Minster history established several of the parameters and benchmarks which have been followed by the editors (and authors) of subsequent cathedral histories. These include Linzee S. Colchester (ed.), *Wells Cathedral: A History* (Shepton Mallet: Open Books, 1982); John Crook (ed.), *Winchester Cathedral: Nine Hundred Years, 1093–1993* (Chichester: Phillimore, 1993); Mary Hobbs (ed.), *Chichester Cathedral: An Historical Survey* (Chichester: Phillimore, 1994); Patrick Collinson, Nigel Ramsay, and Margaret Sparks (eds), *A History of Canterbury Cathedral, 598–1982* (Oxford: Oxford University Press, 1995); Nigel Yates with Paul A. Welsby (eds), *Faith and Fabric: A History of Rochester Cathedral, 604–1994* (Woodbridge: Boydell, 1996); Ian Atherton, Eric Fernie, Christopher Harper-Bill, and Hassell Smith (eds), *Norwich Cathedral: Church, City and Diocese, 1096–1996* (London: Hambledon, 1996); Gerald Aylmer and John Tiller (eds), *Hereford Cathedral: A History* (London: Hambledon, 2000); Peter Meadows and Nigel Ramsay (eds), *A History of Ely Cathedral* (Woodbridge: Boydell, 2003); Derek Keene, R. Arthur Burns, and Andrew Saint (eds), *St Paul's: The Cathedral Church of London, 604–2004* (New Haven, CT, and London: Yale University Press, 2004); John Crawford and Raymond Gillespie (eds), *St Patrick's Cathedral, Dublin: A History* (Dublin: Four Courts Press, 2009); Kenneth Milne (ed.), *Christ Church Cathedral, Dublin: A History* (Dublin: Four Courts Press, 2010); and David Brown (ed.), *Durham Cathedral: History, Fabric and Culture* (London: Yale University Press, 2015). There have also been a number of single-authored cathedral histories, including Nicholas Orme, *Exeter Cathedral: The First Thousand Years, 400–1550* (Exeter: Impress Books, 2009); and Judith Curthoys, *The Cardinal's College: Christ Church, Chapter and Verse* (London: Profile Books, 2012). There has additionally been some recent groundbreaking scholarship on cathedral architecture: Carolyn M. Malone, *Façade as Spectacle: Ritual and Ideology at Wells Cathedral*, Studies in Medieval and Reformation Traditions 102 (Leiden and Boston, MA: Brill, 2004); John S. Hendrix, *Architecture as Cosmology: Lincoln Cathedral and English Gothic Architecture* (New York: Peter Lang, 2011). A number of modern architectural histories of cathedrals and short tours have been published by Scala Publications, including Andrew Shanks on Manchester (2009).

in the history of their localities, and in the wider world more generally. What has set these modern histories apart from their forebears is that they have usually been collaborative projects bringing together (as in this volume) a team of authors, recognizing that no individual could possibly be a specialist in six hundred years of history or more. The decision to have a crew of writers underscores the fact that the editors of these new-generation cathedral histories have envisaged their volumes as speaking to the academic community as well as to interested general readers: the chapters needed to be totally up-to-date with recent scholarship and to place the institutional history within the broader religious, social, political, economic, and cultural history of the periods with which they dealt, and to bring that scholarship to a wider audience. All in all, they have set a benchmark for the writing of the history of religious institutions, communities, and buildings.[55]

This present volume builds on this approach and aspires to be an account of Manchester's Collegiate Church and Cathedral, both as a place of worship and as a religious and social community, paying attention to both internal and external factors. Seeing the building as a place of worship means that some emphasis is placed on what went on in and out of services, including its musical life (as shown in Sarah Boyer's Chapter 10), and on religious and theological matters. Studying the College and Cathedral as a community is reflected in the emphasis on group dynamics, in the social history of religion, and in the desire to relate the internal history of the institution to the external world. These are necessary correctives to those earlier histories which have largely been either architectural inventories, detached from the history of what went on inside and outside the building, or studies of individual key personnel without much reference to the community in which they worked.

Underpinning this history has been a thorough use of as wide a range of sources as possible, going beyond the institution's official records (such as charters, act books, and registers) to investigate correspondence, biographies, social documentation, parliamentary papers, newspapers, and material culture, and understanding these in the context of the rich secondary literature of the relevant periods. These sources have been vital since they have ensured that this history is written using a full spectrum of the available evidence. Given the key role of archives and

55 An Irish historian called the Christ Church Dublin project 'one of the most important events in Irish historiography of the century': quoted in Milne (ed.), *Christ Church*, p. xii.

libraries in providing the infrastructure for this history, Manchester is fortunate in having both Chetham's Library and the Central Library, both of which contain a wealth of well-catalogued local and regional material, much of it pertaining to the Collegiate Church and Cathedral, as well as the Chester and Lancashire Record Offices. But there are documentary gaps. Estates records were secreted by Catholics at the accession of Elizabeth I and, after the dissolution of the College in 1649, muniments were carried to London, some of which were destroyed in the Fire of 1665 and others not returned to Manchester until 2005. Until the early twenty-first century, the Collegiate Church and Cathedral's own records were poorly catalogued. In 2003, the Cathedral appointed an archivist who began the work of putting the archives in order which meant that a modern scholarly history could at last be undertaken and contributors have benefitted hugely from this resource.

One reason why there has not been a modern history of Manchester's College and Cathedral until now is the lack of detailed research on virtually all phases of its history. While almost all the other cathedrals which have had a recent history have had a number of doctoral theses written on aspects of their past which provided valuable starting points for authors writing more comprehensive period overviews, Manchester has been poorly served in this respect, and it is hoped that the present volume will itself be a prompt for further investigation.[56]

The history of Manchester itself also presents some issues which have militated against research into the Collegiate Church and Cathedral. First, its position in the medieval and early modern periods – precisely when other cathedral cities such as Canterbury and York had huge national and international weight – was as but one settlement among many in the region,[57] although the importance of the Collegiate Church in the Elizabethan period as a potential arsenal of Protestantism against Catholic Lancashire

56 Graham Hendy's thesis took the Collegiate Church as one of his four case studies in his discussion of the Georgian Prebendary: Graham A. Hendy, 'The Prebendary in Georgian England: A Case Study of the Cathedral and Collegiate chapters of Manchester, Salisbury, Southwell, and Winchester' (MPhil thesis, Lampeter University, 2007); and the Manchester Canon, Garth Turner, used the example of Manchester in his researches into the twentieth-century Church Commissions on cathedrals: 'Cathedrals and Change in the Twentieth Century. Aspects of the life of the Cathedrals of the Church of England with special reference to the Cathedral Commissions of 1925; 1958; 1992' (PhD thesis, University of Manchester, 2011). By contrast, the authors of some of the other cathedral histories have been able to draw on a larger number of theses and recent research.

57 Alan Kidd, *Manchester. A History*, 4th edn (Lancaster: Carnegie, 2006), p. x, characterises it as 'a minor Lancastrian township'.

has been studied by Christopher Haigh (granted, he found it wanting).[58] Second, when Manchester became 'Cottonopolis', and thus of international and even global importance, it is often assumed that the real significance of the Industrial Revolution for religion in Manchester lies in either the development of Nonconformity in the city and region, which is supposed to have provided the momentum behind most of the innovations of the age, or the marginalization of religion from modern urban life, which according to some led to secularization; neither has been a spur to research on the Anglican Church in Manchester in general, or the Cathedral in particular.[59] These general assumptions were questioned in the volume marking the one hundred and fiftieth year of the creation of Manchester diocese, published in 1997 by the Lancashire and Cheshire Antiquarian Society,[60] but this did not pretend to be a history of the Cathedral, let alone of the Collegiate Church. Henry Rack and Arthur Burns in this current volume remind us that Manchester mill-owners, merchants, and manufacturers could be associated with the Church of England, and the Collegiate Church and Cathedral, as well as with Nonconformity, helping to situate the institution's history against wider developments of the age.[61] And in the face of the novelty and modernity of the late eighteenth and early nineteenth century 'shock city' which so amazed and impressed contemporaries, the existence of the Collegiate Church was in itself a visible reminder that Manchester had a history. After noting the large number of new buildings in Manchester in 1839, the Manchester printer Benjamin Love remarked: 'Notwithstanding this circumstance, Manchester has high claim to antiquity. The Collegiate Church and College extend those claims four hundred years back.'[62]

What, then, does this history of Manchester's Collegiate Church and Cathedral tell us? It certainly sheds light on its local, regional, national, and even international, importance. Its fifteenth- and early sixteenth-century history adds to the debates

58 Christopher Haigh, *Reformation and Resistance in Tudor Lancashire* (Cambridge: Cambridge University Press, 1975).

59 Alan J. Kidd and Terry Wyke (eds), *Manchester: Making the Modern City* (Liverpool: Liverpool University Press, 2016). On the connection between industrialization, urbanization, and secularization, see Alan D. Gilbert, *Religion and Society in Industrial England: Church, Chapel and Social Change, 1740–1914* (London: Longman, 1976).

60 Chris Ford, Michael Powell, and Terry Wyke (eds), *The Church in Cottonopolis: Essays to Mark the 150th Anniversary of the Diocese of Manchester* (Manchester: Lancashire & Cheshire Antiquarian Society, 1997).

61 See also Meriel Boyd, 'In their own image? Church Building in the Deanery of Manchester, 1847 to 1903: Relationships between Donor, Architect, and Churchmanship' (PhD thesis, University of Manchester, 2015).

62 Love, *Manchester as it is*, p. 12.

about the condition of the Church in the century before the Reformation, and its early modern history helps us explore the progress of the Reformation in the north-west. Lucy Wooding's Chapter 3 shows that the foundation of the College and its development in the following century was a sign of the vitality of the late medieval Church and demonstrates how its founding ideals of piety, educational provision, and community service continued after the Reformation. The Edwardian closure of the college and the Marian re-founding illuminate Diarmaid MacCulloch's vision of a religious cultural revolution under Edward, and the reconceptualization of Marian Catholicism by Eamon Duffy and others.[63] Ian Atherton's contribution helps us understand the nature of the Elizabethan and early Stuart Church, and the character of 'Puritanism'. His chapter also aids our understanding of mid-seventeenth-century events, where the Manchester Presbyterian classis evolved from within rather than from outside the religious establishment. Most collegiate churches and cathedrals were badly damaged during this period as a result of Cromwellian iconoclasm, but Manchester's Collegiate Church was almost totally unscathed, and, as Atherton notes, Manchester is the only example where a 'cathedral-type foundation led the Parliamentarians'.[64]

Questions addressed in Henry Rack's Chapter 5 include the complexion of the Church of England after 1660 and the speed of the restoration; the relationship between Jacobitism and the eighteenth-century College; and how far Manchester's College exemplified the religious and political attitudes of the *Ancien Regime* as understood by J. C. D. Clark.[65] How far does the history of the Collegiate Church between the Restoration and the early nineteenth century confirm or complicate the so-called revisionist interpretation of the Church of England in the long eighteenth century?[66] Arthur Burns's Chapter 6 tackles issues of

63 Diarmaid MacCulloch, *Tudor Church Militant: Edward VI and the Protestant Reformation* (London: Allen Lane, 1999); Eamon Duffy, *Fires of Faith. Catholic England under Mary Tudor* (London and New Haven, CT: Yale University Press, 2009).

64 Ian Atherton's Chapter 4, p. 110.

65 J. C. D. Clark, *English Society, 1660–1832: Religion, Ideology and Politics during the Ancien Regime* (Cambridge: Cambridge University Press, 2000; first publ. 1985).

66 For differing views of the Church of England in Lancashire, see Jan M. Albers, 'The Seeds of Contention: Society, Politics, and the Church of England in Lancashire, 1689–1790' (PhD thesis, Yale University, 1988), Mark Smith, *Religion in Industrial Society: Oldham and Saddleworth, 1740–1865* (Oxford: Clarendon, 1994); and Michael Snape, *The Church of England in Industrialising Society: The Lancashire Parish of Whalley in the Eighteenth Century* (Woodbridge: Boydell, 2003).

Church reform, the transfer to Cathedral status, and the emergence of Tractarianism in Manchester in the late nineteenth century.

What makes this history especially distinctive is the role of the Collegiate Church and Cathedral in the modern era. As Manchester was transformed from being the 'greatest mere village in England'[67] to the world's first industrial city, it is worth exploring how the Cathedral responded to such developments, and what its role has been in the subsequent period of industrial decline and in the post-industrial age. Chapters 6, 7 and 8 by Arthur Burns, Matthew Grimley, and Jeremy Morris, respectively, argue for the continuing significance of the Cathedral in periods when its functions have often been seen as increasingly marginal and of limited importance. Moreover, most of the other recent cathedral histories have been about cities whose standing waned in the modern period (for example, Canterbury, Hereford, Norwich, and York), but Manchester provides us with the opposite trajectory, throwing light on the role of the cathedral in what is arguably England's 'second city'.[68]

Manchester's Collegiate Church and Cathedral also has a number of idiosyncratic features which means that this volume brings some new facets to the genre of 'cathedral history'. Most strikingly, it allows us to examine a multi-organizational and multi-functional structure over six hundred years. Despite Samuel Hibbert-Ware's mid-nineteenth-century emphasis on the seamless connections between parish church, College, Cathedral, and diocese, in fact these were separate (if overlapping) legal entities. The Collegiate Church was an extension of an existing parish church before being upgraded, combining the functions of a parish church and a monastery, and until the single enormous parish was divided in 1850 the College was the parish church for the whole of Manchester. The College became a Cathedral in 1847 (with the warden and fellows being called dean and canons from 1840 in preparation). Manchester's history is thus unusual: very few collegiate churches survived the Reformation, and it was one of only four collegiate churches to be elevated to cathedral status in the nineteenth and early twentieth centuries.[69] One of the major interests of its history is how these institutions and structures transformed themselves into one another. These transitions demonstrated not only a remarkable adaptability but

[67] Defoe, *Tour*, p. 243.
[68] Jerome I. Hodos, *Second Cities: Globalization and Local Politics in Manchester and Philadelphia* (Philadelphia, PA: Temple University Press, 2011).
[69] Alongside Ripon (1836), Southwell (1884), and Derby (1927).

also showed how the various functions of parish church, college, and cathedral could co-exist at the same time in a single building, as well as being sources of tension, notably in the mid-nineteenth century, when funding for innovations in the Cathedral was disputed as going against the presumed objectives of the College's founders, and especially after the division of the parish.

Yet the fact that the Cathedral had previously been a College and parish church gave an immediate sense of tradition to the new foundation. The 1851 edition of Benjamin Winckles's *Architectural and Picturesque Illustrations of the Cathedral Churches of England and Wales* advertised its appearance 'with the addition of Manchester Cathedral', remarking that a diocese which had existed for only a little more than three years would expect to have little material for the ecclesiastical historian, but 'happily, however, the religious establishment over which the Bishop of Manchester presides has existed for some centuries, as well as the fabric which now forms his cathedral church'.[70] In the 1870s, when there were discussions about significantly enlarging, rebuilding, or building a cathedral from scratch, better suited to the importance of the second city, either on its present site or nearer Piccadilly (as noted in Clare Hartwell's Chapter 9), one commentator was, on balance, against these schemes, remarking:

> [I]f it were Liverpool or Birmingham, instead of Manchester, we should say, build up your minster by all means, and if you can outdo Ely or Winchester, so much the better. But Manchester has a history, and we should feel a certain pain at seeing that history quite wiped out, even in favour of so great a work. We must confess to a certain satisfaction to seeing the history of the church and city written so plainly as it now is on the material fabric. The three-fold character of the building, parochial, collegiate, and cathedral, answering to as many stages in the history of the city itself, is there continually to be read ...[71]

But even if the College and Cathedral were discrete foundations, nevertheless there has been functional persistence. During the 1921 quincentenary celebrations, Herbert Ryle, Dean of Westminster, spoke of the metamorphosis of the Collegiate Church into a Cathedral, whereby 'its distinctive character', he affirmed,

70 *Benjamin Winckles's Architectural and Picturesque Illustrations of the Cathedral Churches of England and Wales*, 3 vols (London: Bogue, 1851), p. 162.

71 *The Saturday Review: Politics, Literature, Science, Art*, 23 May 1874, p. 647.

'is not forfeited but extended'.[72] Throughout the six hundred-year history of Manchester's Collegiate Church and Cathedral, it is possible to discern that the core aims of the original foundation remained, even when translated into different contexts (seen in surviving the Reformation, the Civil War, the Restoration, and in the various changes of the nineteenth, twentieth, and twenty-first centuries). The organization has been remarkably adept at refashioning and remodelling, and has at times been in the vanguard of cutting-edge ideas; on other occasions it has acted as an 'anchor institution'[73] when everything else around it seemed to be altering. This latest history of Manchester's 'perpetual college' is thus an exploration of continuity and change in a way that is more fundamental than in the study of most other cathedrals and it is this which makes its story so fascinating and enduring.

72 *Ancient Collegiate Church*, p. 61.

73 For the concept, see 'Anchor Institutions', https://community-wealth.org/strategies/panel/anchors/index.html, accessed 3 December 2020. While the concept has been applied most commonly to universities and hospitals, it is used with reference to other institutions such as museums, libraries, and faith-based institutions. It is usually applied to late twentieth- and early twenty-first-century organizations, but the concept could arguably be applied to these institutions, and particularly to cathedral-like churches, over a much longer historical period.

The pre-collegiate church: origins and early development

PETER ARROWSMITH

T HE EARLIEST REFERENCE to a church in Manchester is found in the Domesday survey's account of the Salford Hundred, the late Anglo-Saxon administrative division in which Manchester was located. Writing of the time of King Edward the Confessor in 1066, the survey notes that 'the church of St Mary and the church of St Michael held one carucate of land in Manchester, free from all dues except tax'. Prior to the Norman Conquest, then, there were two local churches, endowed with land totalling one carucate, the amount that a team of oxen could plough each year. This land may have been the later manor of Newton, which was the property of the Parish and Collegiate Church of Manchester and lay to the north-east of the town, at the present Miles Platting and Newton Heath. The location of the Domesday church of St Michael is problematic, but it was possibly on the site of the later parish church of Ashton-under-Lyne, since this was dedicated to the saint and was considered to be a dependency of the parish of Manchester.[1] The obvious location for the Domesday church of St Mary would be on the site of the medieval parish church of Manchester, which had this dedication prior to the foundation in 1421 of the Collegiate Church of St Mary, St George, and St Denys, now Manchester Cathedral. An antiquarian theory, which still has some limited currency, supposed that there had been one or even two earlier churches in an area encompassing St Mary's Gate and Acres Field, the latter being the venue of Manchester's medieval fair which in the early eighteenth century became the site of St Ann's Square

1 James Tait, *Mediaeval Manchester and the Beginnings of Lancashire* (Manchester: Manchester University Press, 1904), pp. 6–7; William Farrer and J. Brownbill (eds), *A History of the County of Lancaster, Volume 4*, Victoria County History (London: Archibald Constable, 1911), p. 348.

Previous spread:
Gargoyle

and St Ann's Church.[2] The evidence is not persuasive. Although it was claimed that human bones had been unearthed in separate locations within this area, no confirmation is known of the existence of an early burial ground. A stone wall uncovered next to St Ann's Church was held to be of an early construction but is almost certainly no older than the Georgian church. The street-name St Mary's Gate can be attributed simply to the fact that land here belonged to the chantry of St Mary in the medieval Parish and Collegiate Church.[3]

The area in which that Parish and Collegiate Church was situated is considered to have been the historic core from which the medieval town of Manchester grew.[4] Later developments have transformed its setting, but originally this core area was bounded on the west and north by the steep rocky banks of the River Irwell and its tributary the River Irk, and on the south was enclosed by Hanging Ditch, a substantial channel which drained into the Irwell. The early street pattern suggests that this channel may have been deliberately extended to form a curving defensive line between the two rivers. The medieval core was not the first known centre of occupation in the city. Manchester was the site of a Roman auxiliary fort and a large civilian settlement or *vicus*, but these lay in Castlefield at the opposite end of Deansgate, itself originally a main Roman road heading north. Antiquarians supposed that there was also Roman occupation in the area of the Cathedral.[5] This is not supported by the relatively few Roman finds discovered here. It is uncertain when the Cathedral area became a focus of settlement. The Anglo-Saxon Chronicle records Manchester as one of several fortified bases, or burhs, established in the early tenth century on the north-west frontier of the kingdom of Mercia. In 919, while an army under Edward the Elder was setting up a burh at Thelwall to the west, the king ordered another force to go to Manchester, then part of the Viking kingdom of Northumbria, and 'repair and man it'. Two

2 Samuel Hibbert-Ware, *The Ancient Parish Church of Manchester, and why it was Collegiated* (Manchester: T. Agnew, 1848), p. 5; C. Roeder, 'The Ancient Churches, the Parsonage, Acres Field, and Acres Fair in Manchester', *TLCAS* 23 (1906, for 1905), pp. 87–99; Arthur J. Dobb, *Like a Mighty Tortoise: A History of the Diocese of Manchester* (Littleborough: Upjohn and Bottomley, 1978), pp. 29–30.

3 J. Lloyd, in Michael Morris (ed.), *Medieval Manchester: A Regional Study*, Archaeology of Greater Manchester 1 (Manchester: Greater Manchester Archaeological Unit, 1983), p. 41.

4 Morris (ed.), *Medieval Manchester*, p. 34.

5 John Whitaker, *The History of Manchester*, 2 vols (London: Dodsley, 1771), vol. 1, pp. 181–6; C. Roeder, 'Recent Roman Discoveries in Deansgate and on Hunt's Bank, and Roman Manchester Re-studied (1897–1900)', *TLCAS* 17 (1900, for 1899), pp. 178–89.

possible locations have been put forward for this burh. One is in the area of Manchester's medieval core, where the burh may have been defended by Hanging Ditch or have comprised a smaller enclosure on the site of Chetham's School of Music. The other possibility is that the burh involved the repair of the Roman fort in Castlefield and in recent studies this has been judged the more likely.[6]

By the end of his reign in 924 Edward the Elder is thought to have annexed the territory 'between the Ribble and the Mersey'. The Salford Hundred, in which Manchester was situated, was one of six such administrative divisions within this territory by 1066. Salford, the eponymous centre of the hundred, was situated on the west bank of the River Irwell, opposite Manchester, and in 1066 was a royal manor with its own hall. In the medieval period and later, uniquely among the townships on the west bank, Salford lay within the parish of Manchester. Neighbouring townships on this side of the river belonged to the parish of Eccles, whose place-name (from the British *eglys) is believed to be indicative of an early church. A fragment of an Anglo-Saxon cross-shaft was discovered not far from Eccles Parish Church during the construction of the Manchester Ship Canal, and the circular form of the churchyard at Eccles may be further evidence of an early foundation. It is quite possible that the parish of Eccles, whose own church was dedicated to St Mary, originally included the area of the parish of Manchester and that the church at Manchester was a later foundation.[7] This may have occurred either as an outcome of the establishment of the burh in 919 or as a result of neighbouring Salford being the chief place within the hundred. Although the Irwell flowed between them, Salford was linked to Manchester by a ford which lay below the medieval church and which very probably gave Salford, 'the willow ford', its name.[8] Salford's late Anglo-Saxon hall may have stood only

6 P. Holdsworth, in Morris (ed.), *Medieval Manchester*, p. 15; N. J. Higham, 'The Cheshire Burhs and the Mercian Frontier to 924', *TLCAS* 85 (1988), p. 210; D. Griffiths, 'The North-West Frontier', in N. J. Higham and D. H. Hill (eds), *Edward the Elder, 899–924* (London: Routledge, 2001), pp. 177–8.

7 Denise Kenyon, *The Origins of Lancashire* (Manchester: Manchester University Press, 1991), pp. 95, 118–19.

8 Joseph Aston, *The Manchester Guide: A brief historical description of the Towns of Manchester & Salford, the Public Buildings, and the Charitable and Literary Institutions* (Manchester: J. Aston, 1804), p. 254; Eilert Ekwall, *The Place-Names of Lancashire* (Manchester: Manchester University Press, 1922), p. 32.

The Angel Stone

a short distance to the south of the ford, on the same spot as the later Salford Hall.[9]

The oldest physical evidence which suggests a place of worship on the site of the Cathedral is the Angel Stone. This is a fragment of red sandstone carved in relief with the figure of a winged angel, holding what appears to be a scroll, with the incised inscription '*In manus tuas dme commedo sp(iritum meum)*' (Into your hands, Lord, I commend my spirit). It was found during restoration work in 1871, embedded just above ground level in the wall of the south porch. The stone was once thought to date from the eighth or ninth century but more recently Elizabeth Coatsworth concluded that, on the evidence of the inscription, iconography, and the standard of the carving, the likely date is in the eleventh or twelfth century, and probably in the Norman

9 Lloyd, in Morris (ed.), *Medieval Manchester*, p. 37.

period rather than before.[10] The exact function of the piece is uncertain. The angel could have formed part of a crucifixion scene, but Coatsworth allows that other interpretations are possible. 'The surviving fragment gives no clue to the original form of the monument: it could have been free-standing or architectural, part of a cross, a grave-slab or tomb, or a panel.'[11]

By the early twelfth century, Manchester was the head manor of a Norman barony, held by the Grelley family and comprising large parts of the Salford Hundred and a smaller number of other manors in southern Lancashire. The family's estates also included lands in East Anglia and the Midlands, where they are known to have resided. Between 1154 and 1162, the Grelleys endowed the parish church of Manchester with additional land, possibly Kirkmanshulme to the south of the modern city centre. This grant was one of a series of twelfth-century benefactions made by the family to churches and religious houses. The most notable was the foundation of a Savigniac (later Cistercian) abbey at their manor of Swineshead in Lincolnshire about 1134, the endowment of which included the manorial mill at Manchester. The Grelleys retained the lordship of Manchester until the death of Thomas Grelley in 1311. It passed to his sister Joan and her husband John de la Warre, whose great-grandson Thomas de la Warre was the co-founder of the Collegiate Church.[12]

The Grelleys had a castle at Manchester, known from a few documentary references between 1184 and 1215. Monies recorded for its repair are modest and it is believed likely that the structure was timber-built. It was probably located just to the north of the parish church, on the spur formed by the confluence of the Irwell and the Irk.[13] By the late thirteenth century, this was the location of Manchester's manor house. In November 1422, the same site, described as the Baron's Hall ('Baronshull') and Baron's Yard, was granted by Thomas de la Warre as accommodation for the

10 Elizabeth Coatsworth, in Morris (ed.), *Medieval Manchester*, pp. 9–12; similarly, Richard N. Bailey, *Corpus of Anglo-Saxon Stone Sculpture, Vol. 9: Cheshire and Lancashire* (Oxford: Oxford University Press for the British Academy, 2010), pp. 264–5, giving the date as twelfth century.

11 Coatsworth, in Morris (ed.), *Medieval Manchester*, p. 10.

12 William Farrer, in William Farrer and J. Brownbill (eds), *A History of the County of Lancaster, Volume 1*, VCH (London: Archibald Constable, 1906), pp. 326–34; W. Farrer (ed.), *Lancashire Inquests, Extents, and Feudal Aids, Part 1*, Record Society of Lancashire and Cheshire 48 ([Liverpool]: the society, 1903), p. 57.

13 P. Holdsworth, in Morris (ed.), *Medieval Manchester*, pp. 36–7; A. Tindall, 'Investigations at Chetham's School, Manchester', *Greater Manchester Archaeological Unit Annual Report 1982–83* (Manchester: University of Manchester Department of Archaeology, 1983), pp. 5–8.

new college of priests.[14] By special good fortune the buildings erected for that purpose still survive. They were converted in the 1650s to Chetham's Hospital, a charitable school for boys, and Library, and now form the core of Chetham's School of Music.

Manchester was a large medieval parish, covering about sixty square miles. In 1291–92 the ecclesiastical valuation of Pope Nicholas IV included fifty benefices in Lancashire, of which Manchester was joint-eighth most valuable.[15] By the thirteenth century, the surroundings of the parish church were being transformed as Manchester developed as a place of economic importance. There was a seignorial borough here by 1282, perhaps founded not much later than the granting of Salford's borough charter in 1230. A weekly market was probably being held in Manchester by the 1220s, when the Grelleys were given permission for an annual fair. Salford received its own market charter in 1228. By the same decade, access between the two places had been improved by the construction of a bridge over the River Irwell. At this date it may have been of timber, but by the later medieval period the bridge was of stone, with a chapel on one of the piers.[16]

Against this changing background, the parish church was undergoing its own physical transformation. Much of the evidence for this was lost in the century following the collegiation of 1421. As described in Chapter 9, the present church postdates that event and represents a Perpendicular rebuilding of the fifteenth and early sixteenth centuries, substantially restored and modified in the nineteenth and twentieth. Briefly, the nave and chancel both have side aisles which in turn were flanked by chantry chapels, resulting in the building's considerable width. In the nineteenth century, the divisions between the chapels adjoining the nave were removed, creating the present outer aisles. A tower, rebuilt in the 1860s, stands at the west end of the nave, and a Lady chapel at the east end of the chancel. What evidence we have for the architectural history of the church prior to the collegiation is partly derived from findings made during restoration works in the nineteenth century. In addition to the Angel Stone, other diagnostic pieces of reused stonework came to light, incorporated within the fabric of the building. A key source is the architect J. S. Crowther, who carried out a major

14 Lloyd, in Morris (ed.), *Medieval Manchester*, p. 39; Hibbert-Ware, *Ancient Parish Church*, pp. 170–2.
15 James Tait, in William Farrer and J. Brownbill (eds), *A History of the County of Lancaster, Volume 2*, VCH (London: Archibald Constable, 1908), pp. 7, 22–3.
16 Lloyd, in Morris (ed.), *Medieval Manchester*, p. 38.

Green's map of Manchester of 1787–94, showing the setting of the church within the town's medieval core

restoration in the 1880s. Details of fragments found at that time and during earlier works are given in his account of the architectural development of the Cathedral, published posthumously in 1893.[17] We also have the manuscripts of the local antiquarian John Owen, which include a record of early stonework observed during restorations of the late 1850s to early 1870s.[18]

Some reused pieces were in the Early English style, which flourished at the end of the twelfth century and in the first half of the thirteenth. The architect J. P. Holden, who in the 1860s took down and rebuilt the tower, informed Crowther that 'many Early English details of excellent workmanship were discovered bedded in the walls, such as base mouldings, arch mouldings, and window tracery'.[19] Early English work, none seemingly in situ, was found in the nave and aisles during Crowther's own

17 J. S. Crowther, *An Architectural History of the Cathedral Church of Manchester dedicated to St. Mary, St. George, and St. Denys*, edited by Frank Renaud (Manchester, J. E. Cornish, 1893).
18 The Owen MSS are held by Manchester Libraries.
19 Crowther, *Architectural History*, p. 11; cf. Owen MSS, vol. 23, pp. 130–1, 136.

restoration work. It included evidence of arcades in the form of the bases and capitals of piers and responds. These remains showed the piers to have been octagonal and 2 feet 6 inches in diameter, suggesting a building of substantial size. Among the fragments were abacus stones which had been adapted as capping for the foundations of the Perpendicular piers of the Collegiate Church. Voussoirs with dog-tooth decoration, an Early English motif, were also believed to have belonged to the arcades.[20] Other stonework was thought to be evidence of a south porch in the Early English period.[21]

The nineteenth-century restorations also revealed stonework in the Decorated style of the fourteenth century. Fragments of window tracery of this period are reported to have been discovered within the walls of three of the chantry chapels, namely St James's chapel on the north side of the nave, and St Nicholas's chapel and St George's chapel on the south.[22] These pieces may originally have belonged to windows in the aisle walls which were taken down when the chapels were built. The largest group of Decorated fragments was brought to light when the chancel arch was rebuilt in the 1880s. Crowther described what was found:

> When the great choir arch at the east end of the nave was taken down, it was discovered that the haunches of the arch and the superincumbent gable wall were largely constructed with the jambs, mullions, sills, and tracery stones of windows of Curvilinear Decorated date, of excellent workmanship, and many of them in perfect preservation. Some of the sills retained the seats for the mullions and jambs, which clearly indicated that they had belonged to windows of two lights.[23]

The evidence from the Decorated period is not confined to such reused fragments. Before the tower was rebuilt, its lower part was a survival of the pre-collegiate church and included a four-teenth-century west doorway.[24] Furthermore, the Cathedral still retains one striking architectural feature which appears to pre-date the collegiation. The arch to the Lady chapel, at the east

20 Crowther, *Architectural History*, pp. 8–11, 19, plate XXXVII. The reused abacus stones were probably the fragments described by John Owen as 'portions of round columns' 2ft 8in to 2ft 10in in diameter which he supposed to be Norman: Owen MSS, vol. 23, pp. 309–10, 336.
21 Crowther, *Architectural History*, pp. 8, 32, plate XXXVII; Owen MSS, vol. 23, facing pp. 139, 334, 336; vol. 27, p. 83.
22 Crowther, *Architectural History*, p. 9; Owen MSS, vol. 23, pp. 87, 309–10, 336.
23 Crowther, *Architectural History*, pp. 9, 13, plate XXXVII.
24 *Ibid.*, p. 12, plate XXXV.

end of the church, is stylistically distinct from the Cathedral's Perpendicular work. Since the time of Crowther, the consensus has favoured a fourteenth-century date for this arch.

The indications are thus that the church standing at the time of the collegiation contained elements from at least two major building phases, the first carried out about the first half of the thirteenth century, the second in the fourteenth. The work in the Early English period seems to have involved the construction of a substantial new nave with aisles. The nave may have reached its present western extent at this time, and certainly no later than the Decorated period when the old tower was constructed at its west end. Crowther supposed that this tower was itself a rebuilding of an Early English predecessor, but the reused Early English fragments found within its fabric could have been taken from the west front of the nave when the fourteenth-century tower was added. Prior to the Perpendicular rebuilding of the church, perhaps the nave arcades were the main surviving Early English features and the predominant style of the church was otherwise the result of fourteenth-century alterations, as suggested by the Decorated tracery discovered within the chancel arch and the chantry chapels.

Crowther believed the pre-collegiate church to have had an aisled Decorated chancel which extended to the present east wall containing the Lady chapel arch. This was challenged by Henry Hudson, an early twentieth-century authority on the Cathedral's fabric and fittings.[25] He thought it more likely that the pre-collegiate church had a shorter aisleless chancel, in keeping with the surviving fourteenth-century chancels of the churches at Nantwich and Stockport in Cheshire. Support was found in the testimony of John Owen. In 1872, between the chancel's north aisle and the choir stalls, Owen had observed what he believed to be remains of an earlier external wall of the chancel, exposed in a trench dug as part of the works for a new organ.[26] As for the Lady chapel arch, Hudson agreed with a probable fourteenth-century date but proposed that the arch had been removed from its original position. The reuse of earlier fabric may have also included the Lady chapel windows, since eighteenth- and early nineteenth-century illustrations show these in a Decorated style.[27] On Hudson's model, the Perpendicular

25 H. A. Hudson, 'An Inquiry into the Structural Development of Manchester Cathedral', *TLCAS* 28 (1911, for 1910), pp. 161–82.
26 Owen MSS, vol. 23, p. 132; Hudson, 'Inquiry', p. 173.
27 Clare Hartwell, Matthew Hyde, and Nikolaus Pevsner, *The Buildings of England. Lancashire: Manchester and the South-East* (New Haven, CT: Yale University Press, 2004), p. 270.

rebuilding saw the replacement of the parochial chancel with a much larger structure presumably considered more fitting for the Collegiate Church.

One detail of the plan of the pre-collegiate church is firmly attested by documentary evidence. In 1422, when Thomas de la Warre gave the site of his manor house as accommodation for the church's new college of priests, included within the grant was a strip of land between that property and 'the north porch of the said church of Manchester'. The north porch was later taken down and the north outer aisle built over its site. Crowther reports that when this aisle was restored in 1884 the foundations of the porch were revealed. Also found were 'several portions of the groin ribs and other details having the distinctive character of the work of the latter half of the 15th century', implying that the porch had been rebuilt following the collegiation.[28]

Archaeology is yet to add to the evidence of the church's early development uncovered during the nineteenth-century restorations. Modern archaeological investigations within the Cathedral have been carried out on two occasions in connection with the laying of new flooring, firstly in the north aisles of the nave in 1986, and more recently when a green underfloor heating system was installed within the Cathedral in 2013. The work recorded burials and ledger stones. However, with the exception of the site of a raisable dais which was also installed in 2013 towards the east end of the nave, the investigations were generally to a shallow depth. No evidence was found of previously unknown walls or the like.[29]

A churchyard used for burials can be assumed to have surrounded the church since the time of its first foundation, although it may not be explicitly documented until the fifteenth century.[30] The present churchyard covers a smaller area than in the medieval and post-medieval periods, having been modified and decreased in size on several occasions in the nineteenth century. On the south, the churchyard originally extended to the edge of Hanging Ditch. Archaeological excavations in 1997 at Cathedral Yard found that the base of the ditch contained waterlogged deposits

28 Crowther, *Architectural History*, p. 21.
29 G. Burns, 'Some Rediscovered Memorial Inscriptions at Manchester Cathedral', *Greater Manchester Archaeological Journal* 2 (1986), pp. 147–51; Matrix Archaeology, 'Manchester Cathedral, Victoria Street, Manchester. Evaluation Test Pitting' (report, 2012); Wessex Archaeology, 'Manchester Cathedral Victoria Street, Manchester. Archaeological Assessment Report of the Excavation and Watching Brief at Manchester Cathedral' (report, 2013).
30 Manchester Archives, L1/51/8/13 no. 12, deed of 1434.

over a metre thick, rich in medieval finds dumped as rubbish.[31] They included animal bones, leather objects and waste, wood, and metal objects, as well as pottery, and amounted to by far the largest medieval assemblage discovered in Manchester.

Access to and from the churchyard across the ditch was provided by the medieval Hanging Bridge, lying almost directly opposite the church's south porch. The bridge is still standing, incorporated within the basement of the Cathedral Visitor Centre. It has two Tudor arches which may be contemporary with the rebuilding of the Collegiate Church during the fifteenth and early sixteenth centuries, but it also seems to incorporate stonework of an earlier structure and there is a reference to Hanging Bridge as early as 1343.[32] The preservation of the bridge has been fortuitous. Successive buildings were erected over the ditch, hiding and protecting the bridge's fabric until its rediscovery during the construction of the present buildings in the late nineteenth century. Together, the Cathedral, Chetham's School of Music, and Hanging Bridge represent the important survival of a closely related group of medieval buildings, central to whose development was the fifteenth-century collegiation, described in the following chapter.

31 Peter Arrowsmith, 'The Medieval Cultural Quarter, Manchester. Vol. 2: Appendices. Archaeological Excavations at Cathedral Yard, 1997 & Archaeological Recording at the Cathedral Visitor Centre, 2001–2' (report for Chetham's School of Music, Manchester Cathedral, and Manchester City Council, 2011), Appendix A.
32 Morris (ed.), *Medieval Manchester*, pp. 48–9; Hartwell, Hyde, and Pevsner, *Lancashire: Manchester and the South-East*, pp. 342–3; Arrowsmith, 'Medieval Cultural Quarter', Appendix B.

✢ 3 ✢

From Foundation to Reformation, 1421–1558

LUCY WOODING

Do we all holy rites.
Let there be sung *Non nobis* and *Te Deum*,
The dead with charity enclosed in clay,
And then to Calais, and to England then,
Where ne'er from France arrived more happy men.[1]

MANCHESTER COLLEGIATE CHURCH was founded in 1421, at a time when victory at the Battle of Agincourt six years earlier was still resonating through political and popular culture. The words of Shakespeare's King Henry V, standing triumphant upon the field of battle, recall how religious sanction was needed to consolidate military success, but also how victory in battle was seen as a sign of divine approbation.[2] In London the news was greeted with 'grete solempnites and processions … with prelattes, prestes, freeres, and other sage men of the cytte', and when the king returned to his capital in triumph, pageantry proclaimed his victory as a blessing from God, choirs dressed as angels sang psalms, and the figure of St George on London Bridge bore a scroll proclaiming *Soli deo honor et gloria*.[3] The

1 Shakespeare, *Henry V*, Act 4, Scene 8, lines 114–18.
2 David Trim, '"Knights of Christ"? Chivalric culture in England, *c.* 1400–*c.* 1550', in David J. B. Trim and Peter J. Balderstone (eds), *Cross, Crown and Community: Religion, Government and Culture in Early Modern England, 1400–1800* (Oxford and New York: Peter Lang, 2004); Matthew Strickland, 'Chivalry, Piety and Conduct', in Anne Curry and Malcolm Mercer (eds), *The Battle of Agincourt* (New Haven, CT, and London: Yale University Press, 2015), pp. 36–49.
3 *Chronicle of the Grey Friars of London*, ed. John Gough Nichols, Camden Society, old series 53 (London: Camden Society, 1852), pp. 12–15. The scroll's inscription means: 'To God alone be the honour and glory': see *Gesta Henrici Quinti: The Deeds of Henry the Fifth*, edited by Frank Taylor and John S. Roskell (Oxford: Clarendon Press, 1975), pp. 100–13 (quotation at pp. 104–5). See also *The Chronicle of Adam Usk, 1377–1421*, edited by Chris Given-Wilson (Oxford: Oxford University Press, 1997),

Previous page:
'Stained abstract'

Treaty of Troyes in 1420 set the seal on his conquests, confirmed his marriage to the French princess Katherine, and granted the joint crown of England and France to their future offspring; a formidable achievement after nearly a century of warfare.[4] This future king of both realms was born in 1421, and in that same year Henry V issued a charter licensing the conversion of the parish church of St Mary in Manchester into a collegiate church, dedicated alongside St Mary to the patron saints of England and France, St George and St Denys.[5]

Manchester in 1421 was a small market town, several days' journey from London. It had been decided in 1359 that it was not significant enough to qualify as a borough, and it would not be given borough status until 1838. A single church would meet the needs of its population until the building of Henry Newcome's Nonconformist chapel in 1693 and the consecration of St Ann's church in 1712. Yet the dedication to St George and St Denys firmly locates Manchester's Collegiate Church within the extraordinary events of Henry V's reign, and within some revitalizing trends in late medieval religion. The dedication to St Denys also helped christen the city's most famous thoroughfare; Deansgate seems to have been a contraction of 'St Denys Gate', which in Elizabethan documents can still be found spelled 'Denysgate'.[6]

Manchester's collegiate foundation was a manifestation of strong political and religious forces which were producing new foundations throughout England. The fourteenth century had ended in political turmoil and anxiety after the dysfunctional reign of Richard II, and the usurpation by Henry IV.[7] Under Henry V Lancastrian power was consolidated, in part through religious patronage which was central to Henry V's

pp. 258–63; Jeremy Catto, 'Religious Change under Henry V', in Gerald Harriss (ed.), *Henry V: The Practice of Kingship* (Oxford: Oxford University Press, 1985), p. 107.

4 Anne Curry, *The Hundred Years War* (Basingstoke: Macmillan, 1993), pp. 103–9; Maurice Keen, 'Diplomacy', in Harriss (ed.), *Henry V*, pp. 193–8.

5 Bertram P. Wolffe, *Henry VI* (London: Eyre Methuen, 1981), p. 28; Manchester, MCA, Mancath/2/1/a/1.

6 Manchester, CL, MS Mun. A.1.9 (2), 10 November 1559, is an indenture concerning a house in 'the highe waye called Denysgate'. Other origins for the name 'Deansgate' have also been suggested, as dating back to Anglo-Saxon times, or taken from the lost River Dene, but these seem less plausible.

7 Michael J. Bennett, *Richard II and the Revolution of 1399* (Stroud: Alan Sutton, 1999); Paul Strohm, *England's Empty Throne: Usurpation and the Language of Legitimation, 1399–1422* (New Haven, CT, and London: Yale University Press, 1998); Given-Wilson, *Henry IV* (New Haven, CT, and London: Yale University Press, 2016),

Above and facing:
The foundation
charter

self-fashioning in an age when a good king was necessarily also a godly king.[8] Religious devotion was also an essential element in popular support for the Hundred Years War, in which St George had been confirmed as England's patron saint and patron of the Order of the Garter.[9] After Agincourt St George was promoted to a double feast and in 1416 the visiting Emperor Sigismund brought the heart of St George as a gift for the king.[10] Manchester's dedication to St George and St Denys thus reflected national concerns and the hopes, fears, and triumphs connected with the wars in France. It was one of a series of fifteenth-century collegiate foundations whose patrons frequently included the Virgin

8 Christopher T. Allmand, *Henry V* (London: Methuen, 1992); Harriss, 'Introduction: the Examplar of Kingship', in Harriss (ed.), *Henry V*, pp. 1–31; Catto, 'Religious Change', p. 108; Gerald Harriss, *Shaping the Nation: England 1360–1461* (Oxford: Clarendon Press, 2005), pp. 588–90.
9 Samantha Riches, *Saint George: Hero, Martyr and Myth* (Stroud: Alan Sutton, 2000), pp. 104–6; W. M. Ormrod, *The Reign of Edward III: Crown and Political Society in England 1327–1377* (New Haven, CT, and London: Yale University Press, 1993), p. 19; Jenny Stratford, 'St George and St Denis', in Curry and Mercer (eds), *Battle of Agincourt*, pp. 50–62.
10 Elizabeth O. Gordon, *Saint George: Champion of Christendom and Patron Saint of England* (London: S. Sonnenschein, 1907), p. 44.

Mary and St George, both viewed as protectors of the realm in the struggle with the French.[11]

These late medieval colleges followed the precedent set by the two great royal foundations of 1348, St George's College in Windsor and St Stephen's College in Westminster, both founded by Edward III, who had thereby laid claim to the sacrality of kingship manifested by his French rivals in their foundation of the Sainte Chapelle in Paris.[12] This intertwining of political aspirations with religious devotion has been described as a new kind of 'political theology', in part intended to portray the king as *miles Christi* (soldier of Christ).[13] Bishops organized a national effort of prayers and processions and parish congregations became intercessors for those fighting overseas. Five centuries later, weekly prayers in Manchester Cathedral during the Second World War would echo this founding principle.[14]

Henry V manifested piety through patronage. Around his royal palace at Sheen on the Thames, he planned to build three great monasteries.[15] Of the two he managed to complete before his untimely death in 1422, one was the Brigittine house of Syon, known for its commitment to scholarship and preaching, its famous library, and the publication of some influential religious books.[16] This was a demonstration of the king's concern for religious renewal and education, and instrumental in these foundations was Bishop Langley of Durham, who would also be

[11] Martin Heale, 'Colleges and Monasteries in Late Medieval England', in Clive Burgess and Martin Heale (eds), *The Late Medieval English College and its Context* (Woodbridge and Rochester, NY: York Medieval Press, 2008), p. 76.

[12] Clive Burgess, 'St George's College, Windsor: Context and Consequence', in Nigel Saul (ed.), *St George's Chapel, Windsor, in the Fourteenth Century* (Woodbridge: Boydell, 2005), pp. 63–96.

[13] Clive Burgess, 'An Institution for all Seasons: The Late Medieval English College', in Burgess and Heale (eds), *Late Medieval English College*, pp. 17–18, 20–1, 25; Catto, 'Religious Change under Henry V', pp. 107–8; R. N. Swanson, *Church and Society in Late Medieval England* (Oxford: Blackwell, 1989), p. 99.

[14] Prayers were held weekly in the Cathedral except during the period from 23 December 1940 to 26 February 1941, when they were moved to St Ann's Church in consequence of the bombing.

[15] Henry V planned a triple foundation of Carthusians, Brigittines, and Celestines, but managed only the first two of these, since the Celestines were a French order unhappy with the king's ambitions in France: see John Matusiak, *Henry V* (Abingdon: Routledge, 2013), pp. 83–4.

[16] E. A. Jones and Alexandra Walsham (eds), *Syon Abbey and its Books: Reading, Writing and Religion c .1400–1700*, Studies in Modern British Religious History 24 (Woodbridge: Boydell, 2010); Susan Powell, *The Birgittines of Syon Abbey: Preaching and Print*, Texts and Transitions 11 (Turnhout: Brepols, 2017); Jan Rhodes, 'Syon Abbey and its Religious Publications in the Sixteenth Century', *JEH* 44 (1993), pp. 11–25.

one of the co-founders of Manchester College.[17] Bishop Langley served as Bishop of Durham from 1406 to 1436, a key figure in the north of England, securing Lancastrian authority in a region which had seen two serious uprisings in 1403 and 1405. His involvement alone shows the significance of the new foundation in Manchester.

Fifteenth-century religion was once assumed by historians to have been moribund and unpopular. More recent research has uncovered a church which was, by contrast, remarkable in its energy, commitment, popularity, and versatility.[18] Collegiate churches were an increasingly popular form of religious foundation which reflected some of these qualities. Colleges contained communities of canons or fellows who were priests rather than monks, and in many ways fulfilled the functions of both monastery and parish church, whilst being easier and less expensive to found than monasteries. Alongside the unbroken cycle of worship and the commemoration of founders and patrons, the warden and fellows also answered the needs of a parish community, dispensing charity and providing education on site with more ease and immediacy than a monastic community. Many parish churches were being 'upgraded' to the rank of collegiate church in this era.[19] Colleges could be adapted to include the

17 R. L. Storey, *Thomas Langley and the Bishopric of Durham, 1406–1435* (London: SPCK, 1961); Ian C. Sharman, *Thomas Langley, the first Spin-Doctor (c. 1353–1437): A Political Biography of the Fifteenth Century's Greatest Statesman* (London: Dovecote-Renaissance, 1999).

18 Eamon Duffy, *The Stripping of the Altars: Traditional Religion in England 1400–1580* (New Haven, CT, and London: Yale University Press, 1992); Swanson, *Church and Society*; Caroline M. Barron and Christopher Harper-Bill (eds), *The Church in Pre-Reformation Society: Essays in Honour of F. R. H. Du Boulay* (Woodbridge: Boydell, 1985); J. J. Scarisbrick, *The Reformation and the English People* (Oxford: Blackwell, 1984); Richard Marks, *Image and Devotion in Late Medieval England* (Stroud: Sutton, 2004); Katherine L. French, *The People of the Parish: Community Life in a Late Medieval English Diocese* (Philadelphia, PA: University of Pennsylvania Press, 2001); Beat Kümin, *The Shaping of a Community: The Rise and Reformation of the English Parish*, c. 1400–1560 (Aldershot: Ashgate, 1996); Andrew D. Brown, *Popular Piety in Late Medieval England: The Diocese of Salisbury 1250–1550* (Oxford: Clarendon Press, 1995); Peter Marshall, *The Catholic Priesthood and the English Reformation* (Oxford: Clarendon Press, 1994); Sarah Beckwith, *Christ's Body: Identity, Culture and Society in Late Medieval Writings* (London: Routledge, 1993); Jonathan Hughes, *Pastors and Visionaries: Religion and Secular Life in Late Medieval Yorkshire* (Woodbridge: Boydell, 1988); George W. Bernard, *The Late Medieval English Church: Vitality and Vulnerability before the Break with Rome* (New Haven, CT, and London: Yale University Press, 2012).

19 David Knowles and R. Neville Hadcock, *Medieval Religious Houses: England and Wales*, 2nd edn (London: Longman, 1971), pp. 37–8; see also Paul Jeffery, *The Collegiate Churches of England and Wales* (London: Robert Hale, 2004).

role of mausoleum for the families of wealthy patrons, or alternatively directed more towards educational provision, as in the case of Oxford and Cambridge colleges.[20] To found a collegiate church was to embrace a flexible and successful model of liturgical provision, pastoral care, and religious renewal.

The illustrious founders of Manchester College linked together the concerns of the regime with the needs of the locality. Thomas Langley, Bishop of Durham, was Lord Chancellor of England under all three Lancastrian kings, whilst Thomas de la Warre's family had been Lords of Manchester since 1347. The de la Warres had served the Black Prince, and Thomas de la Warre's father had fought at Crécy and Poitiers. Langley had been born in Middleton, five miles north of Manchester, where in 1412 he consecrated the new church that he had built and dedicated to St Leonard. Thomas de la Warre was the younger son of Roger, third Baron de la Warre and Lord of Manchester, who after an education at Oxford had pursued a successful career in the church. Rector of Ashton-under-Lyne in 1372, he was made Rector of Swineshead in Lincolnshire – where the church contained the family mausoleum of the de la Warres – in 1378, and from 1382 he was Rector of Manchester. Thomas's grandmother, Margaret, was a Holland, and sister to the first husband of Princess Joan, whose second husband was the Black Prince. It is possible that Thomas was raised in the household of the widowed Princess Joan; he was certainly referred to in a papal dispensation of 1390 as a 'kinsman of Richard II'.[21] Princess Joan's two sons from her first marriage, the Holland brothers, were therefore Thomas de la Warre's first cousins. They became the Earls of Huntingdon and Kent, and it was the illegitimate son of the Earl of Huntingdon, known simply as John Huntingdon, who became the first Warden of Manchester Collegiate Church.

If it was Thomas Langley and Thomas de la Warre who provided the inspiration and the money behind Manchester College, it was John Huntingdon who shaped their vision into the realities of stone and glass, prayer and service. Warden of the College for over thirty years, Huntingdon began the long slow process of rebuilding the existing church. His greatest architectural achievement was the chancel, which is why his funerary brass lies before the altar, with the inscription '*Hic iacet Johannes Huntyngton /*

20 Clive Burgess, 'An Institution for All Seasons', in Burgess and Heale (eds), *Late Medieval English College*, pp. 11–15, 24–5. The famous colleges of St George's, Windsor, and St Stephen's, Westminster, were a blend of several of these elements: Knowles and Hadcock, *Medieval Religious Houses*, p. 39.
21 *Chetham Miscellanies: New Series, Volume VI*, CS ns 94 (Manchester: Chetham Society, 1935), p. 35.

Above and below:
The Huntingdon
rebus

Bacalarius in Decretis / primus Magister siue Custos istius Collegii / Qui novo construxit istam Cancellam'. After giving the date of his death, the inscription concludes '*Cuius anime propicietur*'.[22] At either side of the chancel arch he left another testament in the form of a rebus: two panels, carved on the left side depicting hunting dogs, and on the right in the form of a barrel, or tun. 'Hunting' and 'Tun' were thereby signified, making 'Hunting-don'. Richard Hollingworth, the seventeenth-century fellow of Manchester who wrote the college's history in the 1650s, opined that this was a more ingenious device than that of the Archbishop of Canterbury, John Morton, who had a mulberry tree (*morus* in Latin) upon a barrel or tun.[23] The crest of Manchester Grammar School, itself an offshoot of the collegiate foundation, reproduces the arms of its founder Hugh Oldham, incorporating several owls. In a largely illiterate world, these symbols reinforced the authority of the patrons and protectors of the community.

Sanction for the new Collegiate Church in Manchester came not only from the King and noble patrons but also from the parish itself. In June 1421, a letter was addressed to the Bishop of Coventry and Lichfield, to whose diocese Manchester then belonged, from the churchwardens and gentlemen of the parish, giving their consent to the foundation of the college.[24] In August 1422 there followed the decree by the Bishop himself and the Archdeacon of Chester.[25] Manchester's Collegiate Church was the result of concerted effort from King, nobility, episcopate, local gentry and townsfolk, and the officers of the parish. Its foundation charter bears the name of two churchwardens, described as *humiles* ('of lowly status'), two knights, and nineteen local gentlemen. In late medieval society, the church was viewed as the prized possession of the local community, who shared the responsibility for its upkeep and found a haven for their most important rites of passage within its sacred space. The nature of its origins therefore left Manchester College with a part to play in both national politics and the life of the town itself. Its founding fathers thus established a pattern which went on unfolding in often altered yet always recognizable form for the next six centuries. The history of Manchester's collegiate foundation would continue to reflect trends in politics and religion at

22 'Here lies John Huntingdon, Bachelor in Canon Law, the first Master or Warden of this College, who newly built this Chancel ... whose soul may God pardon.'

23 CL, MS Mun.A.6.51, fol. 9v.

24 MCA, Mancath/2/1/a/2 (14 June 1421).

25 MCA, Mancath/2/1/a/3 (3 August 1422).

the national level, yet it would never forget its primary obligation to the community which surrounded church and college.

The late medieval foundation

Its founders intended that Manchester Collegiate Church should offer the best possible religious provision for the local community, as well as providing prayers for the souls of its benefactors. They provided for a warden, eight fellows, four clerks, and six choristers. The terms of the foundation were intended to limit the abuses of pluralism and non-residence; the papal confirmation of the foundation in 1426 noted that absenteeism had been a long-standing problem.[26] Warden and fellows lived in the college and concentrated their efforts on fulfilling their duties there: in 1546 Henry VIII's commissioners would describe the members of the foundation as 'all bounden to be resident and kepe hospitalitie togithers'.[27] For this reason, although the warden was given a respectable salary, the fellows were given a more modest stipend of £4 per year, with an added 16d each week for commons, which would be dependent on residence. The original endowment of £260 still left £56 surplus each year after the payment of these stipends, which shows their limitation was intended; the extra funds were to be used for charitable purposes and repairs to the church. Langley had a reputation as a strict enforcer of clerical residence. He reformed the statutes of collegiate churches at Auckland and Lanchester and made repeated attempts to reform the collegiate church at Chester-le-Street.[28]

Warden Huntingdon's funerary brass lies between the choir stalls in the chancel, a reminder of the central work of a collegiate church, which was the round of offices sung each day. This was a version of the monastic office, maintaining an unbroken cycle of worship, with particular prayers for the souls of the founders and other important patrons. Intercession was also made for the local community and for all Christian souls; once a year on All Souls' Day all the dead were commemorated. In line with customary late medieval practice, the church also became home to several chantries, where masses sought intercession for members of particular families or guilds. The affairs of the parish

26 Christopher Haigh, *Reformation and Resistance in Tudor Lancashire* (Cambridge: Cambridge University Press, 1975), p. 28.

27 F. R. Raines (ed.), *A History of the Chantries within the County Palatine of Lancaster: Being the Reports of the Royal Commissioners of Henry VIII., Edward VI. and Queen Mary*, CS os 59, 60 (Manchester: Chetham Society, 1862), vol. 1, p. 8.

28 *ODNB, s.n.* 'Langley, Thomas (c. 1360–1437)'.

were put into the hands of two of the foundation, but it is clear that other members of the college frequently had to help out in meeting the needs of the congregation. These would comprise baptisms, churchings, nuptial masses, and funerals, and once a year during Lent, the great work of hearing everyone's annual confession before they took communion at Easter. There was also a constant round of saints' days and festivals which marked out the passage of time. In the many documents from this time in the cathedral archives, it is notable that the actual year was seldom mentioned. Time was marked in regnal years – 'the sixt yere of Edward the Sixt' or 'in the fourth and fifth yere of Philip and Mary' – and specific dates were identified by their proximity to religious feasts.[29] Legal documents requiring the payment of fines might instruct that the money should be handed over 'att the ffest of the purificacion of oure blissed ladie next', with a second payment due at the nativity of St John the Baptist.[30] The marking out of legal or university terms in the twenty-first century with relation to St Michael (Michaelmas), St Hilary, or the Trinity is one small echo of a time when secular affairs were unthinkingly subsumed within the sacred.

The college building which housed the collegiate community was built close to the church, completed more swiftly than the rebuilding of the church itself, which happened in stages. The college is still standing, preserved by its metamorphosis in the 1650s into Chetham's Hospital, School, and Library, and its transformation into Chetham's School of Music during the 1960s. The buildings were lavish by the standards of the 1420s, constructed of red sandstone with thick walls, roofed with stone slates. The warden's lodgings were at one corner of the college, next to the hall, built on the site of the baronial hall of the Lords of Manchester, which had been bequeathed by Thomas de la Warre to the college. There was a square college building, with the fellows' rooms arranged around a two-storey central cloister. A north wing held dormitories, possibly for the choristers and also for the servants, for this was a self-contained community with its own baker and brewer and other household officials to sustain the work of the college.

The collegiate church was closely integrated with the town's community.[31] In the will of the merchant John Garnet, dated 13 March 1528, the testator bequeathed 'my soule to almighty

29 Manchester, JRL, MS TW/544; CL, Hulme Trust Deeds, E.3.8. no. 50. Philip's reign in England started a year after Mary's, when the two married.
30 JRL, CLD/130 (1480).
31 Burgess, 'Institution for All Seasons', p. 11.

god and my body to be buried in Manchester church in suche place as my executours shall lymyte and appoynte'. He left 'to the wardeyn of Manchester my best quyck beest in the name of my mortuary to be praid for'.[32] This was treating the warden no differently from any other parish priest. Another will, dating from 1504, by Elizabeth Beck (whose late husband Thomas may have been father to John Garnet's son-in-law) demonstrates a typical bequest from a wealthy townswoman. Elizabeth decreed that her body 'be buryed within the parishe Church of Manchester in the Chapel foundyd of my husbande wherin his boddye doth rest / unto the whiche Churche I give for my mortuary xs', adding, to ensure the attendance of additional clergy, 'also / to enye preste at the daye of my buryall / yt date there being iiij d'. Elizabeth left money for the poor who carried torches at her funeral, and money to provide them with a dinner. She also gave a handsome endowment of forty pounds to sustain a priest who would pray 'for my soule helth father and mother my husbande and good ffrende'. Thirty shillings went 'to the mendyng of high wayes and repayring therof', in a characteristic display of civic responsibility, which was counted no less a godly work than the giving of charity to the poor. There then followed a very long list of household goods to be disbursed, including to Edward Padley, Vicar of Whalley, twenty pounds and 'a bede of ffethers / a matteres with hanygnge therto / & coveryng ij blankettes / ii payer of shettes and bolster, ii pyllowys / ii pillowbers [pillowcases]' and 'the greatest pott of brasse in the kytchyng'.[33] If the clergy made provision for the souls of the laity, the laity understood their obligation to provide for the more mundane needs of the clergy in their turn.

At a more exalted level, we see the Collegiate Church capable of answering the needs of noble or gentry patrons in much the same way as a monastery might do, serving as a memorial to grandeur and munificence, and ensuring perpetual prayers for the dead.[34] This was reflected in Manchester's relationship with James Stanley, Warden of Manchester College from 1485 and later also Bishop of Ely.[35] Stanley was the sixth son of Thomas Stanley, Earl of Derby, by his first marriage; his father's second marriage was to Lady Margaret Beaufort, mother to Henry VII, which did a great deal to enhance the family's fortunes. Stanley

32 Kew, TNA, Prob/11/23, image 93, John Garnet's will. John's daughter Agnes married Thomas Beck, to whom the testator left a sizeable bequest.

33 TNA, Prob/11/26, image 242, Elizabeth Beck's will.

34 Burgess, 'Institution for All Seasons', pp. 22–3.

35 Stanley's predecessor as Warden of Manchester was another James Stanley, his uncle, with whom he has sometimes been confused.

held the Wardenship from 1485 to 1509, was made Bishop of Ely in 1506, and died in 1515 at Manchester, two days after making his will. He was a great patron of religious institutions, but was not an obviously pious individual, being fond of cock-fighting and having at least three illegitimate children by his housekeeper. He has been described as the greatest sinner on the pre-Reformation bench of bishops, and Hollingworth called him 'more voluptuous than virtuous'.[36] Stanley's bequests included several sets of vestments in rich fabrics embroidered with his coat of arms and gifts of church plate which also bore his coat of arms. His will left detailed instructions for the building of chantry chapels in both Manchester and Ely. Substantial bequests for obits and other prayers in Manchester and Ely were supplemented by bequests 'to every oon of the iiij Orders of Fryers both in Cambrigge and Oxford', the London Greyfriars, houses of friars in Warrington, Preston, Chester, and Lancaster, and the nuns of Chester. This formidable array of intercessors suggests that Stanley felt considerable effort might be required to speed his soul through purgatory. The elder of his two illegitimate sons, John, had fought at Flodden and been knighted; he would go on to found the Stanleys of Hanford in Cheshire. It seems mildly ironic that James left most of his land to this Sir John, 'and hys heires of his body lauffully begotten'.[37]

The warden and fellows may have provided prayers for the nobility and gentry but they were also integrated into the local community in other, more humble ways. Their names appear on a range of fifteenth- and early sixteenth-century documents, as landlords, petitioners, witnesses, executors, and arbitrators. In 1438 we find the Warden, John Huntingdon, and several fellows witnessing a land transaction.[38] In 1549, even as the college was being dissolved by Edward VI, a grant of land by Lord de la Warre was witnessed by several fellows.[39] The surnames of the fellows, deacons, and choristers make clear how closely the college was integrated within Lancashire's community: the names Chetham, Pendleton, Byron, Bexwicke, Mosley, Trafford, and Radcliffe all appear. Nor were the interests of the community limited to Manchester alone. In 1476, Ralph Langley, Warden of Manchester, was responsible for the rebuilding of Oldham

36 Christopher Haigh, *English Reformations: Religion, Politics and Society under the Tudors* (Oxford: Clarendon Press, 1993), p. 10; Richard Hollingworth, *Mancuniensis; or, a History of the Towne of and what is most memorable concerning it* (Manchester: William Willis, 1839), p. 50.

37 TNA, Prob/11/18, image 81, James Stanley's will.

38 Manchester, GMCRO, MS E7/5/1/24.

39 CL, MS LCAS 1/1, 1 July 1549.

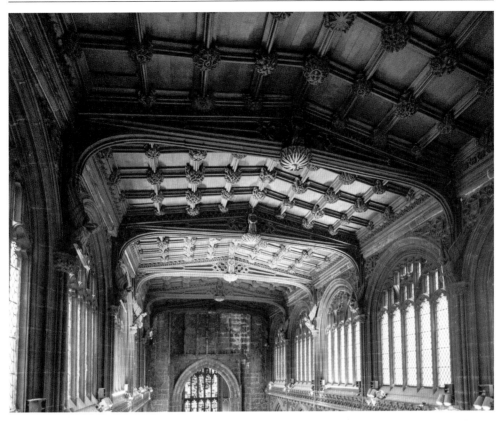

The fifteenth-century
nave roof

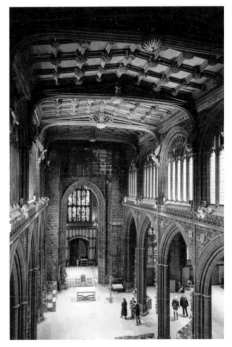

Church, and he helped pay for its ring of bells; back home in Manchester, he is reputed to have built the portion of Manchester's church 'between the pulpit and the steeple'.[40]

The warden and fellows of Manchester frequently acted to keep the peace. As senior figures within the town, who possessed the sanction of religious authority, they could resolve disputes and dictate the terms of settlement. In 1480, during the reign of Edward IV, Warden Langley helped end a dispute between different members of the Chetham family. A formal indenture made note of the 'contumlies and debates' that had raged between Margery Chetham and her sons on the one hand, and Thomas Chetham, the brother of her dead husband, on the other. Langley acted together with representatives of the local gentry to forge a settlement which was both practical and pious. The payment of certain contested sums of money was enforced, but there was also an exhortation for those involved to be friends henceforth, 'as moder as childre, brothre and brothre ogthe to do'.[41]

Very early on in its life, in the latter part of the 1420s (the exact date is unknown), the college was itself involved in a highly charged local dispute. One of the fellows, Thomas Barbour, had in some way offended the Booth family, who arrived to arrest him during Compline, forcing their way into the choir. The locals rallied round to protect all the fellows and get them back safely to their dwelling quarters. Once there, however, they were besieged by the force of five hundred men headed by Sir John Byron, and they had to petition the Council for relief. Huntingdon's request for a commission of *oyer* and *terminer* to settle the matter was written in legal French, and made it clear how much the college owed to 'les bonnes gents de la ville de manchestre'.[42]

Warden Huntingdon established the College as a central part of the town's community and remained in his post for many years until his death in 1458. His name would have resonance for years to come. In 1507 a dispute was being resolved over lands which Huntingdon had bequeathed to the College. On one side of the dispute was Ralph Hulme, who had purchased lands from Huntingdon's heir, John Ravald, who had had no business to sell them, since they were part of Huntingdon's bequest to Manchester College. On the other side were three fellows of the College. The resolution of this dispute was masterly. Both sides relinquished their claim over the lands, with the exception of a few retained

40 F. R. Raines, *The Rectors of Manchester and Wardens of the Collegiate Church of that Town*, 2 vols, CS ns 5, 6 (Manchester: Chetham Society, 1885), vol. 1, pp. 30–1.
41 JRL, MS CLD/271.
42 TNA, SC/8/115/5734; 'the good men of the town of manchester'.

by Hulme, and with the income of these surrendered lands, held in trust, a chantry dedicated to St James was established with a priest instructed to pray for the soul of Huntingdon, but equally for the souls of Hulme's own parents, and 'for the good estate of the said Rauff, Elizabeth his wiff and his childre and heres. And also for the good estate of Thomas Erle of Derby now living and of James Stanley now Bisshop of Ely … and all christen sowles for ever.'[43] By these means everyone received some benefit; the community, the litigants, the parish, even the local nobility. The arbitrators, who comprised the warden, a fellow, and two local laymen, asked that the chantry priests 'shall not forgete us the said arbitors nor our sowles aftur our decesse'.[44] It shows how closely the Collegiate Church, its wardens, and its fellows were involved with Manchester society, and how the town's secular needs were inextricably intertwined with religious belief and practice. John Huntingdon was listed as one of the founders of the chantry which emerged from this settlement, still a name to be reckoned with although he had been dead for half a century.

Education, commemoration, and reform

The fifteenth century was a great age of educational provision. Patrons from the royal family, the episcopate, nobility, gentry, and wealthy merchant communities endowed a great range of colleges, schools, chantries, and libraries. The wealthiest might endow an Oxford or Cambridge college; Lady Margaret Beaufort, mother to Henry VII, founded St John's College and helped establish Christ's College, Cambridge, and her step-son James Stanley (the Warden of Manchester who later became Bishop of Ely) gave generously to both foundations. Another Bishop of Ely, John Alcock, founded Jesus College, Cambridge, but on a smaller scale also endowed in 1486 a chantry and school at the Church of the Holy Trinity in Hull, which would eventually become Hull Grammar School. This dual provision of chantry and school was increasingly common at this time, and this was to have important consequences for Manchester.

Thomas Langley, Manchester's co-founder, built two side chapels in Middleton Parish Church around 1412, and the one dedicated to St Cuthbert was made his chantry chapel after his death. As Bishop of Durham, Langley had also rebuilt the Galilee Chapel in Durham Cathedral around 1420, and he endowed another chantry at the altar there. Both in Middleton and in

43 MCA, Mancath/2/A2 /1.
44 MCA, Mancath/2/A2/1 (1 June 1507).

Durham, the chantry priests were instructed 'to teache one grammar skole fre for pore children'.[45] The school in Middleton (re-founded by Elizabeth I) and Durham School both continue to this day. The primary function of chantry priests was to say masses for the soul of the benefactor, his or her family, and all Christian souls, but it was also important that they contributed to the life of the community.[46] Even when the chantries were dissolved in the reign of Edward VI, the Duchy of Lancaster would go on maintaining the schools which they had created and sustained.[47]

In 1506, Richard Bexwicke, a Manchester merchant, founded the Jesus Chantry within the Collegiate Church, with the understanding that the priest should also offer schooling to local children. This was the beginning of Manchester Grammar School, which in 1515 was set on a more secure footing through the patronage of Hugh Oldham, another local man, by then Bishop of Exeter, along with Richard Bexwicke's wife Joan, who was Hugh Oldham's sister, and Richard and Joan's son Hugh Bexwicke. The Grammar School was built next to the College and the warden and fellows of the College were closely involved with the running of the School. It aimed to give the poor children of Lancashire the chance of an education, lamenting that up until then 'the childeryn in the same cuntrey, havyng pregnant witte, have ben, most parte, brought up rudely and idilly, and not in vertue, connyng, erudition, littature, and in good maners', and it sternly forbade Master and Usher to show favouritism, or take any form of bribe, or turn away any poor boy unless they were suffering from an infectious disease.[48] The school used the fashionable Latin grammar written by John Stanbridge, Master of Magdalen College School in Oxford, the first Renaissance grammar school founded in England.[49] Hugh and Joan's statutes required the Master and Usher of the school to attend divine service every feast or festival day, joining the fellows in the choir if they were themselves in holy orders, and the schoolboys were

45 Storey, *Thomas Langley*, p. 6.
46 Clive Burgess, 'Chantries in the Parish, or "Through the Looking-glass"', *Journal of the British Archaeological Association* 164 (2011), pp. 100–29.
47 Haigh, *Reformation and Resistance*, p. 150.
48 Samuel Hibbert-Ware, *History of the Foundations in Manchester of Christ's College, Chetham's Hospital, and the Free Grammar School*, 3 vols (Manchester: Thomas Agnew and Joseph Zanetti, 1848), vol. 3, pp. 21, 25, 28.
49 *Ibid.*, p. 24; see also Nicholas Orme, *Education in Early Tudor England: Magdalen College Oxford and its School, 1480–1540* (Oxford: Magdalen College, 1998).

The Jesus Chapel

to go in procession on Wednesdays and Fridays to pray for the souls of their benefactors.[50]

The foundation of chantries was about more than just education. Their primary function was to celebrate masses for the souls of the dead, and in so doing to provide both an expression of lay devotion and a physical space within the church which might shape a community of neighbours.[51] Chantries were one of the most characteristic features of the fifteenth-century church, and their history counters some long-held assumptions about late medieval religion. They were the fruit of an initiative by the laity, yet one which brought clergy and laity together in partnership. They answered the individual needs of a small group of family members who needed their dead commemorated, yet chantry priests also served in the parish church and the community at large and prayed not just for their benefactors but for all Christian souls. Chantries handsomely endowed would usually include the building of a chantry chapel, which could add considerably to the space and splendour of a church; yet for those who had less money, a chantry could be established merely by paying a priest to say masses at an existing altar, so this was a form of religious expression open to a fairly broad section of society.[52] Those who established chantries were doing something out of the ordinary, yet something which in no way challenged existing patterns of devotion, but rather consolidated traditional beliefs and practices. They were an example of how the medieval church could expand and diversify religious observance without damaging either the certainties of its doctrine or the cohesion of its parish congregations.

In Manchester at least seven new chantries were founded between 1498 and 1523, in addition to several older ones already in existence. They were founded by a mixture of clergy and laity, from both gentry and merchant backgrounds. The names of the founders – Radcliffe, Chetham, Bexwicke, Huntingdon, Stanley, Beck – show how they represented some important local families.[53] Careful provision was made to keep these chantries work-

50 Raines (ed.), *History of the Chantries*, vol. 2, pp. 246–9.
51 Alan Kreider, *English Chantries: The Road to Dissolution*, Harvard Historical Studies 97 (Cambridge, MA: Harvard University Press, 1979), pp. 5–8; Clive Burgess, '"For the Increase of Divine Service": Chantries in the Parish in Late Medieval Bristol', *JEH* 36 (1985), pp. 46–65; Duffy, *Stripping of the Altars*, pp. 369–70.
52 Haigh, *Reformation and Resistance*, pp. 68–71.
53 1498 Holy Trinity Chantry founded by William Radclyffe, Esq.; 1501 St George's Chantry founded by Robert Chetham, gentleman; 1502 second St George's Chantry founded by William Galey, merchant; 1506 Jesus Chantry founded by Richard Bexwicke, merchant, *et al.*; 1507 St James

ing well. In 1523, there was an investigation by Sir Alexander Radcliffe into the workings of the chantry established in 1501 by the will of Robert Chetham; the new indenture quoted the initial foundation document, and enforced the necessity of maintaining the chantry in St George's Chapel as the founders had intended.[54] In 1507, it was laid down that a group of townsfolk, or their heirs, were responsible for finding a replacement 'yf any prest ... fortune to be of evill disposicion or doo not his duetie so that he shall not be thought mete to contynewe'. Arrangements were made ensuring that there would always be a group of six people carrying this obligation, 'heraftur for ever'.[55] It was firmly expected that these chantries would continue until the end of the world, which gives some idea of how devastating the Reformation, which destroyed the chantries, must have seemed to those of a traditional faith.[56]

These chantries also demonstrate the workings of religious guilds or confraternities.[57] The Jesus Chapel of 1506 was founded by Richard Bexwicke alongside the other 'masters, Wardens, or yeomen, of the guild of St. Saviour and of the name Jesus'.[58] The chantry of the Guild of Our Lady and St George was instituted in 1523. Guilds were religious associations open to men and sometimes also women which offered extra opportunities for the expression of religious devotion, and also gave comfort and security to its members, who took responsibility for other members and their families.[59] If a guild member died in poverty, for example, the guild would feel obliged to give him decent burial and provide for his widow and children. If a member went

Chantry founded by Warden Huntingdon and Ralph Hulme, Esq.; 1515 Chantry of Christ and St John the Baptist founded by James Stanley, Bishop of Ely; 1523 Our Lady and St George's Guild founded by Richard Tetlaw *et al.*

54 CL, MS Mun.E.4.6, Raines Deeds and Papers, bundle no. 9, no. 126, 24 April 1523.

55 MCA, Mancath/2/A2/1 (1 June 1507).

56 Kreider, *English Chantries*; Scarisbrick, *Reformation and the English People*, pp. 85–108.

57 Haigh, *Reformation and Resistance*, p. 67.

58 H. A. Hudson, 'Jesus Chapel, Manchester Cathedral', *TLCAS* 35 (1918), pp. 106–8.

59 David J. F. Crouch, *Piety, Fraternity and Power: Religious Gilds in Late Medieval Yorkshire 1389–1547* (York: York Medieval Press, 2000); Virginia R. Bainbridge, *Gilds in the Medieval Countryside: Social and Religious Change in Cambridgeshire, c. 1350–1550*, Studies in the History of Medieval Religion 10 (Woodbridge: Boydell, 1996); Gervase Rosser, 'Communities of Parish and Guild in the Late Middle Ages', in Susan J. Wright (ed.), *Parish Church and People: Local Studies in Lay Religion 1350–1750* (London: Hutchinson, 1988), pp. 29–55; Caroline M. Barron, 'The Parish Fraternities of Medieval London', in Barron and Harper-Bill (eds), *Church in Pre-Reformation Society*, pp. 13–37.

on pilgrimage, the guild would protect his family and property in his absence – and turn out to welcome him home upon his return. Guild members might help provide dowries for a member's daughter, or give support during a legal case, or lend money in time of need. Guilds would keep their particular feast day with great solemnity, and often organized weekday masses or other devotions, over and above the usual liturgical cycle within the parish church.[60]

The importance of the Jesus Chantry of 1506 can be gauged from the size and splendour of the Jesus Chapel which still stands today. This chapel and its chantry, as the consecration deed stated, was established 'to the praise of God, and to the honour of the Saviour and of the name Jesus', and the guild was to hold in perpetuity 'all and all manner of oblations, obventions, and emoluments whatsoever, which shall be offered and made to the Image of the Saviour in the said chapel'.[61] Dedications to Christ were a manifestation of the cult of the Holy Name of Jesus, which was growing in England in the later fifteenth century, encouraged by the patronage of Lady Margaret Beaufort, who in 1494 secured papal sanction for the new feast day.[62] Masses of the Name of Jesus came with indulgences on a scale which rendered it similar to the feast of Corpus Christi in spiritual importance.[63]

The devotional cult of the Name of Jesus also encouraged private piety. One indication of this was the use of 'IHS' at the start of letters; a surviving letter from Robert Cliff, Warden of Manchester 1506 to 1516, bears this inscription.[64] In the northwest, this cult had been encouraged by William Booth, fellow of Manchester in the 1420s and 1430s and later Archbishop of York, who founded the Collegiate Church of Jesus and the Blessed Virgin Mary at Eccles in 1460. The Booths came from Barton, near Eccles, and William Booth's nephew, John, became Warden of Manchester 1459 to 1465. William Booth also had a

60 Duffy, *Stripping of the Altars*, pp. 141–54.
61 Hudson, 'Jesus Chapel', pp. 105–8.
62 Michael K. Jones and Malcolm G. Underwood, *The King's Mother: Lady Margaret Beaufort, Countess of Richmond and Derby* (Cambridge: Cambridge University Press, 1992), pp. 176–7, 178. See also Susan Wabuda, *Preaching in the English Reformation* (Cambridge: Cambridge University Press, 2002), ch. 4, 'The Name of Jesus', pp. 147–77.
63 Pope Alexander VI, responding to Lady Margaret's petition in 1494, granted an indulgence of 3,000 years of remittance from purgatory to those who celebrated or endowed a votive Mass of the Holy Name for 30 days: see Wabuda, *Preaching in the Reformation*, p. 165; R. N. Swanson, *Indulgences in Late Medieval England: Passports to Paradise?* (Cambridge: Cambridge University Press, 2007), p. 265.
64 Raines, *Rectors of Manchester*, vol. 1, p. 47.

half-brother Laurence, who was Dean of St Paul's in the 1450s; Master of Pembroke Hall, Cambridge; Chancellor of the University; Bishop of Durham; and eventually Archbishop of York after his brother. It was in the 1450s that the Jesus Guild was established at St Paul's, and it is possible that Manchester was following London's example: another link was that of Roger Radclyffe, briefly Warden in 1459, who went on to be Dean of St Paul's thereafter. Manchester's association with the cult of the name of Jesus reflects its links to some of the most dynamic elements in late medieval piety around 1500.

Many of the new trends in religious devotion at this time were fostered by royal or noble patronage. There were several links between Manchester College and Lady Margaret Beaufort, reinforcing both the College's royal connections and its reputation for piety and educational patronage, for both of which Lady Margaret was renowned.[65] The young men educated in her household went on to be influential churchmen and scholars, noted for their religious commitment. Between 1472, when she married Thomas, Lord Stanley, and 1499, when she took a vow of chastity and established her own household at Collyweston, Lady Margaret's chief residences were in Lancashire, at Lathom, near Ormskirk, and Knowsley Hall, near Liverpool. She entertained her son, Henry VII, at both houses during his visit to the north in 1495.[66] She was ideally placed to bestow her patronage on Manchester and she also drew upon the collegiate foundation for her own chaplains and officers. Lady Margaret seems to have worked alongside her husband in furthering piety and charity. They were admitted together to confraternity with the Carthusians in 1478 and the new chapel and almshouse at Lathom was their joint foundation. After 1485, when she became the King's mother, Lady Margaret began to establish herself as a power in her own right, but even then, her associates from her days in Lancashire were not forgotten.[67]

James Stanley, her step-son, was not up to Lady Margaret's usual standards of godliness, but his time as Warden brought many benefits to the College. He oversaw the rebuilding of the north aisle of the church and part of the choir; the misericords on the south side of the choir stalls (which he paid for) carry the Stanley emblems of the eagle and child, and the triskelion, the three-legged symbol of the Isle of Man, given to the Stanleys by Henry IV. Hugh Ashton, who became a fellow of the College

65 Jones and Underwood, *The King's Mother*, pp. 174, 150–2, 180–5, 202–31.
66 *Ibid.*, pp. 97, 147, 153.
67 *Ibid.*, pp. 146–7, 148–9.

in 1492, became Lady Margaret's receiver-general in 1502 and comptroller of her household in 1508. He was a benefactor of her college of St John's in Cambridge, where he endowed four fellowships and four scholarships for men from Lancashire, Yorkshire, or Durham, and he died as Archdeacon of York. Hugh Oldham, the future founder of Manchester Grammar School, was from Salford, brought up in the household of Laurence Booth, and served William Smith, another Lancashire-born protegé of Lady Margaret Beaufort, before entering Lady Margaret's service himself. Oldham was her chancellor until 1503, when he became Bishop of Exeter. Smith became successively Bishop of Coventry and Lichfield, Bishop of Lincoln, and Chancellor of Oxford, where he founded Brasenose College; his career was firmly founded upon Lady Margaret's patronage.[68] Christopher Urswick, Lady Margaret's chaplain, was a fellow of Manchester who rose to a position of great eminence, even appearing briefly in Shakespeare's *Richard III*.[69] As royal almoner, it is probable that he spent little time in Manchester, yet his local ties were strong. His parents had been lay brother and sister at Furness Abbey in Lancashire; he left books to the Dominicans of Lancaster; he acted as executor for Sir John Huddleston, another native of Furness, commissioning on his behalf two large illuminated manuscripts for the Cistercian abbey of Hailes.[70] All these individuals, and others besides, were tied together by their links to Manchester even as they rose to positions of national importance, basking in reflected glory as their patroness assumed the grandeur and influence of a leading royal personage.

As the sixteenth century began, education in England began to take on a humanist edge. Christian humanists sought to revive the Church by rediscovering the wisdom and sanctity of the classical past. They studied Greek, sometimes even Hebrew, in a bid for greater understanding of the Bible, and they studied the works of the ancient Greek and Latin church fathers, to rediscover Christian learning which in subsequent ages had been lost from sight. When Hugh Oldham helped found Manchester Grammar School, he took inspiration from the schools founded by his friends, many of them connections of Lady Margaret Beaufort.[71] William Smith, later Bishop of Lincoln, had founded a school at Lichfield whilst bishop there, as well as providing for a

68 Joseph Mordaunt Crook, *Brasenose: The Biography of an Oxford College* (Oxford: Oxford University Press, 2008), pp. 11–12.
69 William Shakespeare, *Richard III*, Act IV, scene v.
70 *ODNB*, *s.n.* 'Urswick, Christopher (1448? –1522)'.
71 Nicholas Orme, *Medieval Schools: From Roman Britain to Renaissance England* (New Haven, CT: Yale University Press, 2006), p. 241.

master at Farnworth School in Lancashire. Another of Oldham's friends, John Colet, Dean of St Paul's and perhaps England's most famous humanist scholar, had founded St Paul's School in London. St Paul's was intended to produce a new generation of humanist scholars, 'taught al way in good litterature both laten and greke, and goode auctours suych as haue the veray Romayne eliquence Joynyd withe wisdome specially Cristyn auctours that wrote theyre wysdome with clene and chast laten'.[72] In modelling his own foundation on that of Colet and his friends, Oldham signalled his commitment to the principles of humanist reform.

Endowment of schools often went hand in hand with the patronage of university colleges, and those who hailed from the north of England liked to establish permanent links between their institutions and their own part of the country. William Smith as Bishop of Lincoln made bequests to Lincoln College, and also to Oriel College in Oxford; in 1509 he founded Brasenose College, Oxford, with a fellow northerner, Richard Sutton, who later became steward of the Brigittine house at Syon.[73] Smith specified that the fellows of Brasenose should be from the Diocese of Coventry and Lichfield and, if possible, from Lancashire.[74] Local loyalties remained strong. Hugh Oldham seems to have given a bequest to Brasenose too, since his coat of arms appeared in a window in the library there, but his most substantial bequest was to Corpus Christi College, Oxford, founded in 1516 by Richard Fox, Bishop of Winchester. Oldham gave a formidable sum of money and land in Chelsea to help with the foundation, and in his honour one fellowship and one scholarship were reserved for Lancashire men, and daily mass was said for him in the college chapel.[75] Corpus was a college at the cutting edge of ideas about both religion and scholarship in 1513.[76] Fox was a friend of Erasmus, and his college had a pioneering role in bringing the study of Greek and Hebrew into the university. These links between Manchester College and Manchester Grammar School on the one hand and Oxford colleges such as Corpus and Brasenose on the other were maintained for centuries. The appointment of the

72 Statutes of St Paul's School, in Joseph H. Lupton, *A Life of John Colet, D.D., Dean of St Paul's and Founder of St Paul's School* (New York: B. Franklin, 1974), Appendix A, p. 279.

73 Mordaunt Crook, *Brasenose*, pp. 12–13.

74 Manchester remained in the Diocese of Coventry and Lichfield until the Diocese of Chester was founded in 1540.

75 Clive Burgess, 'Fox's Choice: Founding a Secular College in Oxford', in *History of Universities* 32.1–2 (2019), special issue, John Watts (ed.), *Renaissance College: Corpus Christi College, Oxford, in Context, 1450–1600* (Oxford: Oxford University Press, 2019), pp. 24–5.

76 Watts, 'Introduction', *ibid.*, pp. 1–2.

High Master and Usher at Manchester Grammar School passed after the death of the Bexwickes to the President of Corpus, and remained in his hands until 1877, when he was transmuted into a school governor.[77]

Humanist attempts to foster religious renewal have often been wrongly interpreted as the early stages of Reformation. English humanists, for all that they may have prepared the ground for later Protestant advances, were predominantly loyal to the traditional faith, seeking to revive it from within, not destroy it. John Colet had preached some groundbreaking sermons in Oxford in the 1490s, which for the first time took the explicit words of the New Testament as their foundation. Yet Colet envisioned a reform movement firmly located within existing institutions – and encouraged most of all by education. Erasmus helped Colet with the foundation of St Paul's and wrote books for its scholars. Their vision was of a Church strengthened and inspired by the rediscovery of Scripture, not overthrown.[78]

It seems probable that this kind of humanist thinking also reached Manchester. Oldham, Smith, and Stanley all had close links to humanist circles, for Lady Margaret was an important patron of humanist scholarship. These humanists were all formidable scholars, but another distinguishing feature of their group was their celebration of friendship; they wrote to one another in terms of great affection and camaraderie. Christopher Urswick was a friend of Colet and also of Erasmus, who dedicated a translation of Lucian to him, in return for which Urswick gave him a horse.[79] Urswick was another scholar who promoted godly reform whilst defending the traditional faith.[80] There are other indications of an interest in humanist scholarship within the College. In 1553 the fellow of Manchester, Henry Turton, left a

77 Thomas Fowler, *The History of Corpus Christi College: with lists of its Members*, Oxford Historical Society 25 (Oxford: Clarendon Press, 1893), pp. 29, 31.

78 Jonathan Arnold, *Dean John Colet of St Paul's: Humanism and Reform in Early Tudor England*, International Library of Historical Studies 49 (London and New York: I. B. Tauris, 2007); Lucy E. C. Wooding, *Rethinking Catholicism in Reformation England* (Oxford: Oxford University Press, 2000); Richard Rex, *The Theology of John Fisher* (Cambridge: Cambridge University Press, 1991); John B. Gleason, *John Colet* (Berkeley and Los Angeles, CA: University of California Press, 1989); James K. McConica, *English Humanists and Reformation Politics under Henry VIII and Edward VI* (Oxford: Clarendon Press, 1965).

79 Wallace K. Ferguson, 'An Unpublished letter from John Colet, Dean of St Paul's', *American Historical Review* 39 (1934), pp. 696–706; Craig R. Thompson, 'The Translations of Lucian by Erasmus and S. Thomas More', *Revue belge de philologie et d'histoire* 18 (1939), pp. 855–81.

80 Peter I. Kaufman, 'Polydore Vergil and the Strange Disappearance of Christopher Urswick', *Sixteenth Century Journal* 17 (1986), pp. 75–85.

detailed will in which he bequeathed a number of books to the other fellows for their lifetimes, to be left to the college library when they died. These included two volumes of Origen, a copy of Erasmus's *Novum Instrumentum* of 1516 – the re-translation of the New Testament from Greek to Latin which challenged the Vulgate and caused a huge stir across Europe – and Erasmus's *Paraphrases* on the Pauline epistles. These last volumes went to John Coppage, who was definitely not inclined towards Protestantism; he was one of only two fellows mentioned by name in Mary's re-foundation charter, refused to appear for the Elizabethan visitation of 1559, was persecuted and imprisoned as a recusant, and allegedly died in Salford prison in 1584.[81] Once again it seems that Manchester's relatively remote location was no bar to participation in the most important intellectual and spiritual currents of the time.

Reformation

In 1529, King Henry VIII decided that his marriage to his wife of twenty years, Queen Katherine of Aragon, was invalid in the eyes of God. He based this decision on some rather selective reading of the Bible and the indisputable fact that their children kept dying, which he took as proof of divine displeasure. He was encouraged in his convictions by his love for Anne Boleyn, whose appeal may have been enhanced by her enthusiasm for some of the new ideas about biblical revival and religious reform, notions which Henry also found fascinating.[82] The consequences of the King's decision would be far-reaching and destructive. In due course Henry would overturn the power of the Papacy in England, dissolve the monasteries, threaten the colleges and chantries, reconfigure Catholic worship, introduce an English Bible into every parish church, and declare himself the Supreme Head of the Church of England.[83] Those aspects of the faith which Henry himself left untouched were laid open to attack from the more radical thinkers who were encouraged by Henry's actions into thinking, quite mistakenly as it turned out, that the King might be persuaded

81 F. R. Raines, *The Fellows of the Collegiate College of Manchester*, ed. Frank Renaud, CS ns 21, 23 (Manchester: Chetham Society, 1891), part 1, pp. 45–6; William Farrer and J. Brownbill (eds), *A History of the County of Lancaster, Volume 4*, VCH (London: Archibald Constable, 1911), pp. 192–204, 'Manchester: The Parish and Advowson'.

82 Lucy Wooding, *Henry VIII*, 2nd edn (Abingdon: Routledge, 2015), pp. 23–5; Eric Ives, *The Life and Death of Anne Boleyn: 'the most happy'* (Malden, MA: Blackwell, 2004), pp. 260–76, 277–87.

83 Although Henry VIII dissolved the monasteries, it was his son Edward VI who dissolved the chantries in 1547.

into Protestantism. Religious upheaval ensued, and a great deal of confusion. Much of England's religious tradition would find itself open to either official challenge or unofficial criticism, and in Lincolnshire, Yorkshire, County Durham, Cumberland, Northumberland, Westmorland, and Lancashire, resistance to the dissolution of the monasteries prompted the rebellion known as the 'Pilgrimage of Grace', which brought turmoil to the north of England.[84]

The history of Manchester Collegiate Church was played out against this conflicted and turbulent background after 1529. The College feared for its existence under Henry VIII and witnessed the backlash against the Pilgrimage of Grace; it was dissolved under Edward VI, re-founded under Mary I in 1556, and re-founded again as a Protestant institution under Elizabeth I. Only a very few collegiate foundations survived the Reformation in this way, which made Manchester highly unusual, just as in the nineteenth and early twentieth centuries Manchester would be one of just four former colleges elevated to the status of cathedral.[85] Many of its wardens and fellows found themselves caught up in sixteenth-century religious conflicts which were often hard to understand, let alone navigate. At the same time, it could be argued that many of the concerns which had led to its foundation in the fifteenth century were perpetuated throughout the sixteenth century, despite the religious changes, and in this too Manchester encapsulates the experience of the English Reformation.

With the first intimations of the Reformation, Manchester had a narrow escape. In 1536, Thomas Stanley wrote to Lord Darcy concerning the Pilgrimage of Grace that was sweeping across the north, with many in local authority tacitly supportive of the rebels. 'They say those that are up are for the maintenance of Church and Faith and they will not strike against them. This week past, Manchester College should have been pulled down and there would have been a rising, but the commissioners recoiled.'[86] If this suggests a community loyally prepared to defend the Collegiate Church, it also suggests a fair degree of confusion, since the colleges were not supposed to be included in Henry VIII's plans for the dissolution of the monasteries. Many

84 Richard W. Hoyle, *The Pilgrimage of Grace and the Politics of the 1530s* (Oxford: Oxford University Press, 2001), pp. 6–8.

85 The others were Derby, Ripon, and Southwell: Jeffery, *Collegiate Churches*, p. 8.

86 *Letters and Papers, Foreign and Domestic, of the Reign of Henry VIII, 1509–47*, vol. 11, *July–December 1536*, ed. James Gairdner (London: HMSO, 1888), no. 635 (SP 1/107, fol. 126).

rumours were circulating in the north at this time, however, including rumours that parish churches were to be radically reduced in number, and these added to the sense of panic and outrage.[87] Even though Manchester survived the dissolution of the monasteries, the community must have been painfully aware of the destruction of traditional religion which Henry VIII began. John Claydon, one of the fellows from the 1520s, served as one of the King's commissioners witnessing the surrender of the abbeys of Furness and Whalley.[88]

In the north of England, the spread of Lutheran and other reformed ideas from the Continent was seemingly more limited than elsewhere in the country. Monasticism played a far greater role in northern society than it did further south, so the dissolution of the monasteries had a particularly shattering effect upon local society.[89] The Pilgrimage of Grace has been estimated to include at least thirty thousand people, perhaps more.[90] Henry was furious at this disloyalty, all the more since it seriously endangered his regime, and the rebellion was repressed with great savagery. On 1 March 1537, the king's commissioners came to administer the oath of supremacy in Manchester, and the gentry and the commons were compelled to swear loyalty to Henry as Supreme Head of the Church. At the same time, they apprehended a tanner called William Barrett who had been speaking out against the King in Manchester. He reportedly had spread word of heavy financial exactions, including a charge of 6s 8d for every christening and burial, which neatly expresses the anxieties of the time which were both religious and economic in nature. Barrett, like many others, met with a terrible fate; he was hanged in chains in Manchester.[91]

For the rest of Henry's reign there was uncertainty about the future of collegiate foundations, and even the Oxford and Cambridge colleges for a time were in danger of dissolution.[92]

87 Sharon L. Jansen, *Political Protest and Prophecy under Henry VIII* (Woodbridge: Boydell, 1991); Hoyle, *Pilgrimage of Grace*, pp. 88–92.

88 Raines, *Fellows of the Collegiate College of Manchester*, part 1, pp. 39–41.

89 George Bernard, *The King's Reformation: Henry VIII and the Remaking of the English Church* (New Haven, CT, and London: Yale University Press, 2005), pp. 334–5.

90 Anthony Fletcher and Diarmaid MacCulloch, *Tudor Rebellions*, 5th edn (Harlow: Pearson Longman, 2008), p. 34; Peter Marshall, *Heretics and Believers: A History of the English Reformation* (New Haven, CT, and London: Yale University Press, 2017), pp. 244–53.

91 *Letters and Papers, Foreign and Domestic, of the Reign of Henry VIII, 1509–47*, vol. 12 part 1, *January–May 1537*, ed. James Gairdner (London: HMSO, 1890), no. 520.

92 Alec Ryrie, *The Gospel and Henry VIII: Evangelicals in the early English Reformation* (Cambridge: Cambridge University Press, 2003), pp. 164–9.

It was by no means clear that Manchester would weather the storm. This was particularly the case given that Henry was discovering the huge financial dividends of a policy of dissolution. Manchester was a wealthy foundation. The Duchy of Lancaster accounts show that the chantries and colleges of Lancashire had an annual income of £731 15s 2½d in 1547; nearly a third of this was Manchester's yearly income of £230 19s 6d.[93] After the Chantries Act of 1545, Henry VIII's commissioners made a survey of the income and possessions of colleges and chantries. They discovered that in Manchester the foundation consisted of the Warden, George Collier, five of the eight fellows allowed by statute, and the full complement of four deacons and six choristers, with two fellows taking care of the parish, and the rest 'bounde to kepe the quere dalye'. They also noted the 'officers of the howse', including 'the butler the coke and the baker and bruer'. They recorded the obligation of hospitality which made a daily allowance for strangers and the money set aside for the relief of the poor, which they described as 'right grete and chargeable'. They also noted that 'the same college is a paroche churche of it self', catering for some six thousand souls, and that whilst care of the parish was officially in the hands of just two priests, 'many tymes of grete necessitie the rest of the said preistes fellowes of the saide college be enforced to mynystre sacraments to the saide parocheners when the curates bene overcharged'.[94] The impression is of a community working just as its founders had envisaged, although perhaps this was the impression they were trying to give the King's commissioners.

Henry's agents painstakingly recorded the College's possessions, even down to the twenty-three pewter vessels and twelve silver spoons, and the five work horses. It is likely that they received only a partial impression of the College's belongings; most institutions concealed as much as they could when the royal commissioners visited, and the list of church plate held by the College was suspiciously minimal. The list of vestments was longer, including 'one vestement imbrothered with beares', which perhaps bore the bear-and-ragged-staff emblem, since Bishop James Stanley's mother, Eleanor Neville, had been sister to the Earl of Warwick, 'the Kingmaker', whose device it was.[95]

It was in 1547 that the College was finally dissolved, with all other chantries and guilds, during the first year of Edward VI.

93 Robert Somerville, *History of the Duchy of Lancaster, vol. 1, 1265–1603* (London: Duchy of Lancaster, 1953), p. 297.
94 Raines (ed.), *History of the Chantries*, vol. 1, pp. 8–9.
95 *Ibid.*, pp. 10–11.

This time the chantry belonging to the Jesus Guild was included, which had been omitted from the return made by Henry VIII's commissioners, possibly because of its link to the Grammar School.[96] The commissioners on this occasion recorded that 'the Vestiments and Ornaments of the Chauntries were very litle'. They also recorded that the Warden, George Collier, was sixty years old, but that other fellows were in their thirties and forties, including John Coppage, who was forty-eight. Both Collier and Coppage refused to accept the new order, and both would return to the College when it was re-founded under Mary I, as would Ralph Birch, who had withdrawn from the College under Edward VI.[97]

Lancashire is often seen as a heartland of Catholic resistance to the Protestant Reformation, but the truth was more complicated.[98] Protestantism also had its adherents in the north, and Manchester was responsible for producing one of the key figures in early English Protestantism. John Bradford, one of the most modest and likeable of the Marian martyrs, was born and brought up in Manchester, and educated at Manchester Grammar School. At the end of his life, writing from prison, Bradford thanked God 'for my parents, schoolmasters and others, under whose tuition thou hast put me'.[99] He very nearly ended his life in Manchester too, since the Marian authorities at first determined to burn him at the stake in his hometown. In another of his writings from prison, Bradford wrote 'hourly I look when I should be had hence to be conveyed into Lancashire, there to be burned, and to render my life by the providence of God where I first received it by the same providence'.[100] In the end it was decided to burn him in London. Bradford had been converted by a sermon of Hugh Latimer while studying at the Inner Temple; subsequently he had studied at Pembroke Hall in Cambridge, then become a chaplain to Bishop Ridley, and finally one of Edward VI's six chaplains. The King ordained that only two of his chaplains should be at Court at any time, while the other four toured the country, preaching the Protestant faith. Bradford went north, and it is clear from his writings that he found a

96 *Ibid.*, vol. 2, pp. 246–9.

97 *Ibid.*, vol. 1, pp. 9–12, 22; Haigh, *Reformation and Resistance*, pp. 157, 203–5; Thomas F. Mayer (ed.), *The Correspondence of Reginald Pole, vol. 3: A Calendar, 1555–1558: Restoring the English Church* (Aldershot: Ashgate, 2004), p. 398.

98 Haigh, *Reformation and Resistance*, pp. 159–77.

99 *The Writings of John Bradford*, ed. Aubrey Townsend, 2 vols (Cambridge: Parker Society, 1848, 1853), vol. 2, p. xii.

100 *Ibid.*, p. 434.

Protestant community in Manchester to greet him.[101] He wrote to his mother and told her to thank God 'that he hath made the fruit of your womb to be a witness of his glory and attend to the truth, which (I thank God for it) I have truly taught out of the pulpit of Manchester'.[102] Once Mary I had succeeded her half-brother and restored Catholicism, Bradford was condemned and imprisoned. Awaiting his death, he wrote a 'Farewell to Lancashire and Cheshire', which contained a passionate plea for repentance from the places he knew so well.

> Turn unto the Lord, yet once more I heartily beseech the, thou Manchester, thou Ashton-under-line, thou Bolton, Bury, Wigan, Liverpool, Mottrine, Stepport, Winsley, Eccles, Prestwich, Middleton, Radcliffe, and thou city of West-chester, where I have truly taught and preached the word of God. Turn, I say unto you all, and to all the inhabitants thereabouts, unto the Lord our God, and he will turn unto you; he will say unto his angel, 'It is enough, put up thy sword'.[103]

Reformation conflict had penetrated deep into the heart of Manchester's community. Bradford's sister Margaret had married Roger Bexwicke, whose brother Hugh and mother Joan had endowed both the Jesus Chantry and Manchester Grammar School; in general his family was known for its religious conservatism.[104] While in prison, Bradford had several visitors from home; his letters record how George Collier came to visit him, and the visit was also described by John Foxe in his *Acts and Monuments*.[105] Bradford referred to Collier as the former Warden, clearly regarding Manchester College as dissolved, but Collier saw himself as the Warden still; he described himself as such when witnessing a document in 1556. Bradford recorded how 'the said Warden did discommend king Edward, and went about to set forth the authority of the pope, which I withstood'.[106] Another local man who visited was Henry Pendleton, who had preached against Luther under Henry VIII, preached Protestantism under Edward VI, and then recanted again under Mary and been rewarded with several church appointments.[107] John Foxe

101 Haigh, *Reformation and Resistance*, pp. 170–2, 188.
102 *Ibid.*, p. 250.
103 *Writings of John Bradford*, vol. 1, p. 454.
104 Haigh, *Reformation and Resistance*, p. 167.
105 John Foxe, *The Unabridged Acts and Monuments Online* or TAMO, 1563 edn (Sheffield: HRI Online Publications, 2011), pp. 1282–3; online at: www.johnfoxe.org, accessed 29 December 2016.
106 *Writings of John Bradford*, vol. 1, p. 538.
107 *Ibid.*, pp. 541–4; see also *ODNB*, *s.n.* 'Pendleton, Henry (d. 1557)'.

recorded this encounter too, contrasting Bradford's faithfulness with Pendleton's vacillations.[108] In his 'Farewell to Lancashire and Cheshire' Bradford wrote rather sardonically:

> It is told me that Master Pendelton is gone down to preach with you, not as he once recanted ... but to recant that which he hath recanted. How he will speak of me and report tofore I come, when I am come, and when I am burned, I much pass not; for he that is so uncertain and will speak so often against himself, I cannot think he will speak well of me except it make for his purpose and profit ...[109]

Foxe recorded how, after the accession of Mary, Pendleton had encouraged Laurence Saunders to stand firm in his Protestant opinions, and boasted of his own steadfastness, declaring: 'I will see the uttermost drop of this grease of mine molten away, and the last gobbet of this pampered flesh consumed to ashes, before I will forsake God and his truth.'[110] This was all the more solemn a promise since Pendleton's 'pampered flesh' was reportedly ample. Yet he had soon converted back to Catholicism and was responsible for two of the homilies published by Bishop Edmund Bonner of London in 1555, which gave an earnest defence of the Catholic faith. He dwelt on the poverty and distress which had followed the dissolution of the monasteries and chantries, 'the unshameles breakynge of the deade mennes testamentes, and theyr mooste godly intentes, and ordinances'.[111] After his death in 1557, a work was published containing his declaration of loyalty to the Catholic church against slanderous reports to the contrary.[112]

Pendleton might not seem a glittering example of religious loyalty, therefore, but the choices before him and his contemporaries were by no means straightforward. Loyalty to the king or queen was as much a religious duty as fidelity to the church, and to renounce obedience to the Crown in order to give allegiance to a different set of religious ideas was a daring, and to many a disgraceful step to take. Even Thomas Cranmer, Archbishop of Canterbury and Protestant martyr, found himself temporarily

108 *TAMO*, 1563 edn, pp. 1282–3.
109 *The writings of John Bradford*, vol. 1, pp. 449–50.
110 *TAMO*, 1563 edn, p. 1118.
111 Edmund Bonner, *Homelies sette forth by the righte reverende father in God, Edmunde Byshop of London* (London: Jhon Cawodde, 1555), fol. 41v.
112 *A declaration of Hen. Pendleton DD in his sickness, of his faith in all points, as the Catholic church teachest, against sclanderous reports against him* (London: Robert Caley, 1557); see also Susan Brigden, *London and the Reformation* (Oxford: Clarendon Press, 1989), pp. 577–8.

persuaded that allegiance to the Crown should take first place when he recanted briefly his Protestant convictions.[113] Nor was the division between Protestantism and Catholicism as crystal clear as it would later seem. When Pendleton replied to Bradford's taunt, he admitted that he had paid too much attention to the works of Luther and Melanchthon. He denied that he had rejected transubstantiation, but admitted he had said that the name itself could not be found in the Bible. The religious conflicts of the day revolved around many detailed points of doctrine concerning salvation, election, sacraments, free will, and good works, in which scholars and churchmen strove to understand what the Bible meant, and what the Church taught, and struggled to identify the true Church. It was far from easy to distinguish which was the right path to take.

In such circumstances, it is hardly surprising that the fellows of Manchester seem to have had difficulty navigating through such stormy waters. The nephew of Henry Pendleton, one Edward Pendleton, took a slightly different path from his uncle, but one subject to the same difficult choices. He was headmaster of Manchester Grammar School in the last years of Henry VIII, then conformed under Edward VI, and after the dissolution of the College was retained as a preacher. Under Mary he must have shown some renewed Catholic enthusiasm, for he was presented to the living of Eccles, and in 1557 was made a fellow of the restored collegiate foundation.[114] Under Elizabeth I he conformed again, and married, was once more a fellow of Manchester College (re-founded yet again as a Protestant foundation), and remained Vicar of Eccles until his death in 1576. It is easy to condemn such individuals, yet it is possible that his loyalty to his community at Manchester and his parishioners at Eccles remained Pendleton's chief concern.[115] Although the English church was changing, it changed slowly, piece by piece, retaining enough of the past to still seem worthy of loyalty. Although the liturgy was translated into English, many rituals were lost, and many points of doctrine were changed, the buildings still remained the same and some of the rituals persisted, whilst a degree of confusion remained about some of the doctrinal changes. Bradford represents the zealous few who were prepared to die for the series of abstractions that

113 Diarmaid MacCulloch, *Thomas Cranmer: A Life* (New Haven, CT, and London: Yale University Press, 1996), pp. 589–601.
114 Mayer (ed.), *Correspondence of Reginald Pole*, vol. 3, p. 398.
115 The submission to the Elizabethan Settlement of Christopher Trychay, priest at Morebath, might perhaps offer a parallel here: see Eamon Duffy, *The Voices of Morebath* (New Haven, CT, and London: Yale University Press, 2001), pp. 172–82.

were their religious beliefs; the Pendletons were perhaps more representative of the many other believers who might have regretted the changes, but were prepared to tolerate them, or who put the practicalities of parish identity and ministry before other concerns.

If the majority were prepared to accept the religious changes, a few stood firm in their convictions, willing to face persecution if necessary. The re-foundation of Manchester College under Mary I had ensured a solid fellowship of loyal Catholics, part of a wider campaign for Catholic revival in Lancashire.[116] The former fellows George Collier and John Coppage had been reappointed, and made responsible with the new Warden, Laurence Vaux, for the selection of the other fellows.[117] The revival of the College was brief before Mary's death and Elizabeth's accession led to the deprivation of Vaux, Coppage, and others in 1559. It is notable, however, that twenty-five years later, John Coppage, imprisoned in Salford gaol after long service as a recusant priest in the area, had organized himself and eleven other imprisoned priests into what was described as a 'college', maintaining both a common devotional life and ministry to Catholics outside the prison where possible.[118] Manchester's Catholic loyalties were not easily eclipsed.

The career of Laurence Vaux, last Catholic Warden of Manchester, demonstrates the reluctance felt by much of Lancashire to surrender the old faith. He fled into exile under Elizabeth, leaving the College muniments and much of the plate with two local friends, although he took some of the College silver with him. He served sporadically as a recusant priest in Lancashire at points during the 1560s, but at other points he was part of the exile community in Louvain. In 1573, he entered the house of canons regular of St Martin in Louvain; despite his seniority, in his plea for admission to the house he insisted that he be given the lowly status of postulant.[119] However, his mission work in England resumed in 1580. He was finally caught and imprisoned; in 1583 he was described as 'an old massing priest, a Lancashire man born', and from prison he still corresponded with his old friend John Coppage. Held initially in quite civilized surroundings, he was transferred to the Clink once the authorities realized he was the author of the English catechism which was circulating widely in England; a letter to Coppage mentioned three hundred

116 Haigh, *Reformation and Resistance*, pp. 203–5, 205–8.
117 *Ibid.*, p. 203.
118 *Ibid.*, p. 257.
119 CL, MS Mun. A.6.81 (1).

copies being circulated in and around Manchester.[120] Vaux died in prison a couple of years later, allegedly of starvation; his brethren swiftly accorded him the status of martyr.

Vaux's story is notable in several respects. For one thing, he sustained an interest in education; he himself had been educated at Manchester Grammar School, and at Richard Fox's foundation of Corpus Christi in Oxford; as an exile in Louvain he maintained a school there.[121] He also played a key part in framing Elizabethan Catholicism. In the early years of the reign, there was some doubt over whether it was permissible for Catholics to attend Church of England services; Pius V ruled that it was a mortal sin, and in 1566, after a personal audience with the Pope, Vaux was sent to England to communicate this message.[122] He wrote to friends in Lancashire warning that those who attended Protestant service 'do not walk in the state of salvation'.[123] His efforts had sufficient impact that in 1568 a warrant was issued for his arrest, although he managed to evade capture. His work made a significant contribution to the redefinition of Catholic identity as a distinct and nonconformist faith in England.[124]

Vaux's catechism also sheds a fascinating light on English Catholicism at this time. It was eloquent, earthy, addressing the kind of problems faced by ordinary people, from cheating tradesmen to pregnant women seeking abortion, as well as more elevated theological problems. It also avoided the question of transubstantiation, eschewed the word 'Pope' in favour of describing the Pontiff as 'Vicar, Pastour and chief Bishop', and made only passing mention of Purgatory, whilst insisting that 'we do not honour and worship … Sainctes, as putting more confidence and trust in them, then in God, nor with suche honour as is due to God'.[125] In other words, Vaux's Catholicism was

120 Laurence Vaux, *A Catechisme, or Christian Doctrine, Necessary for Children and Ignorant People* (Louvain: J. Fowler, 1567). Further editions appeared in 1574 and 1583; a modern edition was edited by Thomas G. Law, *A catechisme, or, Christian Doctrine, by Laurence Vaux; reprinted from an edition of 1583 with an introductory memoir of the author*, CS ns 4 (Manchester: Chetham Society, 1885). See also Haigh, *Reformation and Resistance*, p. 292.

121 *ODNB, s.n.* 'Vaux, Laurence (1519–1585)'. Vaux briefly attended Queen's College, Oxford, before moving to Corpus Christi College.

122 Alexandra Walsham, *Church Papists: Catholicism, Conformity and Confessional Polemic in Early Modern England*, Studies in History 68 (London: Royal Historical Society, 1993), p. 23.

123 Cited in Alexandra Walsham, 'Yielding to the Extremity of the Time: Conformity and Orthodoxy', in Alexandra Walsham, *Catholic Reformation in Protestant Britain* (Farnham: Ashgate, 2014), p. 57.

124 John Bossy, *The English Catholic Community, 1570–1850* (London: Darton, Longman & Todd, 1975).

125 Vaux, *Catechisme*, fols 9v, 27v–28r.

of a reformed variety, intelligently constructed to avoid painful issues and speak directly to popular need. Had Mary I and her religious settlement survived, he would have been the ideal figure to lead Manchester College in the work of rebuilding the Catholic faith.[126]

The Manchester archives contain an unexpected manuscript concerning Vaux, in the form of a letter of 1885, written in French, which relates how a man walking down a street in Louvain observed a local baker using ancient pieces of manuscript 'pour envelopper les tartes'. Upon investigation, he found that the baker was using the muniments of the house of St Martin, which had been destroyed after the French Revolution. Since three of the manuscripts related to Vaux, he sent them back to Manchester, with a courteous letter explaining the curious circumstances of their rediscovery. One is a legal document listing the pieces of College silver which were still in Vaux's possession when he took his monastic vows; he had made this submission before a notary in an attempt to preserve College property 'until such time as the college should be restored to the Catholic Faith, or until Catholics should live in it'.[127] It was a long time before many Lancashire Catholics surrendered that hope.[128]

Throughout the upheavals of the Reformation, the concern for parish provision in Manchester never went away. In 1546 John Bird, Bishop of the newly created see of Chester, wrote to Henry VIII, petitioning that if the College were to survive, he should be allowed to replace the warden there and dismiss the existing one with a pension, 'for the country thereabouts is populous and much destitute of preachers'. It is clear that whatever happened, the Bishop wanted Manchester College to continue in some shape or form. He suggested that if it were dissolved, then in its place there should be a community consisting of a vicar, four curates, five singing men or clerks, and four choristers.[129] Although he envisaged a smaller and cheaper establishment,

126 Recent research on the church of Mary I has corrected older assumptions about its weaknesses and unpopularity and argued that there was a vibrant and successful Catholic restoration during her reign: see Duffy, *Stripping of the Altars*, ch. 16, pp. 524–64; Eamon Duffy and David Loades (eds), *The Church of Mary Tudor* (Aldershot: Ashgate, 2006); William Wizeman, *The Theology and Spirituality of Mary Tudor's Church* (Aldershot: Ashgate, 2006); Wooding, *Rethinking Catholicism in Reformation England*, pp. 114–80.

127 CL, MS Mun. A.6.81 (2).

128 Bossy, *English Catholic Community*, pp. 91–6.

129 *Letters and Papers, Foreign and Domestic, of the Reign of Henry VIII, 1509–47*, vol. 21 part 1, *January–August 1546*, ed. James Gairdner and Robert H. Brodie (London: HMSO, 1908), no. 967 (BL, Harleian MS 604, fol. 82); Haigh, *Reformation and Resistance*, pp. 8, 13.

there were marked similarities with what had gone before. Bird thought just over £162 would provide for what he would need, with the vicar to be paid £10 per annum, the four curates £8, the five singing-men £6 12s 4d, and the four choristers £3 6s 8d.[130] The most notable gesture towards reform was that Bird proposed appointing a preacher with the handsome stipend of £20 per annum. The importance of Manchester's ongoing musical provision was signalled by the inclusion of a schoolmaster for song who could also 'play on the organs', to be paid £10, the same stipend as the vicar. The proposal for including butler, cook, baker, brewer, and porter at just over £5 p.a. each shows that these individuals were still intended to live in community. Bird's justification for both his proposals was that Manchester had almost '6000 houselling people', or communicants, in need of pastoral care. His vision of a newly constituted foundation was not markedly different from that of the medieval college community.

In 1556, when Mary restored the College, she announced that 'for the zeale we have to godes honour and his divine service, we have restored the incorporacion of the colledge of Manchester, to thintent, god myght be the more diligently servid and that towne the better furnished with preests and men meate for that service, wherof we understand ther is both ther and elsewhere great lacke'. Mary thanked Edward Stanley, Earl of Derby, for showing favour to the college, 'desiringe youe to continue your good favour and charatie to wardes the said incorporacon'.[131] This was the same Earl of Derby to whom in 1549 Edward VI had granted 'the site of the late College of Manchester ... and all houses, buildings etc. thereto belonging'.[132] Yet despite his willingness to profit from the dissolution of the College, the Earl had consistently opposed Protestant reforms in Edward VI's parliaments, and his Catholic sympathies meant that he prospered under Mary I, while clearly supporting the re-foundation of Manchester. The concern for parish provision, despite the vagaries of the mid-Tudor period, and the ongoing importance of local patronage were both important points of continuity.

Fifty years after the Marian re-foundation, in 1606, we find the will of Anthony Mosley, a prosperous clothier, who disbursed £100 in his funerary provision, including 20s for a funeral sermon and the furnishing of a dinner for all mourners,

130 In the *Valor Ecclesiasticus* the college had been valued at £213 10s 11d, so Bishop Bird's scheme was noticeably cheaper.
131 TNA, SP 11/11 no. 39, fol. 86.
132 Preston, LRO, MS DDK/5/3.

with 2d for every poor person there. He also left £500 for the founding of an almshouse, or, if this could not be managed, he arranged for the interest on this sum to be paid out for church repairs, the repairing of bridges and highways, a large amount to the poor, and a bequest 'to poor schollars going out of the free schooles of Manchester, Middleton or Ratchdale to either Universitie'.[133] The traditional mix of piety, educational provision, and service to the community had not been destroyed by the Reformation so much as reconfigured. The Jesus Chantry of 1506 had been primarily intended to ensure masses for the dead, but it had also incorporated schooling for the local boys. In 1653, a library was established in the Jesus Chapel, to be maintained by the town; even in the middle of the Interregnum, when Anglicanism and Catholicism were alike reviled, the intentions of the pre-Reformation founders were still being echoed in muddled form. When Humphrey Chetham's will of 1654 left instructions for the former College to be turned into a hospital and library it was not so much a break with the past as an adaptation of it. In this, as in so much else, the history of Manchester's Collegiate Church is a history of the English church in miniature.

133 J. P. Earwaker (ed.), *Lancashire and Cheshire Wills and Inventories, 1572 to 1696, now preserved at Chester, with an Appendix of Lancashire and Cheshire Wills and Inventories proved at York or Richmond, 1542 to 1649*, CS ns 28 (Manchester: Chetham Society, 1893), pp. 15–20 (Will of Anthony Mosley).

✤ 4 ✤

Manchester Collegiate Church, 1558–1660

IAN ATHERTON

B ETWEEN THE REFORMATION and the Restoration, Manchester
Collegiate Church had more ups and downs than the Grand
Old Duke of York. It was dissolved twice, in 1547 and
1649, restored twice, in 1556 and 1660, and all but dissolved
twice, in 1559 and 1609, requiring two further re-foundations, in
1578 and 1635. As the contemporary church historian Thomas
Fuller remarked, 'This Colledge hath passed many Dissolutions
and refoundations'.[1] This confused history reflected a national
church in which there was no agreed role for a collegiate church
like Manchester. That uncertainty had a profound effect on the
institution and its personnel, for even when the College was not
facing the immediate threat of dissolution, it was never placed
on a secure footing for long.

Collegiate churches had been the institution of choice for
ambitious patrons in the later Middle Ages, providing a flexible
and relatively cheap means of meeting their needs (for burial,
remembrance, and chantries) and those of the wider laity (for
education, religious services, charity, and pastoral provision),
so that Manchester was one of approximately one hundred
and forty such foundations in the later Middle Ages. Moreover,
the combination of the round of liturgical services, preaching,
almsgiving, and educational provision that a collegiate church
provided made them ideally suited for reforming Catholicism.
The Marian re-foundation of Manchester in 1556 was designed
to create a centre of what Christopher Haigh has called 'mili-
tantly Catholic devotion and scholarship' in a populous town at

1 Thomas Fuller, *The history of the worthies of England*, 2 parts (London:
J[ohn]. G[rismond]. W[illiam]. L[eybourne]. and W[illiam]. G[odbid].,
1662), pt 2, p. 120.

Previous spread:
'Exquisite detail'

the heart of an area of south-east Lancashire that was becoming known for its Protestant networks.[2]

All that suddenly changed in 1558 on the death of the Catholic Mary and the accession of her Protestant sister, Elizabeth. Protestantism had no place for either of the functions that had lain at the heart of the pre-Reformation collegiate church – masses for the dead (since Protestants did not believe in purgatory) or the *opus dei*, the constant liturgical round of masses and other church services (since the pre-eminent work of a Protestant minister was preaching the word of God, not celebrating the sacraments). Finding consensus on a new role for Manchester College (and, indeed, all cathedrals and other collegiate churches) within the Protestant establishment – if it were to survive at all – proved to be a slow process, not completed until the later seventeenth century, and one bedevilled by doubt and disagreement.[3] Until a new role was found and widely accepted, the collegiate church lay at the mercy of a rapacious Crown and a greedy laity. The second half of the sixteenth century would see Manchester College embroiled in fraud, embezzlement, and policies designed to make short-term gain out of its estates as Crown and layfolk found willing helpers within the College in the sordid business of asset stripping.

The undead college, 1558–78

The Acts of Supremacy and Uniformity of 1559 formalised the change in England from Roman Catholicism to Protestantism, ushering in a change of services from the Latin rite to the English Book of Common Prayer. At Manchester the acts had a further, unintended consequence: they raised doubts about the very existence of the Collegiate Church. Since the Elizabethan settlement reversed Mary's religious policies, it was debatable whether the Marian re-foundation remained good in law. As Manchester-born Richard Hollingworth put it in his history of Manchester

2 Christopher Haigh, *Reformation and Resistance in Tudor Lancashire* (Cambridge: Cambridge University Press, 1973), pp. 168–75, 202. T. S. Willan, *Elizabethan Manchester*, CS 3rd series 27 (Manchester: Chetham Society, 1980), pp. 39–40 suggests a population of 2,000 in Manchester town *c.* 1600.

3 Ian Atherton, 'Cathedrals', in Anthony Milton (ed.), *The Oxford History of Anglicanism, Volume I: Reformation and Identity, c. 1520–1662* (Oxford: Oxford University Press, 2017), pp. 229–42; Ian Atherton, 'An Apology of the Church of England's Cathedrals', in Angela Ranson, André A. Gazal, and Sarah Bastow (eds), *Defending the Faith: John Jewel and the Elizabethan Church* (University Park, PA: Pennsylvania State University Press, 2018), pp. 98–118.

a century later, from 1559 it seemed that 'the Colledge had either an vncertaine foundation or none at all'.[4] The College persisted, but its continuation was until 1578 in doubt. There was, in addition, the very real possibility that the virgin queen would die and that England would revert to Rome: the last Catholic Warden of Manchester, Laurence Vaux, who was ousted in 1559, was still looking forward in 1573 to a time when 'the college should be restored to the Catholic faith, or ... Catholics should live in it', and he was not alone in such hopes.[5] Only with the benefit of hindsight does that possibility seem peculiar. With the accession of Elizabeth, therefore, Manchester College entered two decades of a twilight, liminal existence, an institutional half-life, neither dead and buried nor fully functioning. It might be thought of as an undead college; far from being the living in the service of the dead, as the medieval church has aptly been described,[6] it was the undead in the service of their own ends.

The change from late medieval Catholicism to early modern Protestantism can be seen in three areas. It is written into the fabric of the College. As Clare Hartwell shows, a near constant series of building works had been undertaken in the century after collegiation, from the rebuilding of the church to the addition of chantry chapels, alongside the construction of collegiate buildings for the warden, fellows, and other staff. Building ceased at the Reformation: barring some repairs and the addition of galleries to incorporate a larger congregation, no new building work was undertaken in the century after Elizabeth's accession.[7]

Second, the accession of Elizabeth also marks a dramatic change in the personnel of the College. In October 1559, royal commissioners visited Manchester to enforce the new religious settlement. Warden Vaux and three 'fellows chaplains', John Coppage, Richard Hart, and James Dugdale, were deprived,

4 Manchester, CL, A.6.51, Richard Hollingworth, 'Mancuniensis', fol. 19r.

5 CL, A.6.81; G. J. Piccope (ed.), *Lancashire and Cheshire Wills and Inventories, Vol. 2*, CS os 51 (Manchester: Chetham Society, 1860), pp. 158–9; Peter Marshall and John Morgan, 'Clerical Conformity and the Elizabethan Settlement Revisited', *HJ* 59 (2016), pp. 21–2.

6 A. N. Galpern, 'The Legacy of Late Medieval Religion in Sixteenth-Century Champagne', in Charles Trinkaus and Heiko A. Oberman (eds), *The Pursuit of Holiness in Late Medieval and Renaissance Religion* (Leiden: Brill, 1974), p. 149.

7 William Farrer and J. Brownbill (eds), *A History of the County of Lancaster, Volume 4*, VCH (London: Archibald Constable, 1911), p. 191.

followed shortly by the departure of a fourth, Edward Pendleton. By 1565 only Robert Prestwiche remained of the Marian fellows.[8]

To replace Vaux, in July 1560 the crown presented William Birch as Warden. Not only was he local, born and educated in Manchester, he had strong Protestant credentials, having been one of Edward VI's four itinerant preachers appointed to spread Protestantism. His tenure at Manchester is clouded in obscurity, and by May 1562 he had been replaced by Thomas Herle.[9] Later tradition held that he resigned, 'wearied out by vain attempts to prevent sacrilege and spoliation', while his subsequent career in Durham diocese adduced both his learning and his radical Protestantism, for he was deprived of his canonry in Durham Cathedral in 1567 for his refusal to wear a surplice when conducting services, a vestment many Puritans saw as a relic of Roman Catholicism to be avoided even though the Crown's official policy was that it should be worn as a mark of conformity to the rules.[10]

The third obvious contrast between the College of the first foundation and that of the second is the obscuring veil that falls in 1559, hiding much from the eyes of later generations. It is not even possible to be certain about the fellowship of the 1560s and 1570s, let alone the minor staff of the College.[11] While

8 Kew, TNA, SP12/10, fols 51r, 184r; Haigh, *Reformation and Resistance*, pp. 333–4; John E. Bailey (ed.), *Inventories of Goods in the Churches and Chapels of Lancashire*, 2 vols, CS os 107, 113 (Manchester: Chetham Society, 1879, 1888), vol. 1, pp. 6–7; Chester, CALS, EDV 1/3, fol. 64r; CL, MS C.6.55, Raines's Lancashire MSS, vol. 22, p. 284; Farrer and Brownbill (eds), *VCH Lancaster*, vol. 4, pp. 359–60. That Pendleton remained as Vicar of Eccles suggests that he resigned rather than that he was deprived. The John Glover who was a singing-man at the College in 1578 may have been a deacon at the College before its dissolution in 1547.

9 *Calendar of the Patent Rolls preserved in the Public Record Office, Elizabeth, Vol. 1: 1558–60* (London: Public Record Office, 1939), p. 419; *Calendar of the Patent Rolls preserved in the Public Record Office, Elizabeth, Vol. 2: 1560–3* (London: Public Record Office, 1939), pp. 280–1; Christopher L. Hunwick, 'Who shall Reform the Reformers? Corruption in the Elizabethan Church of Manchester', *TLCAS* 101 (2005), pp. 86–8; F. R. Raines, *The Rectors of Manchester and Wardens of the Collegiate Church of that Town*, 2 vols, CS ns 5, 6 (Manchester: Chetham Society, 1885), vol. 1, pp. 70–5.

10 Robert Assheton, 'Brief Account of the Collegiate Church of Manchester', 1700, quoted in Raines, *Rectors and Wardens*, vol. 1, p. 72; David Marcombe, 'The Dean and Chapter of Durham, 1558–1603' (PhD thesis, Durham University, 1973), pp. 23, 40–1, 184–5, 189.

11 The standard accounts of the wardens and fellows are Raines, *Rectors and Wardens*; F. R. Raines, *The Fellows of the Collegiate Church of Manchester*, edited by F. Renaud, 2 vols, CS ns 21, 23 (Manchester: Chetham Society, 1891). Raines was an assiduous collector, but his judgement is not to be relied upon, so these volumes must be used with care.

Manchester has a justly famous set of parish registers beginning in 1573, the capitular archive for the late sixteenth and early seventeenth centuries is much less full:[12] the first surviving act book of the meetings of the warden and fellows begins in 1635, and there are no registers of leases granted until the 1670s.[13] In part, that is the fault of two sets of losses a century apart. With the accession of Elizabeth, estate records were secreted by Catholics to frustrate the aims of the Protestant college.[14] After the dissolution of the College in 1649, its muniments were carried to London, but not all were returned at the Restoration in 1660: some papers did not make their way back to Manchester until 2005, while others were destroyed in the Great Fire of London in 1666.[15] In the main, however, that obscurity was a deliberate policy of the early Elizabethan warden and fellows so that they could hide their dubious practices. Before a royal investigation in 1576, a number of the fellows claimed not to know what their colleagues had been up to, leading one of the commissioners to conclude that Warden Herle had been very successful 'in draweinge (as it were) A veyle betwixt him and many [of] his notoryus Faltes'.[16] That veil confused both contemporaries and historians. Samuel Hibbert-Ware, writing in the 1830s, mistakenly concluded that the 1560s were so tranquil that 'there is no remarkable occurrence related of the Church of Manchester'.[17] It is, nonetheless, possible to identify two key themes in the history of the Collegiate Church in the two decades after 1558: the impact of Roman Catholicism on the Protestant College, and the financial problems of the institution.

The process of converting the people from Catholicism to Protestantism was a slow and faltering one. It made more rapid progress in the Manchester area than elsewhere in Lancashire, thanks both to the efforts of John Bradford (as Lucy Wooding has shown) and to the town's links to London through the cloth trade, but recusancy (refusal to attend the services of the

12 Christopher Hunwick, 'Manchester Cathedral Archives', *Lancashire Local Historian* 19 (2006), pp. 1–12.

13 Manchester, MCA, Mancath/2/2/1; Mancath 2/A/1a/1.

14 [John E. Bailey], 'Barlow Hall, Lancashire, and its Lords', *Palatine Notebook* 4 (1884), p. 211.

15 Hollingworth, 'Mancuniensis', fol. 28r; Hunwick, 'Corruption', p. 96; Oxford, Bodl., MS Ashmole 1788, fol. 145a. The papers had been erroneously sent to Ely, but the mistake was not spotted for nearly three hundred and fifty years.

16 Bodl., MS Tanner 144, fols 45–51, 53–9, especially fols 47–8, 59r.

17 Samuel Hibbert-Ware, *The History of the Foundations in Manchester of Christ's College, Chetham's Hospital, and the Free Grammar School*, 3 vols (London, Manchester, and Edinburgh: T. Agnew, 1833–4), vol. 1, p. 81.

established church) and a more ill-defined hankering after Cathol-
icism remained significant influences in south-east Lancashire. In
1565, for example, one Manchester parishioner was reported for
keeping images of the Virgin Mary in his house, and three others
for bringing rosary beads to church.[18] Such passive resistance to
Protestantism was not unusual in early modern England. More
dramatic and less common was the active opposition that the
College met. In March 1574, Oliver Carter, recently appointed
as its preacher, was attacked, stabbed, and nearly killed as he
rode to preach at one of Manchester's dependent chapels.[19] Less
spectacular, but far more important for the sustaining of the rec-
usant community of Lancashire, was the encouragement given
to recusants by the efforts of deprived Warden Vaux, who was
active in person in Lancashire at various times in the 1560s, min-
istering in secret to Catholics and spreading the Pope's instruc-
tions to abstain from attending Church of England services;[20] his
Catechisme was also important for instructing Catholics, and
went through nine editions between 1568 and 1620.[21] Vaux had
also taken almost all the College's plate and vestments when he
fled. Even though he may have lost some to thieves in Ireland,
it was in 1573 still a significant haul including copes, chasubles,
a candelabra, a monstrance, and two silver crowns.[22] Although
Herle was doubtless guilty of exaggeration when he claimed that
Vaux had taken over £333 worth of plate and ornaments, there
is a marked contrast between the wealth of the Henrician and
Marian college, and its poverty under Elizabeth, when it had
only one broken chalice and two copes which had been made
into cushions.[23]

18 CALS, EDV 1/4, fol. 13.
19 London, BL, Lansdowne MS 19, fol. 57r.
20 *ODNB, s.n.* 'Vaux, Laurence (1519–1585)'; Kew, TNA, SP15/11, fol. 75r;
 Haigh, *Reformation and Resistance*, pp. 248–51.
21 ESTC citation numbers S2377, S95655–9, S105380, S113947, S120704,
 http://estc.bl.uk, accessed 29 November 2016. For the importance of Vaux
 and his *Catechisme*, see Alexandra Walsham, 'Wholesome Milk and Strong
 Meat: Peter Canisius's Catechisms and the Conversion of Protestant Brit-
 ain', *British Catholic History* 32 (2015), pp. 293–314; Frederick E. Smith,
 'The Origins of Recusancy in Elizabethan England Reconsidered', *HJ* 60
 (2017), pp. 301–32.
22 R. Hollingworth, *Mancuniensis: or, a History of the Towne of Manchester
 and what is most memorable concerning it* (Manchester: William Willis,
 1839), p. 80; CL, MS A.6.81.
23 BL, Lansdowne MS 19, fol. 57v; York, BIA, V/1571–2, answers of Thomas
 Herle and Nicholas Daniel, June 1571. The Manchester visitation papers of
 1571 are filed loosely after the court book. On that occasion Herle gave an
 even larger figure for the value of plate taken by Vaux. For the ornaments of
 the Henrician college, see Bailey (ed.), *Inventories of Goods*, pp. 4–8. Two

Protestants, of course, eschewed the rich ornaments of Catholic devotion, and so the contrast was official policy, but comparisons between the Catholic and Elizabethan college were made to the detriment of the latter. Nearly two decades after Mary's death, it was alleged that many in Manchester still fondly recalled the charity of the two Marian wardens, remembering George Collier for giving alms to the poor three times a week and for providing coal for the needy, and recollecting that Vaux had been similarly generous. The Protestant Herle, by contrast, was accused of giving nothing to the poor or the college's tenants, 'to the [o]ffence of the godlie, hinderance of Religion, and hir Ma[tie] godly proseedinges'.[24]

For the first twenty years of Elizabeth's reign, Manchester College failed to act as a beacon of Protestantism. Part of the problem was that, despite the change of personnel at the beginning of Elizabeth's reign, a number of the College's clergy and officers were only half-hearted Protestants. At the Archbishop of York's visitation in June 1571, three of the four fellows and all four singing-men were accused of closet Catholicism or unsound doctrine. It was alleged that one of the fellows, Edward Holt, celebrated communion so that it resembled the mass, elevating the elements and then bowing to them. Although the College had created a new office, college preacher, to evangelize the parish, significant doubts were aired about the doctrine of the current preacher, Nicholas Daniel *alias* Evans. His views were sufficiently unorthodox for another fellow to suggest that he had 'preached papisticall doctrine and therfore ys to be suspected of papistree' and promulgated 'faule' and 'evill erronious and hereticall doctrine'. In reality he was no closet Catholic, but his views did amount to 'curious doctryne & not sounde or godlie', and he soon left the College.[25]

The curious case of Nicholas Daniel revealed another problem at Manchester College: the fellows could quickly turn against one another. The visitation of 1571 saw the fellows falling over themselves to accuse one another of misdeeds. They had allegedly ignored the injunctions of the Queen and the Bishop to remove all physical traces of Catholic devotion from the church building, leaving part of the rood loft and various painted images *in situ*. Edward Holt was said to be a drunkard who kept an alehouse in

new chalices were acquired in the 1580s, followed by the gift of two more in 1626: Farrer and Brownbill (eds), *VCH Lancaster*, vol. 4, p. 192.
24 Bodl., MS Tanner 144, fols 56v, 59r.
25 BIA, V/1571–2, answers of Richard Hall, Nicholas Daniel, and Richard Holme, and articles against the preacher; CL, MS C.6.55, Raines's Lancashire MSS, vol. 22, pp. 148, 150–4.

preference to attending sermons; he also conducted clandestine marriages. Richard Hall was also accused of preferring the ale-house to sermons, and of spending his time practising medicine with fatal results for his patients who died through his lack of skill. Richard Holme was said to have bought his fellowship from Nicholas Daniel for £10 despite his lack of qualifications. Although the absence of appropriate statutes by which to govern the College did not help the situation (Manchester, like cathedrals, was waiting for a royal commission to reform its pre-Reformation statutes to make them accord with Protestantism),[26] two connected problems lay behind many of the disorders at Manchester: money and the failings of Thomas Herle as Warden. The Marian College may have approached its full complement of warden, eight fellow chaplains, four clerks, and six choristers,[27] but the early Elizabethan College seems to have maintained only a warden, four fellows (one of them designated as the preacher), two or three clerks to serve the parish, four (occasionally five) singing-men, and four choirboys.[28] Despite this reduced establishment there was insufficient money to pay the stipends of the fellows,[29] which explains why they sought additional income, from medicine to clandestine marriages to tavern keeping. Members of the College even resorted to suing their own institution for payment of their stipend.[30] As Holt admitted in 1576, 'dysordered paymentes be the greatt vnquyetness' of the college.[31]

Herle, a pluralist with canonries in Chester and Worcester cathedrals, a royal chaplaincy, and livings in Exeter and Ely, was routinely absent, perhaps in Manchester for only a tenth part of his wardenship.[32] Through his absence, Herle failed to govern the College adequately or impose order on the fellows,

26 On the failure of attempts to reform cathedral statutes, see James Saunders, 'The Limitations of Statutes: Elizabethan Schemes to Reform New Foundation Cathedral Statutes', *JEH* 48 (1997), pp. 445–67.

27 A list of the clergy at Manchester, undated but showing Vaux as Warden so that it must be from 1558 or 1559, lists seventeen clergy in the parish: CL, MS C.6.55, Raines's Lancashire MSS, vol. 22, p. 284.

28 CALS, EDV 1/3, fol. 64r; BIA, V/1571–2; V/1578–9, call roll for Manchester; BIA, CP.G.1620; Bodl., MS Tanner 144, fols 45–57.

29 BIA, V/1571/2, answers of Hall and Holme.

30 *Ducatus Lancastriae*, 3 vols (London: Record Commission, 1823–34), vol. 2, p. 389; vol. 3, p. 41.

31 Bodl., MS Tanner 144, fol. 49r.

32 BIA, V/1571–2, answers of Herle; J. M. Horn, *Fasti Ecclesiae Anglicanae 1541–1857, Volume 7: Ely, Norwich, Westminster and Worcester Dioceses* (London: University of London, 1992), p. 115; J. M. Horn, D. M. Smith, and P. Mussett, *Fasti Ecclesiae Anglicanae 1541–1857, Volume 11: Carlisle, Chester, Durham, Manchester, Ripon, and Sodor and Man Dioceses* (London: University of London, 2004), p. 53; Clergy of the Church of England Database, person IDs 28977 and 97982 (who appear to be the same

causing 'grett varyennces & vnquyetnes among the company & fellowes', with sometimes one fellow, sometimes another ruling in his place.[33] Thomas Corker, the Precentor and so the Warden's deputy under the Marian charter, tried to govern the College, but he was dismissed about 1565 after passing a fraudulent lease.[34] Thereafter there is no mention of a precentor, leaving the College even more rudderless.

In the 1560s and 1570s, the College's finances were in a parlous state. Following the Corker affair, the Archbishop of Canterbury issued strict injunctions about the warden's residence and about the leasing of the College's estates designed to impose order and financial stability and to prevent fraud, but these orders were quickly ignored.[35] It has traditionally been asserted that Herle is best seen as the epitome of a greedy, worldly cleric. Historians have followed Hollingworth's judgement that Herle was 'a selfish man' and a lukewarm Protestant.[36] It is important to recall, however, that in the early and mid-1560s Herle was seen as sufficiently sound in religion to garner plum appointments being, in the judgement of Archbishop Matthew Parker of Canterbury (a stout defender of collegiate lands), 'a grave priestly man'.[37] Herle did not begin the policy of long, reversionary leases that came in for so much criticism. The saintly Vaux (who even earned the grudging admiration of the Presbyterian Hollingworth as 'laborious learned & in his way devout & conscientious') had granted properties on seventy- and ninety-nine-year reversionary leases so that they were still out of hand in 1649.[38] Moreover, Herle thought that Vaux and others had conspired to hide some of the College's lands to keep them out of the hands of the Protestant chapter.[39] Concealments of lands were common in the mid-sixteenth century, encouraging land-hunting speculators to

person), www.theclergydatabase.org.uk, accessed 28 November 2020; *Calendar of Patent Rolls, 1560–3*, p. 156; Bodl., MS Tanner 144, fol. 59r.

33 Bodl., MS Tanner 144, fol. 49r.

34 MCA, Mancath/2/A/1/Newt/1; BIA, CP.G.1620; Cambridge, Corpus Christi College, Parker Library, MS 144B, p. 844k.

35 MCA, Mancath/2/1/b.

36 Hollingworth, *Mancuniensis*, p. 81; *An account of the wardens of Christ's College Church, Manchester, since the foundation in 1422, to the present time* (London: A. and I. Clarke, 1773), pp. 7–9; Hibbert-Ware, *History of the Foundations*, vol. 1, pp. 80, 86–7; Raines, *Rectors and Wardens*, vol. 1, p. 75; Hunwick, 'Corruption', pp. 91–9.

37 John Bruce and Thomas T. Perowne (eds), *Correspondence of Matthew Parker, D.D., Archbishop of Canterbury*, Parker Society 42 (Cambridge: Cambridge University Press, 1853), pp. 34–6, 259–60.

38 Hollingworth, 'Mancuniensis', fol. 18r; MCA, Mancath2/A/1/Dgate/1/1; Mancath/2/A/3/1/1, fol. 76.

39 [Bailey], 'Barlow Hall', p. 211; TNA, DL1/76/H10.

seek out hidden estates and to share the spoils with the Crown.[40] Manchester did not escape the attentions of the concealed-land hunters: in 1574 Herle complained that Thomas Staunton, a Duchy of Lancaster official, had seized some of the College's lands on the pretext that they were concealed and belonged to the Crown.[41]

The problem for Manchester College was much more serious, for if the 1556 re-foundation of the College was doubtful in law, then the whole College estate might be considered as concealed and properly belonging to the Crown. That crisis called for a number of responses. One was to weave such complex webs of leases that the allegedly concealed lands were themselves concealed. Another was to make the Crown a tenant in the hope of lessening royal pressure for seizures of the land. In December 1576, the warden and fellows granted the College's tithes, in reversion, to the Queen, who then re-granted them to William Killigrew, one of her courtiers. It is possible that other, similar grants were made to the Crown, but they have not survived. The Killigrew lease is often seen as Herle's most egregious offence, impoverishing the College and mortgaging its future: the lands so granted did not return to the chapter's control until the early eighteenth century.[42] Yet such a policy was not necessarily inexpedient. It guaranteed an annual rent from the Crown (in this case £86 14s. a year) from lands of doubtful ownership. It was also a policy tried at similar institutions such as Norwich Cathedral.[43] That Herle was seeking to defend the functions of the College is suggested by his proposal in 1570 that the College be dissolved and all the lands revert to the Crown, which would then make them over to one of the colleges of Cambridge University to train clergy and send preachers into Lancashire.[44]

The final response to these uncertainties was less altruistic: to make an immediate return from lands of which the College might at any point be dispossessed, and from an office in a college which at any point might be declared dissolved. Since Manchester's estate, like all ecclesiastical lands, was let on beneficial leases,

40 Hassell Smith, *County and Court: Government and Politics in Norfolk 1558–1603* (Oxford: Clarendon Press, 1974), pp. 265–75.

41 BL, Lansdowne MS 19, fol. 57v.

42 MCA, Mancath/2/A/2/1/2; John Harland (ed.), *Court Leet Records on the Manor of Manchester in the Sixteenth Century*, 2 vols, CS os 63, 65 (Manchester: Chetham Society, 1864, 1865), vol. 2, p. 80; Hunwick, 'Corruption', pp. 88–9.

43 Ian Atherton, Eric Fernie, Christopher Harper-Bill, and Hassell Smith (eds), *Norwich Cathedral: Church, City and Diocese, 1096–1996* (London: Hambledon, 1996), pp. 527–8, 670.

44 TNA, SP12/68, fol. 25r.

where the annual rent was low but a fine, or lump sum, was taken from the tenants for each new or renewed lease, money could most quickly be made by granting ever more leases. Fines, moreover, often went straight into the pockets of the warden and fellows rather than to the College as an institution. Like early twenty-first-century bankers speculating in sub-prime loans, Herle and others leased and re-leased estates of dubious title with gay abandon. Herle in particular spun complex webs of leases, re-leases and reversionary leases for terms of up to ninety-nine years (when the maximum term set by the Archbishop's instructions was twenty-one years). Great confusion was caused, so that it was not clear who the legal tenant was; where two parties disputed the lease, Herle would take rents from both, and then re-lease the property to a third. Tenants complained that double rents were extorted from them, and that Herle demanded loans which he never repaid. To pack the chapter, Herle attempted to raise two of his associates, Stephen Townsend and one Hiche, to the fellowship, but their status was disputed by the other fellows. Nonetheless, there were also strong suggestions that all the fellows had combined to issue fraudulent leases of College property.[45]

Balancing the competing interests of the College, which needed to make a return from its estates, of the tenants, who wanted lands cheaply, of the population of the parish and wider area, who expected clergy to dispense alms as liberally as possible, and of the local Protestant gentry, who demanded the preaching of the gospel, was always difficult. By 1576, that balance had been overturned. The problem was not leasing estates to the crown, but that the Protestant College could no longer carry out the functions of spreading Protestantism and dispensing charity demanded of it, and that Mancunians had begun to compare it unfavourably with its Catholic predecessor.[46] Encouraged by Oliver Carter, fellow and preacher, in October 1576 the Crown suspended Herle and dissolved the College on the grounds that it 'either has come into our hands as altogether dissolved, or at least, in the judgement of persons skilled in our laws, appears to have no, or a very doubtful foundation'.[47] For the second time in a generation, Manchester College had ceased to be.

45 Bodl., MS Tanner 144, fols 45–51, 53–9; BIA, CP.G.1620.
46 Bodl., MS Tanner 144, fols 56, 59r.
47 BL, Lansdowne MS 23, fol. 106r; Thomas Turner, *The Second Appendix to Mr Turner's Letter to the Bishop of Manchester, consisting of Translations of the several Foundation Charters of the College of Manchester, with other Documents relating to the Collegiate and Parish Church* (London: Thomas Ridgway, 1850), p. xxxvi.

The Elizabethan foundation, 1578–95

Unlike her father or brother, Elizabeth was not a dissolver of ecclesiastical corporations. She had even preserved Westminster Abbey, converting it from a monastery to a secular college (like Manchester) at the beginning of her reign. She preferred to skim off profits from the church, rather than dissolving institutions entirely.[48] There was, moreover, local pressure for the continuation of Manchester College, co-ordinated by Alexander Nowell, a Lancastrian who as Dean of St Paul's held a key role in church structures. He reminded the central government of the College's role in 'the good instruction of the whole people of that country in their duty to God and her Majesty',[49] and he negotiated Herle's resignation, whereby the Warden was recompensed in 1581 with the vicarage of Bromsgrove (where he remained until his death in 1590) despite government fears that Herle was unsuited to any living.[50]

By a charter of 18 July 1578, the Queen formally re-founded 'anew and perfectly' Manchester Collegiate Church, making some important changes from the Marian institution to emphasize its Protestant character.[51] Its dedication was changed to highlight its Protestant mission: no longer the college of SS Mary, George, and Denys, it became 'The College of Christ in Manchester founded by Queen Elizabeth'. Under the warden, and in place of the eight fellow chaplains, four clerks, and six choristers of the Marian foundation, there was a slightly reduced establishment of four fellows, two chaplains or vicars (to serve the parish), four singing-men, and four choirboys. Residence was strictly enjoined on the warden and fellows to prevent the 'very grievous injuries' which the new charter stated that absenteeism had caused the previous foundation. Although the designation of one fellow as preacher disappeared, preaching was enjoined on all the members of the chapter, their change of name from fellow chaplain to fellow signifying that their duties were preaching rather than the cure of souls. The charter's

48 C. S. Knighton and Richard Mortimer (eds), *Westminster Abbey Reformed: Nine Studies, 1540–1640* (Aldershot: Ashgate, 2003); Felicity Heal, 'The Bishops and the Act of Exchange of 1559', *HJ* 17 (1974), pp. 227–46.

49 BL, Lansdowne MS 23, fol. 106r; *ODNB, s.n.* 'Nowell, Alexander (*c.* 1516/17–1602)'; *Second Appendix*, p. xxxvi.

50 TNA, SP12/124, fol. 12; Francis Peck (ed.), *Desiderata Curiosa: or, a collection of divers scarce and curious pieces relating chiefly to matters of English history*, 2 vols (London: Thomas Evans, 1779), vol. 1, p. 92; Clergy of the Church of England Database, person ID 66528, www.theclergydatabase.org.uk, accessed 28 November 2020.

51 *Second Appendix*, pp. xxxvi–xlviii.

nominations to the chapter emphasized the role of Nowell in re-establishing the College. The new Warden was John Woolton, Lancashire born and Nowell's great-nephew.[52] Nowell was made a fellow, as was John Mullins, who had no connections with Lancashire but who was a colleague of Nowell at St Paul's in London.[53] Oliver Carter, who had led the prosecution of Herle, was retained on the chapter, and the fourth fellow was Thomas Williamson, Vicar of Eccles.[54] Two of the fellows of the Marian foundation, Robert Barber and Thomas Richardson, were retained, but demoted to be chaplains; both were in their twenties, considerably younger than the fellows, and neither had served under Herle for long.[55]

The Elizabethan re-foundation did not solve the College's problems. With so much of its estate on long leases, money remained tight, leading to a continuation of familiar problems. Carter supplemented his income by practising the law, while the chaplains celebrated clandestine marriages or kept unlicensed schools.[56] Absenteeism continued: Woolton, Nowell, and Mullins were all drawn away from Manchester by their other benefices. That problem was partly addressed when Woolton resigned in 1580 (on his appointment as Bishop of Exeter) and the wardenship was conferred on William Chaderton, Bishop of Chester, who moved to Manchester, becoming the first warden since Collier to spend a significant time in the town. Bishop Chaderton's wardenship revitalized the College, giving it a measure of official support and a re-energized purpose, the defeat of popery. By his residence, Chaderton made Manchester the centre of his diocese. Important, obstinate recusants were imprisoned in the town.[57] College fellows were given key roles in the battle against superstition and ignorance. When Chaderton established a thrice-yearly preaching exercise at Preston in 1582 designed to instruct and motivate local clergy, he chose Carter as one of the four moderators or leaders, and when that scheme was extended across the entire diocese two years later, Carter was joined by another of the

52 *ODNB*, s.n. 'Woolton, John (c. 1537–1594)'.

53 *ODNB*, s.n. 'Mullins [Molyns], John (d. 1591)'; J. M. Horn, *Fasti Ecclesiae Anglicanae 1541–1857, Volume 1: St. Paul's, London* (London: Athlone Press, 1969), pp. 8, 25.

54 Raines, *Fellows*, vol. 1, p. 80.

55 Bodl., MS Tanner 144, fol. 47r: in 1576 Barber was 27 and Richardson 25. Neither had been fellows in 1572: BIA, CP.G.1620.

56 *ODNB*, s.n. 'Carter, Oliver (d. 1605)'; CALS, EDV 1/6d, fol. 39r; EDV 1/17, fols 98r, 100r; EDV 1/14, fol. 120v; EDV 1/26, fol. 99; EDC 5/1604/4.

57 David Lannon, 'Manchester's New Fleet Prison or House of Correction and other Gaols for Obstinate Recusants', *Recusant History* 29 (2009), pp. 459–86.

William Chaderton,
Warden of
Manchester
1580–95

fellows, Thomas Williamson, as moderators of the exercise at Bury. The aim was to provide intensive instruction for clergy, schoolmasters, and laity through study of the Scriptures, prayers, and preaching; moderators also had powers to punish the misdemeanours of their fellow clergy and inform the Bishop of gross error or misdeeds.[58]

The College thereby came to be enmeshed in networks of godly clergy and laity across Manchester's hinterland as they banded together for strength and comfort in what seemed a hostile environment. That process can be judged from the 1593 will of another Manchester fellow, John Buckley. Two of his companion fellows, one of the chaplains, and three of the singing-men received bequests of books from his substantial library. More significant were bequests of books to clergy and laity across south-east Lancashire and northern Cheshire, from Littleborough in the north to Wilmslow in the south.[59] The impact of Manchester College even further afield is seen in the life of John Bruen, a zealous Cheshire Puritan: in the 1590s he travelled from his home in Bruen Stapleford, Cheshire, to Manchester, a journey of thirty miles, to hear sermons, before moving to Rhodes to be nearer the centre of godly power.[60] Christopher Haigh has criticized Manchester College for having 'failed the protestant cause' under Elizabeth: in his view, the College clergy failed to deliver 'a vigorous evangelistic effort' so that 'secularism and indifference advanced' in the town.[61] Certainly, a rising

58 R. C. Richardson, *Puritanism in North-West England* (Manchester: Manchester University Press, 1972), p. 65; John Strype, *Annals of the Reformation and establishment of religion and other various occurrences in the Church and State of England*, 3rd edn, 2 vols (London: Edward Symon, 1735), vol. 2, pp. 74–5.

59 F. R. Raines (ed.), 'A Description of the State, Civil and Ecclesiastical, of the County of Lancaster', in *Chetham Miscellanies V*, CS os 96 (Manchester: Chetham Society, 1872), pp. 29–36.

60 William Hinde, *A Faithfull Remonstrance of the Holy Life and Happy Death of Iohn Bruen of Bruen-Stapleford in the county of Chester, Esquire* (London: Philemon Stephens and Christopher Meredith, 1641), pp. 100–1, 109–10.

61 Christopher Haigh, 'Puritan Evangelism in the Reign of Elizabeth I', *EHR* 92 (1977), pp. 41–5.

tide of fornicators, drunkards, and non-attenders was reported to the Bishop at visitations: in 1581 there were eight notorious drunkards and six adulterers, while one person was presented for allowing others to drink in his house during church services; but in 1598, six were reported as keeping a bawdy house, eleven as common drunkards, and fifty for fornication or adultery.[62] Those rising numbers, however, suggest more zealous enforcement of the law rather than increasing flouting of it or rising religious indifference. Manchester College may not have evangelized the whole town, let alone the parish or diocese, but from the 1580s it was helping to create and sustain a faction of zealous Puritans in south-east Lancashire and north Cheshire. That, as we shall see, was pregnant for the future.

In these efforts, Chaderton, with the intermittent support of the Earl of Derby and the Privy Council, was prepared to over-look a certain amount of clerical nonconformity in the face of what was seen as the far greater threat from Roman Catholicism – the Privy Council had, after all, described Lancashire in 1574 as 'the very sincke of Poperie, where more unlawfull actes have been comitted and more unlawfull persons holden secrett than in any other parte of the realme'.[63] Preaching against popery became the test of a fellow's worth, not ceremonial conformity. Hence Thomas Williamson was appointed a fellow in 1578 even though as Vicar of Eccles he was already known for refusing the surplice,[64] and neglect of the proper vestments became almost a badge of honour among the College's clergy: the surplice was reported as defective in 1581, and one of the chaplains refused to wear it; two of the fellows did not wear a surplice in 1592; and there was no surplice at the college in 1598.[65] In 1590–91, a concerted attempt was made by the Archbishop of York to enforce conformity, but two of the fellows (Carter and Buckley) and nine other local clergy, with local gentry support, resisted the pressure to conform, and the College continued as the focal point of nonconformity.[66]

62 CALS, EDV 1/6d, fols 39v–40r; Preston, LRO, DDKE/Box 122/1, fols 11v–12r; CALS, EDV 1/10, fols 169–76; EDV 1/12a, fols 90–1.

63 J. R. Dasent (ed.), *Acts of the Privy Council of England*, 32 vols (London: Public Record Office, 1890–1908), vol. 8, p. 277.

64 CL, MS C.6.55, Raines's Lancashire MSS, vol. 22, p. 130.

65 CALS, EDV 1/6d, fol. 49r; EDV 1/10, fol. 168r; EDV 1/12a, fol. 89r.

66 F. R. Raines (ed.), 'A Visitation of the Diocese of Manchester', in *Chetham Miscellanies V*, pp. 9–19; LRO, DDKE/Box 122/1, fols 102v–104v, 107v, 108v–110r, 111r, 112r–114r, 118.

The wardenship of John Dee, 1595–1609

Chaderton resigned as Warden in 1595 on his translation to the see of Lincoln. The new Warden, John Dee, is remembered as one of the most colourful characters ever connected to Manchester: he is the only warden of the college to be the subject of an opera, to be portrayed in a film, or to feature in novels.[67] Only a couple of those novels have a Lancashire setting, one supposing a meeting with Guy Fawkes, another connections to the Pendle witches.[68] Dee's time at Manchester involved neither, but he was nonetheless a significant figure in the history of the College. Dee was the greatest philosopher-scientist in Tudor England: he advised Queen Elizabeth on the most auspicious day for her coronation; his mathematical knowledge was frequently sought by maritime explorers; and he advocated the creation of a British overseas empire. He was also a major figure on the European intellectual stage, known for his mathematical skill, his work as an alchemist, and for the possibility that he might transform base metals into gold; it was on account of the latter that he travelled to Poland and Bohemia in the 1580s. It is, however, Dee's belief that he had communication with angels through a series of mediums or skryers that has excited most posthumous attention.[69]

Despite his great reputation, Dee was, like most scholars, poorly remunerated, and on his return from Poland in 1589 he spent several years pressing the Queen for a position from which he could support his family and work. He sought somewhere in the south-east, but after more than four years was rewarded with the wardenship of Manchester; his appointment, for life, was made on 27 May 1595, although he did not arrive in Manchester until February 1596.[70] For a man who had lived at European courts and conversed with both angels and princes, historians

67 Damon Albarn, *Dr Dee* (2011); *Elizabeth: The Golden Age*, directed by Shekhar Kapur (2007); Peter Ackroyd, *The House of Dr Dee* (London: Penguin, 1994); Phil Rickman, *The Bones of Avalon* (London: Corvus, 2010); Phil Rickman, *The Heresy of Dr Dee* (London: Corvus, 2012).

68 William Harrison Ainsworth, *Guy Fawkes, or The Gunpowder Treason: An Historical Romance* (London: Richard Bentley, 1841); Jeanette Winterson, *The Daylight Gate* (London: Hammer, 2012). Both Ainsworth and Winterson were Manchester-born.

69 *ODNB*, *s.n.* 'Dee, John (1527–1609)'; Benjamin Woolley, *The Queen's Conjuror: The Science and Magic of Dr Dee* (London: HarperCollins, 2002); Edward Worsop, *A Discouerie of Sundrie Errours and Faults Daily Committed by Lande-Meaters, ignorant of arithmetike and geometrie, to the damage, and prejudice of many her Majesties subjects* (London: Gregorie Seton, 1582), sig. G3v.

70 TNA, C66/1428, mm. 40–1; Edward Fenton (ed.), *The Diaries of John Dee* (Charlbury: Day Books, 1998), pp. 246, 268, 273–4.

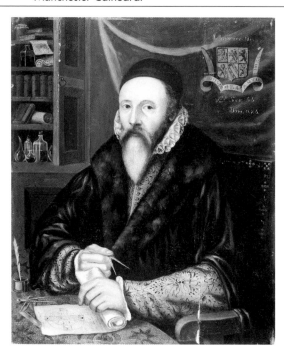

John Dee, Warden
of Manchester
1595–1609

have typically seen Dee's appointment to Manchester as a form
of exile, even a punishment.[71] From the Crown's viewpoint, how-
ever, Dee's preferment to Manchester had a number of advan-
tages. It was a cheap way of rewarding someone who had been
ordained priest since 1554 but who did not want the burdens of
the cure of souls, since parochial duties in the parish could be
undertaken by the chaplains. Dee was known as a peacemaker,
and so seemed suited to a foundation liable to fractious disputes.
Most importantly, though his religion was notoriously hard to
pin down, he had been sufficiently close to militant Protestants
such as the Earl of Leicester and Sir Philip Sidney to suggest that
he might be acceptable to some of the Lancashire godly, while
remaining at heart a conformist so that Archbishop Whitgift of
Canterbury, noted for his campaigns against Puritan noncon-
formity, could suggest Dee as a brake on the Manchester godly.[72]

71 Woolley, *Queen's Conjuror*, pp. 319, 385; Glyn Parry, *The Arch-Conjuror
of England: John Dee* (New Haven, CT: Yale University Press, [2012]),
p. 239; Stephen Bowd, 'John Dee and the Seven in Lancashire: Possession,
Exorcism, and Apocalypse in Elizabethan England', *NH* 47 (2010), p. 233;
Stephen Bowd, 'In the Labyrinth: John Dee and Reformation Manchester',
in Craig Horner (ed.), *Early Modern Manchester*, Manchester Region His-
tory Review 19 (Lancaster: Carnegie, 2008), p. 18.

72 Parry, *Arch-Conjuror*, pp. 28–9; John Aubrey, *Brief Lives*, edited by
Richard Barber (Woodbridge: Boydell, 1982), p. 96; Fenton (ed.), *Diaries*,

Dee vigorously set about two tasks as Warden: putting straight the College's notoriously crooked financial affairs; and enforcing conformity on the College clergy. In the former he was backed by the Earl of Derby, whom he assiduously courted before he left London and who may have let him live in the old college buildings which had passed from the church to the Stanleys in 1547, a notable privilege when no house was assigned to the warden.[73] Dee sought energetically to define the boundaries of Manchester parish and the College's estate, carrying out surveys, fixing boundary stakes, and employing the most famous map-maker in Tudor England, Christopher Saxton, to describe and measure the town.[74] He was particularly concerned about encroachments onto the College's estate at Theale Moor on the boundary between Manchester and Prestwich,[75] and on Newton Heath.[76] He also pursued the College's rights over local tithes with vigour.[77] Various means were used, from persuasion to law suits at the College's manor court of Newton, at the Chester consistory court, and at the court of the Duchy of Lancaster,[78] but success was limited. Many of the problems had plagued the College long before Dee, with tithes notoriously difficult to collect and encroachments legion in an urban environment with an expanding population.[79]

Dee was beset with financial problems as the income from the wardenship failed to live up to his hopes. He was forced to borrow from neighbours, pawn valuables, and rely on the charity of his relatives,[80] and was left bemoaning that he had never endured 'So hard & thinne a dyet' in all his life as at Manchester.

p. 273. For Dee's religious views, see *ODNB*, *s.n.* 'Dee, John'; Parry, *Arch-Conjuror*, p. 47; Woolley, *Queen's Conjuror*, pp. 49–51.

73 Fenton (ed.), *Diaries*, pp. 274, 276–7, 278, 283; Clare Hartwell, *The History and Architecture of Chetham's School and Library* (New Haven, CT, and London: Yale University Press, 2004), pp. 50–3.

74 Fenton (ed.), *Diaries*, p. 282; Stephen Bowd, 'John Dee and Christopher Saxton's Survey of Manchester (1596)'. *NH* 42 (2005), pp. 275–92. In the absence of Saxton's lost survey, Bowd speculates that it was a work of chorography connected to Dee's antiquarian studies, but it may also have helped delineate the possessions of the College.

75 CL, MS C.6.63; TNA, DL44/585; Manchester, JRL, CLD/551.

76 TNA, DL4/42/9; MCA, Mancath/2/1/d/2, 2/A2/2.

77 MCA, Mancath/2/1/d/2; Fenton (ed.), *Diary*, pp. 279, 286, 289.

78 Fenton (ed.), *Diaries*, pp. 279–80, 283, 289; H. T. Crofton, *A History of Newton Chapelry in the Ancient Parish of Manchester*, 3 vols in 4, CS ns 52–5 (Manchester: Chetham Society, 1904–5), vol. 2 pt 1, pp. 72–3; CALS, EDC5/1596/32–33; EDC5/1597/35–42; TNA, DL44/585.

79 TNA, DL1/155/T10; DL1/160/G1; Dasent (ed.), *Acts of the Privy Council*, vol 24, pp. 408–9; Farrer and Brownbill (eds), *VCH Lancaster*, vol. 4, p. 270.

80 Fenton (ed.), *Diaries*, pp. 280–1, 286, 289–90; Piccope (ed.), *Wills and Inventories*, p. 165.

As Warden, he complained bitterly that he was overwhelmed by 'the most intricate, [c]umbersome, and (in manner) lamentable affayres & estate, of this defamed & disordred Colledge', and he self-pityingly claimed that his letters came 'Ex Mancestriano Labyrintho' (from the Manchester labyrinth).[81]

Dee's problems with the College's tenants and neighbours paled alongside the controversies stirred up with other clergy in his attempts to complete his other task as Warden, the enforcement of ceremonial conformity. It was later remembered that he had 'the unhappinesse to be often vext with the Turbulent Fellowes'.[82] They questioned him over his accounts and refused to pay his housing costs,[83] but the underlying disputes were about conformity, and pitched Dee against both fellows and chaplains. Carter harried Dee as he had harried Herle before. In January 1597, Carter threatened to sue Dee; three years later all the fellows petitioned the Bishop of Chester against Dee, leading to Dee's examination by the Bishop's commissioners. The precise details of the allegations are unclear, but he was twice presented to the Bishop (in 1601 and 1604) for failing to preach, while his introduction of an organ into the church was also a bone of contention.[84] Dee complained of Carter's 'impudent and evident disobedience in the church', probably a reference to his refusal to wear a surplice, for which he was presented in 1592 and 1604.[85] A dispute in 1597 between Matthew Palmer, one of the College chaplains, and Mr Heton, whom Dee had installed as College preacher, divided along similar lines, with Robert Birch, one of the fellows, apparently supporting Palmer whom others described as 'mutinous' and 'vncharitable and malitious'.[86]

Dee's credit with the central government and the wider world beyond Manchester had fallen. He was widely mocked and forced to issue several assertions of his own orthodoxy and denials that he conjured devils.[87] He sought to strengthen his position in Manchester by appointing his son Arthur as chapter clerk in

81 Bowd, 'Dee and Reformation Manchester', p. 17.
82 Elias Ashmole, *Theatrum chemicum Britannicum* (London: Nathaniel Brooke, 1652), p. 483, repeated by Hollinworth, 'Mancuniensis', fol. 22r.
83 Fenton (ed.), *Diaries*, p. 285.
84 *Ibid.*, pp. 280, 287–9; CALS, EDV 1/12b, fol. 110r; EDV 1/13, fol. 64r. An organ at Manchester was last mentioned in the visitation of 1571, and had probably been removed shortly thereafter: BIA, V/1571–2, answer of Hall.
85 Fenton (ed.), *Diaries*, p. 284; CALS, EDV 1/10, fol. 168r; EDV 1/12, fol. 64r.
86 Fenton (ed.), *Diaries*, pp. 279–82, 285; LRO, DDKE/Box 122/1, fol. 181v.
87 Bowd, 'Dee and Reformation Manchester', pp. 26, 31, 43; Parry, *Arch-Conjuror*, pp. 256–72.

1600 and marrying him into a local gentry family,[88] but Dee still lacked significant political support locally. On his appointment he had forged links with the Earl of Derby, but Derby was distracted by debts and lawsuits, was forced to sell much local property, and was hence unable to bolster the warden's position in Manchester.[89] Dee departed for London in November 1604 and never returned (though he retained the wardenship until his death in 1609), a tacit admission of defeat.[90]

A Puritan college

Dee's troubles reveal a college and parish dividing into several camps. The fellows were usually a tightly knit group whose shared theology bound them in friendship networks which then crossed differences of status to include lesser clergy and minor officers of the College. Buckley (d. 1593) left books to other fellows, chaplains, and singing-men (but not to the warden); Carter (d. 1605) asked to be buried in the College chancel next to Buckley's grave; while John Glover (d. 1590), one of the singing-men, had a fellow and a singing-man among the overseers of his will.[91] In cathedrals there tended to be a great social divide between the dean and chapter on the one side, and the choir and minor officers on the other, but Manchester was different. The godly's sense of their separation from the superstitious and ungodly transcended such social conventions.[92] Moreover, Manchester did not participate in the development of choral services seen in cathedrals from *c.* 1600: although Dee introduced an organ, an account of the College penned between 1603 and 1609 noted that 'There is no Quiresters kept now'. The College singing-men, therefore, assisted the chaplains in conducting the services, but they did not sing and hence avoided the opprobrium

88 Fenton (ed.), *Diaries*, p. 289; *ODNB*, s.n. 'Dee, Arthur (1579–1651)'.

89 Barry Coward, *The Stanleys, Lords Stanley and Earls of Derby*, CS 3rd series 30 (Manchester: Chetham Society, 1983), pp. 41–52.

90 Bowd, 'Dee and Reformation Manchester', p. 31; Dee's continuing absence may also have been caused by the death of his wife, Jane, of plague in Manchester in March 1605: Ernest Axon (intro.), *The Registers of the Cathedral Church of Manchester: Christenings, Burials, and Weddings, 1573–1616*, edited by Henry Brierley, Lancashire Parish Register Society (Cambridge: Cambridge University Press, 1908), p. 349.

91 LRO, WCW/John Buckley of Manchester, clerk, 1593B; WCW/Oliver Carter of Manchester, clerk, 1605; Piccope (ed.), *Wills and Inventories*, pp. 65–9.

92 For the separation of the godly from the rest of Lancashire, see Raines (ed.), 'Description of the State of the County of Lancaster', signed by seventeen clergy, including Carter and Buckley from Manchester College.

heaped upon choirs by Puritans.[93] The godly at the College had influential protectors among the leading townsfolk and gentry of Manchester, in particular in Nicholas Mosley, a London merchant from a local family, who bought the manor of Manchester in 1596.[94] In an implicit criticism of Dee's wardenship, in 1600 Mancunians petitioned the Privy Council for a new preacher for the town. That came to nothing but, in a further sign of dissatisfaction with Dee's wardenship, the godly laity in the town then hired their own preacher, William Bourne, and in 1603 Mosley so successfully pressed the central government to make Bourne a fellow that Bourne was also promised the wardenship after Dee. Bourne was cast in the same mould as Carter, claiming in 1633 that he had never worn a surplice since his appointment to Manchester.[95] On Carter's death in 1605 Bourne took over the leadership of the godly in Manchester. He was remembered for his constant preaching, adding courses of sermons on Sunday afternoons or Monday mornings, duties which even the 1605 outbreak of plague did not stop, for when the sickness was at its height he took to the fields, preaching in the open air with the townsfolk on one side and the people of outlying districts on the other, so that they did not mix. The theme of almost all his sermons was the dangers of popery, though Hollingworth also recalled his efforts at preventing the profanation of the Sabbath. His credit with local Puritans is seen in his role in procuring and approving ministers for the outlying chapels in the parish, such as Thomas Paget and William Rathband at Blackley and George Gee at Newton; together they 'often met in a kind of consultative classis', a para-presbyterian structure.[96] Bourne's influence stretched far beyond Manchester: in 1637 he was one of thirteen godly clergy in the Midlands and north-west who

93 Ian Payne, *The Provision and Practice of Sacred Music at Cambridge Colleges and selected Cathedrals, c. 1547–c. 1646: A Comparative Study of the Archival Evidence* (London and New York: Garland, 1993), pp. 66–78; Bowd, 'Dee and Reformation Manchester', p. 28; Claire Cross, '"Dens of Loitering Lubbers": Protest against Cathedral Foundations, 1540–1640', in Derek Baker (ed.), *Schism, Heresy and Religious Protest*, SCH 9 (Cambridge: Cambridge University Press, 1972), pp. 231–7.

94 Willan, *Elizabethan Manchester*, pp. 9–17. For the role of the laity in supporting Puritan clergy, see Richardson, *Puritanism*, pp. 121–52.

95 Dasent (ed.), *Acts of the Privy Council*, vol. 31, pp. 44–5; HMC, *Calendar of the Manuscripts of the Most Hon. The Marquis of Salisbury ... preserved at Hatfield House, Hertfordshire, Part XII* (London: HMSO, 1910), p. 643; *CSPD 1603–10*, pp. 41–2; TNA, SP16/259, fol. 170r.

96 Hollingworth, 'Mancuniensis', fols 22r–23r.

corresponded with ministers in New England on questions of church government.[97]

Clerical nonconformity remained a hallmark of the College, with at least one fellow presented for not wearing the surplice at every visitation between 1604 and 1633.[98] Until 1633 the Bishop baulked at further proceedings, conniving at nonconformity for the sake of the fellows' preaching against popery. Turning a blind eye to the fellows, however, allowed nonconformity to spread among the laity. Three of the congregation were reported to the Bishop's visitation in 1608 for receiving communion in their seats (rather than kneeling, as the Prayer Book directed); in 1619 four were proceeded against for the same offence, thirty-four in 1621, thirty-seven in 1622 (when the churchwardens, showing solidarity with the nonconforming laity, refused to present any names), thirteen in 1625, and thirty in 1633. The latter year also saw prosecutions of forty-eight for refusing to kneel during the confession, litany, and other prayers, seven for not standing at the creed, and twenty men for wearing their hat in church.[99] In addition, in August 1622, sixteen of the congregation, in protest at the playing of the organ in the church (which some regarded as a popish instrument) engaged in disruptive psalm singing, attempting to drown out the organ with a different tune, while another parishioner was presented for saying that blowing the organs led to damnation.[100]

The godly did not, however, have everything their way. On Dee's death the wardenship did not go to Bourne, as he and the local godly had hoped, but to a Scot, Richard Murray, formerly a preacher in Edinburgh, who had crossed the border in the wake of the accession of James I in hopes of preferment and was not disappointed. Bourne's nonconformity counted against him: Robert Cecil, the King's chief minister, considered him 'a turbulent person to the State'.[101] Bourne retained his fellowship,

97 Tom Webster, *Godly Clergy in Early Stuart England: The Caroline Puritan Movement*, c. 1620–1643 (Cambridge: Cambridge University Press, 1997), p. 301. Their letter was published in 1643 by Rathband.

98 CALS, EDV 1/13, fol. 64r; EDV 1/15, fol. 133r; EDV 1/17, fol. 101r; EDV 1/22, fol. 116r; EDV 1/24, fol. 126r; EDV 1/26, fol. 98v; BIA, V/1633, fol. 602v.

99 CALS, EDV 1/15, fol. 134r; EDV 1/21, fols 92v, 118v; EDV 1/24, fols 126v, 129v; EDV 1/26, fol. 98v; BIA, V/1633, fols 601–2, 610–12.

100 CALS, EDV 1/24, fol. 128.

101 HMC, *Calendar of the Manuscripts of the Most Hon. The Marquis of Salisbury ... preserved at Hatfield House, Hertfordshire, Part XVI* (London: HMSO, 1933), p. 449; HMC, *Calendar of the Manuscripts of the Most Hon. The Marquis of Salisbury ... preserved at Hatfield House, Hertfordshire, Part XXIII, Addenda 1562–1605* (London: HMSO, 1973), p. 219; *CSPD 1603–10*, p. 498; LRO, DDKE/HMC/23; DDKE/HMC/25.

but the nonconformity of the College was regarded with some suspicion by the central government. When in 1599 four Queen's Preachers for Lancashire were established as part of a drive to convert recusants in the county, none came from Manchester College, a distinct contrast from the use in the previous decades of College fellows as moderators of local exercises, supervising the effort of conversion.[102]

More significantly, from *c.* 1600 a group of strongly conformist parishioners emerged who wished to see the rites and ceremonies of the Book of Common Prayer fully enforced, and who jibbed at the nonconformity of the College clergy. In 1604, they petitioned the Bishop about the Puritan nonconformity of one of the chaplains, Ralph Kirke. In fifteen articles they complained that he changed the words of the Prayer Book and devised his own prayers rather than following the set forms; that he refused to use the sign of the cross in baptism, mocking those parents who pressed him to conform; that he was contemptuous of the Prayer Book for lacking scriptural warrant; that he refused the surplice, describing it as 'a Ragg of ye Pope & a mighty Heresye' adding that those who supported vestments 'can not be saved'; that he failed to demand that worshippers knelt to receive communion; and that he insisted that preaching was necessary for salvation. These complaints were a litany of nonconforming Puritan practices and though directed at Kirke were a criticism of the fellows also, for Robert Birch assisted Kirke in administering communion to those sitting (rather than kneeling) and to those who kept their hats on (rather than going bareheaded), and even to those irreverently leaning over the desks in the quire, while Bourne and Richard Leroyde (who succeeded Kirke on his death of plague in 1605) continued to administer communion to people in their seats.[103] The complaints against Kirke were not an isolated case: a few years later one parishioner was reported for deliberately leaving the church just before the sermon and when admonished for his absence his reported that 'hee would not here mr Burne'.[104]

Here was a parish not simply divided between the godly and the superstitious or idle, as Puritans tended to see the world, but fractured many ways: the godly who sought to use the college to promote their vision of a little Geneva in Lancashire; the tiny numbers of Protestants who, like Henry Holland of Denton,

102 Richardson, *Puritanism*, pp. 20–1.
103 CALS, EDC 5/1604/4; EDV 1/15, fol. 134r; LRO, DDKE/9/121/1; Hollingworth, 'Mancuniensis', fol. 23r.
104 CALS, EDV 1/17, fol. 98r.

separated entirely from the Church of England;[105] recusants like Adam Houlden who abstained from the Protestant church and kept Catholic books in their house; [106] those whose conception of religion and church attendance was rooted more in communal rituals than the pronouncements of Canterbury, York, Geneva, or Rome, such as the wedding parties who were accompanied by the town waits to the church door;[107] those accused of irreverent behaviour, allegedly preferring the alehouse to the church, or caught brawling or working on a Sunday, but who should not be assumed to have had no place for religion or church attendance in their world;[108] and assertive conformists, enthusiasts for the Book of Common Prayer and the established church. The emergence of this last group around 1600 was not restricted to Manchester but was, as Judith Maltby has argued, a nationwide development as the rhythms of the Book of Common Prayer engrained themselves in the lives of worshippers and familiarity with the Elizabethan settlement bred devotion.[109] The divisions within Manchester, however, were drawn more sharply and deeply than elsewhere.

Moreover, by the mid-1620s a new, high church party associated with Richard Neile and William Laud was, with the backing of King Charles I, capturing the higher echelons of the church. They sought to promote conformity, discipline, and ceremonialism in worship. Crucially, for Manchester, they reversed previous thinking, seeing Puritans rather than Catholics as the greater threat to church and state, meaning that the college was in danger of losing its *raison d'être* for which its quirks had previously been overlooked. Presented with evidence of the extent of recusancy in Chester diocese in 1634, Charles I neatly expressed the new order in his complaint that 'The neglect of punishing Puritans breedes Papists'.[110] Moreover, Puritanism was increasingly seen as encouraging disobedience, contempt, and destabilizing views among the laity. At Manchester, for example, the Archbishop of York (by then Richard Neile, one of the leaders of the new direction) was presented with two examples: in 1632, he investigated

105 CALS, EDV 1/24, fol. 123r.
106 CALS, EDV 1/24, fol. 126v, EDV 1/22, fol. 116v.
107 David George (ed.), *Lancashire*, Records of Early English Drama (Toronto, ON: University of Toronto Press, 1991), p. 59.
108 CALS, EDV 1/17, fol. 100r; EDV 1/22, fols 115v, 116v.
109 Judith Maltby, *Prayer Book and People in Elizabethan and Early Stuart England* (Cambridge: Cambridge University Press, 1998); Judith Maltby, '"By this Book": Parishioners, the Prayer Book and the Established Church', in Kenneth Fincham (ed.), *The Early Stuart Church, 1603–42* (Basingstoke: Macmillan, 1993), pp. 115–37.
110 TNA, SP16/259, fol. 171r.

a libel pasted to the church door, threatening God's judgement on the town and comparing Charles I with Pharaoh and the King's rule with the devil's bondage, which seemed to confirm his prejudices about excesses of godly zeal and their connection with rebellion. And in 1635, Adam Byrom, a leading townsman who had been one of those refusing to kneel two years earlier, was prosecuted by the York high commission for disturbing a service in the College (it was alleged that he had interjected that the Book of Common Prayer was leading England back towards Rome) and for contemptuous behaviour towards a cleric and a diocesan official.[111] In 1633, at the Archbishop's visitation, the College received a damning report. 'All thinges & all men were here out of order. The Master & Fellowes never wont to weare surplice, or scarcely to come at prayers, leaving ye office to be done by 2 poor Chaplens ... They haue no Quiristers there, & their men cannot sing: Besides, their Organ is out of tune, and so is everything else.' Moreover, at the same visitation there were complaints that the quire, chapter house, and Derby chapel were all 'in decay'.[112] The faults uncovered in 1633 were not new (the poor state of the church's fabric had been a constant refrain of visitations since 1592);[113] the concerted action of Archbishop and King was. For the first time since 1559, conformity was forced on the warden and fellows, so that, it was reported, 'no man there aliue ever saw [the service] so fully performed before'. Only Bourne refused to wear the surplice and hood, for which he was suspended, a sanction he (and other fellows) had escaped at every previous visitation. Having evaded pressure to repair their chapel for a generation, the Stanleys found it cheaper to gift the chapel to the College for a library than to pay for its repair.[114] In seeking further to remould Manchester Collegiate Church in a new image, however, the King and archbishops were less successful. Like a large oil tanker, the College could not be made to change direction suddenly, particularly in the face of determined opposition from some of the fellows.

111 BL, Harleian MS 2176, fol. 3; BIA, HC.CP.1635/2.
112 TNA, SP16/259, fols 169v–170r; Stafford, SRO, D1287/9/8 (A/92); BIA, V/1633, fol. 599r.
113 CALS, EDV 1/10, fol. 168v; EDV 1/12a, fol. 89r; EDV 1/12b, fol. 109v; EDV 1/15, fol. 132v; EDV 1/24, fol. 120v; EDV 1/26, fol. 100r.
114 SRO, D1287/9/8 (A/92); Bodl., MS Tanner 144, fol. 31. Bourne's suspension had been lifted by 1635; it is not known whether he conformed to the surplice, though the concession that he consented to the chaplains wearing the surplice was wrung out of him.

The Caroline re-foundation of 1635

Richard Murray is remembered as another Herle, a Warden who abused the office and was deprived, and that reputation has coloured all his dealings at Manchester. According to Hollingworth, Murray was not much of a preacher, alleging that he preached only twice in the college, on the first and penultimate verses of the Bible, 'So it was sayd that hee in preaching begunne and ended the bible nor was hee very skillfull in it'. Nonetheless, unlike Dee, he was not presented for failure to preach at a visitation. Hollingworth's gossipy account of Murray's wardenship had little good to say, harping on his alleged failings. 'Preaching once before King James vppon Rom. 1. 16 I am not ashamed of the Gospell of Christ – when hee came to kisse the kings hand His Majesty sayd thou art not ashamed of the Gospell of Christ but by --- the Gospell of Christ may bee ashamed of thee'. Hollingworth's version of the king's *bons mots* glosses over the fact that the Crown presented Murray to Stockport in 1619, so if the story is true it must be from the end of James's reign.[115] Hollingworth also criticized Murray for his haughtiness, with a story that he refused to yield his seat to the Bishop, even arriving for an afternoon service especially early to ensure he was seated before the Bishop entered the church, but similar contests between bishops and deans of cathedrals were common in early modern England.[116]

These were not the foibles that brought Murray down. His undoing was on two counts: money and the opposition of some of the fellows and townsfolk, the same two rocks which had wrecked Herle's career sixty years earlier. Murray's solution to the financial problems of the College was to keep offices unfilled and office holders unpaid. He was presented for such financial irregularities in 1630, when it was alleged that the places of one chaplain, one singing-man, and three choristers had been kept vacant, that accounts were not kept, and that wages were not paid. In addition, further malpractices were soon alleged against

115 The tradition that James I attended a service at the Collegiate Church in 1617 on his progress through Lancashire (John Harland, *Collectanea Relating to Manchester and its Neighbourhood*, CS os 68 [Manchester: Chetham Society, 1866], p. 167) cannot be attested in any of the sparse College records. Moreover, his return from Scotland, by way of Preston, Hoghton, Lathom, and Bewsey Hall, took him some way west of Manchester, and as he concentrated on visiting corporate towns and country seats, there was little reason for him to take a detour to the town: John Nichols (ed.), *The Progresses, Processions, and Magnificent Festivities, of King James the First*, 4 vols (London: Nichols, 1828), vol. 3, pp. 398–405.
116 Hollingworth, 'Mancuniensis', fols 22v–24r.

Murray, including making leases of College property for his private use and not paying the rent due, detaining rents in his own hands, and failing either to keep courts leet or to renew leases, so that the already impoverished College grew yet poorer.[117] Early in 1633, a group of townsfolk, frustrated by Murray's failure to manage the college estate (and hence perhaps fearing for the security of their own tenure of college land), petitioned the King to investigate, setting rolling the case that would bring down Murray eighteen months later.[118]

Murray had practised 'divide and rule', perhaps conscious of the ways that the fellows had turned against Herle and Dee. Around 1633 he tried to create jealousies among the fellows by making Peter Shaw Vice-Warden, whereupon Shaw and Murray ensured that two other fellows, Richard Johnson and Samuel Boardman, were not paid their stipend.[119] Murray no doubt chose Shaw because he was more inclined to bend to the new dictates of the Archbishop. Shaw repaired the chapter house and quire and tried to introduce more ceremonious worship into the College. For that, he complained, other members of the foundation turned against him, branding him an 'Innovator … a persecutor of the godly a time server & deboist Fellow'. Johnson certainly called Shaw *Diabolus Fratrum* (the brother of the devil). Shaw's position was undermined when Murray, eager to divide the fellows further, denied that Shaw, Johnson, or Boardman had been duly appointed. Shaw's authority impugned, his attempt to enforce conformity collapsed.[120] Turning the fellows against him proved as unwise for Murray as it had for Herle. Johnson warned that 'if hee say I am noe felowe I must say hee is noe Warden'. When the King referred the case of Manchester to referees including the Archbishop of Canterbury and the Earl of Manchester, a jumble of further allegations tumbled forth against Murray, from purchasing the parsonage of Wigan from under the nose of the Rector (who happened also to be the Bishop of Chester) to suggestions of sexual impropriety. Not even Murray's courtier-brother the Earl of Annandale could save the Warden against such a tide.[121]

117 Hollingworth, 'Mancuniensis', fol. 24r; CL, MS C.6.55, Raines's Lancashire MSS, vol. 22, fols 132r, 134r; TNA, SP16/261, fols 225v–226r.

118 Bodl., MS Eng. hist. c. 481, fol. 210r.

119 TNA, SP16/261, fol. 225; SP16/263, fol. 89r; BIA, HC.CP.1635/2.

120 TNA, SP16/263, fols 87r–89r; SP16/265, fol. 136r; F. R. Raines, C. W. Sutton, and Ernest Axon (eds), *Life of Humphrey Chetham, Founder of the Chetham Hospital and Library*, Vol. I, CS ns 49 (Manchester: Chetham Society, 1903), p. 51.

121 Raines, Sutton, and Axon (eds), *Life of Chetham*, pp. 51, 54; TNA, SP16/254, fol. 100r; SP16/414, fol. 4r; SP16/261, fols 208v–209r; SP14/44,

Proceedings in the Court of High Commission against Murray opened in April 1634 and concluded in June 1635, the Court finding that in addition to financial improprieties, in 1609 on admission as Warden he had not sworn the oath to obey the College statutes and that consequently he had never legally been Warden. He was excommunicated, deprived of the wardenship, suspended from his other livings, fined the enormous sum of £2,000, and committed to prison. All his brother could do was to secure the mitigation of the fine by half. A broken man, Richard Murray was dead within twenty months.[122]

Judgement against Murray created a problem for the College: if there had been no warden since 1609, what status had the College and what had happened to the estates ostensibly granted and the officers admitted by Murray the non-warden? The answer was that the College was judged to be 'altogether dissolved or truly hath none, or else a very uncertain foundation'; the College had been dissolved since 1609, although no one had noticed. Consequently, it was re-founded on 30 September 1635 as 'Christ's College in Manchester, founded by King Charles the First', the third re-founding in less than eighty years. The foundation was little changed – it had the same lands and rights as previously – although some attempt was made to redress its continuing problems. The warden's power was reduced slightly and that of the fellows correspondingly increased: no longer could the warden leave places vacant or over-rule the fellows in the appointment to College offices. Stipends were increased slightly, so that the warden had £70 a year, fellows £35, chaplains £17 10s, singing-men £10, and choristers £5. The College's most valuable estate, its holdings of tithes, was no longer to be let but kept in hand. The pressing absence of collegiate houses was to be redressed by the chapter quickly, with all fines devoted to the purchase of such houses, in case the offer of £400 from an anonymous donor to buy the College house which had been granted by the Crown to the Stanleys nearly a century earlier came to nought, as indeed it did.[123]

The same four fellows – William Bourne, Samuel Boardman, Richard Johnson, and Peter Shaw – were continued from the previous foundation. It may seem a little odd that the King and the

fol. 32; *ODNB*, *s.n.* 'Murray, John, first earl of Annandale (d. 1640)'; James B. Paul (ed.), *The Scots Peerage*, 9 vols (Edinburgh: David Douglas, 1904–14), vol. 1, pp. 223–8.

122 TNA, SP16/261, fols 11v, 37v, 224v–227r, 228r, 236v; *CSPD 1637–8*, pp. 19, 360.

123 Hibbert, *History of the Foundations*, vol. 1, pp. 152–67, 392–3; Hollingworth, 'Mancuniensis', fol. 25r; SRO, D1287/18/2 (P/309/128, 130).

Archbishop of Canterbury did not take greater steps to ensure a conformable body of fellows, but Archbishop William Laud seems to have been over-confident in his ability to intimidate the college clergy, who meanwhile concealed and obfuscated their own position with practised skill.[124] It may also seem odd that the new Warden was Richard Heyrick, who was to prove one of the leading Presbyterians in the north-west, even odder when it is known that it had already been guessed that he 'should prove an Anti-arminian'.[125] Laud, once again too trusting in his own abilities, believed not only that he had wrung from Heyrick a promise that 'he will doe his duty to ye Church', but also that he could exert sufficient authority over the Warden and fellows to force them to conform and appoint his nominees.[126] Patronage, moreover, was not conducted on solely ideological grounds, with ties of money, lordship, gratitude, and kinship cutting across matters of churchmanship. Heyrick (his name was also spelled Herrick – and Robert Herrick the poet was his cousin) owed his place to the wealth of his father, Sir William Herrick, goldsmith and moneylender. In the later 1620s, Sir William secured a grant of the reversion of the wardenship of Manchester College for his third son Richard, a Norfolk parson and fellow of All Souls' College, Oxford, in lieu of repayment of money he had lent to the Crown. The example of William Bourne, however, showed that a reversionary grant could not automatically be redeemed; but in 1635 Heyrick was able to cash in his grant because of his links with Laud. Heyrick had been a student at St John's, Oxford, when Laud had been its President, and he still had a testimonial from Laud and the fellows dated 1620; he was also nephew of Laud's 'auncient friend' Thomas May. Moreover, Laud and St John's were indebted to the Herricks for a number of benefactions that they had made or facilitated to St John's.[127]

124 SRO, D1287/18/2 (P/309/152); Raines, Sutton, and Axon (eds), *Life of Chetham*, pp. 49–50, 53–4.

125 Raines, Sutton, and Axon (eds), *Life of Chetham*, p. 63; William Laud, *The History of the Troubles and Trial of the most reverend father in God, and blessed martyr, William Laud, Lord Arch-Bishop of Canterbury* (London: R. Chiswell, 1695), p. 369.

126 SRO, D1287/18/2 (P/309/133); Kenneth Fincham (ed.), *The Further Correspondence of William Laud*, Church of England Record Society 23 (Woodbridge: Boydell, 2018), p. 168.

127 Bodl., MS Eng. hist. c. 481, fols 20r, 23r, 64r, 71r, 75r, 79r, 106, 207r–208r, 211r; *ODNB, s.nn.* 'Heyrick, Richard (1600–1667)' and 'Herrick [Heyricke], Sir William (bap. 1582, d.1653)'; Fincham (ed.), *Further Correspondence*, pp. 140–1.

The Indian summer of Manchester College, 1635–60

Heyrick proved a vigorous Warden. The College's first surviving act book shows that between 1635 and 1641 wayward sing-ing-men were disciplined, audits held, offices filled, and a rota devised for catechizing on Sunday afternoons. In the summer of 1636, the chapter agreed to assign houses in Deansgate to the warden and fellows in an attempt to secure their residence in the town, and by 1638 they had used the fines from renewal of leases to repair the church, taking down the roofs of the eastern arm which, in the words of Hollingworth, were then 'built vp againe battled & pinnacled in a seemely yea a stately manner' at a cost, it was claimed a decade later, of between £1,300 and £1,400.[128]

Heyrick has earned a reputation as a 'combative careerist' or a timeserver for securing his promotion under Laud and then weathering the changing climate of the mid-century, hanging on at Manchester until his death in 1667.[129] Rather, he should be seen as someone who was skilful in keeping just the right side of the authorities most of the time. His position in the later 1630s, the coded inferences and pregnant hints in which any criticism of the archbishops needed to be couched, as well as the extent to which he could openly attack current church policy, are all seen in three sermons delivered in Manchester Collegiate Church between 1637 and 1639: one preached on the occasion of the Bishop of Chester's visitation, 24 April 1637 (which survives only in notes taken by one of his hearers); and two on Gunpowder Plot Day 1638 and 1639 (which were published in 1641). Those from 5 November show practised skill in hinting at more than was said, proclaiming one message (a conventional attack on popery) while implying another (a veiled attack on the Crown's policies as too inclined to favour Catholicism).[130] That from 1637 shows Heyrick boldly criticizing the attempt to enforce Laudian ceremonies upon the church: 'ceremonies are not only dead but deadly; they are enmity and they set enmity betwixt man & man' he preached. He admitted that some ceremonies 'must needs bee', but those 'must not bee walls of partition', and yet they had become so for 'the Ceremonies of the few are prest' upon the church at a time when 'drunkenes & blasphemy' were far greater challenges to the life of the nation. He also criticized

128 MCA, Mancath/2/2/1, pp. 10–11, 14–19, 26–8, 36, 40, 46, 48, 54, 62; Hollingworth, 'Mancuniensis', fol. 25r; TNA, C10/1/38.
129 *ODNB, s.n.* 'Heyrick, Richard'; Raines, *Rectors and Wardens*, vol. 2, p. 127.
130 Richard Heyrick, *Three Sermons Preached at the Collegiate Church in Manchester* (London: L. Fawne, 1641), especially pp. 53, 82–3, 91.

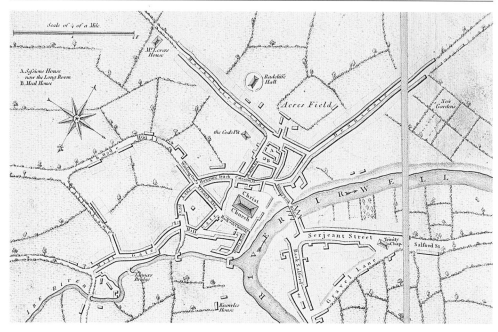

A plan of Manchester and Salford, c. 1650

current appointments in the ministry, for 'refusing puritans are put down when recusant papists are set in places of honor'. Even Heyrick's choice of examples was an implicit critique of the church under Laud, quoting approvingly 'ye zealous Bishop of Lincoln' at the very point when that Bishop, Laud's great opponent, was being harried through the courts on the way to being suspended, fined, and imprisoned.[131]

One of those 'refusing puritans' commended by Heyrick was his life-long friend Thomas Case. The two had met at school, and Case had been Heyrick's curate in Norfolk, but was proceeded against for nonconformity and fled to Manchester in 1636, where Heyrick encouraged him to preach both in the College and the surrounding chapels. He was quickly absorbed into Manchester's Puritan circles, marrying into the Mosley and Booth families in August 1637, placing him at the heart of the local godly.[132] There was even a plan, frustrated in the end, to make him a fellow of the Collegiate Church.[133] Notes taken from two of his sermons at Manchester suggest the semi-separation of the godly, existing at the heart of the parish under the spiritual leadership of the College clergy, but also operating outside the structures of

131 Manchester, GMCRO, Worsley MS M35/5/3/7, fols [22v–7v].
132 *ODNB*, *s.n.* 'Case, Thomas (bap. 1598, d. 1682)'; Matthew Reynolds, *Godly Reformers and their Opponents in Early Modern England: Religion in Norwich c. 1560–1643* (Woodbridge: Boydell, 2005), p. 171.
133 Fincham (ed.), *Further Correspondence*, p. 217.

the established church. They also suggest the coded messages for the godly embedded in public preaching, hints 'covertly insinuated to his Auditors' as one enemy put it. On Easter Day 1637, Case directed his hearers to imitate the risen Christ who kept company only with saints, which could be used as an argument for the separation of the godly from the ungodly and certainly bolstered the Manchester brethren in their practice of meeting together in private houses for prayers and fasts. Case was known for expounding his sermons in private in the houses of the local godly. His sermon in the college two weeks later in April 1637 set out clear rules for such meetings 'for Holy Conference … for policy, schollery, for mechanical conuerse', encouraging the laity to active participation. Even without formal learning, he assured the godly that a lifetime of hearing sermons enabled them 'to Articulat for Canaan' in what he called 'these darke ages', which in 1637 must have sounded to some as a coded reference to Laudian persecution rather than a conventional description of a fallen world.[134]

The growing crisis between England and Scotland from 1637 made many godly more hopeful for the collapse of the Laudian ecclesiastical regime, but it also made the government's ears more attuned to language of the godly, and hence in March 1639 Case was hauled before the Chester consistory court on seventeen points of seditious preaching and activity in and around Manchester. He was charged with disparaging bishops, attacking ceremonies, consorting with and encouraging 'Inconformable persons', repeating his sermons in private houses, supporting the Scottish covenanters and spreading their books; in effect, ministering to a church within the church.[135]

Manchester Collegiate Church in the late 1630s was increasingly Janus-faced. One face of the church shows the appointment of an organist and a master of the choristers, careful attention to the choir with choristers' places filled, singing-men vetted and monitored for musical skill and voice, all suggesting the adoption of choral services as directed by the Laudian vision of the Church of England.[136] The other face was the college's pastoring and fostering of an alternative, shadow church of the godly, eschewing prescribed ceremonies and looking to the Presbyterian Scottish kirk for encouragement.

134 GMCRO, Worsley MS M35/5/3/7, fols [3r–22v]; Fincham (ed.), *Further Correspondence*, p. 214.
135 CALS, EDC 5/1638/112, also copied in CL, MS C.6.55, Raines's Lancashire MSS, vol. 22, pp. 214–26; Fincham (ed.), *Further Correspondence*, p. 214.
136 MCA, Mancath/2/2/1, pp. 8, 26, 36, 48, 50, 54.

At the outbreak of the Civil War in the summer of 1642, Manchester College was instrumental in the town's declaration for the Parliament, leaving it as the only southern Lancashire town not controlled by the Royalists. Heyrick galvanized the town's Parliamentarians into action, drawing up a petition calling on the King to accede to the Parliament's demands and, when that failed, hiring a German military engineer to fortify the town. Shortly thereafter, when Lord Strange (son of the ailing Earl of Derby and the leading Royalist in the north-west) invested Manchester for a week, it was William Bourne who inspired the townsfolk to their successful resistance: he 'took small rest all that weeke but was still at hand upon all occasions to keep up the spirits of the people, with this perswation, not to feare or be dismaied'. In the siege, the church tower, the highest building in the town, was used as a vantage point for snipers.[137] And it was one of the town's clergy (Heyrick, by tradition), who took an account to Parliament of Manchester's resistance that was then published.[138]

The story of most cathedrals in the Civil War is one where cathedral clergy first led the creation of a Royalist party, followed by a Parliamentarian assault on their services and buildings, then the abolition of their foundations.[139] Manchester is different. It is the only example where a cathedral-type foundation led the Parliamentarians rather than the Royalists. Organ and choir disappeared without comment,[140] and the institution ceased to function as a collegiate church, probably between the summer of 1641 (the chapter act book was no longer kept after July

137 George Ormerod (ed.), *Tracts relating to Military Proceedings in Lancashire during the Great Civil War*, CS os 2 (Manchester: Chetham Society, 1844), pp. 8–12; Hollingworth, 'Mancuniensis', fol. 26r; John Rosworme, *Good Service hitherto Ill Rewarded* (London: n.p., 1649), pp. 7, 29; *ODNB, s.n.* 'Rosworm [Rosworme], John (d. in or before 1675)'; William Beamont (ed.), *A Discourse of the Warr in Lancashire*, CS os 62 (Manchester: Chetham Society, 1864), pp. 7–8.

138 Ernest Broxap, *The Great Civil War in Lancashire, 1642–1651* (Manchester: Manchester University Press, 1973), p. 44; *A True and Faithfull Relation of the Besieging of the Towne of Manchester* [London: n.p., 1642].

139 Jacqueline Eales, 'Provincial Preaching and Allegiance in the First English Civil War (1640–6)', in Thomas Cogswell, Richard Cust, and Peter Lake (eds), *Politics, Religion and Popularity in Early Stuart Britain* (Cambridge: Cambridge University Press, 2002), pp. 194–5, 198–200, 203–4; Norman Ellis and Ian Atherton (eds), 'Griffith Higgs's Account of the Sieges of and Iconoclasm at Lichfield Cathedral in 1643', *Midland History* 34 (2009), pp. 233–45; Ian Atherton, 'Cathedrals and the British Revolution', in Michael J. Braddick and David L. Smith (eds), *The Experience of Revolution in Stuart Britain and Ireland: Essays for John Morrill* (Cambridge: Cambridge University Press, 2011), pp. 96–116.

140 An agreement of December 1649 simply mentioned 'a vacant place … where the organs lately stood': GMCRO, M71/4/2/1.

1641, perhaps an indication of such a change)[141] and the siege of the town in September 1642; and yet it continued as a house of preaching under Warden Heyrick. At the end of 1648 it was alleged that three of the pre-war fellows had long been absent: Boardman for ten years, and Johnson and Shaw for six, and that there had not been two chaplains resident at the College for six or seven years, all suggesting changes at the Collegiate Church in 1641–42.[142] Boardman seems to have left Manchester in the summer of 1641 for the rectory of St Magnus, London, a godly parish in the City, and then in 1645 to livings in Parliamentarian Suffolk, where he supported Presbyterianism, dying in 1653 as Rector of Long Melford.[143] Shaw left Manchester, was also ejected from the rectory of Radcliffe in Lancashire, and died c. 1657. Johnson, according to an early eighteenth-century tradition, was hounded out of Manchester by a stone-throwing mob, from whence he fled to Royalist Chester while his wife and brother-in-law were imprisoned. He prospered in the 1650s, however, being appointed Master of the Temple in London, and in 1653 was made a governor of Chetham's Library. He was the only fellow to survive to the Restoration of 1660, when he regained his fellowship at Manchester.[144] The fourth fellow, William Bourne, who remained at the College, died in August 1643. He was the only one to be permanently replaced, by Richard Hollingworth, Minister of Salford.[145]

Through the departure of some fellows and the abandonment of the choral aspects of the foundation, Manchester College discarded one of the faces it presented to the world, leaving it as a centre of godly preaching. That aspect was reinforced as the town became a bastion of the Parliament's cause in the north, attracting exiles fleeing the wars elsewhere. In particular, two Yorkshire divines crossed the Pennines early in the war and helped out at the denuded College. Thomas Birkbeck fled from

141 MCA, Mancath/2/2/1, p. 62.
142 TNA, C10/1/38.
143 George Hennessy, *Novum repertorium ecclesiasticum parochiale Londinense; or, London diocesan clergy succession from the earliest time to the year 1898* (London: Swan Sonnenschein, 1898); A. G. Matthews, *Walker Revised: Being a Revision of John Walker's Sufferings of the Clergy during the Grand Rebellion, 1642–60* (Oxford: Clarendon Press, 1948), pp. 20, 167, 340; TNA, PROB11/231, fols 295v–296r; *The Humble Petition of the Ministers of the Counties of Suffolke and Essex, concerning church-government* (London: Iohn Wright, 1646).
144 Raines, *Fellows*, vol. 1, pp. 122–33, 137; Matthews, *Walker Revised*, pp. 20, 230.
145 Henry Brierley (ed.), *The Registers of the Cathedral Church of Manchester 1616–1653*, Lancashire Parish Register Society 55–6 (Wigan: the society, 1919, 1920), vol. 2, p. 541; Raines, *Fellows*, vol. 1, pp. 138–43.

the Royalists who occupied Sheffield in May 1643 – but returned
to Sheffield the following year. Elkanah Wales, Curate of Pudsey,
was preaching in Manchester in 1643–44.[146] Although neither
was in Manchester for long, one sermon preached by Wales in
the town survives, an eight-thousand-word exposition of the
elect and the law.[147] On the page it may look dry, but one of his
Yorkshire congregation testified to the effect of his preaching
style:

> I have known that holy Mr. Wales spend six or seven hours
> in praying and preaching, and rarely go out of the pulpit; but
> sometimes he would intermit for one quarter of an hour, while
> a few verses of a psalm were sung, and then pray and preach
> again; and O what confession of sin did he make! what tears
> and groans were to be seen and heard in that chapel! I am sure
> it was a place of weepers …[148]

It is notoriously difficult to shed historical light on the daily
and weekly rounds of services and preaching, for the quotidian
routine has left few traces in the historical record, but here we
have an insight into what it was like to worship at Manchester
Collegiate Church. Though this account comes from Wales's
ministry in Yorkshire and relates to a fast day rather than a
Sunday, his preaching style was surely the same at Manchester,
and mirrored that of many Puritan divines. When the Puritan
John Angier, Minister of Denton chapel in Manchester parish
and known as 'Weeping Angier' for his ability to move himself to
tears, preached and prayed at a day of fasting in Manchester Col-
legiate Church in the 1640s, Isaac Ambrose, another Lancashire
godly minister, wrote that Angier 'melted all hearts' and that his
own was 'never in such a melting frame in any publick ordinance
before'.[149] Preaching was an event and some preachers were char-
ismatic performers, not dry lecturers. Hearing a sermon could be
an active, not passive, pursuit, with the congregation expected
to be engaged and to be moved, while some would follow the

146 TNA, C10/1/38; Ronald A. Marchant, *The Puritans and the Church Courts
in the Diocese of York, 1560–1642* (London: Longmans, 1960), pp. 229,
289.
147 BL, Additional MS 4932, fols 146r–151v.
148 Thomas Wright, ed., *The Autobiography of Joseph Lister of Bradford in
Yorkshire* (London: John Russell Smith, 1842), p. 6.
149 Oliver Heywood, *A Narrative of the Holy Life, and Happy Death of that
reverend, faithful and zealous man of God, and minister of the Gospel of
Jesus Christ, Mr. John Angier, many years Pastor of the Church of Christ
at Denton, near Manchester in Lancashire* (London: Thomas Parkhurst,
1683), p. 42.

preacher's scriptural references in their own Bibles.[150] From the late sixteenth century, the focus in services in Manchester was on preaching, not the set liturgy of the Book of Common Prayer. As we have seen, the College's clergy emphasized preaching over the Prayer Book,[151] and were repeatedly charged with omitting parts of the Prayer Book. The lowly place of the Prayer Book at the College is revealed in a vignette from the Archbishop of York's visitation of 1633. Two singing-men read the Litany, including prayers for Queen Anne (wife of James I); but she had died in 1619. The College had not acquired any new prayer books for a decade and a half, and it rather looks as if, in the face of a visit from the Archbishop's officials, the singing-men had cast about for a Book of Common Prayer to mount a show of conformity and found an old, unused one in the back of a cupboard.[152] Such an attitude to the Book of Common Prayer must have meant that the change to the Directory of Public Worship ordered by Parliament in 1645 made little difference to services at Manchester, for though the Directory provided a framework for services rather than a set liturgy to be read out on each occasion, Manchester's clergy had been extemporizing their prayers for many years: charged in 1639 with not adhering to the set prayers, Case admitted he took 'libertie' with the words, claiming to have used a prayer 'agreeing in substance ... though not confining himself to the Letter' of the prescribed form.[153] Three other aspects of the experience of worshipping at Manchester Collegiate Church stand out. One is the continuing disrepair of the fabric across much of the period. Constantly reported at visitations from the 1580s to the 1630s, it was alleged in 1635 that the fabric was in such a poor state that it 'was ready to fall, [and] did hang over the heads of many of them that entered thereunto' so that many parishioners feared to enter.[154] Poetic licence no doubt, but it does convey a sense of the emphasis on the church as congregation rather than the church as building. The second aspect is the great crush of people inside, as the medieval building struggled to contain the expanding population of the township. Galleries were

150 Arnold Hunt, *The Art of Hearing: English Preachers and their Audiences, 1590–1640* (Cambridge: Cambridge University Press, 2010).

151 CALS, EDC 5/1604/4; TNA, SP16/263, fol. 87r.

152 CALS, EDC 5/1604/4; EDC 5/1638/112; BIA, HC.CP.1635/2.

153 CALS, EDC 5/1638/112. Although there is no evidence that the College bought the Directory, it seems inconceivable that divines such as Heyrick would not have used it.

154 CALS, EDV 1/6d, fol. 39r; BIA, V/1633, fol. 599v; Hibbert-Ware, *History of the Foundations*, vol. 1, p. 153.

added in 1617, 1657, and 1660.[155] Case mentioned the 'Crowd or Press in that numerous Congregation' in 1639; a decade later nearly two hundred parishioners complained that 'many of the Inhabitants are forced to sitt farre of soe As they cannot well heare presse to crowd and thrust neare to gether in very uneasie manner'.[156] The third aspect is that though the historical record concentrates on Sunday services – those not attending, or those refusing to conform – the most common services at the Collegiate Church were the occasional offices (baptism, marriage, and burial), conducted in the late 1630s on average nearly thirteen times a week.[157] Henry Newcome, coming to minister at the College in 1657 from the small village of Gawsworth in rural Cheshire, was struck most by the number of burials at Manchester: 'A burial in a month, was as much as happened in the county; and here I visited three or four sick persons a day, – and several burials in a week'.[158]

Under Warden Heyrick, Manchester was celebrated as 'a *Goshen*, a place of light, when most places of the Land have been places of darknesse'.[159] The reputation of Manchester as 'a Town famous for Religion ever since the Reformation' was recognized by March 1641 when a group of inhabitants petitioned Parliament to establish a university for the north of England at Manchester. It was hoped that the old College buildings would serve as the nucleus of the university, supplemented no doubt by the clergy of the Collegiate Church; cathedrals and collegiate churches were, after all, closely related to university colleges. The proposal, however, was still-born, countered by a rival bid from York, and lost in the press of parliamentary business.[160] Heyrick's role was recognized in April 1642 when he was appointed one of the two divines representing Lancashire at the Westminster Assembly, charged with devising a new form of church

155 Hollingworth, 'Mancuniensis', fol. 23v; CALS, EDC 5/1636/48; GMCRO, M71/4/2/1–2; Farrer and Brownbill (eds), *VCH Lancaster*, vol. 4, p. 191.

156 CALS, EDC 5/1638/112; GMCRO, M71/4/2/1.

157 Averages for 1637 calculated from Brierley (ed.), *Registers of Manchester 1616–1653*: 5.4 baptisms, 1.4 marriages and 5.8 burials a week in 1637.

158 Newcome, *Autobiography*, vol. 1, p. 73.

159 Richard Heyrick, *Queen Esthers Resolves: or, A princely pattern of heaven-born resolution, for all the lovers of God and their country* (London: J. Macock, 1646), p. 24; Heyrick, *Three Sermons*, sig. av. Goshen in Egypt was given to the Israelites: Genesis 45:10, 46:34, 47:27.

160 George W. Johnson (ed.), *The Fairfax Correspondence: Memoirs of the reign of Charles the First*, 2 vols (London: Richard Bentley, 1848), vol. 2, pp. 271–80; HMC, *Ninth Report*, 2 vols (London: HMSO, 1883, 1884), vol. 2, pp. 431–2; Atherton, 'Cathedrals', pp. 237–9.

government to replace episcopacy.[161] In December 1644, Heyrick and Hollingworth were among those appointed by Parliament to ordain clergy for Lancashire,[162] and both were leaders of the attempt from February 1647 to create a Presbyterian system in Lancashire. They established a classis or Presbyterian committee of local churches for the Manchester area to replace the bishop and diocese, ordaining clergy, policing orthodoxy, and disciplining congregations. Heyrick or Hollingworth frequently led the classis as moderator. Manchester was one of only a handful of functioning classes in the country although it faced the same problems of all classes of a lack of authority and inability to impose sanctions on those unwilling to accept them.[163] When Lancashire Presbyterian clergy published a declaration of their principles in 1648, Heyrick was the first signatory, Hollingworth the second.[164] For a brief period in the 1640s it appeared as if Manchester Collegiate Church might be the midwife of a Presbyterian church in the north-west of England.

Presbyterianism, however, failed. Nationally, it was undermined by opposition from both Episcopalians on the one side, and Independents (or Congregationalists) and Sectaries on the other. In Manchester that failure was symbolized by the difficulties the College clergy had with Independents, who wished for a greater congregational autonomy than a Presbyterian system allowed. Hollingworth was active against the Independent cause, publishing tracts against Congregationalism and setting up a weekly lecture in Manchester against the Independents.[165] Such efforts were to little avail, for by 1649 Independents under John

161 *Journals of the House of Commons, Vol. II, 1640–1643* ([London]: HMSO, 1802), p. 539.

162 C. H. Firth and R. S. Rait (eds), *Acts and Ordinances of the Interregnum, 1642–1660*, 3 vols (London: HMSO, 1911), vol. 1, p. 579.

163 William A. Shaw (ed.), *Minutes of the Manchester Presbyterian Classis*, 3 vols, CS ns 20, 22, 24 (Manchester: Chetham Society, 1890–1).

164 *The Harmonious Consent of the Ministers of the Province within the County Palatine of Lancaster, with their reverend brethren the ministers of the province of London, in their late testimonie to the trueth of Jesus Christ, and to our solemn league and covenant* (London: Luke Fawne, 1648).

165 Richard Hollingworth, *An Examination of Sundry Scriptures Alleadged by our Dissenting Brethren, in defence of some particulars of their church-way* (London: Thomas Smith, 1645); Richard Hollingworth, *Certain Queres Modestly (though Plainly) Propounded to such as Affect the Congregational-Way* (London: Thomas Smith, 1646); Richard Hollingworth, *A Rejoynder to Master Samuel Eaton and Master Timothy Taylor's Reply* (London: Luke Fawne, 1647); Thomas Edwards, *Gangraena*, 3 vols (London: Ralph Smith, 1646), vol. 3, p. 68; *A New Birth of the Citie-Remonstrance* (London: John Pounset, 1646), p. 5; J. Tilsley, *A True Copy of the Petition of twelve thousand five hundred and upwards of the well-affected gentlemen, ministers, free-holders and others of the County Palatine of Lancaster* (London: Luke Fawne, 1646), p. 15.

Wigan of Birch established a meeting in a part of the old College buildings and 'preached doctrine diametrically opposite to the ministers perswasion under their very nose'.[166]

Heyrick and Hollingworth also faced more material problems. The disruptions of war meant that rents and tithes went unpaid. Furthermore, the war brought to the fore longstanding structural problems of the parish. Like many in Lancashire, Manchester parish was very large; in addition to the Collegiate Church, which ministered directly to Manchester township, there were nine chapelries: Birch, Blackley, Chorlton, Denton, Didsbury, Gorton, Newton, Salford, and Stretford. While the College enjoyed a pre-war annual income valued in 1649 at £615, the curates of the chapels subsisted on £20 a year or less, drawn in almost every case merely from the charity of the congregation.[167] Parliamentary rhetoric about augmenting the income of poor clergy, along with the parliament's attack on cathedrals, deans, and chapters, provided an opportunity for some to assert the needs of their curates against the demands of the Collegiate Church. The Royalism of some of the tenants, and the departure of Johnson and Shaw from Manchester, meant that the College's lands passed from the control of the chapter into the hands of the Parliament's sequestrators, who began to apportion revenues to the impoverished chapels rather than the wealthier College. Accordingly, the College no longer controlled sufficient funds for its full complement of clergy: when Edmund Hopwood, one the chaplains, died of the plague in October 1645, his place was not filled.[168] By the later 1640s, the Collegiate Church, which before the wars had had a staff of seven clergy assisted by a choir of eight, was operating with only three clergy: a Warden (Heyrick), one fellow (Hollingworth), and one minister (William Walker).[169]

Between the mid-1640s and mid-1650s, the College was engaged in a struggle with the parishioners in the chapelries for the profits of the tithes of the parish. In 1648, parishioners dredged up the past failings of the College to blacken its name in the present. They asserted that the College was already 'wholly null

166 *The Life of Adam Martindale*, edited by R. Parkinson, CS os 4 (Manchester: Chetham Society, 1845), p. 75; Hartwell, *Chetham's School*, pp. 57–9. Wigan's congregation later became Baptists.

167 Henry Fishwick (ed.), *Lancashire & Cheshire Church Surveys, 1649–1655*, RSLC 1 ([Manchester]: Lancashire and Cheshire Record Society, 1879), pp. 260–1. Of the chapels, only Salford and Didsbury had any endowment.

168 TNA, C10/1/38; Brierley (ed.), *Registers of Manchester 1616–1653*, p. 575.

169 For Walker (d. June 1651), see Fishwick (ed.), *Church Surveys*, p. 5; Brierley (ed.), *Registers of Manchester 1616–1653*, pp. 252, 261, 606. In 1658 Joshua Stopford was appointed morning lecturer: Shaw (ed.), *Minutes of the Manchester Presbyterian Classis*, vol. 2, p. 301.

and dissolved', because, with a reduced complement of clergy, it was no longer carrying out the duties laid upon it by the 1635 re-foundation charter. Moreover, in an echo of charges against Murray in 1635, they alleged that Heyrick was only 'pretended Warden' because he lacked the required degree, had not taken the appointed oath on admission, and had neglected residence. They denied that Hollingworth had been properly admitted fellow, and concluded that the pretended warden and fellow combined merely 'to enrich themselues and to doe little or nothing' for the rents and tithes they extorted from the parishioners.[170] Tithe strikes continued between 1649 and 1655 despite appeals from Heyrick to deputy lieutenants and justices of the peace, before a combination of the Council of State (the ruling body of the land) and the Trustees for the Maintenance of Ministers (charged with ensuring an adequately paid clergy in England) devised a scheme whereby the chapel curates would receive between £33 and £50 a year, Heyrick £100 (soon raised to £120 and then in 1658 to £150), and Hollingworth £94.[171]

Manchester Collegiate Church's problems between the late 1640s and 1660 should not be exaggerated, however. Although it was formally abolished as a collegiate church in April 1649 (its fourth dissolution in little over a century) when all cathedrals and collegiate churches were disbanded by Act of Parliament,[172] Manchester continued little changed. Heyrick continued to be known as the Warden, Hollingworth as fellow, and the institution as Christ's College in Manchester, while Hollingworth's own history of Manchester makes no mention of the abolition of the Collegiate Church, merely recording that, on 5 November 1649, soldiers seized the College's muniments and carried

170 TNA, C10/1/38; LRO, QSP/64/31. Heyrick may have been only MA, not BD or BCL as required by the charter, and had been absent at the Westminster Assembly for much of the 1640s: Joseph Foster, *Alumni Oxonienses. The Members of the University of Oxford, 1500–1714; their Parentage, Birthplace, and Year of Birth, with a Record of their Degrees*, 4 vols (Oxford: Parker, 1891–2), vol. 2, p. 702.

171 William A. Shaw (ed.), *Minutes of the Committee for the Relief of Plundered Ministers, and of the Trustees for the Maintenance of Ministers, Relating to Lancashire and Cheshire, 1643–1660*, 2 vols, RSLC 28, 34 (Manchester: Record Society of Lancashire and Cheshire, 1893, 1896), vol. 1, pp. 78, 106–7, 112, 114, 252–3; vol. 2, pp. 20–1, 25–6, 36–7, 39, 48, 50–1, 54–5, 64–5, 67, 76–7, 90–1, 228. For the system of clerical stipends and augmentations, see Alex Craven, 'Ministers of State: The Established Church in Lancashire during the English Revolution, 1642–1660', *NH* 43 (2008), pp. 51–69. When Henry Newcome succeeded Hollingworth in 1657 he noted that the congregation made up his stipend from £94 to £120 a year: Newcome, *Autobiography*, vol. 1, p. 70.

172 Firth and Rait (eds), *Acts and Ordinances*, vol. 2, pp. 81–104.

them to London.[173] Heyrick and Hollingworth were occasionally viewed with suspicion by the central government as opponents of the republic and the rule of sectary-saints. Both were briefly arrested for alleged complicity in the 1651 plot of the London Presbyterian Christopher Love to restore Charles II, but they were soon released and in 1654 both were trusted to be named among the Lancashire commissioners for ejecting scandalous and ignorant ministers.[174]

The functioning classis for Manchester and surrounding parishes meant the co-operation of ministers across the parish and beyond. Pulpits were shared. Newcome preached across southern and central Lancashire and Cheshire, while a variety of ministers preached and officiated in the Collegiate Church, perhaps helping to ease some of the tensions between it and the chapelries.[175] Informal networks of clerical sociability of preaching had replaced the pre-war formal collegiality of the warden and fellows.

When Hollingworth died suddenly in November 1656, he was replaced by Henry Newcome, whose autobiography casts light on the church in the later 1650s. It shows an efficiently functioning church and the smooth working of his preaching ministry in the town and across the region, beset only by the kinds of petty squabbles that mark any institution (jealousies in 1658 over the choice of a morning lecturer, for example), and by the worsening political situation in 1659.[176] Historians have given damning judgements about the failure of Presbyterian preaching and godly reformation to effect change in the 1650s,[177] but there are some suggestions that Manchester ought to be added to the short list of local exceptions, where active clergy combined with

173 Brierley (ed.), *Registers of Manchester 1616–1653*, pp. 265, 598, 602; J. Flitcroft and E. Bosdin Leech (eds), *The Registers of the Cathedral Church of Manchester, 1653–1665/6*, Lancashire Parish Register Society 89 (Manchester: the society, 1949), pp. 11, 77; Shaw (ed.), *Minutes of the Manchester Presbyterian Classis*, vol. 2, pp. 146, 149, 155, 157, 165; Hollingworth, 'Mancuniensis', fol. 28r.

174 Newcome, *Autobiography*, vol. 1, p. 33; Bodl., MS Eng. hist. c. 481, fols 212–13; Shaw (ed.), *Minutes of the Manchester Presbyterian Classis*, vol. 2, p. 161; Firth and Rait (eds), *Acts and Ordinances*, vol. 2, pp. 968–90.

175 Newcome, *Autobiography*, vol. 1, pp. 93, 96, 100, 102–3; Flitcroft and Leech (eds), *Registers of Manchester*, pp. 84–93; Shaw (ed.), *Minutes of the Manchester Presbyterian Classis*.

176 Newcome, *Autobiography*, vol. 1, pp. 62–133, esp. 72, 92–3.

177 For example, Christopher Durston, 'Puritan Rule and the Failure of Cultural Revolution, 1645–1660', in Christopher Durston and Jacqueline Eales (eds), *The Culture of English Puritanism, 1560–1700* (Basingstoke: Macmillan, 1996), pp. 210–33; Derek Hirst, 'The Failure of Godly Rule in the English Republic', *Past and Present* 132 (1991), pp. 33–66.

engaged laity to effect some change.[178] The court leet records show that the petty problems of urban life continued – unlawful ale sellers, neighbours who failed to clean the streets, and the like – so that Manchester was no heavenly Jerusalem. However, it is telling that Newcome's autobiography records few difficulties or problems of godly discipline within Manchester. Indeed, one of Newcome's most troubling decisions was merely whether to go and see a travelling show with a horse that could perform tricks. He decided that since 'At the best, it is but curiosity', and that 'To go might be a sin; not to go, I know was no sin', he had best deny himself that vain pleasure. Newcome stressed the impact of his preaching and that by like-minded clergy on the laity. He was struck by how rarely he heard anyone swear in Manchester, 'a people better taught' than he had been accustomed to in rural Cheshire, and when he preached against sitting (rather than kneeling or standing) in prayer, he noted how readily his words were obeyed. Manchester classis continued its monthly meetings between February 1647 and August 1660 almost without interruption, with barely a meeting at which clergy and lay elders from the town were not present. The pool of ruling elders from Manchester Collegiate Church was small, with between two and four attending each classis drawn from a tightly defined group of only sixteen elders across thirteen years, and hardly any problems reported from the congregation to the monthly meeting, suggesting a well-ordered local church. Although Newcome found Quakers 'very insolent and troublesome', Manchester appears to have been less unsettled by Quaker missionaries than many churches, with Newcome noting only that in August 1660 Margaret Fell, 'in sackcloth and ashes … with hair about her ears' stood before the pulpit throughout one of his sermons.[179] At the same time, tensions between Presbyterians and Independents, so marked in the mid-1640s, eased at the end of the 1650s

178 Ann Hughes, '"Popular" Presbyterianism in the 1640s and 1650s: The Cases of Thomas Edwards and Thomas Hall', in Nicholas Tyacke (ed.), *England's Long Reformation 1500–1800* (London: UCL Press, 1998), pp. 235–59; Denise Thomas, 'The Pastoral Ministry of Thomas Hall (1610–1665) in the English Revolution', *Midland History* 38 (2013), pp. 169–93; Bernard Capp, *England's Culture Wars: Puritan Reformation and Its Enemies in the Interregnum, 1649–1660* (Oxford: Oxford University Press, 2020), pp. 221–39.

179 John P. Earwaker (ed.), *The Court Leet Records of the Manor of Manchester … Vol. IV, from the Year 1647 to 1662* (Manchester: Henry Blacklock, 1887); Newcome, *Autobiography*, vol. 1, pp. 41, 82, 101, 109, 128; Shaw (ed.), *Minutes of the Manchester Presbyterian Classis*.

with moves towards accommodation to heal some of the rifts locally.[180]

There were also positive moves to spread Protestantism. The foundation of Chetham's School and Library in the old College buildings in the mid-1650s, under the will of Humphrey Chetham (d. 1653), did not quite meet the plans of the previous decade for a university in Manchester, but the Library gradually created a centre of learning and resources for scholars unrivalled in the north of England. Although not formally linked to the Collegiate Church, Chetham's nomination of both the present fellow Hollingworth and the former fellow Johnson among the trustees suggested an attempt to place Manchester Church close to the heart of the enterprise. Moreover, in 1653 an English library was founded by the town of Manchester in the Jesus chapel of the Collegiate Church, though it was nearly a decade before it was operational.[181] The 1650s, therefore, witnessed attempts to put the Collegiate Church closer to the centre of education in the region, echoing early Reformation attempts to tie collegiate churches to education, learning, and the spread of Protestant ideas.[182]

The Restoration did not at first seem to threaten what Heyrick and Newcome had achieved. Like many Presbyterians they welcomed the Restoration of Charles II in the spring of 1660. Newcome participated in a service in the Collegiate Church at the proclamation of the King on 12 May and preached there on a thanksgiving day for the Restoration on 24 May; that sermon comparing Charles to King David was later published. The following year Heyrick preached on the King's coronation day.[183] But the Restoration did not produce the fruits that they and other Presbyterians hoped, of a broad or comprehensive church settlement encompassing both moderate Episcopalians and Presbyterians. In the summer of 1660, Heyrick found his position challenged by Edward Wolley, who claimed to have a patent

180 Shaw (ed.), *Minutes of the Manchester Presbyterian Classis*, vol. 3, pp. 400–1.

181 James Croston, *The First Free Library in Manchester: A Chapter of Local History* (Manchester: Sowler, 1878).

182 Hartwell, *Chetham's School*, pp. 61–91; Stephen J. Guscott, *Humphrey Chetham, 1580–1653: Fortune, Politics and Mercantile Culture in Seventeenth-Century England*, CS 3rd series 45 (Manchester: Chetham Society, 2003), p. 297. For the Protestant Henrician example, see John Strype, *The Life and Acts of Matthew Parker* (London: J. Wyat, 1711), pp. 8–9.

183 Newcome, *Autobiography*, vol. 1, p. 120; Henry Newcome, *Usurpation Defeated, and David Restored* (London: Henry Eversden, 1660); Richard Heyrick, *A Sermon Preached at the Collegiate Church at Manchester on Tuesday the 23. of April 1661* (London: Ralph Shelmerdine, 1661).

from Charles I for the wardenship. With the help of the Earl of Manchester and the backing of the townsfolk of Manchester, the subtle Heyrick outmanoeuvred Wolley ('a very honest man, but a very great blockhead') and held onto the wardenship. Newcome was not so fortunate, and his hopes of being confirmed in office and made a fellow were dashed: in the scramble for preferment he found that others were fleeter than he, and by 24 August 1660 the three vacant fellowships (Johnson being the only surviving pre-war fellow) had been disposed of. The fellows reluctantly accepted Newcome's popularity in the town and allowed him to remain as a preacher in the Collegiate Church, until, unable to accept the Act of Uniformity and the narrow Anglicanism it imposed, he preached his last sermon in Manchester Collegiate Church on 24 August 1662. By then, the character of the Collegiate Church had already begun to change: two singing-men and four choirboys were admitted on 14 September 1660, and choral services resumed on 28 November 1660.[184] The Indian summer of the Puritan college was over.

Conclusion

Manchester Collegiate Church is best understood as a species of cathedral. Although collegiate churches lacked the formal relationship of a bishop with his cathedral (the seat of his *cathedra* or throne), they resembled cathedrals in other important respects. They were governed by a corporate body, the dean and chapter of a cathedral having similar functions to the warden and fellows of Manchester. All were founded with senior clergy forming the chapter holding property in common, governing lesser clergy (minor canons at a cathedral, the chaplains at Manchester), singing-men or lay clerks, and boy choristers. Collegiate churches were abolished in 1649 by the same legislation that removed cathedrals, and collegiate churches were frequently confused by contemporaries with cathedrals. In a series of Freudian slips, throughout his trial Warden Murray was regularly but erroneously called 'Deane Murray'.[185] As such, collegiate churches and cathedrals have jointly been seen by historians as conservative promoters of high church ceremonialism, the midwives

184 TNA, SP29/17, fol. 157r; *ODNB*, s.n. 'Heyrick, Richard'; Newcome, *Autobiography*, vol. 1, pp. 123–31, 133; Henry Newcome, *The Diary of the Rev. Henry Newcome*, edited by Thomas Heywood, CS os 18 (Manchester: Chetham Society, 1849), p. 114; MCA, Mancath 2/2/1a.

185 Ian Atherton, 'Cathedrals, Laudianism, and the British Churches', *HJ* 53 (2010), pp. 896–7; TNA, SP16/254, fol. 100r; SP16/261, fols 175v, 276r; SP16/316, fol. 65r.

of Laudianism.[186] Manchester was different, the mother church of Lancashire Presbyterianism. Re-founded in 1556 to advance Counter-Reformation Catholicism, it immediately lost that role on the accession of the Protestant Queen Elizabeth, and after two decades of lacking any vocation save self-preservation and corruption, it began to find a new role fighting Catholicism with its 1578 re-foundation. Manchester's classis in the 1640s and 1650s can trace its roots back to connivance at the institution's nonconformity in the cause of defeating Catholicism that was the legacy of 1578. By the time that the Laudian hierarchy established different principles in the 1630s and awoke to the Trojan horse that was the collegiate church, the godly were too well entrenched locally, and there was too little time to impose change before the fall of King Charles's authority brought down episcopacy.

The collegiate church by the later seventeenth century was a very different beast to its pre-1660 incarnation. The Restoration church settlement drove out the Puritan nonconformists from the Church of England, meaning that Manchester could not shelter, let alone foster, the churchmanship for which it had been known for the previous eighty years. Heyrick conformed. Newcome was ejected and eventually founded a Presbyterian chapel in Cross Street, the few hundred yards between it and the college symbolizing the rupture in the mission of Christ's College in Manchester. Once again, the Collegiate Church had only one face to present to the world, but it was the face of Prayer Book, choral services, conformity, and ceremony. Forcibly divorced from the Lancashire godly, the Restoration Collegiate Church could be refashioned, gradually emerging instead as a high church bastion against the same nonconformity it had once helped to nurture.

186 Diarmaid MacCulloch, *All Things Made New: Writings on the Reformation* (London: Allen Lane, 2016), esp. pp. 146–7, 211–13, 225, 360; Graham Parry, *The Arts of the Anglican Counter–Reformation: Glory, Laud and Honour* (Woodbridge: Boydell, 2006), p. 51. For an alternative view see Atherton, 'Cathedrals, Laudianism'.

✠ 5 ✠

The Collegiate Church under the Old Regime, 1660–1829

HENRY RACK

Restoration (1660–1718)

‘WHEN THE WARDEN was restored and Mr Johnson came, I perceived they intended to alter all at the Church to begin the service the next day, and then I saw what was to come. I was then (as I said) a minister without a people, for I have nothing to do in that congregation.’[1] So commented Henry Newcome on the restoration of the Warden and the surviving pre-Interregnum fellow, Richard Johnson (fellow 1632–46, 1660–75). The King quickly appointed the rest of the fellows, and the chapter minutes on 24 September 1660 record that ‘now the Warden and fellows of the College in Manchester ... have made choice of the new officers following’, along with the men and boys ‘skilful in music’, although no chaplains are mentioned before 1665.[2] This observation of 1660 is on a loose page, the first minute since 1641, and the continuous record only begins on 16 December 1662.[3] The process of restoration is only sketchily evidenced, although Newcome’s diary and autobiography help to fill some gaps. Warden Richard Heyrick, that great survivor, had been appointed in 1635, continued as a minister through the Interregnum, and resumed as Warden

1 *The Autobiography of Henry Newcome*, ed. Richard Parkinson, 2 vols, CS os 26, 27 (Manchester: Chetham Society, 1852), vol. 1, p. 126 (14 September 1660).

2 Manchester, MCA, MS 21a/B.

3 MCA, Mancath/2/2/1, Chapter register, p. 63. An extra page, also numbered 63 and attached to page 64, contains a nineteenth-century note of a tradition that the book was lost or destroyed, so the 1660 fragment may be a temporary record before the old book reappeared.

Previous page:
'Light of creation'

until his death in 1666. He claimed entitlement to the post as payment for a debt from King James I.[4]

Newcome had been a minister in the Collegiate Church since 1656 and had hopes of becoming a fellow after the Restoration. He was no doubt encouraged by Charles II's apparent wish for a 'comprehension' (i.e. a revision or relaxation of the Prayer Book and the terms of conformity).[5] Newcome's hopes were frustrated by the rapid restoration of the fellows, despite support from Sir George Booth at Court and a petition from 453 Manchester townspeople.[6] He recorded a detailed conjunction of apparent accidents, clearly regarded as 'special providences', which settled his fate. Viewing them in retrospect, however, he saw they had saved him from conflicts of conscience.[7] He was, nevertheless, allowed to preach the afternoon sermons until the Act of Uniformity was enforced in August 1662.[8]

Meanwhile, on 28 November 1660, 'choir service began' and 'they told us that they set with candles on the table to remind us of the persecutions of former times, when all services were done by candle'. In January 1662 Newcome thought the sacrament had 'more sap and savour in it' though 'administered in those forms [i.e. of the Book of Common Prayer] than sometimes it had.' In May 1662, Johnson read 'the Common Prayer at large' and baptized children with the sign of the cross, 'all but three which he spared with much ado'.[9] In September 1662, Newcome saw one of the fellows in surplice and hood and a chaplain consecrating the eucharist in a surplice. Kneeling at communion was now enforced and he hesitated to sit lest it 'offended' – he saw a woman refused communion for failing to kneel.[10] Newcome continued to attend church and his son (who received Anglican orders) claimed in 1685 that 'my father, mother and sister were with me at the sacrament and complied in the gesture of kneeling'.[11]

4 F. R. Raines, *The Rectors of Manchester and Wardens of the Collegiate Church of that Town*, 2 vols, CS ns 5, 6 (Manchester: Chetham Society, 1885), vol. 2, p. 123.

5 For these possibilities and the uneven process of restoring the old order, see Ian M. Green, *The Re-establishment of the Church of England 1660–63* (Oxford: Oxford University Press, 1978).

6 Newcome, *Autobiography*, p. 125.

7 *Ibid.*, pp. 127–30, reproduced in full from Manchester, CL, MS Mun. A3, p. 123 (25 September 1660).

8 Henry Newcome, *The Diary of the Rev. Henry Newcome*, edited by Thomas Heywood, CS os 18 (Manchester: Chetham Society, 1849), p. 116.

9 Newcome, *Autobiography*, pp. 126, 133; Newcome, *Diary*, pp. 40, 88–9.

10 Newcome, *Diary*, pp. 120, 128, 174.

11 Manchester, MCL, Henry Newcome junior, MS Diary, MS 922.3 N21, pt 2, p. 70, quoted by Catherine Nunn, 'Church or Chapel? Restoration

Yet complete conformity may have been slower in coming than Newcome implies. Warden Nicholas Stratford, who succeeded Heyrick in 1667, appears to have been conciliatory to Dissenters. Newcome saw him as 'a stranger' [i.e. not from the north-west] but 'one more likely to be a mercy to this place. A good man, of a sweet temper ... and seems to resolve to settle in the place and reside. This was thought then, and then it was so.'[12] Stratford was, nevertheless, a conscientious churchman who tightened up discipline and evidently needed to do so. He re-introduced the practice of coming to the communion table to receive the elements. In 1668, he ordered the chaplains to wear surplices and restored antiphonal singing. Also in 1668, he summoned the outlying chapelry clergy and ordered them to observe fees, dues, obedience to the College clergy, and conformity to the Prayer Book rubrics.[13] In his *Dissuasive from Revenge*, addressed to his 'friends, inhabitants of Manchester', published on leaving his post for a London parish in 1684, he claimed he had not left Manchester 'for any unkindness to me on your part' or for gain.[14] Though urging charity to all, along with obedience to magistrates, and not explicitly referring to religious and political party strife, it may be suspected that the sermon reflected his experience of bitter divisions within the town.

He was succeeded by Richard Wroe (fellow from 1675, Warden 1684–1718), a Whig upholding the church's position against Catholics and Dissenters. Wroe appears to have escaped the ferocious party warfare to be experienced by his successor as Warden, Samuel Peploe. He was friendly with Newcome and the Non-juror John Byrom and aided his high church diocesan, Francis Gastrell, in compiling the *Notitia Cestriensis*, a survey of the history and condition of the diocese. He was also interested in natural philosophy and was nicknamed 'silver-tongued Wroe' for his pulpit eloquence.[15] But he was also a clerical JP, of whom a critic said '*Shepherd*, attend to your *Flock*, and leave the *Huntsmen* to look after the *Hounds*.'[16]

Presbyterianism in Manchester 1660–89', in Craig Horner (ed.), *Early Modern Manchester*, Manchester Region History Review 19 (Lancaster: Carnegie, 2008), p. 53.

12 Newcome, *Autobiography*, p. 167. For Stratford, see Raines, *Rectors and Wardens*, vol. 2, pp. 139–47; *ODNB, s.n.* 'Stratford, Nicholas (bap. 1633, d. 1707)'.

13 MCA, Mancath/2/2/1, Chapter register, pp. 86, 88; also quoted in Raines, *Rectors and Wardens*, vol. 2, p. 142.

14 Dedication to the *Dissuasive* (London: Richard Chiswell, 1684).

15 Raines, *Rectors and Wardens*, vol. 2, pp. 148–57; *ODNB, s.n.* 'Wroe, Richard (1641–1717)'.

16 Raines, *Rectors and Wardens*, vol. 2, p. 152.

Conformity was hard to enforce in the parish as a whole, and here it should be remarked that the warden was in the rare if not unique position of being also rector of the parish. Like other large Lancashire parishes, Manchester contained several ancient chapelries so minimally endowed that their perpetual curates depended on voluntary contributions for their support. The contributors would only support clergy of whom they approved. The result was that after the Restoration at least two curates – Henry Finch of Birch (from 1672 to 1697) and John Angier of Denton (from 1632 to his death in 1677), both related to local gentry families – remained in post without conforming.[17] The churchwardens had to send men to 'break up an unlawful assembly' at Birch in September 1683.[18] Gorton also saw sporadic Dissenter use of the chapel in 1668–69 and again later. As late as 1778 and 1789, tithes could not be collected there because of opposition from Presbyterian farmers.[19] These irregularities (though not the resistance to tithes) seem to have ceased early in the 1700s, due to the Presbyterian gentry now conforming and, perhaps, the improvement in stipends through Queen Anne's Bounty. The College, however, could still have problems in asserting its patronage. Warden Peploe was to allow Lady Bland to take over the patronage of Didsbury in return for a contribution to Queen Anne's Bounty, and lay control would continue there in various families.[20]

Conflict in another sense can be seen in the continuation, though patchily and in small numbers, of cases in the church

17 John Booker, *History of the Ancient Chapel of Birch*, CS os 47 (Manchester: Chetham Society, 1859), pp. 63–70, 78–109 (the leading local family regarded this church as their 'domestic chapel'); John Booker, *History of the Ancient Chapel of Denton*, CS os 37 (Manchester: Chetham Society, 1856), pp. 137–40, 149. For other Lancashire examples, see P. J. W. Higson, 'Some Leading Promoters of Nonconformity in Lancashire Chapels', *TLCAS* 75–6 (1965–6), pp. 123–63.

18 Manchester, JRL, MS Eng. 97, Accounts of the Churchwardens of Manchester, 1664–1711, p. 230; selections in *Chetham Miscellanies: New Series, Vol. IV*, CS ns 80 (Manchester: Chetham Society, 1921), p. 23.

19 Newcome, *Autobiography*, p. 171; G. Lyon Turner (ed.), *Original Records of Nonconformity under Persecution and Indulgence*, 3 vols (London: T. Fisher Unwin, 1911), vol. 2, p. 70; Preston, LRO, Kenyon of Peel MSS, DDKE/acc. 7840, HMC/277: all cited in Nunn, 'Church or Chapel?', pp. 49–50; B. Nightingale, *Lancashire Nonconformity, Vol. V: The Churches of Manchester, Oldham, Ashton, &c* (Manchester: John Heywood, 1893), p. 54; Chester, CALS, visitation returns, EDV 7/1, p. 157 (1778), EDV 7/2, p. 147 (1789).

20 MCA, Mancath/2/2/2, Chapter register, 12 December 1726; Raines, *Rectors and Wardens*, vol. 2, p. 162; for earlier problems, see *Notitia Cestriensis, or, Historical Notices of the Diocese of Chester by Bishop Gastrell. Vol. II. Part I*, edited by F. R. Raines, CS os 19 (Manchester: Chetham Society, 1849), p. 87 and note.

courts. These were commonly for sexual offences and some led to public penances. The churchwardens recorded purchase of penance sheets in 1682–83, and cases still occurred into the 1740s of failure to pay church leys (rates) and fornication, both in the town and the chapelries.[21]

The College's control of the town's religious life only encountered a long-term challenge from Dissent through the powerful Cross Street Presbyterian chapel, founded for Henry Newcome in 1697. Throughout the eighteenth century and beyond, it attracted dynasties of leading merchants, manufacturers, and professional men who, we shall see, had a significant influence on the town's political life. Competition within the church establishment came from St Ann's Church, founded in 1712 as (it is often claimed) a deliberate low church, Whig rival to the Tory Jacobite College, though also responding to the spread of the population to the west, away from the Collegiate Church. [22] Its founder, Lady Bland, was certainly the Whig leader of fashion and her assembly was in rivalry with that of the Tory Lady Drake.[23] But the record of those associated with St Ann's is much more varied than this rigid division suggests. The first Rector, Nathaniel Banne, was the son of an ejected minister of 1662 but also a friend of John Byrom the Non-juror. The second, Joseph Hoole, was a former neighbour of the Wesleys in Lincolnshire and Wesley himself, in his early extreme high church days, had attended St Ann's as well as the College on his Manchester visits, as did Harrold the wigmaker, who normally attended the College.[24] Bishop Wilson of Sodor and Man – certainly no low churchman but an upholder of traditional church discipline – attended St Ann's in 1713.[25] John Shaw, the host of the eponymous Tory club, had his children baptized there and Robert Thyer, Chetham's librarian and close associate of the College clergy, was married there.[26]

Tensions between church and Dissent and within the church were certainly common in the early decades of the eighteenth century. In January 1715, on the anniversary of King Charles the

21 JRL, Eng. MS 97, p. 17 and *Chetham Miscellanies, New Series IV*, pp. 21, 15, 16, 22; CALS, EDV 1, pp. 121 (1721), 130 (1740).
22 For St Ann's, see Charles W. Bardsley, *Memorials of St Ann's Church, Manchester, in the last century* (Manchester: Thomas Roworth, 1877).
23 W. H. Thomson, *A History of Manchester to 1852* (Altrincham: Sherratt, 1966), p. 150.
24 Edmund Harrold, *The Diary of Edmund Harrold, Wigmaker of Manchester, 1712–15*, edited by Craig Horner (Aldershot: Ashgate, 2005), p. xxviii.
25 *Ibid.*, pp. xxviii, 36.
26 F. S. Stancliffe, *John Shaw's 1738–1938* (Altrincham: Sherratt and Hughes, 1938), p. 21; Edmund Ogden, 'Robert Thyer, Chetham's Librarian 1732–63', *TLCAS* 42 (1924), p. 72.

Martyr, one of the College clergy preached what appears to be a pro-Sacheverell sermon, when the Doctor's anti-government and mob influence was at its height.[27] During this year of the invasion crisis, mob violence, Jacobite slogans, and window-breaking marked King George's birthday. In June, the mob almost destroyed the Cross Street chapel, with cries of 'Down with the Rump'. This Interregnum party-cry would be invoked against Dissenters and political reformers in Manchester throughout the eighteenth century and beyond. The government compensation payment of £600 to the chapel was the largest of several paid to a string of damaged chapels in the north.[28]

At this point it is convenient to outline the social profile and background of the College clergy.[29] There are no real surprises here. In brief, they were drawn from gentry (often of the town variety) and clergy families. They had strong connections with the north-west by birth and education, a number beginning at the Manchester Grammar School, then came Oxford (often at Brasenose) or Cambridge (often at St John's or Trinity). Some were pluralists, but of their stipends from the College we know little before the 1760s. It is evident that they received dividends varying from year to year and not just the £70 and £35 per annum, for the warden and each fellow respectively, laid down by Charles I's charter.[30] A solitary record from 1697 shows that in that year the warden received £166 13s 4d, the fellows each £83 6s 8d.[31] As to residence, the wardens after Stratford were often absent much of the year, though Wroe was at least invariably present at chapter meetings. All had houses allocated to them in the town, either for their own residence or for generating income for their own choice. The warden was allowed one hundred days and the fellows each eighty days annual absence but

27 Harrold, *Diary*, p. 116. The editor (p. xxix) appears to see this as anti-Sacheverell, surely impossible from this Tory-Jacobite source.

28 For a recent discussion see Kazuhiko Kondo, 'Lost in Translation? Documents relating to the Disturbances at Manchester 1715', in Horner (ed.), *Early Modern Manchester*, pp. 81–94.

29 For what follows I am indebted to a detailed statistical analysis supplementing my own earlier observations, in Graham A. Hendy, 'The Prebends of Georgian England: A Case Study of the Cathedral and Collegiate Churches of Manchester, Salisbury, Southwell and Winchester 1660–1840' (MPhil dissertation, University of Wales, Lampeter, 2007); and his 'Manchester Collegiate Church: the Wardens and Fellows 1660–1840', *TLCAS* 104 (2008), pp. 1–33.

30 CL, MS 4C.22, copy of charter.

31 Recently discovered fragment of Robert Assheton's commonplace book in JRL, MS Eng. 1401; earlier noted in Raines, *Rectors and Wardens*, vol. 2, p. 209, and quoted by Hendy, 'Manchester Collegiate Church', p. 11.

more could be taken on payment of a fine.[32] The chaplains, who did the pastoral work of sick visiting, baptisms, marriages, and funerals, as well as providing daily services, appear to have been paid from fees for marriages and burials, although the charter had allowed them £17 10s 0d per annum. The most egregious example of non-residence in this early post-Restoration period was not of absence from Manchester but the opposite. George Ogden, a devotee of Roman antiquities, also held the appropriate living of Ribchester, site of a Roman fort. However, he preferred to reside in Manchester as fellow despite pointed letters from Bishop Stratford, who said that after ten years of dispensations for repairing his parsonage he no longer had any excuse![33] Of Roger Bolton, indeed, it was said that 'he seldom came to town but when he came for his money, and then he could scarce stay to preach a sermon', though apparently he paid no absence money.[34]

As to the physical condition and appearance of the church in this early period, some clues may be gleaned from the church-wardens' accounts, unfortunately only surviving from 1664 to 1710. The Collegiate Church had suffered less damage than some cathedrals during the Interregnum. Although the accounts speak of dealing with the 'decay of the said Church with its appurtenances', this is repeated as a standard formula. Many repairs are routine and modest, although the roof was 'beautified' for £40, the Ten Commandments written 'new over', and the King's arms 'beautified' in 1664–65. They were repainted in 1673, along with the Lord's Prayer and Creed, while the pulpit was 'coloured and gilded' in 1674. Some of the more regular items refer to repair and reconditioning of bells, destruction of 'vermin', and provision of bread and wine for communion. In 1700, a tapestry portraying Ananias and Sapphira, made in 1661, was installed as an altar-piece.[35] An inventory in 1700 lists communion plate in silver and pewter, service books, a red velvet cloth on the pulpit,

32 CL, MS 4C.22.

33 Correspondence in 1692, in F. R. Raines, *The Fellows of the Collegiate Church of Manchester*, edited by F. Renaud, 2 vols, CS ns 21, 23 (Manchester: Chetham Society, 1891), vol. 1, pp. 185–6.

34 *Ibid.*, vol. 1, pp. 199–200.

35 JRL, MS Eng. 97, pp. 6, 97, 111. For the tapestry, see Joseph Aston, *A Picture of Manchester* (Manchester: Joseph Aston, 1816, reprinted Manchester: E. J. Morten, 1969), p. 164. The reference is to Acts 5:1–11. It was also seen by Bishop Nicholson in 1704: *TLCAS* 22 (1904), p. 186, quoted in Thomson, *Manchester*, p. 148.

a red communion cloth, and one 'great' and four 'little' brass candlesticks, implying altar lights.[36]

We may assume that the statutory round of services and sermons continued, along with the chaplains' pastoral work. Communion was celebrated only monthly until the 1730s.[37] Examples of sermons, worship, and the devotional life of the congregation can be gleaned from Harrold's diary. Notice for attending communion appears to have been given the week before and, like other pious contemporaries, Harrold used a 'Week's Preparation' before receiving holy communion and attended a religious society which read a sermon of Archbishop Tillotson in 1713.[38] As to sermon content, the apparent pro-Sacheverell sermon was noted earlier. More standard fare can be seen in the preaching of Dr Robert Harper (chaplain 1709–15) on the duty of frequent communion, the sacrament being seen as a 'badge' of the Saviour's followers. This resolved Harrold's 'scruples'. Dr John Copley (fellow 1706–32) preached on the duty to live as if the end was at hand, restraining 'unruly passions'. 'Silver-tongued Wroe' preached on marriage (he was thrice married himself). Robert Assheton (fellow 1703–31) preached on fasting in Lent.[39]

Peploe, party, and the Jacobite era, 1718–63

Manchester's population rose from about 16,000 for the whole parish in 1717 (about 12,500 for Manchester and Salford townships) to 19,839 (for Manchester and Salford) in 1758; growth was westwards, in the direction of St Ann's Church.[40] Housing ancillary trades and merchants as well as textile manufactur-

36 Churchwardens' accounts, 29 May 1700: JRL, MS Eng. 97, in *Chetham Miscellanies: New Series IV*, p. 31.

37 The Manchester chaplains' duties were similar to those of minor canons elsewhere, e.g. at Canterbury: Jeremy Gregory, 'The Deacon and Chapter, 1660–1828', in Patrick Collinson, Nigel Ramsay, and Mary Sparks (eds), *A History of Canterbury Cathedral, 598–1982* (Oxford: Oxford University Press, 1995), p. 214.

38 The anonymous *A Week's Preparation towards a Worthy Reception of the Lord's Supper* (London: S. Keble, 1679) reached a revised 52nd edition (by 'a London clergyman') in 1764: J. Wickham Legg, *English Church Life from the Restoration to the Tractarian Movement* (London: Longmans, Green, 1914), p. 339. See also Harrold, *Diary*, pp. 22, 73, 95 (27 July 1712, 17 May, 26 November 1713).

39 CL, MS Mun. A2.137 (1 June 1712); Harrold, *Diary*, pp. 58, 60, 66 (18, 28 January, 8 February, 22 March 1713). None of these sermons were published, although others by the warden and fellows were: see Hendy, 'Manchester Collegiate Church', pp. 31–3.

40 Alfred P. Wadsworth and Julia de L. Mann, *The Cotton Trade and Industrial Lancashire 1600–1780* (Manchester: Manchester University Press, 1931, repr. 1965), pp. 509–10.

ers, Manchester was outstripping Chester as a leisure centre by mid-century. The ruling elite was made up of what were often called the 'principal inhabitants' as distinct from mere 'inhabitants' and 'inferiors'.[41] Members of this elite appeared in the chief offices of the old Court Leet governing body (boroughreeve and constables) and in the parish offices of churchwardens and overseers of the poor. They appeared, too, as subscribers to the infirmary, the theatre, concerts, and assemblies. But they were also identified by religious divisions closely allied with party politics: high church Tories (and Jacobites) with the Collegiate Church; Whigs with the Presbyterian Cross Street chapel and (though less clearly and exclusively than often claimed) with St Ann's.[42]

The Jacobite and 'popish' reputation of Manchester, and especially of its clergy, was sharpened and exaggerated by their friendship with Dr Thomas Deacon, the local Non-juror Bishop in charge of the community of those who had refused to swear allegiance to the Hanoverian monarchy as usurpers of the divinely ordained Stuarts descended from James II, displaced in 1688.[43] College clergy also subscribed to Deacon's writings and recommended and distributed them. Deacon admired the so-called *Apostolic Constitutions* (a fourth-century work wrongly supposed to contain apostolic teaching) and drew on these and other 'primitive' sources for theology and liturgy he deemed superior to that of Rome and the conventional Anglican standards. John Byrom, Non-juror, poet, and shorthand inventor also socialized with College clergy like Thomas Cattell (chaplain 1731–35, fellow 1735–47), and met with them for discussions in Chetham's Library under its librarian Robert Thyer, though St Ann's clergy were also included.[44] It has been well said that

41 Craig Horner, '"Proper Persons to deal with": Identification and Attitudes of Middling Society in Manchester *c.* 1730–60' (PhD dissertation, Manchester Metropolitan University, 2001), pp. 91, 44–50, 125–65, 166–8; Table XIV, p. 105.

42 For their politico-religious affiliations, see *ibid.*, pp. 125–226.

43 For Deacon and what follows, see Henry Broxap, *A Biography of Thomas Deacon, the Manchester Non-juror* (Manchester: Manchester University Press, 1911).

44 For Deacon's writings and his associates, see *ibid.*, Appendix A, pp. 165, 171, 172–9; John Byrom, *Private Journal and Literary Remains [Vol. I, Part I]*, edited by Richard Parkinson, CS os 32 (Manchester: Chetham Society, 1854), pp. 80–1; *ibid.*, Vol. II, Part I, CS os 40 (Manchester: Chetham Society, 1856), p. 60; Raines, *Fellows*, vol. 1, p. 203; Timothy Underhill, '"What have I to do with the ship?": John Byrom and Eighteenth-Century Manchester Politics, with new Verse Attributions', in Horner (ed.), *Early Modern Manchester*, p. 110, for the involvement of Deacon and Byrom with clergy opposed to the Whig Warden Peploe, discussed below. For Thyer, see Ogden, 'Robert Thyer', pp. 1–23.

in this period of fierce political and religious strife and the threat of Jacobite invasion, the Collegiate Church provided 'a ritual forum in which local partisans could carry on their ideological battles'.[45] Three of these battles can now be described, the first of which chiefly involved the College, the others their lay allies in the town at large.

The warden, as a Crown appointment, was in this period a Whig low churchman. The Lancashire and Cheshire clergy were high church and notoriously Tory if not Jacobite.[46] Peploe had reputedly defied the Jacobite invaders in 1715 from his pulpit in Preston, although his appointment as Warden in 1718 seems to have been a reward for his public and extreme attacks on Roman Catholics, with whose theology he associated high Anglican eucharistic teaching.[47] Peploe initially clashed with Bishop Gastrell, who claimed that his higher degree (a necessary qualification for becoming Warden) was invalid as it was from Lambeth, not Oxford or Cambridge. This was settled by King's Bench in 1725, but the hiatus in the chapter minutes from 1717 to 1725 bears silent testimony to the fact that appointments made in those years were irregular and led to rival candidates being put forward for appointment by Peploe and the fellows.[48] On Gastrell's death in 1725, the government added insult to injury by appointing Peploe Bishop of Chester but allowing him to retain the wardenship *in commendam*, thus becoming Visitor of himself and his College! This had to be remedied by an Act of Parliament (1729) making the Crown become Visitor in such circumstances.

There followed a struggle between Peploe and the fellows over rival candidates for a fellowship and chaplaincy during the

45 *ODNB, s.n.* 'Peploe, Samuel (1667–1752)'; Underhill, 'John Byrom', p. 105.

46 See Jan M. Albers, 'Seeds of Contention: Society, Politics and the Church of England in Lancashire 1689–1790' (PhD dissertation, Yale University, 1988); Jan M. Albers, 'Papist Traitors and Presbyterian Rogues: eligious Identities in Eighteenth-Century Lancashire', in John Walsh, Colin Haydon, and Stephen Taylor (eds), *The Church of England c. 1689–c. 1833: From Toleration to the Tractarians* (Cambridge: Cambridge University Press, 1993), pp. 317–33. For the Cheshire clergy's persistent Tory allegiance after 1714, despite the Whig hegemony, see S. W. Baskerville, 'The Political Behaviour of the Cheshire Clergy 1705–52', *NH* 23 (1987), pp. 74–97. For the political connections and 'disaffection' of the College clergy, see Kazuhiko Kondo, 'Church and Politics in "Disaffected Manchester" 1718–31', *Historical Research* 80 (2006), esp. p. 3.

47 Paul G. Green, 'Samuel Peploe and the Ideology of anti-Catholicism in Early Hanoverian England', *THSLC* 145 (1996), pp. 75–94, esp. pp. 79–81.

48 For this and what follows, I draw on visitation records in MCL. There is now a detailed account of Manchester religion and politics up to 1729 in Kondo, 'Church and Politics', pp. 1–24.

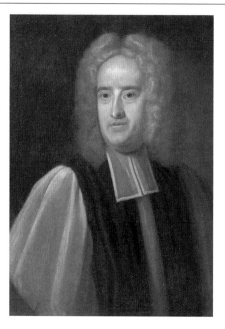

Portrait of
Samuel Peploe Sr,
Warden and Bishop

standoff of 1717–25. Petitions were organized to support the
fellows' candidate, Richard Assheton, one of them involving
Deacon and Byrom, who also penned a satirical attack on Pep-
loe.[49] The appointments were only settled in 1728, along with
Henry Brooke as a not very effective Whig fellow who was also
an indolent head of the Manchester Grammar School.[50] Party
warfare spread to the town with mobs shouting 'Down with
the Rump' and 'King James for ever' in 1727, while the church-
wardens cited two Whigs to the consistory court for illegally dis-
mantling woodwork in the church in 1728.[51] Peploe's aggressive
attitude came out in his visitation of 1727, while still both Bishop
and Warden. The visitation of 1701 had dealt particularly with
property, but Peploe's dealt with duty and obedience to the King
and Warden. 'Have the fellows paid due obedience to his majesty
and encouraged the like with others?', he asked. He also queried
whether they had been 'so resident' as to be able to be 'called
upon to visit the sick and do other offices of piety and charity',
athough by charter these were clearly the chaplains' duties.[52]
Having gained the appointment of his son Samuel Peploe junior
as Warden in his place from 1738, the Bishop conducted another
prolonged and aggressive visitation in 1742–43, targeting the fel-

49 Kondo, 'Church and Politics', p. 11; Underhill, 'John Byrom', pp. 105–10.
50 Raines, *Fellows*, vol. 2, pp. 213–16.
51 Kondo, 'Church and Politics', pp. 13–14; MCL, M39/2/13.
52 MCL, M39/2/5/2, questions 1, 13.

lows and lay officials for alleged misdoings in financial and other matters. Copley and Bolton were accused once again, as in 1727, of defrauding the poor by failing to pay absence fines, although John Copley (one of his fiercest opponents) had died ten years before. Thomas Cattell felt so insulted by the Bishop that he said: 'If his lordship should judge according to that Word Honest which was of large Extent, he might if he pleased try them for being Pick Pockets' [sic]. The chapter clerk and bailiff felt they were being charged with perjury, while Cattell and others were later accused of 'indecent behaviour' towards the Warden. The Bishop nursed the grievances from his days as Warden for years.[53]

These unedifying disputes were clearly charged with a political animus and Peploe's desire for control, but underlying them were also genuine differences on theology and liturgy. Peploe complained that his clergy were failing to conform 'to the constitution of the Church of England' over various rubrics in worship and that, contrary to his wishes, they had introduced a weekly in place of a monthly communion. This evidently reflected a conflict between Peploe's low church views and the more advanced eucharistic theology of the Lancashire clergy; here the influence of Deacon may be seen.[54] On the sacramental question, Peploe, whilst professing willingness to discuss the change, claimed that there were enough additional celebrations elsewhere in the town and preferred catechizing instead. The fellows claimed support from thirty to forty townspeople and that Peploe had given them permission, which he denied. Cattell complained that Peploe's language to them was 'not to be suffered'.[55] While Peploe's initial onslaught on the fellows was proceeding, a remarkable example of the close relationship between politics and religion in the town's public life was being developed. This was the workhouse project, begun in 1729.[56]

53 MCL, 39/2/6/3 (31 July, 2, 3 August, 27, 29 October 1742); M39/2/7/3 (13–14 April 1743).

54 MCL, M39/2/7/3 (14 April 1743); Green, 'Peploe', pp. 79–80, following F. C. Mather, *High Church Prophet: Bishop Samuel Horsley 1733–1806* (Oxford: Oxford University Press, 1992), and Mather, 'Georgian Churchmanship Reconsidered: Some Variations in Anglican Public Worship 1714–1830', *JEH* 36 (1985), pp. 255–83, with Manchester as an example of conservative practices.

55 MCL, M39 /2/7/3 (13, 14 April 1743; John Byrom, *Private Journal and Literary Remains, Vol. II, Part II*, edited by Richard Parkinson, CS os 44 (Manchester: Chetham Society, 1857), p. 357. The editor (p. 348 n. 2) is mistaken, as we shall see, in claiming that Peploe triumphed and that weekly communion was only reintroduced in the nineteenth century.

56 For what follows, see my earlier brief summary, comparing it with the alleged 'corporation' project of 1763, in 'The Manchester Corporation Project: Legend or History?', *TLCAS* 84 (1987), pp. 19–22; simultaneously but

Workhouses for accommodating, disciplining, and (if possible) making a profit from the poor had proliferated since the pioneering example in Bristol in 1696.[57] Although political interests were sometimes involved, the Manchester scheme was apparently unique in the party composition of its governing body. Nineteenth-century local historians tended to describe this as made up of equal numbers of low church Whigs, high church Tories, and Whig Presbyterians. This party identification was correct, though the contemporary documents simply describe them as, firstly, eight nominated by James Chetham esquire, Mr James Bayley boroughreeve, and Abraham Hawarth constable, 'to be of the communion of the Church of England'; secondly, 'eight persons of the same communion 'to be nominated 'by the present Churchwardens of Manchester'; and thirdly, eight 'to be nominated by Mr Thomas Butterworth, Mr Richard Taylor and Mr Jonathan Lees'. Their religious and political affiliations are readily identifiable and are as tradition claims. The subscription list was headed by Bishop Peploe and at least half the names were of Dissenters, almost all from Cross Street with about half a dozen from St Ann's who were likely to have been low church Whigs.[58]

Surprisingly, the high church Tories were slow to realize that they were likely to be in a permanent minority. The alarm was raised by Sir John Bland, Lady Bland's Jacobite son.[59] Then Byrom persuaded Sir Oswald Mosley to oppose the scheme, although he had already begun to build the workhouse (which caused him much trouble later). Byrom also stirred up his London contacts and lawyers connected with the Collegiate Church, Tory

independently, Kondo, 'Church and Politics', pp. 14–24; and documents in Kazuhiko Kondo, 'The Workhouse Issue at Manchester: Select Documents 1729–35, Part I', *Bulletin of the Faculty of Letters, Nagyu University* 33 (Spring 1987); copy by courtesy of the late Professor Douglas Farnie.

57 Between 1696 and 1712 'corporations of the poor became all the rage', following the Bristol example as a model: see Paul Slack, *Poverty and Policy in Tudor and Stuart England* (London: Longman, 1988), pp. 195–200.

58 MCL, F362.51 M1; Kondo, 'Select Documents', pp. 28–33; for a variant in broadside, see *ibid.*, pp. 18–21. Kondo only identifies Whigs, Tories, and Presbyterians from the trustee lists, but many of the subscribers can be shown to be from Cross Street from T. Baker, *Memoirs of a Dissenting Chapel* (London: Simpkin, Marshall, 1884), and others from Cross Street and St Ann's baptismal registers (microfilms in MCL).

59 For Bland, see Evelyn Cruickshanks, Stuart Handley, and D. W. Hughes (eds), *History of Parliament. House of Commons 1690–1715, III. Members A–F* (Cambridge: Cambridge University Press for History of Parliament Trust, 2002), p. 235. For the proceedings of the bill in Parliament, see Stuart Handley, 'Local legislative Initiatives for Economic and Social Developments 1689–1731', *Parliamentary History* 9 (1990), pp. 21–2, 24, 30–4.

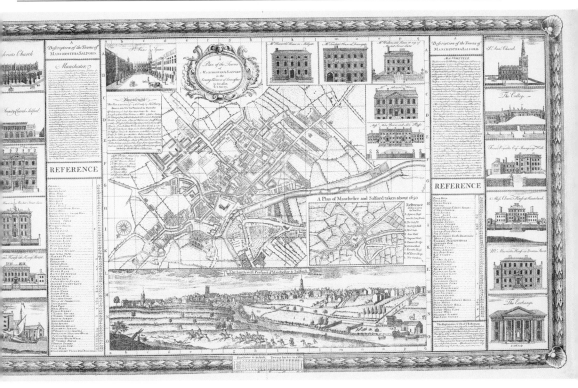

Casson and Berry map of 1746 with panorama and pictures of churches around it

MPs, and others opposed to Walpole's government. The bill's progress was stopped in Parliament and Byrom and his friends were greeted with church bells on their return to Manchester.[60] Apart from party warfare, there were also suspicions that this was a racket intended to monopolize the labour of the poor 'under specious pretences of charity'.[61] There were also cases elsewhere of workhouse schemes in corporate towns which may have included hopes of infiltrating Dissenters into positions of influence despite the Test Acts excluding them.[62] Professor Kondo suspects the Manchester scheme may have concealed such hopes of developing a major influence in local affairs, and he also suggests a contrast between hard-headed Whig attitudes towards the poor and a more paternalistic and personalized Tory ethos of charity expressed in Byrom's injunction 'rich, take care of the poor; one live comfortably with another'.[63] Byrom only

60 John Byrom, *Private Journal and Literary Remains, Vol. I, Part II*, edited by Richard Parkinson, CS os 34 (Manchester: Chetham Society, 1855), pp. 440–92.
61 MCL, F362.51 M 1–2; Kondo, 'Documents', p. 22.
62 For an example, see William Gibson, 'William Talbot and Church Politics 1688–1730', *JEH* 58 (2007), pp. 34–5.
63 Kondo, 'Church and Politics', p. 23; Byrom, *Journal, Vol. I, Part II*, p. 492.

mentioned William Shrigley (chaplain 1735–56) of the College clergy as involved in the campaign, which was clearly dominated by lay officials and Tory friends of the church. This is a reminder of a fact frequently demonstrated in what follows – that the church's role in the town was expressed through them and not simply by the public actions of the clergy.

The clergy were rather more conspicuous during the Jacobite invasion of 1745 and the Prince's entry into the town. A Manchester regiment was raised for him, and Deacon's three sons joined it with tragic results. One died in prison, one was transported, and one executed, his head being mounted on the Manchester Exchange.[64] Byrom's daughter Elizabeth ('Beppy') entered a lively and enthusiastic account of what followed in her diary. Chaplain Shrigley prayed in the Collegiate Church for the King and Prince of Wales while pointedly refraining from identifying which claimants. Chaplain John Clayton is reputed to have prayed for the Prince on his knees in the street as well as in his Salford pulpit and certainly said grace for him. Clayton and Cattell (a fellow often in conflict with Peploe) kissed hands with the Prince, as did Byrom and Deacon, though Beppy says they were 'fetched prisoner' to do so, unlike Clayton and Cattell.[65] Byrom's reluctance may have been misleading, for it has recently been argued that he was far more active and committed to the Jacobite cause than tradition and the later editors of his writings allowed. Thus, his famous quip 'God bless the King … but who is King and who pretender?' was not neutral but implicitly Jacobite by placing both claimants on an equal footing.[66] It has often been claimed that Clayton was suspended from office and then fled from justice. Bishop Peploe in 1746 certainly pressed for Clayton, Cattell, and John Fletcher (clerk to the chapter and in conflict with Peploe earlier) to be prosecuted. Cattell died in 1747 but Clayton appeared at Lancaster assizes for seditious words, although he escaped punishment. While he may have been suspended, he survived to be elected a fellow in 1760 and is said to have moderated his views in later life.[67]

64 Broxap, *Deacon*, pp. 121–2.

65 Byrom, *Journal, Vol. II, Part II*, p. 394. For the story of Clayton praying on his knees, see Josiah Owen, *Jacobite and Nonjuring Principles, freely examined*, 2nd edn (Manchester: R. Whitworth, 1748), pp. 22–3, repeated in Samuel Hibbert-Ware, *The History of the Foundations in Manchester of Christ's College, Chetham's Hospital, and the Free Grammar School*, 3 vols (Manchester: Agnew and Zanetti, 1834), vol. 2, p. 100.

66 Underhill, 'John Byrom', pp. 95–119.

67 B. Stott, 'The Informations laid against certain Townsmen of Manchester in 1746', *TLCAS* 42 (1925), pp. 30–9.

It was events like these which gave Manchester a reputation for Jacobite plotting, disloyalty, and 'popery' for many years. Such charges were made savagely by Josiah Owen, the Presbyterian minister of Rochdale, and more wittily by Thomas Percival of Royton, a Presbyterian turned Anglican. *Whitworth's Manchester Magazine* also joined in. Responses came from Deacon and Byrom under pseudonyms. The College clergy were distrusted for their close connections with Deacon, while Deacon himself was alleged to impose political tests for membership of his church. After Cattell's death, forged papers appeared to show that he and his clerical colleagues were prepared to submit to the Pope and had received a reply.[68] Percival mockingly took the College clergy to task for failing in their duty to attack Deacon's activities, leaving this instead to the Presbyterian Owen, who was thereby 'usurping your office of instructing your parishioners'.[69]

The Tory *Chester Courant* published replies, apparently from Deacon but printed anonymously. Then, in 1749, the same paper published *Manchester Vindicated*, a collection of charges and replies. Critics alleging disloyalty and popery were accused of 'sectarian heterodoxy' and of being 'determined enemies to our ecclesiastical establishment'. The most interesting item was from 'Timothy Tell-Truth', claiming that he had heard no sound of 'Down with the Rump' in the streets. In a tavern, however, he had heard a rumour: 'They are petitioning to have this town made into a corporation. What? – and the mace, I suppose, to be carried each Sunday to the Meeting House – a likely matter truly. – Here, Jack, God bless K– George, I say and down with the Rump.'[70]

There were financial as well as religious grievances against the College. These arose from an Act of 1548 which appeared to give the College a tithe charge of four pence on all the Manchester weavers. This was disputed for many years, and it has been argued by Wadsworth and Mann that 'the root of their [the weavers'] objection seems to have been religious rather than economic'. One man said that his father in 1691 had objected

68 Byrom, *Journal, Vol. II, Part II*, pp. 438–42, 441 n. 4; Owen, *Jacobite and Nonjuring Principles*, p. 159. The forgery is palpable and convincingly exposed by Broxap, *Deacon*, pp. 129–31.

69 [Thomas Percival], *A Letter to the Reverend the Clergy of the Collegiate Church of Manchester* (London: J. Robinson, 1748); extracts from newspapers and Owen in Broxap, *Deacon*, pp. 187–200; for rival Whig and Tory newspapers, see C. Horner, '"That Great Fountain of Truth, Good Manners and What Not": Competing for Hearts and Minds of Newspaper Readers in Manchester 1730–60', *TLCAS* 93 (2001), pp. 51–68.

70 From the *Courant*, 24 February 1749, in [Thomas Deacon], *Manchester Vindicated* (Chester: E. Adams, 1749), pp. 183–4.

as a Dissenter for being 'charged with such payments by the Church'. In 1711, the weavers were denounced from the pulpit. One man claimed a providential judgement had been inflicted on a field which had produced an unexpectedly poor crop. In 1736, a Dissenter objected to paying when his own chapel received nothing. The case was settled in the weavers' favour in 1753.[71] As to the College's finances in this period, the bursar's accounts only survive from 1761, but for that year it may be noted that in round figures the net income was £875, the warden receiving £292 and the fellows each £146.[72] So far as sources of income are concerned these were, apart from tithes, mostly from leases and entry and renewal fines. The charter laid down that only twenty-one-year leases should be granted and none for terms of lives. For many years, leases were for agricultural land and houses in the town. But from the 1750s there was a gradual increase from twenty-one- to forty-year building leases. In 1753, the College built St Mary's Church, the first in the town since St Ann's apart from the suburban St Thomas's, Ardwick, in 1741. St Mary's was usually staffed by College clergy and it was in connection with this initiative that six plots were let on such leases between 1759 and 1764.[73]

Here may also be mentioned the creation of a Collegiate Church charity school in the churchyard in 1762 for sixty boys and sixty girls who would be clothed, taught their letters, and prepared for apprenticeships and service until the age of ten. This was financed from communion collections, plus a penny a week fine for absences. Unusually, both the master and mistress were to be paid the same, initially £24 per annum.[74]

The College's control of the parishioners in terms of the church courts was becoming limited. In 1732, Bishop Peploe was already complaining that the churchwardens were failing in their duty, and in 1742–43 that they were refusing to recognize the jurisdiction of the Rural Dean, who exercised archidiaconal jurisdiction throughout the whole archdeaconry of Chester, Manchester excepted. Hence there were 'greater numbers of bastards than ever were known before'. We may suspect that what lay behind this may have been resistance to Peploe-appointed officials as part of the continuing conflict between warden and fellows.[75] Social concerns could be expressed in more than one

71 Wadsworth and Mann, *Cotton Trade*, pp. 512–13.
72 MCA, CE4/1/1.
73 MCA, CE1/Pars/10/1, 11/1, 12/1, 13/1, 14/1, 15/1. I am indebted to Christopher Hunwick for calling my attention to these examples.
74 MCA, CW1/Sch/1/1 (unpaged at front of book).
75 MCL, MS M39/2/7/6 (30 October 1732); M39/2/7/8 (15 April 1743).

way, formally through church courts but less formally by pamphlet propaganda and controversy. Where moral issues were concerned, men with similar religious and political views could disagree. While the Non-juror John Byrom attacked the Manchester races as leading to disorder and immorality, his friend Thomas Cattell of the College defended them as innocent recreation (though it may be relevant that they were held on Kersal Moor, near the Byrom family home).[76]

Controversy also surrounded the problems raised by the poor, quite apart from the ideological complications of the abortive workhouse scheme. Manchester had numerous traditional charities offering doles of clothes or bread, quite often on condition of church attendance, and more were added in this period. In 1732, Mrs Jane Corles left money to the chaplains for preaching on Sundays and festivals, to encourage poor people to attend. In 1734, Mrs Elizabeth Scholes left them money to preach on St John the Baptist's Day, with money for the poor attending and behaving decently during the service.[77] But harsher views of the poor were also becoming evident as the population increased. The workhouse project was one example, but it is also curious to find John Clayton attacking the poor for idleness, improvidence, and luxury in his *Friendly Advice to the Poor* (1755); curious, because of the apparent concern for paternalism and neighbourliness claimed for high churchmen and Non-jurors like Byrom noted earlier. Already, in Oxford, Clayton had discriminated in favour of the 'deserving poor', of whom much more would be heard in subsequent years. Yet John Wesley, Clayton's friend at Oxford, had a lifelong love for the poor and did not blame them for their plight, an attitude resembling traditional Catholic values rather than Protestant severity.[78]

76 [John Byrom], *A Serious Disswasive [sic] from an intended Subscription, for continuing the Races upon Kersal Moore*, 2nd edn (Manchester: R. Whitworth, 1733); [Thomas Cattell], *Remarks upon the Serious Disswasive [sic] from an intended Subscription* (Manchester: R. Whitworth, 1733).

77 Raines, *Fellows*, vol. 2, pp. 235–6. For a full discussion and list of charities, see Gordon B. Hindle, *Provision for the Relief of the Poor in Manchester 1754–1826*, CS 3rd series 22 (Manchester: Chetham Society, 1975), pp. 130–62, 163–9.

78 Horner sees Clayton as 're-inventing himself' as a good citizen: Horner, '"Proper Persons"', p. 209. For Clayton at Oxford, see Clayton to John Wesley, 1 August 1732, in John Wesley, *Works*, vol. 25 (Oxford: Oxford University Press, 1980), p. 333. For Wesley and the poor, see John Walsh, 'John Wesley and the Community of Goods', in Keith Robbins (ed.), *Protestant Evangelicalism: Britain, Ireland, Germany and America, c. 1750–c. 1950: Essays in Honour of W. R. Ward*, SCH Subsidia 7 (Oxford: Blackwell, 1990), pp. 25–53.

In response to Clayton, Joseph Stot's *Sequel to the Friendly Advice to the Poor of the Town of Manchester* (1756) was not much more sympathetic to them but blamed their poverty on pride rather than idleness. But he showed a political edge as well. There are those among us (he claimed) who hanker after the 'fleshpots of popery and the chains and fetters of a popish reign'. They should reflect on the blessings we now enjoy. The clergy (like Clayton) should be invoking loyalty to King George 'much more than by heaping tythes on the shoulders of the poor'. The (Tory) establishment is not administering poor relief effectively and is failing to prevent exploitation of corn supplies. The point of this was underlined by the so-called 'Shudehill Fight' in 1757, when a mob attacked merchants hoarding to keep up the price of corn. This was when 'Tim Bobbin' satirized in mock-biblical terms the 'lickspittle' Whig newspaper owner as 'Whitaliah', Clayton as 'Clatonijah the priest', and Byrom as 'Byromah the Psalmist'.[79]

In yet another way the Manchester infirmary, founded in 1752 and typical of several such institutions founded in this period, offered an opportunity not only for charity but also for patronage and openings for physicians and surgeons. It was also, Horner argues, an institution which clergy, ministers, and laity of all parties and denominations could support and so overcome the divisions of recent years.[80] But we shall see that there would be conflicts over policy in the 1790s which apparently were influenced by politico-religious divisions.

If we turn now from the political and social roles of the College to what may be felt to be its more central function of providing for public worship, it has to be said that little information has been available apart from the dispute with Peploe regarding communion frequency. However, the financial accounts of the College charity school offer welcome details on communion attendance from 1763. Earlier, we have only the claim by John Wesley on a visit in 1733 that five hundred were present for

79 'Tim Bobbin' [John Collier], 'Truth in a Mask or the Shudehill Fight', in Henry Fishwick (ed.), *The Works of John Collier (Tim Bobbin) in Prose and Verse* (Rochdale: James Clegg, 1894), p. 203. For the context and significance of such attacks, see E. P. Thompson, 'The Moral Economy of the English Crowd in the Eighteenth Century', reprinted with replies to his critics in *Customs in Common* (London: Penguin, 1993), pp. 185–351. Thompson notes (pp. 211, 220–1) that in the Shudehill affray there were also suspicions of adulterated flour and that the 'fight' was aggravated by exploitation of a local corn mill monopoly. For Clayton versus Stot, see Hindle, *Provision for the Poor*, pp. 22–5.

80 So Horner, '"Proper Persons"', p. 213. For the infirmary, see William Brockbank, *Portrait of a Hospital, 1752–1948* (London: Heinemann, 1952).

communion on a Sunday in June.[81] Cattell, during the dispute with Peploe, claimed 'above seven hundred' attending.[82] The school accounts show that in the twelve months from 10 April 1763 to 1 April 1764 there were 13,482 attendances, averaging 259. The highest were Christmas Day 1763 at 625, and Easter Day 1764 at 752. The highest figure on an ordinary Sunday was 322 in November 1763, the lowest 159 in February 1764.[83] Percival's satirical attack on the College gives an account of the chaplains, as if in a stately dance, advancing, turning, and bowing at the *Gloria Mundi* with Clayton apparently making the sign of the cross.[84] Clayton at Oxford certainly followed Deacon in the 'primitive' practices of 'station fasts' on Wednesday and Friday, accepted John Johnson's *Unbloody Sacrifice* argument for the eucharist being a kind of sacrifice, and followed mystical writers in advocating mental as well as vocal prayer. But at Oxford he told Wesley that you should 'steer your course in the due medium between the monkish mysticism of the fourth century and the lukewarm indifference of the present age'. Clayton also ran a successful school in Salford which attracted the sons of those who shared his religious and political views.[85]

From Jacobite to Loyalist, 1763–87

In this period the population continued to grow. The claim of 17,101 for Manchester alone had risen (in a careful survey of 1773–74) to 24,386, and 42,937 for the parish.[86] By 1787, a few new churches had been added: St Paul's (1768, enlarged 1778), St John's (1769), and a chapel of ease for Heaton Norris (1765). The older histories claimed that party conflict before and after 1745 was now beginning to quieten down. Hibbert-Ware supposed that it revived on conventional Whig versus Tory lines in the 1760s, but we shall see that the American War is a more likely period for this development.[87] Recording a visit to Manchester in 1753, Richard Woodward, later an Irish bishop, thought the spirit of party was subsiding and would decline further but for 'a corps of officers here, who assist in keeping up divisions, for otherwise the town of Manchester is pretty unanimous', partly

81 V. H. H. Green, *The Young Mr. Wesley* (London: Arnold, 1961), p. 186.
82 Byrom, *Journal*, Vol. II, Part II, pp. 348–9.
83 MCA, MSCW1/Sch/1/1, pp. 16–20.
84 [Percival], *Letter to the Clergy*, p. 22.
85 Clayton to Wesley, 2 August 1734, in Wesley, *Works*, vol. 25, pp. 392–3. On Clayton, see *ODNB*, s.n. 'Clayton, John (1709–73)'.
86 Wadsworth and Mann, *Cotton Trade*, p. 510.
87 Hibbert-Ware, *History of the Foundations*, vol. 2, p. 156.

owing to the fellows of the College being 'in one party' and in control of 'a vast number of chapels about, which they dispose of with a view to party'.[88] Craig Horner sees events after 1750 as damping down party strife. Thus, support for the infirmary could unite all parties, as could patriotism during the Seven Years' War, and the attention of the rival local papers was diverted from the Jacobite conflict to the Jewish Naturalization Bill (1753) and the advent of Methodism in Manchester.[89]

There was more concern in the 1750s over weavers' combinations (proto unions) to preserve wages and apprenticeship standards, and Thomas Percival of Clayton was attacked by the masters for trying to mediate.[90] Such conflicts, indeed, did not preclude the continuation of sentimental Jacobitism, manifestations of what may be seen as a popular 'Jacobite culture', and the persistence of Whig propaganda portraying Manchester as Jacobite and disloyal. Thus, there were celebrations on 29 May of the return of Charles II with oak boughs, and on the Pretender's birthday in December with wearing of St Andrew's crosses, plaids, and white dresses.[91] A Manchester Independent (Congregationalist) minister noted the commemoration of King Charles the Martyr at the Collegiate Church on 30 January and its decoration with oak boughs on 29 May.[92]

It is in the context of possibly reduced party strife, public concerns about other matters, and political changes early in George III's reign that we must assess a story involving lay officials of the Collegiate Church and their supporters and opponents which has been repeated in Manchester histories since the 1820s. It is alleged that in the early 1760s (the exact date, if given, varies) an attempt was made to erect a municipal or parliamentary borough of Manchester by Act of Parliament. Some accounts add a workhouse or prison, but common to all versions is that the corporation was to be governed by a body made up of equal numbers of high church Tories, low church Whigs, and Presbyterians. The project was defeated when the high church Tories realized that they would be in a permanent minority.[93] This is suspiciously similar to the well-documented workhouse project of 1729, with

88 Quoted in Thomson, *History*, pp. 192–3.
89 Horner, '"That Great Fountain of Truth"', p. 63.
90 *Ibid.*, pp. 64–5.
91 Examples in Paul Monod, *Jacobites and the English People 1688–1786* (Cambridge: Cambridge University Press, 1989), including a bizarre baptismal banquet with politically symbolic food (pp. 272–3); Byrom, *Journal, Vol. II, Part II*, p. 393.
92 MCL, MS M185, Caleb Warhurst, diary, 30 January, 29 May 1758.
93 For what follows see detailed analysis in H. D. Rack, 'The Manchester Corporation Project 1763: Legend or History?' *TLCAS* 84 (1987), pp. 118–42.

the addition of a celebratory procession after the defeat, 'now discontinued', and the idea of a 'corporation'. The only early source ever cited is James Ogden's *Description of Manchester* (1783), whose topographical survey attaches the scheme to the remains of a workhouse, clearly that begun by Mosley in 1729.[94] Ogden gives no date, and for the 'corporation' and procession details one would naturally assume he was referring to the 1729 scheme. Indeed, 'corporation' was sometimes used for the governing bodies of workhouses and we have seen there was gossip about a 'corporation' for Manchester in 1749. Byrom and his friends had been greeted with triumphant bell-ringing in 1731 and an annual commemoration is plausible enough. Apart from Ogden's confused and undated account it appears that neither the 1729 nor alleged 1763 schemes were known except possibly in garbled oral recollections until Edward Baines in 1824–25 wrote of a corporation scheme 'early in George III's reign', citing Ogden as his source. In 1830, Hibbert-Ware gave an account of the 1729 scheme, drawing on the as yet unpublished Byrom papers. He added the corporation scheme, dating it 'about 1763' and citing Baines as his source. Baines in his second edition of 1836 added the 1729 scheme from Hibbert-Ware but noticeably dropped any reference to a workhouse which he had originally added for 1763.[95] Later histories drew upon these accounts with variable details. Whatever exactly happened in (about) 1763, it seems certain that details from 1729 have become confused with it.[96] It must be said that what was plausible (and indeed well-documented) for 1729 is less plausible for 1763, for which we have a solitary undated claim by Ogden twenty years after the alleged event. Indeed, it is even conceivable that a vague tradition of a workhouse and corporation in the form 'early in King George's reign' would fit the 1729 scheme quite well, George II having acceded in 1727. If there ever was a scheme in 1763, it must have been abandoned so quickly that it never reached public record, for example in the press. It is, however,

94 James Ogden, *A Description of Manchester* (1783, reprinted as *Manchester Two Hundred Years Ago*, edited by William E. A. Axon: Swinton: Neil Richardson, 1983), p. 10.

95 Edward Baines, *History, Directory, and Gazetteer of the County Palatine of Lancaster*, 2 vols (Liverpool: William Wales, 1824, 1825), vol. 2, pp. 113–14; Hibbert-Ware, *History of the Foundations*, vol. 1, pp. 77–80; Edward Baines, *History of the County Palatine and Duchy of Lancaster*, 2nd edn, 4 vols (London: Fisher, 1836), vol. 2, pp. 293–4, 356.

96 Kondo, 'Church and Politics' p. 16, recognizes this but appears to take 1763 for granted as a real event, following Ogden and Baines in 1825, supposing that they misunderstood the workhouse scheme for an early attempt at incorporation as in 1763.

just possible that such an abortive scheme was replaced by two less contentious schemes and that imperfect recollections of these and of 1729 were amalgamated to create the myth of 1763.

These schemes were for a new workhouse in 1763–64 and in 1765 a commission for street-widening and fire-fighting, largely forgotten later.[97] There followed a further plan in 1776 for street-widening by subscription, and then the Police Commissioners of 1792. These might be seen as schemes to enable marginal men like the Cross Street Presbyterians to gain influence denied them in the old Court Leet which had hitherto governed the town. It is true that they had by now ceased to occupy the leading position of boroughreeve which they had occasionally held earlier. Certainly, also, they figured in the expected proportions in the new bodies (11 per cent in 1765, 15 per cent in 1776, and at least 10 per cent in the 1792 body). But it is noticeable that the warden and fellows of the Collegiate Church, boroughreeves, and constables were included *ex officio* in the 1765 and 1792 bodies, while the 1776 membership was by subscription. Mixed membership may reflect the decline of party strife. The *ex officio* membership for the warden and fellows illustrates the significance of their public role in the town and its ruling elite. It appears that the 1792 body, whilst not excluding Dissenters, was essentially a bid for power by a Tory elite dissatisfied with the increasingly ineffective administration of the Court Leet, though it only became its open rival after 1800.[98]

Perhaps the most important development of these years was the transition from the old Jacobite loyalties of the Collegiate Church to a more conventional loyalism to church and state. This appears to have happened despite the persistence of the sentimental popular Jacobite culture noted earlier. It has been argued that the crucial tipping point for this in Manchester was

97 Hindle, *Provision for the Poor*, pp. 19, 21–2; MCL, Manchester Local Acts 2, F346.1l1, pp. 855–6. Hindle's survey of the obscure history of Manchester poorhouses before 1790 is complicated by the vagueness of Ogden's account and its inclusion of a workhouse as part of the alleged corporation scheme supposed to have been floated in 1763.

98 For the national phenomenon of 'improvement commissioners', see Sidney and Beatrice Webb, *English Local Government* (London: Longmans, Green, 1922), vol. 4, *On Statutory Authorities for Special Purposes*, ch. 4, pp. 235–46 on Manchester; Arthur Redford, *The History of Local Government in Manchester*, 3 vols (London: Longmans, Green, 1939–40). For 1776, see MCL, F346.1L1, Manchester Local Acts 5, 1776–1826; F346. L1, Police Commissioners, 1790–1831, pp. 1127–1212. The Dissenters are identified from baptismal registers (microfilms in MCL); Baker, *Dissenting Chapel*, for Cross Street and a 'loyal address' by Dissenters; *MM*, 1 January 1793.

the division caused by the American Revolution.[99] In September 1775, an address to the King from Manchester praising his strong line towards the 'deluded and unhappy Americans' received his warm appreciation. The opposition to this claimed that the address was signed by very few 'excepting high Churchmen and men of Jacobite principles'. There was an attempt to counter the address with a petition from Lancashire to stop 'a most unnatural civil war', signed by four thousand people.[100] Marshall notes that the Tory address included 308 Manchester men, the Whig petition only 170. The former included Richard Assheton, Maurice Griffith, and Thomas Aynscough of the College, along with other clergy and laity regularly supporting them. The petition was heavily weighted with Presbyterians. The Jacobite reputation of the town was easy for Whigs to exploit and the kind of popular sentimental Jacobitism illustrated earlier continued for many years. On a visit in 1777, the American loyalist Samuel Curwen described the mixture of old and new buildings, the 'inhospitable and boorish inhabitants', and their 'unintelligible language'. The ladies were violent Jacobites, drinking the Prince's health. Marshall noted, among others, a Quaker woman who was a Jacobite in politics.[101] Yet the King's birthday was celebrated in 1777 and Lord North was warmly greeted when he visited Sir Thomas Egerton in 1782. What matters for our present purpose is Marshall's conclusion that before the war Manchester's political loyalties were still divided between Jacobites and Whigs; but by its close their differences had become those of more conventional Tories and Whigs, and that this 'pointed forward to the 1790s'. James Bradley, in his study of Dissent and reforming politics in eighteenth-century England, comes to similar conclusions. He sees a number of towns where Dissent was strong, including Manchester, as being 'sharply riven over America'. The main body of 'rational Dissent', along with shopkeepers and artisans, tended to prefer measures of conciliation as against the coercion favoured by the affluent elite. He also suggests that these divisions show signs of

99 For what follows, see Peter Marshall, 'Manchester and the American Revolution', *BJRL* 62 (1979), pp. 168–86.

100 Address in Peter Force (ed.), *American Archives*, 4th series, vol. 3 (Washington: M. St Clair Clarke and Peter Force, 1840), pp. 649–51; petition in Mrs Hibbert-Ware, *The Life and Correspondence of Samuel Hibbert-Ware* (Manchester: J. E. Cornish, 1882), pp. 64–6.

101 *Journal of Samuel Curwen, Loyalist*, edited by A. Oliver (Cambridge, MA: Harvard University Press, 1972), pp. 365–6; Marshall, 'American Revolution', p. 175.

continuity with the divisions over repeal of the tests in the late 1780s and parliamentary reform in the 1790s.[102]

The political attitudes of the College clergy were also modified, reflecting this change. Warden Peploe is said to have moderated his views and conciliated his colleagues.[103] But the most striking change was in the College clergy's own attitudes. Peploe was succeeded in 1782 by Richard Assheton, from an old Lancashire family which had supplied several members of the College with Jacobite associations. This Assheton, despite being a Crown appointment, was no Whig, yet became a consistent loyalist in his subsequent actions and associations. Part of the explanation is that he was appointed by the North government just before it was replaced by the Rockingham Whigs. Moreover, although John Clayton (who also seems to have moderated his views) survived as fellow until his death in 1773, a new generation of fellows which had emerged in the 1760s survived into the 1790s and also became consistent 'Church and King' loyalists. They were Thomas Aynscough, Maurice Griffith, James Bayley, and another Richard Assheton.[104]

Manchester loyalism was old-fashioned and traditional. The decline or transmutation of the old divine right, non-resistance sentiments of late seventeenth-century Anglicanism had been a tortuous and painful process provoked by a Roman Catholic King, James II, and Non-jurors could seem to be the people of principle. The full doctrine of indefeasible hereditary right had been lost with the departure of James II and the defeat of the 1745 invasion, yet it can be argued that its underlying emotional and theological force survived. One expedient was to see William and Mary and their successors as beneficiaries of 'providential' acts of God rather than ruling by strict hereditary right. The sense of political authority as given by God, rather than grounded in natural rights or originating in 'the people', persisted strongly, as did the sense that the authority of the state was religiously based and expressed through the established church as the essential ally of the state. 'Church and King' loyalism was as profound a source of support for the ruling order in the 1790s, overshadowed by the French Revolution and war, as it had been for high church

102 Marshall, 'American Revolution', pp. 184–6; James E. Bradley, *Reform, Revolution and English Radicalism: Nonconformity in Eighteenth-Century Politics and Society* (Cambridge: Cambridge University Press, 1990), pp. 13, 342, 371, 380, 428–9.

103 Raines, *Rectors and Wardens*, p. 169.

104 Raines at times confuses this man with the warden of the same name who had not, as stated there, formerly been a fellow but Rector of Middleton: *ibid.*, p. 172.

Tories and Jacobites before 1745. Although Marshall speaks of a transition from Jacobitism to a more conventional Toryism in Manchester, a consensus has emerged that the 'Tory' label after 1760 has no real content. The end of their exclusion from government after George III's accession and the defeat of the Jacobite threat emptied the old party labels of their traditional meaning. J. J. Sack, in describing the transition from 'Jacobite' to 'Conservative', prefers to speak of a 'right wing' cluster of sentiments including (highly relevant to this chapter) attachment to the church establishment and hostility to Catholic emancipation. His findings, however, rely heavily on the London conservative press. It will be convenient to characterize the College clergy and their supporters in what follows simply as 'Church and King' loyalists.[105]

At a more domestic level, from 1761 we have a record of the income of the warden and fellows. In the 1760s that of the warden averaged from £289 to £474, and the fellows from £140 to £237. In the 1770s, income ranged from £308 to £486 for the warden, and £194 to £243 for the fellows. In the 1780s, dividends were from £354 to £531 for the warden, and from £177 to £265 for the fellows. In 1764, an Act of Parliament allowed ninety-nine-year building leases and 'building on the glebe', and Deansgate and Parsonage followed suit in allowing such leases. Yet very few were granted at first and these only added £30 income per annum until a sudden jump in 1796.[106]

We have seen that the charity school accounts from 1764 give a few years of detailed communion attendance followed by annual figures only. In the second half of the 1760s there were attendances of up to 15,000 per annum, but during the second half of the 1770s this dropped to under 10,000, and in the second half of the 1780s they declined further from over 8,000 to under 6,000. In 1778 the total was 9,901, an average of 191, and the 1778 visitation returns broadly confirm this by recording that communion attendance was 'in common' two hundred persons and last Easter Sunday '500 and upwards'.[107] The most surprising information on worship was that Warden

105 Gerald Straka, 'The Final Phase of Divine Right Theory in England 1688–1702', *EHR* 77 (1962), pp. 638–58; J. C. D. Clark, *English Society 1688–1832* (Cambridge: Cambridge University Press, 1985), pp. 173–89; Frank O'Gorman, *The Long Eighteenth Century* (London: Arnold, 1997), pp. 151, 277–86; J. J. Sack, *From Jacobite to Conservative* (Cambridge: Cambridge University Press, 1993), pp. 1–3.

106 MCA, CE1, Title Deeds, CE1/Pars. 1964 /7/8; Mancath/2/2/2, Chapter minutes, 11 October 1764; CE4/1/1, Bursar's book, 1764.

107 MCA, CW1/Sch/1/1; CALS, EDV 7/1/148,

Peploe junior is claimed to have 'thoroughly understood the ver-
nacular of Lancashire and generally addressed the lower orders
in their own uncouth and original tongue, although it is clear
that he had a purer English at his command when the occasion
required it'.[108]

Reformers repelled, 1787–1804

The population continued to grow and the town to expand.
The township population of over 24,000 in 1773–74 had risen
dramatically to over 70,000 by the time of the first census in
1801.[109] The image of a 'factory town' is misleading. Manchester
had long been a service and marketing centre for the region.
Although there was only one factory in 1783 and eighty-six in
1816, warehouses were spreading from the 1780s and by 1825
there were fifty-seven, with one hundred and six firms in Cannon
Street alone, and the larger proportion of regional investors' cap-
ital was invested in them.[110] Nor did the prosperous middling
class lack culture. The older tradition of balls, assemblies, and
theatres was now supplemented by clubs and vehicles for liter-
ary and scientific pursuits, as well as libraries and a variety of
newspapers.[111]

The context in which political and religious developments in
the town took place in the 1790s included war with France from
1793, trade fluctuations, and hunger everywhere in Europe in
1795. There were food riots and campaigns to remove Dissent-
ers' disabilities and for parliamentary reform, which provoked
Church and conservative reactions. Attempts to form trade
unions were met by repressive Combination Acts and if mid-
dle-class reformers were cowed into declarations of 'loyalty',
there were still undercurrents of artisan reform agitation.[112]

Population growth brought more church building, especially
of 'proprietary churches' whose founders were allowed two

108 Raines, *Rectors and Wardens*, p. 169.
109 Thomson, *Manchester*, p. 262. Larger figures sometimes given are adjusted
to boundaries of 1838.
110 Alan Kidd, *Manchester: A History*, 4th edn (Lancaster: Carnegie Press,
2006), pp. 15–22; Pat Hudson, *The Industrial Revolution* (London: Arnold,
1992), p. 121; Donald Read, *Press and People 1790–1850* (London:
Arnold, 1961), p. 8.
111 W. H. Chaloner, 'Manchester in the Latter Half of the Eighteenth Century',
BJRL 42 (1959), pp. 40–60. Unfortunately, he does not explore the cul-
tural activities of church or clergy, although Hendy, *Manchester Collegiate
Church*, pp. 21–2, 25–6, 30–3, cites anecdotes from the old histories and
lists the fellows' publications.
112 For details on this summary, see Kidd, *Manchester*, pp. 60–1, 76–8.

presentations or sixty years' control, after which patronage reverted to the College. In 1788, St James's and St Michael's were added, then St George's (1790), St Clement's (1793), St Peter's (1798), St Stephen's (Salford; 1794), St Mark's (Cheetham Hill; 1794), and St Luke's (1804).[113] These eighteenth-century churches were mostly very plain and built of brick, although St Mary's had a 180-foot Ionic spire and St John's was Gothic in style. There was a dangerous pause in building from 1804 until 1820 that allowed Dissenting and Methodist churches to proliferate.

One significant feature of the rush of new churches was the first appearance of Anglican evangelical incumbents in Manchester. This change was due to the demand for more rented pews and, it can be argued, to the Methodist background of the first generation of these clergy, who attracted Methodist communicants.[114] First came the improbable figure of the founder of St James's, Cornelius Bayley, a former breeches-maker and ex-Methodist. He obtained land from Sir John Parker Mosley, evangelical lord of the manor but also an ex-Methodist hat-maker. Bayley obtained sixty years' presentation by the unexpected help of Richard Assheton, fellow of the Collegiate Church.[115] Mosley Cheek, ex-Methodist preacher but a Mosley on his mother's side, founded St Stephen's, Salford, while Edward Smyth, founder of St Clement's and St Luke's, was an Irish evangelical associate of John Wesley. Charles Burton, of another Methodist family, founded All Saints in 1820.

We have seen that divisions over the American Revolution helped to persuade the younger generation of College clergy to move from Jacobitism to loyalism. What encouraged this and ignited an outspoken and often ferocious 'Church and King' loyalism was the failed campaign in 1787–90 to repeal the Test and Corporation Acts which legally barred Dissenters from offices under the Crown and in corporate towns. This campaign provoked an Anglican backlash, heightened when the Unitarians Joseph Priestley and Richard Price appeared to go beyond

113 Dates given are of construction. St George's was a failed Anglican speculation used by Lady Huntingdon's Connexion until purchased for Anglican use in 1818.

114 See H. D. Rack, 'The Providential Moment: Church Building, Methodism and Evangelical Entryism in Manchester, 1788–1825', *THSLC* 96 (1991), pp. 235–60.

115 'A clergyman of the town', according to Bayley's obituary in the *Christian Observer* 11 (1812), p. 478; identified as Assheton by James Everett: JRL, Methodist Archives, uncatalogued volume of Manchester Methodism notes, p. 445.

campaigning for civil rights and attacked the Church of England. This also alienated orthodox Baptists and Congregationalists.[116]

In Manchester, a meeting of Protestant Dissenters in December 1789 urged a petition against the tests. But in February 1790 there was a protest against the campaign by the Chester diocesan clergy, including the warden and fellows and other Manchester clergy. The same month there was a requisition by seventy-four members of the Church of England against the Dissenters' petition for its 'impropriety' given that the Test and Corporation Acts were the 'great bulwark … of our Glorious Constitution' in 'Church and State'. This cause was celebrated with toasts at dinners to the 'real friends of the town and neighbourhood, members of the Established Church and firm in the Old Cause'.[117]

In July 1791, Priestley's chapel and home in Birmingham were destroyed by a 'Church and King' mob. Manchester was temporarily saved from this as the boroughreeve was Thomas Walker, a reformer and (though an Anglican) a supporter of Dissenters' civil rights. He had won popularity in the town for opposing Pitt's fustian tax in 1784–75.[118] Church and King clubs were set up and typically toasted the upholding of the Tests as 'the bulwark of our happy Constitution', 'stability to the Collegiate Church of Manchester and prosperity to its ministers', 'the Rump in its right place – behind'.[119] Then, in June 1792, the Cross Street and Mosley Street chapels were attacked by a mob using trees uprooted from St Ann's Square as battering rams. In December, the offices of the radical *Manchester Herald* were attacked.[120] Innkeepers refused accommodation for reformers and several reformers were indicted for conspiracy but acquitted.[121]

116 See G. M. Ditchfield, 'The Parliamentary Struggle over the Repeal of the Test and Corporation Acts 1787–90', *EHR* 89 (1974), pp. 551–77; and especially his 'The Campaign in Lancashire and Cheshire for the Repeal of the Test and Corporation Acts 1787–90', *THSLC* 133 (1983), pp. 109–38. For local activities by Baptists and Congregationalists, see MCL, MS 185, Broadside F1790/2/D.

117 CL, W. R. Hay Scrapbook 1, pp. 40, 55; *MM*, 15 December 1789; 2, 9, 23 February 1790.

118 V. A. C. Gatrell, 'Incorporation and the Pursuit of Liberal Hegemony in Manchester 1790–1839', in Derek Fraser (ed.), *Municipal Reform and the Industrial City* (Leicester: Leicester University Press, 1980), p. 32. For Walker and what follows, see Pauline Handforth, 'Manchester Radical Politics 1789–94', *TLCAS* 66 (1956), pp. 87–106; Frida Knight, *The Strange Case of Thomas Walker* (London: Lawrence and Wishart, 1957).

119 *MM*, 5, 6 March 1792.

120 For Church and King mobs, see George Rudé, *The Crowd in History* (New York: Wiley, 1964), pp. 135–48.

121 Knight, *Walker*, p. 153; Gatrell, p. 33; Archibald Prentice, *Historical Sketches and Personal Reminiscences of Manchester* (London: Frank Cass, 1970; first publ. 1851), pp. 419–28.

The clergy, and notably the College clergy, were conspicuous in 'loyal' addresses and organizations against reform. For example, one in December 1792 headed by James Ackers (a regular lay leader in the church and loyalist interest) was signed by the boroughreeve and constables, along with Gatliff, Ethelstone, and James Bayley among the fellows.[122] A loyalist song to the tune of 'Rule Britannia' reflects horror at the French Revolution, with the refrain: 'We Britons still united sing / Old England's glory "Church and King".'[123] An Association for Preserving Constitutional Order and Liberty 'against the vain efforts of levellers and republicans' was founded in which Gatliff, Bayley, and Griffith of the Collegiate Church were active.[124] The boroughreeve refused a request for a town meeting against the sedition bill of 1795 and a counter-petition was signed by Dorning Rasbotham of the College.[125] Faced with all this hostility, aggravated by war and revolution, would-be reformers appeared crushed for a generation. Dissenters and Roman Catholics hastened to sign and publish declarations of loyalty.[126] One vehicle for reformers' continuing action was a peace petition signed by them along with Dissenters and Quakers, but this was countered by one signed by several of the College and other clergy.[127]

It has been argued by Professor Gatrell that Manchester reformers gained a coherent outlook and ideology through the network of family and business interests and the moral and intellectual outlook of the Cross Street and Mosley Street Unitarian chapels. The Tories, he says, lacked this kind of close network. Their gentry were now effectively absent from the town, while the leading Tory manufacturers, such as the Peels and Birleys, were not physically established within the town, nor did they possess a common intellectual tradition. Rather, they drew strength from national ideological trends.[128] Gatrell nevertheless often refers to the 'high church and Tory' character of the ruling elite. It is arguable that they did possess a common ideology of 'Church and King' and associations with the Collegiate Church in particular. What is regularly observable is a body of prominent 'respectable' lay Tory loyalist manufacturers and merchants associated with the College clergy and holding offices in the Court Leet and as

122 *MM*, 11 December 1792; Hay 14, p. 146.
123 Hay Scrapbook 17, pp. 189–90.
124 *MM*, 12 December 1792, 14 January 1793; Prentice, *Sketches*, pp. 421–8.
125 *MM*, 8 December 1795.
126 *MM*, 1, 18 January 1793.
127 *MM*, 27 January, 3 February, 1 December 1795, in Hay Scrapbook 17, pp. 48–9.
128 Gatrell, 'Incorporation', p. 129.

churchwardens and overseers. Their signatures occur regularly in 'loyal' petitions and associations along with the clergy. They include men like James Ackers, Thomas Jackson, C. F. Brandt, Nathan Crompton, and James Billinge, lesser men than the Peels and Birleys but well embedded in the town's affairs. They congregated in John Shaw's punch house, where the toast of 'Church and King and down with the Rump' was apparently still being used throughout the nineteenth century.[129]

It is true that there were still institutions and organizations which were able to obtain support from all parties and religious denominations, though sooner or later they too were liable to be affected by partisanship. A prime example is the town Sunday school organization, set up on an undenominational basis in 1784 and promoted by the town officials following the well-publicized example of Robert Raikes of Gloucester. Even Roman Catholics were included. The motives behind this organization were often made plain. It was not simply for basic education; thus, Thomas Butterworth Bayley, a leading JP, philanthropist, and founder of the improved New Bayley prison, saw the Sunday school as 'one of the most probable means of diffusing sentiments of virtue and religion amongst the common people', especially since children employed on weekdays are on Sundays 'too likely to be idle, mischievous and vitious' [sic].[130] But obedience to their superiors, political loyalty, and accepting the status and role given to them by God were equally important. A correspondent of the *Mercury* in 1789 warned that careful supervision was necessary to ensure 'regularity' and 'order', and above all 'the principles of industry, morality and virtue' needed to be instilled in young minds, especially those of young females at a time of life when they were beset by 'snares'.[131] But we shall see that the organization broke up on sectarian lines in 1800 and by the time of Peterloo in 1819 there were claims that teachers and pupils were wearing radical political favours.

The anti-slave trade campaign also seems initially to have had broad-based support. Thomas Clarkson, during his tours of

129 Stancliffe, *John Shaw's*, p. 59.

130 CL, MS A.6.3, Sunday school minutes, 1 August 1785. For Bayley, see n. 133 below.

131 *MM*, 24 January 1789. On the movement in general, see T. W. Laqueur, *Religion and Respectability. Sunday Schools and Working-Class Culture 1780–1850* (New Haven, CT: Yale University Press, 1976). His claim that they represented working-class values rather than the imposition of middle-class ones has been challenged, e.g. by Malcolm Dick, 'The Myth of the Working-Class Sunday School', *History of Education* 9 (1980), pp. 27–41, but the ethos probably varied. For Manchester, see Alfred P. Wadsworth, 'The First Manchester Sunday Schools', *BJRL* 33 (1951), pp. 299–326.

investigation in 1787, preached in the Collegiate Church. Forty to fifty black people attended and he preached on the Israelites' liberation from Egypt.[132] Here he met T. B. Bayley, but also Thomas Walker and others soon to be local leaders agitating for parliamentary reform.[133] They were influential during the Manchester campaign, sponsoring some of the more controversial techniques of mass petitioning, lobbying MPs on their voting intentions, and supporting the sugar boycott.[134] There were, indeed, Manchester voices raised against the campaign by those involved in African trade. Campaigners claimed in 1787 that they had been open in terms of participation, but that their opponents had organized a counter-petition in secret. A sarcastic correspondent in 1792 asserted that one might as well boycott rum, mahogany, and cotton, as well as sugar, and live on cabbages.[135] Early support was certainly 'respectable', including Warden Assheton, the boroughreeve and constables, and other clergy in 1788.[136] But the Manchester anti-slavery committee was packed with radicals and Dissenters along with Quakers, the College clergy being conspicuously absent.[137] In the face of revolution and slave revolts, even Wilberforce and Clarkson were by now being damned along with political reformers as 'Jacobins'.[138]

The Manchester infirmary had also attracted all-party support, the leading Roman Catholic priest Rowland Broomhead being prominent on the committee for many years. It expanded to include provisions for lunatics, pregnant women, and fever patients, as well as out-patients. But it has been persuasively argued that tensions arose as newcomers, often Dissenters and educated in Scotland, looking for appointments and interested in public health, came up against established medical families like the Halls and Whites, politically as well as medically conservative and allied with the Collegiate clergy. Newcomers like Dr Ferriar were linked with Cross Street chapel.[139] In 1788–92, the disputes

132 Thomas Clarkson, *History of the Rise, Progress and Accomplishment of the Abolition of the African Slave Trade* (London: Longman, 1808; repr. London: Frank Cass, 1968) vol. 1, pp. 418–25, 452–3.

133 *ODNB*, *s.nn.* 'Bayley, Thomas Butterworth (1744–1802)', 'Walker, Thomas (1749–1817)'.

134 Roger Anstey, *The Atlantic Slave Trade and British Abolition 1760–1810* (London: Macmillan, 1975), pp. 79–80, 272; E. M. Hunt, 'The North of England Agitation for the Abolition of the Slave Trade' (MA dissertation, University of Manchester, 1989).

135 MCL, Broadside Collection, F1787/3/Mcr; *MM*, 3 April 1792.

136 *MM*, 15 January 1788.

137 *MM*, 1 January 1788, 1 February 1792.

138 Anstey, *Atlantic Slave Trade*, p. 277.

139 J. V. Pickstone and S. V. F. Butler, 'The Politics of Medicine in Manchester 1788–92: Hospital Reform and Public Health Services in the Early

were over expanding staff, home-visiting, and provision for fever. Those opposed to innovation tended to have associations with the contemporary reaction against all kinds of reform. There was a further dispute in 1796 over the siting of a fever hospital. It has been claimed that this was purely over concern about whether to locate it near a populous area, but it looks as though it was the College clergy and their politically conservative supporters who were opposing the scheme.[140]

The Literary and Philosophical Society, founded in 1781, is another instructive example. It has often been seen as a vehicle for applying practical science to local industry. On the other hand, it has been argued that it represented a bid by non-Anglican and non-traditionally educated people attempting to create an alternative culture.[141] It is certainly noticeable that the society met on Cross Street premises and was full of Cross Street men. Only a handful of Anglican clergy were members and only the chaplain Joshua Brookes from the College, though early members also included the Anglican Hall and White medical families.[142] Gatrell argues that early Cross Street members with progressive political views were frightened off by the conservative backlash, and by 1805 Tory and church supporters like the Peels and Birleys were admitted, as well as local worthies of all sorts with general cultural interests. However, the Portico Library (founded in 1806) appears to have been dominated by Unitarians associated with Cross Street.[143]

It was not only reformers who suffered from 'Church and King' loyalism. In 1801 and 1811, there were attempts to limit toleration of Methodist and other rural itinerant preachers.[144] Yet, as in 1795 so in 1808, peace petitions were supported by veteran reformers and others and opposed by the College and other clergy.[145] There was also the intriguing campaign of Thomas Battye

Industrial City', *Medical History* 28 (1984), pp. 227–49.

140 *Cowdroy's Manchester Gazette*, 23 April 1796; Pickstone and Butler, 'Politics of Medicine', p. 247, see the parties as in the earlier dispute, but W. P. Povey and D. Abst, 'The Manchester House of Recovery 1796', *TLCAS* 84 (1987), pp. 15–48, see the dispute as purely over siting in a populous area.

141 Arnold Thackray, 'Natural Knowledge in Cultural Context: The Manchester Model', *American Historical Review* 69 (1974), pp. 672–709.

142 *Complete List of Members and Officers from its institution on February 28th, 1781, to April 28th, 1896* (Manchester: Literary and Philosophical Society, 1896).

143 Gatrell, 'Incorporation', pp. 32–3; Brenda J. Scragg, *Portico 1806: The Founding Fathers* (Manchester: Portico Library, 2005).

144 W. R. Ward, *Religion and Society in England 1790–1850* (London: Batsford, 1972), pp. 52, 57–62.

145 *MM*, 27, 29 January 1795; 5, 12, 15 March 1808; *Cowdroy's Gazette*, 5, 12, 19 March 1808.

against the churchwardens and overseers of the poor for their failure to keep proper accounts and to collect leys effectively. He also claimed that Richard Unite, the deputy constable, had paid the poor in 'counterfeit copper', citing the evidence of Gatliff, fellow of the Collegiate Church.[146] Battye disclaimed any 'party or political motives', his 'concern being solely for justice'.[147] But it is significant that a rather mysterious body of 'Associated Ley-payers' reported abuses in 1794, and they included Dissenters and others who had supported the peace petition of 1795 and a protest against Pitt's repressive Convention Bill of that year.[148] Battye himself directly attacked the College clergy for appointing a corrupt agent to collect Easter dues from the poor. He also noted that their stipends (which he claimed amounted to £5,000) exceeded the scale laid down by the Charles I charter and that the chaplains charged excessive burial fees from the poor.[149]

So, what was their income? Battye exaggerated, for the bursar's accounts for 1800 show a gross income of £1,851 1s 0d and net £1,592 1s 0d.[150] In the 1790s, it had been £2,129 in 1796 at its highest, the warden's dividend varying from £509 to £605 and the fellows' from £254 to £302. The yield from ninety-nine-year leases had suddenly jumped from £30 10s 0d to £302 per annum in 1796. In 1803, they provided 21 per cent of total income and would rise even higher later. How the warden and fellows had used the income for the benefit of the town since the founding of St Mary's is unclear. Certainly, they regularly supported collections for the poor by (for example) easing the price of grain in 1799.[151] But the soup shops in years of need were organized by the ley-payers led by the boroughreeve and apparently did not involve the clergy, although they regularly contributed to other charities of this kind.[152]

We are now entering a period in which there were more signs of disaffection towards the church and clergy, including

146 For a full account, see Hindle, *Provision for the Poor*, pp. 52–76; His main writings are in CL, volume 4c6–31.

147 Thomas Battye, *A Disclosure of Parochial Abuse, Artifice, & Peculation in the Town of Manchester* (Manchester: J. Thomson, 1796), p. 106, in CL, 4c6–31(1).

148 John Harland (ed.), *Collectanea relating to Manchester and its Neighbourhood at various periods, Vol. II*, CS os 72 (Manchester: Chetham Society, 1867).

149 T[homas]. B[attye]., *Concise Exposition of Tricks and Artifices used in the Collection of Easter Dues* (Manchester: Graham, Hopper, Thomson and Boden, 1800), pp. 3–5, 8, 19–20, 22–4, in CL, 4c6–31(7).

150 MCA, MS CE4/1/2, for 1800 and other years stated.

151 *MM*, 31 December 1799, prints a subscription supported by the warden, three fellows, and a chaplain.

152 *MM*, 8 January 1799; Hindle, *Provision for the Poor*, 90–105, 106–28.

the College clergy, expressed either verbally or by absence from worship. For despite the apparently overwhelming backlash against Dissenters and reformers, Church and King mobs, and repressive legislation, the clergy evidently felt that the church and religion itself were under threat and being abandoned by the lower orders. W. R. Ward argued that the 1790s saw a series of crises in religion as well as in politics. There was 'a swelling tide of anti-establishment sentiment in popular religion' and pressure on the 'denominational order' not only of the established Church but also on Methodism. In the towns this shows in the breakup of the undenominational Sunday school organization; in the countryside (the Anglican heartland) in lay itinerant preaching. Methodism drifted away from its links with the Church of England (though not all Methodists approved), and in 1795 a local option was given for Methodists to receive sacraments from their own preachers instead of the parish church. That year also saw the last Church and King mob in an outlying Manchester township.[153] This was in Failsworth in Newton chapelry, where Presbyterians were attacked with cries of 'Down with the Rump' and 'You are Jacobins, Paineites and Presbyterians'.[154] The old war-cry 'the Church in danger' could still be raised in 1796, though it appears that 'Church and King' graffiti had been replaced with radical slogans by 1800.[155]

Like other apparently non-partisan organizations, the town Sunday school was split in 1800, divided by denominational and (some have argued) political tensions.[156] There were already worries in 1793 when there was a resolution to discharge any teacher 'found to be disaffected to the present government'.[157] In 1800, Bishop Horsley was denouncing non-Anglican schools as 'jacobinical'.[158] The breakup of the Manchester organization in 1800 has been variously explained. The campaign to set up a separate Church of England organization was not led by the College clergy but by the ex-Methodist Cornelius Bayley (by now rigidly Anglican and pro-establishment) and C. P. Myddelton (allegedly also an evangelical, but this is unlikely as he was a curate at St Mary's). Laqueur plays down political motivation, seeing some Anglicans as opposing separation and seeds of separation

153 Ward, *Religion and Society*, pp. 27, 39–40.
154 H. T. Crofton, *A History of Newton Chapelry in the Ancient Parish of Manchester*, 3 vols in 4, CS ns 52–5 (Manchester: Chetham Society, 1904–5), vol. 1, p. 197.
155 *Cowdroy's Gazette*, 20 August 1796; Kidd, *Manchester*, p. 84.
156 Ward, *Religion and Society*, pp. 40–3.
157 CL, MS A.6.3, Sunday school minutes, 7 July 1793.
158 Charge quoted in Ward, *Religion and Society*, p. 41.

as being present from the first because Dissenters were allowed to attend their choice of chapel. The Anglicans then set up their own organization and the old town schools became largely controlled by Methodists.[159] Although the College clergy were not directly involved in the breakup and had not been conspicuous in the old organization, the warden was president of the new Anglican one, with a committee including the boroughreeve and constables. They also benefitted when, after 1800, there was an annual show of Anglican strength in the form of the Whit walks, when Church of England children paraded from St Ann's Square to the Collegiate Church. Immediately after the breakup, Anglican children totalled only 2,500 but numbers increased to 7,000 later.[160]

What increasingly concerned the clergy, however, was the fall in church attendance, particularly by the lower orders. In 1796, a letter from the Manchester clergy, including James Bayley, Maurice Griffith, and Joshua Brookes of the Collegiate Church, complained that 'at least two-thirds of Manchester and Salford's population' (they thought 40–50,000 out of 70,000) 'absent themselves totally from services', and that even middle-class attendance was declining. They attributed this to infidel literature. Significantly, they saw this as a 'flagrant abuse of the civil as well as the divine order'.[161] One response to this was a letter with 'A few Friendly Hints to the Officiating Clergy of Manchester'. This claimed that absences were unlikely to be due to infidel writings but rather to inconsistency between the lives of the clergy (the warden and fellows evidently being in the writer's mind) and the doctrines of Christ – that is, his 'humility and poverty'.[162]

The 1789 episcopal visitation return from the College had claimed optimistically that 'our people in general duly attend' and 'no one is suffered' to be in the streets or public houses during worship. 'Regularity and discipline' (it was claimed) was not exceeded in any similar town. The returns from outlying villages were very different. The Curate of Birch complained that, although the farmers attended, 'the lower sort of mechanics' had little regard for religion or Church attendance.[163]

The report in 1804 for the Collegiate Church from the well-informed Joshua Brookes was much more realistic. He gave broadly accurate figures for non-Anglicans (including 2,000 Methodists and 10,000 Roman Catholics). Despite them, he

159 Laqueur, *Religion and Respectability*, pp. 66–8, 310.
160 *MM*, 8 July 1800; Bardsley, *St Ann's*, p. 127 and Appendix II for Whit walks; Wadsworth, 'First Manchester Sunday Schools', p. 319.
161 *MM*, 15 November 1796.
162 *Cowdroy's Gazette*, 18 February 1797.
163 CALS, EDV 7/2, pp. 136, 143.

hoped 'it may be said "Fear not, O little flock" to our Established Church'. He blamed the growth of Dissent on an influx of sects attracting those moved by 'curiosity' and 'itching ears'. There were non-attenders owing to 'idleness' and 'indifference'. But, most interestingly, he also identified a category of those 'of a sober tone and [who] mind their own business yet disregard public worship, who talk of *Inward Religion*, of the Kingdom of God within them etc., such as Mystics, Swedenborgians, readers and admirers of Jacob Behmen, Madame Bourignon, Madame Guyon and others of that class, and of the Rev. William Law'.[164] Mysticism was a longstanding Manchester tradition, evident in Byrom and his circle but extending lower in the social scale. John Clowes, the Rector of St John's, which had been founded by Byrom's son, was also a Swedenborgian and one of his curates left to found the Swedenborgian Bible Christian sect in Salford. Then there was the prophetess Ann Lee, founder of the Shakers, who had disturbed worship in the Collegiate Church, been imprisoned, and emigrated to America in 1778, where circumstances favoured an expansion denied to her in England.[165]

But it was the chapelries that suffered most from the perceived decline in religious observance, with a variety of reasons being given. Most revealing are the reports from Denton and Heaton Norris. In Denton, due to the prevalence of manufacturing, it was reported that the 'lower classes are very immoral and depraved' and 'daily receding from the sobriety, innocence and simplicity of manners' of 'the peasantry', who were 'principally employed in agriculture'. In Heaton Norris the problem was lack of accommodation in a chapel holding three hundred for a population of four thousand, while the Methodists met in homes and were overseen from Stockport, just over the parish border.[166] There was also criticism of the clergy for 'political preaching', to which the stock response was that if preaching loyalty to the King and those in authority over us was 'political', then so were the writings of St Peter and St Paul. It was becoming common in this period for clergy to serve as magistrates, but bishops seem to

164 CALS, EDV 7/3, p. 325.

165 For a survey of such devotees in 1775, see [Christopher Walton], *Notes and Materials for an adequate Biography of the celebrated divine and theosopher William Law* (London: n.p., 1854), pp. 595–6; J. F. C. Harrison, *The Second Coming* (London: Routledge, 1979), p. 233 n. 32; Theodore Compton, *Life of Rev. John Clowes 1743–1831* (London: James Spiers, 1898); Peter J. Lineham, 'The English Swedenborgians 1770–1840' (DPhil dissertation, University of Sussex, 1978); for the Shakers in context, see Clark Garrett, *Spirit Possession and Popular Religion* (Baltimore, MD: Johns Hopkins University Press, 1987).

166 CALS, EDV 7/3, pp. 156, 232.

have been more concerned about the propriety of clergy serving in the volunteer militia recruited for fear of invasion from abroad and subversion at home, though in Manchester as elsewhere they often served as chaplains.[167]

What should be the church's response to criticism and failure to attend worship? Already in the 1740s in Manchester we have seen that the church courts were becoming inoperative. Perhaps the secular arm would be more effective. A prime target for compulsion was Sabbath-breaking, which was viewed as a major symptom of public indifference to religion and morality and even as threatening divine judgement on the nation in time of war. One motive for founding Sunday schools was to keep children off the streets, and in the 1790s the Sunday school committee urged the town authorities – boroughreeves, constables, churchwardens, overseers – to clamp down on Sabbath-breaking and to force parents in receipt of poor relief to send their children to the schools.[168]

The clergy explained the heinousness of the sin as inviting the wrath of God and even defeat in war. Brookes and other clergy in 1802 urged the town officials to suppress offenders. These officials described a range of offences: cock- and dog-fighting, gaming, shops and public houses opening, and streets full of people during service hours.[169] After the complaints in 1796 about non-attendance, the 'Associated Clergy of the Towns of Manchester and Salford' set up 'lectures' in several churches, presumably on Christian apologetics, following their attribution of absence to 'infidelity'. These continued for several years.[170] After 1800, as we shall see, voluntary organizations for propaganda and education and free seats in churches became the favoured means to attract the absentees.

What about worship? The statutory services continued according to the charter, although we shall see that the future canon C. D. Wray in 1809 thought poorly of their quality. Communion attendance had been steadily falling for years. From 200 in 1778 'regularly attending', it had sunk to 'usually 100' in 1789. The annual total of over 15,000 in 1765 had fallen to just over 3,000 in 1802 (an average of around 60). Unfortunately, Brookes did not give the numbers in 1804, only remarking that they were 'about the same', though probably lessening due to the absence

167 Hay Scrapbook 7, p. 86.
168 CL, MS A6.3, Sunday school minutes, 2 March 1789, 2 January 1792, 1 May 1797, 3 September 1798.
169 MM, 25 April 1795, 28 August 1798, 16 May 1799, 7 July 1801; Hay Scrapbook 16, p. 243; Scrapbook 17, pp. 96–7; MM, 29 June 1802.
170 MM, 24 April 1798 and regularly thereafter.

of the Methodists. Catechizing was not often performed as the chaplains had too many baptisms to perform, but children were prepared for confirmation.[171] What is striking, however, is that all the new churches of all parties had monthly communions and daily prayers during the great festivals. In his important study of regional variations in worship, F. C. Mather cited these phenomena as features of areas like Lancashire including Manchester.[172]

The orthodox and conservative theological tone of the College clergy may be gauged from two anecdotes. It is said that the possible election of Samuel Hall as a chaplain was blocked because he had omitted the Athanasian Creed at a volunteer service in deference to the Unitarian views of its colonel. Aynscough told Hall that the College clergy always recited the creed on the appropriate occasions. Hall, a low churchman, had St Peter's built for him because of this.[173] The other story is that in 1798 Thomas Garnett, the last but one of the Manchester Non-juror bishops, sent the College clergy copies of Deacon's liturgy and prayers, which they said they would be glad to use but could not except by permission of all the bishops.[174] The clergy listed include Gatliff and Brookes but also the evangelical Cornelius Bayley, an improbable admirer of 'primitive Catholic' liturgies, despite his earlier association with John Wesley, that disciple of Dr Deacon in his distant Oxford period.

The diligence of a chaplain like Brookes was exemplary. The fellows at least mostly resided in the town and in this period did not incur penalties for exceeding their allowance of absence – apart from the warden, who was Rector of Middleton and apparently resided there for several years, although he was later accused of allowing his rectory to dilapidate.[175] Beyond their ecclesiastical duties, several of the College clergy in this period were magistrates and the hostility this excited in the next few years will be considered below.

171 CALS, EDV 7/1, p. 148, question 6 (1778); EDV 7/2, p. 136, question 8 (1789); EDV 7/3, p. 325, question 6 (1804); MCA, CW1/Sch1/1, charity school accounts, for communion attendance.
172 F. C. Mather, 'Georgian Churchmanship Reconsidered', *JEH* 35 (1985), pp. 255–83.
173 Raines, *Fellows*, vol. 2, pp. 270–1.
174 Henry Broxap, *The Later Nonjurors* (Cambridge: Cambridge University Press, 1924), pp. 287–8, quoting a letter of 1837.
175 MCA, MS CE4/1/1–2, Bursar's accounts 1784–1800; Raines, *Rectors and Wardens*, vol. 2, pp. 172, 173–4.

Challenge and response, 1804–29

In these years, the town continued to expand; the population rose from 70,409 in 1801 to 79,459 in 1811 and 108,016 in 1821.[176] War until 1815 and trade fluctuations and depressions thereafter continued to provoke unrest, trade union activity, and then processions and meetings for parliamentary reform. Church and King mobs had ceased since 1795 although Church and King clubs continued. Their toasts included 'The Established Church' and 'The Archbishop of Canterbury and clergy of the United Kingdom'.[177] The 'Association for Protecting Liberty and Property against Republicans and Levellers' had so declined that it could not form a committee at a meeting still attended by Gatliff of the Collegiate Church in 1799.[178] However, the Manchester Pitt Club was founded in 1812 and its initial membership of 192 included 31 clergymen, among them W. R. Hay (a leading magistrate and later to be prominent at Peterloo), Warden Blackburn, all the fellows, and the clerk-in-orders C. D. Wray, with Gatliff, Ethelstone, and Wray on the committee. By now Pitt's policies had been misleadingly mythologized.[179] The last food riot in 1812 had followed cancellation of a meeting to congratulate the Prince Regent for retaining a conservative ministry; later agitations were for political reform and suppressed with the help of the military whose barracks encircled the town.[180]

Yet on the face of it the old rulers of the town retained control through the Court Leet, the churchwardens, and the overseers. The newer Police Commissioners were essentially controlled by sections of the same elite, and since it included the borough-reeve, constables, and warden and fellows *ex officio* it did not seem at first to challenge the Court Leet's authority. But from 1807 it became the most important governing authority in the town, especially under the treasurership of Thomas Fleming from 1810–19, aided by deputy-constable Nadin, much hated by reformers.[181]

Whigs, reformers, and Dissenters had to keep their heads down. Nevertheless, there was what Prentice called 'a small but determined band' of would-be reformers who met in the Unitarian Potter brothers' warehouse from 1815. They were part of

176 Figures for the township only: Thomson, *Manchester*, pp. 262, 277, 311.
177 *MM*, 9 March 1802, 8 March 1803.
178 Prentice, *Sketches*, p. 428.
179 *Ibid.*, pp. 429–30; Sack, *Jacobite to Conservative*, pp. 89–90, 101.
180 Kidd, *Manchester*, pp. 77–8, 84–5.
181 Fleming was the first treasurer not to be a member of the Court Leet: Thomson, *Manchester*, pp. 275–6.

a new generation of merchants and manufacturers entering the town between 1810 and 1815, predominantly associated with Dissent. Beginning with opposition to supporting new churches from the rates, they advanced to major campaigns in the second quarter of the century which transformed the government and ruling elite of the town.[182]

In all this, however, it must be emphasized that if the Collegiate Church's power to control events with popular as well as official support was declining, it still had a significant role as part of the public collective identity of the town. A partial comparison can be made with the vivid evocation by Professor McManners of the pre-revolutionary cathedral town of Angers. He wrote that 'Everywhere in Angers one could hear the music of bells ... carrying messages of exhortation, invitation and warning.'[183] On a more modest scale Manchester, whilst lacking the proliferation of churches and religious houses in Angers, experienced in daily life the familiar sound of the Collegiate Church and other bells. Wray, recollecting worship in 1809, lists the sequence of warning bells for daily services, and the role of the College's clock was recorded affectionately by Canon Parkinson.[184] The bells rang for weddings and funerals, fast days, bishops' visitations, celebrations of victories, and (after Trafalgar) a mixture of celebration, relief, and mourning in November 1805. For that event a subscription was raised for the injured sailors and widows, to which the College clergy contributed. A thanksgiving service took place in the Collegiate Church with a 'mourning peal of bells'.[185] A 'muffled peal' was rung for the annual commemoration of King Charles the Martyr to 'commemorate his unhappy fate', and bells were even rung to celebrate the passing of a Street Improvement Bill.[186] There were also several companies of change-ringers who performed in the Collegiate Church as residents or guests. In August 1810, 'the select set of Manchester

182 Leon S. Marshall, *The Development of Public Opinion in Manchester 1780–1820* (Syracuse, NY: Syracuse University Press, 1946), and table of newcomers, p. 224; Donald Read, *Peterloo: The Massacre and its Background* (Manchester: Manchester University Press, 1958); Donald Read, *Press and People 1790–1850* (London: Arnold, 1961); Gatrell, 'Incorporation', pp. 35–7; Kidd, *Manchester*, pp. 60–2.

183 John McManners, *French Ecclesiastical Society under the Ancien Regime: A Study of Angers in the Eighteenth Century* (Manchester: Manchester University Press, 1960), p. 12.

184 Wray, 'Early Recollections', in *A Memoir of the late Rev. C. D. Wray*, edited by Henry Wray (Winchester: Jacob and Johnson, 1867), pp. 155–7; Richard Parkinson, *The Old Church Clock* (London: Rivington, 1852), p. 84.

185 *MM*, 12 November 1805 to 14 January 1806.

186 *MM*, 7 February 1815, 10 July 1821.

Collegiate Church
from Smithy
Door in 'Views of
Ancient Buildings in
Manchester' by J.
Ralston, 1823–25

and Salford Bell-ringers' rang 5,640 changes in three hours and four minutes.[187]

Fast Days were frequent during the war, with exhortations to repentance and humiliation so as to avert the wrath of God in natural or military disasters. It was generally reported that churches were well attended and shops closed, though a more pessimistic note was struck in 1806, when the hope was expressed that services would be well attended as days for religious observance 'are in this licentious age by too many treated only with levity' and we need to 'implore the assistance of an all-wise and overriding providence in the present situation'.[188] In 1808, clergy, including Griffith, Gatliff, and Brookes of the College, issued a message saying that while war was always a problem for Christians, this war was 'not just a threat to peace and trade but against heaven and God'. It was essential to see God's hand in war and peace and bear afflictions patiently. Real Christians 'love King and country better than themselves and God above all'.[189]

Parades of volunteers were a feature of the war years, and 'loyalty' was demonstrated by subscriptions to the war effort and addresses to the King thanking him for defending the constitution in church and state (i.e. opposing Catholic emancipation) in 1807, and to the Regent in 1812 for keeping a conservative ministry. All this was well supported by the warden and fellows along with the Pitt Club in 1812. Here the toasts included: 'may the dreams of universal suffrage and annual parliaments no longer disturb our repose' and one to the memory of Pitt as 'the support of our constitution in Church and state'.[190]

C. W. Ethelstone, fellow and magistrate, weighed in with his *Patriotic Appeal to the good sense of all Parties* (1817) claiming that 'the present form of our government is the most perfect of any in existence with each class acting as a check on the other'. The effects of other constitutions were shown by the French example.[191] Wray attempted a dialogue in the style of the leading Evangelical author Hannah More in his 'The Street Politicians', between two weavers, Will, a reformer, and Thomas, a supporter of the existing order.[192] In the campaigns for and against the

187 *MM*, 28 August 1810.

188 *MM*, 25 February 1806. Other examples in *MM*, 11 February 1801, 25 October 1803, 14 February 1809.

189 *MM*, 16 February 1808.

190 *MM*, 5 May 1807, Prentice, *Sketches*, pp. 428–30.

191 An Antijacobin, *A Patriotic Appeal to the good sense of all Parties in the Sphere of Politics* (Manchester: C. Wheeler, 1817), in CL, 4.C.5.4(30) with MS note identifying the author.

192 *The Street Politicians, or, a debate about the Times* (Manchester: J. Aston, 1817), in CL, 4.C.5.4 (20) with MS note identifying the author.

treatment of the Queen in 1820 (estranged from the King, under investigation for her conduct, and barred from the coronation), the *Morning Chronicle* noted that Dissenting ministers had been supporting her, so there should be no more talk of the 'impropriety' of 'political sermons' from Anglican clergy. Christian politics is 'honouring the King' and 'not meddling with those given to change'.[193] This was in response to a request for a town meeting to plead for an end to proceedings against the Queen, signed by the reforming Potters and the veteran reformer Dr Mitchell. It was opposed by several of the fellows of the College, Wray, other clergy, and H. H. Birley, Tory cotton merchant and future leader of the yeomanry at Peterloo.[194] The College clergy also supported continuing the wartime property tax against reformers wishing to end it.[195]

Although attempts to restrict the Toleration Act in 1801 and 1811 were foiled with Wilberforce's help, the College helped to fend off Catholic emancipation for the time being. A petition against it to the Bishop of Chester was signed by forty-one out of forty-two Manchester clergy, the missing one being accidentally absent.[196] Significant, too, was the presence of the Orange Order in Manchester, which was in some respects a conservative (Tory) political front. It was supported by Ethelstone in a sermon in 1807.[197]

The College clergy continued to perform their religious duties as before. Warden Thomas Blackburne was appointed in 1800. A member of the county gentry, he was promoted by the influence of his brother John, for many years an MP for Lancashire. The Warden was also a Cheshire magistrate.[198] Croxton Johnson and J. H. Mallory (also the Rector of Mobberley) were usually absent for about one hundred days a year above their allowance, but Ethelstone and John Clowes for only a few days and Gatliff also, except in 1819–20 when he was probably suffering from ill-health. Clowes had an estate at Chetham Hall in Broughton and retired there to cultivate his plant collection in 1833.[199]

193 Hay Scrapbook 11, p. 24.
194 *Ibid.*, p. 15; *MM*, 12 May, 21 November, 5 December 1820; *Cowdroy's Gazette*, 21 October 1820.
195 Hay Scrapbook 4, pp. 417–18 (really 317–18); *MM*, 5 March, 12 May 1816.
196 Ward, *Religion and Society*, pp. 52, 54–61; *MM*, 5 May 1807, 11 May 1819; Read, *Peterloo*, p. 27.
197 *MM*, 5 May 1807, 9 November 1813, 18 January 1814.
198 Raines, *Rectors and Wardens*, vol. 2, pp. 176, 178.
199 Absence fines in MCA, CE4/1/2, Bursar's accounts; Raines, *Fellows*, vol. 2, pp. 300, 317, 324, 325, 328.

Chetham's Hospital and Library in James Ogden's *Manchester 200 Years Ago*

As to their income, from 1801–10 the warden received between £517 (1801) and £1,261 (1807), the fellows each between £272 and £630. In 1811–20, the warden received between £688 (1820) and £1,245 (1815), the fellows between £344 and £622. In 1821–30, the warden received between £587 (1830) and £1,132 (1826), each fellow between £293 and £586. The total

gross income in these years ranged from £1,962 (1801) to £4,443 (1807) and net from £1,633 to £3,782.[200]

The most powerful personalities in this period appear to have been Gatliff and Ethelstone, the latter also being a magistrate – as was Mallory. Gatliff was a lifelong supporter of Pitt and his principles, active in the Pitt Club, frequent signatory to 'loyal' declarations, and a leading local opponent of Catholic emancipation. He is said to have dashed from officiating in St Mary's to preach at the Collegiate Church, followed by much of his congregation, being termed an 'itinerant preacher' by the eccentric Brookes. As a competent man of business, he tended to dominate the chapter and his colleagues. He lived for many years in his Didsbury parsonage, which his wife called her 'hermitage', and the historian of the fellows, Raines, delicately remarked that he 'did not always seek his happiness in domestic ties'. By 1840 and in ill health, he disliked Manchester and had not resided there for many years.[201]

Clerical magistrates were significant among the fellows in these years. Of a slightly earlier generation were the Griffiths, father and son (Maurice died in 1798, John in 1809). C. W. Ethelstone then became prominent. He had the reputation of being a wit 'fertile in coarse humour after the manner of Rabelais and Hogarth'. Of a servant girl found drunk in a cellar who claimed before a magistrate to be looking for a spirit, Ethelstone remarked: 'No doubt you met with the *spirit of the cellar*.' He also wrote poetry, and among other things a sermon on the unity of the church (apparently against the Methodists) as well as the 'Patriotic Appeal'.[202]

More picturesque was J. H. Mallory, also a magistrate and an example of the notorious fox-hunting Cheshire clergy who earned the disapproval of the reforming Bishop Blomfield. Meeting a crowd of 'black-coated Nimrods' talking of dogs and horses, he heard Mallory boasting of a horse on which he rode sixty miles non-stop on the Great North Road. To this Blomfield cuttingly responded that he had heard this said of 'Turpin the highwayman'.[203] Blomfield also disapproved of clergymen holding secular jobs (though it is unclear whether this included magistracies). On his visitation to Manchester in 1825, he urged the clergy 'to wear their gowns and clerical hats, or at least the former, on Sundays' as it was 'very desirable that they should

200 MCA, CE4/1/2, Bursar's accounts.
201 Raines, *Fellows*, vol. 2, pp. 296–305.
202 *Ibid.*, pp. 305–19.
203 *Ibid.*, p. 332; further on Mallory, pp. 328–34.

keep up the appearance of ministers of the established Church in a place like Manchester'.[204]

A more favourable impression may be given of devotion to duty by C. D. Wray, who began in the Cathedral as a clerk-in-orders in 1809 but for several years doubled up for an ailing chaplain until being appointed chaplain himself in 1821 and fellow in 1830. Wray was a committed orthodox churchman and Tory keen on developing the worship of the Collegiate Church and active in refurbishing the building in 1814–15.[205] Joshua Brookes, though equally dedicated, became an almost legendary figure for his eccentricities and irascible temper. He figures in Mrs Linnaeus Banks's *Manchester Man* as the Rev. Joshua Streamlet and in Parkinson's *Old Church Clock* as Joshua Rivers.[206] His household included a formidable housekeeper, her 'pert niece', two cats, three pigeons, and for a time a monkey, but also many books. He had much trouble with the Grammar School boys, and was uncouth in speech with a broad Lancashire accent. It is said that faced with the mass weddings common in the Collegiate Church it was once complained that he had married the wrong couple and told them to 'sort themselves out afterwards'. Yet he was also a dedicated and hard-working chaplain, although unfortunately so possessive of parts of the Collegiate Church that on at least three occasions he was suspended for rudeness to officials and colleagues.[207]

With regard to worship, Wray on his arrival in 1809 described the choral service as 'of the most meagre description'. The 6 a.m. service included the litany and a sermon with 200–300 attending. The 1804 visitation reported that this service was on Sundays from March to September, as did Aston in 1816, but the 1821 visitation states that it took place at great festivals.[208] Marriages were performed from 8 a.m. to 10 a.m. Morning Prayer began at 10.30 a.m. All the prayers were read and Wray stated in his 'Memoirs' that only in the last twenty or thirty years (apparently somewhere between 1815 and 1820) was any part chanted. On weekdays only the psalms were chanted and on Sunday even these were read, only part of the metrical psalms being sung. Wray

204 *Memoirs of Bishop Blomfield*, edited by A. W. Blomfield, 2nd edn (London: John Murray, 1864), pp. 84–5. See Blomfield, *Memoirs*, pp. 76, 80, for other comments by the Bishop on Manchester.

205 Wray, *Memoir*, pp. 21, 24–5.

206 Parkinson, *Old Church Clock*, pp. 252, 259.

207 MCA, Mancath/2/2/2, Chapter minutes, 8 January, 26 July, 12 November 1800; 9 February, 24 July 1809; 5 February, 31 December 1810; *ODNB*, *s.n.* 'Brookes, Joshua (1761–1833)'.

208 Wray, *Memoir*, pp. 9, 143; CALS, EDV 7/3, p. 325; Aston, *Picture of Manchester*, p. 67; CALS, EDV 7/6, p. 351.

says that Bishop Law (1812–24), at his first visitation, thought communion attendance so low that it should be reduced from the weekly celebration (which we have seen had been enjoyed since 1743 despite Peploe's objections) to monthly. However, he and Brookes (he said) persuaded Law to compromise at fortnightly, a weekly eucharist only being restored in 1849.[209] The 1821 visitation nevertheless still claimed a weekly eucharist, as had Aston in 1816.[210] That visitation also claimed that attendance at ordinary services was usually 3,000 (a full house), but surely this could not apply to every service. The clergy had complained in 1796 that only 20–30,000 attended worship. The figures Brookes gave in 1804 seem to show that about 17,500 Dissenters attended, and up to 3,000 Sunday school children, while Anglican attendance figures for 1821 were over 9,000 adults, nearly 17,000 including Sunday school children. By then, numbers of Dissenting meeting houses and attendances had certainly increased and they had 15,000 children in Sunday schools.[211] No figures were given for communion attendance in 1804 and 1811, but in 1821 the average attendance was 35.[212] The chaplains were certainly kept busy catering for the whole parish. Wray calculated that between 1809 and 1830 he had baptized 33,211 infants, celebrated 13,196 marriages, and conducted 9,996 burials.[213] The anecdote above about Brookes marrying the wrong couple was not simply an example of eccentricity. It was a scandal that 'couples from miles around who wished to marry in despite of the law and of family disapproval flocked to the Collegiate Church'.[214] Mass baptisms were equally common. Visiting in 1816, Henry Crabbe Robinson, thinking he heard a 'bleating of lambs', found a minister (probably Brookes) walking down a row of infants sprinkling each as he went.[215]

Despite reports of absence from church, there was still support for formal events like episcopal visitations and confirmations. In 1804 the Bishop confirmed 2,734 attendances, in 1811 7,181, in 1814 3,594, in 1817 4,424, though only 2,208 in the

209 Wray, *Memoir*, pp. 9, 58, 143–6, 150.
210 CALS, EDV 7/6, p. 317; Aston, *Picture of Manchester*, pp. 66–7.
211 *MM*, 15 November 1796; CALS, EDV 7/3, p. 325; 7/6, p. 351; Wadsworth, 'Sunday Schools', p. 326; *MG*, 5 May 1821.
212 CALS, EDV 7/6, p. 351.
213 Wray, *Memoir*, p. 36.
214 Ward, *Religion and Society*, p. 109.
215 Henry Crabbe Robinson, *Diary, Reminiscences and Correspondence*, edited by Thomas Sadler, 2nd edn, 3 vols (London: Macmillan, 1869), vol. 2, p. 17.

Collegiate Church.[216] The 1811 visitation recorded continuing problems in the country chapelries (returns for the Collegiate Church are missing). Once again there were complaints about the bad effects of working in factories and damaging moral influences on girls. Heaton Norris continued to complain about Methodist depredations from Stockport and its Sunday school.[217] The complaint of lack of accommodation, especially for the poor, became more common because the Manchester churches, except for the Collegiate Church, were filled with rented pews. Dissenters and Methodists multiplied their churches while no Anglican ones were built between 1804 and 1820. Gatrell says that in 1784 there were three Anglican churches to each Dissenting one, but by 1804 three to four.[218] Wadsworth states that by 1825 there was one Anglican Church to every two Dissenting ones.[219] The problem of lack of accommodation for the poor became a common alibi for their absence and hence there was pressure to build churches with free seats and to provide them in existing churches. The first such appear to have been part of the foundation conditions of St Michael's (1789), followed by St Stephen's, Salford (1794).[220] The 1821 visitation was the first to ask a specific question about free seats. By then all but St Ann's had some (St Stephen's had 200 seats free and 100 at a small rent). St George's (purchased to be a so-called 'free Church') had half its seats free but the rest had them in a distinct minority, mostly as benches in aisles or galleries.[221] There is no return for St Michael's but its consecration deed required seats for the poor.[222] Ironically, most of these churches were not, at this time at least, completely full, which would give ammunition to those opposing building more churches.

There were still pleas to the authorities to enforce Sunday observance. So far as they were effective, they tended to weigh most heavily on the poor. It was pointed out that paying wages on Saturdays forced them to shop on Sundays and encouraged shops to open then.[223] But during this period the most conspicuous efforts to influence the poor were through Bibles, tracts, and education.

216 *MM*, 24 July 1804, 9 July 1811, 20 July 1814, 26 August 1817, 11 August 1820. The larger figures appear to include other churches.
217 CALS, EDV 7/4, pp. 103, 116.
218 Gatrell, 'Incorporation', pp. 35–6, p. 463.
219 Wadsworth, 'First Manchester Sunday Schools', p. 319.
220 CALS EDA/2/8, p. 463; EDA/2/9, p. 214.
221 CALS, EDV 7/6/6, entries for each Church.
222 CALS, EDA 2/8, p. 463.
223 *MM*, 29 December 1818, 26 January 1819; *Manchester Observer*, 16 January 1819; letter on wages in *MG*, 29 September 1821.

The British and Foreign Bible Society, like the old town Sunday school organization, was undenominational and supported by all ranks of the great and good. In 1810, the Manchester branch was organized with Warden Blackburne in the chair, the fellows and Lawrence Peel as vice-presidents, and an Anglican and Dissenter as joint secretaries.[224] But Bishop Pretyman-Tomline of Lincoln, ever suspicious of Dissent, criticized the Society as insufficiently Anglican and recommended the old Society for the Propagation of Christian Knowledge (SPCK) instead, the Prayer Book being necessary as well as the Bible.[225] However, the highly orthodox Wray was still on the Bible Society committee in 1821.[226]

The Religious Tract Society (RTS) was distinctively evangelical and undenominational as its Manchester supporters revealed. In 1813, it claimed to have distributed 29,000 tracts during the previous year. The Independent (Congregationalist) minister William Roby described the Bible Society as the regular troops mounting the main assault while the RTS supporters were like auxiliary troops, 'a cloud of Cossacks, hovering and harrowing the rear'.[227] It is thus not surprising that Ethelstone chaired a meeting to set up a Prayer Book and Tract Society in 1814 with Warden Blackburne as President, the fellows as vice-presidents, and two of the Peels on the committee.[228] Later in the year a district committee of the SPCK was set up with the Earl of Wilton as patron, the Bishop of Chester President, Blackburne and Birley vice-presidents, and the committee including Ethelstone and two other fellows. Perhaps this replaced Ethelstone's proposed society.[229]

A similar division between high church and evangelical can be seen in overseas missions. A petition to Parliament in 1813 to open India to missions attracted 4,000 signatures, including Anglicans, Dissenters, and Methodists.[230] In 1815, a local auxiliary of the Church Missionary Society (CMS), an evangelical Anglican agency, was founded and in the same year a branch of the Wesleyan Methodist Missionary Society.[231] A delegation from London on behalf of the CMS was noticeably not invited to the Collegiate Church later that year.[232]

224 *MM*, 9 January 1810.
225 *Cowdroy's Gazette*, 24 June 1815.
226 *MM*, 10 October 1821.
227 *Aston's Exchange Herald*, 29 June 1813.
228 *MM*, 24 May 1814.
229 *MM*, 22 November 1814.
230 *MM*, 4, 11 May 1813.
231 *MM*, 14 February, 7 March 1815.
232 *MM*, 4 April 1815.

Formal education, above all, was coming to be seen as the panacea for instructing the lower orders in religion, virtue, loyalty, and diligence within their appointed place in society and the economy. We have seen that after the Sunday school break-up in 1800, the children's Whit walks demonstrated Anglican support, but a report in 1821, to be quoted below, would show that Anglican scholars were outnumbered by others.

Although Sunday schools were a necessity for child workers in a factory town, day schools were still desirable and once again demonstrated sectarian divisions. Along with the old Manchester Grammar and Blue Coat Schools and charity schools attached to churches, there now appeared a new type of school, employing monitors (who instructed the children under the eye of the schoolmaster). Lancasterian schools (named after Joseph Lancaster) were undenominational but in practice largely supported by Dissenters, and one was provided for Manchester in 1809.[233] By 1811, it was supported by J. E. Taylor, the founder of the *Manchester Guardian*, although also by Robert Peel junior, even after its Anglican rival was founded which adopted the Bell or Madras (later the National) system. A request to the boroughreeve and constables for a meeting to establish such a school explained that the promoters, especially the clergy, were 'impressed with a sense of the object imposed upon us, of providing for the instruction of the poor in the doctrines of our Church'. Knowledge of 'the national religion cannot be too early incorporated with the rudiments of education'. Supported by the warden and fellows, an organization was set up with the Bishop of Chester as patron, the Earl of Wilton as President, and the warden and fellows with laymen like Birley as vice-presidents.[234] Wray was prominent in this cause. In a pamphlet in 1812 he reported that there were now two schools with 449 and 619 pupils, and he claimed that it was appropriate to use the residue of the Loyal Fund raised during the war to support church schools as 'upholding the Establishment in Church and state'.[235] Another school was founded in 1806 for girls to 'remedy their degraded state' and prepare them for household service. Warden Blackburne, Ethelstone, and Gatliff all subscribed to what would become the Jubilee school.[236] In 1821, after criticism of a very incomplete parliamentary report of educational statistics, the *Manchester Guardian* published a detailed schedule for Manchester. This showed that there were

233 *MM*, 21 March 1809.
234 *MM*, 29 October, 26 November, 10, 17, 24 December 1811.
235 C. D. Wray, *Manchester National Schools* (Manchester: J. Aston, [1812]).
236 *MM*, 18 February, 11 March 1806.

1,232 children in Anglican day schools, 1,271 in Dissenting ones, 7,647 in Anglican Sunday schools, and 23,108 in Protestant and Roman Catholic ones. So Anglican scholars appeared to be outnumbered three to one by others.[237]

Competition in church accommodation seemed equally threatening, especially the lack of free seats for the poor because almost all the Manchester churches were full of rented pews. From 1805 there began to be talk of 'free churches', meaning churches with free seats for the poor.[238] The Collegiate Church was remodelled in 1814–16, partly to increase accommodation.[239] In 1816, a town meeting was called by the warden and fellows, churchwardens, and other laity, to discuss plans for one or more 'free churches' and a committee was set up.[240] Instead of building a new church, they purchased what became known as St George's, the failed Anglican cause taken over by Lady Huntingdon's Connexion. This was bought for £2,250 and consecrated in 1818, half the seats being free.[241] We have seen that by 1821 almost all the Manchester churches were providing free benches for the poor, but in 1818 a government scheme for building new churches promised four for Manchester. A letter in the *Manchester Observer* questioned whether there was any need for new churches since a survey had shown that several town centre churches were far from full. The clergy spoke too much of the spiritual rather than temporal needs of the people and 'their doctrines, to say nothing of their example', were calculated to drive people away. They inculcated passive obedience and condemned the most trivial offences. Was the Founder of Christianity a 'respecter of persons?'[242] Similar charges about poorly attended churches were frequently made by the Unitarian reformer Richard Potter in 1820. One (he claimed) had only 125 attenders, one had 65, and one was closed for lack of any.[243] Although the 1821 visitation does not seem to show churches as empty as this, the lack of free seats had been a real problem until then.

Potter and his radical allies now used the creation of a 'free church' as a vehicle for assaulting the old regime. As well as

237 *MG*, 5 May 1821. *MM*, 17 June 1821, acknowledges only very slightly different figures.
238 *Wheeler's Manchester Chronicle*, 6 May 1805, 8 January 1809; Hay Scrapbook 3, p. 95.
239 *MM*, 7 September 1813, 24 December 1816.
240 *MM*, 2, 16 January 1816.
241 *MM*, 13 January 1818; visitation of 1821, CALS, EDV 7/6, p. 352.
242 *Manchester Observer*, 4 April 1818.
243 *Cowdroy's Gazette*, 29 January 1820.

alleging that there was no need for more churches, they claimed that ley-payers would be saddled with paying for the churches' repairs and very probably for the clergy as well.[244] In a foretaste of even worse scenes to come, there was a vestry meeting in the Collegiate Church in 1818 which unfortunately started late through a miscalculation of service times and led to rowdy crowds of partisans and what Ethelstone later described as a 'bear-garden'. There were shouts of 'Have you been shot at lately?', 'Have you paid your taxes?', 'Presbyterian cant'. There were exchanges later about money-changers violating the temple and the appropriateness of Christ driving them out.[245] It appeared that ley-payers had voted against paying for plate for the new church but that the authorities had ignored this. Potter and his allies kept returning to this issue for several years and after Peterloo in 1819 there was the additional animus against the College clergy over Ethelstone's role as a magistrate on that occasion. They also criticized the building of a chapel for the workhouse. In 1825 they harked back once again to the ignoring of the majority in 1818.[246]

In the troubled years following the end of the war in 1815, economic hardship led to marches and public meetings for parliamentary reform as a solution. This alarmed the 'respectable classes' into severe retaliatory measures. In January 1817, for example, a large town meeting of magistrates and officials was held to consider measures for keeping the peace, including the enrolment of special constables. The meeting was attended by Ethelstone and several other clergy, including the warden as a Cheshire magistrate.[247] Ethelstone also supported 'watch and ward' measures arising from fear of conspiracy.[248] A reform meeting in Peter's Fields in 1819 produced the slogans 'Hunt and liberty', 'No corn laws', and 'The rights of man'. This was one of a series of meetings for parliamentary reform that year addressed by the popular speaker, 'Orator' Henry Hunt. These demonstrations were countered by a meeting for 'maintenance of public peace' and a declaration against disaffection which included Ethelstone and Mallory along with other College clergy, but also Roby, a leading Independent minister.[249]

244 Ward, *Religion and Society*, pp. 110–11.
245 *Manchester Observer*, 2, 23 May 1818; *Manchester Gazette*, 25 May 1818.
246 *Cowdroy's Gazette*, 29 January 1820, 10 June 1821; *MG*, 9, 30 June, 3 August 1821; 2 July 1825.
247 *MM*, 21 January 1817; Hay Scrapbook 7, p. 142.
248 *MM*, 1 April 1817.
249 *MM*, 19 January 1819; *Cowdroy's Gazette*, 17 June 1819; *MM*, 13, 20 July 1819.

Then came the 'Peterloo' meeting of 16 August 1819 and its aftermath. It is unnecessary to detail the course of events and the continuing debate about who was to blame. After a season of mass meetings and mounting alarm from the authorities, another large assembly in Peter's Fields was to be addressed by 'Orator' Hunt. The magistrates were headed by Revd W. R. Hay and Ethelstone read the Riot Act. Deputy-constable Nadin attempted to arrest Hunt and became jammed in the crowd. The half-trained Manchester Yeomanry cavalry, made up of local merchants, manufacturers, and shopkeepers and commanded by Birley, rode to the rescue, panicked, and attacked the crowd, which then had to be dispersed by regular troops. Apparently eleven people were killed and over six hundred injured. Recent research appears to confirm the traditional claim that the demonstration was peaceable, in the face of the revisionist arguments of Robert Walmesley.[250]

The reaction to Peterloo revealed a split in respectable middle-class opinion which foreshadowed a series of assaults on the old regime, including a change in the Collegiate Church's status and role in local society. The *Mercury* blamed Hunt and spoke of the 'necessary action of the troops', while the churchwarden James Brierley thanked them for keeping order. A declaration of loyalty was signed by clergy and laity, headed by the College clergy.[251] The opposition claimed that the meeting was peaceful, not seditious. This was signed by the usual suspects – Richard Potter, Edward Baxter, J. E. Taylor, the veteran Dr Mitchell, and regular critics of the old regime. Anglican clergy were conspicuously absent. An appeal for relief for the victims was, however, published in the *Mercury* as well as *Cowdroy's Gazette*.[252]

Gatrell has claimed that Peterloo 'polarised middle-class opinion for the first time in twenty years' and 'serious radical debate even among the respectable became a legitimate if not a popular pastime'.[253] Sixty-five manufacturers and sixty-eight merchants and dealers signed the petition supporting the actions of the magistrates, while seventy-one manufacturers and thirty-one merchants signed a critical petition.[254] The *Manchester Guardian*, founded by Taylor, became the first reforming paper

250 For a brief account, see Kidd, *Manchester*, pp. 87–92; M. L. Bush, *The Casualties of Peterloo* (Lancaster: Carnegie Publishing, 2005); Robert Walmesley, *Peterloo: The Case Reopened* (Manchester: Manchester University Press, 1969).

251 *MM*, 17, 24 August, 19 October 1819.

252 *Cowdroy's Gazette*, 4, 11 September 1819; *MM*, 7 September 1819.

253 Gatrell, 'Incorporation', p. 35; Prentice, *Sketches*, p. 153.

254 Read, *Peterloo*, p. 7; Prentice, *Sketches*, pp. 130, 179.

Left:
Caricature probably
of C.W. Ethelstone
as 'The Clerical
Magistrate' in *The
Clerical House
that Jack Built* by
W. Hone, 1819

THE CLERICAL MAGISTRATE.

' *The Bishop*. Will you be diligent in Prayers—laying aside the study of the world and the flesh ?——*The Priest*. I will.
The Bishop. Will you maintain and set forwards, as much as lieth in you, quietness, peace, and love, among all Christian People ?——*Priest*. I will.
The Bishop laying his hand upon the head of him that receiveth the order of Priesthood, shall say, RECEIVE THE HOLY GHOST.''
<div align="right">*The Form of Ordination for a Priest*.</div>

———— " The pulpit (in the sober use
Of its legitimate peculiar pow'rs)
Must stand acknowledg'd, while the world shall stand,
The most important and effectual guard,
Support, and ornament of virtue's cause.
* * * *
Behold the picture ! Is it like?

THIS IS A PRIEST,
made ' according to Law',

Facing page:
Caricature of Joshua
Brookes interrupting
lesson reading to
reprove schoolboy

to achieve a permanent existence. By the 1830s reformers would attack the corn laws and support parliamentary, municipal, and church reform, all of which would deeply affect Manchester and the Collegiate Church.

The clergy came in for increasing criticism. Even before Peterloo, the pseudonymous 'Rhadamanthus Keneza' in the *Manchester Observer* claimed an inconsistency between the precepts of the gospel and the lives of the clergy: self-denial and abhorrence of wealth as against power and dignity; the clergy praised war and were grinding the faces of the poor.[255] *Cowdroy's Gazette* claimed that the clergy exacerbated party conflict by supporting ultra-loyalism and condemning all reform as seditious. That was the effect of the church and state connection.[256] The Collegiate clergy were seen as keen and committed politicians, 'their revenues exaggerated, their Fast Days few'. They met 'To preach and pray – in pomp and state / And talk of charity'.[257]

In the wake of Peterloo, the clerical magistrate was savagely caricatured in a cartoon and poem entitled 'The Clerical House that Jack Built', which was probably aimed at Ethelstone. He is shown as a double-headed figure in a double pulpit: the pious preacher with cross and Bible looks one way, the brutal magistrate with gibbet, whip, and handcuffs the other.[258]

But the most significant attack on the church's position as a religious establishment came with the twin blows in 1828–29 of legislation to remove civil disabilities from Dissenters and Roman Catholics. The reaction in Manchester (and elsewhere) to relief for Dissenters was far less explosive than had been the case during the failed attempt of 1787–90. By now it seems often to have been concluded that the tests, whilst offensive to Dissenters' pride, were more symbolic than practical obstacles to obtaining public office, and that their removal was no longer a danger to the church. Although the parliamentary proceedings were fully reported in the local press, it is striking that no attempt seems to have been made to raise a petition in Manchester against the measure. The liberal *Manchester Guardian* had taken over the conservative *Manchester Mercury*, so both papers welcomed repeal of the tests as a matter of course. The *Mercury* even claimed

255 *Manchester Observer*, 19 June, 7 August 1819.
256 *Cowdroy's Gazette*, 23 December 1820.
257 Quoted in Raines, *Fellows*, vol. 2, p. 303.
258 London: William Hone, 1819. A similar attack by Cruickshank aimed at a rather tame rejoinder in 'The Christian House that Jack Built' is reproduced in John Miller, *Religion in the Popular Prints 1600–1832* (Cambridge: Chadwyck-Healey, 1986), pp. 284–5, 286–9. Miller states that it refers especially to Ethelstone.

that most of the clergy had 'too much good sense to see the test as any protection for the Church'.[259] The conservative papers were more doubtful. The *Manchester Courier* argued that the measure should be resisted as being a possible first step towards further attacks on the church, and *Wheeler's Manchester Chronicle* saw the church as being so united with the constitution that a breach in one affected the other.[260] What did cause hesitation among the more liberal was the belief that removal of tests on Dissenters might encourage a united Protestant opposition to Catholic emancipation, which indeed was what some conservatives hoped would happen.[261]

Roman Catholic emancipation was far more controversial, for it seemed to threaten the very basis of a Protestant established church and even the security of the state. Predictably, the *Guardian* and the *Mercury* warmly supported the measure, the latter reflecting the government's view that there was 'no hope of the permanent tranquillity of Ireland while the Catholic question remains unresolved'.[262] The *Manchester Courier*, however, praised the remonstrances of 'supporters of the Protestant Constitution' against 'the feeble, shuffling replies of the newly-enlightened ministers and their liberal allies'.[263] This was a jab against what was seen as the treacherous *volte face* of the Tory ministers Wellington and Peel on the issue. In sharp contrast with the reaction to the emancipation of Dissent, Manchester (and many other places) mounted a determined campaign for an anti-Catholic petition as the measure gathered momentum. That petition was signed by Warden Calvert, all the College, and most if not all the rest of the local clergy.[264] It was argued that while freedom of worship should be open to all, to concede equal political rights to Roman Catholics would endanger 'the Protestant Constitution of these islands' as in 1688.[265] As commonly happened in Manchester disputes, there were claims and counter-claims about the quality of signatures to the petition

259 *MM*, 4 March 1828.
260 *MC*, 1 March 1828; *Wheeler's Manchester Chronicle*, 16 February 1828. For the ownership and character of Manchester newspapers see Read, *Press and People*, pp. 60, 84, 105.
261 On these attitudes, see Michael Watts, *The Dissenters, Volume 2: The Expansion of Evangelical Nonconformity* (Oxford: Clarendon Press, 1995) pp. 417–26; *MG*, 9 February 1828.
262 *MM*, 3 February 1829.
263 *MC*, 21 February 1829.
264 *Wheeler's Manchester Chronicle*, 22 November 1828.
265 *Wheeler's Chronicle*, 29 November 1828.

and the means used to obtain them, it being alleged that Sunday school children and workhouse paupers had been signed up.[266]

It seems appropriate to conclude an account of the Collegiate Church in the long eighteenth century at this point, for these two pieces of legislation began the process of restricting the nature and status of the English established church as it had been understood since 1662.

Conclusion: retrospect and prospect

Until 1828–29, the special position of the established church in relation to the state was still intact in legal terms, at both national and local levels. The Collegiate Church and clergy and their lay officials and supporters still appeared to be the chief ecclesiastical authority in the town and parish, as well as a significant ally of secular authority. They frequently took a lead in local affairs, including patriotic and charitable efforts. The clergy had moved from their suspect Tory Jacobite associations of the earlier eighteenth century to the uncompromising loyalism of the 1790s onwards. This strengthened the traditional alliance of church and state and in the 1790s 'Church and King' became a potent war-cry and platform for suppressing political reformers and smearing their Dissenting associations as treasonable.

Yet this position of privilege and even apparent domination does not quite equate with the claim that has been made by Jonathan Clark that England was a 'confessional state', at least on the continental pattern. This is not to underrate the value and salutary influence of Professor Clark's campaign 'to reintegrate religion into an historical vision which has been almost wholly positivistic' and to show 'the persistence of the ancien regime until 1828–32'.[267] The limitation of the picture of a 'confessional state' in England is most obvious in the provision since 1689, limited though it was, of toleration for Dissenters. Lack of full civil rights also mattered less in non-corporate towns like Manchester, and if anything stimulated action by the weighty Cross Street chapel leaders against the Anglican elite.

Despite the suppression of reformers from the 1790s, the church's control failed to be absolute. The demise of Church and King mobs, the growth of non-Anglican churches, congregations, and schools, and of absenteeism from church, tell their own tale as do the voices of critics, the failure of Sabbath discipline, and

266 *MG*, 28 February, 21, 28 March 1829; *Wheeler's Chronicle*, 21 February 1829.
267 Clark, *English Society*, pp. ix–x.

the increasing recourse to voluntary persuasion. The cracks in the ruling edifice shown by the opposition to using leys to support new churches were deepened by the reaction against Peterloo and the role there of clerical magistrates. These were portents of worse to come. The problems of the church might be seen in terms of control but involved much more than this. It was the real and symbolic role of the church in the political, social, and cultural order seen as divinely ordained which was at stake. This role and the beliefs underlying it were to come under question as never before during the next quarter-century. The old order was shaken locally as well as nationally by the 1832 Reform Act, which gave Manchester MPs, and the Municipal Reform Act, which gave it a corporation led by Dissenters in 1838. Much worse was to precede and follow for the church, and especially the Collegiate Church. The erosion of the Establishment begun with the emancipation of Dissenters and Roman Catholics in 1828–29 continued during the following decades. The Civil Registration Act in 1836 ended the Anglican monopoly of socially valuable rites and records. From 1835, the Ecclesiastical Commissioners began to reduce inequalities in episcopal and clerical responsibilities and revenues. After 1840, the warden and fellows became dean and canons and, after delays over the problem of additional bishops in the Lords, the diocese of Manchester was initiated in 1847.[268] Most damaging to the old ecclesiastical order in Manchester were two public controversies. Opposition to compulsory church rates provoked tumultuous scenes in vestry meetings in the 1830s, as in the nearby cotton towns. Then came what has been called the 'Manchester Church Question', which involved attacks on the Collegiate clergy for their real or imagined wealth, which some claimed could be better administered and should in any case be used for the benefit of the whole town. The College clergy should be less idle and be given pastoral care of district churches. Their attackers included evangelical clergy confined to poor churches and excluded from posts in the Collegiate Church. The result in 1850 was the fashionable expedient of dividing the old large parish into many smaller ones.[269] This completed the changes in the relationship between the former Collegiate Church and its parish, with results to be explored in the next chapter.

268 The Collegiate clergy resisted interference with what they claimed were the conditions of their charter: MCA, Mancath/2/2/2, Chapter minutes, 8 May 1838, 4 March 1839, 8 February 1850.

269 Ward, *Religion and Society*, pp. 178–92, 221–32.

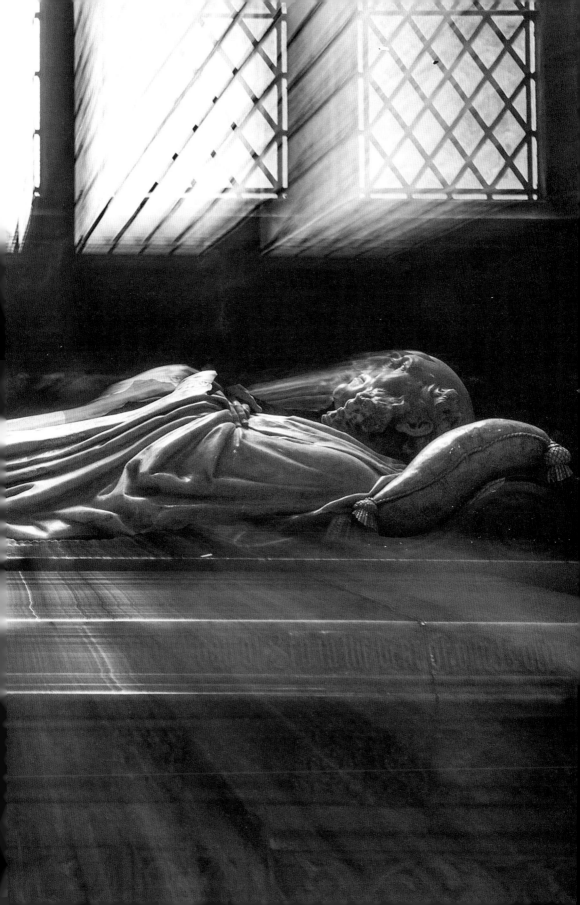

✣ 6 ✣

From 'Th'Owd Church' to Manchester Cathedral, 1830–1914

ARTHUR BURNS

DURING THE FIRST half of the nineteenth century, Manchester came to emblemize the rapid transformation of Britain later identified as an 'industrial revolution'. Its population rose from an already astounding 126,000 in 1821 to 303,000 in 1851, passing 500,000 by the end of the century. Its factories' chimneys defined a 'Cottonopolis' of the mind. Together with the teeming humanity animating its machinery – and the squalor and epidemics that accompanied its settlement in densely packed alleys – the conurbation fascinated and alarmed commentators from Frederic Engels to Benjamin Disraeli, the latter judging Manchester 'as great a human exploit as Athens'.[1] As Disraeli's observation hinted, Manchester also exemplified a shift in cultural dynamics, with its manufacturing, trading, and labouring interests flexing their political and intellectual muscles in the century of Peterloo, the Anti-Corn Law League, and the 'Manchester School' of liberal economics.

Historians dispute the religious consequences of Victorian social change, but contemporaries, not least in interpreting the national religious census of 1851, identified industrial conurbations as significant obstacles to Christianization. The census reported that less than 35 per cent of Manchester's population were churchgoers, of whom only a third were Anglicans, compared with overall figures for England of 61 and 49 per cent respectively.[2] All denominations were alarmed for both the salvational prospects of Mancunians and the city's social order, and responded through church-building and augmenting the clerical

[1] Benjamin Disraeli, *Coningsby*, 3 vols (London: H. Colburn, 1844), Book IV, ch. 1.

[2] Figures recalculated in B. I. Coleman, *The Church of England in the Mid-Nineteenth Century: A Social Geography* (London: Historical Association, 1980), p. 41.

Previous spread: *'Leaving this world'*

workforce. For Anglicans, many of whom viewed Manchester Dissent and Roman Catholicism little more favourably than irreligion, the challenge seemed all the more acute; one demanding, in an episcopal church, more focused leadership. For the sprawling bishopric of Chester encompassed over 4,100 square miles in Cheshire, Lancashire, and substantial portions of Yorkshire, Cumberland, and Westmorland; its far from princely remuneration ensured a swift turnover of bishops, further weakening supervision.

Such concerns led statesmen and churchmen of all parties to demand church reform. The very first proposal in the first report of the Ecclesiastical Commission established in 1835 was for a diocese for Manchester.[3] Respect for life-interests and concern about constitutional repercussions (which initially required that new sees be counterbalanced by mergers), however, meant that it was not until 11 February 1848 that James Prince Lee was enthroned as the first Bishop of a diocese of Manchester, itself created on 1 September 1847, in what was now Manchester Cathedral.[4]

Nineteenth-century chapters in English cathedral histories generally recount the impact of Ecclesiastical Commission reforms, major restorations, developments in decoration, services, and music reflecting the impact of Tractarianism, and efforts to fashion more meaningful relationships with both see city and diocese.[5] These duly figure here. Yet in 1880 Dean Benjamin Cowie would complain that his church had 'scarcely any of the features of a cathedral church, except the name'; in 1905 the retiring minor canon John Elvy, who began service there sixteen years *after* the cathedral was inaugurated, not only entitled his memoirs *Recollections of th'Owd Church*, but wrote that 'the idea [of the Cathedral] has been slow to take root, and has made but tardy progress'.[6] This exaggerated. Yet the circumstances of Manchester Cathedral's creation and the legacy of its former incarnation did render its early history *sui generis*, involving disputes of peculiar intensity and unexpected complications.

3 PP 1836, 36 (no. 86). For the fraught process from which the Manchester bishopric emerged, see P. S. Morrish, 'New Anglican Bishoprics, 1836–1919' (MA thesis, London University, 1965).

4 Under an Order in Council of 10 August 1847: *London Gazette*, 31 August 1847.

5 The standard survey is Philip Barrett, *Barchester: English Cathedral Life in the Nineteenth Century* (London: SPCK, 1993).

6 PP 1884–5 [C.4330], *Second Report of HM Commissioners for inquiring into the condition of cathedral churches ... upon the Cathedral Church of Manchester*, p. 303; John M. Elvy, *Recollections of the Cathedral and Parish Church of Manchester* (Manchester: C. Sever, 1913), pp. 55–6.

George Huntington, clerk-in-orders 1855–67 and author of *Random Recollections of Some Noted Bishops Divines and Worthies of the "Old Church" of Manchester*

Most Anglicans agreed that Manchester needed a *bishop*; but did it need the *Cathedral*, an episcopal *sine qua non* in the 1830s? Opinions on the Collegiate Church's value to Cottonopolis might differ, but it was unequivocally a Manchester institution, whereas the Cathedral would be mother church to a diocese stretching north of Lancaster. The Collegiate Church was also Manchester parish church. As the city's ecclesiastical map evolved through church-building and parochial subdivision, how should its dual role be reflected in the allocation of the burgeoning financial resources generated from its property and services by the dynamic urban economy?

The process by which 'th'Owd Church' metamorphosed into a cathedral would be far from straightforward. For a start, the Ecclesiastical Commission enacted the steps necessary to create

the Cathedral as part of wider legislation[7] preceding the creation of the diocese by seven years: thus the 'warden and fellows' first appeared in their minutes as the 'dean and canons' on 11 April 1840.[8] The longevity of the Collegiate Church's personnel whose life-interests were respected, however, ensured that the full regime of cathedral chapter responsibilities and incomes was not realized until the death of Cecil Daniel Wray in 1866; 'Old Canon Wray – was he ever young?', began George Huntington's memoir, charting an association with the building that had commenced with Wray's appointment as clerk-in-orders in 1809.[9]

The implications of the transformation were most hotly disputed during the creation of the bishopric, which roughly coincided with the appointment of the first Dean under the new dispensation, George Hull Bowers; in 1850 the debate issued in a Manchester Parish Division Act which reconfigured relations between Cathedral and city parishes.[10] But th'Owd Church was not eliminated. Whereas the new bishop was funded by redistributing resources across the episcopate, the new *Cathedral* relied entirely on the monies of the Collegiate Church, with any surplus designated for *nationally* devised schemes of church extension. In consequence, expenditure on controversial Cathedral purposes could be challenged by reference to the supposed intentions of the founders of the predecessor institution.

Above all, however, th'Owd Church lived on in a Mancunian imagination that found it hard to recalibrate its relationship with the ecclesiastical hub of Cottonopolis, perhaps reflecting a need for fixed points of reference in the rapidly changing city. It generated both memoirs and folk memories distinct from those of other cathedrals, with the lay community unusually prominent, and a distinctly secular feel to the portraits of the clergy, epitomized in Isabella Varley Banks's affectionate depiction of Joshua Brookes in *The Manchester Man* (1876), her account of the Peterloo-era city.[11]

Rather than a story of how a Manchester (1) collegiate and (2) parish church became (3) Manchester Cathedral, therefore, it is best to approach this phase of its history as recounting how three

7 3 & 4 Vict. c. 113, the Ecclesiastical Duties and Revenues Act, also known as the Dean and Chapter Act.

8 Manchester, MCA, Mancath/2/2/2, Chapter register, 11 April 1840.

9 George Huntington, *Random Recollections of some Noted Bishops, Divines and Worthies of the 'Old Church' of Manchester* (London: John Hodges, 1896), ch. 13, at p. 283.

10 13 & 14 Vict. c. 41.

11 Mrs G. Linnaeus Banks, *The Manchester Man* (Manchester: E. J. Morten, 1991; first publ. 1876).

different institutions jostled for priority and resource within a single building. If the arrival of the Bishop – a fourth independent variable – saw conflict reach new peaks, however, the previous twenty years had already seen key issues come to a head.

The last years of the Collegiate Church: the 1820s and 1830s

A valuable snapshot of the Collegiate Church at the time of the Great Reform Act is afforded by a parliamentary return setting out incomes and responsibilities as they were in 1829–31. The warden and fellows reported their gross yearly income as £4,650, mostly from rents and tithes, with only £377 coming from fines (fees) on renewals of leases. Outgoings reduced this to £4,025 net, divided between the four fellows and the warden (who took a double share) from which they collectively funded repairs to the choir and salaries of £17 10s each to the two chaplains and £33 10s to the clerk-in-orders. Displaying either astute tactical circumspection or astonishing lack of foresight, the college claimed that fines, rents, and tithe would all yield less in future.[12]

This was a healthy balance sheet. The warden earned more than the Bishop of Llandaff and numerous cathedral deans, while the fellows were better off than many canons elsewhere (for example in Bristol, where £3,629 was divided between a dean and six prebendaries), although they had to provide their own accommodation, their residences being rented out. The sums can also be compared with the incomes associated with Manchester's other churches, which ranged from £380 at St Ann's and £410 p.a. at St Philip's, Salford (held on the College's nomination by Oswald Sargeant, soon to become a fellow himself), to (more typical) figures around £150 per annum at the perpetual curacies of St Andrew, St James, St Mary, St Peter, and St Stephen, with the lowest net income being £72 per annum at St Michael.[13] Far more comfortable was the position of the Collegiate Church's chaplains. Their meagre salaries were supplemented by surplice fees (according to one estimate yielding £1,330 in 1835) and rental income from pews in two of the galleries which 'choked up' the nave, 'rising tier over tier up to the very roof'; the clerk-in-orders similarly profited from fees.[14]

12 PP 1835, 22 (no. 54), *Report of the Commissioners … into the Ecclesiastical Revenues of England and Wales*, appendix, pp. 26–7.
13 *Ibid.*, p. 248.
14 Huntington, *Random Recollections*, p. 289; estimate of fees from Cambridge, UL, MS Add. 8862/5/8, Bowers papers, Edward Birley to G. H. Bowers, 8 July 1847.

College minutes before the early 1830s suggest a calm and untroubled existence enlivened by the occasional exercise of patronage or fellowship election. Two appointments made in this period would experience contrasting fortunes. As already noted, Cecil Wray (1778–1866), raised from clerk-in-orders to chaplain in 1821 and elected fellow in 1830, remained a living embodiment of th'Owd Church long after the creation of the Cathedral (his funeral address, penned by Wray himself some twenty years in advance, still spoke of the 'collegiate church'). 'Able and zealous, but something of a martinet', Wray was a high church Tory, active in the Manchester Pitt and Brunswick Clubs, who relished services for 5 November ('being the Popish Conspiracy … appointed by the Church to be kept holy'). Huntington recalled Wray – notoriously sensitive to 'differences of rank' – arriving in his carriage with two liveried footmen, and, once fellow, extending just two fingers when shaking hands with chaplains and one for curates.[15] Nevertheless, from his Tory vantage-point Wray strove to improve the parishioners' lot, in 1814–15 lobbying the Liverpool government for church extension in Manchester, founding national schools, and leaving a benefaction in his will – 'Canon Wray's Birthday Gift' – anachronistically dedicated to the purchase of worsted stockings for poor churchgoers. His identification with the parish reflects the fact that Wray calculated that, by the time he became a fellow, he had personally baptized more than 33,000, married more than 13,000, and buried almost 10,000 parishioners, a ratio neatly illustrating his experience of the city's demographics. Wray's own burial in 1866 would be the first for fifty years in the overflowing Cathedral churchyard.

Richard Remington, elected vice-chaplain in 1821 and then chaplain in 1825, in 1832 seemed set to follow Wray into the fellowship on fellow John Gatliff's nomination. Three hours' debate on his candidacy issued in an adjournment, however, and an alternative (Sargeant) was put up and elected. This proved a narrow escape. On 23 October 1834, in the parlour of a Back George Street brothel, an inebriated Remington assaulted a deputy constable when surprised with a teenage girl 'in disarray' and himself 'naked all but his shirt and stockings, his trowsers

15 Quotations from Elvy, *Recollections*, p. 30; Huntington, *Random Recollections*, pp. 285, 290. Wray told Bowers that he thought an income of £4,000 gave 'enough for your necessities and a few luxuries' (p. 286). For Wray, see also *Memoirs of the late Rev. C. D. Wray*, edited by Henry Wray (Winchester: Jacob and Johnson, 1867), esp. pp. 87–9 for his funeral; Archibald Prentice, *Historical Sketches and Personal Recollections of Manchester* (London: C. Gilpin, 1851), pp. 336, 431–2, for his politics.

being down about his feet'. A blackmail attempt was foiled, but Remington admitted all to the warden and fellows. His punishment was three years' probationary suspension residing at a distance of at least ten miles (he settled in Aberystwyth); however, in view of his large family, he was allowed £250 per annum from his chaplaincy income. Rumours of further drinking ensured a renewed suspension in 1838; in 1841, a new dean brusquely told him that any return 'would be very offensive to the congregation'. Yet, in 1851 Remington was restored to his duties, dying in post two years later.[16]

Remington's misdemeanours, if widely known, would have provided ammunition to th'Owd Church's critics, who began to grow in number and activity, with the key fault line between critics and defenders falling between the churchwardens and leypayers. Yet conflict even in the 1820s was more than simply a matter of parsimonious parishioners seeking to restrain extravagances, for it was fuelled by divisions over political reform. Also important was a Dissenting interest now confident enough to attack the state-sanctioned establishment for failing the challenge of Cottonopolis, while simultaneously bemoaning the burdens of church rates anticipated from the erection of new Anglican churches for which the purchase of liturgical items provoked angry debates at well-attended vestries.[17] Here churchwardens faced persistent criticism, notably from members of the first or second 'Little Circles' of advanced Nonconformist Manchester liberals, such as the Unitarian cotton merchants Edward Baxter, Richard Potter, and John Edward Taylor (founding editor of the *Manchester Guardian*), the Scots Presbyterian radical Archibald Prentice (owner of the *Manchester Times*), and the radical Quaker James Wroe (editor of the *Manchester Observer*). Was it right that parishioners contributed to the salaries of the organist and singers specified in the college

16 See MCA, Mancath/2/2/2, Chapter register, 30 June 1832; 13 November 1834; 3 January, 4 February 1838; 26 April, 15 December 1851; MCA, 'Personnel', *s.n.* 'Richard Remington', esp. report by Joshua Thomas, 25 October 1834; Samuel Hibbert-Ware, *The History of the Foundations in Manchester of Christ's College, Chetham's Hospital, and the Free Grammar School*, 3 vols (Manchester: Agnew and Zanetti, 1834), vol. 2, p. 351. J. T. Slugg remembered Remington as a 'very genial, friendly, and gentlemanly man, dressed more like an ordinary gentleman than a cleric': *Reminiscences of Manchester Fifty Years Ago* (Manchester: J. E. Cornish, 1881), p. 118.

17 For what follows, see *MG*, 31 May 1823; 29 May, 5 June 1824; 25 June, 2 July 1825; MCA, PP1, MS32/1, undated letter from Wray and Remington. The antagonism was further stoked by a Chancery judgement allowing the College to collect tithes in kind on hay, milk, and potatoes, after an eighteen-year dispute over the moduses: *ibid.*, 22 March, 21 June 1823. See also Derek Fraser, *Urban Politics in Victorian England: The Structure of Politics in Victorian Cities* (Leicester: Leicester University Press, 1976), p. 37.

charters (although parishioners had sought an increase in their number)? Should they have repaired a stove in the College's part of the church? (The churchwardens pointed out that it *warmed* those being baptized or churched.)

Most contention arose over liability for repairs to the south gallery renewed at parish expense in 1817 and from which the chaplains had taken pew rents for some hundred and fifty years. A legal opinion was sought and proved unequivocal: the rents – like the ground rents paid to the chaplains by north gallery pew owners – were illegal, for the services they purported to recompense were required of the chaplains under the charter. Chaplain Wray armed himself with a contrary opinion for a parish meeting on 4 June 1824 attended by some two thousand ratepayers, where he argued that the rents related to additional Sunday morning lectures; when renewing galleries, moreover, in one instance erected and maintained by the chaplains themselves, the parish had been compensated by the sale of fittings. Such arguments cut little ice with Baxter, who believed it the College's responsibility to remunerate the chaplains adequately, and that, converted to free sittings, the galleries might obviate the need for more churches. The *Guardian* reported that only some six hands raised from the churchwardens' pew opposed Taylor's motion for further legal advice; this duly confirmed the original opinion. Nevertheless, a year later parishioners confirmed the status quo, acknowledging that they had endorsed it only a few years before and that incumbent pewholders could not easily be displaced.

Tensions worsened in the early 1830s. In 1832, expenditure on new churches (necessitating a church rate of threepence in the pound for 1831, less than two-thirds of which was collected), exacerbated by the politics of the contemporary Reform Crisis, led to the churchwardens' accounts being greeted with 'hisses and other strong marks of disapprobation'. When a rate of a penny was proposed for 1832–33, Prentice led a leypayers' revolt halving it.[18] In 1833, the church party's slate of candidates for churchwardens and sidesmen was defeated on a show of hands, and only secured through a formal poll (boycotted by the opposition) which allowed heavily rated leypayers to cast plural votes (770 voters yielded 2,059 votes).[19] During the setting

18 *MG*, 2 June 1832, p. 3.

19 This under the Sturges Bourne Act, which the opposition claimed did not apply to Manchester. At his subsequent visitation, Archdeacon Unwin Clerke crumpled up the opposition list presented to him as the true outcome of the meeting and threw it at Wroe: *MG*, 13, 20 April 1833; *MT*, 25 May 1833. For other accounts of church-rate issues in Manchester and wider context, see W. R. Ward, *Religion and Society in England 1790–1850*

of the rate, items of expenditure were repeatedly queried, and a modest proposal of a halfpenny was rejected by almost all the 1,500 present. The poll then demanded by a churchwarden this time gave the church party less satisfaction. A recount did not overturn but merely reduced an opposition majority of 3,511 to 3,507 for postponing the assessment (in effect rejecting it, since it would cost more to collect than it would yield) to a single vote.[20] Battle lines were complex: while the amendment was moved by Congregationalist solicitor George Hadfield and Unitarian warehouseman Thomas Potter (later the first mayor of Manchester), among those backing the proposed rate were another Congregationalist, Samuel Fletcher, and the Methodist churchwarden James Wood. Even the *Manchester Guardian* baulked at so direct a challenge to duly constituted authority. A scrutiny of the votes, initiated by Wood, removed 403 of the opposition's poll and only 273 of the church party's, and the rate could thus belatedly be enforced. Prentice's *Manchester Times* acknowledged merely a hollow victory:

> We believe it is intended that the Church Rate is to be collected only from those that are WILLING to pay it. In this way it will assume the shape of A VOLUNTARY CONTRIBUTION, to which there can be no objection. ... [O]ur conviction has been strengthened that the half-penny rate has not been legally made, and that it cannot be legally demanded, and we mean to act on our conviction by refusing to pay it, if it should happen to be demanded, which, however, we do not expect. We have sufficient reliance on the good sense of the churchwardens to believe that they will not embark on a crusade against the parishioners ...[21]

The dispute proved an important opening round of what became a national controversy over church rates, often serving as a proxy for debate over the merits of establishment *tout court* between church and chapel, until in 1868 legislation finally abolished compulsory rates. Nevertheless, the repercussions and symbolism were peculiarly important in a Manchester simultaneously at war over other aspects of national and local secular reform.

In March 1834 Mancunian 'political Dissent' flexed its muscles in a two-day meeting organized by Hadfield to attack

(London: Batsford, 1972), pp. 179–83; Jacob P. Ellens, *Religious Routes to Gladstonian Liberalism: The Church Rate Conflict in England and Wales 1832–1868* (University Park, PA: Pennsylvania State University Press, 1994), pp. 27–30; Fraser, *Urban Politics*, pp. 37ff.

20 *MT*, 25 May, 1 June 1833.

21 *MT*, 24 August 1833; *MG*, 3 August 1833 (poll result).

establishment via a petition signed by more than thirty thousand people. From this emerged a United Committee of Dissenters to co-ordinate activism across the parish. The church too girded its loins, a Manchester petition in favour of establishment securing up to fifteen thousand signatures, many gathered at Collegiate Church services.[22] Battle was joined on 27 August 1834 in a vestry at which 'a class of men, most of them opulent, and all obviously of a respectable grade of society' filled nave and aisles to overflowing (had the galleries been deliberately locked to exclude a greater attendance?).[23] An amendment to prevent further rate collections until arrears had been gathered won support from some churchmen present by arguing that the rate, 'principally for the Collegiate Church', overburdened Anglicans in townships already supporting local churches; in response the beleaguered churchwardens emphasized that th'Owd Church offered 1,531 free sittings for poor Mancunians, more than any other Anglican building, whereas Dissenters provided none. As in 1833, the massive show of hands supporting the amendment led to a poll, this time fought (sometimes literally) over a week as fleets of coaches and processions brought to it qualified (and, as things grew desperate, unqualified) voters. In terms of head-count the result was 2,947 in favour of the rate (5,897 votes) and 6,065 against (7,019 votes).[24] Several weeks of scrutiny and the disqualification of more than 1,500 votes again saw the rate ultimately 'agreed', this time by a majority of 358. If the previous year's victory was hollow, this was truly a defeat. In 1835 the wardens, condemned by Wroe as 'ultra tories', boldly proclaimed a target of a penny to compensate for the losses resulting from the defiance of previous years. A show of hands rejected the proposal; no poll was called. It was the end of compulsory church rates in Manchester.[25]

These dramatic events disguise a more prosaic reality. The difficulties of the early 1830s had already seen church-rate income decline thanks to less ambitious rates and patchy collection; some Dissenters were more inclined to pay a voluntary levy. The financial consequences proved manageable. Nevertheless, the debates themselves shaped the Church / Cathedral's operating environment over the subsequent forty years. The vestry, and its links into a wider popular political and religious culture, remained a distinctive and febrile element in the polity of the Church,

22 Ward, *Religion and Society*, pp. 180–1; *MT*, 5, 15 July 1834.
23 *The Times*, 30 August 1834.
24 *MT*, 30 August, 6 September 1834; *The Times*, 1 September 1834.
25 *MT*, 25 April, 30 May, 11 June 1835.

shaping the outlook of those fellows / canons who – like Wray, Sargeant, and Richard Parkinson – as chaplains had attempted to chair its meetings. No wonder they sometimes felt embattled; but no wonder also that they felt deeply implicated in the wider life of Cottonopolis. Such awareness was not, however, simply a product of friction. Leading Manchester liberals presented themselves as embodying both the *zeitgeist* and 'Manchester opinion', and historiography focused on the emergent industrial city sometimes took them too readily at their own assessment. But Manchester Toryism was far from finished. Mill-owners were as likely to be observant Anglicans as alienated Dissenters; though losing control of local institutions, the Conservative vote at general elections remained at more than 40 per cent until the 1850s, demonstrating the extent of support among commercial and professional men.[26] Th'Owd Church remained central to the religious lives of many leading Mancunians: friends could point to a communicant body of some 270 on at least 30 occasions annually (which helped explain the controversial annual bill of £37 for communion wine in 1833).[27]

Churchmen and conservatives did not, however, always defend the ecclesiastical status quo, particularly in the parish; this became apparent from the later 1830s as criticism increasingly focused on the Collegiate Church and its fellows. This development was facilitated by the contemporaneous emergence of a novel culture of audit associated with the implementation of national church reforms under successive governments. The Collegiate Church's submissions to royal commissions and select committees yielded statistics concerning, and prompted detailed inquisitions into, its affairs, then pored over in the highly partisan Manchester press. The first report of the Ecclesiastical Commission appeared in time to inform the last exchanges in the church-rate debate in 1835–36; thereafter data updates refuelled discussion at regular intervals.

Faced by apparently utilitarian and rationalizing reform, conservatives instinctively reached for tradition and precedent. But here, too, lay fuel for the fire. When in 1830 the Manchester antiquarian Samuel Hibbert-Ware published a history of the

26 A good account of this is V. A. C. Gatrell, 'The Commercial Middle Class in Manchester, *c.* 1820–1857' (PhD thesis, Cambridge University, 1971), ch. 7, including the claim that the political eclipse of Manchester Toryism in the 1830s may have reflected its leadership's preoccupation with church issues. For the religious affiliations of Manchester industrialists, see Anthony Howe, *The Cotton Masters 1830–1860* (Oxford: Oxford University Press, 1984), pp. 61–71.

27 *MT*, 25 May 1833.

Collegiate Church, the key charters were reproduced without reference to the originals in the muniment chest. The fellows found Hibbert-Ware's work 'sufficiently orthodox', however, to co-operate on a revised version, his friend Wray even allowing him to study documents at home.[28] But by the time this was ready for publication in 1848, the charters were the subject of polemical exchanges between the chapter and its critics. Wray, fearing that 'some may endeavour to turn the records of our Collegiate Church, which now appear in your work, to our injury and even our destruction', insisted on revisions to a nervous preface in which Hibbert-Ware both eschewed party conflict and insisted that, if anywhere at odds, his own interpretation need not necessarily be preferred to that of the fellows, in whose 'erudition, as well as good intentions', he placed the 'deepest confidence'.[29]

The birth of the Cathedral and the Manchester Parish Division Act

The main reason the charters attracted such scrutiny was the College's financial position as revealed in the reports already alluded to. A few miles east from the town centre it owned some thousand acres around Newton Heath.[30] Here the turnpiked Oldham Road and Rochdale canal offered builders enticing prospects, while railway companies planned lines across the estates. Underneath lay coal. Legislation of 1764[31] empowered the warden and fellows to issue ninety-nine-year leases better suited to building interests than traditional twenty-one-year leases. Thus, when in 1835 Mancunians learned that the College anticipated a *drop* in income, they were bemused: was this an obfuscatory gloss on a sacrifice of long-term rental incomes enabling fellows to profit from the heavier entry fines allowed on shorter leases?[32] The College's explanation, supported by some (not entirely disinterested) tenants, was that the apparent moderation of rents

28 See Hibbert-Ware, *History of the Foundations*, vol. 1; Samuel Hibbert-Ware, *The Ancient Parish Church of Manchester, and why it was Collegiated* (Manchester: T. Agnew, 1848), pp. vi–vii; Mrs Hibbert-Ware, *The Life and Correspondence of Samuel Hibbert-Ware* (Manchester: J. E. Cornish, 1882), pp. 393, 475. Ware's Anglicanism was tinged by his familial Presbyterianism: *ibid.*, p. 576.

29 Hibbert-Ware, *Ancient Parish Church*, pp. 195, 200; Hibbert-Ware, *Life*, pp. 567–70.

30 Figure from evidence to the Select Committee on Church Leases in 1838: PP 1837–8 (692), p. 433.

31 4 Geo III c. 73.

32 See *MG*, 25 July, 8 August 1838. The College denied taking fines on ninety-nine-year leases, but its own tithe collector, Philip Lancashire, claimed to have paid such a fine of £100: PP 1837–8 (692), pp. 431, 434.

reflected not just the true value of much of the Newton estate, but also a conscious effort to 'act the part of liberal rather than of hard landlords' by acknowledging that increased property values reflected tenants' own efforts.[33]

Regardless, the College finances blossomed. By 1843 it earned £5,642 gross in a year; by 1849 £6,624, 50 per cent more than in the early 1830s. Although outgoings for expenses, rates, and for repairs at St Mary's, now £1,288, had grown faster, this still left a net income of just under £5,400. As bursar, Sargeant explored the figures before a select committee in 1850.[34] Tithes then yielded £2,838 per annum, with rents bringing in another £2,000 (the canons also each received roughly £100 a year in fines on the twenty-one-year leases), with much smaller sums coming from the leases on five Deansgate buildings.[35] The Bradford colliery in Newton, though yielding poor coal, had since 1842 squeezed another £350 in rent from grumbling mine-owners. A significant new revenue stream derived from land sales to railways and gas-works, which one estimate suggested had raised almost £20,000. Some of this had been invested in stock. Thus £4,793 was put into 3 per cents when received from the Leeds and Manchester Railway in 1838 for a land purchase including the future site of Victoria Station. This was the Walker's Croft pauper burial ground, the consequent gruesome mass exhumations prompting Engels to protest that '[i]f it had been a respectable cemetery, how the bourgeoisie and the clergy would have shrieked at the desecration!'[36] By 1850, the railway company had paid over some £13,000 for Walker's Croft, from which a new burial ground still needed to be purchased.[37]

It was thus a financially strong institution which the Ecclesiastical Commissioners announced in 1836 as intended for a cathedral and encompassed within a broader scheme of reform for cathedrals and collegiate churches. Whereas most collegiate churches were reduced to mere parish churches, Manchester

33 See *MC*, 4 August 1838; *MG*, 23 March 1850. Sargeant gave a more detailed commentary on leasing policies to the Episcopal and Capitular Revenues Commission in 1849: PP 1850 [1175], pp. 186–94.

34 For what follows, see *MG*, 23 March 1850. The manuscript minutes are slightly fuller: London, HLRO, HC/CL/PB/2/18/43.

35 Not included in these figures were the rents derived from their residences, the dean's being worth £200 per annum.

36 MCA, Mancath/2/2/2, Chapter minutes, 5 February 1838, 18 February 1842, 22 January 1845; Frederic Engels, *The Condition of the Working-Class in England in 1844* (London: George Allen & Unwin, 1943), p. 292.

37 13 & 14 Vict. c. 41, preamble.

gained status (while losing some autonomy).[38] Unlike many cathedrals, since it already possessed merely a warden and four fellows, it did not face downsizing of its chapter under the Ecclesiastical Duties and Revenues Act of 1840. Instead, with immediate effect, the 'warden and fellows' metamorphosed into the 'dean and canons'; the chaplains were henceforth 'minor canons'. The Act regulated incomes for cathedral dignitaries to free significant monies for redeployment to under-resourced parishes. The dean and canons of Manchester, however, like those of Durham, St Paul's, and Westminster Abbey, were assigned annual incomes (£2,000 and £1,000 respectively) twice those of most of their peers in recognition of the projected future significance and status of the city.[39] Given that such sums exceeded the warden and fellows' expected shares of the common fund and that life-interests were not affected, the reforms proved more acceptable in Manchester Cathedral than elsewhere.

From outside the College things looked different. The break-neck urbanization raising the church's income simultaneously increased the city's pastoral challenge. As a whole, the Church of England rose to this: one historian, not known for his sympathy to the established church, suggested that it 'has probably never made another missionary effort comparable with its effort to refloat Anglicanism in Manchester in the [nineteenth] century'.[40] Much was done via voluntary agencies. By 1874, the National Society had devoted £50,000 to education in the Manchester diocese, more than any other; both the high church Additional Curates Society and the more evangelical Church Pastoral Aid Society had allocated huge sums to augment clerical manpower, in the latter case more than £1,000 to the city itself in 1846 alone (by 1899, the annual figure had risen to £3,600). In 1834, Chester was the first diocese to establish its own Church Building Society; a separate Manchester and Eccles Church Building Society supplemented its efforts, as did an evangelically driven Ten Churches Association (which managed to build five). In 1872,

38 In 6 & 7 Will. c. 77 (1836); enacted in Order in Council of 12 December 1838.

39 3 & 4 Vict. c. 113, §§1, 56.

40 W. R. Ward, 'The Cost of Establishment: Some Reflections on Church-Building in Manchester', in G. J. Cuming (ed.), *Studies in Church History, Volume III* (Leiden: E. J. Brill, 1966), p. 279. For Manchester church extension, see also Chris Ford, Michael Powell, and Terry Wyke (eds), *The Church in Cottonopolis: Essays to mark the 150th Anniversary of the Diocese of Manchester* (Manchester: Lancashire & Cheshire Antiquarian Society, 1997), *passim*; Arthur J. Dobb, *Like a Mighty Tortoise: A History of the Diocese of Manchester* (Littleborough: Upjohn and Bottomley, 1978).

the Anglican share of Manchester church accommodation consequently stood at a respectable 51 per cent.[41]

Many Mancunians believed that in this collective effort the dean and canons had significantly underperformed. As the future churchwarden John Maclure, then parish constable, complained shortly after the 1840 Act, even *within* the building eight clerics failed to provide an evening service, whereas 'some of their less endowed neighbours, with one curate to assist the incumbent, had had three services in their churches on a Sunday'. Looking ahead, he worried that cathedral habits would reduce the canons' contribution to parochial life (he noted that even under the old dispensation Gatliff as fellow only resided one month a year).[42] Many involved in church extension grumbled that the chapter had been lukewarm, at times opposing schemes perceived to damage its interests. The leading evangelical and anti-Catholic activist Hugh Stowell, for whom Christ Church, Salford, had been erected in 1831 at a cost of some £4,000 by enthusiastic supporters of his ministry as curate at St Stephen's, complained of active opposition from the chapter to this initiative, which had resulted in almost two thousand new sittings (more than a third being free), six Sunday schools, four day schools, and a visiting scheme; he also maintained that the chapter had initially resisted Bishop Sumner's call for a local church-building society, and had only begun to play a part once rival initiatives had been inaugurated. The chapter could show *some* support for church extension: in 1850 Sargeant maintained that the chapter had collectively given £1,500 to the Manchester and Eccles Society (which Sargeant chaired), and had worked to create new parish districts, while as individuals they subscribed to societies and supported school projects. Stowell was not alone, however, in convicting them of a 'general reluctance'.[43]

This lack of support was the more galling given that the parish church could be presented as impeding the day-to-day pastoral work of its daughter churches, notably through the rites of passage which were such a striking feature of its routines. Stowell complained that, until the Bishop had stepped in, marriages and

41 *Ibid.*, pp. 278–9.

42 John Maclure, *Some Remarks on the State of the Established Church in Manchester* (Manchester: C. Ambery, 1841), pp. 17, 21.

43 HLRO, HC/CL/PB/2/18/43, Minutes of Rectory Bill, 21 March 1850, fols 46, 86–8, 93; 20 March 1859, fols 133, 179–80; see also Maclure, *Remarks*, pp. 17–18. Stowell's biographer thought that the sponsors of Christ Church feared that existing Manchester preferment would never be offered to the Calvinist Stowell by the warden and fellows: J. B. Marsden, *Memoirs of the Life and Labours of Hugh Stowell, M.A.* (London: Hamilton, Adams, & Co., 1868), pp. 39–40.

baptisms at Christ Church had required the payment of a dupli-
cate fee (sometimes from his own pocket) to th'Owd Church.
In 1850, he reckoned there were three times as many baptisms
among the poor since the Bishop's intervention.[44] It was not just
the fees that prompted concern: so too did the indecorous con-
fusion attendant on Cathedral rites. In later years this provoked
nostalgia for a quaint local custom and awe at the stamina of
officiating ministers such as John Elvy, who as curate and minor
canon from 1863 to 1905 conducted 19,000 baptisms and 9,000
weddings (sometimes in 'railfuls'). The registers for 1838 reveal
an annual total of 5,163 baptisms, 2,615 marriages, and 1,457
funerals, with an average of 150 banns published each Sunday.[45]
Baptisms lacked solemnity, with the Black Boar's Head tavern
doing well before the service both from sales of liquor and as
the place where Christian names were recorded on slips of paper
for the clergy. Marriages were worse. Some seeking anonymity
exploited the promising circumstances generated by the profu-
sion of banns and poor acoustics – churchwarden Richard Birley
could only distinguish a single surname among those announced
one week in 1850. Manchester incumbents complained that
under-age and other illicit couples evaded detection in significant
numbers by resorting to the Cathedral.[46] It did happen. Thomas
Buxton and Elizabeth Hickman were married before 9 a.m. on
10 June 1828.[47] Later that day Hickman's uncle, from whom
she anticipated an inheritance of some £40,000, forcibly car-
ried off his sixteen-year-old niece before this eloping Derbyshire
couple could consummate their marriage. In 1829, Buxton was
convicted of conspiracy. The evidence of John Neal, the deputy
parish clerk, offered a telling indictment of the complicity of both
church officers and clergy in banns that stated both parties as 'of
this parish'. Neal explained that Humphrey Nichols, parish clerk
since 1818 (his father having paid more than £1,000 to secure
him the position's lucrative fee income from its owners, the de
Trafford family), had explicitly instructed him *not* to ask couples
if they were Manchester residents unless they volunteered the
information. Neal had collaborated despite the marriage's suspi-

44 HLRO, HC/CL/PB/2/18/43, 21 March 1850, fol. 58.

45 Elvy, *Recollections*, pp. 23, 84–5; analysis by Henry Hudson. For a clas-
sic description of the marriage service, see George Head, *A Home Tour
through the Manufacturing Districts of England, in the Summer of 1835*
(London: J. Murray, 1836), pp. 70–3.

46 HLRO, HC/CL/PB/2/18/43, 21 March 1850, fols 284, 143, 154, 165, 204;
22 March, fols 299–312.

47 For what follows, see *The Examiner*, 22 June 1828; *Morning Post*, 24
March 1829; *House of Lords Journal*, 9 June 1830.

ciously rushed organization the night before by the Manchester publican Benjamin Wild, with the only clergyman available to conduct it his friend the librarian at Chetham's. It was appropriate that the final hour of the universal right of parishioners of the original Manchester parish to marry in the Cathedral came with the death of Nichols in 1875, though even then the practice revived briefly in 1878 until a legal opinion finally settled that the Manchester Parish Act had indeed ended it.[48]

Critics also began to scrutinize the chapter for evidence of their commitment to Cottonopolis. In 1841, Maclure remarked on the irony that a 'reform' ministry had replaced the Tory, Lancastrian, and Ardwick resident Warden Dr Calvert, whose funeral in 1840 was a major Manchester occasion, with the Whig aristocrat, scholar, and former MP William Herbert, a superannuated pluralist (he was then Rector of Spofforth in Yorkshire, a cure of a mere 2,000 souls worth more than £1,500 per annum) who would die in his London home in 1847.[49] Canon Richard Parkinson came to embody the issue. Appointed fellow in 1833, Parkinson was an industrious high church Protestant cleric and antiquarian (helping establish the Chetham Society) and '[b]y far the most popular preacher heard in the Old Church for many a year', expounding on – and quoted by Engels regarding – social conditions in the city, whose career and life both ended shortly after being struck by paralysis while preaching in the Cathedral in 1857. One memoirist characterized him as an 'Old Church Worthy' distinguished by his 'sound judgment, sunshiny presence, genial disposition and thoroughly practical character'.[50] In 1846, he nevertheless accepted the Cumberland living of St Bees and the associated post of Principal of its College, which took him away from Manchester for nine months of the year; in 1847 he also acquired the Hertfordshire living of Northaw. He did not resign his Manchester preferment. Parkinson was not alone as a pluralist. His fellow canon, Robert Cox Clifton, promoted

48 *MG*, 21 April 1879; Nichols (1791–1875) had since 1835 seen his life interest exercised by deputy. For this and other details, see Oldham Historical Research Group, www.pixnet.co.uk/Oldham-hrg/archives/rowbottom/pages/072-page.html, accessed 11 July 2016.

49 Maclure, *Remarks*, p. 18; F. R. Raines, *The Rectors of Manchester and Wardens of the Collegiate Church of that Town*, 2 vols, CS ns 5, 6 (Manchester: Chetham Society, 1885), vol. 2. Raines nonetheless judged that Herbert displayed 'a restless desire to do good in Manchester' which 'enabled him to infuse a large portion of charity and forbearance into the seething community by which he was surrounded' (p. 185).

50 Huntington, *Random Recollections*, p. 277; Engels, *Condition of the Working-Class*, p. 125; John Evans, *Canon Parkinson* (Manchester: Abel Heywood, 1878), pp. 3–4.

from clerk-in-orders to canon in 1843, was Rector of Somerton, Oxfordshire, where he also served as Rural Dean.

The issue suddenly gathered steam in the first half of 1847. On 9 February the future Earl of Derby and Conservative Prime Minister Edward Stanley presented a petition from the church-wardens to the House of Lords, protesting that parish revenues paid for a chapter claiming exemption from residence and pastoral responsibility. A month later, the exclusively Anglican Manchester Church Reform Association (MCRA) was established to pursue a new ecclesiastical settlement in the parish, including among its leading figures Tories such as Richard Birley of the manufacturing dynasty and the lawyer Stephen Heelis.[51] Whereas in the 1830s the fellows and churchwardens had been allies in controversy with other parishioners, now they were at odds in a debate which saw some of the newly confident commercial classes taking a lead. The urgency of the campaign reflected the opportunity its leaders identified in the conjunction of the imminent arrival of a bishop, the death of Dean Herbert on 28 May 1847, and the scandal around Parkinson.

The urgency was appreciated in the chapter. Although, in virtually his last act as Dean, Herbert complained of inaccuracies in the petition, a chapter on 12 May agreed to work with the churchwardens to ensure that any surplus accruing beyond the incomes allocated under the 1840 Act should be devoted exclusively to the parish's spiritual needs. Meanwhile, revenues from thirty-one acres of prime building land on the Newton estate should be set aside to obviate the need for double fees and to endow the chapter's poorest Manchester livings. Furthermore, the statutes should be amended to require all future canons simultaneously to hold one of the chapter's Manchester livings.[52]

The churchwardens were content, judging that thus they had 'obtained all, and more than all, they had ever sought for'.[53] But the chapter's hopes of ending the dispute were dashed when the Association chose to regard the initiative only as a starting point. Convening first churchwardens and then a large but exclusively Anglican public meeting at the Town Hall, the Association resolved to accept no settlement that did not prioritize provision for the parish over the chapter (who should rather be financed by

51 *Hansard*, 9 February 1847, cols 991–1004; London, CERC, ECE/7/1/4531/1, 'Manchester Chapter re Manchester Parish Division Act', *Rules of the Association of Members of the Established Church for promoting a Reform in the Ecclesiastical Provision for the Parish of Manchester*.
52 MCA, Mancath/2/2/2, Chapter register, 12 May 1847.
53 CERC, ECE/7/1/4531/1, churchwardens to Heelis *et al.*, 22 June 1847.

the Ecclesiastical Commissioners).[54] Increasingly tetchy interactions, not helped by (on the one side) Birley's efforts to insert the reformers' proposals into the impending Bishopric Bill, and (on the other) by the decision of the newly appointed Dean Bowers to postpone leaving his Covent Garden parish for the north until March 1848,[55] led to competing memorials to the Commissioners. The reformers' initiatives were well received in Westminster. Equally significantly, whereas in 1847 Bishop Sumner of Chester had accepted that cure of souls rested with the chaplains,[56] the new Bishop, James Prince Lee, was less convinced. George Huntington later captured the Cathedral's view of their new prelate in recording that he entered on his new duties with 'a stern resolution', perhaps his 'domineering manner' reflecting the scars of controversies relating to his previous position as headmaster of King Edward's School, Birmingham.[57] The reformers courted Prince Lee's support. In April 1849, a slate of MCRA candidates (Birley, John Morley, and Thomas Clegg) defeated the candidates named by the retiring churchwardens in the election to succeed them.[58] By January 1850, they had a draft bill ready to present to a parish meeting which endorsed its despatch to Westminster.[59]

The Manchester Parish Division Act[60] received royal assent on 29 July 1850, having been introduced as a bill six months earlier by Joseph Brotherton, the Cowherdite Bible Christian who served as Salford's first MP, supported by the two Manchester MPs, the Quaker John Bright, and the Anglican Thomas Milner Gibson – all three sitting on the Liberal benches. It marked an epoch in the life of the young Cathedral and its relations with its city, and also promised to bring some respite from a tumultuous era of parish conflict. Manchester presses had poured forth a flood of pamphlet and newspaper comment since the Parkinson

54 *MG*, 5 June, 17 July 1847.
55 See *MC*, 8 January 1848; *MT* of the same date thrilled to Birley's 'caustic and happy' account of the negotiations. See also *Copy of Correspondence between the Association of Members of the Established Church for promoting a reform in the Ecclesiastical Provision for the Parish of Manchester and the Dean and Canons of Manchester* (Manchester: Cave & Sever, 1847).
56 Cambridge, MS Add. 8862/5/4, Herbert to Sumner, 23 February 1847, Sumner to Herbert, 1 March 1847.
57 Huntington, *Random Recollections*, pp. 10–11; *ODNB*, *s.n.* 'Lee, James Prince (1804–1869)'; David Newsome, *Godliness and Good Learning: Four Studies of a Victorian Ideal* (London: John Murray, 1961), ch. 2, at p. 127 (the classic account).
58 *MG*, 26, 29 April 1848; 11, 14 April 1849.
59 *MG*, 12 January 1850.
60 13 & 14 Vict. c. 41, 'An Act to authorize the division of the Parish of Manchester into several parishes, and for the application of the revenues of the Collegiate and Parish Church, and for other purposes.'

affair. The London barrister Thomas Turner, through a series of letters in the *Guardian* and then a hundred-page missive to Prince Lee, advocated reform through a painstaking analysis of the Church's charters and other documents, providing full translations (another barrister, Thomas Wheeler, produced a new edition of the Caroline charter). The chapter and their chief champion, Canon Clifton, who bravely entered the lists in the character of a parishioner at the parish meeting, generally came off badly in these exchanges, not least in their opponents' demonstration of past (deliberate? – at least, to Prince Lee, 'very remarkable') misquotation from the charters, and in their efforts to suggest that most of their property was unrelated to their rectoral responsibilities.[61] There had also been petitions and printed addresses posted on the walls of the churchyard raising the cry of 'The Old Church in danger';[62] while vestries and parish meetings had once more become heated and on occasion virtually riotous occasions. The Cathedral clergy no longer attended to chair; and in their absence supporters and opponents of reform clashed not only with each other but with a large and vociferous body of Manchester Chartists, headed by the radical bookseller William Willis and Reginald John Richardson. The Chartists sought to overturn the 'Sturges Bourne' tyranny of the propertied classes in the vestry, their several triumphs in shows of hands for electing chairmen and churchwardens being overturned by a combination of stubborn refusal to acknowledge their presence and resort to polls, the law, and even fisticuffs (during a re-run of the 1850 vestry election in the Cathedral, despite the presence of the police Willis's coat was torn, the beleaguered Chartist exclaiming: 'Am I to be murdered here?').[63]

These excitements provided a backdrop to, and running commentary on, the Bill's parliamentary progress. Both sides

61 Thomas Turner, *A Letter on the Collegiate Parish Church of Manchester with remarks on the Bill before Parliament for the Division of the Parish, and other Purposes, addressed (by Permission) to the Right Reverend James Prince, Lord Bishop of Manchester* (London: J. Ridgway, 1850); *The First Appendix to Mr Turner's Letter to the Bishop of Manchester: consisting of Six Letters on the Collegiate Church of Manchester, addressed principally to Henry Charlewood Esqr of Manchester and first published in the Manchester Guardian newspaper in the course of the year 1848* (London: J. Ridgway, 1850); Thomas Turner, *The Second Appendix to Mr Turner's Letter to the Bishop of Manchester, consisting of Translations of the several Foundation Charters of the College of Manchester, with other Documents relating to the Collegiate and Parish Church* (London: Thomas Ridgway, 1850); Thomas Wheeler, *The foundation charter of Christ's College, Manchester* (Manchester: Cave and Sever, 1847).
62 *MG*, 9 January 1850.
63 *MG*, 1 June 1850.

spent lavishly: the Reform Association estimated their costs at £3,700, while the chapter received more than £1,000 towards their costs of £1,542 from lay supporters including the Byrom heiress Eleanora Atherton (sufficiently supportive of the chapter to have given them in 1840 the patronage of Holy Trinity, Hulme, which she had erected at the cost of £10,000), the mill-owner George Faulkner, the future Conservative MP William Cunliffe Brooks, and Thomas Hornby, who 'earnestly' hoped 'that each member of the chapter may be long spared to us to shine as lights in the world advancing the doctrine of God'.[64] The key struggles came at the committee stage, when over eight days witnesses – including canons Sargeant and Clifton, Bishop Prince Lee, Manchester clergy including Stowell, and laymen such as churchwardens Birley and Morley, the MCRA-supporting cotton magnate Robert Gardner, and, on the other side, the merchant drysalter James Collier Harter – were examined on the foundation documents, chapter finances and pastoral work, and the relations of Cathedral and parish. Their testimonies and cross-examinations provide an invaluable source for the historian of the early Victorian Cathedral.[65]

The churchwardens' bill proposed dividing the parish into independent rectories by means of Ecclesiastical Commission grants facilitated by an increased surplus from the chapter funds. This would be achieved by halving the incomes of the dean and canons from £2,000 to £1,000 and £1,000 to £500 respectively. The dean would receive an additional £500 to reflect formal recognition as rector of a residual Cathedral parish on its northern side, in serving which he would be assisted by the minor canons, in future appointed by him alone and receiving fixed salaries of £250 rather than fees (including the abolished double dues). In addition, two canons only should be required to hold Manchester livings (a concession to secure Prince Lee's support, the Bishop wanting the other two as patronage disposable to the rest of the diocese).

Before it passed, however, the Bill underwent what the *Manchester Courier* dubbed a 'marvellous' transformation. The chapter secured changes which brought the Act closer to their original scheme. All four canons would have parish responsibilities (at St Philip, Salford; St George, Hulme; and St Andrew and St Matthew, Manchester); the clerk-in-orders was saved from proposed abolition, and the minor canons remained chapter

64 *MG*, 27 November 1850; MCA, Mancath/2/2/2, Chapter register, 13 February 1851; Cambridge, UL, MS Add. 8862/5/5.
65 HLRO, HC/CL/PB/2/18/43 (also reports in *MG*).

appointments rather than effectively decanal curates; the dean would not formally become rector of the residual parish. In addition, clauses increasing the Bishop's visitorial powers and transferring to him chapter patronage were removed; an attempt to substitute all church rates in Manchester with chapter monies was blocked; and eligibility for support from chapter funds was narrowed. The cuts to the chapter salaries were reduced, leaving unconditional incomes of £1,500 and £600.

The reformers had nevertheless achieved some of their most important objectives. They obtained a statement of the Dean's pastoral responsibility for the Cathedral district (and saw off a capitular amendment to designate the Derby chapel alone as the parish church); they had ended double fees; they had reduced the threshold at which a surplus was freed for redistribution, and established a scheme for retaining this locally in order to raise all incomes in the ancient parish first to £150 and then £250 per annum, and potentially to increase endowments. The following November the churchwardens were rewarded by fellow parishioners for their sacrifice of 'comfort, social position, time and money' to the cause by a presentation of silver plate.[66]

The Act is important not just for having helped resolve issues handicapping the Anglican mission to Manchester, but also because it crystallized while *failing to resolve* equally important issues in the relation of the new Cathedral and see city. If the Act of 1840 prepared the Collegiate Church for its role as Cathedral, the 1850 Act explicitly preserved key elements of the former's constitution and parochial role rather than completing the transformation. Moreover, by establishing the direct link between surpluses at the Cathedral and the reinforcement of parochial machinery, it begged questions as to what represented legitimate expenditure at the Cathedral beyond clerical salaries and basic maintenance. These would inevitably arise should it be considered that the Cathedral's liturgical life required significant alteration to befit its new status. Finally, and ominously, it set the chapter directly at loggerheads with their new Bishop. It was only too appropriate that the Act contained the word 'Division' in its title.

66 For the chapter wash-up of the process, see Cambridge, UL, MS Add 8862/5/5, Bowers papers, clearly shared by 'sources close to the chapter' with *MC*, 20 July 1850; *MG*, 29 November 1851.

The Cathedral in the 1850s and 1860s

When the fifty-three-year-old Dean Bowers arrived in Manchester in 1847, some concerned that life-interests might delay reform took comfort from his apparent frailty and grey, grim expression (preserved in photographs, although George Huntington recalled a 'genial glow' that 'illuminated his face like a sunbeam in snowtime'). But Bowers flourished. The stocky, snuff-addicted, and humanely good-humoured Dean would resign in 1872 having provided the fledgling Cathedral with sustained, effective, and non-partisan leadership: one obituary noted that 'no party could claim him as their own; he was alike averse from the extreme views of the Ritualistic and (so-called) Evangelical sections of the church, though giving each of them credit for honesty of purpose and believing the establishment wide enough to accommodate them both' (he also campaigned for a revised Prayer Book acceptable to Nonconformists).[67] That Bowers was the first non-pluralist Dean of the period was helpful in the circumstances of his accession, as was his keen interest in congregational worship and opposition to pew rents, realized in his support for the foundation of St Alban, Cheetwood, in 1856, where he became patron of a church with free seating.

The fledgling Cathedral benefited from its engaged Dean, but suffered from a disengaged Bishop. Prince Lee's enthronement in February 1848 was, even to the sceptical *Manchester Times*, which had no time for bishops, 'a most extraordinary sensation'. The poor sightlines in the building combined with overcrowding to compromise the dignity of the new prelate's entry: 'ladies occupying the upper north steps of the altar having risen to their feet, so as to exclude all behind them from a sight, angry cries of "sit down ladies" and a slight scream from some of the fair, so unexpectedly shut out from the ceremonies, added to the strangeness and excitability of the scene'.[68] It was emblematic of Prince Lee's relation with his Cathedral that immediately after enthronement he left for Whalley Range to lay the foundation stone of a new church. Thereafter, as even the sympathetic clerk-in-orders, George Huntington, was forced to admit, 'intercourse with Bishop Lee was chiefly confined to visits of business to St James's Square'. Andrew Boutflower was blunt: 'He was never on intimate terms with the Dean and Chapter, and it was under-

67 For pen portraits, see Huntington, *Random Recollections*, ch. 11; Andrew Boutflower, *Personal Reminiscences of Manchester Cathedral* (Leighton Buzzard: Faith Press, 1913), pp. 47–8. Quotation from *MG*, 5 July 1872.
68 *MT*, 12 February 1848.

George Hull Bowers, Dean 1847–72, displaying little evidence of the 'genial glow' that George Huntington claimed 'illuminated his face like a sunbeam in snowtime'

stood (whether true or not, I do not know) that they refused him the use of the Cathedral pulpit.'[69] It did not help that the chapter and not the Bishop appointed canons until Wray's death in 1866 removed the last pre-reform fellow. They did not look far. All four appointed before 1866 had prior connections with th'Owd Church: John Howard Marsden and Charles Richson had been clerks-in-orders and William Wilson a minor canon, while Nicholas Gibson had served as Wray's curate. Lee had to content himself with nominating the honorary canons inaugurated in

69 Huntington, *Random Recollections*, p. 21; Boutflower, *Personal Reminiscences*, p. 37.

1849, something he did with such frequency that Bowers joked that he would have to house them in loose-boxes.[70] After 1866 things were different: Lee's two appointments – Edward Birch and Richard Durnford – were honorary canons and diocesan officers otherwise unconnected with the Cathedral. It was perhaps no coincidence that their tenures were significantly shorter than those of the preceding generation of in-house canons: both were gone within two years, Birch to the vicarage of Blackburn, and Durnford to the see of Chichester. There was some irony in the fact that while the 1850 Act promoted canonical residence in Manchester, the change in patronage potentially transformed the canonries from the pinnacles of clerical achievement in Cottonopolis to temporary staging-posts in high-flying ecclesiastical careers.

The 'Mancunian' chapter of the 1850s and 1860s played a significant role in city life, even if they retained livings outside; there felt something pointed, indeed, about Wray's taking the living of Runcton in Norfolk only a year after the 1850 Act (in contrast, the first of the promised formal annexations of rectories to canonries took place only in 1858, when Richson's canonry was conjoined with St Andrew's, Ancoats). But Wray remained active in the Sunday school, whose scholars he fed hot cross buns each Good Friday, just as every Christmas he dined older communicants, and annually treated local curates. On each birthday he distributed a corresponding number of packs of tea and sugar. Wray's Tory paternalism could also have a radical edge: he chaired the Manchester Committee of the Ten Hours Movement. Richson was more of a moderniser: a key figure in educational reform, while clerk-in-orders he was secretary of the local Church Education Society and in 1851 campaigned unsuccessfully for the legislation needed to secure a rate in its support, later collaborating with local advocates of secular provision to develop the approach that would underpin the 1870 Education Act. He was important in the foundation of the Manchester and Salford Sanitary Association in 1853. Clifton was similarly active in civic voluntaryism, serving as a trustee of Owens College and treasurer of the Royal Infirmary, and taking an interest in Manchester's ragged schools.[71] Marsden was the least visible in the Cathedral, but this perhaps reflected as much his position

70 W. R. W. Stephens, *A Memoir of Richard Durnford, D.D., sometime Bishop of Chichester* (London: John Murray, 1899), p. 96; Huntington, *Random Reminiscences*, pp. 258–9.

71 Huntington, *Random Reminiscences*, pp. 286–7; *ODNB, s.nn.* 'Richson, Charles (1806–1874)', 'Clifton, Robert Cox (1810–1861)'; *MG*, 3 August 1861; Michael Leach, 'John Howard Marsden (1803–1891), first Disney

as Prince Lee's chaplain (and the alignment that implied) as his other activities, which included serving as the first Disney Professor of Archaeology at Cambridge.

Engagement with the city was eased by a less troubled period in the vestry, symbolized by the fact that from 1852 the lesser Cathedral clergy once more took the chair and in a conciliatory gesture on the part of the parish, the nomination of Hugh Birley, not involved in the reform agitation, as churchwarden. The effectiveness of the 1850 Act was hard to assess before life-interests worked themselves out and the revenues generated a surplus. In the interim, the building itself became the focus of attention. Looming over everything else (in every sense) was the tower, by 1852 in such a condition that the bells could no longer be rung. Critical reports on the state of the chancel had been another stick with which to beat the chapter, but the churchwardens had problems of their own in maintaining the fabric without a compulsory rate. During the early 1840s the voluntary charge had raised just over £1,000 per annum, but it fell to £580 by 1851, despite the assessed property now being valued at around £1.5 million.

The 1850s and 1860s nevertheless witnessed the first substantial phase of a programme of restoration and improvement that by 1885 would have seen some £64,000 expended since 1840, of which the dean and chapter and Ecclesiastical Commission between them accounted for less than £10,000.[72] Symbolic of the wider process was work on the tower, partially demolished in 1858 following an alarming architect's report (the strict demarcation of responsibility within the church clear from the fact that this left no trace in the chapter minutes!), and then taken down to its foundations in 1863. The completion of its replacement, some fifteen feet higher than the original, was finally celebrated in June 1867. Alongside there were repairs to the clerestory, ceilings, and roofs; the Trinity, Ely, and Trafford chapels were restored; heating and seating were renovated. A new organ was installed; and the south porch was patched up in 1872, before attention turned to Brown's chapel.

Funding this work was a considerable achievement on the part of the churchwardens and vestry. Early in the 1850s, churchwardens had hoped that Dissenters who baulked at funding Cathedral services might cheerfully contribute to the

Professor of Archaeology at the University of Cambridge 1851–1865', *Bulletin of the History of Archaeology* 17 (2007), pp. 35–9.

72 PP 1884–5 [C.4371], *Final report of … Commissioners for Inquiring into the condition of Cathedral Churches*, p. 45.

maintenance of such an important civic building, and that transferring the costs of church music to the congregation might swell the voluntary rate thus reserved for less contentious expenditure on the fabric; they also looked optimistically to revenues from gallery pew rents reassigned from the minor canons to supporting repairs.[73] The latter, however, only generated annual sums of £200 to £300, while by 1857 the rate could not even fund the services.[74] The only solution lay in voluntary subscriptions and substantial individual philanthropy, such as the gift of the organ from William Henry Houldsworth (churchwarden, builder of the largest cotton mill in the world at Reddish Mill, and later Conservative MP for Manchester North-West), inaugurated on a restored rood screen after long negotiations with the chapter in 1872, a decade after its predecessor had been removed from the same position. The critical situation of the tower in 1858 provided particular impetus, and nine individuals pledged £500 apiece to a repair fund (including Eleanor Atherton, J. C. Harter, the banker Benjamin Heywood, and the cotton masters Robert Barnes, Thomas Bazley, and George Faulkner); the mayor pledged £100. Support emerged even amongst those usually at odds with the parish elite: thus a motion that a special vestry be convened to levy an emergency rate was proposed by Thomas Storey, whose Chartist-inspired protest against plural voting in the vestry had rumbled on since 1850, and seconded by the Chartist Richardson.[75] Alongside the tower fund a general subscription also raised significant sums, both in large donations (such as Atherton's £1,500) and smaller amounts, such that by 1862 it stood at £16,193.

In 1860, the chapter reviewed their own restoration efforts, as they approached the Ecclesiastical Commissioners unsuccessfully for a loan to help address urgent issues. In 1849, they had envisaged more than a decade of works at £300 a year, but they had achieved this figure only three times in disbursing just under £2,500. This had financed work on the choir clerestory, roof and aisles, the chapter house, and the installation of an episcopal throne. But like the churchwardens, the chapter also benefited from lay contributions, as when William Andrews, brother of the deputy parish clerk and a devoted disciple of Wray, paid £550 for a new east window in 1857 and then in 1859 repaved

73 MG, 14 April 1852.
74 MT, 11 April 1855, 18 April 1857; MG, 26 March 1856, 15 April 1857.
75 MG, 7, 10 April, 12 June 1858.

the chancel with encaustic tiles to celebrate fifty years of Wray's association with the Cathedral.[76]

One argument for such renovations was that Manchester Cathedral, according to one commentator, 'known as the very poorest and worst conditioned of all', disgraced 'one of the richest cities in the kingdom'.[77] Such sentiments prompted the abortive scheme for a new, bigger, and much more elaborate Gothic building, designed by Richard Herbert Carpenter, to be erected in Piccadilly, that Canon Nathaniel Woodard persuaded his colleagues to adopt in 1874.[78] Bishop Fraser regretted that instead the city made do with 'a fine parish church, and nothing more', believing that Carpenter's building would have acted as 'a great educator and solemnizer of the religious feelings of the people'.[79]

It could be argued, however, that this outcome captured something essential about the post-1850 Cathedral, for it was as a parish church that it was still widely viewed. Much of the loyalty it attracted, and which prompted the subscriptions to renovate it, was rooted in this fact: indeed, Woodard's scheme foundered partly because of strong local feeling 'against the destruction of many of the dear and sacred associations with the stones of the old parish church'.[80] This sentiment owed much to the continuity in personnel already remarked upon, and the clergy's own understanding of their roles. Thus, Parkinson regarded 'canon' as a nickname, preferring to be a *fellow* – 'it reminds me of men and days gone by' – while William Wilbraham Johnson thought of himself as a 'chaplain' rather than minor canon though elected in 1854 (even official documents could struggle: the chapter minuted Henry Holme Westmore's appointment in 1853 as a 'Chaplain, vicar or minor canon'). It was also manifest in a street culture informed by the Cathedral's ongoing role in rites of passage – as in the hansom cabbie who expressed bewilderment when a fare asked for the Cathedral, never having heard of it, but knew instantly where to go when told it was 'T'Ould Church'.[81] It was most apparent, however, in the world of the elite Mancu-

76 MCA, Mancath/2/2/2, Chapter register, 24 December 1851; 2 February 1853; 1 December 1857; 10 December 1858; 27 January, 3 March 1860; Wray, *Memoirs*, p. 64.

77 *MG*, 23 April 1874.

78 MCA, Mancath/2/2/3, Chapter register, 21 April 1874.

79 Quoted by Michael Hennell, *The Deans and Canons of Manchester Cathedral, 1840–1948* (Manchester: Manchester Cathedral, 1988), p. 18.

80 John Otter, *Nathaniel Woodard: A Memoir of his Life* (London: Bodley Head, 1925), p. 260.

81 Evans, *Canon Parkinson*, p. 14; Boutflower, *Personal Reminiscences*, p. 5; MCA, Mancath/2/2/2, Chapter register, 2 February 1853.

nians who rented pews in the galleries and Trafford chapel, those Parkinson called 'this zealous race of grey-haired members of the "old church"', and Huntington 'old church worthies'.[82] This group headed subscription lists, made handsome donations, and helped fix the collective memory of the church through their appearances in – or by penning memoirs associated with – it, their stories seamlessly crossing the inauguration of the Cathedral.[83] Such figures gave the Cathedral community definition and specificity unique among English cathedrals. The ethos outlived the grey-haired elders, and it received its most eloquent articulation in the *Personal Reminiscences* of the surgeon Andrew Boutflower (1845–1932), penned in 1912, which blended his own recollections as churchgoer, sidesman and churchwarden with those of his father John (1797–1889), another physician, at whose gossipy Sunday lunches for Cathedral clergy the minor canon John Elvy learned much old-church lore. Huntington remembered the Boutflowers sitting in their north gallery pew close by the distiller and wine merchant George Pilkington (1800–64),[84] the latter the epitome of his 'batch' of worthies, who also included Boutflower senior, the brothers William and Charles Andrew, and Humphrey Nichols. Having sung in the choir as an orphan educated at Chetham College, Pilkington had come over sixty years later to occupy a pew as a leading Manchester merchant. He was wealthy enough to commission the statue of Chetham that still stands in the Cathedral and also three sanctuary windows; he bequeathed £2,000 to establish Pilkington's Charity, which enabled the minor canons and churchwardens to supply clothing to the poor. The mix of religious solemnity and clubbable conviviality which enveloped the relations of worthies and minor Cathedral clergy was exemplified in Pilkington's stipulation that the distribution should follow a Cathedral sermon on his birthday, the participation of the distributors being encouraged by a benefaction for an accompanying dinner. Huntington saw something *sui generis* here: Pilkington was 'an earnest, humble-minded Christian and Churchman, of a type, I venture to think, produceable only in the Old Church', whose attributes he claimed had 'done more to form the character of Manchester

82 Evans, *Canon Parkinson*, p. 13; Huntington, *Random Recollections*, ch. 15.

83 One favoured memory was the celebrated Spanish mezzo-soprano Maria Malibran's death during the 1836 Music Festival held in the church, and her subsequent temporary interment in the south choir aisle: Boutflower, *Personal Reminiscences*, p. 13.

84 Boutflower, *Personal Reminiscences*, pp. i–iv; for Andrew Boutflower, see his obituary in the *British Medical Journal*, 18 June 1932, p. 1152.

Churchmen than any cause or all causes put together'.[85] This was hyperbole: but it might be argued that if Wray was correct in arguing that attendance at th'Owd Church was one of three attributes of a Manchester gentleman (the others being taking *The Times* and membership of the Pitt Club),[86] then the wealthy commercial men who occupied its best seats were of a different complexion from those taking prime spots in most English cathedrals, and the sociability that extended beyond and around them gave a particular colour to Cathedral life.[87]

The memoirs associated with the Cathedral bring out the importance of its liturgical life to congregation and clergy alike, both celebrating the large attendances. The Cathedral Commission of 1852 provides a snapshot of services in the early Cathedral, which had evolved from those of the Collegiate Church. Sunday services, in the nave, had a parochial orientation. An early 7 a.m. 'lecture' service taken by the minor canons, of prayers and sermon (supported by a specific endowment from the rents in the north gallery, and which some recalled had attracted two or three hundred people in the early 1800s), was followed by another service at 10.30 a.m. at which a canon read the prayers, canticles were sung to simple chants, and a sermon was delivered; then at 3.30 p.m. came a service with sermon and anthem. Communion was weekly, though it had been fortnightly before 1849. On weekdays more cathedral-like services but with a reduced number of singers were held in the choir at 11 a.m. and 3.30 p.m.[88] This pattern prevailed until 1 May 1859, when the Derby chapel, renovated for this purpose with open pews and seating for a choir by the churchwarden Herbert Birley (another scion of the manufacturing dynasty), played host to a new Sunday evening service which attracted more than twice the two hundred and fifty worshippers who could be accommodated in the chapel itself; once renovations permitted, the service was relocated to the nave. Part of its appeal lay in the participation of a voluntary choir and deliberately accessible music. Bowers hoped it would consolidate the work of district visiting, which could only be

85 Huntington, *Random Recollections*, pp. 304–7, 317; MG, 2 March 1864.
86 Huntington, *Random Recollections*, p. 286.
87 Embodied strikingly when junior clergy, choirmen, churchwardens, and sidesmen met for musical suppers at the Dog and Partridge in Fennel Street. Boutflower later treated the voluntary choir to annual dinners at the Temperance Hotel in Corporation Street and organized annual outings: Boutflower, *Personal Reminiscences*, pp. 61–2.
88 PP 1854 [1822], *First Report of Her Majesty's Commissioners ... into the state and condition of the Cathedral and Collegiate Churches in England and Wales*, pp. 521, 523–4; Wray, *Memoirs*, pp. 143–5; Boutflower, *Personal Reminiscences*, p. 22.

H. H. Westmore,
minor canon
1853–70

judged effective 'when it obliges the consciences of men to seek
after and to employ the church's ordinances in all their fullness'.[89]
The initiative, which mimicked nave services introduced the year
before at St Paul's, owed much to the 'dogged' application of
minor canon Westmore, who, with active support from Birley,
George Huntington as clerk-in-orders, and Bowers (who left a
legacy to sustain the services), established the services in the face
of opposition from Wray and indifference from the Bishop and
other canons.[90] Westmore's concern for his parishioners was also

89 MC, 7 May 1859.
90 MG, 2 September 1890; Elvy, *Recollections*, pp. 33–4 (misdated to 1857);
 Huntington, *Random Recollections*, pp. 289–90; Barrett, *Barchester*, p. 119.

apparent in the introduction of an 8 a.m. communion in the Derby chapel and his funding a curacy in the residual parish, to which John Elvy was the first appointee in 1863.[91]

If these developments indicate a more harmonious relationship between the Cathedral and Manchester than had characterized the 1840s, financial issues could still unsettle things. In 1853, the chapter reported their annual income as some £7,600 with no surplus; a surplus (of £61) was paid to the Commissioners in 1853, which by 1858 the chapter believed could be guaranteed in future to exceed £600 (that year had seen £835 payable from an income of £8,206). They were correct. Income passed the £10,000 mark in 1866, by which time the Commissioners were due just over £2,411; by 1875 it would reach £20,000, with the Commissioners themselves due over £10,000.[92] These increases reflected more than Manchester's prosperity and the proceeds of land sales. In 1861, the chapter revised its estate management, overhauled audit procedures, increased the bursar's stipend, and discussed policy with the Commissioners after they were audited themselves. The Commissioners' actuary advocated abandoning twenty-one-year leases; by issuing perpetual leases on good building land, returns might be increased by 25 per cent. The chapter saw his point, and the first 999-year lease was sealed in September 1861, with 99 years from this point the preferred shorter term.[93] That others, too, had a stake in chapter finances was recognized in 1872 when a consultative committee, including both Hugh Birley and William Houldsworth, was established 'to afford the public of Manchester an increased assurance that the parochial interests were anxiously cared for by the Chapter in dealing with the estates'.[94]

In 1858, the chapter memorialized the Commissioners to request that what had become a reliable revenue stream should now be applied to local purposes, as the 1850 Act required.[95] The Commissioners won few Mancunian friends when they announced that, given the limited sums involved, they planned not to augment local incomes but only to match-fund endowments by others, prompting alarmed memorials from

91 Huntington, *Random Recollections*, p. 291; Elvy, *Recollections*, pp. 17, 33.
92 CERC, ECE/7/1/4532/1, Estates Committee, 13 January 1859; MCA, Mancath/2/2/2, Chapter register, *passim*.
93 MCA, Mancath/2/2/2, Chapter register, 7 September, 19 December 1861; 19 December 1866; CERC, ECE/7/1/4532/1, report on estates, 8 November 1859, and subsequent correspondence.
94 MCA, Mancath/2/2/3, Chapter register, 19 January 1872.
95 MCA, Mancath/2/2/2, Chapter register, 22 January 1858; CERC, ECE/7/1/4532/1, memorials of 7 July 1857, 26 March 1858.

Manchester clergy and churchmen alike. The audit encouraged a more ambitious policy, the Commission in 1860 announcing that it would allocate £800 in endowment, or income support of up to £150 per annum, to benefices worth less than £200 per annum and neither in private patronage nor annexed to the Cathedral canonries; but this resulted in augmentations only to seven livings in the Bishop's gift or that of trusts and no fewer than nine in the chapter's patronage, with no consideration given to the presence of free sittings. Prince Lee commented that 'a scheme more calculated to excite censure and give dissatisfaction could hardly have been devised'.[96] The growth in the surplus over the 1860s allowed the commissioners to raise the ceiling on grants and to extend the scheme to livings in private hands: by 1869, a permanent annual charge of almost £2,000 had been assigned to augment the endowments of some twenty benefices, alongside £800 to subsidize incomes directly; by 1874, the permanent charge was £3,039 in favour of twenty-eight benefices, which were thus raised to an annual income of at least £150, and the Commissioners could contemplate no longer supporting Manchester livings from their common fund and relying on the chapter revenues, as well as imposing conditions relating to free seating.[97] This was certainly progress. But as the income of the chapter rose, the sense that the settlement of 1850 might have been too generous to the Cathedral and its clergy acquired the potential to aggravate other disputes.

Ritual and rebuilding: the Cathedral of the 1870s and 1880s

Significant changes in personnel during the early 1870s ushered in a new era in the Cathedral's history. In 1870, there was a new Bishop: James Fraser, who shared Prince Lee's educational interests (these prompted Gladstone to select him for Manchester). Fraser proved more energetic and less neurotic than his predecessor. Despite significant disagreements, the chapter found him easier to deal with: he was just more interested in the Cathedral and its pastoral potential, as was apparent from his convening there in November 1874 the first Manchester diocesan conference. A moderate high churchman, Fraser was liberal both in politics and his views on ecclesiastical practice, though to his critics this reflected a lack of spiritual depth and empathy

96 PP Eng. 1861 [226], *Return of churches in parish of Manchester to which allowance has been made by Ecclesiastical Coms. out of surplus chapter revenue*, contains the correspondence.

97 CERC, ECE/7/1/4532/1, Estates Committee, 30 July 1874.

James Fraser,
Bishop of
Manchester, a
photograph given
to the surgeon
Andrew Boutflower

highlighted when he was reluctantly spurred to disciplinary action by others. Their chief complaint was the protracted 'Miles Platting' case, which saw a ritualist Manchester incumbent ultimately imprisoned for contempt of court in 1881, Fraser having refused to veto a prosecution under Disraeli's Public Worship Regulation Act of 1874.[98]

At the Cathedral, Bowers was succeeded as Dean in 1872 by Benjamin Cowie, whose Tractarian credentials were confirmed by serving as W. J. E. Bennett's curate at St Paul's, Knightsbridge,

98 For Miles Platting, see James Bentley, *Ritualism and Politics in Victorian Britain* (Oxford: Oxford University Press, 1978), pp. 105–12, quoting one verdict: 'omnipresence was his forte, and omniscience his foible'; Otter, *Woodard*, p. 244.

and in the elaborate ritual he conducted when a London rector. Two years before, Nathaniel Woodard, another enthusiast for the Oxford Movement, had taken up Gladstone's offer of Durnford's stall (in the premier's gift as he had promoted the latter). Thus it was that Gladstone effected a significant shift in the chapter's theological complexion; there was a striking contrast with Fraser's contemporaneous appointments, both less advanced and local churchmen: William Crane, who had previously served as clerk-in-orders, and Charles Wright Woodhouse, formerly of St Bees and Blackburn, where he had worked hard to mitigate the impact of the Cotton Famine in the early 1860s.

The liturgical consequences became apparent at Cowie's first Easter services in 1873. Whispers of 'popery' greeted the novelty of choristers parading in mauve cassocks beneath their surplices at the morning service, while in the evening Elvy failed to persuade adult voluntary choirmen to process, the whole contingent being replaced before the next evening service, which they watched *en bloc* from a gallery. Two days later a Cathedral[99] regular, John Smith of Collyhurst, attended the vestry to ask whether the proposed slate of churchwardens was sufficiently 'true to the principles of the Reformation' to resist unwelcome 'innovations' introduced by 'strangers'. Smith won cheers from those desiring Manchester 'to retain its reputation not only as a commercial, but as a Protestant Christian community', and, despite the Dean himself pleading with the vestry to be judged on his preaching rather than 'small and unimportant things', secured a poll. This generated a four-day campaign reminiscent of those of the 1830s, with the contest not only pitching 'high' and 'moderate' Anglican churchmen against an alliance of 'low' Anglicans and Dissenters, but also Liberal against Conservative. The opposition candidates' manifesto was the work of the Manchester Orangeman, temperance and Tory activist William Touchstone, while the Orange order turned out its considerable support in St Michael's ward as the Protestant party triumphed by 1,336 votes to 1,008.[100]

This excitement proved to be the opening round in a protracted dispute over the character of the Cathedral's services and teaching which persisted throughout the 1870s, fuelled in part by the parochial disputes over ritual at Miles Platting and

99 Or, as he tellingly preferred it, 'our Old Parish Church of Manchester'. For this and what follows, see *MG*, 16, 21 April 1873; Smith to editor, 18 April 1873.

100 For Touchstone, see Manchester Orange, www.manchesterorange.co.uk/History/bro-william-touchstone, accessed 16 October 2017; *Birmingham Daily Post*, 21 April 1873.

St John, Hulme. These imparted a resonance to developments at the Cathedral that might (in a less febrile atmosphere than that encouraged by the Public Worship Regulation Act) have appeared merely to be part of the development of services appropriate to a Cathedral. It was also the case, however, that both Woodard and Cowie were unafraid of sponsoring Anglo-Catholic innovations, and Cowie sufficiently incautious as to refer to the city's low churchmen as 'pothouse protestants'. By the time of a rowdy Easter vestry in 1874, some Mancunians detected in the Cathedral a programmatic assault on the city's Protestant culture: the placing of a cross on the communion table; the introduction of a weekly offertory; embroidery draping the pulpit on the Feast of the Purification; and the adoption of the eastward position at communion. The churchwardens defended the offertory as a pragmatic and beneficial rationalization of almsgiving, but otherwise insisted that the innovations were beyond their purview; moreover, calm discussions with the Dean (which had already rescued both the prayer before, and the blessing after, the sermon) were more likely to succeed than confrontation. This failed to satisfy the chief agitators, who disputed minor canon Clementi Smith's decision to close the meeting and left shouting anti-Catholic slogans.[101] Tempers remained high a year later, when the Easter vestry removed to the Town Hall to avoid disgrace in the Cathedral. Some acknowledged progress on processions and drapery, but one chapel was denounced as 'a perfect model of a Masshouse' as the leaders of the Protestant party, frustrated in efforts to convene a special vestry to denounce a sermon by Woodard which the churchwardens had referred to Bishop Fraser as potentially stating the doctrine of the mass, vented that frustration.

Relations with the Bishop inevitably suffered. Fraser refused to entertain the charge against Woodard (while acknowledging that the canon was 'a High Churchman of a somewhat pronounced type'), yet had to do so on the basis solely of Woodard's assurances, as the canon declined to share the sermon text with him. His patience was soon tried again. In 1876, Fraser committed to a Manchester and Salford Church mission, with each incumbent selecting his own missioner. As rector of the residual parish, Cowie's determination to appoint 'the most earnest and persuasive preacher I could find' led him to choose (but only as his second choice) William Knox-Little, an advanced high churchman he

101 *MG*, 8 April 1874, *MT*, 11 April 1874. Clementi Smith, characterized by a friend as 'latitudinarian', was heckled as a 'Puseyite': Boutflower, *Personal Reminiscences*, p. 57.

had shortly before appointed to St Alban, Cheetwood, where his protégé maintained a high-profile ritualist ministry.[102] Mancunian low churchmen complained that participating evangelical clergy would be 'caught in a net' by a ritualist plot to embroil them in a compromising 'mixed mission' alongside 'Romanesque' infiltrators. Some evangelicals disowned the protests, but controversy swiftly gathered steam. Cowie stood firm when the Mission Committee informally begged him to reconsider, while Knox-Little publicly offered his support to the ritualist 'martyr' Arthur Tooth after his incarceration in January 1877. The diocesan role of the Cathedral made its mission an especially sensitive issue, but its continuing parochial status prevented both Bishop and churchwardens from challenging the rector's decision (the chapter were not implicated). On 16 January 1877, the churchwardens received a petition against Knox-Little's appointment with more than two thousand signatures, but could only express sympathy and counsel against any disorder. Meanwhile a clearly irritated Fraser found his public statements – on a mission explicitly designed to get back to Christian fundamentals – diverted into tip-toeing through the minefield of church-party tensions as he sought to distinguish between 'false and true sacerdotalism … Could they not forget their differences, which after all were very minor ones, even for an hour?'

In the event, however, Knox-Little's mission surpassed even Cowie's hopes of attracting 'the solid and vigorous' people of Manchester. It appears to have silenced all but his most decided critics (the 'Protestant' churchwarden Alderman Joseph Lamb remarking that 'never were the services plainer than they were during the Mission week', and that Knox-Little had preached 'earnestly, eloquently and sincerely'). Manchester papers noted record attendances at the intense programme of mission services at the Cathedral (with even on weekdays an early communion succeeded by morning service and an address at 11 a.m., evening service at 3.30 p.m., and a mission service at 7.30 p.m.). Most striking of all were short services of thirty minutes' duration held twice around midday, aimed at those engaged in commercial activity: long queues formed and a crush developed as the congregations rotated. The Dean and his allies congratulated themselves on their success; and a few months later Knox-Little was back delivering Lent and Advent sermons in the Cathedral.[103]

102 For this and what follows, see *MC*, *MT*, *MEN*, and *MG*, September 1876–February 1877, *passim*; quotations from *MC*, 8, 17 January 1877; 21 December 1876; 23 February 1877.
103 See *MC*, 7 April 1877; W. J. Knox-Little, *Characteristics and Motives of the Christian Life* (London: Rivingtons, 1881 edn).

Cathedral services and furniture nonetheless constituted a running sore over the next few years, exacerbated by the ongoing parochial disputes. Cowie introduced a provocative motion on ritual to the Manchester church conference in 1881 and emerged as a public critic of the Bishop's legalistic approach to the Miles Platting Case in January 1883. Woodard, meanwhile, was completely alienated from his former episcopal protector, refusing to speak on platforms where the Bishop was also present. (He would later refuse to contribute to the erection of Fraser's Cathedral effigy on the grounds that he was unfit as a 'model for young men to follow in teaching the doctrines of the Church of England'.[104]) Similarly unhelpful was Bishop Fraser's announcement to a specially convened diocesan synod in 1881 that the Cathedral defined the limits of ritual permissible in the diocese, thus establishing it as both an extremity and a contestable benchmark. The next Easter vestry found it only too easy to focus on the seasonal decoration of the communion table (two tall candlesticks, flower vases, and a florally bedecked cross).[105] The churchwardens held the middle ground between the Dean and the 'Protestant parishioners', making sympathetic noises when the latter articulated their grievances, but still insisting that 'if the gentlemen who found fault with the churchwardens for not finding fault with the Dean, for not insulting him, and not instituting a lawsuit against him, would come and look round the Cathedral and then speak honestly and impartially, they would be obliged to confess that there was not a scrap of Ritualism to be seen there'.[106] Their difficult position was slightly alleviated by the clearly political dimensions to the protests, with references to Gladstone's role in Cowie's appointment at the 1878 vestry provoking cries of 'No politics'.

Cowie's departure on his appointment as Dean of Exeter in 1884 might have alleviated tensions; indeed, the first response of some in the vestry was to seek a petition to the new dean asking for the restoration of services to the *status quo ante* of 1835, just as two years later they wanted the new and broad church Bishop James Moorhouse to put a stop to Romanizing during his formal visitation of the Cathedral. However, Gladstone selected

104 *MC*, 14 October 1881; Otter, *Woodard*, pp. 302, 322.
105 A year before, ex-churchwarden Lamb had focused on the draping of the cross on Good Friday, that 'senseless piece of wood covered with crapes': *MT*, 23 April 1881, 15 April 1882. For the Bishop's declaration, see Thomas Hughes, *James Fraser, Second Bishop of Manchester* (London: Macmillan, 1887), p. 318; for Cowie as critic of Fraser, see *MC*, 18 January 1883; for Lamb, see *MT*, 28 August 1891.
106 *MC*, 7 April 1877.

his personal friend and staunch Liberal John Oakley, another critic of Fraser's response to Miles Platting, who had himself exercised a ritualist ministry at St Saviour, Hoxton. Vestry discontent over services and fittings persisted throughout Oakley's tenure. The focus was frequently a copy of Carlo Dolci's *Christ's head in thorns*, which survived repeated condemnatory vestry resolutions until removed from the Chetham chapel in 1887, and later the same chapel's restored piscina. As a counter-measure some called for more prominent display of the Ten Commandments. The issue never quite reached the fever pitch of the early decade, however, as indicated by a motion to petition Oakley only attracting the support of half a dozen vestrymen.[107]

A further indication of the limits of disaffection is that it proved no obstacle to the simultaneous implementation of the most ambitious stage of the restoration of the parochial end of the Cathedral. The stonework of the nave and aisles was replaced following the discovery of its decayed condition on the removal of Roman cement. Like the earlier restoration, this expensive work, carried out between 1882 and 1889 and costing more than £35,000, spoke eloquently of the parochial relationship with the building. Not only did prominent citizens assume individual financial responsibility for particular sections (for example, the chancel arch paid for by James Worrall of the Ordsall Dyeworks and the MP and calico-manufacturer F. W. Grafton), but the decision not to 'improve' or extend, but rather as far as possible to replicate the main body of the old building, despite the scale of the works required, reaffirmed the iconic significance of th'Owd Church's fabric to the Manchester community. One significant addition (of no little importance to this present volume) was, however, the building of a dedicated muniment room over a north porch to allow the removal of the Church's archives from the Stanley chapel, the necessary works being financed by a munificent memorial gift from the family of the recently deceased alderman James Craven.

Oakley found himself at odds not just with Protestant and Conservative parishioners but with some of his chapter colleagues (probably most of all Crane), the sympathetic Elvy recalling Oakley's quip that the chapter consisted of 'four deans and one subdean'.[108] This antagonism was partly a consequence of character: Oakley bounced with energy and confidence, his lack

107 For reports of relevant vestries, see *MT*, 19 April 1884, 11 April 1885, 1 May 1886, 7 April 1888, 27 April 1889, 12 April 1890.

108 See *ODNB*, s.n. 'Oakley, John (1834–1890)'; Elvy, *Recollections*, pp. 28–9; Boutflower, *Personal Reminiscences*, pp. 49–50; Hennell, *Deans and Canons*, p. 21; *MG*, 11 June 1890.

of pretension and openness combining with an outspokenness that frequently antagonized others, especially those who did not share his Gladstonian constitutional politics or his explicit Christian Socialism. It did not help that Oakley was the first Dean not merely to feature in the pages of the *Manchester Guardian* but himself to contribute regularly under a pen-name, *Vicesimus*. Until his premature death at the age of fifty-five in 1890, apparently worn out by his labours, Oakley exploited his position to engage with important city issues, intervening in the gas strike, supporting educational initiatives, and, in the best Mauricean tradition, bringing together men of various political and religious opinions and social classes for discussion of key issues.

Seen from the choir end of the Cathedral, the 1870s and 1880s witnessed significant progress in equipping the church with the characteristic features of a Cathedral, some of which, such as the controversial cassocking of the choir, have already been discussed. Another dimension feeding into the ritual dispute was a parallel but less ambitious programme of restoration and decoration alongside that financed by the parish: happily for the chapter, the impact of Roman cement had been less catastrophic away from the nave, and they could support their own expenditure through frequent gifts from the congregation. The Chetham chapel was a focus of efforts in 1874–75, costing £762. Cathedral processes were also overhauled. Additional payments attached to key chapter roles were augmented, the bursar's compensation reaching £200 in 1877; subordinate posts, such as the clerk-in-orders, had both duties and income revised upwards; the vergers were fitted out in uniform (1876); and a sacristan appointed. The importance of the choral services was recognized in initiatives supporting music. One minor canon was designated precentor by 1874, and paid an additional £50 from 1875, when the organist's salary rose to £200. In the same year, it was decided to secure premises for a choir school and to employ a master; in 1877 an additional singing-man was added to the choir. At the same time, the residual parish remained a key focus for the Dean in particular; on his appointment Cowie secured new chapter orders insisting that 'all the clergy of this residuary parish should be recognised with [the dean] in the choir, and should, when present at the service, appear in surplice, hood and stole'.[109]

All this cost money. These initiatives were possible not least because of the continued mushrooming of the Cathedral revenues.

[109] Key developments recorded in MCA, Mancath/2/2/3, Chapter register, 30 December 1872; 10 April 1873; 27 July 1874; 20 March, 21 September 1875; 20 March, 8 May 1876; 12 November, 8 December 1877.

In the quarter-century following 1870, the gross annual income rose from £11,372 to £31,018. From the perspective of the dean and chapter, the sums required to finance their initiatives might consequently appear easily absorbed by this revenue stream, and appropriately reflected the responsibilities of managing it. Between 1870 and 1880, disbursements rose from £3,734 to £5,944; meanwhile, the surplus paid to the Ecclesiastical Commission for redistribution increased from £2,825 to £14,451. On 31 December 1877, by which date all incumbents in Manchester received an income of at least £150 per year, the chapter recorded in their minutes that it was

> Resolved, that since up to this time, since the collegiate church has been made a cathedral, very little has been done to give additional dignity to the celebration of divine service, because the chapter wished to increase the surplus revenues, the time has now arrived that a larger portion of the revenues of the chapter may be used for the purpose of improving the choir school.

Three years later, Cowie himself reflected the same sentiments when he told the Cathedral Commissioners that '[t]he organization of a cathedral on a real basis ought to come first. At present we are only a college, hampered in many ways by being a parish church.'[110]

As before, however, things looked rather different to outside observers. In the context of significant church extension in Manchester sponsored by Fraser, which relied on the increase of the revenues to secure endowments for the new livings, the income was watched jealously by incumbents anxious that their interests should not take second place. Matters came to a head at the end of the 1870s, when the Ecclesiastical Commissioners refused to consider applications for monies to endow four new churches in the ancient parish – for which no pew rents had been established on the understanding that the Commission would provide – a decision which was linked to the failure of the surplus to increase between 1877 and 1878. A committee of rectors (prominent among them the Mancunian-born and bred Joseph Nunn, Rector of St Thomas Ardwick, described in his *Times* obituary as a 'controversialist and a hard hitter ... occasionally in a minority of one')[111] formed to argue that the explanation for this in turn was supplied by increased expenditure within the Cathedral. Fraser wrote to Cowie expressing his sympathy for the position of the

110 *Ibid.*, 31 December 1877; [C.4330], *Second Report*, p. 303.
111 *The Times*, 19 July 1918.

complainants, which he regarded as 'temperately stated' given the 'huge sums' involved. In reply Cowie insisted that the first claim on the income *must* be 'the maintenance with proper and suitable solemnity of the service of God and then the maintenance of the clergy'.[112] In consequence, over the following decade, the hybrid nature of the Cathedral generated a protracted, damaging, and costly dispute as the issues underlying the 1850 Act were resurrected with consequences that once more marked out the history of Manchester Cathedral from that of others.

Initial attempts to persuade the Dean to limit expenditure voluntarily failed. The protestors submitted a case to Chancery, *The Attorney General* v *The Dean and Chapter of Manchester*. This, following failed attempts by both chapter and Commissioners to have it thrown out, did not receive a definitive judgment until April 1884, with supplementary decisions delivered in December 1886. The case against the Cathedral was once again based on readings of the foundation documents, this time through the lens of the 1850 Act. It began with digging into the specifics of the rising expenditure, noting the new payments to officers both old and new; expenditure on choristers beyond the establishment detailed in the foundation charters; and repairs to the chapels around the choir. Any or all of these might contribute to (or, indeed, be essential to) sustaining the dignity of the Cathedral. But they were nonetheless all unauthorized by the charters and moreover illegitimately augmented the newly designated incomes of the dean and canons specified by the 1850 Act as deductible before surplus income was paid over to the Commissioners.

The judgment found entirely against the chapter. Without fresh legislative authority, canons could not be paid more than their designated salaries even if they took on additional roles; no money could be spent on repairs unless authorized in advance by the Bishop, and even then only on the chapter's part of the building (and not, for example, on the Chetham chapel); the choir should be limited to its Caroline foundation of four singing-men and boys; there was no basis for expenditure on the choir school or its master, both declared *ultra vires*; and the Commissioners were judged negligent in having failed to challenge the chapter's accounts in order to maximize the sums available for redistribution.[113] Thus it was that the chapter minutes for 1885 record a sorry tale of retrenchment. The choirboys were sent to the National School for education, and their master dismissed, with

112 Recorded in MCA, Mancath/2/2/3, Chapter register, 16 September 1879.
113 For the judgment, see MC, 12 April 1884.

the choir-school furnishings and house disposed of; the dismayed singing-men were informed of impending redundancies.[114]

The aftermath of the case left no party completely satisfied. The surplus rose by £700 in 1885, but there was no step-change, and by 1890 its overall increase since the 1884 judgment was just under £1,500, even though disbursements still lay below their 1884 level (although this was slightly more than the increase in the overall income over this period). There was frustration in the chapter, as despite widespread recognition that the Cathedral needed to be placed on a more secure footing, there was insufficient consensus on how to achieve this, despite the coincidence of national discussion of cathedral reform stimulated by the reports of the 1879–85 Cathedral Commission. After the Chancery judgment the Commissioners recommended special legislation, only to find themselves subject to lobbying by the Manchester incumbents, and were left weakly calling for unspecified change. The best they managed was qualified endorsement of proposals drawn up by Bishop Fraser and Cathedral representatives in 1871 which suggested reducing the number of canons to three, severing them from their parishes, annexing one to the archdeaconry of Manchester and another to half a divided residual parish, while the third directed diocesan education. The number of minor canons would be raised to four, and their incomes increased along with that of the canons; new residences would be obtained, ideally in a close, to promote attendance. Finally, a fixed sum would be assigned for maintenance of services, the distribution of which would be left entirely to the chapter.[115] However, when published, these recommendations met with a suspicious response from parochial champions, for whom they failed to address Manchester's pastoral needs, their qualms increased by the presence of Oakley and Crane among the seven signatories. Bishop Moorhouse's efforts to devise a legislative solution at the end of the decade also rankled with Nunn and his allies. Moorhouse, who when Bishop of Melbourne had once before sought to develop a Cathedral into a true diocesan centre, looked to sever two canonries from parochial responsibilities to enable them to work as diocesan agents. Nunn commented that 'the reversal of revenues of the parishes to the diocese, was a thing they should resist from the beginning'.[116] The initiative petered out, the Bishop's frustrations being clearly articulated in his 1902 address at his visitation of the Cathedral when he

114 MCA, Mancath/2/2/3, Chapter register, 28 February, 25 May 1885.
115 [C.4330], *Second Report*, pp. 289–92.
116 MC, 27 November 1889.

lamented the failure to realize a more 'missionary model' of its function. Moorhouse did, however, achieve one objective in his plan to engage the Cathedral in diocesan life when in 1890 he co-operated with the chapter to open a 'Scholæ Episcopi' to prepare candidates for the intellectual challenges of ordination examinations while actively engaged in urban parish work.[117] At various moments both Moorhouse and his successor in 1903, Bishop Edmund Knox, contemplated a future in which the deanery might form the basis for a suffragan bishop, but the schemes came to naught. There was thus no new major legislative and structural answer to the problematic relation of Cathedral and city at the end of the nineteenth century; and, if a resolution of sorts was achieved before the Great War, it involved men rather than measures.

Dean Maclure's Cathedral

If a solution to such difficulties lay in a man, it would have been hard to find a better candidate than Oakley's successor as Dean in 1890. Edward Craig Maclure was not only a Mancunian, but the son of churchwarden John Maclure prominent in the Cathedral debates of the 1840s, and elder brother of the MP John William Maclure, who as churchwarden since 1881 had helped ensure the restoration of the building; the family engagement was completed by his nephew Francis, sidesman alongside his father and uncle. What one late commentator dubbed 'the regime of Maclures' was not only authentically Mancunian, but also embraced both Liberal and Conservative (Dean and churchwarden respectively), and was, in church-party terms, non-aligned: in 1900 the Dean described himself to the vestry as 'not a Papist or a Ritualist. I am a downright good high, low, broad, protestant, evangelical, catholic churchman.' With a strong track record in parish work and education behind him, Maclure found his fellow northerner Moorhouse a ready and reliable ally (it was only Maclure's elevation to the deanery that frustrated Moorhouse's intention to appoint him Archdeacon); when occasion demanded, both engaged as robustly as their critics in the rough and tumble of

117 See prospectus in *MG*, 18 January 1890; visitation address in MCA, Mancath/2/2/3, Chapter register, 3 March 1902. Another defeat came in 1887, when Moorhouse's proposal that stalls be provided for the honorary canons in the Cathedral was judged *ultra vires* under the terms of the Chancery judgment, making it something of an irony that Joseph Nunn was installed into his non-existent stall as honorary canon in 1891: *ibid.*, 6 June, 14 November 1887; 28 April 1891.

Manchester religious debate.[118] Maclure's appointment had an immediate impact. When the Easter vestry convened in April 1891, the new Dean presided in person, winning glowing reviews in local papers for dextrous chairmanship which rendered the meeting 'singularly unanimous and harmonious' and hints that

118 For Maclure, see *ODNB*, *s.n.* 'Maclure, Edward Craig (1833–1906)'; C. H. Dant, *Distinguished Churchmen and Phases of Church Work* (London: Anthony Treherne, 1902), ch. 4; *MT*, 20 April 1900; *MC*, 18 April 1913 (review of Boutflower, *Personal Reminiscences*); Edith C. Rickards, *Bishop Moorhouse of Melbourne and Manchester* (London: John Murray, 1920), p. 147.

Sir John William
Maclure, Bart, MP,
churchwarden
1881–96

he would pursue a 'reasonable and popular' line; the *Manchester Times* judged his arrival good news for all of 'moderate views', especially the 'average churchman who likes a bright, hearty, musical service'. The *Courier* thought that the positive vibes might tempt the new Dean to judge his post 'a bed of roses'. (If so, it was not long before he was pricked by the thorns.[119]) The Maclure connections with the Manchester lay community made the brothers unrivalled as fundraisers for the Cathedral, and thus it was that the 'regime' left an impressive legacy of material improvements before the Dean's death in 1906, including the new west end, the vestries and libraries to the north-east of the building, and (with the assistance of the Manchester corporation) the rearranged and renovated churchyard.

Underpinning the success of the regime was, of course, the underlying financial strength of the institution, which continued

119 *MC*, 1 April 1891; *MT*, 22 April 1892.

to grow until the First World War. The gross annual income, which in 1890 stood at £27,357, had a decade later climbed to £36,616; by 1904, with more income from railway sources, it had reached £46,460, and in 1912 it stood at £53,190. By then, annual expenditure stood at £13,250 in comparison to £5,155 in 1890. With well over £30,000 now available for redistribution by the Ecclesiastical Commissioners, it gradually proved possible to undo the damage done by the 1884 Chancery judgment to make provision for Cathedral music and services while at the same time supporting increased provision for the parochial needs of the city and residual parish. Chapter minutes record regular attention to the state of the choir and fabric, with little of the recent *Sturm und Drang*. The one major piece of legislation which concerned the dean and canons was the Manchester Canonries Act of 1899. This both directly addressed one aspect of the Cathedral economy that otherwise risked becoming scandalous and offered a partial solution to the issue of funding services. Under the Act, it was agreed as vacancies arose to sell the former residences, whose rental incomes had hitherto significantly augmented 'official' canonical incomes (if unequally, with the senior canon receiving £1,300 per annum from his residence, the Insurance Buildings in King Street). From the sales, no more than £250 would go to the incoming canon, equalizing their incomes, while the remainder would support Cathedral 'services and ministrations'. The Act came into force in 1904 with the death of Canon Crane, the sitting canons agreeing to take a financial hit to enable progress to be made.[120]

More generally, the chapter found more unanimity, or at least discipline, under Maclure's 'firm' leadership (he was, Boutflower suggested, a 'typical autocrat').[121] The one enduring new canon from the 1880s, John Davenport Kelly,[122] was another Mancunian; Julius Lloyd, a Fraser protégé who succeeded Woodard in 1891, collapsed dead on the platform of the Church Day Schools Association within a year, his place being taken by Edward Lee Hicks. The turnover under Maclure concluded with Joseph John Scott, who took Crane's place on the latter's death in 1903, and John Charles Wright, appointed just before Maclure's death in 1906, the first of Bishop Knox's appointments (he had previ-

120 62 & 63 Vict. c. 28; see also MCA, Mancath/2/2/3, Chapter register, 22 December 1897, 2 September 1899, 4 January 1904; Boutflower, *Personal Reminiscences*, p. 52.

121 *Ibid.*, p. 50.

122 Appointed in 1884 when Archdeacon George Anson, who had replaced Gibson two years before, resigned rather than take on the living of St Matthew, Campfield, assigned to the canonry on the death of the incumbent.

ously served as Knox's curate). None of Maclure's colleagues had the potential to offend Manchester's Protestants in the manner of Cowie, Oakley, or Woodard, being more inclined to devote themselves to causes such as education rather than the advancement of controversial doctrine or ritual. Potentially most controversial, and most interesting, was Hicks. Precisely described, in the taxonomy of the Edwardian church, as a 'radical churchman', Hicks blended influences such as Ruskin and Maurice into a stance that aligned easily with the New Liberalism then achieving traction in secular politics. He was a distinctly political canon. Yet his politics were rooted in practice. Hicks devoted himself to his canonical parish of St Philip, Salford, to whose more than ten thousand largely working-class parishioners he offered new lay agency (including the Church Army and female church workers), a bold choice of curates (including Conrad Noel), and willingness to co-operate across denominational boundaries. His parochial and wider preoccupations met in his devotion to the cause of temperance, where his close alignment with Sir Wilfrid Lawson's United Kingdom Alliance was one ground for those (at one point including the Archbishop of Canterbury) who dismissed him as a 'faddist'.[123] Hicks was not afraid to speak out: he followed Oakley in contributing to the *Guardian* (under the pseudonym *Quartus*), being a close friend of its editor C. P. Scott, participated in the Christian Social Union (though he would never call himself a Christian Socialist), and chaired the Manchester Citizens Association, which addressed local housing issues. Moreover, whereas he avoided the directly political in his parish pulpit, in the Cathedral he felt able to articulate his opposition to the South African War, his 'pro-Boer' preaching outraging Manchester Conservatives. In his last years in Manchester, Hicks's open Liberalism placed him directly at odds with the equally openly Conservative Bishop Knox. A clash on the church school question culminated in a bitter letter to the *Guardian*, entitled 'The Church as Electioneer', in which Hicks complained at Knox's mobilization of the diocesan machinery: 'Why are we warned so often not to talk politics in the pulpit, if we are told to rally Churchmen to vote only for "Church interests", which avowedly means voting only for Tory candidates?'[124] When Hicks departed the Cathedral to become Bishop of Ely in

123 For Hicks, see *ODNB*, *s.n.* 'Hicks, Edward Lee (1843–1919)'; Graham Neville, *Radical Churchman: Edward Lee Hicks and the New Liberalism* (Oxford: Clarendon Press, 1998); Conrad Noel, *An Autobiography* (London: J. M. Dent, 1945), pp. 50–1; P. F. Clarke, *Lancashire and the New Liberalism* (Cambridge: Cambridge University Press, 1971), pp. 71–2.

124 *MG*, 13 December 1909.

Edward Lee Hicks
photographed when
Bishop of Ely, *c.*
1916

1910, he left an important legacy, in particular in modelling an effective approach to the canons' parishes; his work was a key inspiration to his effectual successor in his stall and parish, Peter Green, whose important urban ministry is more appropriately covered elsewhere.[125]

In the Cathedral, Maclure's approach to services was in effect to preserve the *status quo ante* on his appointment, which pre-empted charges of ritual innovation but also entailed no

125 Green took the stall in 1911, after J. G. Simpson had held it for less than a year before moving on. The other new appointments to the chapter before the outbreak of the First World War were Edward Richardson (1909) and Douglas S. Johnson (1913).

significant retreat from former practice. This was too conserva-
tive for those like Boutflower who would have preferred a more
elaborate ritual.[126] But even Boutflower conceded that Maclure
was 'very fond of æsthetics, and had a great love for fancy ritual'
for its own sake, rather than for its doctrinal symbolism. When
innovation came, it derived from other sources. The minor
clergy, following the example of Elvy, who by the time of his
retirement as minor canon in 1905 had acquired Wray-like status
as a living embodiment of th'Owd Church, could themselves try
to drive change, or test the limits of Maclure's tolerance. Thus,
in 1901, having initially denied that wine and water were mixed
at any service and that wafer bread was used, Maclure had later
to report that he had been forced to step in to discipline a curate
adopting them both.[127] A second factor was the growing strength
of the musical tradition, which meant that the choral aspect of the
services attracted more (and much more favourable) attention,
and also that at times musical taste could produce unintended
theological problems. In 1892, Maclure enjoyed a performance
of Rossini's *Stabat Mater*, but on closer inspection was troubled
by the Marian tendencies of the text which had also provoked
Protestant protests; he stated that he would not allow a repeat
performance.[128] Another development in the early twentieth-cen-
tury services more closely aligned with engagement with the city
exemplified by Maclure and Hicks in their different ways was
the growing provision of special services for specific groups or
occasions in Manchester. These ranged from a memorial service
for all those who had died during 1900 and similarly solemn
affairs associated with the assassination of President McKinley of
the United States (1901) and the death of Lord Salisbury (1903),
to happier occasions such as the restoration of peace in 1902,
the jubilee of Owens College, and (most strikingly) services for
organizations and groups such as Friendly Societies, and later,
under Dean Welldon, railwaymen (1906) and butchers (1909).
Even the Church League for Women's Suffrage was granted
permission for a service in 1912, if the list of preachers was
submitted in advance.[129]

126 In his *Personal Reminiscences*, p. 69, Boutflower described the 'advance'
in ritual as 'very slow': 'There is still too much of the Mace, and too little
of the Processional Cross.' He tried to rectify this with the gift of a proces-
sional cross in 1911: it was refused: MCA, Mancath/2/2/4, Chapter register,
29 December 1911.
127 *MC*, 13 April 1901.
128 *MC*, 27, 30 April 1892.
129 *MG*, 31 December 1900; 18 September 1901; 9 June 1902; 22 June, 28
August 1903; 26 April 1909; MCA, Mancath/2/2/3, Chapter register, 9
October 1906; Mancath/2/2/4, Chapter register, 2 December 1912.

If this paints a picture of a comparatively untroubled Cathedral in this final phase of its Victorian and Edwardian era, it is, in one respect at least, misleading. Across the country the ritual question acquired additional political resonance at the turn of the century, becoming a significant issue at the 1900 general election.[130] This added a new dynamic to the popular Protestant anti-Catholic tradition which had troubled the Cathedral in the 1880s. As already indicated, Maclure's direct engagement with the vestry and eschewal of innovations at first paid dividends. Some former leaders of the Protestant party now sometimes rallied around the Dean, notably Joseph Snape, Salford Conservative alderman and printer who, despite reservations, welcomed the fact that 'they were now having services ... in which they could all heartily join'.[131] Much of the time, when challenged in the vestry on ritualism, Maclure either directed complainants to the Archdeacon as the correct procedure before summarily closing the meetings, or could rely on allies to argue that 'innovations' in fact derived from earlier regimes. He faced stronger challenges over the actions of some visiting clergy; in 1893, there were complaints that Bishop Jayne of Chester had preached the doctrine of purgatory, and William Knox-Little that of confession, the latter also raising Protestant hackles when he appeared to denounce evening communion from the pulpit in 1898, on which point the Dean remonstrated with him.[132] However, the atmosphere rapidly worsened from 1894, the year in which the Allen family donated a new reredos designed by Basil Champneys which provoked immediate hostility from Protestant critics who found it (in the words of their leading spokesman, William Evenis Rudolph) both 'hideous and idolatrous'.

In 1895, the 'official' slates of churchwardens and sidesmen were challenged for the first time in years in an explicit move to increase evangelical representation, the stand-off seeing, despite Snape's protests, Maclure's nephew displaced as sidesman; by 1897 the opposition was beginning to talk of reviving demands for formal polls in elections.[133] Talk of the ballot reflected the fact that the Protestant party could now begin to draw on organizational machinery assembled for the wider national conflict over ritualism. In 1894, a Manchester branch of the national Protestant League was established; by the end of the century,

130 See Paul Nicholls, *Khaki and the Confessional: A Study of a Religious Issue at the 1900 General Election in England* (Melbourne: History Department, University of Melbourne, 2000).

131 *MC*, 1 April 1891.

132 *MC*, 7 April 1893, 31 March 1894.

133 *MC*, 20 April 1895.

when it was holding large rallies addressed by John Kensit, it joined the Orange order among the bodies which could be mobilized for vestry politics. With this accession of strength, as one later hostile observer opined, the vestry became the Protestants' 'playground and annual exhibition'.[134] In 1899, the League secured a compromise list of churchwardens drawn from both the official and unofficial lists; for 1900, it planned to ensure that the vestry would pass a motion condemning the reredos despite Maclure's repeated position that such motions were *ultra vires*. That vestry, relocated to the Cathedral schools in anticipation of trouble, duly proved contentious and loud, not least thanks to overcrowding, Maclure mounting a chair to preserve his authority. Churchwarden Boutflower told the emerging champion of the Protestant party, Thomas Hayward, that he did not give 'the toss of a button' for his motion, and for his pains was deposed along with his fellow churchwardens by a Protestant League slate headed by Hayward. The one consolation was that the motion had not been put, the Dean having obtained a legal opinion on the matter; but in 1901, Maclure was not present at the vestry and never returned, on the grounds that it was over-reaching itself. To some high churchmen, it felt absurd that the governance of the parish church of the residual parish could thus be shaped by a vestry meeting still open to the whole body of ratepayers in the ancient parish, a point underlined when the following year, under an elected lay chair, a 'Wesleyan churchman' nominated a sidesman. Hayward, who as churchwarden found Cathedral services too offensive to take communion there, was one of the Moston parishioners who in 1899 had set up a breakaway evangelical church at Lightbowne in protest at their Vicar's ritual practices; indeed, he served as president of what some contemporaries, including the Dean's son, the ritually inclined Kenneth Maclure, Rector of St Alban's, Cheetwood, condemned as a 'schism shop'.[135] Even *sans* Dean the atmosphere in the vestries of the early 1900s was consequently heated and fractious, press reports recounting heckles of 'shut up', 'He's a Roman Catholic', and 'Go to Rome'. These may have reflected a growing sense of frustration as, despite capturing the vestry and now being free to pass motions on the reredos, lights, vestments, and services, 'Protestants' discovered that their triumph seemed without consequence. One pained 'Manchester parishioner' complained to the *Manchester Courier*:

134 *MC*, 24 April 1903.
135 *MC*, 23 March 1900.

Do merchants, manufacturers, tradesmen, shopkeepers, and parishioners leave their occupations, in the precious hours of the day, for nothing? Do vestry meetings largely attended for 20 successive years convey no meaning? Has the most-crowded, indignant, and decided vestry meeting this Easter ever known in all the Cathedral annals no lessons for wise and observing men? Have protesting resolutions, carried I believe at every Cathedral vestry this 20 years – protesting resolutions against a Romish ritual, which this Protestant nation hates and which wonderfully progressing Englishmen have done altogether without for hundreds of years – no weight?[136]

The frustration only increased when the arrival of the evangelical Bishop Knox in 1903 was not followed by a decisive episcopal intervention in the Cathedral, insult being added to injury when Knox adopted his usual practice of abiding by local custom, and consequently himself celebrated communion in the Cathedral adopting the eastward position. Until 1906, the vestries were no place for the faint-hearted.

The eve of war

And then – suddenly – peace. The *Manchester Courier* reported the Easter Vestry of 1907 as 'brief and cordial'. A dean was back in the chair, thanking the churchwardens and sidesmen for their help and unanimity. He concluded his address to the sound of 'Hear Hear!' as he declared that 'I shall go from this meeting with new heart for the work which lies – I will not say before me, but which lies before us all.'[137] It was the same up to the outbreak of war: mutual congratulation, shared jokes, discussion of repairs and the installation of electric light in the Cathedral, celebration of the music and special services, calculations of attendance (in 1914, the Dean suggested perhaps a quarter of a million people in the course of the year, and ten thousand in Holy Week).[138] In 1911, William Touchstone, so often involved in Protestant agitation as Conservative Orangeman, not only attended, but pronounced that 'they had got as near his ideal of a Lord Bishop, a Lord Dean, churchwardens, and sidesmen as they ever would this side of the Jordan ("Hear, Hear", and laughter)'.[139]

136 *MC*, 15 April 1901. For other vestries, see *MC*, 3 April 1902, 16 April 1903.
137 *MC*, 4 April 1907.
138 See *MC*, 23 April 1908, 16 April 1909; *MG*, 31 March 1910, 20 April 1911, 11 April 1912, 23 March 1913; *MEN*, 15 April 1914.
139 *MG*, 20 April 1911.

The explanation was that this was a different dean. On Maclure's death Prime Minister Campbell-Bannerman first offered the post to Hicks, but only on condition of a review of Cathedral finances and of the adjustment of the services in a Protestant direction, indicating the reach of the agitation. In a principled response, Hicks refused, adopting Maclure's line that the 'simple and dignified services' were fine as they stood, advising the premier: '[A]s an average Lancashire churchman, I would beg of you to avoid needless friction and collision on such a delicate matter as this. I am confident that you have been seriously misinformed as to the facts of the case.'[140] Instead the deanery went to James Edward Cowell Welldon, the ex-Bishop of Calcutta. Welldon was an evangelical.

An appraisal of Welldon's tenure is as much the task of a later chapter as of this. It would be fair to say that he has had a rough press; Michael Hennell endorsed a biting critique by Peter Green in his 1988 study of the deans and canons of Manchester, emphasizing his lack of gravity and focus, and self-absorption. Hennell, however, wrote without full awareness of the vestry battles of the preceding decade, which merit scant mention in his volume (which, as it proclaims – bearing out the point made at the start of this chapter about the need to chart the history of multiple institutions inhabiting a single building – is indeed a history of the *deans and canons*, not of the parish church). A more charitable view, at least of Welldon's early years, might be that his 'robust common sense and untarnished sincerity', devotion to the national, and hence inclusive, character of the church (and of the Cathedral, which he declared he wished to make 'co-extensive with what was lawful in the Church of England'), and easy manner were precisely what the situation called for. He was received with gratitude by exhausted and dispirited Protestants, but not inclined to change things in ways that would alienate the high churchmen in the congregation. He was fully aware of how things had changed. In 1914, he permitted himself a short retrospective in his address to the vestry.

Time was, he said, when this room (the Cathedral schools) was a scene of more interest and excitement than it was now. He did not doubt that some of the old hands who were there would look back with a certain amount of affection at those stormy days. He sometimes felt that when he passed away people would look upon the letters after his name – D.D. – and say 'Dull Dean'. He used to come there and feel like 'Daniel in

140 Neville, *Hicks*, p. 122.

the lions' den'. Upon the whole it was well for the Cathedral that peace and not war should prevail.

His, of course, was not the only retrospective, with both Elvy's volume and Boutflower's recollections appearing in print the previous year. On the eve of the First World War, the Cathedral had found collectively a breathing space to take stock.

From our more distant perspective, one view of the first seventy-five years of the deans and canons of Manchester might be that the attempt to create a Cathedral had been, as Cowie had observed in the 1880s, a botched job, with the shortcomings of the original prospectus paid for in energy-sapping disputes that distracted from, and disrupted, its core mission. A different view might be that these same disputes testified to a degree of engagement with a see city and its laity that by the end of the nineteenth century most other cathedrals were desperate to achieve, one underpinned and deepened by the continuing parochial responsibilities of not just the canons but also the dean. Such engagement was not one which pitched sacerdotalist clergy into battle with an anti-clerical laity, but one in which committed Mancunian Anglicans of different traditions, both lay and clerical, sought to fashion an institution which reflected the community which they wished to inhabit, and for which th'Owd Church – and increasingly the Cathedral in its own right – still stood as a surprisingly potent symbol, worth fighting over. There is surely something to be said for both interpretations, but perhaps the second has hitherto been unduly overshadowed by the first.

The Cathedral, 1914–83

MATTHEW GRIMLEY

You could still be a Manchester man in the true sense that you lived in Manchester and knew, and were interested in, all that appertained to the city's well-being. I think there can hardly have been a citizen who did not know who was his Lord Mayor and who were the councillors and aldermen representing his civic ward. The Bishop was our bishop and the cathedral was our cathedral, still intimate and familiar enough to be called by many 't'owd Church'.[1]

WHEN THE NOVELIST Howard Spring arrived in the city to work on the *Manchester Guardian* in 1915, Manchester Cathedral was still widely regarded, and loved, as the city's parish church. Redevelopment and slum clearance meant that the population of the Cathedral parish declined from 7,000 in 1891 to 700 in 1918, and was to go down to 281 by 1951.[2] But as in the nineteenth century, the Cathedral continued successfully to present itself as an embodiment of broader civic identity. Addressing the vestry meeting of the Cathedral in April 1914, J. E. C. Welldon (Dean, 1906–18) proclaimed that he saw the role of the Cathedral as being, 'not to draw away worshippers from the parish churches, but to act as a rallying point of moral and spiritual activity for the whole city'.[3]

Welldon's successors faced three major obstacles in attempting to be a 'rallying point' for the twentieth-century city. The first was that the city was changing shape. Its centre of gravity was

1 Howard Spring, *The Autobiography of Howard Spring* (London: Collins, 1971), pp. 130–1.
2 Eric Saxon, 'Rise and Fall of Churches', in Chris Ford, Michael Powell, and Terry Wyke (eds), *The Church in Cottonopolis* (Manchester: Lancashire and Cheshire Antiquarian Society, 1997), pp. 136–8.
3 'Manchester Cathedral: Its Place in the Life of the City', *MG*, 16 April 1914, p. 9.

Previous page:
'Abstract organ'

moving away from the Cathedral. Inter-war commercial buildings like the Ship Canal Building (1926) were symbolically much taller than the Cathedral (or any other existing building in the city), while the civic quarter expanded with the building of the Central Library (1934) and Town Hall Extension (1938). This separation was exacerbated, first by the bombing of the Cathedral area in the Second World War, and then by the depredations of post-war town planners, who almost choked the Cathedral by surrounding it with large modern buildings.

A second problem afflicted the city as a whole – its loss of national and international influence. Many of the things that had made Manchester internationally famous – cotton, free trade, Liberalism – were in terminal decline by the inter-war period. More generally, all British provincial cities diminished in status as power and prestige drained towards London. The *Manchester Guardian*'s decision in the late 1950s to move its operations to London and drop the moniker 'Manchester' was a significant moment. The city did retain some old sources of cultural capital (like the Hallé Orchestra), and gained new ones (like Granada TV). Charlotte Wildman has recently demonstrated the dynamism and optimism of urban redevelopment programmes from the end of the First World War onwards, which did not suggest a dramatic loss of confidence.[4] Nevertheless, it remains true that, over time, Manchester lost its nineteenth-century pre-eminence. By 1976, A. J. P. Taylor could write that 'Manchester has become an agreeable provincial town. It is no longer one of the world's great cities'.[5] Manchester Cathedral thus faced a double predicament: it occupied an increasingly peripheral place in a city that was itself increasingly peripheral to national life.

A third obstacle for the Cathedral was the general decline in religious observance and identification that occurred in Britain between 1914 and 1983. Historians remain divided about the timing and causes of this decline, but that there was a decline is not in dispute. In Manchester there was also a decline in a common Protestant identity that had defined itself against Catholicism. The demise of sectarianism was welcome for the city as a whole, but it did have implications for a Cathedral that had historically derived some of its popularity from being a symbol of Protestant identity in the city.

4 Charlotte Wildman, *Urban Redevelopment and Modernity in Liverpool and Manchester, 1918–1939* (London: Bloomsbury, 2016).
5 A. J. P. Taylor, *Essays in English History* (Harmondsworth: Pelican, 1976), p. 307.

None of these obstacles was insuperable, and successive deans and canons proved resourceful at finding ways of remaining a 'rallying point'. They did this partly by identifying the Cathedral with social justice and ecumenism, partly by making it a site of mourning for the two World Wars, and partly by musical, artistic, and liturgical innovation. They were also fortunate in retaining resources (both accumulated civic goodwill and large property holdings) that many English cathedrals did not enjoy.

War and the Cathedral, 1914–18

The Dean of Manchester on the eve of the First World War was J. E. C. Welldon, a former Headmaster of Harrow and Bishop of Calcutta, who had been Dean since 1906. An expansive figure (he was 6 feet 5 inches tall, and had been known affectionately by Harrovians as 'the Porker'), he relished the public prominence that went with his job. He described the Dean's role in his memoirs:

> Like the Cathedral itself, he is an institution of the city. He spends his life going up and down among the people. Everybody knows him, and he is supposed to know everybody. He is expected to interest himself in all the activities of civic life, except perhaps business and politics; he is a younger brother of the Lord Mayor, he sits on an indefinite number of committees; he makes speeches on all subjects known to him, and sometimes, I am afraid, unknown.[6]

But the public profile of the Dean in the city was belied by the fact that, formally, he had little power over the services in the Cathedral (other than the Sunday evening service), and could only preach, or nominate a preacher, on four major festivals (Christmas, Easter, Ascension, and Whitsun) each year. This meant that deans were forced to innovate by inventing new forms of special service, which were outside the control of the chapter. Welldon led the way here, instituting special services for railwaymen, butchers, the Orders of Foresters and Buffaloes, Scouts, Guides, teachers, Lads' Clubs, the Sunday Ragged School Union, non-militant suffragists, actors, the UK Alliance (the temperance campaign group), the TUC, the ILP, and the National Evangelical Free Church Council. Some of these services, especially the

6 J. E. C. Welldon, *Recollections and Reflections* (London: Cassell, 1915), p. 372. Some Mancunians seem to have found Welldon's public utterances rather fatuous. He was once accosted on a tram by an elderly woman who complained: 'Dean, I tell you what it is – you spout too much': *ibid.*, p. 363.

James Welldon,
Dean 1906–18

annual actors' service, became well-established civic traditions, the Dean visiting the dressing rooms of the city's theatres during pantomime season to invite actors to the service.

Welldon continued the campaigning role of the Edwardian canon Edward Lee Hicks, protesting against the drink trade, and serving as local President of the Christian Social Union. He would visit factories and lecture workers in their lunch hours, sometimes on the evils of drink, sometimes on other social questions. He was also a supporter of women's suffrage, declaring in a sermon in May 1914 that 'there was no more reason for binding the minds of women in England than for binding their feet in China'. But he also warned against 'the evils attaching

to the policy of militant suffragism'.[7] Addressing the moderate National Union of Women's Suffrage Societies at a service the following month, he told them that 'their duty was to show the world that they could discharge novel obligations and accept new responsibilities without any sacrifice of the reserve, reverence, and purity that had always sanctified women in the eyes of the Christian Church. He enjoined them to do no deed that would make the name of women disreputable'.[8] His criticism of militant tactics came home to roost on 20 July 1914, when two suffragettes disrupted the morning service, shouting 'Oh God, help Emmeline Pankhurst and all those being forcibly fed in prison. Help them to endure unto the end for the sake of all women who come after them.'[9]

But the suffragette clamour was soon drowned out by a more distant conflict. The *Manchester Guardian* of 29 June 1914, which carried a report on the suffrage service in the Cathedral, also covered the assassination of Archduke Franz Ferdinand. When Britain entered the war five weeks later, crowds thronged the Cathedral for a service of 'supplication and consecration'. Welldon told the congregation that 'we have entered upon war, not with a light heart, but a clear conscience. We have been, and we are, lovers of peace.' The tone of the service was low-key rather than jingoistic, but at the end of the service, as the congregation dispersed, Sydney Nicholson played 'Rule Britannia' on the organ.[10] Peter Green recalled that 'the effect was amazing. Grown men could be seen with the tears running down their faces. The familiar air released deep springs of emotion which were ready to be touched.'[11]

At first, the First World War did not bring enormous disruption to the Cathedral. Belgian refugees were accommodated at the Cathedral Country Home at Mellor in Derbyshire.[12] The Precentor, Dennis Jones, joined up, fighting in the Dardanelles campaign in 1915.[13] But gradually the war began to impinge

7 'The Rights of Women from the Christian Point of View', MG, 11 May 1914, p. 11.
8 'Women at the Cathedral: The Dean and the Suffrage', MG, 29 June 1914, p. 11.
9 'An Interruption by Suffragettes', MG, 20 July 1914, p. 11.
10 'At the Cathedral: Crowded Congregation Offers Supplication', MG, 8 August 1914, p. 10.
11 Peter Green, *The Problem of Art: A Text-Book of Aesthetics* (London: Longmans, 1937), p. 166.
12 'Manchester and the War: More Belgians come to the Port of Refuge', MG, 13 October 1914, p. 8.
13 Manchester, MCA, Mancath/2/2/4, Chapter minutes, 7 September 1914; 'Dardanelles Letters', MG, 26 June 1915, p. 7. Jones was later mentioned in despatches.

more directly. Several former choristers were killed and were later commemorated in a window in the music room. There was some criticism of the chapter's expenditure in wartime. In 1915, when it proposed to spend £500 on a bishop's throne as a memorial to Bishop Moorhouse, a former Archdeacon of Manchester, James Wilson, complained in the press that 'it appears to me a very bad example for Churchmen at this time to spend so large a sum, and to employ so much skilled labour, on what is an ecclesiastical luxury'.[14] Wilson argued that the money should instead be invested in the War Loan, and the interest used for training priests, but his objections were ignored.

Although he never doubted the rightness of the British cause, Welldon's tone throughout the war was moderate and anti-militaristic. He called militarism 'a hateful thing; hateful to man and hateful to God'. He expressed the hope that after the war, 'there would be no feeling of revenge, no desire to do any wrong, to inflict any penalty but what was essential to the purpose for which the war had been undertaken'.[15] (Although after the destruction of Louvain by the Germans, he did say that 'those ashes cried out for vengeance to heaven'.[16]) He insisted on honouring a preaching invitation to Edward Lyttelton, headmaster of Eton, in April 1915, shortly after Lyttelton had made some controversial remarks suggesting that it was wrong to condemn the German nation as a whole for the war, and urging a generous peace settlement. There were small protests outside the Cathedral, and cries of 'Pro-German' on Lyttelton's departure, but the service passed off peacefully.[17] When the Kaiser was ill in January 1916, Welldon asked his congregation to pray for him.[18] Even more controversially, he declared in 1916 that 'many of the conscientious objectors were persons for whom he felt deep respect', and that they were 'not slackers or shirkers ... and were, he believed, good patriots', although he went on to say that 'it was not their heart but their head which seemed to him to be at fault'.[19]

The Cathedral became a locus of mass mourning during the First World War, especially for the different battalions of the

14 James Wilson, letter, 'The Bishop Moorhouse Memorial', *MG*, 2 August 1915, p. 7.
15 'The Cathedral: At the Intercessory Service', *MG*, 17 October 1914, p. 10.
16 'Manchester and the War', *MG*, 5 September, p. 4
17 'Dr Lyttelton in Manchester: Huge Crowds but no Disorder', *MG*, 12 April 1915, p. 6.
18 'Prayers for the Kaiser: The Dean's Request at the Cathedral', *MG*, 17 January 1916, p. 3.
19 'Conscience and War: Bishop Welldon's Questions', *MG*, 27 March 1916, p. 10.

Manchester Regiment. This was especially true after Gallipoli in 1915, at which large numbers of Manchester territorials fell, and again after the huge losses of the 16th Battalion at 'Manchester Hill' in Northern France in March 1918.[20] Wounded soldiers attended many of these services, as a *Manchester Guardian* correspondent in August 1915 described: 'Some of them were in khaki and some in the easy suits of blue which are worn in the wards. Bandages on head or arm gleamed with an arresting whiteness in the sombre interior. Many of the men limped from their wounds, and some were on crutches.'[21] Another moving spectacle was apparent at the memorial service for Edith Cavell (who had briefly lived in Manchester during 1906–07) in October 1915, at which the congregation was 'for the most part a great assemblage of women, among whom were many nurses, rendered conspicuous by their uniforms of blue and grey, with patches of red'. Once again, Welldon urged his congregation to 'think no thought of vengeance'.[22] A plaque in memory of Cavell was placed on the north wall in 1916.

The scale of losses in the First World War had theological implications, which were felt in Manchester as elsewhere, and which led to a personality clash between the Dean and his evangelical Bishop, E. A. Knox. The issue was prayers for the dead, which were traditionally not part of the Anglican liturgy, but which were increasingly demanded by the bereaved in war.[23] As early as December 1914, Welldon had begun experimenting with a Russian liturgy that included prayers for the dead, arguing in a sermon that 'in the dark hour of the national life if he were asked by some bereaved ones if they might pray for the souls of those they had lost he would reply that in so doing they were not departing from the spirit of the Church, but only doing what Christians and Churchmen in all ages had done before them'.[24]

When the archbishops of Canterbury and York approved new forms of prayer for the dead, the Cathedral, along with many other churches in the diocese, adopted them. This was too much for Knox, who wrote to the clergy of his diocese saying that he could 'grant no permission' for prayers for the dead. Welldon

20 'The Ardwicks' Losses: Memorial Service in the Cathedral', 15 June 1915, p. 9; 'Seventh Manchesters: Memorial Service at the Cathedral', *MG*, 1 July 1915, p. 3; 'Honouring the 16th: A Cathedral Service', *MG*, 16 April 1918, p. 5.

21 'Wounded Soldiers at the Cathedral', *MG*, 5 August 1915, p. 9

22 'Manchester Cathedral Memorial Service', *MG*, 30 October 1915, p. 11.

23 Michael Snape, 'Perceptions of the Afterlife during the First World War', in Peter Clarke and Tony Claydon (eds), *The Church, The Afterlife, and the Fate of the Soul*, SCH 45 (Woodbridge: Boydell, 2008), p. 379.

24 'Bishop Welldon and Prayers for the Dead', *MG*, 21 December 1914, p. 10.

reacted with a public expression of defiance, saying that 'at the present time, when so many hearts were yearning for those whom they had loved and lost and still loved intensely, it seemed to him almost cruel to shut the door upon the possibility of pleading for their loved ones at the throne of the all merciful Father'.[25] Welldon also denied that Knox could dictate Cathedral services. 'The Bishop is not Ordinary of the Cathedral, so that there is no question of disobedience to his authority', he insisted. 'I am merely exercising the freedom which belongs to me, and I do not think the Bishop wishes to interfere with the services at the Cathedral.'[26] It may have come as a relief to both men when Welldon became Dean of Durham in 1918, leaving his successor, W. S. Swayne, to preside over the Armistice celebrations in the Cathedral. Knox retired two years later, in 1920.

Commemoration and restoration, 1918–39

In the years immediately after the War, the Cathedral's role in commemorating the dead still dominated. In a sombre echo of the services initiated by Welldon before the War, memorial services were held for the war dead of different trades and professions. A much happier commemoration was the celebration of the quincentenary of the Cathedral in May and June 1921, which demonstrated the affection in which it was still held in the city. The celebrations were designed to reach all parts of civic life; as Dean Gough McCormick (who had become Dean in 1919, when Swayne succeeded Hicks as Bishop of Lincoln) put it, 'the message of the Church, and that for which the Church stands, was … deliberately given to the different classes of the community'.[27] There were special services for teachers, trades unionists, Free Churchmen, women, and children. A series of lectures on five centuries of religious history was also given by, among others, the historian T. F. Tout and W. R. Inge, Dean of St Paul's. The musical repertoire ran from the fifteenth century to the present.

The quincentenary illustrated two particular aspects of the Cathedral's identity that were to become increasingly important in the inter-war period: ecumenism and social concern. The special service for Free Churchmen demonstrated the improved relationships between Cathedral and local Nonconformity.

25 'Prayers for the Dead: The Dean and the Bishop of Manchester', *MG*, 30 July 1917, p. 2.
26 'Prayers for the Dead: The Dean and the Bishop of Manchester', *MG*, 31 July 1917, p. 5.
27 *The Ancient Collegiate Church of Manchester: Quincentenary Celebrations 1421–1921* (Manchester: Sherratt and Hughes, 1921).

Church–chapel conflict was already in decline before the First World War, causing Welldon to comment in 1915 that 'nowhere has the theological bitterness between the Church and Nonconformity been less acute than in Manchester of later years'.[28] A number of inter-denominational services had been held in the Cathedral during the First World War. But the participation of Free Churchmen in the quincentenary celebrations was on a much bigger scale, with Baptist, Primitive Methodist, United Methodist, Congregationalist, and Presbyterian ministers taking part in a special service, which included prayers for unity. This was a moment at which hopes for reunion of the Protestant churches were high, and in his sermon, McCormick referred to the 'Appeal to all Christian People' issued by the Archbishop of Canterbury the previous year.[29]

The non-inclusion of Roman Catholics in the quincentenary proceedings, however, indicated the limits of ecumenism; Father Power of the Holy Name Church lamented to the *Manchester Guardian* that 'they could not resist a feeling of sadness at the outstanding fact that the old Church, where so many masses had been offered in the past, was witnessing its quincentenary without the holy sacrifice', although he added that even if Catholics had been invited, they would not have taken part.[30] The Catholic Bishop of Salford, Louis Charles Casartelli, said that some Catholics would be 'inclined to be amused at what would remind them of a pageant by Mohammedans in Constantinople to commemorate the founding of Santa Sophia by Justinian'.[31] But despite these objections, relations with the Catholic hierarchy were generally improving; Dean Swayne, who played golf with his Catholic counterpart Canon Walsh, remarked that 'in no place have I found the Roman brethren so friendly and indeed cordial as at Manchester'.[32] Ecumenical ties continued to improve in the inter-war period. A symbolic moment was the funeral of that great avatar of civic Dissent, the Unitarian C. P. Scott, in the Cathedral in 1932.[33] This sense of joint-ownership of the Cathedral, extending to non-Anglicans and even non-Christians, contrasted with events in nearby Liverpool. Here, too, the chapter of the new Cathedral attempted to reach out to non-Anglicans, including Unitarians, but with less happy results. The chapter's

28 Welldon, *Recollections and Reflections*, p. 380.
29 *Quincentenary Celebrations*, p. 80.
30 'A Catholic Critic of the Celebration', MG, 6 June 1921, p. 12.
31 'A Catholic Foundation: Bishop Casartelli on the Collegiate Church', MG, 30 May 1921, p. 12.
32 W. S. Swayne, *Parson's Pleasure* (Edinburgh: Blackwood, 1934), p. 253.
33 'Funeral of Mr C. P. Scott', MG, 6 January 1932, p. 4.

invitation to two Unitarians, L. P. Jacks and Lawrence Redfern, to preach led to protests from Anglo-Catholics like Lord Hugh Cecil and the breakdown of relations between the Bishop and his Dean.

Another facet of city life that had been prominent in the 1921 celebrations was the trade union movement. The quincentenary occurred during the miners' strike, and collections from one of the services were given to the Council, 'in view of the present distressing conditions due to industrial troubles'.[34] Returning to Manchester for the occasion, Welldon preached a sermon to a congregation of trade unionists in which he obliquely criticized trade unions by comparing them with the medieval guildsmen who had built the Collegiate Church: 'What was the spirit of the men who built the Cathedrals in old time? They built as men who knew the dignity of work. They asked themselves not, How little need I do? but rather, How much can I do? The labourer today asks, or too often asks, what he can get, not what he can give.' Welldon also warned of the impact of strikes on innocent citizens.[35] Strikes would continue to be a preoccupation for Cathedral clergy throughout the inter-war period, as industrial conflict, poverty, and unemployment worsened. Hewlett Johnson (who succeeded as Dean on McCormick's death from kidney disease and pneumonia in 1924) appealed on behalf of miners' families in 1928. He was also involved in attempts at brokering agreement in the General Strike, chairing a meeting convened by C. P. Scott to ask the government to negotiate with the TUC, and the TUC to call off the strike.[36] But he does not seem to have made any public statements about the strike, beyond signing a letter from local churchmen supporting a relief fund for miners' families.[37] Hewlett Johnson's own sympathies were with the miners, but his plutocratic family connections made intervention difficult; one uncle was Chairman of the Mine Owners' Federation, and another headed the Wigan Coal Company. At Manchester, he did not subscribe to the pro-Soviet views that were later to make him notorious; a later Dean, Alfred Jowett, recalled being accosted at Hewlett Johnson's memorial service by an elderly lady who said "e were quite sensible until he left us'.[38]

34 'Labour and Free Speech', *MG*, 16 June 1921, p. 8.
35 *Quincentenary Celebrations*, pp. 108, 103–4.
36 David Ayerst, *Guardian: Biography of a Newspaper* (London: Collins, 1971), p. 465.
37 'A Miners' Distress Fund', *MG*, 4 June 1926, p. 11.
38 MCA, Alfred Jowett papers, PP/4/1/4/7, speech by Jowett on being made Freeman of Manchester, 5 April 1984; the woman was probably Alice Price.

The brand of social concern espoused by the chapter was typically moderate, communitarian Christian socialism. It was critical of the excesses of capitalism, but also concerned by the growth of class consciousness. It was also not above criticizing the habits of the working classes; like Welldon, Peter Green combined campaigns for housing reform with ones against drink and gambling, becoming renowned as 'the terror of the bookies'.[39] Another thing that blunted the Cathedral's social radicalism was that it was itself a large landlord in Manchester, and so was itself implicated in poor housing. It did try to address this, by allocating land to the Council of Christian Congregations to build three-bedroomed houses at low rent for large families. Chapter minutes from the 1930s also reveal a number of discussions with municipal officials about whether to demolish or renovate sub-standard housing.

As well as the quincentenary celebrations, the inter-war period also saw the continuation of older popular rituals associated with the Cathedral, each of which gave a prominent role to the dean. The first of these was the Sunday evening service, which enjoyed attendances of over two thousand in its heyday, and which the dean controlled by virtue of his continuing role as Rector.[40] The style of this service, with congregational singing and well-known visiting preachers, was deliberately demotic. By the 1920s, motor transport meant that it could now reach a wider suburban audience. Manchester was not the only Cathedral to benefit from this new mobility; a similar 8.30 p.m. service drew huge congregations to the newly consecrated Liverpool Cathedral.[41]

A second popular ritual was the Whit Walk on Whit Monday, an annual Protestant rejoinder to the Catholic procession on Whit Friday. Here, a procession of Sunday school children wound around the city and it ended with a service in the Cathedral. Welldon's successor, W. S. Swayne (Dean, 1918–19), recounted leading the procession in 1919:

> The Whit Monday procession of scholars in Church Sunday schools in Manchester is without parallel in England ... The whole of the centre is given over to the procession. Traffic is stopped on the route. The trams are directed. In places which are suitable stands are erected, where seats can be hired by

39 'Obituary: Canon Peter Green', the *Guardian*, 18 November 1961, p. 9.
40 Swayne, *Parson's Pleasure*, pp. 235, 244.
41 For the Liverpool Sunday evening service, see F. W. Dillistone, *Charles Raven: Naturalist, Historian, Theologian* (London: Hodder and Stoughton, 1975), pp. 147–8. I am grateful to Garth Turner for pointing out this parallel.

those who do not want to stand in the streets. Every window is crowded and the pavements are thick with people … The children converged on Albert Square, opposite the Town Hall. The square held some 20,000 of them. The Dean ascended a high pulpit, and did his best briefly to address the assembly. The procession was then formed, and led and accompanied by many bands moved over a circular route to the Cathedral. There some 4,000 elder children from selected schools entered the cathedral for a brief service, and the others waited outside.[42]

This occasion was still getting 20,000 walkers in 1938 (down from a peak of 30,000 in 1904, though the number had usually hovered around 25,000 in the first two decades of the century). It was never as important as a symbol of communal identity for Anglicans as it was for Catholics, and the adamantly Protestant Bishop Knox did not participate in it.[43] Both the Whit Walks and the Sunday evening service survived in attenuated form after 1945, and though television (reputedly *The Forsyte Saga*) reduced congregations for the Sunday evening service, the Whit Walk was still drawing 10,000 participants in 1970.[44] A third ritual that remained popular in the inter-war period was the annual service for particular professions. McCormick added a new one for sportsmen, while his flamboyant successor Hewlett Johnson was well suited to the pageantry of the actors' service, although a photograph of him posing with chorus girls on a tour of dressing rooms to drum up support for the service brought complaints in the *Manchester City News*.[45]

Gough McCormick and Hewlett Johnson were both particularly successful deans because they were able to establish an intimate connection with their audiences, and because both had something of the showman about them. McCormick was a popular after-dinner speaker, whose untimely death in 1924 came as a terrible shock to the city. The *Manchester Guardian* commented:

42 Swayne, *Parson's Pleasure*, p. 240.
43 Steven Fielding, *Class and Ethnicity: Irish Catholics in England 1880–1939* (Buckingham: Open University Press, 1993), p. 75; for the importance of the Catholic ceremony, see Charlotte Wildman, 'Religious Selfhoods and the City in Inter-War Manchester', *Urban History* 38 (2011), pp. 103–23; see also Charlotte Wildman, 'The Spectacle of the City in Manchester and Liverpool, 1920–40' (PhD thesis, Manchester University, 2007).
44 Untitled photograph, the *Guardian*, 26 May 1970, p. 26.
45 *Manchester City News*, 23 May 1925, quoted in Robert Hughes, *The Red Dean: The Life and Riddle of Dr Hewlett Johnson* (Worthing: Churchman, 1987), p. 50.

… it may well be questioned whether any man ever impressed himself on the life of a great community, and won the affection and esteem of all classes in it, as rapidly as Dr McCormick did on his appointment to the Deanery of Manchester. From his first appearance he won all hearts, and his popularity, far from waning, as quickly won popularities often do, increased steadily up to the end.[46]

McCormick was a hard act to follow, but it helped that Hewlett Johnson was himself a Mancunian. He also had a shrewd eye for the grand gesture, opening the west doors of the Cathedral so that passers-by could see inside.[47] A contemporary later recalled that 'when he preached at Manchester Cathedral it was something to see the congregation lining the pathway along which he would leave the building after the service'.[48]

Though less flamboyant than his deans, Peter Green also had the sort of common touch that endeared him to the public. Green had come to the Cathedral in 1911, having already been vicar of another church in Salford. An ascetic vegetarian and teetotaller with a sharp tongue, he seemed an unlikely figure to inspire devotion, but he earned it through his dedication to the poor of Salford, and his skills as a popular expositor of Christianity. He wrote voluminously, publishing thirty-eight books, and taking over Hicks's column in the *Manchester Guardian*, which he wrote under the pseudonym *Artifex* for forty-four years. His dedication to Salford was attested to by his repeated and legendary refusal of preferment. He turned down the chance to succeed Hicks at Lincoln in 1919 (the job went to his Dean, Swayne, instead), William Temple's suggestion that he become first Bishop of Blackburn, and an offer of the bishopric of Birmingham from Ramsay MacDonald in 1924. He justified his refusal of Lincoln to Archbishop Davidson on the grounds that bishops' incomes were a stumbling block to the Church. He also declined to become Bishop of New Guinea.

Green was sometimes described as an 'evangelical tractarian'. His evangelical side led him to emphasize the importance of conversion, and he conducted numerous parochial missions, in Manchester, Blackpool, and elsewhere. His tractarian side was apparent from his daily celebration of holy communion in St Philip's Church, which was the centrepiece of his devotional life. When the other canonries were separated from the incumbencies of nearby parishes in 1926, Green refused to give up St Philip's,

46 'Death of the Dean of Manchester', *MG*, 1 September 1924, p. 6.
47 'An Open Cathedral', *MG*, 27 June 1925, p. 15.
48 George Mould, *Manchester Memories* (Lavenham: Dalton, 1972), p. 72.

threatening to resign if this separation was made compulsory. 'Had I nine lives as a cat,' he used to say, 'I should have been a parish priest every time.'[49] But he was also punctilious in his performance of duties in the Cathedral, serving as Sub-Dean and helping set up the Friends of the Cathedral.

Not all clergy could adapt to the demotic style exemplified by Green, McCormick, and Hewlett Johnson. Garfield Williams, who succeeded Johnson in 1931, was shy and lacked his predecessor's panache. As we shall see, these weaknesses were to undermine his position with the chapter. More surprising was Bishop William Temple's failure to establish a rapport with Manchester audiences. His friend Walter Moberly, Vice-Chancellor of the University, described watching the Bishop pitch his message too high when addressing a group of schoolchildren in the Cathedral, thus mystifying his audience. Moberly noted that while Temple was admired by Manchester people, 'I do not think Manchester ever quite took him to its heart … I fancy he was felt just a little too impersonal and intellectual for real warmth of intimacy.'[50]

After Temple's departure to York in 1929, and Hewlett Johnson's preferment to Canterbury in 1931, the theological complexion of the chapter changed. Both the new Bishop, Guy Warman, and the new Dean, Garfield Williams, were evangelicals. They attempted to improve the standard of worship in the Cathedral, and to stamp out ritualistic practices. The chapter minutes for 23 September 1932 recorded 'that the Dean and Chapter consider the present behaviour of some of the choir boys during service to be most unsatisfactory'.[51] In May 1936, the minutes lamented the variety of liturgical practices that 'during the last few years … has been casually and almost unconsciously growing up in Manchester Cathedral', including the singing of communion by the celebrant, and bowing to the high altar. The chapter resolved to 'put an end to this unorganised and unauthorised variation'. It also demanded 'reverent and orderly' behaviour from clergy and choristers, noting that 'slackness, "lolling about" and an ambling gait are things that are noticed by worshippers, and do so much to distract people from concentration upon the worship of God'.[52]

49 H. A. Sheen, *Canon Peter Green: A Biography of a Great Parish Priest* (London: Hodder and Stoughton, 1965), p. 23.

50 Quoted in F. A. Iremonger, *William Temple, Archbishop of Canterbury: His Life and Letters* (London: Oxford University Press, 1948), p. 318.

51 MCA, Mancath/2/2/5, Chapter minutes, p. 14 (23 September 1932).

52 *Ibid.*, p. 123 (18 May 1936).

The reforms of the inter-war period were not just liturgical; the administration of the Cathedral, and its place in the diocese, were also reformed significantly. The creation of a separate diocese of Blackburn meant that the Cathedral could now concentrate on ministering to Greater Manchester, rather than far-flung parts of Lancashire. The separation of canonries from city parishes in 1926 (although Peter Green elected to remain as vicar of St Philip's, Salford) meant that canons could spend more time in the Cathedral. Manchester also retained a financial advantage over other Anglican cathedrals, because as one of only two foundations not required to hand over their estates under the Cathedrals Measure of 1931, it was allowed to keep a portion of surplus revenue, subject to the agreement of the Ecclesiastical Commission and the Bishop.[53] New statutes gave Bishop the right to act as visitor of the Cathedral, and also for the first time made the dean and chapter responsible for the whole fabric of the Cathedral. Having undertaken these new responsibilities, the dean and chapter launched an appeal for £2,500 to improve the Cathedral fabric, and also set up the Friends of Manchester Cathedral, in 1937.[54]

There had already been a number of physical improvements to the fabric of the Cathedral in the 1930s. Sir Percy Worthington's choir school and refectory were opened in 1933, adorned with Eric Gill's carved panel depicting the patron saints of the Cathedral, *St Mary, St Denys and St George with the Christ Child*. The Derby chapel was renovated in 1936, and renamed as a regimental chapel for the Manchester Regiment, with a shrine for the 14,209 killed in the First World War, among them Wilfred Owen (the names of the Second World War dead were added when the chapel was rebuilt after the bombing of 1940). Under the aegis of the 1937 appeal, the Cathedral was further renovated and cleaned in time for the centenary of Manchester's incorporation as a borough in 1938. There is pathos in the chapter's pride in the beautification of the Cathedral in the late 1930s; they could not have guessed what was about to befall the building.

Among the subscribers to the restoration appeal was the Council of Manchester and Salford Jews, the President of which, Nathan Laski (father of the political theorist Harold), explained that 'we think that as Jews we have an equal interest as citizens

53 From 1926 to 1963, some canonries were linked to diocesan jobs; during most of that period the Archdeacon of Manchester and Bishop of Middleton were *ex officio* canons.
54 'Manchester Cathedral: An Appeal', *MG*, 20 December 1937, p. 16.

in keeping the cathedral in good order'.[55] Others also remarked on this Jewish sense of attachment to the Cathedral. An Anglican memoirist, George Mould, described meeting a Jewish friend in the Cathedral during a Brotherhood Week led by the local Council of Christians and Jews:

> I was interested to find a Jewish friend of mine – a solicitor – leading a party including Jews and non-Jews and talking about the features of the building with great affection. I expressed surprise that he should be doing this. 'Why not?', he asked. 'I went to the Grammar School and this was our Church'.[56]

The sense of solidarity between Jews and Christians in the city became more pronounced in 1938–39. When the Chief Rabbi declared a 'Day of Intercession for the Sufferers from the Renewed Attack on Religious and Human Freedom' in July 1938, the Cathedral included intercessions for persecuted Jews in its services, and the Archdeacon, Selwyn Bean, confessed in his sermon that 'the hands of the Christian Church were not at all clean with regard to its treatment of the Jews'.[57]

Devastation: the Second World War

The outbreak of war in 1939 caused immediate disruption much greater than that caused by the First World War. The choir school was evacuated to Thornton Hall, Cleveleys, near Blackpool in 1939. After briefly returning to Manchester in 1940, it was then closed for the duration of the war in 1940, and never reopened thereafter. The Sunday evening service was moved to afternoons, and the statutory choir replaced by the voluntary choir.[58] Most catastrophically of all, the Cathedral was severely damaged by a parachuted landmine during the Manchester Blitz of 22–23 December 1940. In his eyewitness account of the bombing raid, from the vantage point of the Victoria and Grosvenor hotels, Garfield Williams described how he saw the Cathedral windows lit up by the burning Shambles nearby. He called the spectacle 'a thing of entrancing, shocking, devastating beauty'. By daybreak, he assumed that the Cathedral itself had been spared, and went to sleep in a shelter, but his relief turned out to be premature, because a final bomb exploded on the north-east corner of the Cathedral. 'The noise of the fires was so terrific that we did not

55 'Manchester Jews and Cathedral: Gift to Repair Fund', *MG*, 17 January 1938, p. 13.
56 Mould, *Manchester Memories*, p. 82.
57 'Persecution of the Jews', *MG*, 18 July 1938, p. 13.
58 'Manchester Cathedral', *MG*, 4 September 1939, p. 1.

hear anything', Garfield Williams recalled. 'The sensation was just like an earthquake – I had been in earthquakes before in India, so the sensation was not new.'[59]

An even more vivid account of the blast was given by a passing policeman:

> I was having a walk round at about 5 o'clock in the morning with another chap, and we were passing the Cathedral talking away, and suddenly everything around us went black, the air was full of sparks, and I saw the west doors of the Cathedral coming out, and I knew they didn't open outwards, they opened inwards – but not this time. And the blast picked me up and put me into the middle of the road. I broke my pipe in the passage, I opened my mouth to swear and the stem dropped out as well. And my friend had been sucked in by the blast against the wall, and he said he had never seen anything so funny in his life. I hit the deck in the middle of the road and all I could think of was that the Cathedral tower would be down on me and I had better get under the doorway, and I bounced out of the road into the doorway. It didn't come down. That shakes you up a little bit. We weren't quite so joyous after that. We went and had a look at the Cathedral, everything looked all right – chairs in there and in darkness. So we found an air-raid shelter and sat down quietly for ten minutes. One of my uniformed colleagues was standing near the bomb when it hit the Cathedral, and I saw his overcoat afterwards. He was left with a corset. It stripped the skin off his overcoat, it blew his steel helmet off, and when we got it, it looked like a trilby hat.[60]

As Garfield Williams discovered when he entered the building, the damage to the interior was much worse than the policeman had suspected:

> The blast had lifted the whole lead roof of the Cathedral up and then dropped it back, miraculously, in place. Every window and door had gone; chairs, ornaments, carpets, furnishings, had been just swept up into the air and dropped in

59 Garfield Williams, 'The Cathedral and its Future', in *Our Blitz, Red Skies over Manchester: The Daily Dispatch and Evening Chronicle record in Story and Picture the German Bombing Attack on the Greater Manchester Area, with Special Reference to the nights December 22nd and 23rd 1940* (Bolton: Aurora, 1945, reprinted 1995), p. 45.

60 Unnamed former policeman in Ken Howarth (ed.), *Manchester Wartime Memories: An Illustrated Collection of Oral History Memories of Manchester in the Second World War* (Manchester: Manchester Library and Information Service, 2006), pp. 42–3.

heaps anywhere. The High Altar was just a heap of rubbish ten feet high. The two organs were scattered about in little bits. The great carved stalls were joined together in the centre so as to make an inverted V. The Lady Chapel, the Ely Chapel and much of the regimental chapel had simply disappeared. Showers of sparks still swept across the place, but the old Cathedral just refused to burn.[61]

The response of the Cathedral staff on the morning of 23 December was swift and phlegmatic. The prompt action of the Cathedral architect, Hubert Worthington, in bringing craftsmen in to secure the choir stalls and recover their oak fragments, was decisive in ensuring that they could subsequently be reassembled.[62] On walking to Salford a few hours after the blast to check on Peter Green's whereabouts, Garfield Williams found him 'exuberant … like a man walking to the pavilion carrying his bat after knocking up a century'.[63] Frank Woolnough reputedly told a verger to raise the Union flag on the tower, where it flew until the end of the war.[64] Cathedral services continued in St Ann's Church.

After Coventry, Manchester was the most severely damaged cathedral in Britain. It did not have the iconic power of Coventry (or St Paul's), and the Free Trade Hall was a more redolent Blitz ruin for Manchester than the Cathedral. Nevertheless, the speed with which the Cathedral was reopened (on Ash Wednesday 1941) probably helped to counter the despondency that Mass Observation investigators had encountered in central Manchester in the immediate aftermath of the December 1940 Blitz.[65] Garfield Williams recounted how the first contribution to the appeal on the morning after the blast, was a pound note given him by a local Congregationalist minister who had tears in his eyes at the Cathedral's plight.[66] Once again, the Jewish community also contributed to the restoration.[67] It was a sign of the popular estimation in which the Cathedral was held that it had successfully raised enough money for repairs by 1952.

VE Day and VJ Day were celebrated by continuous services in the Cathedral from 9 a.m. to 6 p.m.; at the civic service on

61 Garfield Williams, 'The Cathedral and its Future', p. 45.
62 *ODNB*, *s.n.* 'Worthington Family (per. 1849–1963), Architects'.
63 Garfield Williams, 'The Cathedral and its Future', p. 45.
64 MCA, Ian Molloy, 'Manchester Cathedral: My Memories of 1953–1964', unpublished typescript, p. 11.
65 B. Beaven and D. Thoms, 'The Blitz and Civilian Morale in Three Northern Cities', *Northern History* 32 (1996), pp. 195–203.
66 Garfield Williams, 'The Cathedral and its Future', p. 45.
67 'Jews' Gift for Cathedral Reconstruction', *MG*, 7 March 1941, p. 6.

Photograph of the Cathedral shortly after the Second World War, with rubble visible in the foreground

VE Day, the congregation was so huge that large crowds were forced to stand outside and watch services through the doors.[68] Restoration work on the damaged Cathedral began in the following year, under the supervision of Hubert Worthington (who had succeeded his father as cathedral architect in 1938), and took a decade to complete. The Lady chapel was rebuilt, and the Manchester Regimental chapel repaired, with a new shrine to the dead of the Second World War. The

Workmen restoring the Cathedral

roof was re-leaded, the organ replaced, and the windows reglazed with clear glass (except in the east window) to allow more light into the Cathedral. The fragments of wood reclaimed by Hubert Worthington after the blast were reinserted into the choir stalls, and 192 new panels fitted in the choir roof.[69]

68 'Manchester's Victory Day Celebrations', *MG*, 9 May 1945, p, 6; 'V. J. Rejoicings in Manchester', *MG*, 16 August 1945, p. 3; 'Manchester's Thanksgiving: Cathedral Congregation Overflows into the Yard', *MG*, 14 May 1945, p. 3.
69 Hubert Worthington, 'Introduction', *Manchester Cathedral: A Book of Pictures* (Manchester: Manchester Cathedral, 1958); Hedley Hodkin, *The Pictorial History of Manchester Cathedral* (London: Pitkin, 1966).

Post-war conflicts, 1945–64

The damage to the wider environment around the Cathedral lasted much longer than that to the Cathedral fabric, and was less conclusively resolved after the war. Many of the streets and buildings around the Cathedral had been severely damaged; the question was how to replace them. The dean and chapter wrote to the Town Clerk in March 1942, urging that 'Manchester Cathedral is a building of such outstanding historical and architectural interest that the consideration of its surroundings should exercise an important influence in the city plan', and noting that Coventry Cathedral was already being made central to the planned rebuilding of Coventry.[70] Their prayers seemed to be answered in the 1945 *City of Manchester Plan* by the City Surveyor, Roland Nicholas, who lamented that it was a 'tragedy' that Manchester's two greatest historic buildings, the Cathedral and Chetham's, were 'mainly hidden and almost wholly marred by their surrounding structures'. The plan sought to develop the Cathedral area as an ecclesiastical quarter 'endowed with an atmosphere of peace and tranquillity, contrasting with the busy life of the neighbouring business quarter'.[71] A garden would link the two buildings, and cover the River Irwell, with traffic diverted away from the Cathedral. But Nicholas noted prophetically that 'it may be a long time before the Cathedral precinct can be realised as a whole', because the existing buildings around the Cathedral had some years of useful life. Ironically, it was to take another bomb close to the Cathedral – the IRA attack in 1996 – for Nicholas's vision to be partially realized.

Other, more piecemeal, development plans that *were* implemented in the 1960s and 1970s cut the Cathedral off from the rest of the city. This was a source of anxiety to the chapter, which also had conflicting interests because, as a major landlord in its own right, it was seeking to profit from the redevelopment of its properties in Deansgate. Although the area around the Cathedral was designated as a conservation area in 1972, large numbers of buildings within it were demolished or mutilated, and by 1983, the Victorian Society was decrying 'the planning disaster which has created a wasteland at the core of this great city'.[72]

70 MCA, Mancath/2/2/5, Chapter minutes, 10 March 1942.
71 Roland Nicholas, *City of Manchester Plan* (Norwich: Jarrold for Manchester Corporation, 1945), p. 195, p. 184.
72 Save Britain's Heritage and Victorian Society Manchester Group, *Manchester: The Disappearing Cathedral Conservation Area* (London: Save Britain's Heritage and Victorian Society Manchester Group, 1983).

The war did not only damage the fabric of the Cathedral; it also led to a period of deteriorating relations between successive deans and the chapter. The very limited powers that the statutes gave the dean were a factor here. Another factor was the entrenched position of some members of the chapter. Frank Woolnough and Selwyn Bean, the gaiter-wearing Archdeacon of Manchester, had both been canons since 1934, as had Peter Green since 1911, while Garfield Williams had been Dean since 1931. Woolnough in particular seems to have been an autocrat, described by a later canon as a 'martinet', and (reputedly) by Peter Green as having done more damage to the church in Manchester than anyone since Oliver Cromwell.[73] A major conflict blew up in 1942, when Garfield Williams asked the chapter whether the Cathedral could find office space for an ecumenical body, the Manchester Council of Christian Congregations. Selwyn Bean objected that the statutes forbade accommodating a non-Anglican body. The rest of the chapter sided with Bean, whereupon the Dean asked Bishop Guy Warman (as visitor) to rule on his interpretation of the statutes. The Bishop agreed with Bean, but Williams insisted that the chapter minutes record his refusal to associate himself with the chapter's decision 'in any way whatsoever'.[74] As well as his shy manner, Williams's long absences owing to ill health during the war had probably weakened his position with the chapter.

A few years later, a similar deadlock occurred between the chapter and Williams's successor, the former Bishop of Singapore, Leonard Wilson. Wilson was keen to experiment with new forms of service, but fell foul of the traditionalism of a chapter wedded to the resumption of pre-war patterns of worship.[75] He appealed to Bishop Billy Greer, asking for clarification of the rule that the dean could only preach on four statutory days each year. The Bishop was also asked to rule on whether the dean or Woolnough was responsible for administration in the Cathedral (the chapter had voted to give Woolnough overall administrative authority in 1949).[76] This clash was clearly one of two autocratic personalities, and Wilson's impatience with the pettifogging of

73 Michael Hennell, *The Deans and Canons of Manchester Cathedral, 1840–1948* (Manchester: Manchester Cathedral, 1988), pp. 50–1; Molloy, 'My Memories', p. 12.

74 MCA, Mancath/2/2/5, Chapter minutes, 31 July, 3, 4 August, 13 October 1942.

75 Roy McKay, *John Leonard Wilson: Confessor for the Faith* (London: Hodder and Stoughton, 1973), ch. 8; *ODNB, s.n.* 'Wilson (John) Leonard (1897–1970)'.

76 MCA, Mancath/2/2/6, Chapter minutes, 30 October 1951, 6 May 1949.

the chapter was probably exacerbated by his own imprisonment and torture at the hands of the Japanese in Changi prison in Singapore a few years before. As a former bishop, he was also unused to being trammelled by a chapter. The impasse was only really eased by his departure to be Bishop of Birmingham in 1953, and his replacement by Herbert Arthur Jones.

Under Jones, some aspects of Cathedral life did enjoy a renaissance in the 1950s. This was particularly true of music. Allan Wicks, the Organist and Master of the Choristers from 1954 to 1961, has variously been hailed as 'the greatest cathedral organist' and 'one of the most inspired and charismatic choirmasters' of his generation, and succeeded in reviving the reputation of the Cathedral choir. He presided over the rebuilding of the organ, and commissioned new organ work from rising composers like Peter Maxwell Davies, Iain Hamilton, and Malcolm Williamson. He was also the first person in Britain to champion the work of Olivier Messiaen and widened the choral repertoire to include more *avant-garde* works. He established the cantata choir and a small orchestra to perform longer works at Tuesday evening concerts, among them the first performance of Stravinsky's *Canticum Sacrum*.[77]

Aesthetic as well as musical improvements also continued in Dean Jones's time. He commissioned Carel Weight's series of murals of the Sermon on the Mount and the Beatitudes, painted within the fifteenth-century tracery over the door to the Chapter House, which were dedicated in 1963 (Stanley Spencer had originally been considered, but died too soon). These placed the Beatitudes in modern settings, including (for 'Blessed are the Persecuted') a victim of racial violence. Another modern reworking of a biblical image was Sir Charles Wheeler's *Lancashire Madonna*, a golden statue clad in a traditional Lancashire mill-worker's shawl. On its unveiling in 1958, Jones acclaimed it as 'a fine culmination to the great work of reconstruction at the Cathedral'.[78]

The Cathedral also engaged with new forms of popular culture. Although television had done for the popularity of the Sunday evening service, the Cathedral chapter had been quick to spot its potential, collaborating with both the BBC and Granada TV, whose first day on air in May 1956 had ended with an

77 'Allan Wicks', *The Times*, 11 February 2010; Philip Moore, 'Allan Wicks', the *Guardian*, 5 March 2010; 'Adventures in Church Music', the *Guardian*, 27 July 1961, p. 17.

78 'Cathedral Statue', MG, 7 April 1958, p. 10; see also Terry Wyke with Harry Cocks, *Public Sculpture of Greater Manchester* (Liverpool: Liverpool University Press, 2004), pp. 59–60.

Epilogue sung by the choristers. Alfred Jowett's colleague Canon Frank Wright later served as an advisor to Granada, continuing the connections with the local media pioneered by Edward Lee Hicks and Peter Green. The Cathedral's role as a focus for civic grief continued with the 1958 Munich air crash, when separate services were held for dead journalists and footballers, and again in 1980, when a charter flight from Manchester crashed on Tenerife.

Rejuvenation and radicalism, 1964–83

It was only with the retirements of the three elderly canons, Green (at the age of 89 in 1956, after 45 years as a canon, though he had given up his parish in 1950), Woolnough (aged 76 in 1960, after 26 years as a canon), and Bean (aged 79 in 1966, after 31 years as a canon and Archdeacon) that the Cathedral was able to rejuvenate.[79] Under the 1963 Cathedrals Measure, new canons were no longer to hold senior diocesan office, which meant that they no longer had independent power bases of their own. Two of the new appointees, Ronald Preston, and Alfred Jowett, who replaced Jones as Dean in 1964, had been protégés of Bishop Leslie Hunter in Sheffield (as had Ted Wickham, Bishop of Mid-

dleton, who was not a chapter member), and they brought Hunter's enthusiasm for urban ministry with them across the Pennines. The new recruits to the Chapter were also more theologically liberal than their evangelical (or, in the case of Green, 'catholic evangelical') predecessors. Several of them were appointed by the succession of liberal-minded post-war bishops, Billy Greer (1947–70), Patrick Rodger (1970–78), and Stanley Booth-Clibborn (1979–92). Rodger and Booth-Clibborn were active campaigners for

Alfred Jowett,
Dean 1964–83

79 Under the 1963 Cathedrals Measure, two canonries were paid for by the Church Commissioners, and could no longer be attached to diocesan posts. The Bishop of Middleton had already ceased to be a member of chapter in 1956, when Frank Woods resigned his canonry while remaining Bishop.

women's ordination, as was Jowett; like Jowett, Booth-Clibborn had begun his career under Leslie Hunter in Sheffield. It was mutually agreeable that bishops and canons were so like-minded; significantly, the chapter refused to countenance the conservative evangelical John Stott as their Bishop when canvassed by Number 10 in 1969, insisting that 'an appointment of this kind would be quite disastrous for the diocese'.[80]

Jowett was the preeminent figure in the post-war life of the Cathedral and had a particular sense of its mission as 'a base from which we can go out and serve the world'.[81] As he pointed out in his farewell sermon in 1983, his manifold commitments and enthusiasms meant that his influence was multi-faceted:

> This Dean of Manchester appears different to different people. To some people he is mad about education, to some he is deeply concerned about community relations, to some he is passionately concerned about church unity, especially if he can pursue unity with the Church in France! To some he is a bit of a counsellor, to some he is a lecturer on theological and literary topics. But who is he <u>really</u>? Does he really exist, this protean Dean-like shape?[82]

As Jowett indicated, education was one of his central preoccupations. A former English teacher, he lectured to the University extra-mural department and the Workers' Educational Association as Dean. He was also an active member of the city Education Committee. His literary enthusiasms also led him to make the Cathedral a centre for theatrical performance. He established the biennial Manchester Cathedral Arts Festival from 1964; this included a spectacular on the history of the Cathedral in 1966 narrated by Violet Carson, who played Ena Sharples in *Coronation Street*. (The actress had a long association with the Cathedral, which hosted her wedding in 1926 and her memorial service in 1984.) The Cathedral served as a temporary home for the Royal Exchange Theatre in the mid-1970s, while the Royal Exchange itself was being converted into a theatre. A memorial service for Michael Elliott, one of the theatre's founding artistic directors, was held in the Cathedral in 1984.

Jowett's main liturgical innovation was replacing the traditional Sunday morning matins and communion with a new form of communion service in 1968. The *Guardian* hailed 'the first

80 MCA, P4/2, Jowett Papers, Jowett to John Hewitt, 17 November 1969.
81 Alfred Jowett, 'Preface' to *Manchester Cathedral 1421–1971* (Manchester: Manchester Cathedral, 1971)
82 Alfred Jowett, last sermon as Dean of Manchester. I am grateful to Garth Turner for a copy of this sermon.

major changes in more than four hundred years in the authorised services at Manchester Cathedral' (though experiments with a family service had in fact begun in 1961). The new service aimed to increase lay participation, with the celebrant facing the people across the altar rather than looking eastwards. Jowett explained that 'the intention was to re-emphasise the family meal nature of the Holy Communion'.[83] He favoured the use of ordinary bread, rather than communion wafers, as a way of emphasizing the Incarnation.[84]

Jowett also continued Jones's attempts to beautify the interior of the Cathedral, commissioning Antony Hollaway to produce five stained glass windows at the west end to replace the windows destroyed in the Blitz and to bring colour to that end of the Cathedral. Hollaway had, coincidentally, been a pupil of Jowett's at Poole Grammar School, but his commission came at the instigation of the Cathedral architect, Harry Fairhurst, with whom he had already collaborated on several projects.[85] The windows, installed between 1973 and 1995, depicted the three patron saints of the Cathedral, St George (1973), St Denys (1976), and St Mary (1980), along with the Creation (1991) and Revelation (1995). Included in the St Denys window was the basilica of St Sernin, Toulouse, which was twinned with the Cathedral at the behest of Jowett, who was a keen Francophile given to sporting a beret. This led to the creation of the Association Culturelle et Amicale Toulouse Manchester (ACATOM), and to a series of exchanges between the two congregations over a period of thirty years.[86] Several cathedrals attempted twinning arrangements in the post-war period, but Manchester's was one of the most successful. Jowett's championing of the exchange also derived from his internationalism. He had been a conscientious objector in the Second World War, and remained active in the peace movement, a commitment he shared with his Bishop Billy Greer, who was a supporter of CND.

Jowett was also committed to a number of other political causes. A particular concern was race relations, and he served as Deputy Chairman of the Community Relations Commission

83 'New Communion Service for Cathedral', the *Guardian*, 29 February 1968, p. 4.
84 Garth Turner, 'Alfred Jowett', the *Guardian*, 11 August 2004.
85 Keith New, 'Tony Hollaway', the *Guardian*, 13 September 2000.
86 Garth Turner, 'Cathedrals and Change in the Twentieth Century: Aspects of the Life of the Cathedrals of the Church of England with special reference to the Cathedral Commissions of 1925, 1958, 1992' (PhD thesis, University of Manchester, 2011), pp. 133–4. I am grateful to Dr Turner for additional information about the Toulouse exchange.

from 1972 to 1977. This was an onerous role (effectively full-time for the first two years), and at one point he considered resigning as Dean and moving to London. He was also a Vice-Chairman of the Campaign for Homosexual Equality. Jowett was a Christian socialist in the incarnationalist tradition, and though he was careful not to align himself publicly with the party, his wife Margaret had been a Labour councillor in Sheffield in the 1950s and hosted meetings of the Prestwich Labour Party in the Manchester Deanery. A list of the topics discussed by the 'Topic of the Week' luncheon club, which Jowett set up in 1965, gives a flavour of his political and aesthetic enthusiasms in the late 1960s:

> Rhodesia, United Nations, Rent Acts, espionage, arts, homosexuality, the moon, medicine, architecture, the Dead Sea Scrolls, public relations, Kenya, race relations, trades unionism, the Church, comprehensive education, sex and morality, the Consumer Association, Russian education, divorce by consent, homelessness, the newspaper crisis, China, India, ordination of women, Nigeria, censorship of plays, Christian Aid, Israel.[87]

Jowett's political engagement sometimes led him into controversy; he was attacked by the Nigerian Government for comments he made on Biafra, and by the national press for daring to suggest that popular hymns like 'Hills of the North, Rejoice' were outmoded and racist.[88] But he benefited from sharing a vision and outlook with his canons in a way that many of his predecessors had not done. Such was their unanimity that in 1969 the dean and chapter collectively wrote a letter to *Theology* defending the scheme for Anglican-Methodist reunion.[89] Frank Wright shared Jowett's enthusiasm for adult education, while his commitment to women's ordination was shared by a later canon, Christopher Hall, whose father Ronald had been the first Anglican bishop to ordain a woman, in wartime Hong Kong. Most important was Jowett's affinity with Ronald Preston – like him, a Sheffield protégé of Leslie Hunter – who was residentiary canon theologian from 1957, sub-dean in 1970–71, and remained active in the Cathedral as an honorary canon while Professor of Social and Pastoral Theology at the University from 1970. Preston was one of the foremost Anglican writers on social ethics in the post-war period, taking forward the Christian socialist

87 *Manchester Cathedral, 1421–1971*, p. 15.
88 Baden Hickman, 'Nigerian Request for Censure of Dean', the *Guardian*, 18 July 1968, p. 5.
89 '"Yes" and Again "No"', *Theology* 72 (1969), pp. 75–6.

tradition of R. H. Tawney (who had taught him at the LSE) but tempering it with the realism of Reinhold Niebuhr (his putative PhD supervisor, before the Second World War intervened) and with the experience of post-war political and economic change. Preston was also an enthusiastic ecumenist, and was seconded to Geneva as head of the Church and Society unit of the World Council of Churches in the late 1960s.[90]

The chapter's radicalism had its limits. Like Welldon with the suffragettes, Jowett found himself on the receiving end of militant protest in 1969, when a service of prayer for racial harmony in protest against a tour by the South African Springboks was disrupted by six uniformed Black Power activists, who gave the black power salute, shouting 'Power to the people. Power to the Black People'.[91] Jowett was a rather moderate Christian socialist, for example defending the church's established status as an instrument for social justice.[92] In this respect he stood in the tradition of Welldon and other key figures in the twentieth-century history of the Cathedral, such as Edward Lee Hicks, William Temple, Billy Greer, and Ronald Preston.

Just as Welldon had done, Jowett believed in the Cathedral's symbolic importance in the midst of the city. On its 550th anniversary in 1971, he wrote that although it was no longer the city's largest building,

> A comparatively small and very beautiful building like ours can stand in these days as a threefold symbol. It is a symbol of excellence in an age whose material standards are not always very high; it is a symbol of beauty in an age where ugliness often predominates; it is a symbol of servanthood in an age when people think that the biggest is best and that power is to be worshipped.[93]

Despite the efforts of the Luftwaffe and the city planners, Jowett's Manchester would still have been recognizable to Welldon, as an industrial city with a large, cohesive working class. The full implications of some of the massive social upheavals that Manchester experienced after 1945 (de-industrialization, re-housing,

90 For Preston's career, see *ODNB*, *s.n.* 'Preston, Ronald Haydn (1913–2001)'; 'The Rev. Prof. Ronald Preston', the *Daily Telegraph*, 15 December 2001.

91 Baden Hickman, 'Black Power Group Interrupts Service', the *Guardian*, 26 November 1969, p. 1.

92 Alfred Jowett, 'The Church in the Local Situation', in Leslie Hunter (ed.), *The English Church: A New Look* (Harmondsworth: Penguin, 1966), pp. 95–106.

93 Alfred Jowett, 'Manchester Cathedral: Serving God and Man', in *Manchester Cathedral, 1921–1971*, p. 1.

youth unemployment, and the influx of new immigrant communities) did not manifest themselves until the end of Jowett's time as Dean. They did so with alarming force in the 1981 Moss Side riots, which portended new challenges for Cathedral and city alike in the final decades of the twentieth century.

IN MEMORY OF CAPTAIN JACK BROWN

✣ 8 ✣

The Cathedral, 1983 to the present

JEREMY MORRIS

Walking round [Manchester Cathedral] is to walk through
stories of how the modern world emerged and where it is going
… It is to traverse the pre-modern age … to journey across
sites of early mills of the first industrial revolution … [and to
encounter] the new Marks and Spencer's store, the biggest in
the world, and the great Arena for mass leisure productions
of a global kind … the new cathedrals of a post-industrial and
post-modern world.[1]

JOHN ATHERTON WAS WRITING of Manchester Cathedral and
its environs at the end of the twentieth century, noting the
series of transitions through which the city had gone, and
which the changing fortunes of the Cathedral had charted. As
he implied, the last transition, of all those Manchester had faced
in the previous two hundred years, had been the least expected
of all: the transformation of the city from the devastation of
de-industrialization in the 1980s into an apparently rejuvenated
centre of leisure, entertainment, consumerism, and art, a 'club-
bing' capital as well as a testimony to the fluidity of capital and
financial services. A chapter that brings the story of Manchester
Cathedral into the early twenty-first century thus needs to situate
itself above all with regard to the contradictions embedded in
this recent transformation of the city's fortunes: the resurgence
and rebuilding of the city, at one level, coupled with persisting
deep poverty and social deprivation. How did the role of the
Cathedral in Manchester change, through this period, and did it
adapt successfully or not to the rapidly changing world around
it? In what sense at the beginning of the twenty-first century
could the Cathedral act as a symbol of challenge or as a symbol

1 John Atherton, *Public Theology for Changing Times* (London: SPCK,
2000), p. 66.

Previous spread:
Regimental chapel

of unity and reassurance in contemporary culture, when considering, for example, the 2007 furore surrounding the use of the Cathedral in the computer game 'Resistance: Fall of Man', or the picketing of the Cathedral in 2009 by the British National Party?

In a way that once must have seemed unimaginable, by then the Cathedral had emerged from the shadows of Manchester's industrial past and reinvented itself as the public face of the city. Physically and materially, this was a journey from obscurity to new urban space, but paradoxically it cut across the arc of church decline in Manchester. The Cathedral managed to reconceive itself, and to assert its continuing role, at a time when the difficulties facing all the traditional Christian denominations were becoming more entrenched, and more intractable, in the city at large. The public prominence of the Cathedral had local and particular roots, but it also shared in the general experience of cathedrals in modern Britain, as they thrived both as places of worship and as sites of tourism even as parishes amalgamated and churches closed around them. Most of the significant statistical indices for the diocese of Manchester as a whole, including the city, showed a remorseless downward trend in the last two decades of the twentieth century and the first decade of the twenty-first, although there were some signs that actual attendance had stabilized by the turn of the century. Rounded numbers on the parish electoral rolls – the closest the Church of England comes to a formal indication of 'membership' – for the diocese fell from 38,000 in 1996 to 33,100 in 2010.[2] Average weekly attendance in all the diocese's churches (including the Cathedral) remained roughly stable between 2001 and 2009, falling marginally from 34,700 to 34,400.[3] The number of full-time, stipendiary clergy fell from 379 in 2000 to 237 in 2011, though this was mitigated by an increase in 'self-supporting', or non-stipendiary clergy.[4] While the diocese fell back, the Cathedral flourished: its service registers appear to show no decline in average attendance from the 1980s through to the 2010s, and the number of special services and other events if anything increased in that period.[5]

2 Archbishops' Council, *Church Statistics 2010/11* (London: Archbishops' Council, 2012), p. 18.

3 Statistics at www.churchofengland.org/media//1341635/2001_2009attendanceandaffiliation.xls, accessed 10 January 2013.

4 Statistics at www.churchofengland.org/media/1518071/2000_2011ministry_summaryfiles_revised.xls, accessed 10 January 2013.

5 Direct comparison across the period is difficult as detailed statistics of attendance were not kept until the 2000s; the average weekly communicant numbers at the main Sunday morning service remained stable, at around a hundred.

The Waddington and Riley years

No account of a cathedral's history can aspire to comprehensiveness if it reckons only on narrating the policies and perspectives of its deans, and the 'great man' view of history is all too easy a temptation when considering changes in the life of a cathedral over decades, especially noting the gendered nature of such a view. Certainly, policy can change dramatically between deans, and the personality of a dean can facilitate or obstruct necessary changes. But the historian must keep an eye on longer-term trends, on institutional pressures and developments, and on the broader context, as well as on the many other people who contribute to the life of a cathedral. Therefore, the history of the Cathedral in these years cannot adequately be described in terms of leading clergy alone. Even so, a dean is, after all, the leader of a community, and the succession of deans provides a useful a basic narrative of a cathedral's life.

The retirement of Alfred Jowett came to be seen, in retrospect, as a watershed in the history of Manchester Cathedral. Even the most powerful of deans – and Jowett, though 'a remarkable man, and an unconventional dean', was no dictator (indeed one colleague described him as a 'gentle soul') – could achieve little without men and women of ability working with them.[6] But Jowett's near twenty-year tenure of office, with his political commitments and his close relationship with the city authorities, coincided with Manchester's last great flourish as a manufacturing city, before the devastating onset of industrial decline and unemployment in the 1970s and 1980s. It symbolized a style of Anglican social commitment exemplified in the work of Ronald Preston, the canon theologian who served as Professor in Manchester University's Theology department and stood in the line of the social theology of William Temple and Maurice Reckitt.[7] Not only was the city to change in the closing decades of the twentieth century, however, but so too was the governance of the Cathedral, as the most comprehensive overhaul of English cathedrals' finance and organization was carried out in the 1990s. This was a period of rapid change for cathedrals nationally, then, and particularly so for Manchester.[8]

6 Interview with B. Harris, 5 September 2013, transcript in Manchester, MCA; Garth Turner, 'The Very Revd Alfred Jowett', the *Guardian*, 11 August 2004.
7 *ODNB*, *s.n.* 'Preston, Ronald Haydn, 1913–2001'.
8 I am grateful to Sarah Bates for comments on this and a number of other paragraphs.

Robert Waddington, Jowett's successor, came to Manchester in 1984 with a ministerial career almost entirely in education, and in particular with seven years as General Secretary of the General Synod's Board of Education behind him. His background was southern (born in Bognor Regis), private school (Dulwich College), and Oxbridge (Selwyn College, Cambridge) – not at all unusual in a senior Church of England clergyman of his era, but not on the surface promising for Manchester. More to the point, his personality and interests were a world away from those of his great predecessor. One colleague was to observe that they could be said 'by a kind of process of dialectic' to redress what some might have seen as weaknesses in Jowett's work, including his apparent lack of interest in the Cathedral's liturgy and congregational life.[9] A tall, lean, and scholarly man, Waddington was, as one obituary testified, a 'private, contemplative priest', and apparently a 'contained celibate'.[10] He had been shaped by the discipline of the Oratory of the Good Shepherd, an Anglican order of celibate clergy, and was its Superior from 1987 to 1990. Another colleague was to comment that he was 'a man of contradictions', both self-disciplined and ascetic, but also 'a bit of an aesthete', enjoying good food and wine, art, and flashy cars.[11]

Unfortunately, there was another and more sinister side to the man. Waddington's reputation as Dean of Manchester is inevitably overshadowed now by the allegations which emerged in 2013 that he had groomed and sexually abused a choirboy from the Cathedral choir, beginning in 1984 and lasting, it seems, all the way through his tenure of the position.[12] The allegations surfaced as a result of investigative journalism by *The Times* and the *Australian*, which uncovered a series of allegations of systematic abuse dating back to Waddington's years in Australia. Waddington's death six years earlier meant that the allegations could not come to trial, but they were sufficiently numerous and well attested that there seems little reason to doubt their essential veracity, and that makes assessment of his ministry (and his approach to education in particular) especially difficult and sensitive. They triggered the commissioning by the Archbishop of York of a major inquiry both into the handling of the allegations themselves and into the Church of England's policies and practices on child protection. Conducted by Judge Sally Cahill

9 Garth Turner, private communication to the author, October 2011.
10 'The Very Rev. Robert Waddington', the *Independent*, 11 July 2007.
11 Notes by Albert Radcliffe, in the author's possession.
12 'I was the boyfriend of a monster … So what does that make me?', *The Times*, 10 May 2013; 'Child Sex Scandal in Two Countries rocks Anglican Church', the *Australian*, 10 May 2013.

QC, this reported in October 2014 and found 'systemic' failures by church authorities in the handling of the complaints against Waddington, though it was not tasked to address the substance of the allegations themselves.[13] Commenting in response to the report, which covered the handling of complaints about actions over almost half a century, the Archbishop acknowledged that '[n]o inquiry can ever make up for the suffering, ongoing harm and abuse of trust to which this report relates'.[14] It is impossible not to reckon with the pain and anger Waddington's actions caused, and to set that betrayal of his own beliefs and commitments against his apparent devotion and discipline. It is hard to escape the conclusion that in that contradiction something of the very centre of Waddington's personality and motivation has to be discerned. The distress and damage caused by the apparent failure of church authorities to note or attend to these allegations over many years, as in other cases, also has to be acknowledged. By its very nature, sexual abuse is often a matter of secrets and deception, and Waddington's death robbed those he had abused and hurt of the chance to confront him with the consequences of what he had done. What follows here is simply an attempt to record the main outlines of his public role as Dean, and as such does not touch directly on Waddington's inner contradictions.

Waddington's expertise in educational policy was considerable, and his interest in education – always bearing in mind the distressing subject-matter of the foregoing paragraph – on the surface of things continued unabated throughout his deanship. He had been a teacher and chaplain in Australia for fifteen years, and as General Secretary of the Board of Education had overseen the preparation of the Board's 1984 report *A Future in Partnership*, which committed the Church of England to an expansion of its involvement in education at every level, including increasing the number of Church secondary schools.[15] He chaired the Diocesan Education Committee, and was convinced of the importance of church schools in Manchester, not least because they were a vital point of contact for the church with a society which was increasingly multi-religious and multi-cultural. He was, by all accounts, a creative and imaginative teacher, whose usual Sunday sermons were often 'somewhat opaque', except on

13 The *Guardian*, 22 October 2014.

14 'Statement from the Archbishop of York', www.archbishopofyork.org/articles.php/3168/statement-from-the-archbishop-of-york, accessed December 2016.

15 *A Future in Partnership: A Green Paper for Discussion* (London: National Society for Promoting Religious Education, 1984).

those occasions when he was preaching to children and adopted some brilliantly ingenious device to illustrate a particular point.[16]

Waddington's lasting innovation was probably the reordering of the Cathedral's nave for the Sunday liturgy, giving much greater prominence to the nave altar, and clearing the space around it. Under Jowett, the nave altar had been, according to Garth Turner, the Precentor, a 'shoddy, unworthy object', wheeled out as necessary every Sunday.[17] Waddington instead made the reconfiguring of the Sunday liturgy a priority, installing a permanent nave altar, and taking an active interest in the weekday services as well, something that Jowett had not done. In this way, it could be said that he was a 'bridge linking the old way of being a cathedral with the new'.[18] Although these changes were fully in line with the ideals of the Liturgical Movement, nevertheless Waddington's own liturgical style was 'markedly old-fashioned', based perhaps on what he had learned at Ely Theological College in the 1950s.[19]

With the vital caveat about Waddington's mixed motives, and the impact of his actions on those boys he is alleged to have abused, to those unaware of that shadow side of his ministry his deanship looked like a re-centring of the Cathedral's priorities away from an outward-going and active involvement in the life of the City, towards a greater cultivation of relationships and life within the Cathedral's congregation. According to one colleague, he was fundamentally collegial in his relationships with colleagues, encouraging the practice of having lunch together once a week, which 'not only fostered the sense of the cathedral being a family but ... was also essential for good communication between the different departments'.[20] Against this must be set the view of another colleague, however, who felt he was 'a much less secure person [than Jowett] ... [he] wasn't able to allow things to happen as they would, but wanted to keep a tighter rein on things'.[21] He was a natural administrator, good at delegating and determined to bring the Cathedral's administration into the computer age. By his retirement in 1993 he had evidently done much to develop and enhance the Cathedral's own life, though it was arguable that he had, in contrast with Jowett, neglected its influence in the wider city, something accentuated by his own

16 Turner, private communication.
17 *Ibid.*
18 Radcliffe notes.
19 Turner, private communication.
20 Radcliffe notes.
21 Harris interview.

tendency to retreat into himself at times.[22] He was also deeply disappointed by the failure of an ambitious fundraising appeal. Manchester, unusually amongst English cathedrals, continued to maintain its own estates and investments, yet found itself continually hard-pressed financially. The appeal was not for money for restoration of the Cathedral fabric, however. Riding on the back of plans for city regeneration, Waddington announced a £2 million appeal to build an office block that would provide long-term income for the Cathedral, and also to build a new organ. The planned Gateway building was to cost £1.3 million, and the proceeds of leases would fund new developments (including a centre for the homeless), and also act as an emergency fund for any restoration requirements.[23] But the appeal was launched at a bad time for property development, and close to Waddington's retirement. As chapter heard in September 1993, it had attracted fewer than a hundred donors, and raised only £271,000, with appeal costs of some £126,000 to be deducted.[24] Moreover, the diocese had launched its own appeal at the same time, without consulting him; 'Waddington felt he had been undercut.'[25]

It fell to Waddington's successor, Kenneth Riley, who arrived towards the end of 1993, to see the Cathedral into a new millennium, and through one of the great modern events in Manchester's history, the IRA bomb of 1996. Riley's background was more varied ministerially than Waddington's, but he also had significant educational experience. After training at Wycliffe Hall in Oxford, much of his ministry had been spent in the neighbouring diocese of Liverpool, after a stint as chaplain to the theological college at Brasted in Kent, and then as senior chaplain at Oundle School. At Liverpool he had been appointed chaplain to the University, but while he was in post he had engineered a fusion of the incumbency of Mossley Hill with the chaplaincy team, and eventually had moved into the position, first, of canon treasurer at Liverpool Cathedral, and then of precentor. Experience in these two different cathedral roles must have proved particularly useful when he moved to Manchester as Dean at the end of 1993. But the change in scale was striking, he said: 'Everything in Liverpool Cathedral was on a huge scale – the move to Manchester was something of a shock. At Manchester I found that you could have eye to eye contact with most of the

22 Turner, private communication.
23 *The Times*, 28 December 1991.
24 MCA, Mancath/2/2/11, Chapter minutes, 7 September 1993; I should record here my gratitude to the Dean and chapter for permission to use chapter records.
25 Harris interview.

congregation – something quite impossible in Liverpool!'[26] Also striking was the contrast between the commanding position of the Cathedral in Liverpool, and that of Manchester. Riley found the Cathedral boxed in by taller buildings, and not really 'on the map': 'It looked as though the city had turned its back on the cathedral', with 1960s concrete development effectively cutting off the Cathedral from the city, along Deansgate. 'Lots of people drove past,' he added, 'without really seeing the cathedral', something that could not, of course, be said of Liverpool.[27]

Liverpool and Manchester, rival cities of the north-west, were strikingly different in their history, the one a great port, looking westwards to Ireland and North America, the other a great industrial and manufacturing city. Riley's experience in the one might not necessarily have translated into something useful in the other, but probably almost no one appointed from outside the diocese at that time could have had a broader knowledge of English cathedral life, for since 1991 he had been a member of the Cathedrals Commission appointed by Archbishop George Carey to investigate the governance of cathedrals, and in that capacity had visited many of the cathedrals himself, as well as seeing the reports on those visited by others. 'So I had a good idea of the cathedral world.' The relatively low church Riley, in contrast to his predecessor, was content to leave the pattern of Cathedral worship he had inherited largely untouched, although it was in his time that the Church of England phased out the Alternative Service Book of 1980 and brought into use Common Worship, from 2000 on. But in this, the Cathedral merely kept in step with the wider church. Riley's priorities lay elsewhere. He concluded that Manchester Cathedral needed to overcome its division from the city. Clearly what he meant by that primarily was a physical division, separating the medieval Cathedral from the dense, overbearing cityscape in which it was situated. Jowett, of course, had overcome the division in a different way, a predominantly personal one which followed from his close involvement in city politics and municipal life. Riley's approach was to be that of a builder, even though he did not see himself as such.[28]

Three projects in particular marked the changing life of the Cathedral in Riley's years. The first, and in a sense both the smallest and yet the one which most signalled the Cathedral's commitment to the needs of the city at large, was the Booth Centre, a drop-in facility offering advice and assistance for the

26 MCA, transcript of interview with Kenneth Riley, 10 July 2013.
27 Riley interview.
28 *Ibid.*

homeless, sited at the west end of the Cathedral, but with access from an external door punched through the medieval fabric, for which special permission was required from English Heritage. As noted above, Riley's predecessor had entertained the idea of a centre for the many homeless in Manchester, but nothing had come of it with the failure of the 1991 appeal. The Centre was created after Lifeshare, a charity working with the homeless in Manchester, found on its nightly soup-runs that many of its clients were asking for somewhere to go during the day for advice and help, and wrote to the Dean to see whether the Cathedral could make available any land for a temporary building.[29] Riley showed the charity the brass rubbing centre at the west end of the Cathedral, and it was eventually agreed to convert this into a permanent facility for the homeless. The Centre was named after the Booth Charities, an ancient family trust established particularly for the poor of Salford, which was prevailed upon to donate much of the £75,000 required to fit the room out, although help was also received from the Peter Kershaw Trust and Lifeshare.[30] It was opened in mid-1995 with a ceremony at which John Gormley, who had lived on the streets himself, was presented with the key to the door.[31] The Centre was in effect a partnership with Lifeshare, and Amanda Croome, its first manager, has described how it was eventually established, in 1997, as an independent trust operating out of part of the Cathedral's structure, a highly unusual arrangement in English cathedrals.[32] The 1980s and early 1990s had been a time of deepening crisis in housing, as council housing was wound down, the 'care in the community' programme forced the closure of large-scale mental health institutions, and high unemployment, especially in once-prosperous industrial areas such as the Manchester conurbation, meant that some people had fallen through the various welfare safety-nets that ought to have helped them to remain off the streets. The Booth Centre was thus a worthy addition to the Cathedral's activity, and to its ministry in the city. Its very success, as its range of activities expanded considerably through the late 1990s and into the new millennium, was likely to mean that its location at the Cathedral itself would prove short-lived, as plans were entertained nearly twenty years on from its opening

29 Cathedral Oral Histories, interview with Amanda Croome, undated but *c.* 2005.
30 Riley interview.
31 *Crux: The Monthly Magazine of the Diocese of Manchester*, June 1995.
32 Croome interview.

to move it to more extensive accommodation a short distance away.[33]

The second building project was ambitious, namely that of a new 'close' for the dean and the canons. Riley found the old Deanery in Bury New Road 'not a very satisfactory working Deanery at all', tucked away as it was in a little wood with little parking space.[34] But the sale of a large Victorian house owned by the chapter further up the same road and opposite the Bishop's house, and of the old Deanery, yielded land and cash for a major development. Booth-Clibborn Court, when finished in 1999, consisted of a Deanery, two canon's houses, and three staff houses. The staff houses were eventually let out for rent. The distance of two and a half miles from the Cathedral itself was regrettable but probably inevitable, given the crowded and commercial nature of the area around the Cathedral. Garth Turner considered that, in his time on the chapter, living some way out from the city centre inhibited full participation in the daily worship of the Cathedral.[35] This is one of the more obvious contrasts between the modern, 'industrial' or urban cathedrals, many of them ex-parish churches, and the historic medieval cathedrals where a collegiate, corporate life was in a sense easier to sustain, though bringing with it the risk of claustrophobia for residents of the close. Manchester was no Barchester, it goes without saying. Riley's scheme could not change that, but it certainly strengthened and overhauled the Cathedral's residential provision.

The third project, a new visitor centre, though relatively modest in itself, followed on from the devastation caused by the IRA bomb. There had actually been two earlier IRA bombs in Manchester, in 1992, one of which – in Cateaton Street – had been close enough to cause some damage to the Cathedral's glass.[36] But on 15 June 1996, in almost the last act of Irish Republican terrorism in Britain in the twentieth century, the IRA detonated a massive bomb from a van parked in the centre of Manchester, in Corporation Street, not far from the Cathedral. Warning was given and people evacuated, and no one was killed, though over two hundred were injured, mostly in a minor way. But the material damage the bomb – reputedly the largest ever exploded on mainland Britain in peacetime – caused was immense, covering much of the city centre and amounting to over £700 million in terms of rebuilding costs. The Cathedral hosted

33 'The Booth Centre secures a new Building', www.boothcentre.org, accessed 5 September 2013.
34 Riley interview.
35 Garth Turner, private communication.
36 MCA, Mancath/2/2/11, Chapter minutes, 15 December 1992.

a commemorative service one year on from the blast. As Riley said, remembering that dreadful day in the service order, 'some narrowly escaped death, many were injured, others lost their homes or their livelihoods and everyone was stunned by the sheer scale of the damage'.[37] The Cathedral was also damaged, and some thought this fortunate, from the point of view of a shared destruction and of the willingness of the city at large to recognize the needs of the Cathedral.[38] Cracks were made in the ceiling by the blast, and windows were shattered, including ironically the window in the Manchester Regiment's chapel commemorating the Blitz. The Dean reported to the *Guardian* that the roof had definitely lifted during the blast, as the lead had moved, and the windows in his own office were completely blown in.[39] Although extensive in its way, and estimated at around £250,000 in cost, the damage to the Cathedral fabric was relatively easily repaired. Of much more moment were the implications for the broader situation of the Cathedral. Hugh Pearman wrote in *The Sunday Times* of 'the eternal paradox of the bombed city [that] after the shock of the devastation and casualties comes the hope that out of terrible evil may come some good: there is an opportunity to build a better city'.[40]

Soon after his arrival, and two years before the bomb, Riley had asked an architect friend in Liverpool to draw up a speculative plan of what the setting of the Cathedral could look like, with an imaginative scheme of redevelopment around it. The drawings were 'openly displayed on top of [his] bookshelves' for important visitors, including the Lord Mayor, to see. But at that stage no one was really interested, because of the cost involved. The bomb changed all that, according to Riley: 'someone in the city said they knew what the Dean wanted, because they'd seen the plans ... All the building blocks in those plans came to pass, which was so unexpected.'[41] Riley again claimed, perhaps with irony, a certain providential opportunity in all this ('There is a saying that God sometimes allows us magnificent opportunities, brilliantly disguised as insoluble problems'), though he was not alone in that.[42] Riley's speculative plans certainly came in handy, though the truth is also that, by the mid-1990s, the

37 MCA, CW4/5, Churchwardens' Scrapbook, service order, 'Suddenly, one Saturday: An Ecumenical Service on the Anniversary of the Manchester Explosion'.
38 MCA, transcript of interview with Alan Wolstencroft, 4 September 2013.
39 'After the Horror, the Heartache', the *Guardian*, 4 July 1996.
40 'Shattered City can find a new Heart', *The Sunday Times*, 23 June 1996.
41 Riley interview.
42 'Suddenly, One Saturday'; Wolstencroft interview.

tide in municipal planning had long turned against large, severe concrete city-centre developments, and city planners were much more alert to the commercial and social opportunities of open spaces in city centres: much of the redevelopment of the centre of Manchester after the bomb was really down to changes in planning fashion.[43] Redevelopment of the city centre had already begun, much earlier in the 1990s, and well before the IRA bomb.[44] It was the city planners who decided to create a 'medieval quarter' around the Cathedral, moving some of Manchester's oldest buildings, including the Wellington pub, there in the process. But this gave Riley and the Chapter a chance to press for the council to take on the building of a new visitors' centre, after they conceded that derelict land owned by the Cathedral could be taken over by the council: 'we agreed to their plan, and they agreed to build our new Visitors Centre'.[45] As a result, as Albert Radcliffe acknowledged, what little remained of old Manchester 'sits now outside the cathedral, thanks to the Chapter'.[46] The chapter minutes tell a rather more complicated story than this apparently neat outcome might suggest, with prolonged and seemingly (to read between the lines) frustrated discussion about the way in which the Council's Millennium Committee initially raised alternative possibilities.[47]

There were other benefits too, after the bomb. Exactly a week later, the Cathedral hosted a commemorative service, to which the emergency services and some of the injured came. That, and the service held a year on, which was televised and followed by a 'robust interview' of Gerry Adams by Gloria Hunniford, helped to arouse public interest and draw the city into the Cathedral's orbit. Riley also sat on the Lord Mayor's committee examining cases of hardship (mostly business people whose business had been lost or damaged in the blast) and chaired public meetings at the Cathedral where people could vent their frustration at the seemingly slow pace of rebuilding. 'In these ways,' Riley has said, 'the cathedral has moved to the centre of the city's awareness.' The completion of the immediate environs of the Cathedral was celebrated in 1999 at a civic function in the new Marks and Spencer building. The visit of the Queen to Manchester in 2002 to mark the beginning of the Commonwealth Games was an

43 I am grateful to Dr N. Bullock for general background in this paragraph.

44 Ray King, *Detonation: Rebirth of a City* (Appleton: Clear Publications, 2006).

45 Riley interview.

46 Cathedral Oral Histories, interview with Albert Radcliffe, undated but *c.* 2005.

47 Chapter minutes, 19 May 1997.

opportunity for the Dean, through the Lord Lieutenant to whom he was Chaplain, to invite her to a service at the Cathedral too, 'rounding off the whole bomb thing'.[48] Over a thousand people were present at what was in effect an ecumenical service celebrating the 'miracle of Manchester', with both the Anglican Bishop of Manchester and the Catholic Bishop of Salford speaking, and with the Queen presenting an original copy of the first 1996 plan for the city's rebuilding to the Cathedral archives.[49]

As explained earlier, the risk of shaping a narrative around the succession of deans is that it may appear to overemphasize individual agency, rather than collective or collegiate responsibility. It is hard to gauge to what extent this would be true of Riley's deanship. Clearly, he was not solely responsible for the building developments of these years, nor for the Cathedral's response to the 1996 bomb. Albert Radcliffe, canon pastor from 1991 to 2000, later felt that there had been a shift in his time away from the collegial model he experienced when he first joined the chapter, and that some of the checks and balances of the Church of England at that time, when bishops were a little more distant and the relationship of the dean to the canons was one of *primus inter pares*, had disappeared.[50] Alan Wolstencroft, Archdeacon of Manchester from 1998 to 2004 and residentiary canon, concurred, sensing that Jowett was the last Dean of Manchester to act 'truly collegially'. Yet one of the most controversial episodes of Riley's time at Manchester was a decision that did not directly concern him. This was the withdrawal of permission for the Lesbian and Gay Christian Movement (LGCM) to hold a service at the Cathedral at the end of a conference in 2003. LGCM had invited Bishop Gene Robinson, the openly gay Bishop of New Hampshire whose consecration had triggered division and conflict in the Anglican Communion, to preach. Riley was away on sabbatical, and in his absence, and under some pressure from the Bishop, despite the service having been booked for many months, the chapter was obliged to withdraw permission.[51] Inevitably this was roundly criticized in some newspapers, the *Guardian*, for example, running a report under the headline 'Manchester Cathedral Drops Gay Service'.[52] But issues such as this merely reflected the rapidly changing context in which the Cathedral found itself, and what, on a wider scale, was fast becoming perhaps the most divisive period in the history of Anglicanism.

48 Riley interview.
49 *MEN*, 25 July 2002.
50 Radcliffe interview.
51 Wolstencroft interview.
52 The *Guardian*, 5 September 2003.

When Riley retired in 2005, the achievements of his period of office were not to be measured by matters that essentially were of passing controversy, but by the remarkable change in the Cathedral's situation, despite the shock of the 1996 bomb.

Riley was replaced by Rogers Govender, who took up the deanship early in 2006. An assessment of his tenure of the position lies strictly beyond the scope of this chapter, since it was incomplete at time of writing. But his appointment marked something of a change of direction from that of his predecessor. Partly this was because of his very different background and experience: born in South Africa of Hindu parents, and ordained there, he had come to England as recently as 2001, taking up an incumbency in Didsbury, and then becoming Area Dean, before moving to the Cathedral five years later. The celebration of diversity, and the promotion of community unity and social and racial justice, have been central to his ministry, both in South Africa and in Manchester, and he has made them priorities of his office. As he said later to the *Asian Express*, 'I'm interested in people living in peace; people learning about each other, people appreciating diversity and variety ... I'm interested in celebrating differences and in stopping people seeing differences as obstacles.'[53] Yet, like his predecessor, Govender also saw the vital importance of protecting the Cathedral itself, and promoting its value as a symbolic centre for the city. He committed the Cathedral to a phased renewal of its building, which included a complete overhaul of the underfloor heating system in 2013, necessitating the closure of the building for almost a year, and the erection of a temporary

Rogers Govender,
Dean 2006–present

[53] The *Asian Express*, 16 August 2016.

structure for services on Victoria Street.[54] It also involved the installation of a new organ, with sponsorship from the Stoller Charitable Trust, at a cost of over £2.5 million; built by Tickells, and finally completed in early 2017, the new instrument returned the Cathedral's organ to its original, pre-war position on the screen.[55] Future scheduled work included restoration of the tower. Govender's deanship thus promised both continuity with his predecessors, and a significant shift in the Cathedral's public profile.

Finance and governance

A cathedral is a complex community, made up of many different groups of staff carrying out many different activities, and its governance and financial administration are also complex accordingly. Whilst Manchester Cathedral is, in comparison with the giants of York, Lincoln, and Canterbury, a relatively small building, its prominence as the chief surviving medieval building in Manchester and its civic role nevertheless mean that its late-twentieth century history has been no less subject to change in these areas than its larger rivals. As Michael Sadgrove has commented, 'the evolution of parish church cathedrals since the nineteenth century has been hesitant, muddled and beset by unclear aims and considerable self-doubt'.[56] Sadgrove may have been particularly influenced by his experience on the chapter at Sheffield where, until cathedral reform in the late 1990s, the Cathedral came to be governed by two separate but parallel councils, a cathedral council and a parish church council. Manchester Cathedral is sometimes included amongst the parish church cathedrals, and sometimes not. Unlike many of the newer cathedral establishments, such as those at Leicester, Bradford, and Blackburn, it had a dean rather than a provost from the beginning, and whilst holding on to its geographical parish, its constitution precluded the creation of a parish church council. A voluntary Cathedral Community Committee met throughout this period, however, acting as a conduit for the congregation's concerns, and reporting to the chapter.

54 Ecclesiastical and Heritage World, 'Green Heating System is Centrepiece of Cathedral Restoration', www.ecclesiasticalandheritageworld.co.uk/news/585-green-heating-system-is-centrepiece-of-cathedral-restoration, accessed July 2017.

55 See www.manchestercathedral.org/music/the-organ, accessed July 2017.

56 Michael Sadgrove, 'Cathedrals and Urban Life', in Stephen Platten and Christopher Lewis (eds), *Dreaming Spires? Cathedrals in a New Age* (London: SPCK, 2006), p. 95.

Inevitably one of the greatest burdens of cathedral chapters is their responsibility for cathedral fabric. The cost of maintaining these ancient historic buildings is immense, and demands much hard work. The changing legislative climate as it has affected 'heritage' and conservation has played its part, too. Until the reforms of the nineteenth century, cathedral chapters could at least draw on their own historic resources to fund and maintain their buildings, although stories of neglect are many in the eighteenth and early nineteenth centuries.[57] Though a medieval building, Manchester's relatively small size and the chapter's retention of extensive estates perhaps gave it a measure of security, but it too suffered increasingly, as all cathedrals did, during the late nineteenth and twentieth centuries, as revenue dwindled. The sheer prominence of these buildings, however, as well as the role they played in attracting tourism, meant that in time there was broad consensus in favour of moving towards some public subsidy of fabric works. Under the Care of Cathedrals Measure, passed in 1990, in return for qualifying for the first time for possible government funding for fabric restoration, cathedral chapters ceded some control over programmes of maintenance and restoration. A national Cathedrals Fabric Commission was established to oversee works and manage applications for public 'heritage' funding, and each cathedral was required to establish a Fabric Advisory Committee. Over the next twenty years, Manchester was to receive advice on restoration of the organ, the position of the *pulpitum*, the treatment of medieval human remains discovered in 2005 in the area of the Hanging Bridge, and on extensive works planned in the new millennium for the Cathedral precinct, for internal reordering, and for underfloor heating.[58] But formal state aid was to wait many years, coming only for the first time in 2009 with the award of £120,000 to reroof the south aisle.[59]

Much more significant, though perhaps invisible to many 'on the ground', was the introduction of the Cathedrals Measure in 1999, which overhauled the governance of the Church of England's cathedrals with the intention of achieving greater efficiency and accountability. Manchester was not involved in the two controversies which prompted the creation of the

57 Cf. Philip Barrett, *Barchester: English Cathedral Life in the Nineteenth Century* (London: SPCK, 1993), p. 231: 'Many English cathedral fabrics were in a deplorable condition in the early nineteenth century.'
58 I am indebted to Anne Locke of the Cathedrals Fabric Commission for England for this information.
59 I am indebted to John Prichard, Manchester Cathedral's architect, for this information.

Archbishops' Commission on Cathedrals in 1991 – that over Hereford Cathedral's abortive attempt to sell the Mappa Mundi, and the bitter infighting in Lincoln Cathedral's chapter after the appointment of Brandon Jackson as Dean in 1989 and the botched tour of Australia with its copy of Magna Carta – but Ken Riley was a member of the Commission, and an enthusiastic advocate of its proposals embodied in the report *Heritage and Renewal* (1994).[60] The Commission came into being against a background of intensifying concern for accountability and effective management in the church. Not only were the cathedrals under scrutiny, but the disastrous asset management of the Church Commmissioners during the financial crash of the early 1990s was to trigger another Commission on the direction and oversight of the Church of England's affairs, leading to the establishment of the Archbishops' Council in 1999. As Garth Turner has observed, 'Evaluation, openness, accountability, transparency, became vogue-words. Chapters, reluctant to publish their accounts and secretive, were dissenters; their procedures exposed them to danger.'[61]

The Cathedrals Commission did its work from 1992 to 1994. Views submitted were varied. The Bishop of Manchester, Christopher Mayfield, new in post, affirmed the importance of a 'healthy degree of independence' for cathedrals, and valued the chapter's support for his ministry; others were much more critical.[62] *Heritage and Renewal* attempted to examine and sharpen or redefine the functions of a cathedral, drawing attention to the way in which its primary role as the mother church of the diocese, and 'seat' of the bishop, had often been undermined in the past by fierce defence of a chapter's autonomy, by a disregard sometimes of wider diocesan needs, and by a tendency to regard cathedral office not so much as a reward system, but as another dimension of the local church's service of the community. It acknowledged that independence was important, but asserted a 'practical rather than an ideological independence', for there should be no sense in which 'those who serve in cathedrals enjoy an independence against the authority structure of the Church in general', since there is a single church, in which 'a measure of independent action may need to be secured for some of its

60 See, for example, Kenneth Riley, '1997 and all that!', *Manchester Cathedral News*, January 1997.

61 Garth Turner, 'Cathedrals and Change in the Twentieth Century: Aspects of the Life of the Cathedrals of the Church of England with Special Reference to the Cathedral Commissions of 1927; 1958; 1992' (PhD thesis, Manchester University, 2011), p. 62.

62 *Ibid.*, pp. 66–7.

institutions in order that they may have practical means of ful-filling specified functions'.[63] Cathedrals and their communities of clergy and other workers were fully part 'of an integrated Christian presence in English society', and their work therefore – from the perspective of the church as a whole – should be 'accountable and efficient'.[64] To that end, the Report proposed mechanisms by which the wider community of the diocese could have representation in a cathedral's governance, and therefore by which the work of the cathedral could be subject to closer scrutiny by the church at large. The main provisions of the meas-ure that issued from adoption of the Report by General Synod included the appointment of lay members of the chapter, the cre-ation of a Cathedral Council to include representatives from the diocese and wider community, and a constitutional framework covering the relationship between these bodies; the inclusion of all cathedrals essentially forced a uniform structure of govern-ance on them, and in the newer cathedrals the office of provost disappeared, to be replaced by that of dean. Turner's judgement is harsh: 'The blaze of the bonfire of history and tradition was fanned by the watchword "accountability".'[65]

In the case of Manchester, these proposals took some time to implement. Membership of the chapter was expanded to include four lay canons, appointed for various specialist skills and expe-rience to strengthen the Cathedral's business and administrative practice. A Council for Manchester Cathedral was indeed cre-ated, but not until 2008, under Riley's successor, Rogers Goven-der. It was composed of lay and ordained members, and its task, according to the revised statutes, was 'to further and support the work of the cathedral in its spiritual, pastoral, evangelistic, social and ecumenical work', to which end it was 'required to advise upon the direction and oversight of this work by the Chapter'.[66]

Broader changes were also afoot with regard to finance. The parlous state of most cathedrals' finances had been noted long before. The report of the Cathedrals Commission of 1958, for example, had highlighted the financial crisis the Commissioners had uncovered, denuded as the cathedrals had been by nine-teenth-century transfer of most of their assets to the Ecclesiastical Commission.[67] Manchester, unusually, had held on to many of

63 *Heritage and Renewal. The Report of the Archbishops' Commission on Cathedrals* (London: Church House Publishing, 1994), p. 7.
64 *Ibid.*, p. 15.
65 Turner, 'Cathedrals and Change', p. 92.
66 Manchester Cathedral, www.manchestercathedral.org/community/chap-ter-council-community, accessed 6 February 2014.
67 Turner, 'Cathedrals and Change', p. 38.

its significant estates, especially those at Newton and Kirkman-shulme.[68] These and other investments continued to supply the bulk of the Cathedral's financial needs, although by the late twentieth century they had long ceased to cover all activities. Tourism was no answer. The tables covering sources of cathedral visitor income in 1992 in *Heritage and Renewal* make sobering reading in relation to Manchester: just £3,000 of shop and refectory income (this was before the opening of the Visitor Centre), a net loss of £1,000 overall from visitors, and just £265 gross revenue from the sale of guide books.[69] Manchester could improve somewhat its visitor experience (and the opening of the Visitor Centre of course was crucial here) but it was never going to be able to see the resulting income as more than a small part of the needed sums. Thus, efficient management of the chapter estates and investments remained an important element of long-term financial security. By 2008, over £800,000 of the Cathedral's total income of £1,113,000 came from that source.[70] Into the 2010s, this remained the picture.

But another asset available to the chapter was of course the building itself. In the 1990s and 2000s the chapter moved reluctantly, but with gathering pace, to open up the building and market it for conferences, concerts, and banquets. This was far from uncontroversial, and there were always risks inherent in it. John Baker, the Bishop of Salisbury, had warned his cathedral chapter in 1991 that the temptation was to see a cathedral's 'cultural drawing power as a major means of financing its work', and yet as soon as that happened 'the need for money begins to control decision-making and to determine priorities'.[71] But, as Turner observed, drawing on his own experience of Manchester, there was something 'austere and unworldly, even unrealistic' about such views, for without money cathedrals cannot function, and the constant preoccupation with balancing budgets under pressure can itself be sapping.[72] Manchester's willingness to use its building creatively strengthened its financial position, and arguably brought a different kind of constituency into the building. In 2012 alone, the total raised by income-generating events

68 Michael Hennell, *The Deans and Canons of Manchester Cathedral, 1840–1948* (Manchester: Manchester Cathedral, 1988), p. 6.
69 *Heritage and Renewal*, pp. 228, 231.
70 MCA, Manchester Cathedral, Annual Report and Financial Statements for the year ended 31 December 2008.
71 Turner, 'Cathedrals and Change', p. 52.
72 *Ibid.*

was over £136,000.[73] Govender was quoted in the *Manchester Evening News* as saying that these events had effectively helped the Cathedral to turn its finances round: 'We have always survived hand to mouth, now we have some surplus funds ... these events are ways of raising maximum income.'[74] The same article pointed out that the Cathedral did not charge an entry fee, but needed over £1 million a year to cover its costs. Recent acts had included Sinead O'Connor, Aled Jones, Jethro Tull, and Marina and The Diamonds.

The Cathedral's life and worship

There is a common view that the second half of the twentieth century saw a profound change in the life of cathedrals in Britain, so that they ceased to be ecclesiastical backwaters and became much more active and central to the mission and ministry of the dioceses they purported to serve.[75] This hardly seems fair to the spirit of the reforming deans of the nineteenth and early twentieth centuries. But there is evidence certainly of new challenges faced in the late twentieth century, and of institutional responses, as indicated in the previous section. Trevor Beeson's diary of his deanship of Winchester charts the twin pressures of financial difficulty (exacerbated in the 1980s and early 1990s by inflation) and the growing impact of mass tourism.[76] In the same decade that Winchester brought forward plans for a new visitor centre, Manchester was doing the same, and many other cathedrals likewise. Platten and Lewis are tempted to see the growth of visitor interest in cathedrals as a significant shift in patterns of popular piety, especially taking into account the perceptible growth in cathedral congregations across the country: arguably, they suggest, cathedral attendance suits those 'who feel an allegiance to the Christian faith, but who are wary of too much commitment', for, as they point out, parish churches can make heavy demands of worshippers, whereas cathedrals allow

73 Manchester Cathedral, Annual General Meeting report, www.manchestercathedral.org/upload/userfiles/file/FINAL%20Annual%20General%20Meeting%20and%20Easter%20Vestry%20Meeting%202015%20jo.pdf, accessed July 2017.

74 *MEN*, 19 April 2012.

75 See in particular Platten and Lewis (eds), *Dreaming Spires?*, pp. 1–2, drawing in particular on Trevor Beeson's views in *The Deans* (London: SCM, 2004).

76 Trevor Beeson, *A Dean's Diary: Winchester 1987–1996* (London: SCM, 1997).

for a 'far looser connection'.[77] In suggesting this, inevitably they have in mind Grace Davie's 'believing without belonging' thesis, namely the suggestion that, in Europe particularly, contemporary religiosity is characterized by a persistence of belief along with a widespread suspicion of institutional commitment.[78]

There was certainly evidence to support this thesis at Manchester Cathedral in this period. In addition to the usual weekly round of services, by the 1980s it was hosting an impressive number of additional or special services for community organizations, charities, and individuals. Organization of these services, and their staffing, was a significant commitment for the chapter. In 1984 alone, for example, right at the beginning of Robert Waddington's deanship, the scrapbook of services in the archives suggest there were at least twenty-six additional services, most of them drawing considerable numbers of people. They included memorial services, civic services, services for schools, and services for organizations such as the Mother's Union, the Manchester Festival, the Far East Prisoners of War Association, the British Medical Association, and the Army Cadets.[79] A major feature on the Cathedral's celebration of Easter in the *Guardian* two years later contrasted the liveliness of the Cathedral's life and ministry with the decline in churchgoing apparent elsewhere. Suggesting that Easter that year was 'probably the most profane England has known', still the Cathedral was one of the places where 'the Easter hymns and prayers seem set to sound above the cash registers' rattle for a long time to come'.[80] For such a promisingly optimistic theme, much of the article in fact concentrated on the apparent paucity of congregations at the Easter services, noting that the very impressiveness of the architecture reduced a congregation of a hundred to 'something very sparse and meagre indeed'. It did not seem to have occurred to the journalist concerned that the sense of being overwhelmed by a sacred space that this apparent paucity engendered might have been precisely the goal of the medieval builders. The article missed the key point that the Cathedral's local significance was not registered in terms of Easter numbers alone, but in terms of outreach, and in this it was to demonstrate convincingly its service of the wider community in the following decades. In 2015, the main Easter Sunday service attracted a congregation of over 400, with over 220 communicants; but this was part of

77 Platten and Lewis (eds), *Dreaming Spires?*, pp. 6–7.
78 See Grace Davie, *Religion in Britain since 1945: Believing without Belonging* (Oxford: Blackwell, 1994).
79 MCA, CW 4/6, Churchwardens' Scrapbook.
80 H. Whewell, 'Acts of Good Faith', the *Guardian*, 31 March 1986.

an intense cycle of Holy Week and Easter services which brought in many other hundreds of attenders, including an Easter Vigil with Confirmation when 239 attended.[81] But again it was the special services, sometimes occasioned by tragic local events, that really registered the community reach of the Cathedral. One example that made international news was the memorial service for the footballer George Best in March 2006.[82] When two women police officers were murdered in Mottram, Greater Manchester, in 2012, for example, the funerals took place at the Cathedral, packed the main body of the Cathedral itself, and attracted crowds of thousands in the streets around it.[83] Again, in 2017, after the suicide bombing at a concert in Manchester Arena in which 23 people were killed and 139 injured, it was the Cathedral that hosted the funerals of many of the victims, and which became a focus of grief in the days after the bombing and of commemoration on the anniversary of the attack.[84] Given the extraordinary resonance the Cathedral had come to acquire over the previous decades as a site of special significance in the city for the marking of particular moments of commemoration, mourning, and celebration, it was perhaps apposite that the first ever national conference for cathedrals, bringing together clerical and lay staff from cathedrals across England, took place at Manchester Cathedral in September 2018, under the title 'Sacred Space: Common Ground'.[85]

Manchester Cathedral has thus certainly shared in the general trend, noted by many commentators, for people to turn to churches as identifiably 'public' or community spaces in which they can recognize, with Philip Larkin, that they are standing in a 'serious house on serious earth'.[86] This is particularly true of occasions of trauma, grief, and loss. Books of condolences increasingly through the 1990s and 2000s proved an immensely popular way for people to register their respect and sense of connection with those who have lost loved ones, and the Cathedral certainly shared in this practice. The Asian tsunami of December 2004, which probably killed over 200,000 people, was recog-

81 MCA, Register of services, 29 May 2014 to 17 September 2015.

82 *MEN*, 13 March 2006, www.manchestereveningnews.co.uk/news/greater-manchester-news/a-service-of-farewell-to-the-best-1023424, accessed 29 November 2018.

83 *Daily Post*, 16 October 2012.

84 'Manchester Arena Attacking: Thousands to mark Anniversary', the *Guardian*, 22 May 2018.

85 Manchester Cathedral, www.manchestercathedral.org/news/571/national-cathedrals-conference-sacred-spaces, accessed 29 November 2018.

86 Philip Larkin, 'Churchgoing', *Collected Poems* (London: Faber & Faber, 1988), p. 97.

nized this way, for example.[87] Three and a half years earlier, a memorial service had been held for those who had lost their lives in the terrorist attacks in America on 11 September 2001, drawing civic leaders from across Manchester.[88]

One of the 'growth' areas of cathedral work in the late twentieth century was education. As already noted, this was a priority of Waddington's tenure as Dean. But significant development occurred afterwards, with the growing impact of changes in the national curriculum which encouraged greater interaction between schools and local historical sites. The retirement of a residentiary canon in 2000 enabled Ken Riley to appoint the Cathedral's first lay education officer to work with local schools.[89] Mid-week visits by school groups, and others, became a regular feature of the Cathedral's life. A study of the economic and social impact of cathedrals commissioned jointly by English Heritage and the Association of English Cathedrals found that, by 2004, educational visits alone to cathedrals had reached well over 360,000 – a figure which was probably a significant underestimate.[90] Manchester Cathedral's Education Department continued to thrive into the 2010s, welcoming over 3,500 pupils a year, through a variety of projects. As the 2015 report noted, for many pupils 'this is maybe the first time [they] have stepped inside a place of worship'; there was a missional dimension too, in other words.[91]

The Cathedral also continued its well-established tradition – shared of course with other cathedrals and the 'greater' churches – of acting as a patron of the arts. When asked by the 'English Cathedrals and the Visual Arts' project run by Tom Devonshire-Jones and Graham Howes in 2003 about its motivation for commissioning art, the anonymous respondent replied on behalf of the chapter, 'A closer walk with God to the chippy! Transcendence come to Manchester in the Chapel of "the people's building".' However the same respondent replied, laconically, 'Rarely discussed' to the question 'How seriously does your Chapter take the relationship between religion, artworks, beliefs and experience in your own public space; among (a) congregation and (b)

87 *Crux*, February 2005.
88 *This is Lancashire*, 23 January 2002.
89 *Crux*, April 2005.
90 ECOTEC, *The Economic and Social Impact of Cathedrals in England* (2004), p. 48, www.nerip.com/download.aspx?id=466, accessed June 2015.
91 Manchester Cathedral, Annual General Meeting 2015 report.

visitors?'[92] That may reflect merely the inevitable jostling of other issues for a busy chapter's attention, rather than a positive lack of interest; certainly in terms of activity this was not a lean period for the Cathedral's relationship with the arts.

In the Cathedral itself, the chief illustration of this commitment to art was a sequence of stained-glass windows, including five commissioned from the artist Antony Hollaway under Waddington and then Riley, and then a triptych commissioned from the painter Mark Cazalet. The 'Creation' window, dedicated in June 1991, and the 'Revelation' window, dedicated in November 1995, completed the sequence of five west windows Hollaway began in 1973 with the St George window. As Hollaway's *Guardian* obituarist put it, 'This series is a remarkable, sustained achievement. Their world of colour and form goes beyond abstraction to describe, in some purely ineffable way, the spiritual life.'[93] The 'Healing' window, installed at the east end of the south quire aisle in 2004 and designed by Linda Walton, commemorated the restoration of the Cathedral and city after the IRA bomb. The most recent window, at the east end of the north quire aisle (and therefore near to Margaret Traherne's 1966 'Fire' window at the east end of the Manchester Regiment chapel) on the theme of 'Hope' was unveiled in October 2016; designed by Alan Davis, its images of hope included a bee, which was fast becoming a symbol of the Cathedral after the establishment of several bee hives on the roof in 2012, just as it was a symbol of industriousness for the city as a whole.[94] The Cazalet triptych was commissioned as an altar-piece for the Fraser chapel, refurbished in order to provide a place of quiet prayer for visitors, and depicts St George and St Denys on the outer panels, with the central panel – apparently an image of the Holy Trinity – a young man and young woman seated at a table, eating fish and chips, with an old man looking on.[95] In startling, light, bright colours, and a profusion of curves reminiscent in some ways of the work of Stanley Spencer, the triptych is in the shape of a dressing-table mirror, though its form is for all that traditional. Christopher Howse implied that the Trinitarian image echoed that of Andrei Rublev's famous icon of the Trinity, though he protested about

92 Questionnaire in private possession of the author; I am grateful to the late Graham Howes for giving this to me.

93 Keith New, 'Tony Hollaway', the *Guardian*, 13 September 2000.

94 See www.manchestercathedral.org/news/148/bees-in-the-belfry, accessed July 2018; I am grateful to Dympna Gould for pointing out this connection to me.

95 Alan Wolstencroft, 'Prayer First – the Fraser Chapel', *Manchester Cathedral News*, January 2002.

the use of a woman as potentially misleading in terms of the traditional iconography: 'the relations within the Trinity have been likened in Christian formularies to begetting and being begotten, rather than to giving birth and being born'.[96] Cazalet's work has had impact in other ways too, though: the portrayal of Jesus as black was deliberately copied nearly ten years later by the Cathedral authorities in the making of the fifteen-foot high processional giants of St George and the Dragon, attracting notoriety and opposition from, amongst others, the English Defence League.[97]

The Cathedral's commitment to sustaining the choral tradition, pursued in close association with Chetham's School of Music, remained a priority. In addition to the regular choral establishment, committed to singing choral evensong most days of the week, and including around twenty boys and girls and nine lay clerks, throughout this period there was also a voluntary choir, drawn from enthusiastic local people, which helped to cover those occasions when the regular choir did not sing. Other ensembles at various times also performed regularly in the Cathedral, including a cantata choir. The cost of maintaining the

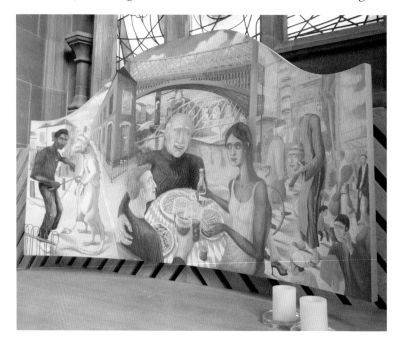

Mark Cazalet
triptych

96 Christopher Howse, 'Sacred Mysteries', the *Daily Telegraph*, 4 May 2002.
97 See www.manchestercathedral.org/news/53/the-giants, accessed 14 June 2013.

Antony Hollaway,
Creation window
with font

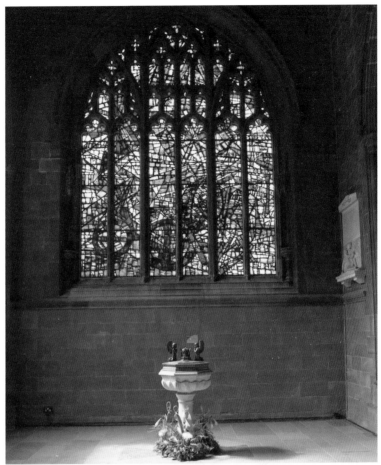

Antony Hollaway,
Creation window

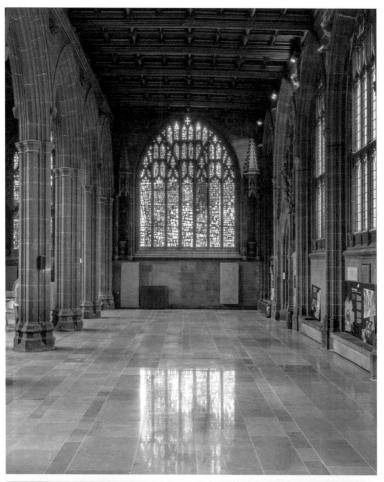

Antony Hollaway,
Revelation window

Antony Hollaway,
Revelation window

Facing page:
Antony Hollaway, St
George window

Above:
Antony Hollaway, St
Mary window

Facing page:
Antony Hollaway, St
Denys window

+ THIS INSCRIPTION CELEBRATES 25 YEARS OF THE JUMELAGE
BETWEEN THIS CATHEDRAL & THE BASILICA OF St SERNIN TOULOUSE 1994

musical establishment was considerable, with school fees to be paid at Chetham's, organists' salaries, and maintenance of the organ and of the music library. The total varied from year to year, but almost invariably represented the single greatest element of routine annual expenditure; in 2001, for example, the combined figure for 'Services and music' was over £180,000, nearly all of which would have been on music.[98] Seven years earlier, the decision had been taken to add girl choristers to sing alongside the boys in the main choir, albeit at first in limited numbers.[99] Manchester was not the first English cathedral to have girl choristers, but this was a forward-looking decision nonetheless, and it was unusual in that the girls were included into what became a fully mixed choir, rather than being formed into a parallel girls' choir.

That particular decision was of course a reflection of wider changes in the Church. With the opening of the diaconate to women in 1987, and then the priesthood in 1992, the possibility of having a woman on the chapter was raised. This did not actually happen until 2005, close to the end of Riley's term of office, when Anne Hollinghurst was appointed as Bishop's chaplain and residentiary canon. But it set a precedent. By 2015, there were three female members of chapter out of eight, though two were lay canons. Anne Hollinghurst had by then moved on herself, first to an incumbency in St Albans, and then to become one of the Church of England's first women bishops, as Suffragan Bishop of Aston.

Conclusion: the Cathedral and the city

Unlike many of the great medieval cathedrals of England, Manchester had always lacked a close and a surrounding close wall to cut it off from the wider community. Gates were simply not there to shut people out. Yet, like many other cathedrals and 'great churches' it had had to cultivate its own devotional practice, and its responsibility to the diocese: in the past this had set it apart from the religious life of the very mixed city – with substantial Dissenting and Catholic congregations – in which it was set, something which became even more complex in the late twentieth century with the rise of significant Muslim, Hindu, and other faith communities. Here the predicament of a cathedral placed at the very heart of a modern industrial city was particularly relevant. The intense and productive relationship Alfred Jowett

98 MCA, Annual Report and Financial Statements, year ended 31 December 2001.
99 *The Times*, 14 September 1994.

had built up with the city, and especially with the city authorities, may have given both him and the Cathedral a high profile in Manchester itself, but to a considerable extent it flew in the face of the churchwide pressures on cathedrals throughout the twentieth century to become much more consciously and directly the central focus of a whole diocese. The commissions of 1927 and 1958 had clearly emphasized the diocesan role over that of more local visibility. This view had been starkly pinpointed early in the century by F. S. M. Bennett, Dean of Chester: 'A cathedral is not merely a parish church on a huge scale. It is the Family House of God of a diocese, which is quite a different thing ... A cathedral must keep itself diocesan. It will always be tempted to become too parochial in its city and its city will always love to have it so.'[100] Grace Davie also noted these tensions: cathedrals are frequented by 'regular and irregular worshippers, pilgrims, visitors and tourists, bearing in mind that the lines between these groups are frequently blurred'.[101] But this is consistent, she said, with the experience of Europe generally, with a declining capacity on the part of the historic churches to 'discipline the religious thinking of large sections of the population' and a simultaneous widening range of religious choice, primarily due to patterns of migration and immigration.[102] This, as John Inge has pointed out, raises further difficulties for cathedrals when they try to engage with the wider culture:

> There is a big question here about what cathedrals can do to engage with a greater proportion of the population. They are in a double bind not that dissimilar to the BBC. If they change what they offer in seeking to broaden their appeal, they will be accused of 'dumbing down'. If they remain as they are they will be berated for catering only for a small elite.[103]

Yet it was precisely the challenge of Manchester's city context nonetheless to attempt to ride these tensions creatively, and to strengthen the Cathedral's outreach in the wider community at the same time as continuing to act as a resource for the whole diocese.

This could be done in different ways. One was that of theological reflection on the Cathedral's own context. If Waddington, at

100 F. S. M. Bennett, *The Nature of a Cathedral* (Chester: Phillipson & Golder, 1925), quoted in Sadgrove, 'Cathedrals and Urban Life', p. 85.
101 Grace Davie, 'A Post-script', in Platten and Lewis (eds), *Dreaming Spires?*, p. 148.
102 *Ibid.*, p. 145.
103 John Inge, 'Cathedrals, Outreach and Education', in Platten and Lewis (eds), *Dreaming Spires?*, p. 35.

least in some respects and despite his abusive behaviour, helped to strengthen briefly the relationship between the Cathedral and the city's schools, nevertheless one of the most abiding educational dimensions of the Cathedral's work into the early twenty-first century remained its relationship with the Religions and Theology Department of Manchester University. This was a large and strong department, which had thrived through the period when, nationally, Christian Theology, at least in its traditional modes, was shrinking as an academic subject. The links were many, but they were especially concentrated in the person of two of the Cathedral's canon theologians, namely in this period John Atherton and his successor Andrew Shanks. Both contributed substantially to the life of the University, researched, and published extensively. Atherton is particularly interesting in this regard, because his exploration of social theology traced a course of development that put at the centre, and also reflected, the changing fortunes of the city itself. He stood very much in continuity with the tradition of Anglican social theology represented by his predecessor, Ronald Preston. Strongly influenced by William Temple, according to one colleague Preston 'was a theological and political realist who had no time for solutions that were not grounded in hard economic and historical reality'.[104]

The same can be said for Atherton too. One of his early books, *The Scandal of Poverty* (1983), contained a strong vein of criticism of the Thatcher Government's policies on welfare and public spending.[105] In taking this stance, he was well aware of the deepening social and economic malaise of the north-west, noting, for example, that labourers were now chasing jobs there at the rate of 679 unemployed for every one job available.[106] Atherton was not one of the authors of the *Faith in the City* report (1985), but he was Director of the William Temple Foundation, which acted as a resource for the Archbishop's Commission, and his views were very much consonant with the report. His own *Faith in the Nation* (1988) reflected a growing unease at the conventional models of political action and analysis, and in particular an awareness of deindustrialization, a process which was particularly afflicting Manchester and its environs.[107] *Christianity and the Market* (1992) went a step further, absorbing the

104 Albert Radcliffe, 'Ronald Haydn Preston 1913–2001', *Manchester Cathedral News*, January 2002.

105 John Atherton, *The Scandal of Poverty: Priorities for the Emerging Church* (London: Mowbray, 1983).

106 *Ibid.*, p. 66.

107 John Atherton, *Faith in the Nation: A Christian Vision for Britain* (London: SPCK, 1988).

lessons of the collapse of Communism in Eastern Europe and the Soviet Union, and recognizing the potential of the market to deliver social benefits – 'the market economy now occupies the high ground for Christian social thought in facing the contemporary context' – in a move which he admitted looked like a change of mind.[108] This was not a change of ideals, he said, but rather a response to 'developments in the modern context'.[109] By this time, Manchester's transformation into the clubbing and consumer capital of the north-west was under way, with new, small-scale enterprises beginning to take up some of the slack of long-term unemployment. In effect, Atherton recognized that Christians must come to terms with the persistence of the market economy, an argument carried further in later works such as *Marginalization* (2003).[110] In trying to chart a way in which Christians could continue to stand up for the poor and marginalized, and at the same time make the best use of the opportunities for the common good the market economy presented, Atherton was in a sense doing no more, nor no less, than making sense of the experience of Manchester the city in his own time at the Cathedral. His successor, Andrew Shanks, carried on that tradition, although focused more specifically on the nature of theology as a civil and public discourse.[111]

Another direction of engagement was that of race and interfaith relations. Like some other northern and Midlands cathedrals at the end of the twentieth century, Manchester began to make a name for itself as a focus of discussion and reflection, and of worship and action, on the relationship between different ethnic and faith groups in the city. Though no one could accuse him of being a one-issue dean, nevertheless the appointment of Govender in 2006 perhaps inevitably lent an especial impetus to this work. Certainly, he was not afraid to take up potentially controversial or unpopular positions on matters of political conscience. In late 2007, for example, the Cathedral aligned itself with other city centre churches in criticizing the government's policies towards asylum seekers.[112] In Govender's years of office would come the picketing of the Cathedral by the ultra-right British National Party in 2009, prompting him to confront the BNP outside the Cathedral and reject their language

108 John Atherton, *Christianity and the Market: Christian Social Thought for our Times* (London: SPCK, 1992), p. 263.
109 *Ibid.*, p. 264.
110 John Atherton, *Marginalization* (London: SCM, 2003).
111 See, for example, Andrew Shanks, *The Other Calling: Theology, Intellectual Vocation and Truth* (Oxford: Blackwell, 2007).
112 *Bolton News*, 1 January 2008.

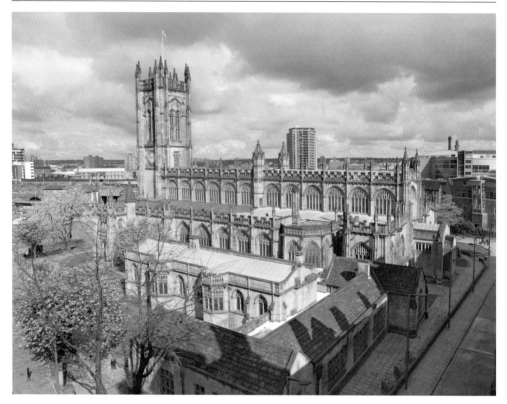

Manchester
Cathedral front

of intolerance; as he said, 'We are proud to be part of the Hope
Not Hate campaign; we reject the teachings of the BNP and
believe Jesus would reject the BNP as well.'[113] Further contro-
versy would come the following year, when a black puppet of
the patron saint of England, inspired by Cazalet's triptych in the
Fraser chapel, formed the centrepiece of a street parade aimed
at claiming back celebrations of St George's Day from the BNP
and the English Defence League. As Canon Theologian Andrew
Shanks argued, '[t]here is a war going on about the flag and the
meaning of it and we are doing our damnedest to interpret it our
way'.[114] A year later, the controversy erupted again, with press
interest focusing this time on the number of threatening and
abusive letters Shanks received.[115] Govender's uncompromising
stance on social and racial justice, supported by his colleagues,
made the Cathedral emblematic of a city striving to overcome its
own internal divisions.

113 *MEN*, 2 June 2009.
114 *MEN*, 20 December 2010.
115 The *Independent*, 22 April 2011; also *MEN*, 7 May 2011.

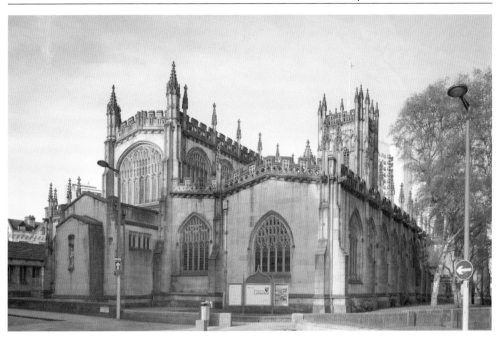

Manchester
Cathedral rear

Inevitably, at the time of writing it is not possible to reach a definitive judgement about the success or otherwise of this strategy. It is arguable that, amongst English cathedrals, in the early twenty-first-century Manchester has been one of the more successful in offering itself as an example of a historic 'great' church which has been able to maintain a broad, representative function for the city running alongside its more strictly religious function, and that the combination of the two has been particularly potent in the story of Manchester's fall and rise since the 1980s. As Chris Baker has acknowledged, '[i]n the space of less than 20 years Manchester has successfully transformed itself from a declining *Cottonopolis* ... to an *Ideopolis* (a new city region whose capital is now predicated on the ability to create knowledge, ideas and information)'.[116] The Cathedral has reflected that change in its own development, seeing its situation transformed through the aftermath of the IRA bomb into one in which it can function not just geographically and socially as the historic centre of the city, but as a resource for the Manchester city and region. At the same time, it has not ceased to develop its spiritual life and mission.

116 Chris Baker, 'Entry to Enterprise: Constructing Local Political Economies in Manchester', in John Atherton and Hannah Skinner (eds), *Through the Eye of a Needle: Theological Conversations over Political Economy* (Peterborough: Epworth, 2007), pp. 191–2.

Architecture

CLARE HARTWELL

W<small>HEN CELIA FIENNES VISITED</small> Manchester in 1698, she described the parish church standing 'high soe that walking around the Church yard you see the whole town'.[1] The building, now Manchester Cathedral, gradually lost visual dominance as the city expanded during the nineteenth and twentieth centuries. Nevertheless, it has been identified as an exceptional example of a collegiate church; John Harvey described it as 'one of the best examples of the [Perpendicular] style, with its spreading array of chapels, its grand tower, and exquisitely carved stalls',[2] and Paul Jeffery as 'a very splendid building'.[3] Despite this, the fabric has not been the subject of detailed analysis since the early twentieth century. Serious attempts to unravel the building's history started with Samuel Hibbert-Ware's *History of the Foundations of Manchester of Christ's College, Chetham's Hospital and the Free Grammar School* (3 vols, 1828–33), with a section on the architecture of the building by John Palmer (1785–1846), who was an architect, historian, and genealogist responsible for work on the fabric of the church. The most exhaustive study is *The Cathedral Church of Manchester* by the principal Victorian restorer, J. S. Crowther (1820–93), published posthumously in 1893. Finally, Henry Hudson published *The Mediaeval Woodwork of Manchester Cathedral* (1924). He was one of the most serious students of the building and its contents and was responsible for a number of articles in the *Transactions of the Lancashire and Cheshire Antiquarian Society.*

1 Christopher Morris (ed.), *The Illustrated Journeys of Celia Fiennes, 1685– c. 1712* (London: Macdonald, 1982), p. 184.
2 John Harvey, *Gothic England: A Survey of National Culture, 1330–1550* (London: Batsford, 1947), p. 34.
3 Paul Jeffery, *The Collegiate Churches of England and Wales* (London: Robert Hale, 2004), p. 202.

Previous spread: 'Eerie'

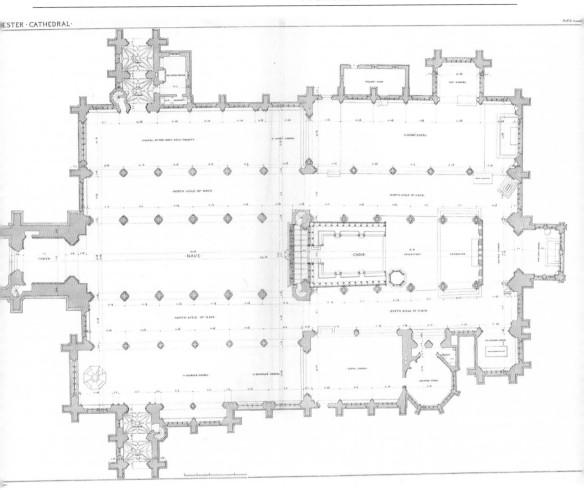

Plan of the Cathedral
by J. S. Crowther

The church is the result of substantial rebuilding which took place after a college of priests was formed in 1421. There seem to have been several campaigns of building during the fifteenth century which were apparently instigated or overseen by successive wardens of the College. The founders of the College and the complex web of connections and influences surrounding the institution are discussed in Chapter 3. The project was well organized and well funded, with income from rectorial tithes augmented by gifts of lands in and around Manchester by the rector, lord of the manor, and co-founder of the institution, Thomas de la Warre.[4] Further grants were made to the first Warden, John Huntingdon, by de la Warre's successor, Reginald

4 John Harland (ed.), *Mamecestre: being Chapters from the Early Recorded History of the Barony, the Lordship or Manor, the Vill, Borough or Town*

West, over the period 1430–36.[5] Work on the building was later undertaken for others, including the fifth Warden, James Stanley II. By the opening of the sixteenth century, the church was larger and more elaborate than any non-monastic church in Lancashire, with numerous chantry chapels erected by local aristocratic and mercantile families, an aisled choir with magnificent stalls, and a polygonal chapter house.

Members of the College were provided with a spacious purpose-built accommodation on the site of de la Warre's Manchester manor house, known as Baronshull or Baronsyard. It is not clear whether the manor house was standing at that time, but there is no evidence that any part of it was incorporated into the new College premises. Tree-ring analysis of structural timbers shows that College building was probably under way by 1424 and certainly by 1429,[6] indicating that housing College members was high on the list of priorities. The building (now Chetham's School and Library) is exceptionally well preserved, built of stone, consisting of hall and lodgings around a courtyard, with services, including a double-height kitchen, in a long east wing. The open hall retains its dais and screen, with richly appointed two-storey warden's lodgings at the high end. Fellows' accommodation consists of rooms on two storeys around a cloister on three sides of the courtyard with a gallery at first-floor level.[7] Together the church and domestic quarters represent one of the most complete examples of their type and date in the country.

Little is known about the architectural character of the church prior to 1421, but fragments discovered during restoration or rebuilding indicate substantial stone-built predecessors, discussed in Chapter 2. The sequence of building after 1421 is difficult to unravel. Priscilla Metcalfe and Nikolaus Pevsner, for example, found 'no stylistic case for placing one detail before another', to the extent that 'no sequence of building can be deduced from them'.[8] There is little reliable documentary evidence to assist.

of Manchester, Volume III, CS os 58 (Manchester, Chetham Society, 1862), p. 469.

5 F. R. Raines, The Rectors of Manchester and Wardens of the Collegiate Church of that Town, 2 vols, CS ns 5, 6 (Manchester: Chetham Society, 1885), vol. 1, p. 17.

6 Ian Tyers, Tree-Ring Analysis of Timbers from Chetham's Library and School, Long Millgate, Manchester (London: English Heritage, 2002).

7 For a fuller description, see Clare Hartwell, The History and Architecture of Chetham's School and Library (New Haven, CT, and London: Yale University Press, 2004).

8 Priscilla Metcalfe and Nikolaus Pevsner, The Cathedrals of England: Midland, Eastern and Northern England (Harmondsworth: Viking, 1985), pp. 242–3.

A discussion of sources was published in 1885,[9] including reference to a manuscript found at the College of Arms with some details of the College's wardens and their activities, copied from a source apparently compiled between 1603 and 1608,[10] which can no longer be traced. The manuscript itself has also apparently gone missing. Wills, deeds, and associated records were helpful; other sources included Richard Hollingworth's *Mancuniensis* (*c.* 1650) and various eighteenth-century printed documents.

The project of creating a new building for the College began with a campaign to rebuild the choir, which was started by the first Warden, John Huntingdon (1422–58), although it is not clear how far this work progressed. The nave is traditionally attributed to the third Warden, Ralph Langley (1465–81), while the fifth Warden, James Stanley II (1485–1506), is known to have started a chantry chapel and co-sponsored the choir furnishings; the architectural evidence suggests there was a very substantial rebuilding during the period of his incumbency. The usual alterations and repairs followed the Reformation, with much work undertaken in the early nineteenth century. The tower was largely replaced in the 1860s and a thoroughgoing restoration followed during the late nineteenth century by J. S. Crowther. Basil Champneys added an adjunct to the west end, completed in 1898, and provided additional accommodation in an extension soon afterwards. This building was extended by Percy Scott Worthington in 1933–24. Serious damage was caused to the fabric by an incendiary bomb in 1940, which destroyed the outer walls of the Lady chapel, much of the east wall of the St John the Baptist chapel, the whole of the Ely chapel (attached to the north side of the St John the Baptist chapel), the roof of the chapter house, and other parts of the building on the north and east sides. The damage was repaired under the Cathedral architect, Sir Hubert Worthington.

Following from this general outline, the surviving fabric and archival material allow a picture of the church to be built up. Illustrations of the west tower before it was replaced in 1862–68 show that the base and the west doorway appear to have been of fourteenth-century date. The upper part looked like late fifteenth-century work, but it has not been related to any specific campaign or benefaction. There are few regional parallels for the richness of its decoration, which intensified in the upper stages

9 Raines, *Rectors and Wardens*.
10 H. A. Hudson, 'A List of the Wardens of the College of Manchester with Remarks upon an Early MS Catalogue and an Early Printed List', *TLCAS* 33 (1915), pp. 178–91.

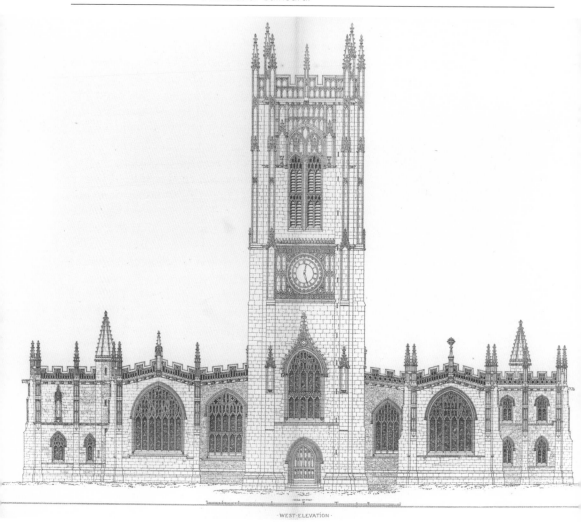

WEST ELEVATION

West elevation.
Measured drawing
by J. S. Crowther

and culminated in angle pinnacles, with centre pinnacles and
an enriched parapet. The detail was reproduced with varying
degrees of accuracy and the whole tower was made taller than
the original. John Harvey, on the basis of its previous appear-
ance, described it as 'one of the quiet triumphs of the last days
of Perpendicular'.[11] A battlemented clerestory runs from tower to
chancel. The detail and decoration are largely nineteenth century
in origin; eighteenth- and early nineteenth-century engravings
show a flat traceried parapet, possibly the replacement of earlier
work. The regular character of the broad clerestory windows,
set closely together one to a bay, suggests a single campaign of

Facing page:
West elevation
with additions by
Basil Champneys

11 Harvey, *Gothic England*, p. 233.

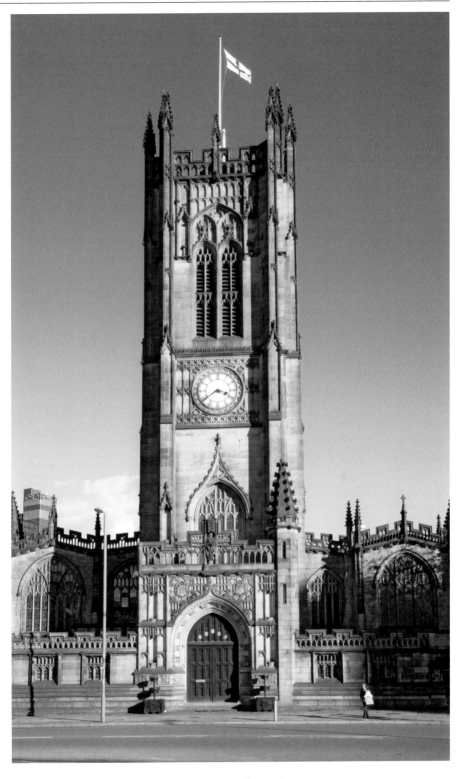

work (the tracery was replaced in 1815 and again in the 1870s), comparable with the Perpendicular clerestories of churches in the south of the region, especially in Cheshire. In many of these cases the clerestory runs straight through from tower to chancel; examples include Astbury Parish Church in Cheshire. At Manchester, on the other hand, the line is broken, interrupted by the turret terminations of the stair-towers which served to give access to the top of the *pulpitum*. A local parallel is Eccles Parish Church in Salford, with similar stair-towers and broad clerestory windows. Harvey sees the Manchester windows in general as an 'evenly-balanced and fine blend' of Northern and Western traditions.[12] Some of the tracery, however, is unlikely to reflect the original. A good deal of it had probably already succumbed to the depredations of time and pollution by the opening of the nineteenth century, and the extensive rebuilding of that period meant later restorers often had little to go on. Others, especially those with supertransoms on the south side, appear to follow designs suggested in late eighteenth- and early nineteenth-century engravings, and may therefore have some claim to authenticity.

Almost all the lower windows on the north and south sides of the building lit chapels which had been added piecemeal to the outer walls of the aisles. Seven new chantries were founded in the church after 1421, adding to a handful already in existence. Chapels relating to them were built or rebuilt at times[13] but their outer stonework was very largely refaced or replaced in nineteenth-century restorations. It is not always possible to relate the date of the foundation to the building work, while more than one foundation might share the same altar; however, some indications can be given. Starting to the east of the south porch and proceeding anti-clockwise, the two-bay St George chapel was probably founded or augmented in 1503. The neighbouring St Nicholas chapel, also of two bays, seems to have been of ancient foundation, but may have been rebuilt when it was conveyed to the de Trafford family in 1470. During work undertaken here in 1809 the 'form of the ancient windows were [*sic*] destroyed'.[14] Next in the sequence, in a high-status position south of the choir,

12 *Ibid.*, p. 71.

13 For details, see F. R. Raines (ed.), *A History of the Chantries within the County Palatine of Lancaster: Being the Reports of the Royal Commissioners of Henry VIII., Edward VI. and Queen Mary*, CS os 59, 60 (Manchester: Chetham Society, 1862).

14 Samuel Hibbert-Ware, *History of the Foundations in Manchester of Christ's College, Chetham's Hospital, and the Free Grammar School*, 3 vols (Manchester: Thomas Agnew and Joseph Zanetti, 1848; first publ. 1828–33), vol. 2, p. 223.

Facing page:
Interior from the west

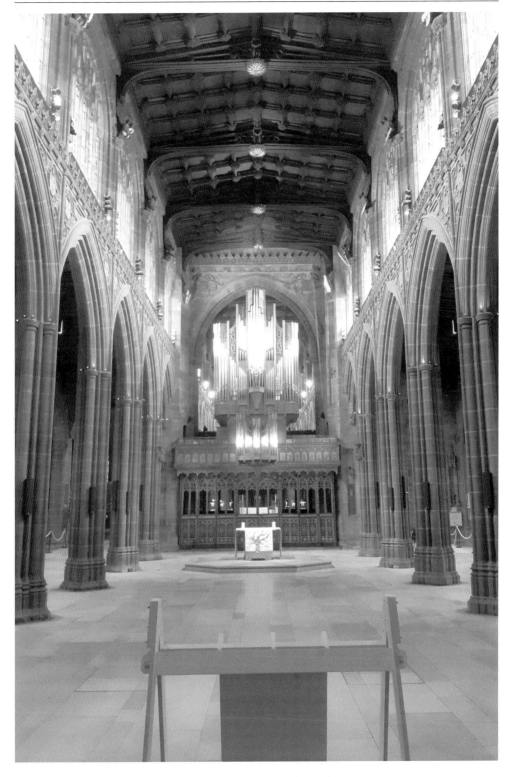

the three-bay Jesus chapel was licensed in 1506 and built for Richard Bexwyk (or Beswick) and the Guild of Saint Saviour and the Name of Jesus. Bexwyk, who was from a local merchant family, also co-sponsored the choir stalls.[15] There follows on this side a chapter house, much rebuilt after bomb damage in 1940, and the Fraser chapel, added by Crowther in 1890, apparently re-using a medieval aisle window. At the east end, the Lady chapel outer walls were rebuilt after 1940. On the north side of the choir the St John the Baptist or Derby (now Regimental) chapel, with a five-bay arcade towards the choir, was started c. 1513 for Warden James Stanley II, and finished by his son or nephew John Stanley, who built an attached chapel (the Ely chapel) in honour of Stanley in 1514–15. This was demolished in 1940 when the main chapel was also badly damaged. Next comes the single-bay St James's chapel, established in 1507 in resolution of a dispute arising from Warden Huntingdon's will. Finally comes the single-bay Holy Trinity chapel at the west end, associated with the Radcliffe family of Ordsall and thought to have been built c. 1498. When the chapels were created, original aisle walls and windows may have been re-used, as seems to be the case of the St John the Baptist chapel; others may have been built anew. Some groupings have coherence, such as the windows with stilted arches and heavy supertransoms lighting the Jesus chapel. Another group, on the north side of the St John the Baptist chapel, was replaced in 1828 'in exactly the same form of mouldings, tracery and ornaments'.[16] Both porches are by Crowther, and the south-west baptistery was added to his design in 1892. Most of the west walls flanking the present west porch were rebuilt by John Palmer in the early nineteenth century.

The great width of the nave is a striking feature of the interior. The decommissioned chapels, having lost original divisions and screens, create the appearance of outer aisles on each side, where continuous arcades parallel with the main nave arcades were built by Crowther to replace the partitions between the nave and chapels. The six-bay nave and six-bay choir are almost equal in dimensions and height, divided by a chancel arch and a *pulpitum* or screen, with the big staircase towers on each side. There is an impression of architectural unity, with the nave and choir arcades and clerestories sharing similar form and decorative detail, although their ceilings differ.

15 H. A. Hudson, 'Jesus Chapel, Manchester Cathedral: Licence for Service', *TLCAS* 35 (1917), pp. 105–8.

16 Hibbert-Ware, *History of the Foundations*, vol. 2, p. 215.

The fabric of the nave is almost wholly Victorian. Arcades were replaced by Crowther, by his own account, as an exact copy of what he found. That this is so in general terms is confirmed by comparing his work with engravings and descriptions made before he started. The exception is the east face of the tower with the tower arch, retained in the 1860s rebuilding (presumably in order to avoid having to prop up the arcades), complete with evidence of the damage caused in the early nineteenth century by gouging the surface to receive Roman cement. Enough survives to show that surface treatment of the east face takes the form of cusped panelling, like that of the inner arch of the chapter house and window reveals of the east wall. The detail is Perpendicular, and the panelling may have been introduced to harmonize the appearance of the wall, which exhibits various anomalies. One striking feature is the alignment of the north arcade, which is offset to the north, showing that it was built or rebuilt to line up with the chancel arch, rather than with the tower arch. When the original north arcade was replaced in 1883–84, Crowther was convinced that he had found evidence that it had been taken down and rebuilt on a new line, rather than being replaced. Crowther's facsimile arcades, 'faithfully reproduced, line for line and joint by joint',[17] are of a piece with the clerestory, also a reproduction and also following the original work. Distinctive features of the arcades are the spandrels, richly decorated with carved shields in quatrefoils and mouchettes. Shafts rise from high, stepped polygonal bases with a slim shaft at the front rising to the frieze where it is stopped but reappears above on the other side to form part of a cluster of shafts dividing the windows of the clerestory. The feet of the camber beams of the ceiling are adorned by largely original carved wooden minstrel angels. There are seven figures on each side with different instruments, wind on the north side, strings on the south (except the clavicymbal, accidentally transposed with the portative organ during a restoration). The exact date of the ensemble has not been established, and it may have been an addition to the ceiling rather than being contemporary with it. The roof structure was entirely replaced by Crowther, which means that any evidence for alterations, modifications, and repairs was lost, but the angels, carved figures, and bosses were carefully conserved (by the standards of the day) and replaced largely in their original positions on a facsimile structure. Carved figures holding shields against the beams of each bay stand above a boss decorated with

17 Joseph S. Crowther, *An Architectural History of the Cathedral Church of Manchester* (Manchester: J. E. Cornish, 1893), p. 19.

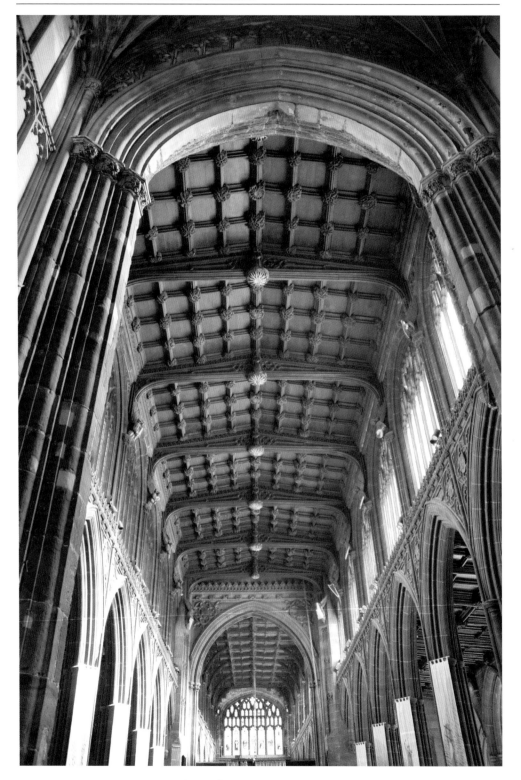

Facing page and right:
Nave ceilings with minstrel angels

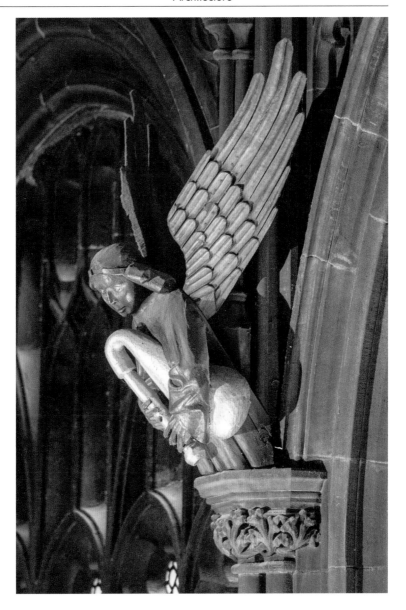

a sun design. Heavily moulded timbers form compartments with bosses carved from the solid wood. A variety of subjects is shown in the boss carvings, including a distinctive, repeating design of a sun-in-splendour with praying figures.

The local parallel for the ceiling is at nearby Eccles Parish Church, which, as we have seen, has similar chancel towers and nave clerestory. It also exhibits the same modification of the north arcade, offset with regard to the tower arch to create a broader nave. The Eccles nave ceiling is strikingly similar (without the

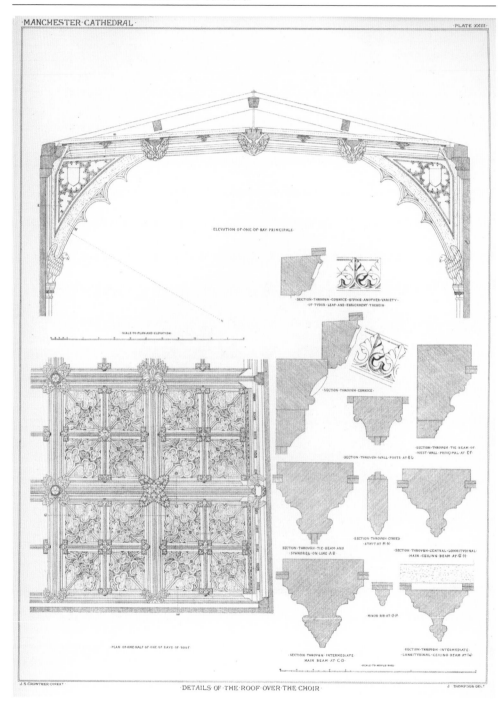

DETAILS·OF·THE·ROOF·OVER·THE·CHOIR·

Drawing of the choir
ceiling details from
J. S. Crowther

minstrel angels) but on a smaller scale. It is constructed according to the same principles and has similar figures on the trusses. Many of the bosses are of identical design, in particular those with praying figures and a sun-in-splendour motif. The latter is an emblem traditionally associated with the York dynasty, and its presence in the Manchester and Eccles roofs has been interpreted as evidence for Yorkist allegiances, and perhaps construction during the reign of Edward IV (1461–83). The connection with Eccles was through the Booth family and their close associates, the Langley family. William Booth, a fellow of the Manchester College, founded a college at Eccles in 1460; his half-brother Laurence Booth, Bishop of Durham and confessor to Edward IV, had Eccles connections and co-founded a chantry there c. 1450. William Booth's nephew John Booth was installed as Warden of the Manchester College in 1459. Manchester's nave is traditionally attributed to the third Warden, Ralph Langley (1465–81), who had family connections with the Booths and who rebuilt the church 'between the pulpit and the steeple', according to a later account.[18] The similarities between the roofs indicate that they probably emanated from the same workshop, but evidence for the dates is lacking.

The Manchester chancel arch was completely rebuilt by Crowther. The facsimile detailing is reminiscent of that at Mold Parish Church (Clwyd), rebuilt under the patronage of the Stanley family in the late fifteenth century. The flanking stair-towers are of different diameters and Crowther surmised that the one on the south side was of a date with the tower arch, while that on the north side was rebuilt to align with the rebuilt north nave arcade.[19] This brings us to the choir, which was restored but not rebuilt in the nineteenth century, retaining much medieval fabric. The first Warden, John Huntingdon, built the choir '*de novo*' according to a seventeenth-century transcription of the inscription on his brass.[20] Raines quotes a source which credits Huntingdon with building the choir with aisles on both sides thirty yards in length and twenty yards wide 'from the two great pinnacles where the organ stood betwixt, to the east end of the church'.[21] More evidence is provided by a will made by Huntingdon in 1454. An associated deed made provision for the 'edificacon expences costs and bygging [building] of the newe worke by me begonen of the chauncell of the Kirke of our Lady

18 Raines, *Rectors and Wardens*, vol. 1, p. 31.
19 Crowther, *Cathedral Church*, p. 24.
20 E. F. Letts, 'Warden Huntyngton', *TLCAS* 2 (1884), p. 95.
21 Raines, *Rectors and Wardens*, vol. 1, p. 17.

of Manchest'r',[22] indicating that the work had been started, 'begonen' implying it was unfinished at the time. Its extent at the time of Huntingdon's death four years later is unknown, and the land he left to provide funds for finishing the work and for other purposes remained in private hands. As late as 1506 it was found that the 'will as yette, as wee can p'ceive, hath not been fulfilled'.[23] In the end the endowment was used to form a chantry and build a chapel. Thus, while it seems certain that Huntingdon was responsible for at least beginning to build the choir, how much was completed, and how much survives, is the subject of debate. Apart from his rebus carved in the roof timbers of the choir and features of the easternmost end of the choir (see below), firm evidence for his work remains elusive.

The choir arcades are slimmer and more delicate versions of the nineteenth-century copies of the nave, with similar bases and similar carved detail to the spandrels. The arcades are splayed so that the choir west end is 25ft 4in wide narrowing to 22ft 1in at the east end. There are regional parallels, such as Astbury and Weaverham churches in Cheshire (fourteenth and fifteenth centuries), and there can be no doubt the feature was intentional and probably contrived when the north arcade of the nave was rebuilt north of the original line. One effect is to give the appearance of greater length, another to introduce focus, while space and a grand setting was created for new furnishings and stalls. At the east end the arcades are grafted on to what is clearly earlier work in the east wall. The arcade responds are not of the same build as the arcade, having coarser mouldings and obvious signs of botching, with arches awkwardly stilted at the east end. There are also differences in the heights of string courses. Windows in the wall have hollow-moulded reveals with traceried panels. Little canopies within the frame suggest that statuary was incorporated. Polygonal pier bases and moulding profiles are apparently of fifteenth-century date, and the bases of the Lady chapel arch seem to belong to the same series. In contrast, the chapel arch responds display a narrow chamfer or fillet which is carried through to the cap, a feature found nowhere else in the building. This is the only identifiable masonry of possible fourteenth-century date, but it looks as if it has been re-used or re-set and it is impossible to know if it is *in situ* or from elsewhere in the building. The east wall may represent evidence for the choir started by

22 J. P. Earwaker, 'The Will of Warden Huntingdon, 1458', *TLCAS* 4 (1886), p. 149.

23 *Notitia Cestriensis, or, Historical Notices of the Diocese of Chester by Bishop Gastrell. Vol. II, Part I*, edited by F. R. Raines, CS os 19 (Manchester: Chetham Society, 1849), p. 60.

John Huntingdon before his death in 1458, left standing when the remainder of the building was remodelled decades later. Why this should have been, when there appeared to be ample funds for a thoroughgoing rebuilding, is far from clear. The difficulties in the setting out and design of the choir ceiling must have been considerable, since the tapering plan means, as later restorers recorded, 'no two panels are the same'.[24] This ceiling is an extraordinary piece of work, with open arch-braces and delicately traceried panels. There are carved eagles, a Stanley emblem, and angels bearing shields at wall plate level. Bosses are unlike those of the nave roof, without any of the same motifs. The ceiling is said to have been taken down and repaired in 1638, the date reputedly carved in the roof at the east end, though it is not easily visible. All the structural timbers were replaced by Crowther, keeping the original carved work, and much was repaired again after bomb damage in 1940. Crowther thought he had found evidence for a substantial remodelling of the roof, which he attributed to the alteration of an existing roof constructed for Huntingdon to make it fit with a new arcade alignment. Although what he saw could have been seventeenth-century botching, his theory is lent weight by the appearance of Huntingdon's rebus (on one side a man goes hunting, on the other he draws drinks from a tun) in the spandrels at the west end of the roof, though they have been reset and could be commemorative (the rehearsal of these motifs in the entrance to the Lady chapel is of nineteenth-century date). Whatever the true explanation, the fact that the nave and choir arcades and clerestories are very similar in design, while the ceilings associated with them are quite different, is one of the puzzles presented by the fabric of the building.

The view that the present choir is the work Huntingdon undertook before 1458 was promoted by Crowther and led later commentators such as John Harvey to suggest that Huntingdon's work anticipated motifs seen in churches in East Anglia, in particular those associated with the mason John Wastell.[25] An alternative interpretation would be substantial rebuilding at a later date after Huntingdon's time, using masons familiar with Wastell's work, or even Wastell himself. The most likely patron for such work was Warden James Stanley II (successor to an uncle of the same name). Stanley was the sixth son of Thomas Stanley, first Earl of Derby (1435–1504). His career in the church began at the age of fourteen as a canon at Southwell Minster

24 Hubert Worthington, 'Manchester Cathedral Restoration', *TLCAS* 57 (1945–6), p. 296.

25 Harvey, *Gothic England*, p. 217.

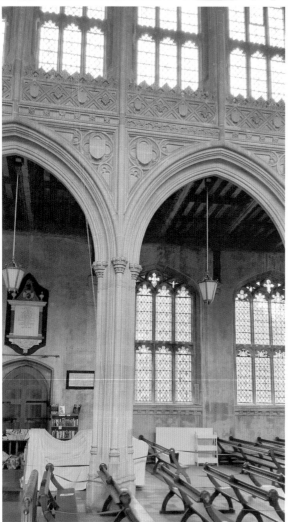

Detail of nave
arcade of St
Peter and St Paul
Lavenham

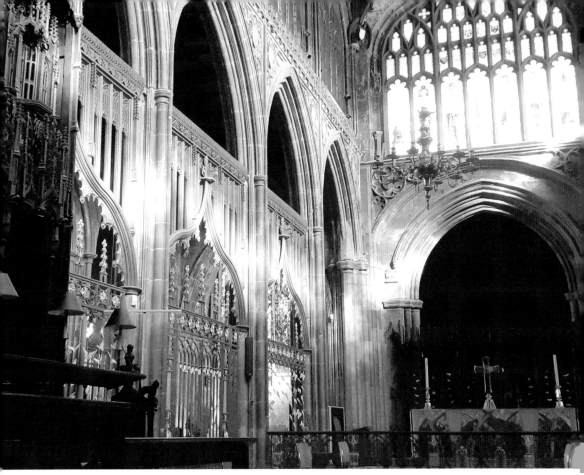

Comparable detail
of Manchester
arcade

and culminated with the bishopric of Ely.[26] Thomas Stanley had
become a Privy Councillor in 1471, Steward of the Royal House-
hold in 1472, High Constable of England in 1484, and first Earl
of Derby in 1485, after decisive intervention at Bosworth and the
accession of Henry VII. His second wife was the king's mother,
Lady Margaret Beaufort (1441–1509). The family and their
protégées enjoyed extraordinary ecclesiastical prominence, the
roll-call including Archbishop Thomas Savage of York, Bishop
Hugh Oldham of Exeter, and Bishop William Smith of Lincoln,
as they followed a policy of acquisition of ecclesiastical assets
throughout the fifteenth century, including monopolization of the
wardenship of the Manchester College between 1481 and 1506
to promote family members and to ensure that their protégés
succeeded to the office thereafter.[27] Lady Margaret Beaufort's
connections had consolidated the family's position in the highest

26 *ODNB*, *s.n.* 'Stanley, James (*c.* 1465–1515)'.
27 P. Hosker, 'The Stanleys of Lathom and Ecclesiastical Patronage in the
 North-West of England during the Fifteenth Century', *NH* 18 (1982),
 pp. 212–27.

court circles . She lived mainly at Derby's Knowsley and Lathom seats in Lancashire and her household included several men from the Manchester area with connections to the Manchester College (for more detail, see Chapter 3). She also had interests in Cambridge, where she founded St John's College and was a patron of the rebuilding of Great St Mary's Church, for which John Wastell was master mason. His other work there included completion of King's College chapel; Henry VII personally rewarded him and paid for an exhibition for his son's education at Cambridge University in 1506.[28] These connections make a link with Wastell's workshop and the Manchester church feasible. Stylistic parallels include distinctive arcade spandrel decoration with a shield in a quatrefoil, seen in the arcades of Great St Mary's, Cambridge (c. 1491), and those of Wastell's parish churches of Lavenham (c. 1495) and Saffron Walden (c. 1497). These details are strikingly similar to the treatment of the Manchester arcades.

It seems likely, therefore, that Stanley rebuilt the choir and also very substantially remodelled the nave, introducing the clerestory and possibly having the upper part of the tower rebuilt. Whilst there is no documentary evidence for this, Stanley's will, and that of his executor and nephew (or illegitimate son) John Stanley, show that he arranged for the building of chapels on the north side of the choir (the present Regimental chapel and demolished Ely chapel), which the younger Stanley seems to have completed.[29] On the north side of the choir the St John the Baptist (later the Derby, now the Regimental chapel), was probably started in 1513. Although the east wall was largely replaced after 1940, part of the north wall is original. The details and mouldings of the east wall can be related to those of the outer north wall of the north chapel (St John the Baptist), which was apparently the original aisle wall rebuilt in a new position further north to accommodate the chapel, the windows flanked by wall brackets supported by a grotesques and beasts. As we have seen, it is likely that this is an original aisle wall moved outwards when the chapel was built. The chapel's south arcade, with a deep hollow moulding and flared polygonal caps to the shafts, is enriched in bays one and two from the east by a slim central pier, thereafter omitted. This change might indicate a hiatus between James Stanley's death and completion of the work by John Stanley.

28 Francis Woodman, *The Architectural History of King's College Chapel* (London: Routledge & Kegan Paul, 1986).

29 William F. Irvine (ed.), *A Collection of Lancashire and Cheshire Wills not now to be found in any Probate Registry, 1301–1752*, RSLC 30 (London: Wyman, 1896), pp. 48–9.

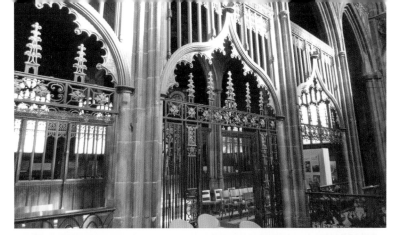

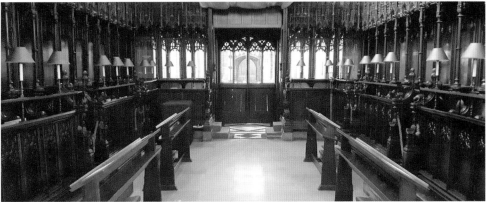

The choir

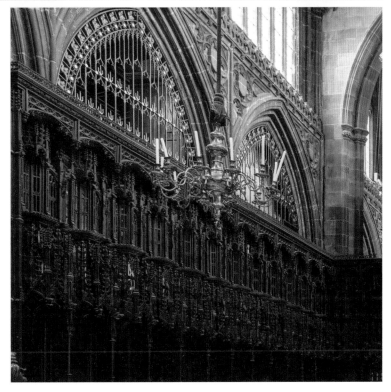

It should be noted that this chapel is aligned with the splayed arcade of the choir.

On the south side of the choir, aligned with the nave rather than the splayed line of the choir, are the chapter house (east) and the Jesus chapel, licensed in 1506. The latter escaped wholesale restoration, but the stonework is badly damaged, probably deliberately, to provide a matrix for Roman cement applied in the early nineteenth century. A small single-storey building attached to the east side of the chapel is described as Hulme's Chantry on historic plans, but this appears to have been demolished in the late nineteenth century. Traceried panels flank the windows, and the circular pier of the north arcade has a crude banded and battlemented cap and rises from a high polygonal base. The wall between the chapel and the chapter house is of rough stonework, compromised by later interventions relating to the organ and the boiler. A new sequence of blind arches begins to the east of the chapel, similar in style but more crisply executed. Within this wall the chapter house entrance, with paired doorways on each side of a massive compound pier, has cusped blind panelling in the reveal and over the entrance. This leads to an octagonal chamber, heavily restored in the mid-nineteenth century and again after damage in 1940, leaving little obvious original work. Foundations discovered in 1828 and other evidence uncovered during later restorations suggested that there may have been a rectangular predecessor building of unknown function. This seems to indicate that the chapter house and work to the east on this side may be part of a one fairly late campaign of work, using a polygonal plan without a central pillar, recalling thirteenth-century examples at York and Southwell. It is plausible that this work was undertaken for Warden James Stanley II, and can be associated with the resplendent new stalls provided for college members. Although chapter houses are usual in monastic contexts, and in major minster and cathedral churches, they are by no means a usual adjunct of collegiate churches, although they are or were found at Howden (Yorkshire, East Riding), at Warwick, and possibly at Crediton (Devon). The provision of one at Manchester reflects the importance of the institution and can be seen as a sign of ambition.

Manchester has exceptional medieval choir stalls, probably installed c. 1500–06, amongst the finest in the North of England. Warden James Stanley II was co-sponsor, with Stanley arms and emblems prominently displayed on the south side. The absence of episcopal references is a good indication that they were finished before Stanley became Bishop of Ely in 1506. Richard Bexwyk or Beswick, a merchant and contemporary of Stanley, who was

instrumental in founding the Jesus chapel, seems to have been the other sponsor; his arms appear on the desk standard of the north-east stall. There are thirty stalls, twelve on each side and six returned on the west side. The canopies are intricately carved in three distinct designs, with an upper tier reproducing the detail of the canopy beneath in simpler form. All the panels are traceried. A tester or horizontal cornice tops everything off, the detail of the design slightly different on each side. Manchester is one of the earliest known uses of this device in stall work, which unifies the composition by placing it within a frame, contrasting with the forest of spires which distinguish earlier examples, where the emphasis is more on vertical lines and compartmentalization of the stalls. Beverley is a later example of the same type of horizontal cornice, and another possible parallel is noted by J. S. Purvis, who describes part of an early sixteenth-century tester (reused as an altar rail) at Leake, near Northallerton, which may have originated at Bridlington Priory.[30] The stalls of honour on each side of the entrance from the nave are more ornate, with four-sided instead of three-sided fronts. That on the south side, probably reserved for the warden of the College, is the most densely detailed, but work above the central entrance is facsimile of the 1950s. The entercloses (undersides of the canopies above the seats) are hexagonal and vaulted, with pierced traceried panels. Those of the seats of honour are elaborated by a little central pendant. The stall desks are decorated with tracery and poppy-head standards. Distinctive features are the projecting fronts with detached diagonal shafts housed at the base in little buildings with crocketed gables and tiled roofs. The uppermost stage has open tracery and it supports a bracket upon which sits an animal or beast. The handrests incorporate well integrated, vigorous designs, mainly floral but with some animals and heads. Of the bench ends, that of the warden's stall incorporates a carved rendition of the Lathom Legend, with an eagle in its nest containing a baby wearing a flowing robe. The Lathom arms are said to have been adopted by the Stanleys when an alliance was formed with the family in 1385. Two more renditions of the eagle and child crest appear on the stall, one on a handrest, the other on a misericord.

The Manchester stalls have been associated with examples in Yorkshire, particularly those at Ripon (*c.* 1489–94), and Beverley (*c.* 1520–24). The stall work and its carvings in both these places exhibit obvious similarities with that at Manchester. Purvis adds

30 J. S. Purvis, 'The Ripon Carvers and the Lost Choir Stalls of Bridlington Priory', *Yorkshire Archaeological Journal* 19 (1927–29), p. 162.

the dispersed furnishings of Bridlington Priory dated to 1519 (and, more remotely, fifteenth-century work in East Anglia) to the group.[31] Parallels can be detected in the treatment of the desks, especially the detached shafts, the misericords, and other details. (The misericords are described in detail and discussed in Chapter 12.) The workshop of William Bromflet has been associated by Purvis with the Yorkshire and Manchester work, although he is careful to note that positive proof is lacking.[32] Charles Tracy's analysis acknowledges similarities and argues that a more complex set of influences should be considered, proposing the involvement of at least six master carvers (three at Ripon, and at least one each at Manchester, Jervaulx, and Beverley).[33] The connection between different master carvers and the relationship between carving workshops is difficult to unravel, and rarely elucidated by documentary evidence. When it comes to particular motifs and the dissemination of style it is clear, as Purvis has shown,[34] that Continental prints were used as models for some of the carved work.

The *pulpitum*, which also acted as a rood screen, was part of the scheme and bequests in the 1520s towards costs of the rood celure suggest a date for the completion of the structure. It has been very greatly altered. The rood, vault, and rood loft front were removed at an unknown date, and further alteration and damage occurred when a gallery, removed in 1847, was built against it. Various other depredations occurred, and it was removed and stored in the choir in the 1860s. It was reinstated and rebuilt by G. G. Scott, using the firm of Farmer & Brindley during the 1870s. A completely new loft and vaulting was created, with replacement of much other timberwork, in some cases reworking original timbers. The west side of the screen was cut into hinged sections, probably to facilitate clear views through to the altar. Any original paintwork appears to have been removed, and a new painted scheme was introduced by Scott.

There are a number of medieval screens in the building, many of them greatly restored. Of these the most significant is that of the Lady chapel, which has been dated to *c.* 1440 and is a good deal earlier than most of the other medieval woodwork. Only fragments have survived damage, including bomb damage in 1940, but it is important stylistically and historically, retaining

31 *Ibid.*

32 *Ibid.*, p. 197.

33 Charles Tracy, *English Gothic Choir-Stalls 1400–1550* (Woodbridge: Boydell, 1990), pp. 21–31.

34 J. S. Purvis, 'The Use of Continental Woodcuts and Prints by the "Ripon School" of Woodcarvers', *Archaeologia* 85 (1936), pp. 107–28.

carved figures apparently on the theme of virgin martyrs, with a George and dragon. Other medieval screen work is also much restored. The Jesus chapel screen, for example, is probably contemporary with the chapel itself, i.e. c. 1506, and is of fairly conventional design.

The building history after the Reformation was largely one of repair and restoration, although few records of work undertaken survive until the eighteenth century.[35] After the college was re-founded in 1635, repairs seem to have included work to the choir roof, which had a date of 1636 at the east end. Not long afterwards, in 1642, the church was used as a base during the Civil War to repel Royalist incursions from across the river in Salford. There is no detailed account of the effect upon the church, but it was probably at this time that a good deal of the glass was lost. Works in the eighteenth century included one commemorated in a reset panel dated 1742 in the choir ceiling and a reordering of the choir which took place in 1750. It was probably at this time that memorials in the floor of the sanctuary were taken up, including that of Warden John Huntingdon. A faculty was obtained to:

> enlarge the floorspace included within the rails of the Communion Table within the Choir of the Collegiate Church, by removing the wooden rails and erecting iron rails as much forward towards the west as shall be deemed convenient, and to the extremity of the choir towards the north and south; take down the woodwork screens which separate the choir from the north and south aisles or raise the same to the height of the tabernacle work, as shall be thought most convenient, and to continue the iron rails from the front northward and southward up to the columns which support the piece of tapestry over the Communion Table and the Cornish above it; to raise the floor within the rails a step or two higher and also the Tapestry and Cornish to be raised as high as might be expedient but not to intercept the light from the east window; to remove 2 pews now standing in the choir into the north and south aisles (making room by removing benches) and putting them for the general use of the parishioners at prayer and at holy communion; to put two steps up to the iron rails from the north and south aisles, a step up across the middle of the

35 For a list of restorations, see T. Locke Worthington, *An Historical Account & Illustrated Description of the Cathedral Church of Manchester* (Manchester: J. E. Cornish, 1884), pp. 49–52.

Choir for the more decent approach to the rails, and 2 further steps close to the said rails.[36]

Part of this work survives, including the altar rails, which have been attributed to the smith Benjamin Yates, pupil of Robert Bakewell.[37] Also surviving are the parcloses which incorporate medieval screens reconfigured as big Tudor arches, and railings resembling crocketed spirelets, in an interesting and unusual example of mid-eighteenth-century Gothick style.

Significant repairs and alterations were made to the nave in the early nineteenth century, prompted partly by the need to accommodate an increased parish population. Eight new churches had been provided in Manchester between 1756 and 1794 for the rapidly growing town, but the rate of increase in population had accelerated enormously thereafter, with numbers in the Manchester township increasing from around 20,000 in 1770 to more than 182,000 in 1831. The work to the building was paid for by the parish and by some of those who retained ownership of or responsibility for the certain chapels. Accommodation was increased by the erection and re-erection of large galleries, with columns to support them, around the sides of the nave. The architect Robert Goldsmith was responsible for this work, which included family pews.[38] At about the same time there was extensive replacement of the fabric of the north and west sides of the nave, largely under the direction of the architect John Palmer. The interior was then covered with Roman cement. An indication of the approach is given by an account of work to the north-west corner of the nave, which in 1816 was 'entirely rebuilt, on the old foundations, at the expence of the parish … an exact counterpart both in stile and character to the old work'.[39] At the same time the windows were elongated to allow more light to penetrate. The reputation of John Palmer has been tarnished ever since, perhaps somewhat unfairly. His estimation of features since removed which included 'obelisks that would defy all the skill and ingenuity of a Palladio or Scamozzi to describe them, or even find proper appellation whereby to denominate them' gives a fair idea of some of the eighteenth-century work and he sought to distance himself from some of the most damaging

36 Terry Friedman, *The Eighteenth-Century Church in Britain, Documents* (New Haven, CT, and London: Yale University Press, 2011), CD ROM, Doc. 128.

37 *Ibid.*

38 Manchester, MCA, Mancath/2/B/1, Correspondence etc relating to proposed alterations.

39 Hibbert-Ware, *History of the Foundations*, vol. 2, pp. 213–14.

alterations undertaken. As usual, the builders were blamed.[40] His detailed drawings, many of which were later used as the basis of engravings for Hibbert-Ware's *History*, are a principal source for the appearance of the building prior to later nineteenth-century restorations and include views of some of the chapels before their screens were removed. It was during this phase of work that the churchyard was closed to burials (through a faculty of 1819) and new walls and new railings, designed by the architect Richard Lane, were erected.

Work continued, largely in piecemeal fashion, with a peak at about the time of the creation of the diocese in 1847, when Isaac & J. P. Holden undertook various projects, including restoration of the chapter house and re-pewing. Meanwhile proposals for an entirely new building to serve as the cathedral of the new diocese were being formulated, and when this was thought to be too ambitious, plans for very substantial rebuilding and remodelling were drawn up, both by the architect R. H. Carpenter. These were later abandoned. Substantial restoration was again in view in 1857, when Sir G. G. Scott was invited to visit the building and advise on some of the works which were being planned, which included the replacement of the tower. Scott sent a detailed letter to the churchwardens expressing his 'sincere grief to see that noble structure taken down' and advised against its destruction, saying: 'it is an idea, for my own part, that I should never for a moment have entertained'.[41] Despite this advice, the tower was almost completely replaced by the Holden firm in 1862–68, leaving only part of the inner east wall and tower arch. Architects later involved in what were essentially exercises in patching up, with replacement of part of the clerestory, works to the south porch, and so on, included William Dawes and J. E. Gregan. Anonymous letters in the architectural press show there was local disquiet about what was going on. One published in the *Builder* in 1862 called for local citizens to rise up and 'save their Cathedral from further vandalism'.[42] Just over a decade later, a correspondent to the *Building News* in 1874 complained that the building 'has been tampered with under the name of "Restoration" ... Old buildings are less the property of the local guardians than they are of the country generally.'[43]

Crowther's thorough restoration of the nave, with complete replacement of the arcades and rebuilding of the ceiling and roof,

40 *Ibid.*, p. 233.
41 MCA, Mancath/2/B/4, Papers concerning replacement of the medieval tower.
42 *The Builder*, 8 November 1862, p. 810.
43 *Building News*, 16 February 1874, p. 59.

was started in 1882. Crowther was an established and highly regarded church architect who restored several medieval churches in the region. A serious student of medieval ecclesiastical architecture, he had collaborated with the architect Henry Bowman in the publication of *Churches of the Middle Ages* (editions of 1845 and 1853). His work at Manchester Cathedral affords an interesting illustration of changing tastes. When he restored St Helen, Tarporley (Cheshire), in 1861, he described the late fifteenth- or early sixteenth-century work there as 'immeasurably inferior' to the earlier fabric and referred to the 'debased character' of other late medieval work.[44] Despite his reservations, he was at pains to try to retrieve the building history and retained the spirit of the despised later work in this restoration. By the time that he began his work on the Cathedral, on fabric of undoubted mid- or late fifteenth-century date, his attitude seems to have changed, for example in his description of the nave arcades as 'lovely creations'.[45] This reflects a growing appreciation of a style which since the 1840s had been languishing in the wilderness of Ecclesiological disapprobation while the use of revived 'Middle Pointed' style was promoted. Perpendicular style as a source was gradually rehabilitated from the 1870s, before entering the architectural mainstream in the decades which followed.

Crowther described his restoration of the Cathedral as 'of so difficult, and not unfrequently of so critical a character, as to require great caution, and necessarily entailing a slow rate of progress in its execution'.[46] Emphasizing that he had reproduced the medieval work he found, he blamed the early nineteenth-century work for significantly weakening the structure. His careful restoration was accompanied by the production of detailed drawings and painstaking attempts to retrieve the building history. However much the loss of original medieval work may be regretted, Crowther's restoration of the nave is a monument to Victorian scholarship and to the Victorian conservation movement. Had the work been undertaken a few decades earlier or by a less able practitioner, there can be little doubt that we would be far less well informed about the history and development of the building.

Crowther added a north porch (dated 1888), replacing a predecessor mentioned in documents which must have been lost during or before the eighteenth century. The exterior is richly

44 Matthew Hyde, 'Joseph Stretch Crowther' (MA dissertation, University of Keele, 1992), p. 24.

45 Crowther, *Cathedral Church*, p. 26.

46 *Ibid.*, preface (unpaginated).

carved and there is a heated room on the ground floor and an upper muniment room, with a fine stone vaulted ceiling. Security and fireproof qualities were driving factors in the design. Crowther's south porch of 1891 is richly treated outside, with an attached stair-turret. In the following year he created a baptistery in the south-west corner of the building beside the south porch, occasioning a minor extension and a new window. Another addition by Crowther, east of the chapter house, is the Fraser chapel of 1890. It was erected in memory of Bishop Fraser, apparently re-using the aisle wall, but the exterior was damaged in 1940. The exterior of the chapel included corbels with heads of Bishop Fraser and Queen Victoria, carved by Ralph Wales of Earp, Son & Hobbs.

The west end of the Cathedral was remodelled by Basil Champneys (1842–1935), to mark Queen Victoria's Diamond Jubilee of 1897 and was dedicated in 1898. Champneys' best-known work in Manchester is his magnificent John Rylands Library, built in 1890–99, which doubtless commended him to the Cathedral authorities. The need for a new west entrance was set out by the Dean in 1896, in an interview with the *Manchester Guardian*,[47] accompanied by a drawing of the design by Champneys with only minor differences to that executed. The Dean explained that there was a need to provide a covered way into the Cathedral from the west end on ceremonial and special occasions, with a special vestry for visiting dignitaries, which would 'enhance the artistic value of the west front'. The scheme was the culmination of a protracted design process, during which George Frederick Bodley had been appointed by the Cathedral to act as a consultant, probably partly because the authorities were sensitive to critical press coverage of earlier designs by Champneys; pencil sketches and reproductions of some of these drafts survive in the Cathedral archives.[48] The executed design takes the form of a frontispiece in revived Perpendicular style with a central porch flanked by lower ranges containing the vestries and offices. An offset crocketed turret introduces interest and asymmetry to the design, making visual reference to Crowther's recently completed south porch, which has a similar turret feature. The sculpture of Queen Victoria is by her daughter, the sculptor HRH Princess Louise, Duchess of Argyll.

The provision of accommodation for the Cathedral library and choir soon followed. Champneys drew up designs in 1902–03

47 MG, 5 May 1896, p. 9.
48 MCA, Mancath/2/B/11, Basil Champneys, Records relating to the Victoria porch.

for a building attached by a low corridor to the Jesus chapel, on the south side of the Cathedral. Until that time the Jesus chapel had been used as a library and after the new accommodation was finished it was cleared, plaster was removed, and it was converted to serve as the consistory court. A brass plaque in the chapel records that it had become the property of the Byrom family of Kersal Cell and that they relinquished their rights to it in 1904. Champneys' attached building was described by Nikolaus Pevsner in 1969 (and in revised editions of the *Buildings of England* series) as 'excellent, as one would expect, subdued in contrast to the porches, yet charmingly varied in the grouping and with felicitous decorative passages such as the bay windows'.[49] The building introduces domestic motifs, suited to its use and distinguishing it from the main building. The interior is cleverly designed and the principal original spaces survive largely intact, with a good range of original interior features and furnishings.

Additions to the annexe were made by the Cathedral architect Percy Scott Worthington (1864–1939), of the firm of Thomas Worthington & Son, in 1933–34. The work was designed to accommodate the choir school of thirty boys, providing classrooms, refectory, kitchen, and common room. Worthington's work is understated and sensitive, adopting a severely stripped Tudor domestic idiom including more explicit ecclesiastical references, with the use of traceried windows, for the part nearest the main building. A notable feature of this work is the carved relief panel showing the Virgin and Child, St Denys, and St George by Eric Gill (1933).

The Cathedral was badly damaged by a bomb during the Second World War. Restoration was undertaken by Hubert Worthington (1886–1963), who had succeeded his half-brother Percy as Cathedral architect. The Ely chapel, projecting on the northeast side, was completely destroyed, as were parts of the outer walls of the east end, including almost the whole of the Lady chapel, part of the Fraser chapel, and the chapter house roof. The reinstatement of the Lady chapel in particular is a triumph of sensitive and undemonstrative design, dignified and restrained, making no effort to compete with the older work around. It is adorned by a gilded sculpture of the Virgin and Child by Charles Wheeler. The choir stalls and choir ceiling were restored by the firm of James Brown of Wilmslow, who assembled a team of craftsmen for the purpose. Since that time, various alterations and repairs have been undertaken under the supervision of

49 Nikolaus Pevsner, *The Buildings of England: Lancashire 1, The Industrial and Commercial South* (Harmondsworth: Penguin, 1969), p. 276.

successive Cathedral architects, including Harry Fairhurst, Barry Rawson, and more recently John Prichard and Ulrike Knox. One of the most substantial challenges followed damage caused by a terrorist bomb which exploded nearby in 1996.

Manchester Cathedral is one of the most rewarding and significant medieval buildings in the region, reflecting the ambitions and achievements of aristocratic and mercantile patrons in national, rather than merely local, contexts. The survival of the original domestic building of the College is remarkable, while the architectural, stylistic, and artistic influences and connections are worthy subjects for further research. In addition, the story of rebuilding, repair, and restoration represents a fascinating record of changing attitudes, practices, and perceptions over succeeding centuries.

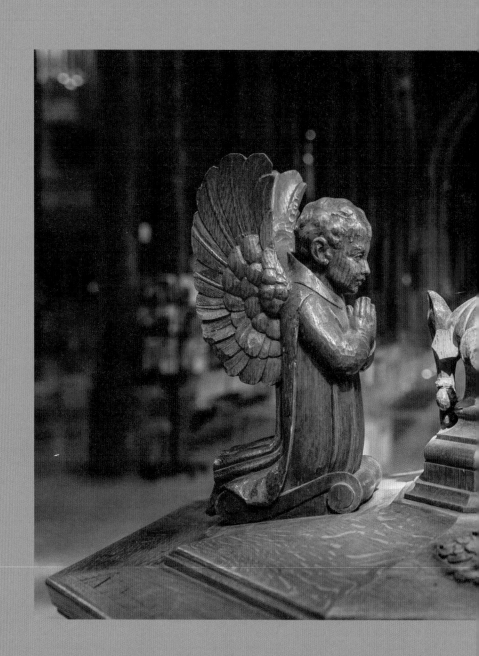

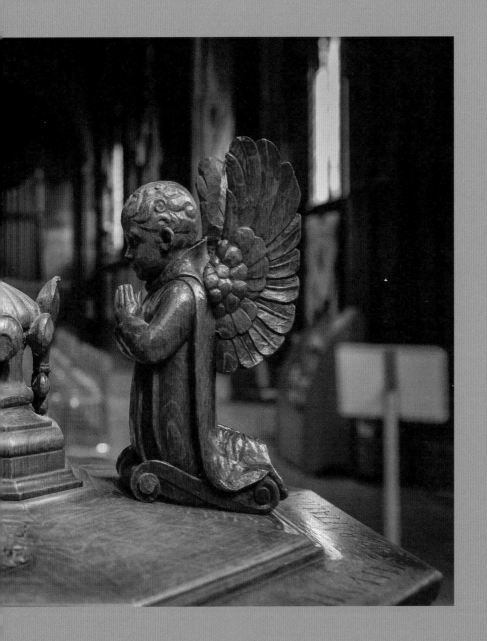

Music

SARAH BOYER

P ROVISION FOR MUSIC was made from the foundations of the Collegiate Church, and early documents list four clerks and six choristers among the College officers. This is a small number of singers, smaller than might have been expected for such an establishment, and it was to have far-reaching consequences, both musically and legally. Numbers shrank further when the Elizabethan charter of 1578 confirmed the singers as four men and four boys. By then the choir[1] was well established, judging from the number of requests it received to sing at funerals 'after the old custom'. Sixty years later, details of its business begin to emerge when appointments and dismissals are recorded, together with attempts by the College to impose order and raise musical standards. Commissions for new organs are noted, and the body responsible for each is named.

The church had divided loyalties, being both a Collegiate Church and a parish church. As a result, the building was maintained by College and parish, with clear lines of demarcation between the two; goods and equipment were purchased exclusively for College or parish use (including an organ apiece), and a style of worship was practised which was specific to each. Over the years the relationship became increasingly uneasy, and tensions surfaced from time to time. Each had an effect on music, and the type and choice of pieces for services, be they collegiate or parish, could and did provide a flashpoint for tensions, both within and outside the church.

Until well into the nineteenth century, evidence for what the choir sang is patchy. No choir or organ book is known to

1 The term 'choir' (as distinct from any chantry choir, the voluntary choir, or the cantata choir) is used here to refer to the statuable body of singers.

Previous spread:
'Christ's cross,
carried on wings'

have survived, and information rests on chance references and sporadic music publications. From 1863, when the precentor's registers begin, all service music is identified; and the result is a record, unique to this Cathedral, of what was actually sung: far more useful, in that sense, than a venerable manuscript. Evidence for how the choir sang is also patchy, and not encouraging, if the occasional eye-witness account can be believed.

With the twentieth century came a sense that the Cathedral was drawing breath and taking stock, both of itself and of its relationships with the city of Manchester and beyond; the twenty-first century is concerned with renewal. At every stage, music is involved. As a result, provision for music, be it musicians, instruments, or repertoire, can be seen as a mirror to this institution. Though driven in part by its own aesthetic, music presents an acutely sensitive indicator of a church's health, wealth, standing, relationships, and liturgical proclivities; and through it can be traced the changes in each.

Manchester's Collegiate Church was created out of St Mary's Parish Church in 1421. Its founders, Thomas de la Warre and Thomas Langley, Bishop of Durham, aimed 'from certain pious and rational [*causes*, or perhaps *premises*] ... towards the augment of divine worship'.[2] Langley and his advisors[3] were responsible for the number and make-up of the College personnel ('and in and of the said church a certain college, consisting of one master, or keeper, and of so many fellows, chaplains, and other assistants, as to the same Bishop, John, Nicholas, Richard, and Richard, and to the aforesaid Thomas de la Warre, shall seem expedient'),[4] which was defined the following year, as 'one warden, or master, eight fellows, four clerks and six choristers'.[5] The new church, housed in St Mary's, would serve both parish

2 'ex certis ... [*causis*, vel forsitan *premissis*] piis et racionabilibus ac ad divini cultus augmentum': Thomas de la Warre to William, Bishop of Coventry and Lichfield, presenting John Huntingdon, first Warden of the College, 23 November 1422, in Samuel Hibbert-Ware, *The History of the Foundations in Manchester of Christ's College, Chetham's Hospital, and the Free Grammar School*, 3 vols (London: William Pickering, 1834), vol. 2, p. 173.

3 John Henege and Nicholas Motte (parsons of Swineshevede), Richard Lumbard (former parson of Holtham), and Richard Frith.

4 'et in et de eadem ecclesiâ quoddam collegium, de uno magistro sive custode capellano, et de tot sociis capellanis et aliis ministris, quot eisdem Episcopo, Johanni, Nicholao, Ricardo et Ricardo, ac praefato Thomae de la Warre videbitur expedire': First Charter, 22 May 1421. A copy is displayed in the Cathedral, and a translation given in Hibbert-Ware, *History of the Foundations*, vol. 2, pp. 40–1.

5 'uno magistro sive custode capellano et octo sociis capellanis quatuor clericis et sex choristis': Huntingdon's letter of presentation, *ibid.*, p. 173.

and college, and the project had the consent of the parishioners.[6] In keeping with this dual function, the College retained its allegiance to St Mary, taking Denys and George as additional patronal saints. Its warden was also rector of the parish, and the fellows included two parish priests (as well as two canons and four deacons). The building was maintained by the College (who had responsibility for the quire – the area in the main body of the church, east of the nave and transepts – and organ, east end, and chapter house) and the parish (who maintained the nave [and organ if it had one], tower, bells, and churchyard).[7]

Music was now needed for two types of service. College worship, or 'cathedral service',[8] took place in the quire and was the more elaborate: it included daily mass, vespers, compline and other canonical hours, psalms, and processions. The music would have been, in the main, plainsong chant and faburden[9] (and, from the 1460s, probably some polyphony, at least in the more important services), sung unaccompanied. At this stage the organ would not have accompanied or even doubled the singers, but, where present, was used to enhance the general effect – as 'a producer of cheerful though fairly random noise'.[10] Parish services, held in the nave, probably continued much as before (that is daily matins, high mass, and vespers), sung in plainsong but possibly in faburden, given that professional musicians were now on hand.

6 MCA, MS 26, Letter from the Churchwardens and Gentlemen of the Parish of Manchester, in Christopher Hunwick, 'Manchester Cathedral Archives', *Lancashire Local Historian* 19 (2006), p. 5.

7 The parish also paid the bellringers, sexton, and clerk: JRL, MS Eng. 97, Accounts of the Churchwardens of Manchester, 1664–1711. Parish and College functioned independently for centuries, each producing its own set of accounts. This arrangement ceased in 1933, when the Parish of Manchester Revenues Measure gave responsibility for the [entire] fabric to the dean and chapter.

8 That is, 'choral service'. The term 'cathedral service' was used throughout the sixteenth and seventeenth centuries, sometimes disparagingly, as a means of distinguishing the sung service from the said (or parish) service. Bishop Gastrell's Visitation of 1717 gives an example of such usage: *Notitia Cestriensis, or, Historical Notices of the Diocese of Chester by Bishop Gastrell. Vol. II. Part I*, edited by F. R. Raines, CS os 19 (Manchester: Chetham Society, 1849), p. 57.

9 This was the practice of harmonizing the simpler types of chant, especially psalm chants, by improvisation. At its most simple the chant (given in the cantus, or upper, line) was doubled at the 6th below, by the tenor. During the fifteenth century a third line, the altus, was often added, in parallel 4ths below the cantus. Finally, in the sixteenth century a free bass was often used: then the altus, if used, moved freely and fleshed out the harmony.

10 Roger Bowers, 'The Liturgy of the Cathedral and its Music, *c.* 1075–1642', in Patrick Collinson, Nigel Ramsay, and Mary Sparks (eds), *A History of Canterbury Cathedral, 598–1982* (Oxford: Oxford University Press, 1995), p. 417.

There is some evidence to suggest that the College inherited an organ from St Mary's (at least one instrument would have been needed for its services), situated on the screen and accessible by stairs. Hudson refers to a source giving the dimensions of the quire[11] as thirty yards in length 'from the two great pinnacles, where the organs stood betwixt, to the east end of the church'.[12] Certainly the size and status of St Mary's make it more than likely that the building would have held an organ. Both Arrowsmith and Hartwell suggest the church was large, possibly equalling the present Cathedral in length,[13] with two chantries: and it stood within a huge and increasingly wealthy parish of sixty square miles, containing at least thirty townships.

By the 1450s the choir was up and running. Warden Huntingdon left payments (of 3s 4d and 1s respectively) to those clerks and choristers who attended his funeral in 1458,[14] and by the sixteenth century it was well established. Thomas Pendleton's will of 1534 wanted 'ye qwere to be ordred after ye olde accustome',[15] and in 1545 William Trafford directed that 'my saule masse and dirige shalbe songen in the quere in the churche of Manchester'.[16] Choir numbers were maintained, and, certainly in the 1540s, singers were being replaced. Two documents, of 1545 and 1547–48,[17] reveal that while the number of fellows may have fluctuated (five in a total of eight in 1545, and six out of eight in 1547–48), the number of parish priests and singers is maintained, despite changes of personnel.[18] It is now, in 1545, that singers are first identified:

11 The new quire built by John Huntingdon (Warden 1422–58).

12 London, College of Arms, MS C.37 (a copy of an earlier source, now lost), in H. A. Hudson, 'The Organs and Organists of the Cathedral and Parish Church of Manchester', *TLCAS* 31 (1913), p. 111.

13 See, in this volume, Peter Arrowsmith, Chapter 2; Clare Hartwell, Chapter 9.

14 J. P. Earwaker, 'The Will of Warden Huntingdon, 1458', *TLCAS* 3 (1885), p. 152.

15 G. J. Piccope (ed.), *Lancashire and Cheshire Wills and Inventories, Vol. 2*, CS os 51 (Manchester: Chetham Society, 1860), p. 187.

16 His will was made on 27 December 1545: *ibid.*, p. 64.

17 Commissions of Enquiry, 1545 and '1547–8 2 Edward VI', in F. R. Raines (ed.), *A History of the Chantries within the County Palatine of Lancaster: Being the Reports of the Royal Commissioners of Henry VIII., Edward VI. and Queen Mary*, CS os 59, 60 (Manchester: Chetham Society, 1862), vol. 1, pp. 7. 19.

18 Nomenclature is not always consistent in these documents: parish priests, for instance, are styled as 'curates' or 'incumbents', while adult singers are given as 'deacons' or 'clerks'; the boys are consistently 'choristers'.

Deacons	Choristers
Rauff Prowdelove	Edwarde Worthington
John Smythe	Alexandre Barneslawe
George Natchell	James Smythe
Edwarde Burye	Francys Mosselye
	Henrye Dogeson
	Henry Michell

Two years later (John) Prowdelove and Bury/e have been replaced by John Glover and Thurston T[h]ompson (though whether voice for voice is not known); remarkably the same boys are in place. The men were quite young (three were 26 in 1547, and the fourth, John Smythe, was 30; the boys' ages are not given), and they were paid £5 14s per annum; the boys received £4 7s 8d. They were still singing the following year, when the College was dissolved, and each man received a payment of £5 6s, virtually a year's salary.

Music was evidently important in the College, and a number of chantry founders specified that their commemorations be sung rather than said. John Huntingdon provided for a sung requiem,[19] and James Stanley, in his will of 20 March 1514, left £20 per annum 'for ... two priests to sing in my said chapel'.[20] Thomas Pendleton was more specific, leaving 'To an honest and vertuous prest for ye space of fyve yers next ensuing my dethe yerlye iiij li [£4] to synge for my saule and my frends saules and to saye masse ons in the weke of scala celi.'[21]

By 1523, the Collegiate Church had approximately nine chantries,[22] each with at least one priest;[23] twenty-five years later, at the dissolution, seven chantry priests were known to be serving in the church.[24] Though their duties varied according to the

19 On the day following the anniversary of his death he wanted 'a Mass of Requiem ... with Note': *Notitia Cestrensis*, Vol. II Part I, pp. 62–3.

20 Hibbert-Ware, *History of the Foundations*, vol. 2, p. 57.

21 Piccope (ed.), *Lancashire and Cheshire Wills and Inventories*, p. 187.

22 Seven were founded between 1498 and 1523: two were older: Raines (ed.), *Chantries*, pp. 25–6.

23 The Stanley bequest allowed for two priests. Bexwicke's bequest, in 1509, made provision for up to four: Raines (ed.), *Chantries*, p. 49; see discussion below.

24 Each was awarded a pension at the dissolution, and each is named: Edward Baines, *History, Directory, and Gazetteer of the County Palatine of Lancaster* (1824–5), in Samuel Hibbert-Ware, *The Ancient Parish Church of Manchester, and why it was Collegiated* (Manchester: T. Agnew, 1848), p. 69.

individual bequest, chantry priests would normally be expected to recite (or sing) a private mass each day for their founder, and, in parish churches, to assist the priest in singing the daily services. If there were enough men, they formed a plainsong choir; both Raines and Bowers cite numerous instances where daily parish services were carried by these men.[25]

Their presence in the Collegiate Church, where they were treated as members of College, with the same rights as the fellows,[26] raises questions about the day-to-day size of the choir, at least as far as the men are concerned. They probably sang parish services, but whether independently of, or in conjunction with, the College choir[27] is not known. But in College services, some at least were expected to participate fully. Huntingdon intended his chantry priest to 'be attendant in the Quere of the said College Church, according as other Chantry Priests are'.[28] Bexwick's bequest to the Jesus chapel in 1509 provided for up to four chaplains

> ... in the said Chapel or Collegiate Church ... either to celebrate and keep half of the choir, or in the choir ... to celebrate early morning mass, vespers, complin, and other canonical hours, and all of them in the same to chant, read and officiate, according to the ordinal and office, or according as other Conducts, Priests and Fellows of the aforesaid College do ...[29]

They are unlikely to have sung anything more elaborate than plainsong, though: only very rarely are chantry priests known to have sung polyphony.[30] But the resultant ensemble could have numbered about thirteen men (with a possible nine chantry priests and four statutory men) and six boys, a much more workable size and balance. The effect on the sound and the services must have been considerable when, after 1548, the chantry priests sang no more.

Quite what the (statutory) choir was singing is not known, though occasional glimpses survive of its repertoire. One dates from 1533, when Henry Turton, one of the fellows, drew up his will.[31] He made three bequests of music, including two to

25 Raines (ed.), *Chantries*, pp. 49–50; Roger Bowers, 'Liturgy and Music in the Role of the Chantry Priest', *Journal of the British Archaeological Association* 164 (2011), pp. 130–56.

26 Indenture, 1 December 1509, in Raines (ed.), *Chantries*, p. 49.

27 From now on, references to 'the choir' will be to the statutory or College choir, unless otherwise stated.

28 *Notitia Cestriensis, Vol. II Part I*, p. 61.

29 Raines (ed.), *Chantries*, p. 49.

30 Bowers, 'Liturgy and Music', p. 131.

31 Piccope (ed.), *Lancashire and Cheshire Wills and Inventories*, pp. 12–13.

the College. The first was 'all my pryksonge[32] bookis of masse, antems[33] and sqwares'. These would have been probably hand-written copies of polyphonic music (whether in choir-book or part-book format is not clear), as the earliest printed polyphony in England dates from 1530. There were evidently quite a few of them: Turton refers to 'all', not just 'my', books. They may have been compiled for his own use (i.e. they were not the remnants of a set), possibly in order to follow the service, or for study.[34] They were obviously dear to his heart, since, other possessions notwithstanding, these are the first items he gives away. As well they might have been, as even for the time they are rare, and some are cutting-edge, compositionally. The critical term is 'sqware', that is music using a pre-existing bottom line, a technique found in fifteenth- and sixteenth-century English music of various styles and genres: when re-worked the borrowed material can appear in any line/s, decorated or presented literally, although squares can be presented in monody as a basis for unwritten polyphony. That Turton puts 'sqware' into a different category here, distinct from 'masse' and 'antem', might imply monophonic presentation,[35] though his umbrella term 'pricksong' rather negates that. The date of 1533 is an early one for such music: currently some of the earliest examples known are three masses found in the Gyffard part-books, but they were not begun until the 1560s.[36]

They are unlikely to have formed part of the choir's repertoire, though: this bequest was made to the College, and not 'to ye use of [the] qwer', as Turton worded a subsequent gift in his will. But their presence in Manchester suggests that one member of the College at least was very much aware of current developments in liturgical music.

The choir did receive a 'new ymnall' for its use, which the precentor was directed to copy.[37] (Music copying was a traditional part of a precentor's duties, for which he would be paid extra.) Turton's wording, in his choice of adjective and noun, might

32 That is, mensural music, probably polyphony.

33 Piccope (ed.), *Lancashire and Cheshire Wills and Inventories*, p. 13. Turton probably means 'motet' here. Strictly speaking, the term 'ant[h]em' means 'antiphon'; less strictly, anything sung antiphonally.

34 Several singleton part-books survive which appear to have the former function, including Oxford, St John's College, Music MSS 180, 181; London, LPL, MS 764.

35 Margaret Bent, 'Square', *Grove Music Online*, https://doi.org/10.1093/gmo/9781561592630.article.26475, accessed 12 August 2010.

36 London, BL, Additional MSS 17802–5. One mass is by William Whytbroke and two by William Mundy, described as 'apon the square'.

37 This was Turton's twelfth bequest: 'a new ymnall to ye use of qwer for ye pre[centor] to ocupy'.

suggest this was a printed book, though his description of the other music bequest (his fourteenth, to Sir John Adamson) as 'a pryntyd musyke boke' rather negates that. This would have been for the sole use of the choir. The congregation would not have had access to such a book: indeed, congregational participation in the services was virtually non-existent at this time, as it was in the rest of the country, and confined to said responses, repeating the General Confession, the Lord's Prayer, and Responses to the Commandments.[38]

Fifteen years after Turton drew up his will, the College was no more, having been dissolved in 1547. The warden had been deprived and College House (residence of the collegiate body) given to the Earl of Derby, who turned it into a vicarage. He did, however, provide three or four ministers to officiate in the church.[39] Services would have reverted to the 'parish' variety, and music provision to its former, simpler function. 'Cathedral service', with its complex liturgy, elaborate music, and professional choir, was at an end, and also the employment and careers of several professional musicians.

With Mary's accession to the throne in 1553, the liturgy changed again. In many respects the Queen moved cautiously at first, waiting for Parliament to repeal the Act of Uniformity and restore the Roman form of worship as it existed in the final year of Henry VIII's reign. Formal reconciliation with Rome and the restoration of papal supremacy were achieved a year later, in November 1554.[40] Then the old form of Latin worship blazed forth, with as much pomp and splendour as could be managed. It was a wonderful time for churches: fabric and organs were repaired, old part-books brought back into use, and liturgical music was copied and even printed in England once more.[41] Manchester was dealt with quite early on in Mary's reign, and the College was re-founded in 1556.

Mary's charter is now lost, but Hollingworth maintains that she 'appointed one master or keeper, eight fellowes chaplaines, four clerkes, and six choristers', in addition to confirming and re-establishing the statutes of the first foundation. In theory the

38 Nicholas Temperley, *The Music of the English Parish Church*, 2 vols (Cambridge: Cambridge University Press, 1979), vol. 1, p. 37, has found no evidence of congregational participation in church music before 1559.

39 Richard Hollingworth, *Mancuniensis: or, a History of the Towne of Manchester and what is most memorable concerning it* (Manchester: William Willis, 1839), p. 63.

40 Temperley, *Music*, vol. 1, p. 27.

41 *Ibid.*; Robert R. Steele, *The Earliest English Music Printing: A Description and Bibliography of English Printed Music to the Close of the Sixteenth Century* (London: Bibliographical Society, 1903).

number and balance of the choir was retained, but in practice it seems that the number of boys varied: two sources of *c.* 1556 cite four, which would give a balance of four to four.[42] Provision continued to be made for a precentor (who was responsible for the direction of choral services) but, as before, no mention is made of an organist.

There was much to do: the music, liturgy, and churchmanship would have been new for the boys and unfamiliar to those men that had returned to the choir,[43] and they were on their own now, with no chantry priests to augment the sound. But they must have accomplished something fairly quickly as, in the same year, Thomas Grene, yeoman of Manchester, directed his executors to 'caus masse and dirige to be songen in ye qwere of Manchester wt ye company there to pray for my sawll … accordyng to the laudable custome of ye qwere'.[44] Then, in 1558, all changed again.

Elizabeth inherited a maelstrom of tensions within the Anglican church, and a great deal of unease concerning the position of Manchester, situated within a county seen as a hotbed of Puritanism and Roman Catholicism. So, the Crown promoted the College as 'a noble and useful foundation for learning and propagation of religion in these northern parts',[45] and trimmed its sails financially.

The College was in serious trouble by the 1570s, hated in the town and being systematically stripped of its assets by the Warden, Thomas Herle. It might have been ruined but for the intervention of Oliver Carter, one of the fellows, who contacted (among others) Alexander Nowell, Dean of St Paul's Cathedral from 1560 until his death in 1602 and a fervent Lancastrian, who set up an enquiry. The Commissioners met in September 1576, and one of the sixty or so witnesses was Robert Leighe, 'one of the foure clerks of the sayd College', who complained

42 Thomas Tanner, *Notitia Monastica: or, An Account of all the abbies, priories, and houses of friers, formerly in England and Wales*, edited by Joseph Nasmith (Cambridge: John Nichols, 1787); G. T. O. Bridgeman, *The History of the Church and Manor of Wigan, in the County of Lancaster*, 4 vols, CS ns 15–18 (Manchester: Chetham Society, 1888–90), in Peter le Huray, *Music and the Reformation in England, 1549–1660* (Cambridge: Cambridge University Press, 1978; first publ. 1967), p. 16.

43 Temperley, *Music*, vol. 1, p. 37, suggests that churches coped with the continual changes of liturgy in the second half of the sixteenth century by making the smallest possible alterations to their usual music practice.

44 Piccope (ed.), *Lancashire and Cheshire Wills and Inventories*, p. 148.

45 John Strype, *Annals of the Reformation and Establishment of Religion, and other various occurrences in the Church of England, during Queen Elizabeth's happy reign*, 4 vols in 7, in *Works* (Oxford: Clarendon Press, 1824), in Hibbert-Ware, *History of the Foundations*, vol. 1, p. 81.

of not being paid.[46] As a result, the warden and other fellows implicated in the affair were dismissed and the Queen re-founded the College in 1578 under the name of Christ's College in Manchester. Her charter (of which a copy is on display in the Cathedral) sets out arrangements for attendance, salaries, sources of revenue, and so on, and identifies College posts and personnel. In line with current thinking, the warden was to be appointed by the Crown; the four (no longer eight) fellows were to be 'godly, honest and learned men ... able to teach the people'.[47] The size (and balance) of the choir was changed: 'that there be in the said college for ever, four laymen and four children, skilled in music, to sing, say prayers, read chapters and continue other divine exercises, in the said collegiate church'.[48] Once again this probably confirmed existing practice, since thirteen years previously, at the 1565 visitation, the choir was singing with a ratio of four men to four boys.

Singers are named in the visitation documents of 1565 and 1578 and in Elizabeth's charter of 1578, and we meet the Leighe / Lyghe family, who would be with the choir for the best part of eighty years:

	1565 Visitation[49]	1578 Visitation[50]	1578 Charter[51]
Men:	Robert Leighe	Robert Lyghe	Robert Leighe
	Charles Leighe	Charles Lyghe	Charles Leighe
	John Smith	Philip Gosnehall	Philip Gosnett
	John Glover[52]	John Glover	John Glover
		John Gee	

46 Oxford, Bodl., MS Tanner 144, Proceedings before Commissioners inquiring into the state of Manchester Collegiate Church, 1576, fol. 47v.

47 Hollingworth, *Mancuniensis*, p. 86.

48 Hibbert-Ware, *History of the Foundations*, vol. 1, p. 92. The men were paid fourpence-halfpenny and the boys twopence-halfpenny farthing for each day's attendance, and were promised that any vacancy (no matter how frequent) would always be filled.

49 Chester, Cheshire Archives and Local Studies, EDV 1/3, Chester Diocesan Correction Book, 1563–65, fol. 64r, gives the clergy list for the 1565 visitation of the Collegiate Church.

50 York, BIA, V/1578–1579, 1578 visitation of the Collegiate Church. Documents include a roll of names.

51 A copy is displayed in the Cathedral, and a translation given in Hibbert-Ware, *History of the Foundations*, vol. 1, pp. 89–99.

52 Possibly the same as was singing in 1547 (see above). He died in 1590: 'John Glover on [sic] of our singinge men' and was buried on 6 September: Ernest Axon (intro.), *The Registers of the Cathedral Church of Manchester: Christenings, Burials, and Weddings, 1573–1616*, edited by Henry Brierley, Lancashire Parish Register Society (Cambridge: Cambridge University Press, 1908), p. 278.

Boys:	William Glover	Hugh Shawcrosse	Hugh Shallcross
	Alex Massye	Mark Leonard	Mark Leonard
	Noe Heaven	William Ellam	William Ellam
	Philip Gosnell	[Robert Walker]	Anthony Glover

As would be expected, the men are the more stable group, and three sing throughout this time. It is likely that Philip Gosnell sang with the choir as boy and man.[53] Unusually, five singing men presented their patents to the visitation of 1578, although the fifth, John Gee, is not mentioned in the charter.

What voice they sang is not known, but the equal ratio of men to boys was not unusual for a collegiate church (cathedrals and other foundations tended to sing two to one).[54] A maximum of four men would give one singer per line, with one remaining, and this equal division between men's voices is found in other choirs, on the rare occasions that an overall balance is specified. Norwich Cathedral aimed for a choir of five countertenors, five tenors and five basses from 1620: the 'extra' voice, for Norwich sang with sixteen men, was to be a countertenor or a bass, never a tenor.[55]

Musically much was now in place at the College: the choir was up to strength, and the personnel stable (boys notwithstanding). But this very stability had potential to cause problems to any cleric with reforming zeal. These men were local, unlikely to move, longstanding members of the choir (some possibly from Mary's time), with more years of service than some senior members of College, and they presented a united front in clinging to the old ways. Each was accused in 1571 of being 'not of sound religion, favoureth papystry & heresies pryvatelye asmuch as lyethe in them & neuer favoureth the professors of the gospell'.[56] Did this affect their singing? Probably not, since most musicians

53 He died in 1604: 'Phillippe Gossenhill one of the Singingmen', and was buried on 2 March: *ibid.*, p. 345.

54 See Le Huray, *Music and the Reformation*, pp. 14–17.

55 Norwich, Norfolk Record Office, DCN 28/1, in Stamford E. Lehmberg, *Cathedrals under Siege: Cathedrals in English Society, 1600–1700* (Exeter: Exeter University Press, 1996), p. 169. Others thought the same about tenors. In 1636, William Laud recommended the appointment of a tenor to Wells Cathedral, noting: 'Soe farr am I from desiring the choice of a tenor in the roome of a basse or countertenor, as that I shall never thinke it fitt, where the number is soe few, to have a tenor chosen at all, where a basse or counter-tenor may be had … I thank you for giveing me an accompt, how unfitt it might prove for your church service to choose a tenor at this present': Wells, Wells Cathedral Library, Ledger Book G, p. 256, in Lehmberg, *Cathedrals under Siege*, p. 169.

56 BIA, V/1571–2, metropolitan visitation of York province, 1571–72.

are fairly adaptable when dealing with a range of musical styles and functions. But it may have affected their churchmanship,[57] and the presence of a sullen group, united in its passive resistance to change, would surely have had a dampening effect on the atmosphere.

The College had an organ, though, much to the irritation of Richard Hall, one of the fellows, who complained to the visitation in 1571 that 'the flore and pyce of our rode loft remaneth wth organnes vppon contrary to my lord byshope hys appointment'.[58] This is the earliest confirmation that an instrument was in place, and it stood on the quire, or rood, screen, the traditional position, and where an organ had been a century earlier.[59] Nothing is known about its function, specification, or maker: possibly it was a choir organ[60] for the use of the College. Perhaps the 'extra' singer noted above was needed as organist: since there was no separate organist's post at Manchester, one of the singers would have been expected to play.[61]

At some point in the next twenty years or so the organ was removed or destroyed, to the delight of some who viewed it as 'another popish remnant for the ungodly'.[62] It took John Dee (Warden 1595–1608) four years to persuade the fellows to accept, and then only grudgingly, the use of an organ in the church. An instrument was finally installed, and Dee noted in his diary for 18 July 1600 that 'the organs, upon condition, was [sic] admitted'.[63] Less than two months later, his efforts would be held against him when he appeared at the Chester Consistory

57 Years later, in 1633, John Leigh, 'Singingman', was one of forty-seven people arraigned for refusing to kneel at the confession, litany, and prayers: BIA, V/1633, fols 611r–612v. Robert Leigh may have been involved in a much more serious incident involving the music, in 1622 (see below).

58 BIA, V/1571–2.

59 See n. 12 above.

60 The 'choir' or 'chair' organ would have accompanied services in the quire. Sometimes the instrument was part of the 'great' organ (used for accompanying singing in the nave); on other occasions it was a separate instrument. Somewhat confusingly the instrument is described in contemporary sources in both singular and plural forms, as 'an organ' or 'a pair of organs'.

61 Such an arrangement was not unusual and seems to have been the norm in cathedrals of the New Foundation until well into the sixteenth century. Even the Chapel Royal did not appoint a separate organist until Queen Elizabeth's reign. Nevertheless, when Manchester used an organist, one-quarter of the choirmen became unavailable.

62 Bodl., MS Ashmole 487, July, September 1600, in Glyn Parry, *The Arch-Conjuror of England: John Dee* (New Haven, CT: Yale University Press, 2011), p. 254.

63 Edward Fenton (ed.), *The Diaries of John Dee* (Charlbury: Day Books, 1998), p. 287.

Court: one of the charges made against him was the introduction of an organ.[64]

Even when compared with other collegiate churches, Manchester's choir was small: Ludlow was singing with six men and six boys after 1547,[65] while Ripon in 1604 had six men, eight boys, and an organist.[66] As a result, the College would have had to choose its music carefully. The choir could just about have sung unaccompanied in six parts, with the boys two to a line and the men one, but it was risky and did not allow for absentees. Anything needing accompaniment would have affected the size of the choir. Since the distinction between parish and cathedral service continued to be maintained, the choir's main duty would have been the sung service on Sundays, with the weekday, or parish service, being said – or sung in plainsong. The difference now was that music in worship was increasingly viewed as a political football, exemplified by the adoption (or not) of metrical psalms.

Metrical psalms first appeared in England in the 1550s and spread like wildfire. Quite apart from the pleasure of community singing – which was great – this was the first opportunity 'the people' had ever had of musical participation in the service, and they seized it with gusto. This played straight into the hands of the Puritans, who argued that music should be an offering made direct to God by the congregation, rather than one made on its behalf by a professional mediator in the shape of a choir; this in turn undermined the need and cost of maintaining a group of singers and an organ.[67] Furthermore, psalm texts were taken from Scripture, they were familiar, and, being sung in homophony, the words were audible.[68] The reaction against metrical psalms came from the educated and aristocratic classes, and was no less immediate, fuelled in part by the poor quality of some of

64 In a hearing on 11 September: Chester Archives and Local Studies, EDV 1/13, fol. 64r.
65 Temperley, *Music*, vol. 1, p. 349. Ludlow was rather unusual: as the seat of the Lord President of the Welsh Marches it became, in Elizabethan times, 'a kind of miniature Chapel Royal'.
66 Le Huray, *Music and the Reformation*, p. 16.
67 Doubtless either or both were an issue in some parishes.
68 Mutterings against 'cathedral music' on the grounds of audibility were growing louder. To give but one example, Erasmus, shortly after visiting Cambridge in 1516, wrote in his commentary on the New Testament: 'Modern church music is so constructed that the congregation cannot hear one distinct word. The choristers themselves do not understand what they are singing, yet according to priests and monks it constitutes the whole of religion': Temperley, *Music*, vol. 1, p. 10.

the Sternhold and Hopkins verses;[69] and debate concerning the role and style of church music became polarized on social and sectarian lines. Gradually a working compromise was reached, and by the 1570s most parish churches were incorporating metrical psalms into their Sunday services (that is, after the sermon, in the nave, with congregation and choir), although the doctrinal and legal case for doing this does not seem to have been argued. There is no reason to suppose that Manchester did things differently, but it meant that 'cathedral service' had to function in an uneasy atmosphere, not helped by the state of the building or the Calvinistic leanings of its churchmen.

The 1590 visitation found that 'none of the Fellows, Ministers or Choristers, do wear Surplices in time of Prayers and Ministration of the Sacraments, which is indecent and offensive in such a Collegiate Church and contrary to Her Majesty's Laws and Injunctions in that case provided'.[70] After one of the College clergy described the surplice as 'a ragg of the Pope, and a mightie heresie in the Church',[71] it could have come as no surprise that the next visitation, two years later, found the College (i.e. parish) chaplains administering the sacraments without a surplice, and deficient in teaching the catechism, maintaining the registers (of christenings, marriages, and burials), and visiting the sick. The clerk, George Bibbie, was 'unlearned and unfitt for that office, he cannott read the first lesson'.[72] Books, church goods, and vestments were in poor repair, and stored carelessly, and the church was dirty. Bells were rung 'more than is necessarie at Burialls'.[73] The churchwardens had not kept up with repairs to the fabric (a date was set by which work should be completed):[74] nor were they providing sufficient 'Collectors for the poore', as required by the statutes.

In October 1622, it was the turn of the College authorities. The Warden, Richard Murray, was ordered to appear before the Visitor (i.e. the Bishop) as a result of 'the Quire or Chancell being

69 A good example is Sternhold's treatment of Psalm 34:8–10: Temperley, *Music*, vol. 1, p. 23.

70 The visitation took place on 31 May 1590, and the College was given until the following Michaelmas to make improvements: 'A Visitation of the Diocese of Chester, 1590', in F. R. Raines (ed.), *Chetham Miscellanies, Volume V*, CS os 96 (Manchester: Chetham Society, 1875), p. 4.

71 *Ibid.*, p. 5.

72 William F. Irvine, 'Church Discipline in the Sixteenth Century, as shown by Extracts from the Bishop of Chester's MS Visitation Books for the Deanery of Manchester', *TLCAS* 13 (1895), p. 64.

73 *Ibid.*

74 The Feast of the Annunciation, 25 March or Lady Day: Irvine, 'Church Discipline', p. 64.

farre out of repaires through his defaults'.[75] Murray appears to have been universally loathed, and services were being held in an increasingly mutinous atmosphere.[76] Many parishioners now refused to kneel before receiving communion, and earlier that year two incidents came to light concerning the music. The first was a spat between one Thomas Robinson and the organ blower, who was accused of saying that 'Ralph Lownde was damned for blowing the Organs'.[77] Robinson was obviously unafraid of authority, since Mr Lownde was no mere organist's assistant, but clerk to the College.[78] The second disrupted the service itself. On Saturday 13 August, it was reported that 'Robert Leech[79] and several others joyned with those that began to sing the Psalme before the Organes played, and singing in a contrary Tune to the Organes causing a confusions [sic]'.[80] This is an ugly incident, particularly if it involved the choir, and how it all calmed down has not been recorded: nor is it known whether the perpetrators were bent on mischief or wanting to make a point. The subsequent atmosphere must have been poisonous.

By 1630 the choir was barely viable, and comprised three men and a boy.[81] Salaries were in arrears, vacancies remained unfilled, the organ was not being maintained, and the building was unsafe: 'the choir-part was growing very ruinous, and that the roof was so crazy as to be in danger of falling'.[82] So bad was the quire 'that many parishioners durst hardly fetch thence the spiritual food of their souls for the danger of their bodies'.[83]

75 Piccope's MS, p. 79, in *The Rectors of Manchester and Wardens of the Collegiate Church of that Town*, 2 vols, CS ns 5, 6 (Manchester: Chetham Society, 1885), vol. 2, p. 113; twenty-two volumes of Piccope manuscripts are held by Chetham Library.

76 Hollingworth, *Mancuniensis*, p. 109, in Raines, *Rectors and Wardens*, vol. 2, p. 113, talks of his 'arrogance' in requiring 'the Fellows, Chaplains, singing men and Choristers, to go before him to church', and was unhappy with his ostentatious style of living. Murray also had a disagreement with the Bishop of Chester over seating precedence in the Collegiate Church: Hibbert-Ware, *History of the Foundations*, vol. 1, p. 138.

77 Piccope's MS, p. 80, in Raines, *Rectors and Wardens*, vol. 2, p. 113.

78 A post he held until his death in 1636: Burial Register, 24 March 1636, in Hudson, 'Organs and Organists', p. 116.

79 Could this have been Robert Leigh? One of that name was named as singing-man in 1604: Axon (intro.), *Registers*, p. 347. The family had also long been connected with the choir, and there had been controversy concerning their churchmanship in 1571 (see above).

80 Piccope's MS, p. 80, in Raines, *Rectors and Wardens*, vol. 2, p. 113.

81 'Lancashire MSS Correction Books', in *Notitia Cestriensis, Vol. II Part III*, edited by F. R. Raines, CS os 22 (Manchester: Chetham Society, 1850), p. 132.

82 Hibbert-Ware, *History of the Foundations*, vol. 1, p. 149.

83 Charter of Charles I (1635): *ibid.*, vol. 1, p. 153; for a translation, see *ibid.*, pp. 152–67.

Everyone blamed Murray, who was continually absent, and a petition was made to the King. Charles swung into action. The case was considered by the Ecclesiastical Commissioners, who in 1633 found, among several other concerns, the church 'altogether out of order, where there is neither singingmen, nor quiristers, nor organ fit to be used'.[84]

After much deliberation Murray was dismissed, and Charles dissolved and re-founded the College in 1635, retaining the name of Christ's College. His charter, a copy of which is on display in the Cathedral, is detailed and thorough, and acknowledges the situation and the effect it was having: 'for many years together the places of the fellows, chaplains, laymen, and choristers, have remained void, to the disgrace of the divine worship, and detriment of the college and the parishioners'.[85] This time the College, finally, began to put its house in order: a 'Chatechiser' was appointed to teach on Sunday afternoons,[86] vacancies were to be filled within thirty days,[87] and the Bishop (of Chester) was to make a triennial inspection.

Places in the choir were to be confirmed after a successful probationary period, and a disciplinary procedure was drawn up for miscreants. Posts of master of the choristers, instructor (of the boys), organist, and bailiff were identified and were to be filled from among the men, each being elected annually in December. From now on the men had the opportunity of taking a far more active part in College worship: 'The singing-men, for the tyme to come, may bee clerks as well as laycks, and preach if they can.'[88]

The number and balance of the choir was retained as four to four, although as the organist continued to be taken from the singers this could vary in practice. The men are named as Charles Leigh the elder (who became master of the choristers), (William) John Leigh (organist), Charles Leigh the younger (bailiff), and Peter Starkey/is.[89] The boys were Charles Leigh [sic], Jonathan Ridge, George Warburton, and Edmund Hall. Much was now in place for the choir, not least a fresh start, but any hopes for a revitalization of College music were thwarted by the antipathy

84 *CSPD 1633–4*, p. 444.

85 Hibbert-Ware, *History of the Foundations*, vol. 1, p. 156.

86 10 August 1637: Manchester, MCA, Mancath/2/2/1, 'A Register booke for the Colledge of Christ in Manchester founded by Kinge Charles, the 2d of Octobe. Ao dmi 1635', p. 27.

87 For details of the appointment process, see Hibbert-Ware, *History of the Foundations*, vol. 1, p. 156.

88 Richard Johnson (the Subwarden) to Humphrey Chetham, 7 September 1635, in Hibbert-Ware, *History of the Foundations*, vol. 1, p. 393.

89 MCA, Mancath/2/2/1, Chapter register, fol. 4r.

of the new Warden, Richard Heyrick (Warden 1635–67), who 'stamped on musical services with both his feet'.[90]

We do at least know more about the singers, and, thanks to the chapter registers which have survived from 2 October 1635, names now become personalities. Thus, Peter Starkey was sacked in 1638, following repeated warnings. Notwithstanding his 'contempts and neglects of his place', his musical shortcomings (an 'insufficiency both in skill and voyce' – a nice distinction)[91] were probably the final straw for the College. John Leigh, on the other hand, kept his place, despite regular appearances before the warden and fellows over the next five years, 'convicted to have been notoriously drunken contrary to his faith and promise given divers tymes';[92] possibly, as organist, he was too valuable to lose.

The College probably continued to function normally until about 1641: the warden preached there on 8 July 1640,[93] and a year later the fellows were still dealing with John Leigh. From then on it is difficult to imagine 'cathedral service' continuing, when throughout the country choir music and instruments were being systematically destroyed: indeed, organs were specifically targeted in the Ordinance of 9 May 1644, drawn up 'For the speedy demolishing of all organs, images, and all matters of superstitious monuments in all Cathedralls, and Collegiate or Parish Churches and Chapels, throughout the Kingdom of England and the dominion of Wales'.[94] Church buildings were attacked and desecrated: many were used as ammunition warehouses, military staging posts, and even prisons.

Manchester itself had been under siege in 1642, and its deeds were forcibly removed after an ugly incident seven years later. On 5 November 1649, the Independents 'sett up a meeting in the Colledge ... the Chapterhouse door and the Colledge chest were broke open, and the Colledge deedes were seised on by some souldiers and sent up to London'.[95] By 1656, the College clergy, including the warden, were in prison. Three years later, the College was sequestered and its lands, revenues, and goods seized.

90 S. Andrew, 'Music in Lancashire during the Eighteenth Century', in Henry Fishwick and P. H. Ditchfield (eds), *Memorials of Old Lancashire* (London: Bemrose, 1909), vol. 2, p. 109.

91 MCA, Mancath/2/2/1, Chapter register, p. 48 (1 October 1638).

92 *Ibid.*; Leigh was appearing between September 1636 (p. 14) and July 1641 (p. 62).

93 Hibbert-Ware, *History of the Foundations*, vol. 1, p. 162.

94 Hudson, 'Organs and Organists', p. 116.

95 Hollingworth, *Mancuniensis*, p. 123.

During the 1640s services were taken by the Presbyterians. Music would have been confined to metrical psalms, probably now sung unaccompanied, as at least one organ seems to have gone (see below). The order of service would have followed that set out in the Directory of Public Worship,[96] with the sermon given centre stage, and (for the first and only time in English worship) a legally sanctioned place for metrical psalms. These services proved extremely popular, and in order to accommodate the increase in congregation extra seats were installed in 1649 'where the organs lately stood',[97] presumably in the organ loft at the west end of the quire. Nine years later, as a result of a benefaction by Richard Hollingworth, another gallery was built, making a total of three.[98]

Nevertheless, the return of the monarchy in 1660 was greeted with genuine enthusiasm. Henry Newcome reported that on Saturday 12 May, the people 'resolved to proclaim the king in Manchester, and we went first into the church, and sang a Psa[l]m, and after I went up into the pulpit, and prayed'.[99] Official celebrations included a joint service with College and town dignitaries, at which the bells were rung. Afterwards, all went in procession 'with the town musick playing before them upon loud instruments', and then to a feast, also serenaded by the 'music of the town'.[100]

College officers had returned by mid-September, and immediately set about returning the church to its previous style of worship, as Newcome sadly noted in his diary: 'When [on Friday 14 September] the Warden was returned. and Mr Johnson [the Sub-Warden] came, I perceived they intended to alter all at the church to begin the service the next day, and then I saw what was come.'[101] Choral services probably resumed on Wednesday 28 November,[102] so the process of appointing and rehearsing singers

96 That is, Introductory Prayer, Bible readings, Psalm, Prayers, Sermon, Prayers, Psalm (optional), Blessing and dismissal: Temperley, *Music*, vol. 1, p. 78.

97 Manch. Corp.D, in William Farrer and J. Brownbill (eds), *A History of the County of Lancaster, Volume 4*, Victoria County History (London: Archibald Constable, 1911), pp. 187–92 and n. 1.

98 See note 111 below.

99 Henry Newcome, *The Autobiography of Henry Newcome*, edited by Richard Parkinson, 2 vols, CS os 26, 27 (Manchester: Chetham Society, 1852), vol 1, p. 120.

100 Hibbert-Ware, *History of the Foundations*, vol. 1, pp. 358–9.

101 Newcome, *Autobiography*, vol. 1, p. 126. He continued to preach at the Collegiate Church until the following Easter.

102 Newcome's phrase is 'The choir service began at Manchester': *ibid.*, p. 133. This could imply the quire area of the church or the body of singers. The latter seems likely, since other College officers (including the organist and

would have been going on for some time before that; William Carter was reinstated as organist and master of the choristers.[103] Doubtless some of the men returned, although their names would not appear in the registers for another four years. For a generation of boys, however, choral services – their repertoire, churchmanship, and use of the organ – were completely new.

It was not only boys who were intrigued. Pepys attended service at the Chapel Royal on 8 July 1660, where 'I heard very good musique, the first time that ever I remember to have heard the organs, and singing men in surplices, in my life.'[104] Nearer to home Roger Lowe travelled to Winwick (near Warrington) on 17 March 1662/3 'to heare organes. I never heard any before.' He was in the Collegiate Church on [Tuesday] 'Dec 22. 1665. We came to Manchester, & in the first place we went to church & looked about us, and anon the quiristers came & we stayed morneinge prayer, I was exceedingly taken with the mellodie.'[105]

Lowe does not say whether the singing was accompanied, although choral services would have been difficult to manage without an instrument. Quite what was being used is uncertain since contemporary references are scattered and ambiguous. Nevertheless, there are hints which suggest that both College and parish had their own instrument at this time. The College commissioned Smith to build an organ in 1682/3 (see below), 'the old organ having fallen into decay'.[106] And the parish replaced its venerable instrument in 1745: 'the organ is said ... to have suffered [during the Commonwealth, along with the windows] being then accounted a good one, but that which served the choir afterwards was defective, and the present grand organ was substituted in its stead by contribution'.[107]

master of the choristers) were in place, and there may be some evidence to suggest that the church had a functioning organ at this time (see below).

103 Carter was first appointed organist and master of the choristers in December 1638. His post was re-confirmed on 16 December 1662: MCA, Mancath/2/2/1, Chapter register, p. 63.

104 *The Diary of Samuel Pepys*, edited by Robert Latham and William Matthews, 11 vols (London: G. Bell, 1970–83), vol. 1, p. 195.

105 Hudson, 'Organs and Organists', p. 118.

106 According to 'an old account in MS., now in the Manchester Free Reference Library' [now the Central Library]: Hudson, 'Organs and Organists', pp. 122–3.

107 *Ibid.*, p. 123. Hudson is using Ogden's account of the organs, but he gives neither title nor whereabouts of this source. There is a very puzzling comment from J. H. Sperling, in his survey of church organs carried out in the nineteenth century, to the effect that the Collegiate Church had a Smith or Dallam instrument in place in 1660, which was transferred to Rochdale Parish Church in 1710: James Boeringer (ed.), *Organa Britannica: Organs in Great Britain 1660–1860. A Complete Edition of the Sperling Notebooks and Drawings in the Library of the Royal College of Organists*, 3

The Collegiate Church itself seems to have escaped fairly lightly during the Interregnum, possibly because of its Puritan leanings, or because it slipped easily into its other function as parish church, or because there was little worth destroying. The churchwardens' accounts for 1666 mention 'the decayes' of the church,[108] and outline the repairs needed to the fabric and windows (though they give no price), for which reparation would be sought. Even so the interior remained very plain, for when Viscount Torrington visited over a century later, in 1790, he found 'the old massive stalls are very venerable, but there are no monuments, or stain'd glass about the church'.[109] New vestments and service books were purchased, though, and some brought back into use, including 'an Ould Service Booke', which was sent for binding in 1669 at a cost of 8d.[110] Another gallery was erected in 1660, at the west end, 'to accommodate the Chetham Hospital boys',[111] and College business resumed, with the chapter minutes recording its day-to-day activities.

In 1667, Nicholas Stratford succeeded Heyrick as Warden, serving until 1684. He transformed music at the College, and 'through much tribulation revived choral services at the Collegiate Church, and made new statutes for the regulation of the singing men and boys, eventually, in 1684, building a Father Schmidt [Smith] organ and restoring the old daily Matin and Evensong'.[112] A year after Stratford was installed came a drive to improve choir discipline and standards. A system of fines was set out for absences, and the quality of men's voices monitored. George Warburton was dismissed in April 1668, 'not for any misdemeanour in life or conversation but for defect of voice and skill in Musick', receiving six months' salary in compensation. His successor, William Keyes, was, in addition to his singing

vols (Lewisburg, PA: Bucknell University Press, 1986), vol. 2, pp. 104–5. Sperling is a highly respected source, but there is no mention of such an instrument in the Collegiate Church documents.

108 At a meeting on 27 May: JRL, MS Eng. 97, p. 21.

109 John Byng, Viscount Torrington, *The Torrington Diaries, 1781–1794*, edited by C. Bruyn Andrews, 4 vols (London: Eyre & Spottiswoode, 1934–38), vol. 2, p. 206.

110 JRL, MS Eng. 97, p. 65. The two new books cost 13s 3d each.

111 Andrew Boutflower, *Personal Reminiscences of Manchester Cathedral* (Leighton Buzzard: Faith Press, 1913), p. 20. By now there were three galleries: the first erected in 1617 by the merchant Humphrey Booth; the second which was requested in 1649, putting seats in the organ gallery, erected in 1657 and funded by Hollingworth; and the third in 1660. Traditionally galleries were the province of the College chaplains, who were allowed to rent out the seats: CL, MS f.942.72 R121, 'Archbishop Rushton's Visitation Books, 1846', vol. 42, p. 66.

112 Andrew, 'Music in Lancashire', p. 109.

duties, expected 'to instruct the Boyes', for which he was paid 20s a year.[113]

It all must have had some effect, as prospective singers were now willing to wait for a vacancy to come up; it was three months before Gerard Key was admitted in October 1668, and he was asked to 'take pains with the other Singingmen and to instruct them further in Quier service'.[114] Presumably their churchmanship needed attention, not surprisingly, given that several men were new to the choir and others rather rusty after eleven years' absence. Their singing must have been wanting, though, as in 1670 the chapter decided Mr Key's tuition was needed twice weekly (on Wednesdays and Fridays) 'until such times as they shall be capable competently to sing what is requi[red] for them in the quire'.[115] Parish services were probably also a little messy, and in February 1668/9 the chapter set up a rota of two clerks and two singing-men to augment the responses in the Sunday (parish) services.[116] But choir discipline was slack, and later that year, in November 1669, Clay, Grimshaw, and Hollingworth were fined a shilling apiece, 'for absence from Quier service' without any reason.[117] A few years later, in April 1672, Grimshaw was convicted by the chapter of 'drunckenesse, swearing, frequenting of Ale-houses and singing of obscene songs', the first of many occasions.[118] Soon after this he was suspended, only to re-surface five years later in the minutes, when he was elected College bailiff.[119]

Somewhat ominously, choir places were not always being filled: two of the men's places remained empty in January 1679/80,[120] and absences were on the rise, even among the boys. The chapter minutes had complained in October 1679 that 'the singingmen and singing boys have notoriously neglected to attend divine service'.[121] There is some evidence of continuity to the choir, though, with a number of boys returning to sing after their voices had broken. Israel Johnson, who 'by reason of ye decay of his voice is become useless to ye Quire', was admitted as

113 MCA, Mancath/2/2/1, Chapter register, p. 88 (29 April 1668).
114 The chapter had still to decide on his remuneration: *ibid.*, p. 92 (6 October 1668).
115 *Ibid.*, p. 96 (14 April 1670).
116 *Ibid.*, p. 93 (19 February 1668/9).
117 *Ibid.*, p. 94 (6 November 1669).
118 *Ibid.*, p. 105 (13 April 1672).
119 *Ibid.*, p. 125 (11 December 1677). He had died by 19 January 1679/80, when his successor was appointed: *ibid.*, p. 140.
120 *Ibid.*, p. 140 (19 January 1679/80).
121 *Ibid.*, p. 141 (2 October 1679).

singing-man a year later, in November 1686.[122] Thomas Abbott was another returnee.[123]

With the 1680s came a drive to refurbish the church, much of it funded by the parish. The bells were re-cast *c.* 1679–80.[124] Matthew Booth received £3 5s 6d for 'Beautifying the Angells' in April 1684,[125] and part of the porch was rebuilt the following year. In February 1682/3 the chapter commissioned a new organ. It was to be a College instrument, 'for the use of the Quier only',[126] and the builder was Father Smith, then at the height of his fame.[127] It had eight stops,[128] and cost £100 (which the chapter allocated in two instalments: an advance payment of £50, with the remainder to be made following its installation).[129] Installed on the east side of the quire screen[130] and used for daily services,[131] its sound was highly regarded, even into the twentieth century. Kendrick Pyne, Cathedral organist between 1876 and 1908, found it 'singularly sweet in tone and extraordinarily full in quantity of sound. It is virtually as it ever was, save for some treble octaves of pipes which were substituted for some so decayed that it was necessary to replace them … For all practical purposes it represents Father Smith at his best.'[132] It was destroyed in the bombing of 1940.

By 1714, the College was using an organist in addition to its complement of singers.[133] Three years later, in 1717, the Bishop's visitation found 'cathedral' service performed by the four singing

122 *Ibid.*, pp. 168, 172 (21 September 1685, 10 November 1686).

123 He left in 1690, returning nine years later: *ibid.*, pp. 187, 213.

124 A team of experienced ringers was appointed in order to prevent misuse of the new bells, which had damaged the previous set: JRL, MS Eng. 97, p. 174.

125 *Ibid.*, p. 241 (23 April 1684).

126 MCA, Mancath/2/2/1, Chapter register, p. 158 (6 February 1682/3).

127 That is Bernard Schmidt (*c.* 1630–1708), one of the two foremost organ-builders in England. Once again, the College was fully abreast of current developments, this time in organ building.

128 The specification is given in E. J. Hopkins and Edward F. Rimbault, *The Organ, its History and Construction* (London: Robert Cocks, 1855), p. 510.

129 It is smaller than others Smith was building at the time. Those for St Giles'-in-the-Fields (1671) and St Margaret's, Westminster (1675), cost £200 each: that for St Peter's, Cornhill (1681), cost £210: Hudson, 'Organs and Organists', p. 119.

130 It subsequently moved around, both within and outside the church.

131 John M. Elvy, *Recollections of the Cathedral and Parish Church of Manchester* (Manchester: C. Sever, 1913), p. 45.

132 Hudson, 'Organs and Organists', pp. 121–2.

133 This was when Edward Betts (then master of the choristers) succeeded Edward Edge as organist on 18 September 1714. 'Mr Edward Betts resigned his place as singingman and [was] chosen organist in the room of Mr Edward Edge, deceased': MCA, Mancath/2/2/1, Chapter register, p. 261.

Father Smith organ
in the north quire
aisle, some time after
1891

men, four choristers, and the organist.[134] Not until ten years after that did a chapter minute of 16 December 1727 confirm 'yt there shall be an organist distinct from a Singing man who shall constantly attend upon ye duty of ye Choire and have a Salary appointed for him'.[135] In June 1728, Edward Betts was appointed, at a salary of £20 per annum. Having an 'extra' singer would have opened up possibilities for more adventurous music and eased the inevitable problem of absences. The attendance of Prince Charles Edward Stuart at Sunday service in 1745 brought

134 *Notitia Cestrensis, Vol. II Part III*, p. 57, in Temperley, *Music*, vol. 1, p. 350.
135 MCA, Mancath/2/2/2, Chapter register, p. 9.

the Collegiate Church into the national spotlight. He sat in the warden's stall and the sermon was preached by his chaplain. The service over, Prince Charles reviewed his troops in the churchyard before they all retreated to Scotland. It is popularly supposed that 'Farewell Manchester' was sung, or played, as they left.[136]

Hints of the College's eighteenth-century repertoire now begin to appear, in two publications compiled by successive College organists. The first, *An Introduction to the Skill of Musick*, by Edward Betts (organist from September 1714 until his death in 1767), was published in 1724. Written for 'the Encouragement of the unlearned' and 'the Improvement of young Practitioners', Betts may have intended it for local use, since the book was printed and sold in Manchester. It gives a brief introduction to rudiments and principles of ornamentation, and music for six chants, two hymns, two psalm tunes, and a canon four in one. There are hints on technique ('how to run a Division', 'how to make a Shake', and so on) and suggestions for repertoire (several chants are labelled 'for Choir Musick'). Betts's eighteen years from 1706 as instructor and master of the choristers would have been invaluable here, and with a working knowledge of the repertoire and access to College sources he was in an excellent position to select music, possibly from the choir's current repertoire, with which to illustrate his book. The pieces are from a variety of composers (although none is attributed), including Blow, Humfrey, Hawkins, and Purcell; but with no services or anthems included it is difficult to assess the College repertoire on the basis of this collection.

Forty years later John Wainwright took a rather different approach. His *Collection of Psalm Tunes, Anthems, Hymns and Chants for 1, 2, 3, 4 voices Composed by Mr John Wainwright Organist of the Collegiate church of Manchester*, published on 21 October 1766,[137] is just that: a compilation of his music and

136 This music had a busy time in the eighteenth century. Composed by Revd William Felton, prebendary of Hereford Cathedral, as part of one of his keyboard concertos, it was published about 1740, later reappearing with variations as 'Felton's Gavot'. At some point words were added. Subsequent manifestations included a Lichfield Morris dance (where the dance attached to it is called Ring O' Bells) and an appearance in Bremner's *Collection of Airs and Marches* for 2 violins or German flutes, published in Edinburgh in 1756. The music must have remained in the Manchester area, since Chappell states that it was also played 'when the unfortunate Manchester youth, Dawson, was executed in 1746': W. Chappell, *The Ballad Literature and Popular Music of the olden time*, 2 vols (London: Cramer, Beale, and Chappell, 1855, 1859; facsimile edition New York: Dover Publications, 1965), vol. 2, p. 91.

137 According to the *Manchester Mercury* of that date, in Sally Drage, 'The Wainwright Family: A Reappraisal – Part 1', *Manchester Sounds* 3 (2002), p. 100.

a calling-card for the composer. There are no teaching aims here, and the publication looks nationwide, being printed in London and sold throughout the country. Perhaps Wainwright was a young-ish man in a hurry: certainly in describing himself as College organist he was somewhat quick off the mark. Though Betts had died about six months earlier, Wainwright's own appointment, as singing man, organist, and instructor of the choristers was not confirmed until the following year, in May 1767.[138] Perhaps he had been acting as assistant before this, since Betts would have been an old man by then, having been with the College for over sixty years. Wainwright includes the same type of music as does Betts, though his collection is larger and slightly differently focused – with six chants, two hymns, twenty-one metrical psalms, and four anthems.

It is likely that the College would have sung some or all of this music, since few organists and choirmasters can resist the opportunity of having their music performed, and it is possible that some pieces were written with the choir in mind. As always it is the anthems that are the most revealing. Three are verse anthems scored for solo bass and four-part choir (Bass / Treble, Alto, Tenor, Bass) and basso continuo in two cases, and Treble, Bass/Treble, Alto, Tenor, Bass and basso continuo in the other,[139] so at least one of the Manchester basses was fairly competent and able to take solo lines. The solos are agile, but not outrageously so, and the effect is light and tuneful. Wainwright's music did not last long in the College repertoire, though, and had disappeared completely by the end of the nineteenth century.

The 'extra' item in this collection is 'A Hymn for Christmas Day. The words by Dr Byrom of Manchester', better known as 'Christians Awake, salute the happy morn', and it is the piece that puts Wainwright, nay even the College, on the map.[140] Musically it is very simple: six 4-bar phrases, with the final two dove-tailing into each other, by way of building up momentum; the key is unchanging, apart from a brief excursion to the relative minor, and the harmony consists overwhelmingly of primary chords. The setting is strophic and syllabic, with ten syllables per line, and the melody is tuneful and memorable, built on a series of ascending phrases, which works well

138 MCA, Mancath/2/2/2, Chapter register, p. 119 (12 May 1767).

139 They are 'Bow down thine ear' and 'Thou O God art praised in Sion' (both Bass / Treble, Alto, Tenor, Bass and *basso continuo*), and 'Rejoice in the Lord' (Treble, Bass / Treble, Alto, Tenor, Bass).

140 The tune had first appeared five years earlier, in Caleb Ashworth, *Collection of Tunes, Part 1* (London: J. Buckland, [*c.* 1760]). There it was unattributed and set for four parts, to a metre of 10.10.10.10.11.11.

with these words. By an odd coincidence, as this chapter was being prepared, a manuscript surfaced containing the piece. The book, a handwritten collection of eight anthems,[141] gives as its final and ninth item 'An Ode for Christmas day. The words by Dr Byrom Set to Music by John Wainwright'. Inside the back cover, in the same hand, is 'Isaacc Ogden His Book 1766', the same year as Wainwright's publication. Wainwright is unlikely to have been used as a copy source, though, judging from the type of variant. Ogden's is the simpler version: the bass is unfigured, there is no four-part SATB ending, nor decoration on 'joyful', and the first verse only is given, despite the manuscript having room for more. There is an uncorrected error in the bass of the fourth beat in bar 5, and a corrected error in the subsequent bar, though Ogden does not repeat the mistake given in the printed version where the key signature is incorrect for the chorus phrase. He slightly slows the lead into the final one: by ending the penultimate phrase with a pause, he begins the next one with a minim. Ogden's version is entitled 'Ode', the printed one as 'hymn'.

The provenance and function of Ogden's book have yet to be established, though the inclusion of Wainwright's piece and the name 'Isaacc Ogden' argue for a strong connection with the Manchester area.[142] The thrust of the contents is toward a parish or country church repertoire, with half the pieces composed by William Knapp.[143] Any group that attempted this music must have been reasonably proficient, since it is scored for four, sometimes five, parts, with soloists of each voice; and an organ would have been needed for one of the anthems, 'Sing O ye heavens'. Might Mr Ogden's book have been used for parish services at the College?

141 'For my trouble I called upon the Lord', William Knapp; 'O Lord God of my salvation', Mr Richardson; 'O clap your hands', William Knapp; 'Sing O heavens', [not attributed]; 'Clap your hands together', Ticco junior; 'Be thou my judge O Lord', William Knapp; 'I heard a great voice', William Knapp; 'I will sing unto the Lord as long as I live', Dr Croft; and 'An Ode for Christmas Day', John Wainwright.

142 The surname is common in Oldham and Ashton under Lyne. Ogdens had been associated with the Collegiate Church since the seventeenth century: George Ogden was one of the fellows from 1675 until his death in 1706, and several Ogdens appear as choristers from the 1790s. This 'Isaac' Ogden has not been positively identified, but a 'Mr Ogden' (b. 1718) wrote an anonymous account of the organs of the Collegiate Church (see above): see Hudson, 'Organs and Organists', p. 123.

143 Knapp (1698–1768) was one of the most popular composers in England for country, i.e. parish church choirs. Whilst his music is simple, it is never bland, and his harmony has vigour and originality.

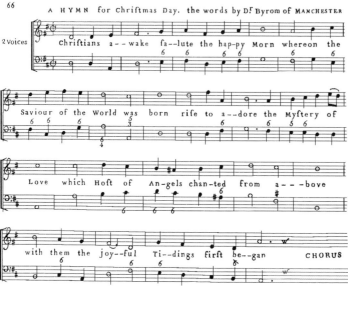

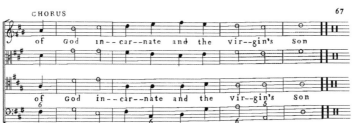

Then to the watchful Shepherds it was told,
who heard th'Angelic herald's Voice, behold.
I bring good Tidings of a Saviour's Birth,
To you and all the Nations upon Earth;
This Day hath God fulfill'd his promis'd word;
This Day is born a Saviour, Christ, the Lord:
In David's City, Shepherds, ye shall find,
The long foretold Redeemer of Mankind;
Wrapt up in swaddling Cloaths, the Babe divine
Lies in a Manger; this shall be your Sign.
He spake, and straitway the Celestial Choir,
In Hymns of Joy, unknown before, conspire:
The Praises of redeeming Love they sung,
And Heav'ns whole Orb with Hallelujah's rung;
God's highest Glory was their Anthem still,
Peace upon Earth, and mutual Good-will.
To Bethlehem straight th'enlightened Shepherds ran,
To see the Wonder God had wrought for Man;
And found with Joseph and the blessed Maid,
Her Son, the Saviour, in a Manger laid:
Amaz'd, the wond'rous Story they proclaim;

The first Apostles of his Infant Fame:
while Mary keeps and ponders in her Heart,
The Heav'nly Vision which the Swains impart;
They to their Flocks, still praising God, return,
And their glad Hearts within their Bosoms burn.
Let us, like these good Shepherds then, employ
Our gratefull Voices to proclaim the Joy:
Like Mary, let us ponder in our Mind
God's wond'rous Love in saving lost Mankind:
Artless, and watchful, as these favour'd Swains;
while Virgin Meekness in the Heart remains:
Trace we the Babe, who has retriev'd our Loss,
From his poor Manger to his bitter Cross:
Treading his Steps, assisted by his Grace,
'Till Man's first Heav'nly State again takes Place;
Then may we hope, th'Angelic Thrones among,
To sing, redeem'd, a glad Triumphal Song:
He that was born, upon this Joyful Day,
Around us all, his Glory shall display;
Sav'd by his Love, incessant we shall sing
Of Angels, and of Angel-Men, the King.

'Christians awake' in
'Mr Ogden's book'

By the end of the eighteenth century, the standard of the choir was probably fairly low: certainly Torrington was not impressed when he visited in 1790, arriving 'just at prayer-time, where the singing was too bad to tempt my continuance'.[144] But the College merely reflected the national decline in the state of the Church, in which nepotism, pluralism, and absenteeism were rife, and too many senior clerics were living in comfort, in contrast to their impoverished and isolated curates. Church buildings were often not maintained, and some clergy saw little point in having music as part of the service, let alone in spending money on it, which in turn affected the quality and morale of those in musical posts.[145]

Manchester itself, on the other hand, was not in decline: quite the reverse, in fact, having become the centre of the Industrial Revolution almost overnight. For several years it had hosted a series of musical festivals (1770, 1777, 1785, and 1792), consisting of concerts – sacred and more serious in the morning, secular and more showy in the evening – and dances, with the profits going to charity. The morning concerts were built round performances of oratorio (Handel, especially *Messiah*, in the

144 Torrington, *Diaries*, vol. 2, p. 206.
145 As S. S. Wesley was well aware, in his *A few words on Cathedral Music and the Musical System of the Church, with a Plan of Reform* (London: F. & J. Rivington, 1849), p. 11.

eighteenth century, and Haydn, Beethoven, and Mendelssohn in the nineteenth), and were held in the Collegiate Church.[146]

Musical festivals became very popular in the nineteenth century, due in part to the opening up of the railways, with their ability to move large numbers of people, both audience and performers.[147] They operated virtually on a national circuit, headed by an impresario and a nucleus of performers who moved from one festival to another; local musicians supplied the choirs and much of the orchestra. Given Manchester's growing importance as a city, it is perhaps surprising that only two were held there in the nineteenth century, in 1828 and 1836: possibly competition from nearby Liverpool was too great (in the first half of the century seven Musical Festivals were held in Liverpool), or maybe the disastrous events of the 1836 festival proved too much for the organizers.

Whatever the reasons, the two festivals Manchester did host were big, and the Collegiate Church was turned into a virtual concert hall in time for the first one. The Great, or parish, organ was taken down from the quire screen, moved to the west end, enlarged,[148] and surrounded by a platform: a gallery was erected facing this, covering the screen and stalls.[149] Illustrations show the church as it (probably) looked for the 1836 festival, and (although their accuracy cannot be verified) the energy and apparent impunity with which these wholesale changes were made to a building still needing to accommodate daily services is striking. While moving the Great organ made sense for parish services, providing the console remained as in the illustrations (indeed the instrument was to remain at the west end for the next thirty or so years), the boxing-in of the quire would have left a very gloomy space in which to worship. It also left the tiny Father Smith organ, still on the screen, as the sole accompaniment for daily College services: hardly fitting for the dignity of the new Cathedral and now difficult for the organist to see the

146 The 1770 Festival was held at St John's, Byrom Street, between 29 and 31 August.

147 Lewis Foreman, 'The Twilight of an Age: The Manchester Grand Festivals of 1828 and 1836, the Development of the Railway, and the English Choral Festival in the Nineteenth Century', *Manchester Sounds* 6 (2005–06), pp. 35–69.

148 According to the festival handbook, it 'received an entirely new case and a great number of additional pipes … also … a great increase in power, so that during the performance of the oratorios it was exceedingly effective and admired': Hudson, 'Organs and Organists', p. 125.

149 Access was via 'a specially constructed staircase which led up through the window above the Derby Chapel door': *ibid.*, p. 121. Seats cost one guinea each.

singers in the quire. Not until 1861 would a larger instrument be installed (the Nicholson organ, see below), and that lasted barely ten years.

The 1836 festival was the largest and most ambitious to date, and took place 13–16 September. It comprised seven concerts, preceded by a service at the Collegiate Church, and a ball, and ended with a fancy-dress ball. The opening concert was monumental in scale: a complete performance of *The Creation* in the first half, with extracts from Mozart's *Requiem* and the premiere of Bishop's cantata *The Seventh Way*, separated by four vocal numbers, in the second half. The orchestra numbered over two hundred players (including about seventy strings), and whilst it may have been an *ad hoc* group, many of the principals were leading players, including Lindley on 'cello and Dragonetti on double bass: almost half of them came up from London, with the remainder travelling from north-west England and Ireland. Balancing the orchestra was a choir of over two hundred local amateur singers, including an entire section of (fifty-three) male altos.

Apart from providing a concert venue and conducting the opening service, the College had little to do with the festival. The church did, however, provide the backdrop for the dramatic final days of the celebrated soprano soloist, Madam Maria-Felicia Malibran. Unwell from the day she arrived, Malibran was unable to attend rehearsals, and struggled to get through several concerts. Having finally consented to receive medical treatment, she sang at the evening concert on 15 September, against the advice of doctors, 'lest people should think it is only a sham',[150] but collapsed at the end and died five days later.

It was during the nineteenth century that concerns for cathedral singers, particularly the boys, moved centre stage. To an extent Manchester escaped most of the criticism, being a 'mere' collegiate church, though it did not escape the notice of Miss Maria Hackett, who for years had been writing to deans up and down the land concerning conditions and rights of choristers. She visited every cathedral in England and Wales to see conditions for herself,[151] and in the 1820s was in correspondence with Dr Blackburne (Warden at Manchester 1800–23), who replied:

150 CL, MS C01/10, Sermon preached on the occasion of Mme Malibran's funeral, 2 October 1836, p. 21. The funeral was held at the Collegiate Church, where she was interred, albeit briefly.

151 Her findings were published as *A Brief Account of Cathedral and Collegiate Schools* (London: J. Nichols, 1827).

The Warden and the Fellows are not confined to any particular class in their selection of boys, the statutes requiring only that they should have musical talents. They are admitted at about seven years of age, and leave when the voice begins to break. They attend service in the Choir every day at ten and four. They are taught Music by the Organist; and the excellent Free School for English and Latin founded by Bishop Oldham [Manchester Grammar School] is open to their instruction … The Choristers receive annually £5 from the College, and one penny each from the marriages, which averages to each boy about three shillings weekly; so that their income will be about five shillings per week.[152]

Galleries in the Collegiate Church at the time of the 1836 Musical Festival: *left* – patrons' gallery, over the quire, *right* – platform at the west end, where the performance would have taken place (the Parish organ can be seen in its 'new' position)

This annual total of about £13 compares favourably with rates from other choirs at the time. Worcester Cathedral was paying its boys £10 per annum, while senior choristers at St Paul's received

152 *Ibid.*, p. 41.

£16 and the juniors £10 per annum (although it is not clear whether these sums included fees for weddings).[153]

Nevertheless, the Manchester choir was having to work hard with fifteen College services a week in 1816, two each weekday and three on Sundays, plus the parish service on Sunday. Special services, such as confirmations and ordinations,[154] or weddings, baptisms, and funerals,[155] plus attendant rehearsals, were additional. This was covered by a statuable number of four men and four boys, when up to full strength and with no absentees. They must have struggled to keep up, and much of the repertoire would have been beyond their reach. This had not gone unnoticed by the authorities, who on 21 June 1801 appointed Joseph Platt 'Supernumery [sic] singingman at £20 pa'.[156] From then on, the chapter minutes go very quiet, although, in view of what happened later, the concern with choir numbers did not go away. In a letter to Maria Hackett written shortly before his death in 1823, Dr Blackburne admitted that 'the statuable number of Choristers was insufficient for the due performance of the Choral Service, and that an augmentation would be desirable':[157] it came in the 1850s.

By now concerns about the choir were being aired in the press. On 20 March 1852, the *Manchester Courier* noted that 'there is no choir [of any merit, presumably] at our Cathedral ... I do hope that the state of matters ... will not be suffered to continue ... it is a stigma on the musical taste of the town generally'.[158] On 6 March, the Manchester correspondent for the *Musical World* bemoaned the fashion for churches to purchase new organs at the expense of raising the standards of their choirs: 'let us have a good choir without an organ, rather than a fine organ without

153 *Ibid.*

154 MCA, Ian Molloy, 'Manchester Cathedral: My Memories of 1953–1964', unpublished typescript, pp. 27–8, gives details of those from his time.

155 These services took place on an industrial scale, and Joshua Brookes, one of the chaplains, was thought to be 'the most prolific baptiser, marrier and burier in the country ever': Hunwick, 'Manchester Cathedral Archives', p. 7. Elvy, *Recollections*, p. 38, records that one Christmas day morning eighty weddings were held, and that it took until 4 p.m. to complete the paperwork.

156 MCA, Mancath/2/2/2, Chapter register, p. 249.

157 Hackett, *Cathedral and Collegiate Schools*, p. 41 n. Dr Blackburne refers only to the situation for boys, since Miss Hackett was concerned with conditions for choristers.

158 James Berrow, 'A Tale from Two Cities: John Nicholson of Worcester, Manchester Cathedral and Ouseley, 1861', *British Institute of Organ Studies Journal* 19 (1995), p. 5.

a choir ... Let us endeavour to get rid of the disgrace and shame of the meagre apology for music now existing in our churches.'[159]

With the change of status from college to cathedral in 1847, came an acknowledgement of the increased and increasing role of the choir, and a second group of singers was put in place. This was the voluntary choir, who took on the special services and the new Sunday evening services introduced in 1857; these proved enormously popular, quickly outgrowing the Derby chapel where they were originally housed and moving into the nave. The singers (men and boys) were quite distinct from those of the statutory choir,[160] and the two groups very rarely joined forces (almost the only exception being the service held after the Whit Walks).[161] Some years later a third group, the cantata choir, was formed to perform concerts and oratorios, often alongside the statutory choir. This group included women.

By 1853, the statutory choir had been augmented to include an additional six men and six boys for weekday services (giving a total of ten men and ten boys), and a further six men on Sundays (i.e. sixteen men and ten boys), with inevitable consequences for balance.[162] The extra singers were paid from a combination of private subscription, individual donors, and chapter revenues. The number of extra weekday men varied over the years, according to the returns made by the chapter:[163] indeed an article in the *Manchester Guardian* from 1870 ignored them altogether, listing the music staff as 'organist, 4 singingmen, 4 singingboys & 6 probationers', and noting that the 'ordinary week-day choir is augmented on Sundays by 6 additional men, 2 of whom are voluntary'.[164] Such use of chapter money proved the final straw in a series of ever-deteriorating relations between College and parish,[165] who in 1884 took the dean and canons (as the warden and fellows were now titled) to court for misappropriation of funds. Tensions between College and parish had surfaced from

159 *Ibid.*

160 The boys were taken, in the main, from Chetham's Hospital and Manchester Grammar School. Not until the 1960s did some former members of the statutory choir begin singing with the voluntary choir: Malloy, 'My Memories', p. 35.

161 See *ibid.*, pp. 28–9.

162 *The Attorney-General v. the Dean and Canons of Manchester* [transcript of the judgment of Mr Justice North (Manchester: n.p., 1884)], copy in JRL, Richard C. Christie Printed Collection, 23.b.14(11).

163 *Ibid.*, pp. 20–1.

164 'From our own correspondent', *MG*, 23 July 1870.

165 Berrow, 'A Tale from Two Cities', p. 10, cites several examples from the Vestry minutes.

time to time as each asserted its right to part of the building[166] or an area of responsibility, but from the late eighteenth century the parish began to flex its muscles more frequently, and relations worsened.

By now it was established that the parish would share the College organist, a practice that had begun in 1782.[167] Nevertheless, when the post became vacant later that year it was the parish and not the College which advertised the vacancy, paying for notices in two London papers on three occasions.[168] In 1834 it withdrew its stipend and appointed its own player. This was J. J. Harris, whom the parish had taken on three years earlier as singing master to improve the Sunday services,[169] and who was currently a member of the College choir. For the next fourteen years the church had two organists: William Sudlow for the College / Cathedral and J. J. Harris for the parish. The situation remained unresolved until Sudlow's death in 1848, when Harris succeeded him as Cathedral organist after resigning his place in the choir.

The installation of the new Nicholson organ in 1861 was another source of irritation: by being placed 'on the portion of the church which belongs to the parish … its cost has been entirely defrayed by the parishioners; so that the clergy, who did not contribute at all to its erection, had no right whatever to interfere'.[170] Its position was also impractical when it came to accompanying the services, which did not help, and the range of its sound was controversial from the start. Ten years later, in 1871, it was replaced by a new instrument, built by Hill and Son, with the main part on the screen, and the choir now visible to the player.

So, there were tensions aplenty for the court case. In it the parish argued that a substantial, and greatly increased, proportion of revenues was now being spent on a larger and more expensive choir, with the result that far less 'surplus' money was

166 As in February 1691/2, when the College had a lock put on 'the seat or Pew at ye west end of ye Quire being ye passage to ye Organ-loft, in order to ye asserting & makeing out their right, title & claim to ye said seat or Pew', which they backed by a threat of legal action in 1705: MCA, Mancath/2/2/1, Chapter register, p. 189.

167 At that stage the parish was paying the organist £15 per annum, which was increased to £45 in 1795.

168 Watkins Shaw, *The Succession of Organists of the Chapel Royal and the Cathedrals of England and Wales from c. 1538* (Oxford: Clarendon Press, 1991), p. 188.

169 Another example of the parish's growing independence: *ibid.*, p. 189.

170 *Musical World*, 15 June 1861, in Berrow, 'A Tale from Two Cities', p. 10. The organ occupied the second and third bay (from the screen) of the north quire aisle.

available for the needy parishes of Manchester. The case centred round the wording of the 1635 Charter, with its provision for a choir of four men and four boys. This, the chapter maintained, represented a minimum number of singers, which 'though possibly adequate for a mere Collegiate church, is wholly inadequate for the proper performance of Cathedral services'.[171] Furthermore, the 1850 Manchester Rectory Divisions Act (which broke up the parish of Manchester into a number of smaller parishes, leaving the Cathedral with a city-centre parish of one square mile) allowed the chapter to keep back a certain amount of money at its discretion; by not augmenting the choir it would have failed in its duty. The Attorney-General found in favour of an increase in payment to the singers, but could not support an increase in their number, finding that the Charter provided for four men and four boys, 'neither more nor less'.[172]

From 1863, when the precentor's registers begin, the College repertoire can finally be assessed. The registers list the canticles, hymns, and anthems for each service, and continue to this day in a virtually unbroken run, save for an eight-year gap between 1871 and 1878.[173] They reveal a growing confidence on the part of the Cathedral, both musically and liturgically, driven in part by the increasing size and importance of the city. Nowhere is this more apparent than in the services for Holy Week. At first (from 1863) choral services were held only on the morning and evening of Easter Sunday and Monday, with none on Good Friday; from 1887 they were taking place twice daily throughout Holy Week.[174] The repertoire changed much more slowly, however, and remained within the eighteenth- and nineteenth-century English choral tradition for a very long time. Doubtless this was done in part for practical reasons, since this music was accessible, tuneful, and so much easier to sing than (for example) the repertory of the sixteenth and seventeenth centuries, with its independent lines and rhythmic and harmonic complexity. As a result, music for Holy Week hardly varied from one year to the next, at least in the 1860s. In common with most cathedrals of the time, Gounod, Spohr, Mendelssohn, and Goss were the most popular composers, with Handel, or at least *Messiah*,

171 Attorney-General's report, p. 20.
172 Attorney-General's report, pp. 20–1.
173 And an eight-month gap in 2020, when the COVID pandemic brought all services to a halt.
174 The number of said services also increased: by 1882 these were held (each with sermon) every day in Holy Week, with three on Ash Wednesday and Maundy Thursday, and four on Good Friday (including an 'Easter eve vigil') and Easter Sunday; Easter Monday had two.

providing the mainstay of the anthem repertoire: most numbers from Part the Second were plundered to provide tuneful music for Easter.[175] Manchester also had its favourite pieces to which it clung tenaciously. Once Elvey's *Christ is risen* appeared in 1866, it was sung on at least one occasion for the next thirty Easters, and his *Daughters of Jerusalem* was performed each Easter for years. Music in the service list is very second-rate, though to be fair to the Cathedral most of it (including settings by Calkin, Travers, Politt, and Turle) was given only one Easter airing: the favoured settings (Rogers in D, Kelway in B minor, and Goss in E)[176] were of rather better quality. Somewhat surprisingly, given the Cathedral's eighteenth- and nineteenth-century comfort zone, Gibbons's *Service in F* (dating from the early seventeenth century) was by far the most popular setting at this time.

The Cathedral compiled its own set of anthems, which it used from about 1863 until 1901. Consisting of single printed copies and inserts from the *Musical Times*, the pieces were numbered and re-paginated. The volumes run roughly chronologically in order of composition; within each, composers are grouped together. Their music is presented (generally) in alphabetical order of title. (The Cathedral also used printed collections, such as those published by Novello.) The repertoire is firmly rooted in the nineteenth century (five books give virtually nothing else); the eighteenth century is represented by two volumes, and everything earlier in one. By far the most popular composers, judging from the number of their pieces, are Mendelssohn (29) and Goss (20), followed by Barnby and Elvey (each with 10), and Gounod (9). Earlier composers are represented by Boyce (9), Handel (8, all from *Messiah*), and Purcell (7). In general, this was very much a late Victorian repertoire, with its emphasis on short, simple, tuneful settings, a regular metre and symmetrical phrasing, with words often sacrificed as a result. But times were changing, and very gradually the repertoire expanded and became more adventurous, until by the end of the century the Cathedral was singing Gibbons' 'Hosanna to the Son of David', Stanford in B flat, and exotica such as Mozart's 'Jesu word of God' and Fauré's 'Crown ye with palms', both in English translation. Rossini's *Stabat Mater* (performed at a 'Special Musical Service' on Good Friday 1892) is the first time a Latin title (whatever language it was sung in) appears in the music lists.

The standard of the choir was gradually rising, and the anonymous author of the *Manchester Guardian* article of 1870

175 That is, choral numbers: others were re-scored for a variety of soloists.
176 Heard on 10, 8, and 10 Easters respectively.

referred to above claimed, somewhat disingenuously, that 'since Bridge's appointment standards have vastly improved'.[177] As he was writing this less than six months into Bridge's tenure, any changes must have been fairly immediate, and it rather calls into question his conclusion that '[i]t was for a long time the fashion to point to Manchester as having the very worst service of any of the cathedrals, which it must be admitted was saying a great deal. We are now living in happier times ... [and] services at Manchester are above the average, and excelled by few of the cathedrals.'[178]

As the Cathedral moved into the twentieth century, there is a sense that it was drawing breath and taking stock, both of itself and its place within the wider community. Services were taking different forms, as the chapter struggled to make worship more appealing. By 1915 they included a Lantern Service on Good Friday at 8 p.m., when 'Prayers and Hymns will be thrown on the screen so that all can join in heartily'.[179] Annual services were held for (among others) butchers, teachers, 'all persons connected with the Theatres and Music Halls', and railwaymen. The latter occasions were especially elaborate, being preceded by a lengthy procession and accompanied by bands. The Whit Walks never lost their popularity either. The company would assemble in Albert Square, and in 1911 the following instructions were issued: 'At 9.10 the assembly will be sounded and earnest attention is requested, and that everyone present will watch the Conductor's beat and sing heartily. A sustained chord will be played by the bands before each hymn. The singing must commence with the next beat.'[180] They began with 'Onward Christian Soldiers', continued with 'All people that on earth do dwell', prayers, and the National Anthem, at which point the procession began to make its way to the Cathedral. Headed by four police horses, followed by the statutory choir, the voluntary choir, and processions from the three parishes selected to attend that year, it must have been quite a sight for the crowds that inevitably assembled. Indeed, by the 1950s it was estimated that the procession was taking over four hours to pass at any point.[181]

Each year before Easter the *St Matthew Passion* was performed, with orchestra and two of the Cathedral choirs. The statutory choir took the bulk of the music, reinforced by the 'Special' choir (probably the cantata choir, since sopranos are mentioned) for the

177 Sir John Frederick Bridge, Cathedral organist 1869–75.
178 *MG*, 23 July 1870.
179 CL, C01/206, Advertisement for the Lantern Service, 1915.
180 CL, C01/49, Typed instructions for singers on the Whit Walk, 5 June 1911.
181 Molloy, 'My Memories', pp. 28–9.

chorales, in which the congregation were expected to join. Sydney Nicholson (Cathedral organist 1909–18) directed that these were to be sung 'with a firm, sustained tone; no breaks after pauses. only very slight attention should be paid to the marks of expression; the general range of tone should be "forte"'.[182] Manchester treated these performances as a service, and included prayers and a sermon, which must have made the occasion fairly lengthy. So, in response to 'a desire … for some abbreviation', the Cathedral cut the sermon and several musical numbers in time for the 1914 performance, while pleading with the congregation 'for a liberal offering, as the money contributed in past years has not been nearly adequate to the expenses of the service'.[183]

The organ was inaugurated that year, after a rebuild by Hill and Son,[184] with a number of recitals and concerts from players with connections to the Cathedral, followed by a series of midday organ recitals given by those from further afield. Herbert Brewer, organist of Gloucester Cathedral, was the soloist in November 1912. His programme, which follows the Manchester convention of opening prayers, with a hymn at the mid-point of the recital, is very much of its time and began with a transcription of music from *Finlandia*,[185] before continuing with more traditional fare including items by Rheinberger, Saint-Saëns, and Widor. A collection was taken to 'further the interests of deserving choristers on leaving the choir'.[186]

There were now twenty boys in the choir, who were admitted after a successful audition and probationary period (usually about three months). By the 1930s, competition for places was intense, and, for the two evenings a year on which voice trials took place, 'the whole of the south side of the cathedral was filled with boys and their hopeful parents … It was quite a production line as one after another boy was shepherded along to the choir vestry, and one after another came out again'.[187] Once in

182 CL, 1/203b, undated typewritten sheet.

183 CL, Co1/149, Note from the Dean, J. E. C. Welldon, 6 April 1914.

184 The majority of the instrument was now divided on each side of the choir stalls, with a second Great division on the screen. It was subsequently maintained by Harrison and Harrison, who altered and revoiced it in 1918, returning for further work in 1934 when electro-pneumatic action was added. The quire organ was enclosed and remodelled, and the Father Smith organ connected to the main console, while also remaining playable from its own keyboard.

185 Dr Brewer was famed for his performance of transcriptions: Watkins Shaw, *Succession of Organists*, p. 128.

186 CL, Co1/96.

187 This was in 1933. Selected boys were then given further voice tests and a written examination: Ernest Tomlinson, 'Learning to be a Composer', *Manchester Sounds* 8 (2009–10), pp. 37–8.

the choir, the highest standards were expected. In Dr Archibald Wilson's time (Cathedral organist and choirmaster between 1919 and 1943) a post-mortem was held after every weekday choral evensong, when the head chorister would go up to the organ loft to receive his comments. 'The rest of us had to wait in trepidation in the vestry, until the head boy returned with, all too often, the dreaded words, "all stay". (Groan, groan.) What we had to stay for was, as likely or not, that one of our monotones had dropped a quarter of a tone, or wasn't in perfect unison.'[188] Choir practices were held every day, except for Friday,[189] and the choir could expect to sing between seven and eleven services a week, for forty-five weeks each year. Service music was chosen by the precentor, who was also responsible for the organization and conduct of the service and for supervising the men and boys 'both in Church and also during their training and instruction'.[190] It included responses (Anglican) chant, anthems, and – once a month in the Sunday afternoon services – 'cantatas'.[191]

Since 1911 boys had been required to attend the Cathedral 'properly dressed in black Eton jackets, turned down collars and square caps', and, somewhat tellingly, to be 'present at the beginning and stay to the end of all services'.[192] Their behaviour, even during the service, was to be a cause of concern for many years. In 1932, it was considered 'most unsatisfactory',[193] and four years later it was no better. The chapter demanded an end to the 'slackness', 'lolling about', and 'ambling gait' of both choristers and clergy, who in future were to show 'reverent and orderly behaviour'.[194] Boys were also expected, depending on seniority, to lead the processions, maintain choir discipline, and distribute service sheets and music for the choir. Permission to sing 'anywhere in public' had first to be obtained from both the

188 *Ibid.*, p. 41.
189 By the 1950s, practices were as follows (Molloy, 'My Memories', p. 27):
 Monday: boys 4.30–*c.* 5.30 p.m. (evensong 5.30 p.m.).
 Tuesday: full (boys and men) 5 p.m. (evensong 5.30 p.m.).
 Wednesday and Thursday: boys 5 p.m. (evensong 5.30 p.m.).
 Friday: boys' day off.
 Saturday: full 2 p.m. (evensong 3.30 p.m.).
 Sunday: boys 9.30–*c.* 10.30 a.m. (matins 10.30 a.m., choral eucharist 11.30, choral evensong 3.30 p.m.).
190 CL, 101/1, 'A New Statute concerning the Chaplains or Minor Canons', 6 April 1908. The precentor also noted details of the service music (see above).
191 These could include Bach's *Magnificat*, Parry's *Blest Pair of Sirens*, or even a shortened oratorio or other choral work, such as *Messiah* or Brahms's *German Requiem*.
192 CL, C01/39, 'Regulations for Choristers and Probationers', *c.* 1911.
193 MCA, Mancath/2/2/5, Chapter minutes, p. 14 (23 September 1932).
194 *Ibid.*, p. 123 (18 May 1936).

precentor and the organist. They were paid between £2 and £20 per annum according to rank.[195]

It is in this century that the boys' voices are finally heard, quite literally, in a series of memoirs now held at Chetham's Library, both written and spoken. As a result, names become personalities, and all manner of impressions and incidents have been preserved which otherwise would have been lost. The accounts reveal a great sense of pride at being a member of this group, and a growing *esprit de corps*, doubtless strengthened by regular outings to nearby attractions or beauty spots, and the annual choir camp in August (former choristers had their own camp and Association). More than that is an awareness of the effect of being part of the choir: 'The constant exposure to great music and the insistence on highest professionalism were fundamental factors in making this the defining time of my life', remembered Ernest Tomlinson.[196] Having been suspended for a week, another former chorister 'suddenly realised that the choir could manage without me and that, as a part of the human condition, one day it would have to do so. Nobody is indispensable. Of all the lessons which I learned at school and in the cathedral this was the most valuable and enduring.'[197]

If surviving sources are to be believed, the First World War had little effect on the Cathedral: services continued, the choir remained in place, and the fabric survived intact. Things were very different in 1939. Even before war had been declared 'Saturday morning, 2 September, found the whole choir [i.e. the boys], along with thousands of other Manchester school children waiting [at] … Victoria station … complete with attaché cases, gas-masks and luggage labels round our necks … awaiting the trains that would evacuate us to safer places.' The choristers were housed in Thornton Hall, near Blackpool, and '[t]he uprooting from Manchester changed the whole ethos of the choir and its school'.[198] Some months later the school closed, and the boys returned home and to their local schools. Cathedral worship continued, though, with weekday services sung by the men, joined by the boys at the weekend (for Saturday Evensong and the Sunday services). Appointments were made to the choir, and the boys continued to receive their salary, albeit at pre-war rates.

195 CL, Co1/39, 'Regulations'.
196 Tomlinson, 'Learning to be a Composer', p. 38.
197 Molloy, 'My Memories', p. 26.
198 Tomlinson, 'Learning to be a Composer', p. 53.

The following year, on 23 December 1940, the Cathedral was bombed. A landmine exploded near the north-east corner of the building, causing extensive damage:

> The Derby Chapel ... and the Lady Chapel have been blown all to bits. All the glass is gone throughout the whole building. The bomb fell some ten yards away in the street at the North East corner The old Father Smith organ is shattered to fragments. The big organ is badly damaged, but can be put right after the war ... The inside [of the Cathedral] looked very desolate with pieces of the organ scattered all over the place, but W [Canon Woolnough][199] said they will hold service there next Wednesday [26 February 1941] at 11.0 a.m. It will be a big push to do so.[200]

The loss of the little Father Smith organ is especially poignant. It had survived virtually unaltered for over two hundred and fifty years and was generally regarded as 'a little gem' and an example of 'Father Smith at his best'.[201] Canon Woolnough, on the other hand, must have had mixed feelings about the destruction. It was common knowledge that he hoped Hitler would 'drop a bomb which will get rid of those awful stained glass windows and destroy that reredos':[202] now he had his wish. As a result, Cathedral services moved to nearby St Ann's, returning 'home' after a few months, to a grand piano replacing the organ.

The Cathedral organist at this time was Norman Cocker (1889–1953): conjuror, amateur cook, cinema organist, and highly-respected player and choir trainer. Using his stop list, Harrison and Harrison, the organ builders, assembled a temporary two-manual organ in 1943, playable from the main console. The instrument was considered 'masterly', 'one of the most enthralling organs I have met',[203] and Cocker's playing exploited its colours to the full, mesmerizing one observer who sat with him at the console one evensong.[204] But for Cocker the best was yet to come, and he was already occupied with the design of a new instrument the Cathedral would build once the war was

199 For one chorister's impression of Canon Woolnough, see Molloy, 'My Memories', pp. 11–12.

200 CL, Diary of E. B. Leech, unpaginated typescript. Leech (1875–1950) was a Manchester physician, and wrote the account after visiting the Cathedral some months after the bombing.

201 Hudson, 'Organs and Organists', p. 122.

202 Tomlinson, 'Learning to be a Composer', p. 56.

203 C. Clutton, 'The Organ in the Church of the Messiah, Birmingham', *The Organ* 24 (1944), pp. 8–16, in R. Firman, 'Norman Cocker', *Manchester Sounds* 2 (2001), p. 120.

204 This was Bernard B. Edmonds: *ibid.*

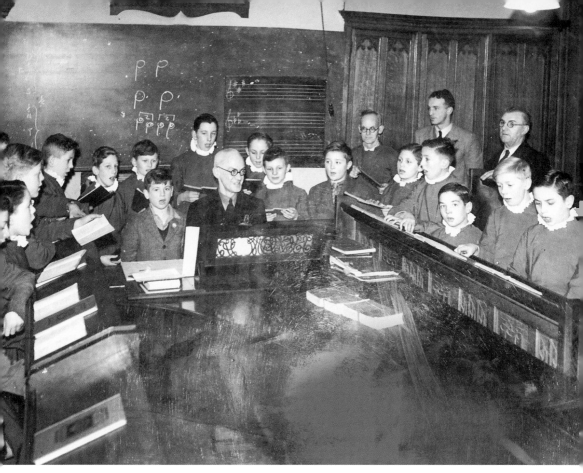

Norman Cocker
rehearsing the
statutory choir, c.
1950

over. Unusually for his time, Cocker recognized the multiplicity of roles and sounds needed in a cathedral organ, which must be capable of accompanying soloists, choir, and congregation, in addition to performing solo works in its own right, in an ever-increasing range of styles and idioms. 'A cathedral organ should therefore', he observed, 'be akin to a chameleon, capable of accommodating itself to any situation'.[205] Technically this new instrument would be dazzling, with three organs, five consoles, and a master console carrying nearly four hundred stops. It was rumoured that one console would be sited in the chancel, one in the nave, one in the Lady chapel, one at the west end, and one in a pub in Bury. Alas, Cocker did not live to hear the new instrument, which would not be installed until 1957.

With the war over, the 1950s saw a huge sense of energy and renewal in the Cathedral. It was sorely needed. The building was still being repaired, closing each August until 1954 for work

205 Norman Cocker, 'The Organs of Manchester Cathedral, 1934–1940', *The Organ* 22 (1942), pp. 49–62, in Firman, 'Cocker', p. 121.

to be carried out,[206] the new organ was not yet built, and the statutory choir needed rebuilding. It had recently begun to take its choristers from Chetham's Hospital School,[207] an arrangement which caused some difficulty for the new organist and choirmaster, Allan Wicks (at the Cathedral between 1954 and 1961). A former chorister remembers him asking

> ... why it was necessary for all the choristers to come from Chetham's and I am convinced that this had nothing to do with the musical abilities of the choristers. It had more to do with the personalities of some of them. I can also recall him saying to me ... that he did not know what he was going to do about soloists because most of the boys said they did not want to do solo singing. In a cathedral, this should be unthinkable but it was a spin-off from the ethos where, if a boy was seen to conform to any sort of normal standard, he was regarded as a creep and treated accordingly by the other boys.[208]

Nevertheless, Wicks re-invigorated music at the Cathedral, almost immediately rationalizing the number and balance of the choir. Having inherited a situation where the men, but not the boys, were augmented for the weekend services, thus affecting the balance, Wicks's choir sang with twenty boys and eight men throughout the week. The repertoire also changed, to encompass a greater range of musical style, with contemporary composers such as Britten and Leighton well represented. Wicks was fortunate to have Wentworth Megicks as precentor, since the two men obviously thought along the same lines in their selection of service music. The size of the music list is astonishing. In the two months between September and October 1954 the choir was singing 102 settings of services, anthems, and so on, rising to 200 by February 1955.[209] The repertoire now spanned about seven centuries (and included plainsong), and the balance of style was very different from that of the anthem collection mentioned earlier. Far greater weight was now given to English Renaissance composers and, in the main, music was sung in its original language. Wicks also introduced a processional Litany to the Cathedral: 'Tallis' Litany for Five voices would be sung by the precentor and the choir on a Sunday morning led by a crucifer.' Herding the choir and clergy round the Cathedral in real

206 The Regimental chapel and the Lady chapel were not finished until the 1950s.

207 Chetham's School and Nicholls' Hospital School had recently merged to form Chetham's Hospital School.

208 Molloy, 'My Memories', p. 15.

209 *Ibid.*, pp. 36–49.

time took some skill, and the process was not always without incident.[210] Special services cropped up from time to time, both regular and unusual, such as the Ordination, Assize, and Founders' Day Services. After the Munich air disaster in 1958, which killed many of the Manchester United footballers, two services were needed. The second was broadcast live on radio, and the commentator was Kenneth Wolstenholme. He was heard to say that the red surplices and white collars and ruffs of the choir were being worn in memory of the United team.[211]

It was during Wicks's time that broadcasting began to come of age, and from the mid-1950s the choir took part in several live choral evensongs for radio, and some for BBC television: from 1957 the choir was much in demand from the new Manchester-based Granada TV. The 1960s saw the first of the choir tours to Norway, France, and further afield. This must have marked quite a change for the Cathedral authorities. Having become accustomed in recent years to the choir's absence in August, they now had to consider the prospect of losing their singers at other times in the year, and of hosting a visiting choir or choirs. The Cathedral was becoming a venue for concerts, and a series was held on Tuesday evenings. Peter Maxwell Davies' organ fantasia on *O magnum mysterium* received its premiere at one on 26 October 1960, and the first British performance of Stravinsky's *O sacrum convivium* took place at another.

The combination of a more diverse repertoire, and the possibility of broadcasts, concerts, tours, and recordings must have made the choir more attractive to prospective singers; but it took its toll on the boys, who were becoming younger with every generation. Voices were breaking earlier, which affected the sound and the boys' tenure in the choir. This in turn meant that they were less experienced musically, and less of a support (vocally, musically, and in their churchmanship) to younger boys. Manchester was not the only choral institution to be faced with this dilemma and, in common with many others, began to consider the possibility of admitting girls to the choir. There were many practical advantages to this arrangement, not least the relief of the pressure on the boys: also, the girls' sound is rather different, giving the possibility of a different colour to the treble line. There are no compelling theological arguments against their singing, and society would argue that they should be given the opportunity anyway. But there are caveats: the vast majority of English church music is written for an all-male sound, that

210 *Ibid.*, p. 18.
211 *Ibid.*, p. 32.

the presence of fewer boy choristers in this generation affects the next generation of tenors and basses, and that by and large girls' voices are less strong and so more children are needed to fill a large cathedral space. Nevertheless, most choral institutions now admit girls, although the great majority run two treble lines, a boys' and a girls', and the sexes are not mixed. The general perception is that the girls drive the boys away, and there is evidence to support this: where choirs have become mixed, boys have often left, and, crucially, have not been replaced by new boys.[212] Manchester, however, runs a mixed treble line; this decision was taken in Stuart Beer's time as organist and choirmaster (1980–92), for a pragmatic reason: the need to maintain a treble line. Ironically, this works to the girls' advantage, since – almost alone in Anglican cathedrals – Manchester treats them as equals in the choir. (Elsewhere the weight of daily services continues to be borne by the boys.) But it sometimes struggles to fill the top line, and does not always reach its former total of twenty. (This change of balance, with a more equal ratio of trebles to men, lies closer to the original ratio of four to four, especially when the comparative youth of the current children's voices is taken into account.) To encourage prospective choristers, the Cathedral hosts taster days, which give children the opportunity of singing with the choir and exploring the Cathedral.

In a concern for inclusiveness and accessibility, the Cathedral promotes itself as a secular venue, available for hire (be it corporate entertainment, conferences, or concerts). As a concert hall, it is kept very busy, and provides a diverse programme of classical music, given by professional orchestras and student ensembles from Chetham's and the Royal Northern College of Music, and more popular styles. This 'wider musical life of the Cathedral' is one of the key aspects of the Manchester Cathedral Development Project, which aims to renew the heart of Manchester and Salford by focusing on the Cathedral buildings and their surroundings.

The Cathedral has undergone extensive renovation and repairs, an endowment fund has been established 'to support the wider musical life of the Cathedral and its partnership with Chetham's School of Music', and in 2017 a new organ was installed. The Stoller organ (named after Norman Stoller, a local businessman and philanthropist, who in 2014 gave £2.5 million

212 *In Tune with Heaven: The Report of the Archbishops' Commission on Church Music* (London: Church House Publishing / Hodder and Stoughton, 1992); Martin J. Freke, 'Organists in the Church of England 1950–1999: An Ethnographic and Contextual Study in Relation to the Dioceses of Bristol and Bath and Wells' (PhD thesis, University of the West of England, 2006), pp. 189–90.

Facing page:
The Stoller organ: west front, facing into nave

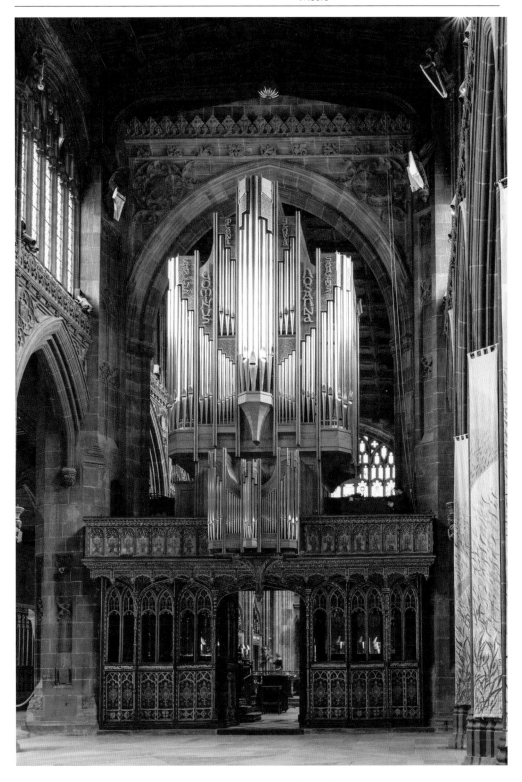

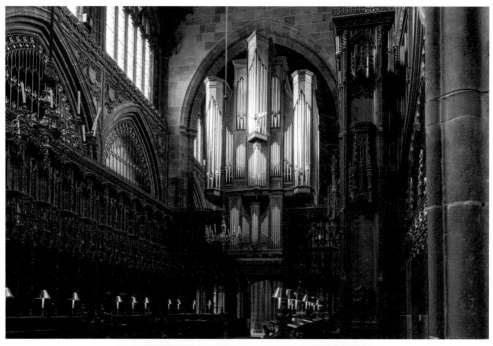

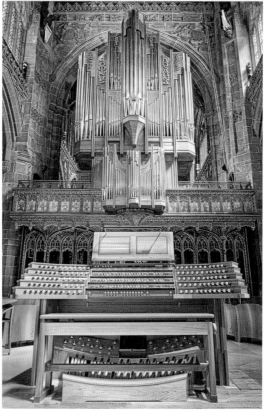

Above:
The Stoller organ:
east front, facing
into quire

Left:
The Stoller organ:
nave console

for the instrument) built by the firm of Ken Tickell stands on the screen, where its predecessors stood for centuries. Its position and specification reflect its dual role of supporting both the nave and the quire. It has made a dramatic difference to the Cathedral, both visually and aurally.[213]

Then, in March 2020, with so much in place, the Cathedral fell silent, COVID-19 having achieved what two World Wars, religious upheaval, and a Civil War had failed to do – to bring a halt to almost six hundred years of choral services. The Cathedral is having to adapt to a changed and changing climate, with any plans it may make for a phased re-introduction of choral services (and congregational singing) being subject to immediate cancellation as Government regulations change. But as restrictions gradually ease, there comes an opportunity for renewal and for taking stock: 2021 is the six-hundredth anniversary of Henry V's charter that transformed St Mary's Parish Church into the Collegiate Church, and thence to the Cathedral. Its very survival should be cause for celebration, although this church has done more than simply endure. There is much to celebrate, and at the beat and heart of it all will be the music.

[213] Details of its specification and build can be found on the Cathedral website, www.manchestercathedral.org, accessed 22 September 2020.

Memorials*

TERRY WYKE

We confess that in our 'great mercantile city' (as strangers emphatically term it) we can offer no inducements to the ramblings of the mere enthusiast who seeks in our streets temples dedicated to the muses – in our church-yards catacombs of heroes – and in our ancient cathedrals effigies of the learned men and martyrs who have once made this space their habitation …

(James Wheeler, *Manchester* [1836])[1]

I N WRITING ONE of the earliest histories of Manchester, James Wheeler was aware that whilst the town had become regarded as the entrepreneurial hothouse of the new industrial society, it could lay claim to a far longer history. The Collegiate Church was one of the buildings which Wheeler examined to reveal that past. It was by any measure one of Manchester's oldest buildings, the place in which for centuries the affairs of the parish had been settled; the place where the heads of Catholic recusants had been spiked; the place where the Young Pretender had attended service before leading his army towards Derby and disaster; the place where turbulent public meetings in the early decades of the nineteenth century exposed deepening political and religious divisions. Yet, when Wheeler visited this 'antique oratory', it contained, surprisingly for the mother church of an extensive and wealthy district, very few notable funerary memorials.

The vast majority of people who died in Manchester before the end of the eighteenth century could expect, and indeed expected, to be buried in the graveyard of the parish church.

* I am most grateful to Alan Kidd and Clare Hartwell for commenting on an earlier draft of this chapter.
1 James Wheeler, *Manchester: Its political, social, and commercial history, ancient and modern* (Manchester: Love and Barton, 1836), p. 437.

Previous spread: 'Healing window abstract'

Little is known about changes in funeral practices in Manchester itself over these centuries but as numbers increased, the majority of such burials – 93,880 are identified in the registers between 1573 and 1800 – were likely to have been in common graves.[2] Pressure on space meant that burials were seldom permanent, graves eventually being re-opened and the remains exhumed to make way for new bodies. Burial in what was regarded as the more hallowed and less likely to be disturbed ground inside the church was preferred.[3] But a coffined burial inside the church was for those of a higher social status who could afford the fees, a hierarchical distinction that was aptly expressed in an eighteenth-century epitaph:

> Here lay I at the chapel door,
> Here lay I because I'm poor,
> The farther in the more you'll pay,
> Here lay I as warm as they.[4]

For burials, the Collegiate Church was divided into three areas, namely the choir, controlled by the warden and fellows; the chantries, which were in the hands of a small number of local families; and the nave that was part of the parish church. Control and use of the floor and wall space in these areas was to change over the centuries. Pressures on space and alterations to the interior meant that funerary memorials might be moved to a different part of the church, or just removed and then lost. As such, the memorials displayed in the Cathedral today should be regarded as survivors from a much larger group.

Only a small number of memorials, all brasses and all incomplete, survive from the early centuries of the Collegiate Church. The best known is the brass of the first Warden, John Huntingdon, who died in 1457 and was buried in the choir close to the altar. Presumably finished and fixed shortly after his death, it was of a conventional design, depicting him in eucharistic vestments, with an inscription above his head.[5] The brass appears to have remained in its original location until the mid-eighteenth century,

2 Richard Parkinson, 'On the Origin, Custody and Value of Parish Registers, with an Abstract of the Registers of the Collegiate Church of Manchester', *Journal of the Statistical Society of London* 5/3 (1842), p. 260.
3 Clare Gittings, *Death, Burial and the Individual in Early Modern England* (London: Croom Helm, 1984); Thomas W. Laqueur, *The Work of the Dead: A Cultural History of Mortal Remains* (Princeton, NJ: Princeton University Press, 2015), pp. 112–17.
4 Frederick Burgess, *English Churchyard Memorials* (London: SPCK, 1979), p. 20.
5 The inscription reads 'Dne dilexi decore domus tue': ('Lord, I have loved the habitation of Thy house'): James L. Thornely, *The Monumental Brasses*

when the construction of a larger vault beneath the choir resulted in the brass and its gravestone being removed and placed there.[6] Access to the vault was from the north choir aisle, and in the following decades rubbings were made of the brass. In 1906, it was decided to restore the brass and it was removed from the vault, incomplete and badly worn. Barkentin and Krall, a London-based firm specializing in ecclesiastical metalwork, carried out the subsequent restoration, the heavily restored brass being fixed on a black marble slab in the new pavement in front of the altar in 1907.[7]

The only known tomb in the Collegiate Church from this early period was that of the fifth Warden, James Stanley, later Bishop of Ely, who died in 1515. Located in a small purpose-built chapel on the north side of the St John the Baptist chantry, it was an altar tomb topped with a brass of the bishop in ecclesiastical robes holding a crozier in his left hand, the sides of the tomb decorated with brass figures kneeling in prayer and the coats of arms of Stanley and Ely. It attracted some notoriety because of the stories told of Stanley's irregular private life. Over the centuries its condition, including the effigy, deteriorated. The local antiquarian John Owen noted restoration work on the tomb in the mid-nineteenth century, work that would have involved the removal and re-fixing of the brass:

> 1859 Jany 20: This afternoon the slab belonging to the tomb of Bishop Stanley was taken off, and broken up, a new slab is preparing but of Yorkshire stone, the old one is evidently from Collyhurst; the moulding of edges, having been worn and disfigured, had at some time been repaired with plaster or cement. The moulded edges of the new stone are copied from the original, the shields around the sides of the old Tomb are not reproduced in the new one.[8]

Neither the chapel nor the tomb survived the 1940 Blitz but the 'mutilated remains' of the brass were rescued. The surviving pieces of the effigy were cleaned, mounted, and placed in the rebuilt Regimental chapel, it having been decided not to rebuild the Ely chapel.

of Lancashire and Cheshire (Hull: William Andrews, 1893), pp. 18–19; E. F. Letts, 'Warden Huntyngton', TLCAS 2 (1884), pp. 92–107.

6 H. A. Hudson, 'Notes upon the Huntingdon and Stanley Brasses in Manchester Cathedral', TLCAS 31 (1913), pp. 141–2.

7 MG, 9 January 1907, p. 12.

8 E. F. Letts, 'The Stanley Chapel in Manchester Cathedral and its Founder', TLCAS 6 (1888), p. 172 n. 2.

Fragments of other pre-Reformation brasses, also mounted on wooden boards, are now displayed on the outside of the Regimental chapel. The first is a pointed canopy, part of a more elaborate memorial, dating from *c.* 1480, relating to the Radcliffes of Ordsall, important landowners and supporters of the church in the late medieval period. A brass of Sir Alexander Radclyff (in armour) and his wife Alice dates from *c.* 1540, the original comprising the two figures and 'an inscription four shields and at least one group of children'.[9] The female figure has attracted additional interest because it is a palimpsest.[10] It is unclear if this brass is connected to the two 'Alabaster Statues (so it is sayd)' of the Radcliffes, remains of which were in the north choir at the time Richard Hollingworth wrote his history of Manchester in the 1650s but have since gone missing.[11] Unanswered questions also surround the worn and incomplete brass of Sir John Byrom and his wife Margaret (now outside Jesus chapel), which was originally set on a Purbeck marble stone on the floor of the Lady chapel. Dating from the second half of the fifteenth century and attributed to a London workshop, in its original form 'there were canopies over each of the figures' but over the centuries it became extremely worn, the Revd Ernest Letts noting that it was among the fragments of brasses saved before the repaving of the Lady chapel and choir in the nineteenth century.[12] This was at a time when the Collegiate Church had yet to fully appreciate the historical significance of its pre-Reformation brasses, allowing them to be 'torn from their beds in the floor of the choir, and "carted away" to make way for those tiles so dear to the heart of the "restoring" church-warden'.[13]

Up to the eighteenth century, only a small number of memorials were placed in the Collegiate Church. They were generally simple in design, even when marking the deaths of members of those wealthy families – Byrom, Chetham, Trafford – into whose hands the chantry chapels had passed,[14] and, somewhat predictably, the Collegiate Church is not mentioned in pioneering

9 E. F. Letts, 'The Radclyffe Brasses in Manchester Cathedral', *TLCAS* 9 (1891), pp. 90–100.
10 Herbert W. Macklin, *The Brasses of England* (London: Methuen, 1907), pp. 249–56.
11 Richard Hollingworth, *Mancuniensis: or, a History of the Towne of Manchester and what is most memorable concerning it* (Manchester: William Willis, 1839), p. 45.
12 E. F. Letts, 'On some Fragments of an old Brass in Manchester Cathedral', *TLCAS* 1 (1883), pp. 87–95.
13 Thornely, *Monumental Brasses*, p. 14.
14 Arthur J. Dobb, *Like a Mighty Tortoise: A History of the Diocese of Manchester* (Littleborough: Upjohn and Bottomley, 1978), pp. 34–9.

Brass plaques to
Anthony Mosley and
Oswald Mosley

HIC ADIACET CORPVS ANTONIJ MOSLEY
MERCATORIS QVI OBIJT 25 MARTIJ ANO DNI
1607 AÑO ÆTATIS SVÆ 70 HABENS TEMPORE
MORTIS SVÆ ♰ ALICIA VXOREM SVAM SVPERSTITE
5 FILIOS VIZ: OSWALDV FRANCISCV EDWARDV
RICHARDV ET ROWLANDV ET TRES FILIAS
VIZ: HELENAM ALICIAM ET ANNAM.

HIC ADIACET CORPVS OSWALDI MOSLEY
DE ANCOATES ARMIGERI QVI OBIJT 9 DIE NOVEM
AN DÑI 1630, ANNO ÆTATIS SVÆ 47 HABENS
TEMPORE MORTIS SVÆ PER ANNAM VXOREM
SVAM SVPSTITEM 5 FILIOS VIZ NICHOLA EDVAR
OSWALDV SAMVELE & FRANCISCV & TRES
FILIAS VIZ ANNAM MARGARETA & MARIE

studies such as the Preston-born John Weever's *Ancient Funerall Monuments* (1631).[15] This is evident in two brass plaques placed in the Jesus chapel to members of one of the most influential local families: the first to the textile merchant, Antony Mosley (d. 1607), who is shown with his wife and eight children, kneeling in prayer; the second of a similar design depicting his son 'Oswaldi de Ancoates' (d. 1630) kneeling with his family in prayer, the family coat of arms in this brass being less worn. Although not without merit, both are rather conventional, indeed modest, memorials compared to that commemorating Antony's brother Sir Nicholas Mosley (d. 1612) in St James's, Didsbury, an impressive wall effigy in which he is shown wearing the robes of the Lord Mayor of London.[16]

Such memorials can be read as public statements of the social status of an individual or family, but one must also remember that they were also personal expressions of loss. This was the case with the marble ledgerstone on which beneath Robert Lever's coat of arms were listed the names of six of his children who died between 1635 and 1647 (now in the north-west nave). It was not to become one of the missing stones from inside the Collegiate Church, later generations finding in the names and the accompanying verse a heartfelt reminder of the grief experienced by parents in losing children, even in an age of high infant mortality.

> Had they liv'd to th'age of Man,
> This Inch had growne but to a Span.
> But now they take the lesser Roomes.
> Rock't from their Cradles to their Toombes

Although some early historians of the Collegiate Church suggested that it 'suffered much from the Oliverian tomahawk' in the Civil Wars, the actual damage to the fabric appears to have been relatively slight, the building providing thin pickings for Puritan iconoclasts searching for 'monuments of superstition or idolatry' to obliterate.[17] Whilst the screen in the Lady chapel was damaged, there is no record (for instance) of the Stanley tomb, whose brass would have been an obvious target, being wrecked.

15 Nigel Llewellyn, *Funeral Monuments in Post-Reformation England* (Cambridge: Cambridge University Press, 2001).

16 E. F. Letts, 'The Family of Mosley and their Brasses in Manchester Cathedral', *TLCAS* 11(1893), pp. 82–102; Clare Hartwell, Matthew Hyde, and Nikolaus Pevsner, *The Buildings of England. Lancashire: Manchester and the South-East* (New Haven, CT: Yale University Press, 2004), pp. 441–2.

17 Samuel Hibbert-Ware, *The History of the Foundations in Manchester of Christ's College, Chetham's Hospital, and the Free Grammar School*, 3 vols (London, Manchester, and Edinburgh: T. Agnew, 1833–34), vol. 2, pp. 337–8.

This is not to rule out other possible acts of destruction by the 'Reforming Rabble', but Manchester is not specifically identified in the most recent scholarly study of iconoclasm.[18]

It seems more plausible that it was not the 'Oliverian toma-hawk' that brought change to the interior, rather the increasing pressures on space which began to see graves being re-opened and older ledger stones turned over and re-used. These pressures were evident when in 1649 the charge for burying adults in 'the parish part of the church' was doubled to ten shillings, except in the 'middle ally and two cross allys', where it was 13s 4d, the sextons' reports confirming that the charges for intramural burial followed the practice of differential pricing seen in other churches, fees increasing the closer the grave was to the chancel.[19] Unlike its records of baptisms, weddings, and burials, many of these particular church records have not survived, Samuel Hibbert-Ware being informed that 'many leaves of their volumes have been cut away wholesale, to light tobacco-pipes by the customers of the Grey Horse public house in Smithy Door'.[20]

Burials continued to take place in both the main body of the Collegiate Church and the former chantries. Although the clergy were in a stronger position to secure burial inside the Collegiate Church, very few memorials have survived. One of the most notable is the brass memorial plaque to Richard Heyrick, Warden from 1635 to 1667, now located by the doorway into the Chapter House. Provided by his second wife, Anna Maria, it included a lengthy epitaph written by Thomas Case, a friend since their student days at Oxford, identifying traits which help to explain how Heyrick managed to survive the perilous politics of the age, leading him to be re-appointed as Warden after the Restoration.[21] Graves in the chancel may have been less likely to be disturbed than those in the nave, but it did not follow that memorial tablets, particularly smaller ones attached to pillars, were safe. A memorial to Revd Richard Ward (d. 1789) on a pillar in the Derby chapel was to go missing, as was a marble

18 John Walter, *Crowds and Popular Politics in Early Modern England* (Manchester: Manchester University Press, 2006), p. 194; Julie Spraggon, *Puritan Iconoclasm during the English Civil War* (Woodbridge: Boydell, 2003).

19 Hibbert-Ware, *History of the Foundations* (1848 edn), vol. 2, p. 261; Vanessa Harding, *The Dead and the Living in Paris and London, 1500–1670* (Cambridge: Cambridge University Press, 2002), pp. 129–31.

20 Hibbert-Ware, *History of the Foundations* (1834 edn), vol. 2, p. 262; Michael Powell and Christopher Hunwick, 'The Manchester Cathedral Sextons' Registers', *Local Historian* 39 (2009), pp. 300–13.

21 James Reid, *Memoirs of the lives and writings of those eminent Divines, who convened in the famous assembly at Westminster, in the seventeenth century*, 2 vols in 1 (Paisley: S. and A. Young, 1811, 1815), vol. 2, pp. 31–2.

tablet recording the burial of Susannah Georgiana Wray, the ten-year-old daughter of Revd Henry Wray, who died in 1790.[22] A marble monument presented by his Salford pupils to the Revd John Clayton, a Jacobite supporter and author of *Friendly Advice to the Poor* (1755), was also to be lost.[23]

Erecting memorials was less problematic for those families who controlled their own mortuary chapels. However, this did not mean that memorials were secure. Older memorials in particular were vulnerable when the ownership of chapels changed. This was evident in the early seventeenth century, when the Biron chapel passed into the hands of the Chetham family, the latter placing their own memorial stones on the altar tombs of the Birleys.[24] Other Chetham memorials included wall-mounted ones to Samuel Chetham of Turton and Clayton (d. 1744) and Edward Chetham (d. 1769). Both included portraits but the marble bust of Samuel, wearing a toga, was the more elaborate.[25] These are now on the list of missing memorials, as is a marble wall monument to the merchant Gamaliel Lloyd (d. 1749), which was in the St George's chantry. It was placed there by his son, George (d. 1783), whose own memorial, an oval marble tablet, has also disappeared.[26] A brass plaque recording the death in 1691 of the lawyer and landowner William Hulme has survived. It was on a stone fixed to the floor in the family's chapel on the south side of the Jesus chapel. Other parts of the memorial have been lost, which is perhaps not surprising since it was reported that by the late eighteenth century this small chapel was being used as a charnel house.[27] Hulme is now best remembered for providing the monies to establish schools in Manchester, Oldham, and Bury, as well as scholarships at Brasenose College, Oxford.[28]

Plaques recording gifts to the Collegiate Church have also been lost. Here the list includes a wooden board placed in the south aisle of the choir in 1700 recognizing Nathaniel Edmondson,

22 John Palmer, *Brief Guide to the Collegiate Church of Christ Manchester* (Manchester: John Parker, 1829), pp. 26–7.
23 The inscription began with a list of his traits: 'manly cheerfulness, strict integrity, diffusive charity, heroic forgiveness and serenity of temper under disappointments': William E. A. Axon, *The Annals of Manchester* (Manchester: John Heywood, 1886), p. 102.
24 The case with Jacob Chetham (d. 1697) and George Chetham (d. 1709).
25 Hibbert-Ware, *History of the Foundations* (1834 edn), pp. 339–41.
26 *Ibid.*, pp. 265–6; Gordon B. Hindle, *Provision for the Relief of the Poor in Manchester 1754–1826*, Chetham Society 3rd series 22 (Manchester: Manchester University Press, 1975), p. 161.
27 Hibbert-Ware, *History of the Foundations* (1834 edn), pp. 321–2.
28 James Croston, *Hulme's Charity: William Hulme, the 'Founder' and his Foundation* (Manchester: Thomas Sowler, 1877); ODNB, *s.n.* 'Hulme, William (bap. 1631, d. 1691)'.

SACRED to the Memory
of. M.^{rs} Ann Hinde.
Widow of the Rev.^d John Hinde,
formerly Fellow of this Church.
She lived a Pattern of Exemplary Piety:
and the present Truftees have Erected
this Monum.^t as a Grateful Remembrance
of her Diftinguifhed Charity to the Poor
of Manchefter and Stretford,
by the Eftablifhment of the
Green-Gown School.
for the Cloathing and Educating
24 poor Children; which, by good
Management and a Concurrence
of fortunate Circumftances,
are in the Year 1788.
increafed to the Number of 50.
She died in the Year 1724.
Aged 70.

Stone tablet erected by the trustees of the Green-Gown School in memory of Mrs Ann Hinde

a woollen-draper, who had paid for 'ye marble in ye Quire'.[29] Also lost is the oval plaque recording Samuel Brooke's gift in 1700 of an Arras tapestry depicting the deaths of Ananias and Sapphira that covered the oak altar screen, a feature of the Collegiate Church until its removal in the nineteenth century.[30] One

29 Palmer, *Brief Guide*, p. 26.
30 John Harland (ed.), *Collectanea relating to Manchester and its Neighbourhood at various periods*, Vol. II, CS os 72 (Manchester: Chetham Society,

memorial that has survived was raised in 1788 by the trustees of the Green-Gown School, a charity founded from a bequest left by Ann Hinde, the widow of one of the fellows, who had died in 1724 (now in the north-west nave). Predictably, the inscription on the marble mural tablet acknowledged her benevolence before going on to praise the trustees, who through 'good management and a concurrence of fortunate circumstances' were now educating fifty rather than the original twenty-four children of the honest poor in Manchester and Stretford. This public record of charity can be connected back to the much larger wooden tables of benefactions at the west end of the church, which listed the names – beginning with Walter Nugent and his mother in 1609 – of individuals who had given monies and land to the church, the interest of which was usually distributed annually to the poor.[31] When and why these 'title deeds of the poor' were lost is unknown.

Of the small number of memorials to survive from the eighteenth century, two deserve notice. The first is the brass plaque which marked the grave of Lady Barbara Fitzroy, daughter of the Duke of Cleveland and granddaughter of Charles II, who died in Manchester in 1734. Later removed, framed, and placed on the south aisle wall, the plaque included the royal coat of arms. Her burial at the west end of the choir was a statement of the church's support for restoring the Stuart bloodline, support that was evident during the unsuccessful rebellions in 1715 and 1745. Fitzroy had lived with the Dawson family in Manchester, whose name was to be remembered in the annals of English Jacobitism because James Dawson was among the officers of the Manchester Regiment to be hanged, drawn, and quartered in London in 1746. Less well remembered is his younger brother William, who was buried in the same grave as Fitzroy. His plaque, which has not survived, ignored the usual platitudes, declaring:

> He desired to be buried with the above named lady, not only to testify his gratitude to the memory of a kind benefactress: although he never reaped any of those advantages from her bounty to his family she intended. But because his fate was similar to hers. For she was disowned by her Mother. And he was disinherited by his Father.[32]

1867), p. 104. The tapestry was rolled up and apparently forgotten until rediscovered in 1904; and placed in the Jesus chapel. It was to survive the Blitz: *MG*, 25 April 1950, p. 5.

31 Hibbert-Ware, *History of the Foundations* (1848 edn), p. 263.

32 *Ibid.*, p. 248.

The other memorial is the grey and white marble wall tablet to the Manchester dyer Thomas Ogden, who died in 1766 (now in south nave, near the Chapter House). As the Latin inscription indicates, it was raised by his son, Samuel Ogden, a clergyman who was to be appointed Woodwardian Professor of Fossils (later Geology) at the University of Cambridge, at a time when ecclesiastical explanations of the age of the earth remained dominant.[33] The little-known Christopher Moon of Manchester was the sculptor.

By the 1780s, Manchester was in the grip of the world's first industrial revolution. Galloping urbanization caused Manchester to break through its ancient boundaries: the township's population increasing from some 70,000 in 1801 to over 185,000 in 1851. Industrialization contributed to a period of intense social, political, and religious change, developments which impacted on the Collegiate Church. By the 1840s, beginning with the Ecclesiastical Commissioners Act, important changes were to be made to the organization of the church, leading in 1847 to the establishment of the diocese.

The relentless increase in population also caused a burial crisis. This was most evident at the Collegiate Church, where pressure of numbers had resulted in an overspill churchyard being opened on the Chetham College side of Fennel Street in 1768, and in 1815 the establishment of a much larger parochial burial ground further to the north in Walkers Croft. This was followed in 1819 by the momentous decision to close the old churchyard, bringing to an end almost a millennium of burials on the site.[34] Inside the Collegiate Church, burials were to continue but in ever smaller numbers, in part because an increase in the number of pews reduced the available space. In addition, concerns began to be voiced about the consequences of disturbing existing graves. Thomas Clegg, who served as churchwarden in the 1840s, was reflecting what had become the familiar public health trope, when he reported that the settling of the floor in the main part of the church caused 'crevices in the earth, through which there emanated most seriously and alarmingly bad smells'.[35] Stonemasons using 'Roman cement' to fill the cracks struggled to complete the work. No doubt when Hibbert-Ware noted that the gravestone of Roger Nowell (who had died in 1731) had become part of the floor of a 'pig-stye in the back-yard

33 *ODNB, s.n.* 'Ogden, Samuel (1716–1778)'.
34 The Fennel Street ground was consecrated in June 1768; see the petition regarding a proposed burial ground at Hunts Bank: Manchester, MCL, M39/2/14/1, M3/2/1024.
35 *MG*, 3 May 1854, p. 9.

of the Flying Horse public house', his intention was to do more than send shivers of revulsion through his readers.[36] This was to be added to the criticisms of what some regarded as the church's apparent indifference towards the conducting of christenings and weddings, which were widely reported as unseemly wholesale ceremonies,[37] and gossip-generating incidents such as the hasty if temporary burial of the opera superstar Maria Malibran.[38] Such matters were contributing to the haemorrhaging of prestige and influence away from the Collegiate Church, a not insignificant part of the wider shift in the political and religious balance of power taking place in the city. Burials inside the church finally ceased in 1862.

New memorials were installed inside the Collegiate Church though none comparable to those raised to Revd John Clowes in St John's, Manchester (John Flaxman), or the Revd James Lyon in St Mary's, Prestwich (Robert William Sievier), both of which would not have been out of place in a fine London church. Of those that are displayed, a number confirm the church to be one of the key centres of local loyalism which met the threat of revolution in the early 1790s, the buttons on the uniform worn by the first King and Country club in Manchester carrying an image of the Collegiate Church.[39] Samuel Taylor of Moston, a fervent loyalist, was to be remembered by a white marble trapezium wall plaque in the form of a sarcophagus surmounted by a triangular pediment which included his coat of arms (now in the north nave). What the inscription pointedly referred to as his 'most ardent spirit of loyalty' included founding the Manchester and Salford Rifle Regiment of Volunteers, that was to take part

36 Hibbert-Ware, *History of the Foundations* (1848 edn), p. 251. When Branwell Brontë visited the church in around 1841 he was surprised to see what he took to be the gravedigger's tools – 'crowbar, mattock, spade, barrow, planks and ropes' – stored in the Lady chapel: Francis A. Leyland, *The Brontë Family, with special reference to Branwell Brontë*, 2 vols (London: Hurst and Blackett, 1886), vol 1, p. 290.

37 The annual average of baptisms for the years 1701–20 was 255.3, compared to 2991.2 for 1801–20, the annual averages of marriages for the same periods being 135.5 and 1520.7: Parkinson, 'Origin, Custody and Value of Parish Registers', p. 260. The diarist Henry Crabb Robinson provided a memorable description of the religious rite that was 'christening by wholesale' at the old church following a visit in 1816: *Diary, Reminiscences and Correspondence of Henry Crabb Robinson* (London: Macmillan, 1872), p. 337.

38 April Fitzlyon, *Maria Malibran. Diva of the Romantic Age* (London: Souvenir Press, 1987), pp. 236–41; *MG*, 1 October 1836, p. 3.

39 Katrina Navickas, '"The Spirit of Loyalty": Material Culture, Space and the Construction of an English Loyalist Memory, 1790– 1840', in Allan Blackstock and Frank O'Gorman (eds), *Loyalism and the Formation of the British World, 1775–1914* (Woodbridge: Boydell, 2014), p. 59.

in suppressing the 1798 uprising in Ireland, whilst Taylor's fervent anti-Catholicism saw him serve as the first Grand Master of the English Loyal Orange Institution, the country's first Orange Lodges having been founded in Manchester.[40] Orangeist sympathies were strong among the college clergy and they must have welcomed the memorial as much as they did the parades that made a point of calling at the Collegiate Church. The memorial inscription to another thoroughbred 'Church and King' man, Edward Greaves, pointedly stated that he had been High Sheriff of the County Palatine in 1812, one of the most industrially troubled years of the early nineteenth century when protesters were severely punished. The oblong memorial which included the family coat of arms also recorded that he was buried in a vault beneath the former Brown's chapel, one of the first chantries to be purchased by the churchwardens.[41] A lack of natural light made it difficult to appreciate the memorial, an absence that may have encouraged the mistaken belief that the sculptor was Chantrey.[42] Loyalists were at ease within the church and one should not be surprised to learn that although William Hulton, chairman of the magistrates at Peterloo, was neither buried or memorialized there, the family coat of arms was to be found on a pew, nor that the Riot Act on the afternoon of 16 August 1819 was read by the Revd Charles Wickstead Ethelstone, a clergyman who was known for his strong voice and who became a fellow of the Collegiate Church.[43]

Other memorials were less politically explicit: Jonathan Dawson, who died in 1840, was to be remembered as having been 'actively engaged as one of the Churchwardens of the Parish in the repair and enlargement of this Church in the year 1815', yet his loyalist credentials were unchallengeable. He was a frequenter of John Shaw's Club, the convivial meeting place near the church where the town's 'thoroughgoing tories of the old school, genuine church-and-king-men' met to toast Pitt and damn the radicals.[44] Another loyalist, Charles Lawson, High Master of

40 Frank Neal, 'Manchester Origins of the English Orange Order', *Manchester Region History Review* 4 (1998), pp. 12–24.

41 Axon, *Annals of Manchester*, p. 142, gives the purchase price as £900 in 1810.

42 Palmer, *Brief Guide*, p. 21; Hibbert-Ware, *History of the Foundations* (1848 edn), vol. 2, pp. 254–5.

43 Robert Walmsley, *Peterloo. The Case Reopened* (Manchester: Manchester University Press, 1969), pp. 15, 83; Donald Read, *Peterloo: The Massacre and its Background* (Manchester: Manchester University Press, 1958), p. 143; Hibbert-Ware, *History of the Foundations* (1848 edn), vol. 2, p. 247.

44 Harland, *Collectanea Vol. II*, p. 7.

Manchester Grammar School from 1764 until his death in 1807, was remembered with an obelisk-shaped marble wall monument, a gift from the school's pupils. Originally above the doors of the chapter house, but now in the Regimental chapel, it was the work of John Bacon the younger, whose London studio was kept busy meeting the demand for memorials, from minor provincial churches to prestigious London commissions, including Westminster Abbey. The design, which had echoes of Flaxman's memorial to another headmaster, Joseph Warton, in Winchester Cathedral, was in the fashionable neoclassical style, depicting Lawson seated, flanked by two of his pupils, one kneeling and holding an open book, the other standing with his right hand resting on a bust of Homer. A former pupil, Revd Frodsham Hodson, Principal of Brasenose College, provided the Latin inscription, an epigraph which may have stirred memories not of Lawson's politics but the teaching methods of 'Long Millgate's flogging Turk'. It is noteworthy as being one of the few figurative mural sculptures in the church.[45]

One of the most admired of the nineteenth-century mural memorials honoured the Manchester businessman Dauntesey Hulme, who during his lifetime had used his substantial wealth to support local charities, especially the Manchester Infirmary.[46] It was commissioned by the Infirmary's trustees, who, having rejected the idea of a monument in the hospital grounds in Piccadilly, agreed to place it in the church where Hulme had worshipped and served as churchwarden. The marble composition of the Good Samaritan assisting the fallen traveller was from the studio of Richard Westmacott[47] and was originally placed on the side wall in front of the Trafford chapel.

Burials in the family vaults continued in the first half of the nineteenth century, although there were fewer memorials than interments. This included in the Trafford chapel (formerly St Nicholas chantry) a white and black marble wall memorial to Elizabeth Trafford, who died in 1813. It depicted a kneeling female mourning, her head bowed over an urn. George Napper, who had worked for John Bacon in London before moving to Manchester, was the artist. It was commissioned by her husband,

45 *Inscription from the monument erected to the memory of the late Charles Lawson, M.A.* (Manchester: C. Wheeler, n.d.), broadside in CL; MG, 23 August 1887, p. 8. Manchester Grammar School was located in Long Millgate from 1518 until its removal to Rusholme in 1931.

46 Edwin Butterworth, *A Biography of eminent natives, residents and benefactors of the town of Manchester* ([Manchester]: J. Bradshaw, 1829), p. 31.

47 'We believe it was chiefly, if not solely, executed by Mr Westmacott junior': MC, 12 December 1829, p. 3.

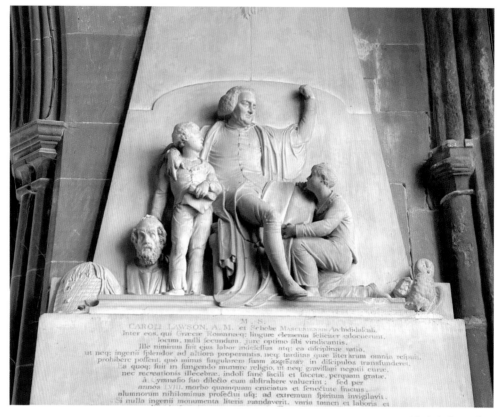

M S.
CAROLI LAWSON, A. M. et Scholæ Mascuniensis Archididaskali.
Inter eos, qui Græcæ Romanæq; linguæ elementa feliciter edocuerunt.
locum, nulli secundum, jure optimo sibi vindicantis.
Ille nimirum fuit ejus labor indefessus atq; ea disciplinæ ratio,
ut neq; ingenii splendor ad altiora properantis, neq; tarditas quæ literarum omnia resinai,
prohibere possent, quo minus singularem suam ακριβειαν in discipulos transfunderet.
Ea quoq; fuit in fungendo munere religio, ut neq; gravissimi negotii curæ,
nec recreationis illecebræ, indoli sanè facili et facetæ, perquam gratæ.
à Gymnasio suo dilecto eum abstrahere valuerint : sed per
annos LVIII. morbo quamquam cruciatus et senectute fractus,
alumnorum nihilominus profectui usq; ad extremum spiritum invigilavit.
Si nulla ingenii monumenta literis mandaverit, varia tamen et laboris et

John Trafford, who was tellingly described as a 'true and well-tried patriot' on his death in October 1815. Others to be buried in the family vault included Maria Trafford (1826), Elizabeth Trafford (1828), Clementina Trafford (1834), and Thomas William de Trafford (1844). Sir Thomas Joseph de Trafford and his wife, Laura, were the last to be buried there (1852). Members of the Byrom family also continued to be buried in their mortuary chapel. A single ledger stone set into the floor records ten family members from 1668 to 1785, including John Byrom, famous for inventing 'Universal English Shorthand' and writing the Christmas hymn 'Christians, Awake! Salute the Happy Morn'. Edward Byrom, the founder of St John's Church, was also buried in the family vault. His fortune passed to his two daughters, Ann and Eleanora, both of whom have marble wall tablets in the chapel (now in the Jesus chapel, north of the arch). Eleanora never married and, although it was not mentioned on the wall tablet, she was renowned for her charity, her name appearing near the top of many Manchester subscription lists. The family continued to claim its rights over the chapel and in 1904, when the chapel was finally transferred to the church, Edward Byrom insisted (as

Obelisk-shaped marble wall memorial to Charles Lawson (John Bacon the younger, 1810)

Marble wall
memorial to
Dauntesey Hulme ,
relief depicting the
Good Samaritan
(Richard Westmacott
Jnr, 1829)

stated on the brass plaque mounted on the outer wall) that its
identity as a chapel should continue.[48]

Improvements, beginning with Palmer's programme to 'beau-
tify' the interior, contributed to the removal and, in some cases,
the loss of memorials. Not all were funerary memorials. Some-
time after the end of the Napoleonic war, the wooden royal arms
of Charles I was taken down and removed to the ringing room in
the tower, this important patriotic symbol eventually being lost.
Less obvious was the loss of a plaque celebrating the first ringing
of Bob Major by the Manchester Collegiate Church Society of
Change-Ringers, a peal rung to mark the new year of 1819.[49]
However, whilst the fate of many memorial plaques, such as that
marking the burial of Major Richard Cust on a pillar close to the
south door, is unknown, others were treated with greater respect.
This, to give one important example, was the case with the Hey-
rick tablet, when well-intentioned efforts to warm the Collegiate

48 W. H. Thomson, *The Byroms of Manchester*, 3 vols (Manchester: W. H.
 Thomson, 1959–69).
49 Hibbert-Ware, *History of the Foundations* (1848), vol 2, p. 248.

Thomas Fleming
statue (Edward
Hodges Baily,
1852).
The inscription
extols Fleming's
contribution to the
development of
Manchester

Church by installing a 'preposterous iron stove' caused it to be moved.[50]

The absence of major memorials in what after 1847 was now the Cathedral church of the new diocese could be said to have ended in the early 1850s with the installation of two marble portrait statues. The first one was of the Manchester business-man and prominent Tory, Thomas Fleming. At first sight it can be read as an uncomplicated if expensive family memorial pro-vided by his children, William and Mary Fleming, yet it was also overtly political in celebrating Fleming's achievements in public office. Edward Hodges Baily, a much-admired London sculptor whose reputation was based on neoclassical works such as 'Eve at the Fountain' and the statue of Nelson in Trafalgar Square, was the artist. Fleming was depicted wearing an open frock coat, knee breeches, and shoes with bows. The all-impor-tant likeness was considered to be good. However, it was the lengthy inscription on the drum pedestal which suggested that it was more than a simple family tribute. This commended Flem-ing's work in improving Manchester, particularly the measure ensuring 'the appropriation of the gas profits to public purposes'. Pointedly referred to as a 'true description' by the conservative *Manchester Courier*, the inscription was written by the lawyer, bibliophile, fellow churchman and Tory, James Crossley. It was a declaration of Fleming's contribution to governing Manchester before municipal power passed into the hands of the Liberals. Crossley's tribute was making public the Conservative version of that history in a prominent public space, though it may be surmised that had not the political landscape changed after 1838 then the statue might have found a place in the town hall in King Street, another public project in which Fleming had been involved. The Cathedral readily agreed to install a statue to one of Manchester's leading Tory churchmen, placing it at the east end of the south aisle in September 1852.[51]

Humphrey Chetham was the subject of the second statue. Chetham was a seventeenth-century textile merchant who used part of his fortune to establish a number of charities, the most important of which were a school for educating forty poor boys and a library for the use of the inhabitants of the town. Chetham had worshipped at the Collegiate Church and was buried there in

50 *Ibid.*, p. 303.
51 Terry Wyke and Harry Cocks, *Public Sculpture of Greater Manchester* (Liverpool: Liverpool University Press, 2004), pp. 55–7; Stephen F. Collins (ed.), *James Crossley: A Manchester Man of Letters*, CS 3rd series 50 (Man-chester: Chetham Society, 2012), p. 51.

1653.[52] Both the school and the library had close links with the Collegiate Church, the charity scholars having their own pews. Chetham's charities ensured that his name was kept alive and over the years proposals were made for a memorial, including placing a marble stone over his burial place. But, as with a later proposal to build a memorial tower at Turton, near Bolton, nothing was done. When one looked at the memorial stones in the Chetham chapel, as Wheeler did in 1836, the only legible ones recorded the names of other members of the family.[53] As the bicentenary of Chetham's death approached, George Pilkington, a churchman who put his success in business down to his education at Chetham's School, decided to commission a statue to be placed inside the Cathedral. William Theed, who had been a pupil in Baily's studio, was the chosen artist. Theed depicted Chetham seated, dressed in early seventeenth-century costume, the likeness being based on the portrait in Chetham's Library. In his right hand he was holding a copy of his will. Seated on the stone steps by his feet was a Chetham bluecoat boy pointing to a verse from the Book of Psalms.[54] The statue was placed at the east end of the north aisle, close to the Chetham chapel, in October 1853. Although the gift was anonymous, it was widely known that Pilkington was the donor.[55] It was an admired work and was to be one of only three memorials in the church that Baedeker drew to the attention of visitors in his authoritative guidebook.[56] The Fleming and Chetham statues became points of interest (both were to be railed) even though most visitors, like Nathaniel Hawthorne, came chiefly to see the richly carved choir stalls and misericords.[57]

Expectations that the Fleming and Chetham statues might encourage the commissioning of other impressive memorials were not to be realized. The early 1870s saw an excited debate over whether a city of the rank of Manchester ought to build a new cathedral, either by integrating the existing church into the

52 Stephen J. Guscott, *Humphrey Chetham, 1580–1653: Fortune, Politics and Mercantile Culture in Seventeenth–Century England*, CS 3rd series 45 (Manchester: Chetham Society, 2003).

53 Wheeler, *Manchester*, pp. 368–9.

54 The inscription on the book reads: 'He hath dispersed abroad, and given to the poor and his righteousness remaineth for ever' (Psalm 112:9).

55 Terry Wyke, '"So honest a physiognomy": Memorialising Humphrey Chetham', *TLCAS* 99 (2003), pp. 21–41.

56 Karl Baedeker, *Great Britain. Handbook for Travellers*, 4th edn (Leipzig: Karl Baedeker, 1897), p. 347.

57 Nathaniel Hawthorne, *Our Old Home* (London: Smith Elder, 1864 edn), p. 359; Helen M. Pratt, *The Cathedral Churches of England: Their Architecture, History and Antiquities* (London: John Murray, 1910), p. 324.

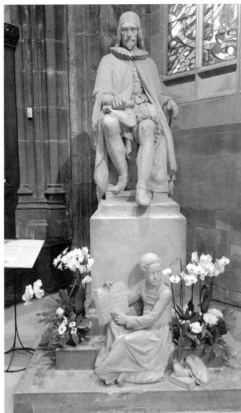

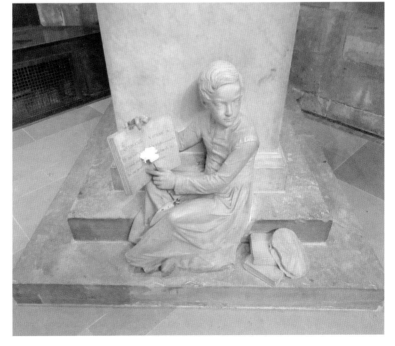

Clockwise from top left:
Humphrey Chetham statue (William Theed, 1853) in 1900;
Humphrey Chetham statue today;
Detail of Chetham School pupil with hand and feet damaged by bomb, December 1940

new building or, even more ambitiously, by replacing it with an entirely new one.[58] Bishop Fraser was supportive of the project but Richard Carpenter's ambitious plans were to run aground on financial rocks as well as resistance to the idea from within the dean and chapter and the wider church. Matthew Hadfield's Catholic Cathedral's spire on the city skyline was not to be challenged. The way forward was to continue to restore the existing building.

The ongoing restorations inevitably caused disruption to the Cathedral but they were not without their discoveries. Best known was the uncovering during work on the north porch of a fragment of reddish sandstone on which was the carved image of a (headless) angel and a partial inscription. It became the subject of much speculation and investigation, particularly that it was evidence of a pre-Norman church on or near the site of the present Cathedral. The 'Angel Stone' was to be recognized as the 'earliest Christian monument within the city', and it was initially placed on display by the Jesus chapel.[59]

No further major monuments were to be unveiled in the Cathedral until the 1880s, when two striking memorials were installed, both altar tombs surmounted by life-size recumbent effigies. The first honoured Hugh Birley who had died in September 1883. Birley, like Fleming before him, was a prominent Tory, having been elected as MP for the borough in 1868. He was also an active churchman (two of his brothers were Church of England ministers), and exceptionally generous in financing new churches and schools in working-class districts such as Hulme.[60] The memorial was paid for by friends and admirers, including the Diocesan Church Building Society and Diocesan Board of Education. Joseph S. Crowther, the architect responsible for the ongoing restoration, designed the Gothic-inspired altar tomb of polished Caen stone which was decorated with the arms of the diocese and the Birley family. The life-size figure of Birley was in alabaster. Unveiled in November 1886, it was placed in the north chancel aisle, close to the Chetham statue.[61]

58 *British Architect*, 1 May 1874, p. 273; MC, 13 June 1874, p. 2, 24 June 1874, p. 6; *The Builder*, 8 August 1874, p. 664.

59 For the most recent assessment of the date of the stone, see Elizabeth Coatsworth, in Michael Morris (ed.), *Medieval Manchester: A Regional Study*, Archaeology of Greater Manchester 1 (Manchester: Greater Manchester Archaeological Unit, 1983), pp. 9–12; MG, 15 February 1905, p. 5.

60 Obituary in MC, 10 September 1883, p. 5; it is surprising that he is not included in the *ODNB*.

61 MC, 16 February 1884, p. 6; MEN, 9 October 1885, p. 2, MG, 22 September 1886, p. 8; MC, 6 November 1886, p. 6.

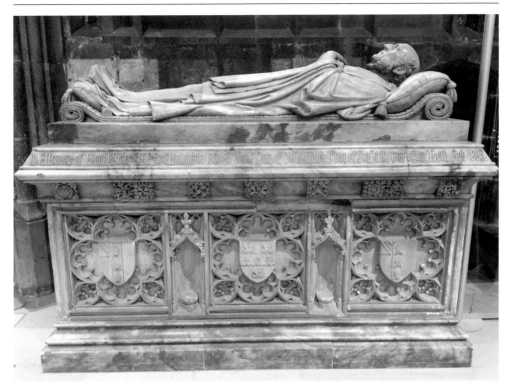

Effigy of Herbert Birley on free-standing tomb chest (Earp, Son and Hobbs, 1886). Now in south-east chancel but originally in the north chancel aisle, head damaged during 1940 bombing

By that date Crowther was already engaged in designing a further memorial. This was for the second Bishop of Manchester, James Fraser, whose death in 1885 was met, unlike that of his predecessor, by numerous calls for memorials to recognize the work of the 'People's Bishop'. A bronze statue (Thomas Woolner) in Albert Square was Manchester's main public tribute, whilst memorial windows were to be placed in a number of churches.[62] In his design of the diocesan memorial, Crowther followed the architectural language of the Birley tomb. Fraser's tomb, however, was to have a far more spectacular setting, being housed in a separate chapel, the gift of his widow, Agnes. Crowther, busy working on the restoration, designed a neat small square chapel at the east end of the south chancel aisle.[63] The decorated tomb chest included marble statuettes of the apostles on the two long sides, while 'on the eastern end was a representation of the Lord as The Light of the World, on the western end as The Good Shepherd'.[64] Like the Birley memorial, it was sculpted by the London

62 Wyke and Cocks, *Public Sculpture*, pp. 16–18.
63 The exterior of the chapel included corbels with heads of Bishop Fraser and Queen Victoria, carved by Ralph Wales of Earp, Son and Hobbs.
64 Joseph S. Crowther, *An Architectural History of the Cathedral Church of Manchester* (Manchester: J. E. Cornish, 1893), pp. 45–6; *Manchester*

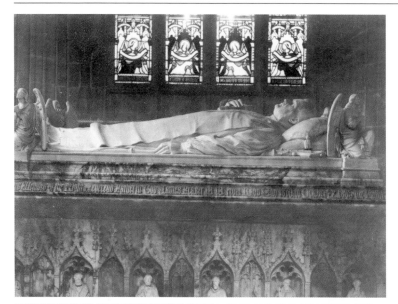

Alabaster effigy of James Fraser recumbent on tomb chest, wearing clerical vestments, holding a prayer book, kneeling angels at four corners. (James Forsyth, 1886) c. 1900. Tomb chest carved by Earp, Son and Hobbs

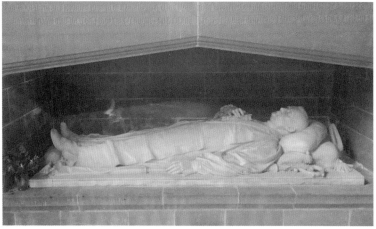

Bishop Fraser today in tomb recess, south wall of Fraser Chapel

and Manchester firm of Earp, Son and Hobbs. On the top of the cenotaph (Fraser was buried in Ufton Nervet, Berkshire) was the figure of Fraser in his bishop's robes, carved by James Forsyth. The inscription on the tomb made it clear that this was the diocesan tribute. It was unveiled in July 1887, a brass wall plaque recording that the chapel was the gift of his widow.[65]

Coloured glass windows became one of the principal features in Crowther's restoration scheme. In the final quarter of the

Weekly Times, 9 July 1887, p. 5; *Illustrated London News*, 4 June 1887, p. 11.

65 A memorial window to Agnes was placed in the chapel in September 1898, recognizing her substantial gifts to the diocese.

century some twenty new windows were installed, the Cathedral displaying glass from the workshops of many of the country's leading makers, including Burlison and Grylls, Clayton and Bell, Shrigley and Hunt, and Wailes of Newcastle. The Manchester firm of Edmundson's also received commissions.[66] Many of these were given as memorials. The most discussed window, however, honoured not a local individual but General Gordon. Christopher Schofield, a Manchester chemical manufacturer, was not alone in regarding Gordon as the ideal Christian soldier, but his decision to commission a window to mark Gordon's heroic death was an exceptional tribute. The new window was placed in the north nave in 1888, Wilson and Whitehouse's design depicting Gordon in Khartoum, flanked by Sudanese natives, looking out for the relief column.[67] It was the only window that usually merited attention in the guidebooks to the city.[68]

As all the glass was to be lost in the 1940 Blitz, only a small number of the original plaques now remain as reminders of this outburst of giving which made a considerable difference to the interior of the Cathedral. These include in the north-west nave two plaques, one recording the gift of a four-light window depicting incidents in the life of Joseph (Hardman's of Birmingham), a gift in 1887 from James Beard of Ancoats and Levenshulme;[69] the other of a window in memory of Lucinda and Maria Smith given by their brother, Stephen.[70] There is also, on the nave south side, a lancet-shaped brass plaque marking the gift of a window to Sir John William Maclure, 'dedicated by his sorrowing children'.[71] One of Manchester's leading Conservatives, Maclure's renowned organizational skills had been important in raising money for the rolling restoration, a contribution that is also acknowledged in a brass wall tablet in the Jesus chapel.[72]

66 For a list of windows, see Thomas Perkins, *The Cathedral Church of Manchester: A short History and Description of the Church and of the Collegiate Buildings now known as Chetham's Hospital* (London: George Bell, 1901), pp. 47–53.

67 John Wolffe, *Great Deaths: Grieving, Religion and Nationhood in Victorian and Edwardian Britain* (Oxford: Oxford University Press, 2000), pp. 147–56; MG, 28 September 1888, p. 5; MC, 1 October 1888, p. 6.

68 Anon., *The Cathedrals of England and Wales*, 2 vols (London and New York: Cassell, 1906), vol. 2, p. 132.

69 MC, 12 May 1887, p. 6; 14 May 1887, p. 16.

70 The window included scenes depicting 'the stoning of St. Stephen, the Conversion of Saul, St. Paul and Barnabas, and St. Paul before Agrippa' (Burlison & Grylls): Perkins, *Cathedral Church*, p. 52.

71 MEN, 14 June 1902, p. 5; Perkins, *Cathedral Church*, p. 53. Among his own gifts to the Cathedral was a window which included a representation of 'Joshua at the fall of Jericho' by Clayton & Bell.

72 It reads 'This tablet was erected as a record of the fact that a large part of the money expended upon these vestries was contributed in memory of Sir

Opinions about the new glass in 'T'Owd Church' differed. Some preferred the transparent gloom of the ancient plain glass, asserting that modern glass reduced the light entering the Cathedral, an important factor in Manchester where 'at the best too much sunlight is not usually observable in this region of smoky chimneys and polluted atmosphere'.[73] For other worshippers and visitors, the subjects represented and the bursts of colour both helped to make the interior a more inviting and contemplative space. This ambivalence was even evident in Revd Thomas Perkins's Edwardian guidebook, which felt it necessary to temper the expectations of 'cathedral hunters' even before they entered the church:

> ... the exterior of the Cathedral Church at Manchester lacks somewhat of the charm that so many of our old cathedrals possess. There is no wide-spreading close with its smooth turf and immemorial elms, no birds to fly round tower and pinnacle, and break the silence of the home of ancient peace with their songs or cries, but ever we hear the scream of railway engines, the bells of tramcars, and the roar of the traffic along a busy thoroughfare. The surrounding buildings are not now, as in many cathedral cities, the residences of Dean and Canons, quaint and mediaeval, with stone mullioned windows and ivy-covered walls, but modern erections, shops, and warehouses, and hotels.[74]

Further improvements continued to be made to the Cathedral in the opening years of the new century. The west porch, designed by Basil Champneys as a tribute to Queen Victoria's Diamond Jubilee, was finally completed in 1901. A life-size statue of the Queen, sculpted by her daughter Princess Louise, was placed above the doorway in the following year, the subsidiary niches intended for the Cathedral's patron saints being left untenanted.[75] Champneys was also responsible for designing the large annexe on the south side of the Cathedral. This was dedicated in 1904 and included a life-size statue of Bishop Moorhouse in his episcopal robes, holding his pastoral staff.[76] As photographs and

John William Maclure. Bart. who himself when he was Warden helped to raise the sum of £50,000 for rebuilding the nave of the cathedral.'

[73] P. H. Ditchfield, *The Cathedrals of Great Britain* (London, J. M. Dent, 1902), p. 267.

[74] Perkins, *Cathedral Church*, p. 24.

[75] Unveiled by the Prince of Wales, the future George V: *MC*, 12 March 1902, 13 March 1902; *Manchester City News*, 3 January 1925.

[76] *MG*, 7 October 1903, 18 August 1904; *Manchester Evening Chronicle*, 16 July 1904.

postcards of the time show, these new extensions were easy to identify, standing out against the now smoke-stained stonework of the Victorian restoration. They also show that what remained of the churchyard had been landscaped.

Soon after its completion, the interior of the Victoria porch became a more conspicuous entrance, following the decision to use the space to display military memorials. These included a large bronze tablet recording the names of the men of the Manchester Regiment who had died in the South African War (1899–1902), part of a memorial project which included a statue in St Ann's Square. Another bronze memorial listed the forty-one officers and soldiers of the 1st King's (Dragoon) Guards also killed in the conflict.[77] Two smaller brass plaques were more unusual in that they were not provided by local regiments. One memorialized Lt Col Arthur William Valentine Plunkett and fellow officers of the King's African Rifles, who had been killed in a disastrous battle that Plunkett had fought against the Dervishes in Somaliland.[78] It was presented by his mother. The other remembered Colonel Henry Darlington who had died accidentally from a gunshot at his home in Wigan, a tribute from members of the Church Lads' Brigade, with which he been associated for many years.[79]

New memorials were also placed in the main body of the Cathedral in the Edwardian years. Without question the most surprising was that marking the passing of Dean Edward Maclure. It took the form of a medieval full-length portrait brass, a choice that was probably influenced by the decision taken to restore the Huntingdon brass. Champneys advised on its design, the work being carried out by Barkentin and Krall. Given Maclure's popularity, not least because of his work in promoting Church of England education in the city (he was chairman of the Manchester School Board and vice-chairman of its successor, the Manchester Education Committee) a memorial tribute was expected,[80] but the more conventional response at this time would have been to commission a window similar to those installed to mark the passing of Dean George Bowers and Dean John Oakley.[81] Both the Maclure and Huntingdon brasses

77 *MG*, 18 May 1904, p. 10.

78 Roy Irons, *Churchill and the Mad Mullah of Somaliland* (Barnsley: Pen & Sword, 2013), pp. 59–68.

79 *Wigan Observer*, 23 August 1904, p. 6; *MC*, 23 November 1906, p. 10.

80 Maclure who had served as Dean from 1890 described himself on one occasion as 'a downright High-Low-Evangelical-Catholic-Churchman': obituaries in *MC* and *MG*, 8 May 1906.

81 *MC*, 3 August 1874, p. 7; 27 May 1892, p. 8.

were let into the new pavement in the choir, the latter, as one would expect, being placed closest to the altar.[82]

The First World War further strengthened the links between the Cathedral and military in the city. Large congregations attended services to remember those from local regiments who had been killed in battles from the Western Front to Mesopotamia, as was also the case with those memorial services honouring national figures such as Kitchener and Edith Cavell, the latter leading to calls for a local memorial. Days of national prayer also saw the Cathedral crowded. The long relationship between the Cathedral and the military continued in the years after the war. July 1 saw the Manchester Pals and others attending the annual service commemorating the Battle of the Somme. It was at this service in 1923 that a bronze memorial tablet, the work of Hubert Worthington, was unveiled, beneath the colours of the City Battalions.[83] The Cathedral's links with the Manchester Regiment were further strengthened, when, following the example in other churches, a separate regimental chapel was established in what originally had been the St John the Baptist chantry, later the Derby chapel. It was dedicated on Remembrance Day, 1936. The scheme received the approval of the Earl of Derby, whose many official positions included being honorary colonel of the regiment. The new chapel featured a poignant memorial in the form of an oak case containing the regiment's rolls of honour, four volumes listing the names of the 14,209 men who had lost their lives in the Great War.

Other memorials were to be placed outside the Cathedral, in what was now a smaller but more carefully maintained churchyard. A stone cross, designed by Hubert Worthington, commemorating Joseph Gough McCormick, Dean from 1920 to 1924, was placed on the lawn in front of the Moorhouse statue.[84] It was not the only memorial to McCormick, as when the bells were recast in the mid-1920s, one of the ten bells was given by members of the congregation in memory of him.[85] The landscaped churchyard was to be further reduced by the building of the choir school. Completed in 1933, it included above the entrance door a stone panel carved by Eric Gill, depicting Mary holding the infant Christ, flanked by St Denys and St George. It was to become one of the Cathedral's most admired sculptures.[86] Less

82 *MG*, 10 July 1906, p. 4; 25 July 1906, p. 4.
83 *MG*, 3 July 1923, p. 11.
84 *Manchester City News*, 6 September 1924. The cross was unveiled in June 1926.
85 *MG*, 20 October 1925, p. 14.
86 Wyke and Cocks, *Public Sculpture*, p. 59.

attention is given to the grave in front of the school entrance. The Revd Cecil Daniel Wray was the last person to be buried in the churchyard, his burial in 1866 requiring a special Home Office order as the churchyard had been officially closed. Wray had served in the church for over fifty years, and it was said he knew and loved every stone in the building.[87] His grave is easily found, unlike the inscription which recorded that the repaving of the chancel completed in 1859 had been in honour of Wray's fiftieth year at the church.[88]

Sunday 22nd to Tuesday 24th December 1940 were black-edged days in the long history of the church, the building being severely damaged when the Luftwaffe bombed Manchester. Substantial parts of the Cathedral were almost completely destroyed, including all the memorial glass. Hubert Worthington was to be in charge of the restoration.[89] The Regimental chapel was almost entirely rebuilt and at remarkable speed given the post-war shortages. It was rededicated in the presence of the Queen Consort (she was Colonel-in-Chief of the regiment) in 1951.[90] A memorial stone honouring Edward Stanley, 17th Earl of Derby, was let into the floor of the chapel. New names were to be added to the roll of honour, and in the following years further brass and stone plaques remembered those killed in conflicts from Malaya to Northern Ireland. These new memorials, however, could not eclipse historically the Bishop Stanley brass, which had been rescued, understandably damaged, from what remained of the Ely chapel. The brass was repaired and cleaned, and because it had been decided not to rebuild the Ely chapel, it was mounted on a wooden board and fixed on the wall where the entrance to the chapel had been.

The Christmas Blitz also damaged the Humphrey Chetham statue, most obviously on his left knee and the scroll in his right hand, as well as the schoolboy who lost both feet and part of his cap. Located further away from the Regimental chapel, the statue of Fleming suffered less damage (missing thumb on the right hand and chipped scroll). In the rebuilding after the war both statues were moved to other areas of the Cathedral before being returned in 2013 close to their original locations, their war wounds still visible. The two tomb memorials suffered only minor damage in 1940. In the years of rebuilding and restoration that followed, Birley's nose was repaired and his tomb removed to the south

87 *MC*, 5 May 1866, p. 2.
88 *MC*, 28 April 1866, p. 6. His name is still remembered today through the annual Sock Appeal, originally Canon Wray's Birthday Gift.
89 Dobb, *Like a Mighty Tortoise*, pp. 50–4.
90 *MG*, 17 November 1951, p. 3.

chancel aisle. Bomb damage to Bishop Fraser's tomb was also slight, but in the re-organization of the church in the post-war years it underwent a far more radical transformation, the decision being taken to redesign the chapel by removing the tomb chest and placing the marble effigy of Fraser in a wall recess.[91]

As the rebuilding of the Cathedral progressed, one important monument was added to the exterior. This was a bronze gilt statue of Mary and the infant Jesus, placed in a niche of the rebuilt Lady chapel. The 'Lancashire Madonna', as it became known, was the work of Sir Charles Wheeler.[92] Later, five large circular plaques were to be displayed along the wall in Cathedral Street providing information on individuals who had been important in the history of the church in the city: Thomas de la Warre, John Bradford, Edward Barlow, James Prince Lee, William Temple, and Peter Green.

Since the completion of the restoration, a number of memorial tablets, usually stone, have been installed, principally on the south nave wall, remembering individuals who have served the Cathedral. These include Lewis Hadfield Orford, chapter clerk and diocesan registrar (brass), and the architects Raymond Wood-Jones and Sir Hubert Worthington, the latter also having had the Fire window dedicated to him in the Regimental chapel, a gift presented by his friends in his old regiment. In 1997, a brass plaque to Lieutenant Wilfred Owen MC, 'Poet & Soldier', was also placed in the Regimental chapel.[93] Recognizing the links between the Cathedral and the city, tablets have been raised to mark more recent events, notably the bomb exploded by the IRA in the city centre in 1996. Another plaque acknowledges the financial help provided by one of the district's oldest charities established in the seventeenth century by the textile merchant Humphrey Booth the elder, who worshipped at and was buried in the Collegiate Church. Ledger-stones have also been placed in the south aisle remembering recent bishops, beginning with Guy Warman (1929–47). Only one significant piece of sculpture was placed inside the Cathedral in these years: Josefina de Vasconcello's 'Holy Night', in 1992, one of a series of works on the theme of the Nativity by the artist which can be seen in a number of churches, including the Anglican cathedrals in Blackburn and Liverpool.

Funerary memorials provide important insights into a community's religious beliefs and observances as well as into the

91 Dobb, *Like a Mighty Tortoise*, p. 48.
92 Wyke and Cocks, *Public Sculpture*, pp. 59–60.
93 Owen joined the Manchester Regiment in 1916 and was killed in fighting near Ors in northern France on 4 November 1918.

wider social and political attitudes of the times in which they were created. What is evident from this rapid chronological overview is that only a relatively small number of memorials were ever installed inside the Cathedral over six centuries. Of course, only a tiny fraction of those who were buried at the Collegiate Church were buried inside the Church, of whom an even smaller number were to have funerary monuments, remembering that not all those who had memorials were interred inside the Church. This was due to a number of factors, including the limited floor and wall space available and the actions of those who controlled those spaces. Building and restoration work, especially since the nineteenth century, further reduced the available space and also resulted in the removal and disappearance of memorials. The funerary monuments were not only small in number but in their form and design were essentially derivative. With the exception of a commission such as Theed's statue of Humphrey Chetham, the majority of larger works were unexceptionable, even when families looked to London-based studios rather than local firms. Even then, the finished works were in the minor key and none were by the leading artists of the day: the portrait statue of Fleming is by Baily, not Chantrey; the tombs of Birley and Fraser are by Crowther, not Gilbert or even Manchester's own sculptor in residence, John Cassidy. Brass memorial plaques, which in the last hundred and fifty years came to outnumber works in stone, were mostly conventional in design and characterized by a calligraphy that was pleasing but typical. It is perhaps understandable why the memorials and monuments have received cursory attention from either social or art historians working on broader themes. Nineteenth-century guides such as Baedeker, which brought only three memorials to readers' attention,[94] were rather more polite than Murray's popular guidebooks, which struck a more general note of disappointment, observing that 'even the Cathedral, venerable as it is, does not soar above the dignity of a collegiate church, whilst many country churches exist equal, if not superior to it, in architectural beauties'.[95] Changes in more recent decades may warrant a more positive assessment but for those visiting the Cathedral, especially for the first time, it is other features of the exterior and interior rather than its historically revealing memorials that attract their attention.

94 They were the Stanley and Fraser tombs, and the Chetham statue: Baedeker, *Great Britain*, p. 347.

95 [G. P. Bevan], *Handbook for Shropshire, Cheshire, and Lancashire* (London: John Murray, 1870), p. 169.

✣ **12** ✣

Misericords

JOHN DICKINSON

THE EAGLE AND CHILD, the Elephant and Castle, the Angel, the Lion, the Stag and the Unicorn – not a list of public houses located in and around Manchester, but some of the misericords in Manchester Cathedral. Misericords, those carved images found under the choir stalls, offer glances of the ordinary, the real, the imagined, and the fantastic. They highlight hidden worlds and tell tales from the edge; they are the wooden equivalent of the marginalia in illuminated manuscripts. This chapter offers an introduction to the misericords of Manchester, describing the carvings and providing a context in which to understand the images and their meanings.

Before diving beneath the seats, we begin with a brief contextual explanation. Misericords are hinged seats found in abbeys, cathedrals, churches, and other religious houses where the canonical hours were performed. Performing the hours is a religious practice in which prayer and devotion are observed at eight specified times throughout the day. In the medieval period, these devotions were performed standing in the choir, and the misericord developed initially as a means to support the older monks. A misericord, from the Latin word for mercy, is a ledge on the underside of the hinged choir seat that, when lifted, allows the user respite during devotions. Originally undecorated, over time simple foliate motifs were added and this, in turn, led to much more elaborate designs using a huge variety of subjects and images.[1]

1 For a full introduction to English misericords, see Francis Bond, *Wood Carvings in English Churches: Misericords* (London: Oxford University Press, 1910); Christa Grossinger, *The World Turned Upside Down: English Misericords* (London: Harvey Miller, 1997); or G. L. Remnant, *A Catalogue of Misericords in Great Britain* (Oxford: Clarendon Press, 1998).

Previous spread:
'Musically faithful'

In England, only 4.5 per cent of misericords have a religious image (most commonly an angel) and only 1.5 per cent show a scriptural scene.[2] Much more common are images of plants, animals (including monsters), and people. Most carvings depict the ordinary low everyday world, as opposed to the high sacred one found (for example) on altar carvings, but there are many that can be described as fantastic and satirical or simply as funny. Misericords are at the margins of church decoration and, like the images that appear in the margins of medieval manuscripts, they depict the edge of order. While the altar reflects the high, the misericords, hidden in the dark beneath the seats, or beneath the monks, were quiet reminders of that non-sacred dis-ordering presence against which monks must always guard.[3] A term used at the time to describe these types of images was *babewyn*, a term Michael Camille translates as 'monkey-business'.[4]

Manchester's misericords are comparatively late. The earliest surviving set of choir stalls with misericords in England is Salisbury (*c.* 1245) and the earliest figurative (i.e. highly decorated) set is Exeter (*c.* 1250).[5] Manchester's were installed in the first decade of the sixteenth century.[6] It is generally accepted that they were initiated under the wardenship of James Stanley (Warden 1485–1506), but may not have been completed until his nephew, of the same name, took over the post.[7]

Two men provided the financing for the stalls, Warden Stanley and Richard Beswicke (also spelt Bexwicke or Bexwyk). Stanley provided for the south side, while Beswicke paid for the north.[8] The family crest or cipher of each can be seen carved into the desk at the end of their respective sides. Richard Beswicke was a prosperous and very generous local merchant. Charles Tracey quotes a plea from the Abbot of Whalley, dated 1511, in which Beswicke is referred to as 'an exceptional benefactor' who 'built at his own charge a chapel and one side of the "Queer" of the said College Church, which cost him 300 or 400 marks or more'.[9]

2 Marshal Laird, *English Misericords* (London: John Murray, 1986), p. 10.
3 Michael Camille, *Image on the Edge: The Margins of Medieval Art* (London: Reaktion Books, 1992), p. 93.
4 *Ibid.*, p. 12.
5 Grossinger, *World Turned Upside Down*, p. 23.
6 Bond, *Misericords*, p. 227, suggests a definitive date of 1508, while Grossinger, *World Turned Upside Down*, p. 24, is more circumspect with a date of *c.* 1506.
7 Charles Tracey, *English Gothic Choir-Stalls 1400–1540* (Woodbridge: Boydell, 1990), p. 21; Beatrice Home, *Chester, Manchester & Liverpool* (London: J. M. Dent, 1925), p. 110.
8 Tracey, *English Gothic Choir-Stalls*, p. 21.
9 *Ibid.*; 300 to 400 marks would equate roughly to £1.2 to £1.6 million in modern currency: Epsom and Ewell History Explorer,

Who actually carved these misericords is a subject of specula-
tion and debate. Detailed historical records are not available, but
Francis Bond suggested in 1910 that it was quite conceivable that
some of the same carvers' may have been involved in Manchester,
Ripon Cathedral (carved *c.* 1500), and Beverley Minster (carved
1520).[10] Tracey, in his work of 1990, cites J. S Purvis who in 1929
suggested the name of William Bromflet.[11] Bromflet, also known
as William Carver, was a Ripon-based carver who appeared in
the Cathedral accounts book and Purvis argued that there was
sufficient stylistic overlap between the three sets of carvings, as
well as other minor works in the region, to ascribe them either
to an individual (Bromflet) or to a single approach (the Ripon
School). Tracey contests this view and provides a re-assessment
in which the aesthetic similarities, described as 'a regional period
style', are deemed insufficient in the face of 'the lack of co-ordi-
nation in the assembly of the furniture, and the disparity of the
carving styles'.[12] However, Christa Grossinger, in her critically
important work of 1997, continues to associate Bromflet with
Manchester,[13] and Malcolm Jones, writing in 2000, states that
there can be 'no doubt' that some of the carvings at Beverley are
directly copied from Manchester in a 'striking correspondence'.[14]

Interestingly, while dismissing Bromflet as the carver, Tracey
nonetheless states that in Manchester 'all the decorative carving
was done by one man'.[15] This may be applicable to the tracery in
the choir stalls, but the same cannot be said for the misericords.
As will be shown, the detail and skill in the carvings are markedly
different and while it is entirely likely that a single individual, be
that Bromflet or another, oversaw the project, there was certainly
more than one pair of hands involved in the work.

Manchester has a set of thirty misericords. These are distrib-
uted with twelve to both the north and south side of the choir
and three to each side of the choir's west entrance through the
rood screen. Using the Remnant methodology,[16] these are num-
bered as N1–N15 and S1–S15, with N1 and S1 being the closest
seat to the altar on the north and south side respectively. Each

www.epsomandewellhistoryexplorer.org.uk/WhatsItWorth.html.

10 Francis Bond, *Wood Carvings in English Churches: Stalls and Tabernacle Work* (London: Oxford University Press, 1910), p. 61.

11 Tracey, *English Gothic Choir-Stalls*, p. 16.

12 *Ibid.*, p. 30.

13 Grossinger, *World Turned Upside Down*, p. 24.

14 Malcolm Jones, 'The Misericords', in Rosemary Horrox (ed.), *Beverley Minster: An Illustrated History* (Beverley: Friends of Beverley Minster, 2000) p. 158.

15 Tracey, *English Gothic Choir-Stalls*, p. 21.

16 Remnant, *Catalogue of Misericords*.

misericord contains a main central carving and two side carvings, commonly called supporters. These supporters are connected to the main image via a rope or branch that appears to be knotted with a flower or leaf. In a few cases the images in the supporters are connected with the main carving, but most are not.

Between the seats are carved armrests, the majority of which have a floral or foliate design. On the north side two armrests depict lions, one a wyvern and one a man's head, while on the south side one depicts an eagle and stag and two depict a man dressed as a fool. Beatrice Home suggests that the fool is an oblique reference to Warden Stanley's family. Henry Tudor had had Sir William Stanley, James's brother, executed. He later visited Thomas Stanley, another brother and the Earl of Derby, at Lathom House, the family seat. While touring the house, both Henry Tudor and Thomas Stanley went out on to 'a high roof unprotected by any battlements', where Thomas's fool, it is told, whispered: 'Tom, remember Will', suggesting an opportunity for revenge – an opportunity not taken.[17] Whether such a reference in the carving was intentional is pure speculation, but there are sufficient other references to the Stanley family in the stalls to make it entertainingly plausible.

Before describing each of the misericords, a general word on the carvings' condition. For carvings that are five hundred years old and have been in general usage for that entire period, they are remarkably well preserved. That said two, N4 and N12, are damaged almost beyond recognition and others, notably N11 and S3, are also badly affected. While the historical records do not exist, it is clear from examination that in all cases the damage was inflicted intentionally. The most likely scenario is that they were damaged either during the Protestant Reformation of the sixteenth century or later during the Puritan era. N12 is identifiable as a biblical scene (see below), and it is not unreasonable to assume N4 was something similar. This would have exposed both to zealous iconoclasm.[18] N11 and S3, on the other hand, while not religious in nature, depict scenes which could be deemed offensive and, in the case of N11, belittling to men. Again, this may account for the overzealous reaction. A few of the others also have damage, often heads being removed, and these will be noted in the descriptions.

I shall now take each misericord in turn, starting on the southern side.

17 Home, *Chester, Manchester & Liverpool*, p. 114.
18 See Eamon Duffy, *The Stripping of the Altars: Traditional Religion in England* (New Haven, CT, and London: Yale University Press, 1992).

S1 – Main image: Griffin, supporters: Floral

Of all the misericords, this is the most unintentionally damaged. It appears to have been subject to years of rubbing which has worn off many of the original features. However, enough remains that it can be clearly identified as a griffin. Griffins are a monstrous combination of lion and eagle, and a comparison between this carving and S6 and S14 demonstrates how the carver has combined these two to create the image. Griffins are an example of a theriomorphic combination, in which a monster inhabits two or more of the four elements, in this case air and earth; such unnatural combinations were deemed to be against God's will.[19] However, as is common in medieval symbolism, the griffin can be seen as either good or evil, depending on the context.[20]

S2 – Main image: Antelope, supporters: Floral

To the carver, an antelope would be as alien a creature as the griffin in S1 and, as with the griffin, he would have been dependent on a pattern or a print which he could copy.[21] It is clear it is an antelope owing to the serrated horns and long lion-like tail.[22] While this is a perfectly adequate carving, it lacks the skill and panache that can be seen in others in the set.

S3 – Main image: Sow playing bagpipes, supporters: Sow playing harp (left) and Sow with saddle (right)

A sow plays the bagpipes while her piglets dance; this appears to be an example of a *drolerie*, an image primarily designed to amuse the viewer.[23] Some have suggested that the squeal of a pig bears a certain resemblance to the music of a bagpipe and this could explain the humour.[24] However, the pig had a chequered reputation, being associated with such positive features as fecundity and motherhood (as the sow in this image illustrates)

19 David Williams, *Deformed Discourse: The Function of the Monster in Medieval Thought and Literature* (Exeter: University of Exeter Press, 1996), p. 179.

20 Janetta Rebold Benton, *The Medieval Menagerie: Animals in the Art of the Middle Ages* (New York: Abbeville Press, 1992), p. 130.

21 Grossinger, *World Turned Upside Down*, p. 26.

22 Richard Barber, *Bestiary: Being an English Version of the Bodleian Library, Oxford M.S. Bodley 764 with all the original Miniatures reproduced in Facsimile* (London: Folio Society, 1992), p. 34.

23 Malcolm Jones, *The Secret Middle Ages: Discovering the Real Medieval World* (Stroud: Sutton Publishing, 2002), p. 144.

24 *Ibid.*, p. 157.

but also with filth, gluttony, and uncleanliness.[25] The bagpipes too were associated with the low and the bawdy.[26] That the sow has had her face cut out and three of the four piglets have been beheaded would suggest that someone did find the image offensive rather than simply amusing.

S4 – Main image: Wildman fighting dragon, supporters: Foliate

The Wildman, also called a wodehouse, was a popular image in misericords (as was his cousin, the Green Man). Initially seen as savages who had spurned the civilized ordering influence of God and Christianity, by the time the Manchester carving was completed wildmen had begun to take on the characteristics of the 'noble savage', one not besmirched by the trappings of the world, or, in the words of Malcolm Jones, 'The Hairy Anchorite'.[27] This Wildman is clearly not as wild as some: his hair and beard are well coiffured and he is sporting a rather fine belt. He is also attacking a dragon, an evil creature (see S13). The dragon has some webbing on its wings, a short tail, and a dog-like muzzle. There do not appear to be any ridges on its back.

S5 – Main image: Lion fighting dragon, supporters: Lions with tongues stuck out

A lion fighting a dragon is a classic representation of good versus evil. The lion, king of the beasts and Lion of Judah, is a representation of Christ, while the dragon is an abomination to God (see S13). Typical of the image, the lion is on top and, while the dragon is making a good fight, it is clear that the lion will end victorious. The dragon in this carving is very similar to the one in S4, with the same dog-like muzzle; however, there are clear differences. The webbing in the wings is more pronounced, there are clear ridges along the dragon's back, and the tail is long and corkscrewed. This, when taken with the other dragon carvings, strongly suggests different carvers.

S6 – Main image: Lion with tree, supporters: Floral

The lion in medieval representation could be both good (*in bono*) and evil (*in malo*). As the image was very popular and hence very

25 see Claudine Fabre-Vasas (trans. Carol Volk), *The Singular Beast: Jews, Christians, and the Pig* (New York: Columbia University Press, 1997).

26 Grossinger, *World Turned Upside Down*, p. 99.

27 Jones, *Secret Middle Ages*, p. 65.

common, it became necessary to be able to differentiate quickly. The motif that emerged as indicative was the hair: the curlier the mane, the more *in bono* the lion.[28] This lion in Manchester has a very wavy mane and is thus clearly good. He is also a magnificent carving. Comparing the manes between this lion and that in S5, the S5 lion's hair, while still curly, has these curls represented through a series of parallel lines, whereas here each hair is individually designed, with curlicues and depth. There is also nobility in the facial features. Compare this with the antelope in S2 or the creature in N10 and it is clear that the same hands did not produce each.

S7 – Main image: Bear baiting, supporters: Floral

Bear baiting, in which a bear is made to fight dogs, was a popular pastime. It is clear upon examination of the image that this is baiting, as opposed to the hunting that can be seen in N6: the bear has a collar around its neck, and tucked under the dog on the far left-hand side of the image can be seen the ring to which the chain on the collar has been attached. While the composition of the image makes good use of the space, this is not one of the stronger carvings in Manchester, with each of the creatures quite simply or even crudely represented.

S8 – Main image: Pedlar and apes, supporters: Ape with urine flask (left) and Ape with baby (right)

This, perhaps along with N1, is the gem in the Manchester collection. The image depicts a pedlar sleeping while a group of apes ransacks his wares. The ape was considered a creature that did not accept its lot in life and would always try to be something it was not: a human.[29] The modern words 'simian' and 'similar' share a Latin root, and it is thus that apes ape. In earlier times this made apes and monkeys representations of evil, as they did not accept the will of God, but by the time this carving was made they were merely 'the prime representation of human foolishness and sinfulness'.[30]

We can see many of seven deadly sins represented in this depiction. The apes' greed led them to steal from the pedlar, their envy made them want the human things and their pride led them into the belief that stolen trinkets make them as man. The

28 Benton, *Medieval Menagerie*, p. 85.
29 Camille, *Image on the Edge*, p. 12.
30 Grossinger, *World Turned Upside Down*, p. 99.

The pedlar and the apes

blissfully sleeping pedlar is the embodiment of sloth. The cause of his slumbers could well be either lust or gluttony and one can only foretell his wrath upon awakening.

This is one misericord where the supporters clearly relate to and extend the central image. The ape on the left is examining a urine flask, thus satirizing the medical profession. Satirizing doctors was common as captured in the medieval warning 'he is a fool who makes his physician his heir'.[31] The ape on the right has kidnapped a baby, again showing its desire to be human.

S9 – Main image: Chanticleer, supporters: Young foxes at school (left) and Fox reading (right)

A fox stealing a bird is a traditional beast fable. The version from Chaucer's 'Nun's Priest's Tale' in *The Canterbury Tales* is a well-known variant.[32] The fox, whom Chaucer names Russell, through guile and cunning lures out the cockerel, Chanticleer, snatches him, and runs to the woods to consume his prize (in the tale Chanticleer escapes using his own trickery, but that is not depicted here). As in Chaucer's tale, the 'blessed widow' and one of her two children are present. The key difference between the tale and the image is that Chanticleer is depicted here as a goose.

31 David Sprunger, 'Parodic Animal Physicians from the Margins of Medieval Manuscripts', in Nona C. Flores (ed.), *Animals in the Middle Ages* (New York: Routledge, 1996), p. 68.

32 Geoffrey Chaucer (trans. Nevill Coghill), *The Canterbury Tales* (London: Cresset Press, 1992), pp. 136–42.

The fox stealing the goose

This is probably because the goose's long neck is more adaptable stylistically to carving. However, to reinforce the fact that this is a literary allusion, the fox in the right supporter is seen reading a book, while on the left two fox kits are seen studying a text beneath their stern teacher who stands over them wielding a birch switch.[33]

S10 – Main image: Two wildmen jousting, supporters: Foliate

As with S4, wildmen populate this misericord. In this case they are jousting. That they are wildmen is clear, as each is barefoot, although like S4 they are otherwise well groomed. That they are jousting represents a societal inversion (see N1), as jousting was a sport restricted to the nobility,[34] and while these wildmen might be 'noble savages' there is more emphasis on 'savage' than 'noble'. The man on the right is astride a horse. The man on the left, although his steed is damaged, appears to be riding a camel. Two humps can be plainly seen and the long neck would also suggest a Bactrian charger. Camels, not unlike the antelope in S2, would not have been seen by the carvers, but as biblical creatures would commonly feature in carvings and other works of art.

33 For more details, see John Dickinson, *Misericords of North-West England: Their Nature and Significance* (Lancaster: Lancaster University Press, 2008), pp. 98–104.

34 Suzanne Comte (trans. David Macrae), *Everyday Life in the Middle Ages* (Bologna: Liber, 1978), p. 108.

Traditionally the Bestiary associated camels with the humility of Christ,[35] but it is not clear that this was intended with this image.

S11 – Main image: Elephant and castle, supporters: Floral

The elephant has long been represented in misericords, indeed the earliest decorated set in England, Exeter, contains a fine example. Often the elephant is depicted with a howdah, the traditional Hindi carriage, on its back. However, this conventional carriage morphed in the medieval imagination: elephants grew and so did their loads, until we arrive at the popular image of the giant elephant with a whole castle strapped in place. The elephant represented here, typically, bears little resemblance to the actual animal. The ears look more like windmill sails and in keeping with the popular myth, the beast has no knees.[36] However, it is the castle that holds the greater interest.

The elephant and castle

The castle depicted on the back of the elephant could well be a representation of Lathom House, the Stanley family seat. Lathom House, near Ormskirk in Lancashire, was described as a 'Northern Court' and a 'haven of wealth and political influence in an otherwise backward area'.[37] Built *c.* 1496, an account from

35 Barber, *Bestiary*, p. 96.
36 Bond, *Misericords*, p. 30.
37 Stephen Bull, *The Civil Wars in Lancashire* (Lancaster: Carnegie Publishing, 2009), p. 18.

the mid-seventeenth-century Bishop Rutter, quoted in Seacome's *House of Stanley*, describes the house as

> ... encompassed with a strong wall of two yards thick; upon these walls were nine towers, flanking each other, and in every tower there were six pieces of ordinance, that played three one way and three the other ... besides all these, there was a high tower, called the Eagle Tower, in the midst of the house, surmounting all the rest; and a gate house has also two high and strong buildings with a strong tower on each side of it.[38]

While the castle in the misericord would be an artist's impression, there are enough similarities between the image and the description to suggest a connection. This is a connection strengthened by the other Stanley allusions seen nearby in S12, S14, and most notably S15.

S12 – Main image: Angel with shield, supporters: Floral

Angels are the most common religious image to find on a misericord.[39] This angel has curlier hair than many and is an excellent example of the type; the drapery of the gown is particularly impressive. However, what is most noticeable about this carving is the shield the angel holds and the distinct *ny tree cassyn* or 'three legs' carved thereon; the same three legs that emblazon the Manx coat of arms. This is another reference to the Stanley family. James Stanley's ancestor John Stanley (*c.* 1350–1414) had been granted suzerainty of the Isle of Man by Henry IV and adopted the title King of Mann, a title held by the Stanley family until *c.* 1505, when Thomas Stanley, the 2nd Earl of Derby, changed 'King' to 'Lord'.[40]

S13 – Main image: Dragon, supporters: Floral

Like the griffin in S1, the dragon is a theriomorphic combination. The dragon is worse, however, as with its beastly body, its leathery wings, and its fire breathing it combines three of the four elements: earth, air, and fire (and as it is closely associated with its watery cousin the leviathan, it can be seen to cross all four). As the medieval mind thought that God had decreed that every creature should be associated with only one of the four

38 *Ibid.*, p. 185.
39 Laird, *English Misericords*, p. 10.
40 H.S. Corran, *The Isle of Man* (David and Charles: Newton Abbot, 1977), p. 49.

elements, and to be content therein, the dragon, with its transgression to exist in all four, is the creature most commonly used in medieval art to represent sin.[41] It was the rule breaker and embodied the coming together of all that should by God's will be held separate.[42]

That said, this representation of a dragon is an excellent carving and this dragon has been done with greater skill than those in S4, S5, and N10. The basics are the same, with the dog-like muzzle, the flat teeth, and the webbed wings, although there is less webbing in this example than in S5. The corkscrew tail is in common with S5, but not S4 or N10. However, the balance of the elements of the carving and the attention to detail marks this as the finest in this set. The skin, for example, has been carefully worked to create a life-like leather effect, and the use of space and flow moving left from wing to head to ear to wing clearly shows a master carver at his art.

S14 – Main image: Eagle, supporters: Crowned eagle talons

An eagle in flight is depicted in this misericord. A comparison between it and S13 is instructive. Unlike the balanced dragon in S13, this eagle appears cramped. The wings are furled over as though pushed down by the ledge, or the monk upon it. Both talons appear to emerge from the body with only the slightest reference to the necessity of legs, and the talons themselves are huge, far larger than the head and beak. The carver has not commanded his space, it has commanded him, and a lopsided asymmetrical eagle is the result. This is somewhat surprising, as it is reasonable to assume that the eagle is also a reference to the Stanleys, not least as the supporters for this misericord represent eagle talons with crowns upon them, a badge of the Stanley family.[43]

S15 – Main image: Lathom Legend, supporters: Foliate

S15 was the warden's seat, also known as the dean's stall, and so would have been where James himself sat. It is therefore not surprising, given the other references to his family, that he kept the most obvious one for his own place. Depicted here, as well as on the desk end by the western entrance to the choir, is what is

41 Benton, *Medieval Menagerie*, p. 41.
42 Williams, *Deformed Discourse*, p. 202.
43 Peter Draper, *The House of Stanley; including the Sieges of Latham House* (T. Hutton, 1864), p. 306.

The eagle and child (demonstrating the Lathom legend as it relates to the Stanleys)

called the Lathom Legend. The legend tells of an Irish queen who is forced to flee to the forest. Pregnant, she gives birth to twins, a boy and a girl, both of whom are snatched from her. The girl does poorly and is taken by fairies to become a banshee, but the boy is kidnapped by an eagle and taken to Lathom Park. There he is discovered by Lord Lathom and adopted. He inherits the family estate, marries, and has a daughter who in turn marries a Stanley. That Stanley becomes the first lord of that name and takes the eagle and child as his arms.[44]

Unusually for a misericord, the image depicts two sequential scenes from the legend. The first, on the left, shows the chid wrapped in swaddling, high aloft in an eagle nest, the eagle standing over him while two servants of Lord Lathom look on. The second shows the same two servants returning to Lathom House, presumably to tell the lord about the child, as they do not seem to have him with them. A comparison of the building with that in S11 provides further evidence that both are representations of the actual Lathom House.

44 Jennifer Westwood and Jacqueline Simpson, *The Lore of the Land: A Guide to England's Legends from Spring-Heeled Jack to the Witches of Warboys* (London: Penguin, 2005), p. 400.

N1 – Main image: Rabbits' revenge, supporters: Floral

Probably the best known of all the misericords in Manchester, as a misericord image it is unique. It depicts a scene of social inversion where the rabbits have revenged their many ancestors by catching the hunter and his dog. The scene shows the rabbits in their kitchen. The huntsman, complete with hunting horn at his belt, is tied to a spit and is being slowly roasted: the flames of the fire can be seen carved into the back of the image. Four pots line up before the fire and in one furthest to the right a dog can be seen being stewed as a side dish. Three rabbits are visible, albeit two are damaged, and one is depicted reaching into a salt box, a must for any good kitchen, to ensure that the dog is seasoned just so.

Rabbit's revenge

The carving is taken directly from a popular print of the day drawn by Israhel von Meckenem (1465–1503), a goldsmith who was active in Bocholt in the Lower Rhine,[45] and demonstrates the influence that continental print-work was having on English carving in the early sixteenth century.[46] This in turn was influenced by the thinking of the day, and particularly that of Erasmus of Rotterdam (*c.* 1466–1536). Erasmus wrote about

45 Christa Grossinger, *Humour and Folly in Secular and Profane Prints of Northern Europe 1430–1540* (London: Harvey Miller, [*c.* 2002]), p. 44.
46 Grossinger, *World Turned Upside Down*, p. 67.

ollas ostentare, which he translated 'to make a show with kitchen pots'.[47] This is using the mundane or the low, often through humour, to demonstrate things of great importance; a social inversion or (as Christa Grossinger calls it) a world upside down. In rabbits' revenge not only is there the obvious biblical teaching that the meek are blessed for they shall inherit the earth, but there is also a subtler political meaning about the possible ramifications of suppression.

N2 – Main image: Unicorn, supporters: Floral

The unicorn, the single-horned horse, is a mythical beast that was another traditional representation of Christ. Drawn from the Song of Songs (2:9), 'My beloved is like the son of the unicorns', unicorns were seen as another metaphor for the divine, their single horn representing the mystery of the Trinity.[48] Unfortunately, Manchester's unicorn is not a particularly successful representation of the type. The carving is, by comparison with (for example) N1, crude. The muzzle could belong to a dog as much as a horse. The horn is serrated like those of the antelope in S2, but this appears to have been accomplished by a series of amateurish chisel chops. Finally, the animal has, for some unknown reason, been given lion's paws as opposed to hooves. Like S2, this appears to be the work of the least skilled of the Manchester carvers.

N3 – Main image: Basilisk fighting cockerel, supporters: Floral

The damaged creature on the right side of the misericord appears to be either a basilisk or a cockatrice. Such a creature, mythology would purport, is hatched when 'the egg of a cock seven years of age is laid in the warmth of a dunghill and there it is incubated by a snake or a toad'.[49] The resultant creature, no bigger than a chicken, is a winged venomous lizard with a serpent's tail, which can kill by shooting poison from its eyes. Here the creature appears to be meeting its 'father' in a less than familial embrace. The cockerel, while also damaged to the head, still shows a fine comb and excellent plumage. Basilisks, who represented the

47 Diane Scillia, 'Hunter Rabbits / Hares in Fifteenth- and Sixteenth- Century Northern European Arts Parody and Carnival', in David Smith (ed.), *Parody and Festivity in Early Modern Art: Essays on Comedy as Social Vision* (London: Routledge, 2012), p. 42.

48 Barber, *Bestiary*, p. 37.

49 Bond, *Misericords*, p. 55.

devil, were, in some cases, represented with crowns. This may suggest one reason why the head has been hacked away.

N4 – Main image badly damaged, supporters: Floral

Like N12, this image has, but for two trees on the edges, been totally destroyed. It would have been two figures, but beyond that any further comment would be pure supposition.

N5 – Main image: Hunt scene: Deer being dressed, supporters: Floral

N5 and N6 are paired and both show scenes from a hunt (technically, N6 comes first). This scene shows the stag being cleaned, or unmade. The huntsman would have slit the throat to drain the blood (such a cut is clearly visible in the carving, although this could also be the wound inflicted by the dog in N6), and is now in the process of slicing open the carcass to remove the entrails and other organs. It was necessary to do this work as quickly as possible after the kill, as the meat would otherwise quickly begin to spoil. This is why the scene is depicted in the woods. The unmaking was the seventh of eight stages in the hunt and was often very ritualized.[50]

N6 – Main image: Hunt scene: Dog taking deer, supporters: Floral

In medieval hunting, the noblest form was hunting *par force de chiens* (by force with dogs).[51] This was an eight-stage process whereby the deer, or hart, would be sought (the quest), pursued with dogs, and eventually killed by the huntsman, someone of nobility. Problematically, in this image the dog has been allowed to go beyond its remit and is killing the deer. The dog clearly has its jaws around the throat of the stag and the lowing tongue would suggest that the animal, if not already dead, is so close that any hunter's blow would be redundant. In hunting the dog's role was to pursue the hart until it was either exhausted or cornered (in formal terms, at bay). The hunter would then step in and make the kill. That this is not happening in this scene would suggest that this is another expression of opprobrium of disorder and a reminder to know one's place.

50 Richard Almond, *Medieval Hunting* (Stroud: Sutton, 2003), pp. 75–81.
51 *Ibid.*

N7 – Main image: Fox riding hound, supporters: Floral

This is another representation of social inversion. Here the fox, so often the hunted, has turned the tables and is now the hunter, complete with a hunting dog which he rides in splendour. His success can be seen in the rabbit hanging from his pole, while three birds look down from the safety of the trees surrounding. The fox is a perennially popular subject in misericords (see also S9), his association with cunning and deception making him a favourite.[52] The most popular representation of a fox in the arts is the character of Reynard, made famous through the epic poem of Pierre de Saint Cloud and, in England, through William Caxton's publication in 1481 of the *History of Reynard the Fox*. Reynard 'gets what he wants, rarely gets caught, even more rarely gets punished, and never shows anything akin to genuine remorse'.[53]

N8 – Main image: Men playing tric trac, supporters: Floral

While the hunting in N5 and N6 may be the sport of kings, N8 shows a much more lowly domestic scene. In it two men are involved in a game while in the background their wives busy themselves in domestic duties. The game is called *tric trac* and is a precursor to backgammon.[54] The pieces are clearly visible on the board and even appear to be set up nearly as they would be for the opening moves of backgammon today. The man on the right appears to be rolling the dice, and on the table next to him appears a plate for snacks. It is a scene of domestic relaxation.

The women (it is safe to assume wives) have not been offered this same comfort, for both are involved in work. The woman on the left is carding wool, an initial stage in the process where raw wool is pulled between two rough paddles (or carders) so as to remove impurities and align the wool fibres prior to spinning. The carders are clear in her hands, as is the ball of fleece and readied rolls of fibre at her feet. The woman on the right is drawing a glass of beer from a barrel: the spigot is clearly shown, and there is a convenient space on the table next to the *tric trac* board for her to place it. It is worth noting that while the men are wholly intact, both women have been significantly damaged.

52 Dorothy Yamamoto, *The Boundaries of the Human in Medieval English Literature* (London: Oxford University Press, 2000), p. 60.

53 Dickinson, *Misericords of North-West England*, p. 100; see also Kenneth Varty, *Reynard the Fox: A Study of the Fox in Medieval English Art* (Leicester: Leicester University Press, 1967).

54 Remnant, *Catalogue of Misericords*, p. 85.

N9 – Main image: Man or child in conch fighting dragon, supporters: Floral

A strange image in Manchester and the one that most defies interpretation. It shows what appears to be a man, although some such as G. L. Remnant have suggested that it is a child,[55] with a spear fighting a wyvern, a two-legged dragon. The difficulty arises in that the man or child is inside a conch shell. As an image, a person in a shell is relatively common; similar ones can be seen in Bakewell, Chester, Lincoln, and Nantwich. But as Pritchard, writing on Nantwich, states the meaning is 'obscure',[56] and while Grossinger suggests it represents a battle of good versus evil she acknowledges that it 'needs further explanation'.[57] The conch shell was, at times, associated with the goddess Venus, as was the child god Cupid.[58] That could make this image a battle between the two greatest vices that those of the church were meant to avoid: earthly sexual love (Cupid in the conch) and the sins of the devil himself (the wyvern / dragon). However, that would create its own issues, as Cupid's spear appears to have successfully pierced the wyvern's head (one of the spine ridges is out of alignment with the others and could well be the spear tip); that would suggest that sexuality can conquer sin, an unlikely teaching for the time and place. The wyvern provides another example of a dragon in Manchester that demonstrates the variation in carving choices and skills. This example has quite rudimentary webbing that is rough and unevenly spaced. The spine ridges are very pronounced, and the legs are those of a lion but, unlike N10, S5, or S13, the paws lack claws.

N10 – Main image: Dragon / Manticore, supporters: Foliate

A dragon, but perhaps not a dragon at all: Remnant, in his catalogue, describes this as a dragon biting his own back.[59] A close inspection of the image, however, suggests that it may be a manticore. A manticore is a monstrous winged lion, and in this image, there are significant lion-like qualities. The feet are lion's paws (compare to S6), the tail is plumed, and there is carving in the flank that could be designed to represent fur. However, there are

55 *Ibid.*
56 R. E. Pritchard, *The Choir and Misericords of St Mary's Nantwich* (Nantwich: Johnsons, n.d.), p. 8.
57 Grossinger, *World Turned Upside Down*, p. 82.
58 Theresa Tinkle, *Medieval Venuses and Cupids: Sexuality, Hermeneutics, and English Poetry* (Stanford, CA: Stanford University Press, 1996), p. 91.
59 Remnant, *Catalogue of Misericords*, p. 85.

Above and facing page: Dragons

some issues with this interpretation. The mane, while possibly represented by a single curlicue of hair, is very understated and the head bears far greater resemblance to the other dragons in S4, S5, S13, N10, and N13 than it does to the lion's head in S5 and S6, although it lacks the spine ridges seen in S5, N9, and N13. Whatever the creature may be, while the action of biting (or possibly cleaning) provides a strong subject, particularly in the raising sinews in the neck, this is not one of the better carvings in the collection.

N11 – Main image: Marital strife, supporters: Floral

A woman scolds her cowering husband while the soup runs away from the broken pot between them. While damaged, one assumes she would have been wielding the soup ladle and he, even more damaged, can still be seen to be kneeling with his back to his wife. Scenes of marital strife are very common in misericords, with the women almost inevitably gaining the upper hand and the man being humiliated. Two interpretations are regularly provided, and the truth inevitably lays somewhere between them.

The first sees the woman as virago, not virago in the positive sense of heroic, but as a pejorative for women who go beyond

their place and disrupt cultural expectations. As Grossinger comments, 'misogyny was widespread in the Middle Ages and men liked to hear preachers attacking women'.[60] In this interpretation, these images are warnings that unless tightly controlled, women will become violent or shrewish and must therefore be kept in check. The second interpretation, while maintaining the key theme of control, inverts the players. Medieval marriage litigation stated that 'a husband should treat his wife with conjugal affection, at table and in bed'.[61] In other words, while men may control everywhere else, in the kitchen the wife was in charge. Hardly modern equality, it nonetheless fits the scene in the misericord where the man has interfered, the soup has been spilt, and the woman is, rightly, providing him with his comeuppance.

N12 – Main image badly damaged, supporters: Foliate

As with N4, this image is badly damaged. However, unlike N4, its original image can be surmised. It is most likely an image taken from the Numbers 13:23: 'And they came unto the brook of Eshcol, and cut down from thence a branch with one cluster of grapes, and they bare it between two upon a staff; and they brought of the pomegranates, and of the figs.' The two figures are clear, as is the fact that there is something between them. However, the reason why there can be confidence is that there is a similar one undamaged at Ripon Cathedral.

N13 – Main image: Wyverns fighting, supporters: Floral

This final image of dragons / wyverns shows two that are locked in combat. The spine ridges are the most pronounced in these creatures, and extend not only along the back, but over the skull and onto the forehead (otherwise only seen in N9). Uniquely, in Manchester these ridges also extend the full length of the body and onto the tail. The wings are the only example to show the under-wing. However, rather than the webbed carving seen in both the other images in the set and (importantly) the other aspects of the wings in this image, the under-wing is represented via a series of parallel wave lines. Whilst it is possible to conjecture, as Tracey does, that the same man carved all of these images, the variations in style, as well as skill, within the dragons alone would suggest otherwise.

60 Grossinger, *World Turned Upside Down*, p. 78.
61 Jean Leclercq, *Monks on Marriage: A Twelfth-Century View* (New York: Seabury Press, 1982), p. 61.

N14 – Main image: Pelican in her piety, supporters: Foliate

The pelican in her piety is a classic christological image that, as Bond notes, 'occurs in endless profusion in the bosses of vaults, in stained glass, on misericords and elsewhere'.[62] The telling of the tale varies slightly, with either the pelican cutting her own breast to bring her dead babies back to life with the nourishment of her blood, or simply using it to continue to feed them. Whichever the variation, the allusion to salvation through the blood of Christ is clear. In the Manchester variant, it is quite a thin-necked bird with a very round and very large eye. The resemblance to an actual pelican is small, but that is typical of the motif. Two chicks have lost their heads.

N15 – Main image: Angel with shield, supporters: Foliate

A pair with S12, there are nonetheless a few variations between the two angelic presences. While both are excellent, if anything this is the better of the two. The wings are more convincingly carved, the curve and play of feathers better managed. The hair, while still curly, is less like a judge's wig and the face is friendlier. The shield in this case is a simple cross, probably of St George.

By way of conclusion, we offer a thought beyond what the images represent and what they may have meant to those viewing them in their historic context. As examples of late medieval art, or simply as objects of art with no further context, the best of these carvings are exquisite. In each there is life captured by the carvers' hands, a flight of imagination sparked, and a necessity instilled to return again and again to look afresh. In their day, these carvings were hidden away in the dark recesses, designed to remind the monks to be on guard against the ills of humanity. Now they stand testimony, like the Cathedral around them, not to humanity's ills, but to its vivacity and its talent.

62 Bond, *Misericords*, p. 45.

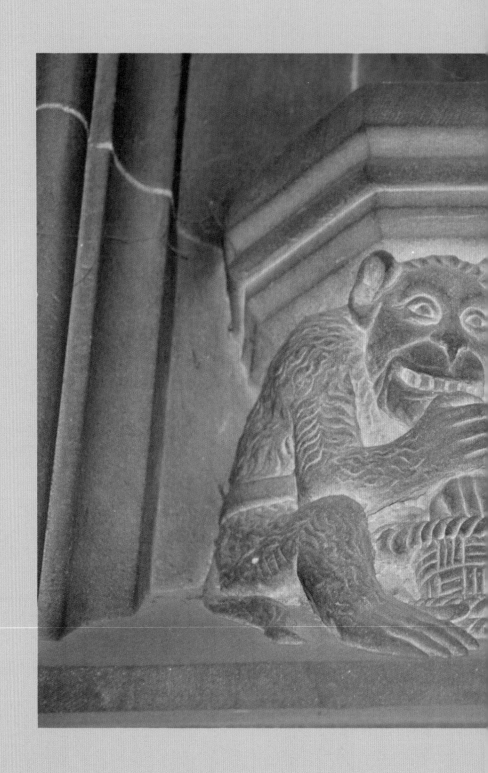

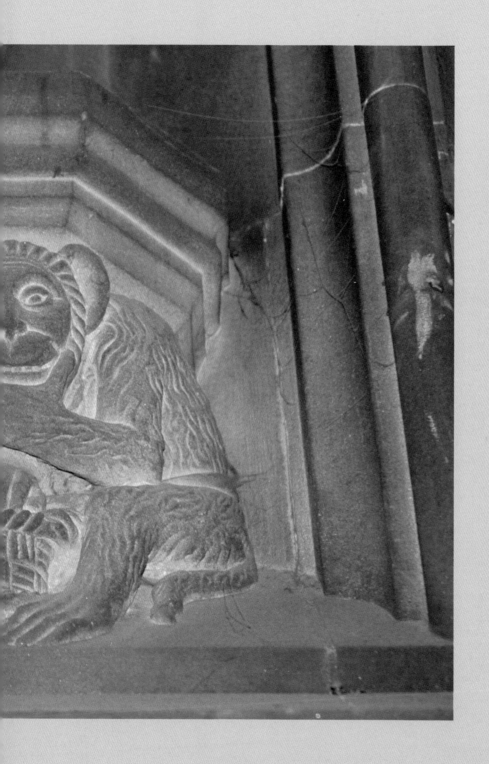

✜ 13 ✜

Stained glass

MARION McCLINTOCK

T HE CATHEDRAL'S INTERNAL FITTINGS include an important and growing collection of modern stained glass, all dating from the 1960s onwards. This chapter briefly sets the scene for the collection, describes each of the windows containing stained glass, and considers future opportunities.

To understand the significance of the collection, it is important to see stained glass in the context of medieval places of worship, where stained glass took its place alongside stone sculptures, exquisite woodwork, iron and metalwork, mosaics, and rich tapestries. These artefacts, dedicated to the glory of God, portrayed biblical and other religious stories for the purposes of both teaching and worship. We forget how rich in colour and imagery pre-Reformation churches were. Stained glass, in which pre-shaped pieces of glass using fired colour are held in lead cames that in turn rely on the stone surround of the lights of a particular window for stability and framing, combines artistry with the highest engineering skills. Stained glass windows, as the most potent continuation of pre-Reformation splendour, combine sacred imagery with wonderful designs that, illuminated by natural light, bring churches and cathedrals to vivid life.

The use of stained glass was largely discontinued in churches after the Reformation, and much of what had been in place was destroyed, particularly during the Civil War. We are indebted to the Revd Henry Hudson for gathering together and transmitting what information there is about early stained glass at Manchester.[1] Drawing on the survey by Richard Hollingworth (fellow of the Collegiate Church 1643–56), in turn augmented by Samuel Hibbert-Ware's *History of the Foundations of Manchester*

[1] H. A. Hudson, 'The Ancient Glass of the Cathedral Church of Manchester', *TLCAS* 25 (1908), pp. 119–45, including helpful colour plates.

Previous spread: Monkeys

(3 volumes, 1828–33), we learn of richly painted windows. These include the east window of the south aisle depicting Michael and the nine orders of angels fighting the dragon, and the east window of the north aisle showing St Austen and St Ambrose singing the *Te Deum*. In the clerestory range were images of the Virgin Mary in each middle stanchion, and along the north side were representations of Christ's arrest and crucifixion (the Passion window). Windows representing St John the Baptist and Christ were to be found in the chapel of that name (now the Regimental chapel).

The destruction during the Civil War was not complete, and remnants of glass remained in place. The construction of galleries, commencing with Humphrey Booth of Salford in 1617 and concluding with the Strangeways gallery of 1660, no doubt obscured the windows and made them less liable to alteration. A rather controversial step in the 1830s by the Archdeacon of Stowe and curate of Messingham Church, Lincolnshire, the Venerable William Brocklehurst Stonehouse, was to use his Manchester connections to procure some fragments from the Collegiate Church. These pieces of light tinted, yellow glass were installed in the east window at Messingham, and in the south aisle, including broken inscriptions and parts of some figures, where they remain to this day. While we may not approve of such cavalier treatment of ecclesiastical treasures, these actions ensured that at least some small pieces of original Manchester glass remain to us. Speculation continues, but without any certainty, about what other pieces might have been similarly rescued, some of which could still be extant.

After the Collegiate Church's elevation to Cathedral in 1847, much restoration work took place internally and externally. There are just two clues about whether stained glass was involved. Hudson refers to the repair of all windows with new mullions in 1845, and to the arrangement of figure subjects of modern glass inserted in some windows in 1866 and 1869.[2] The second indication, about the design of the east wall of the quire looking into the Lady chapel, is a black and white photograph that forms a frontispiece to the 1910 *Transactions of the Lancashire and Cheshire Antiquarian Society*.[3] This illustration shows the lower section of the east window and interior windows of the Lady chapel completely filled with stained glass figures of characteristic nineteenth-century design, none of which are extant today. When the Luftwaffe bombs of 23 December 1940

2 *Ibid.*, pp. 127, 130.
3 'East Wall of Choir, Manchester Cathedral', *TLCAS* 28 (1911), frontispiece.

severely damaged the Cathedral, presumably these were among the windows that were all blown out by the blast.

The Dean, the Very Revd F. Garfield H. Williams, was in the habit of staying at the nearby Mitre Hotel when bombing was expected. He was on the scene that night, and by the next morning Hubert Worthington, the Cathedral architect, visited the building and began the extensive work of restoration that continued until 1955.[4] Worthington's decision about the windows was to use panels of clear or slightly tinted glass, known as Norman slab glass, from Sunderland,[5] rather than attempt any stained glass. The single exception was the restored east window of the 1940s (see below).

By the 1960s, however, a different approach was taken. The Fire window (see below) was the first indication of a new approach to stained glass at the Cathedral, and for the first time made use of abstract rather than representational design. In 1970, an offer of funding came from the Anderson family for at least one new window, and the chapter commissioned a study by the then Cathedral architect, Harry M. Fairhurst, in conjunction with Antony Hollaway ARCA, to examine what policy to follow. Fairhurst and Hollaway examined light levels in the building, the liturgical uses of the space, and the different approaches required for different elevations; cool for the south face, warmer for the north, and potentially stronger and darker colours for the west to manage the glare from that direction. A 1988 sketch shows the plan that they developed, as amended part way through the project.[6]

The scheme that was followed for the east and west windows, described below, draws on some of the earlier suggestions. The description first details the windows of the east facade, moving from left to right (north to south).

The Fire window, commissioned without the benefit of a defined scheme, was installed in the rebuilt east window of the Regimental chapel (formerly the chapel of St John the Baptist and then the Derby chapel). It was paid for by officers of the Manchester Regiment and dedicated on 5 July 1966 in

4 Manchester, Manchester Cathedral Archives, Martyn Coppin, 'Proposal for a new stained glass window: East end, north quire aisle' (Manchester Cathedral for the Cathedrals Fabric Commission for England, December 2014), contains a valuable summary of history and policy relating to the Cathedral's stained glass windows.

5 Arthur J. Dobb, *Like a Mighty Tortoise: A History of the Diocese of Manchester* (Littleborough: Upjohn and Bottomley, 1978), pp. 50, 53.

6 Manchester Cathedral Archives, 'Plan of subjects', from Harry M. Fairhurst, 'Position Report on Windows' (1988).

Hazel Margaret
Traherne, Fire
window

Michael Taylor,
'Red' (Fire window)

commemoration of Manchester's part in two World Wars and in memory of Sir Hubert Worthington, whose eighty-sixth birthday it would have been. The design was by Hazel Margaret Traherne (1919–2006), a textile and stained glass artist who over a long creative life concentrated increasingly on the use of colour as her primary focus. She worked with many leading twentieth-century artists, including Basil Spence at Coventry Cathedral, where in 1961 she produced ten *dalles de verre* windows for the Chapel of Unity that explored colour alone for the first time. The window design, across five lights and the Perpendicular style tracery above, deploys a colour range from lemon yellow and vermillion to deepest red, and vividly depicts the form of flames and the intensity of fire.[7] A prize-winning photograph by Michael Taylor of 2018 brings out the subtlety of the design, including the variation in intensity of colour and the relative opaque and transparent qualities of different sections.[8] The window was damaged in the IRA bombing of 15 June 1996 and Traherne personally supervised its repair, using German glass.

[7] Manchester, MCM, FC30(a), Shelf 3.2.
[8] 'Capture the Cathedral Winner announced!', *Manchester Cathedral News*, August 2018, p. 8.

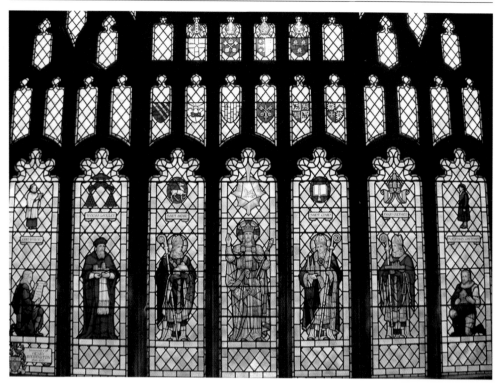

Gerald Smith,
east window (detail)

The Hope window, by Alan Davis, was installed in the five-light window of the north-east quire aisle in 2016, and is dedicated to the character and vibrancy of Manchester, as a place where young people can grow and flourish. The patron was The Oglesby Charitable Trust, founded by Jean and Michael Oglesby, and the window was dedicated on 6 December 2016. Davis drew attention to the theme of

> growth and regeneration, including tree and flower forms which move upwards through the central lancet. There is a pattern of woven fabric, relating to the textile industries and to the concept of God as "weaver" of the universe. The tilted cross in the centre of the window symbolises Christ's final journey, while the angle adds dynamism, a sense of forward movement.[9]

Visitors take particular pleasure in identifying the presence of the Manchester bee in the design, a motif also picked up in the recently installed liturgical furniture in the nave.

9 'The Dedication of the Hope Window', Manchester Cathedral order of service, 6 December 2016, p. 4.

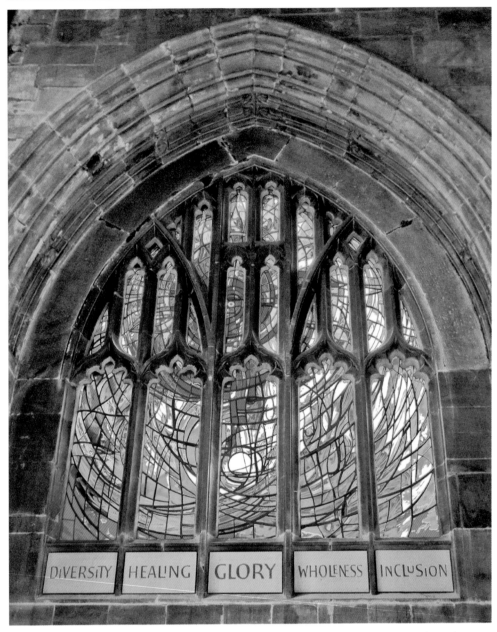

Linda Walton,
Healing window

The east window, positioned above the east wall of the Lady chapel, was part of the rebuilt east facade after 1945, in a window with seven short lights and Perpendicular-style tracery above. The artist was Gerald Smith (1883–1959), whose background was in in the A. K. Nicolson Studios, and is in a traditional style of the late nineteenth or early twentieth centuries. The design was in memory of Henry Boddington (1849–1925), and depicts seven figures; John

Linda Walton,
Healing window

Byrom, Thomas Langley, St Aidan, Christ in Majesty, St Chad, Hugh Oldham, and Humphrey Chetham. Some shields and other motifs are clustered in the tracery above, set in plain glass. Within the Lady chapel to the east of the east window, the high-level windows to north and south include some lettering designed by David Peace (1915–2003), a town planner and distinguished glass engraver, following in the tradition of Eric Gill.

✠ **455** ✠

Mark Cazalet,
Fraser chapel
window

The Healing window, by Linda Walton, was installed in the five-light window of the south-east quire aisle in 2004, above the east door, which was formerly a workman's door of *c.* 1900. The abstract design relates to the renowned medical endeavours and industry of the city of Manchester and expresses thanksgiving for doctors, nurses, and all involved in the ministry of healing. Smaller panels at the bottom of each light carry the words: 'Diversity, Healing, Glory, Holiness, Inclusion.' The patron was Dr B. Anthony Enoch (d. 2019), and the window was dedicated on St Luke's Eve, 14 October 2004.[10]

The Fraser chapel window completes the fenestration of the east facade. The chapel, built in 1890, is dedicated to the second Bishop of Manchester, James Fraser, and was commissioned by his widow. There is panel of stained glass at the base of the window, across three lights. Designed by Mark Cazalet (b. 1964) and entitled 'Flight', it shows the dove returning to the ark with a branch in its beak. The window was dedicated on Advent Sunday, 2 December 2001.[11] A reredos in the chapel was designed by the same artist.

10 MCM, CO.1/1197 and 1197(a), Shelf 3.2.
11 MCM, CO.1/1092(a), Shelf 3.2.

It is to Antony Hollaway (1928–2000) that the credit belongs for the chief glory of Manchester's stained glass, in a suite of five windows at the west end of the Cathedral that were installed in the period from 1972 to 1995. Hollaway was a painter, muralist, and art teacher, who had already worked on commissions in

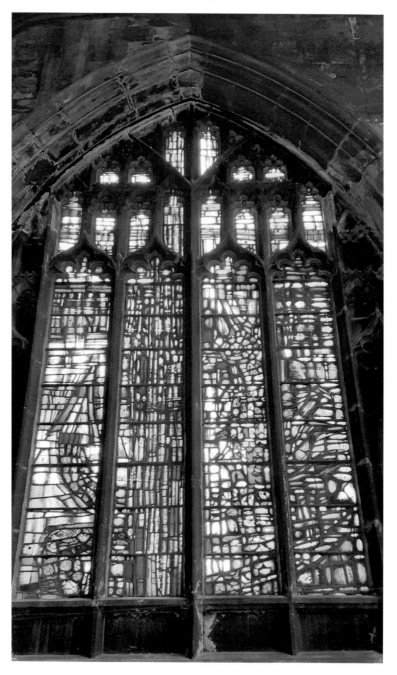

Antony Hollaway,
St George window

Cheshire and Liverpool before coming to Manchester. In 1963 he set up his own small company to facilitate his work.

The scheme across the west wall windows includes three that mark the triple dedication of the former Collegiate Church in 1421 to saints George, Mary, and Denys; these three are flanked to south and north by two further depictions, of the Creation and of Revelation. There are recognizable forms and symbols within complex designs that reward constant return, coupled with exquisite control of many hundreds of pieces of glass. As Clare Hartwell observes, the pieces of glass are 'grouped and accumulated so that colour families are created from pieces of varying hues and shades. The lead-work is an integral part of the composition, used to create shape and movement. For these characteristics, Hollaway is surely heir to the Arts and Crafts tradition.'[12]

The first window to be completed, for St George, was funded by Mrs Frances Anderson in memory of her husband, and the other four by the Friends of Manchester Cathedral. The five windows, working from left to right (south to north) across the west facade of nave and tower, are as reproduced above.

The baptistery was built in 1891–92, complete with an additional window that has six lights. The theme of the window is creation, with references to the Genesis story of the six days in which God created the firmament and fixed two lights in it, the sun to rule the day and the moon to rule the night, the signs of the seasons, symbols of man and woman, and indications of flying forms and a serpent. The forms are complex but are held under control to produce a vision of order forming out of chaos, and there is a richness and variety of colour and form that creates a sense of movement and intense vitality. The window was dedicated by the Dean on the Feast of St Peter, 29 June 1991.[13]

The St George window is set in the original nave fabric and has four lights. This was the first of the five designs, of 1972, and is the most directly representational of them. The design includes the white cross of Christianity and the red cross of St George superimposed on a dragon form with prominent tail, scales, and eye. The story of St George, although he is the patron saint of England, originates in the Middle East and is now recognized as having reached this country through the Crusades. The window was dedicated on 1 October 1972.

12 Clare Hartwell, 'Stained Glass', in Paul Dobraszczyk and Sarah Butler (eds), *Manchester: Something rich and strange* (Manchester: Manchester University Press, 2020), p. 72.
13 MCM, CO.1/810(a), Shelf 3.2.

Antony Hollaway,
Creation window

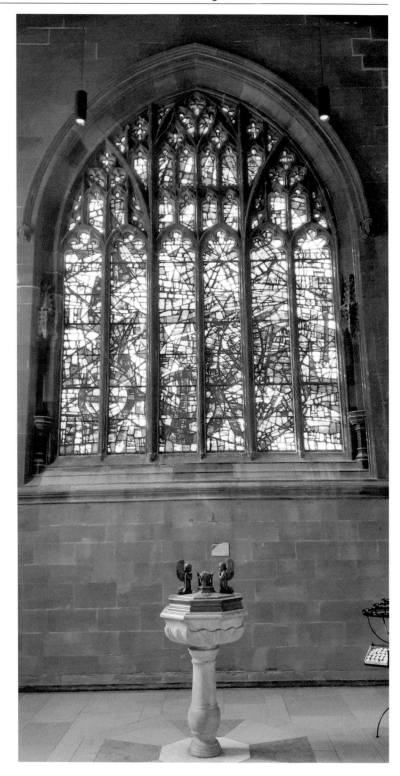

The window to St Mary is the central window of the five, set back and elevated above the others as part of the rebuilt tower, completed in 1868. The window is of five lights, divided by a prominent transom. Because of both its position in the scheme, and the significance of the Virgin Mary as Mother of God, particular care was taken to emphasize the monumentality and dignity appropriate to the architecture and to the original patron saint of the church's earliest foundation. A large circle in the upper tier of lights, the ancient symbol of Christian perfection, is symbolically marred by the death of Jesus in the form of a white shaft of light, representing a sword. There are seven shades of blue within a circle bounded by arcs of red and yellow.

Antony Hollaway,
St Mary window
seen through
doorway at night

Superimposed on these blocks of colour are letter forms that can be assembled to read verses from the Magnificat. The use of letter forms was subsequently carried through in the design of the Stoller Organ that faces the St Mary window across the Nave. The window was dedicated on 22 May 1980.[14]

The St Denys window is also set in the original nave fabric, and has five lights, again divided into two by a heavy transom. The design complements that for St George. The large circle in the upper tier of lights represents the martyrdom in Paris, early in the fourth century, of the Italian priest and his two deacons, St

14 MCM, CO.1/711, Shelf 3.2.

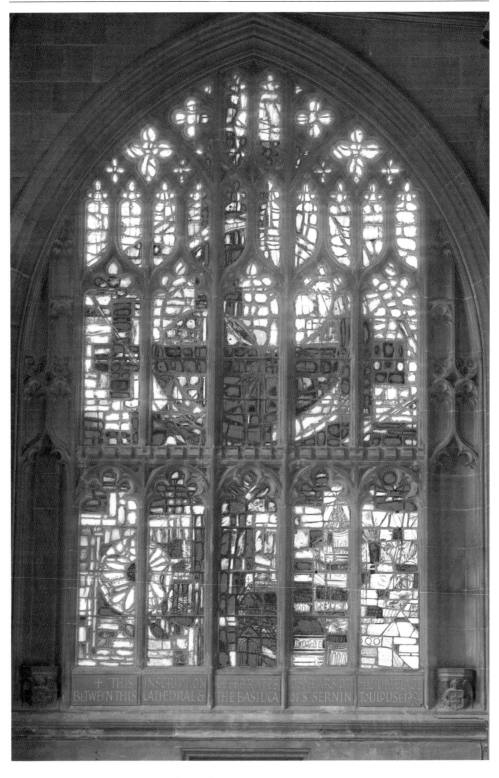

Facing page:
Antony Hollaway,
St Denys window

Eleutherius and St Rusticus. St Denys became the patron saint of France, and the whole design is supported by the Cross of Lorraine. Below the window is a metal panel bearing the following words: +THIS / INSCRIPTION / CELEBRATES / 25 YEARS OF / THE JUMELAGE / BETWEEN THIS / CATHEDRAL & / THE BASILICA / OF ST SERNIN / TOULOUSE 1994. The window was dedicated by the Bishop of Manchester on 4 September 1976.[15]

The Revelation window, the last to be completed, is also the largest, with seven lights. It is located in the outer north aisle. The design, drawing on the mysteries of the Book of Revelation, is also the most abstract of the five, and relates to the stones of the heavenly city. The intense blue of the panel near the centre of the composition touches on Wassily Kandinsky's colour of eternity, drawing the spectator into worlds as yet unknown. The design, although on the largest scale of the five and extending into the intricate Perpendicular tracery, uses the device of myriads of small, quasi-rectangular pieces of glass held within delicate cames to make a tapestry-like effect that rewards steady and intense exploration. The formality of the relationships between the blocks of design across the window makes an interesting comparison with the exuberance of its next nearest companion in time, the Creation window. It is the work of a superbly confident and technically brilliant craftsman and artist. The window was dedicated by the Dean of Manchester on 4 November 1995.[16]

The five windows taken together, and particularly when considered chronologically, display a creative imagination that was continuing to develop and mature. Hollaway's early death in 2000 deprived the Cathedral of the opportunity to consider designs for some of the additional two dozen windows of the south and north facades. At the time of writing, these windows, in their clusters of two or three that mark former chantry groupings, remain with the plain glass inserted in the 1940s. The exception is the single window of the former St James's chapel in the centre of the north wall, in a rather forbidding dark green. Whether additional stained glass windows are added in the future will depend on the generosity of patrons, allied to the ability of further stained glass artists to match the quality of the best of the existing windows to east and west.

15 MCM, CO.1/670, Shelf 3.2.
16 MCM, CO.1/835, Shelf 3.2.

Index